D1158119

CONSTANTINE THE GREAT

CONSTANTINE THE

York's Roman Emperor

Edited by Elizabeth Hartley, Jane Hawkes, Martin Henig with Frances Mee

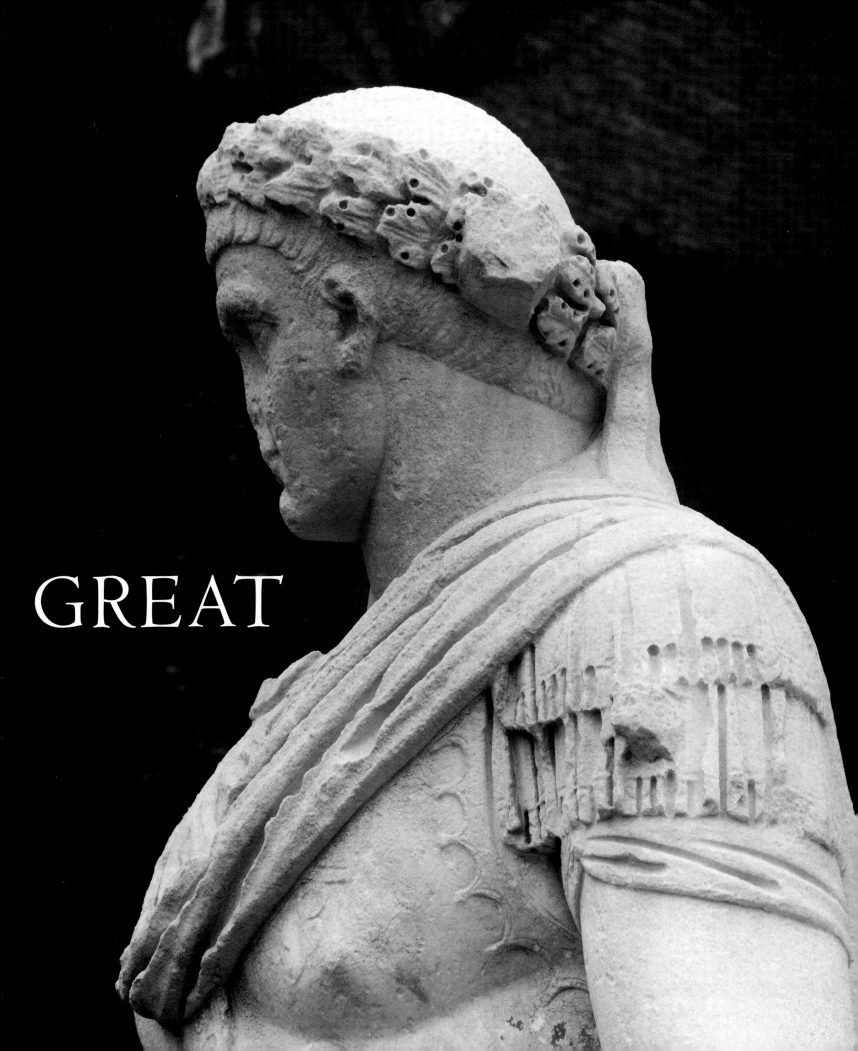

GREAT

First published in 2006 by

York Museums and Gallery Trust
St Mary's Lodge
Marygate
York YO30 7DR

Company Registration No. 4381647
Registered Charity No. 1092466

in association with

Lund Humphries
Gower House
Croft Road
Aldershot
Hampshire GU11 3HR

and

Suite 420
101 Cherry Street
Burlington
VT 05401-4405
USA

Lund Humphries is part of Ashgate Publishing

www.lundhumphries.com

Constantine The Great: York's Roman Emperor
© 2006 York Museums Trust

Published on the occasion of the exhibition
Constantine the Great – York's Roman Emperor
at the Yorkshire Museum, Museum Gardens,
York YO1 7FR
31 March – 29 October 2006

Texts copyright © the authors

British Library Cataloguing-in-Publication
Data
A catalogue record for this book is available
from the British Library

Library of Congress Control Number
2005921566
Hardback ISBN 0 85331 928 6
Paperback ISBN 0 905807 21 9

Designed by Sally Jeffery
Printed in Slovenia under the supervision of
Compass Press Ltd

Illustration, previous page: Statue of
Constantine, Rome

YORK MUSEUMS AND GALLERY TRUST

The York Museums and Gallery Trust ("York Museums Trust") was established in August 2002 to manage the York Castle Museum, Yorkshire Museum and Gardens, York Art Gallery and York St Mary's, all of which were formerly managed by the City of York Council. The Trust cares for the collections and manages the buildings that they occupy, working in partnership with the City of York Council to improve the museums and gallery for local residents and visitors to the city.

PREFACE

In 2001 the Yorkshire Museum mounted a major exhibition on Alcuin, as one of five exhibitions across Europe celebrating aspects of Charlemagne respectively in Paderborn, Barcelona, Brescia, Split and York. This year the York Museums Trust is proud to mount an exhibition on an even more ambitious scale on Constantine the Great, as one of a series of three exhibitions on the same theme involving also the cities of Rimini in Italy (2005) and Trier in Germany (2007). These exhibitions differ significantly in focus and content and only a few objects will be seen in all three – one of which is the marble head of Constantine from York. Together and separately they constitute a significant contribution to our understanding of a crucial episode in our own history.

My fellow trustees and I are delighted that this exhibition has been made possible. We are deeply indebted to our financial supporters, to the team of academic advisers, to our lenders from Britain, Germany and the Netherlands, and to our own staff. All of these are listed elsewhere in this publication.

It remains only for people to come from far and wide to benefit from this unique opportunity, to enjoy the exhibition and to share in the celebration of a seminal moment in European history: the day when Constantine was proclaimed Emperor in York on 25 July 306.

Robin Guthrie

Chairman

CONTENTS

FOREWORD

Constantine the Great: York's Roman Emperor would be an ambitious project for any museum to organise. For York Museums Trust, established in 2002, it is an indication of our aspirations for the Yorkshire Museum and its central role in contributing to the cultural profile of York.

Constantine the Great was proclaimed Emperor in York on 25 July 306. The exhibition celebrates the 1700th anniversary of this significant event which resulted in Constantine turning the history of the world on a new course. Under his rule the persecution of Christians was ended and religious tolerance was permitted, with Christianity being legitimised within the empire for the first time.

Constantine the Great: York's Roman Emperor is a major loan exhibition bringing together over 270 objects from the late Roman world, loaned from 36 museums across the UK and Europe.

The idea of the exhibition was suggested by Elizabeth Hartley who, as the Curator of Archaeology, was keen to mark the anniversary with an exhibition and scholarly catalogue. The project was supported with great enthusiasm by Robin Guthrie, who as the Chairman of York Museums Trust, championed the project from the outset.

Anyone who has been involved in organising such a project knows the time, commitment and costs involved in mounting a major international exhibition with a fully researched and illustrated publication. Elizabeth Hartley took on the task as the Curator of the Constantine Project and has worked tirelessly in researching and selecting all the items for the exhibition as well as overseeing the production of this beautiful and informative book.

We are very grateful to all the contributors of the essays and the catalogue entries, who have been drawn from specialists working in both museums and universities. In particular our warmest thanks go to Professor Averil Cameron who has played a key role in the whole project and without whose support the project would not have been possible. We are also grateful for the collaboration of Lund Humphries Publishers in the preparation and production of this book.

It has been very encouraging that from the start of the project we have had much interest and willingness on the part of museums to help with loans and illustrations. The British Museum has been a great support with the loan of very important objects. Through the British Museum UK Partnership of which York is the lead partner for Yorkshire, it has also been able to help financially through the Dorset Foundation.

The Victoria and Albert Museum, British Library, Museum of London as well as the Fitzwilliam Museum and Ashmolean Museum and the National Museums of Scotland have also kindly lent important objects. We have also been exceptionally fortunate in that many smaller museums throughout the country have released their significant Roman works for inclusion in the exhibition as well as private lenders. Finally, although the loans from the Netherlands and Germany, particularly Trier, are a numerically small part of the exhibition, their importance is such that they add a major dimension to the exhibition, for which we are very grateful.

We have been fortunate in securing major grants from the Heritage Lottery Fund, The Foyle Foundation and The Henry Moore Foundation as well as local trusts supporting both the publication and the exhibition. Our supporters are listed on page 8 and we take this opportunity to thank them all for their support and contribution in helping to make this happen. The Constantine project has been welcomed in the city of York and supported as one of the most important events during 2006. We are especially pleased that the Shepherd Building Group agreed to be our main Business Sponsor of the project.

Finally, I would like to thank and congratulate all my colleagues who have worked in a wide variety of capacities to make this project a reality. The early commitment of the Trustees to the project before the funding was in place and their faith in the importance of the idea and our ability to make it happen have been central to its success.

Janet Barnes
Chief Executive

FINANCIAL SUPPORTERS

Exhibition

Anonymous benefactors

City of York Council

Constantine Ltd

Dorset Foundation

The Henry Moore Foundation

Heritage Lottery Fund

The Joseph Rowntree Foundation

Shepherd Building Group

The Foyle Foundation

York@Large

Publication

Anonymous benefactors

The Earl Fitzwilliam Charitable Trust

The Paul Mellon Centre for Studies in British Art

R M Burton Charitable Trust

The Roman Research Trust

The Sheldon Memorial Trust

Yorkshire Philosophical Society

LIST OF LENDERS

The following individuals and institutions have lent objects to the exhibition *Constantine the Great: York's Roman Emperor*, Yorkshire Museum, York, 31 March to 29 October 2006. The catalogue number of each object is given after the lender's name.

Germany

Bonn, Rheinisches Landesmuseum Bonn: 69, 123–4, 141

Cologne, Römisch-Germanisches Museum der Stadt Köln: 61, 81, 122, 134

Trier, Bischöfliches Dom- und Diözesanmuseum Trier: 105, 140

Trier, Rheinisches Landesmuseum Trier: 73, 97–104

The Netherlands

Leiden, Rijksmuseum van Oudheden: 139, 232

Utrecht, Geld en Bankmuseum, Utrecht: 76, 79

Private collections

The Content Family of Ancient Cameos. Property of Philippa Content: 75

Governors of the Dr Pusey Memorial Fund, The Principal and Chapter, Pusey House, Oxford: 112–3

United Kingdom

Bath, Roman Baths Museum & Pump Room, Bath and North East Somerset Council: 74, 131

Cambridge, Syndics of the Fitzwilliam Museum: 72, 96

Cambridge, University Museum of Archaeology and Anthropology: 144–5, 149, 191

Canterbury, Dean and Chapter of Canterbury and the Parochial Church Council of Reculver: 267–72

Carlisle, Museums and Arts Service, Carlisle: 2, 118–20, 183, 192

Chesters Fort, English Heritage (Trustees of the Clayton Collection): 8, 180

Cirencester, Cotswold Museum Services, Corinium Museum: 154–5

Corbridge, English Heritage (Trustees of the Corbridge Excavation Fund): 179

Dewsbury, The Minster Church of All Saints: 273–5

Dorchester, The Archaeological Collections of the Dorset Natural History and Archaeological Society at the Dorset County Museum: 135, 182, 193

Edinburgh, Trustees of the National Museums of Scotland: 148, 234–66

Hull and East Riding Museum, Hull Museums and Art Gallery: 138

Lincoln, The Collection: Art and Archaeology in Lincolnshire: 194

Liverpool, National Museums of Liverpool (World Museum Liverpool): 137, 230

London, Trustees of the British Museum: 3–6, 11–33, 35–40, 42, 45–60, 77–8, 82–9, 91–5, 114–5, 121, 125, 159–68, 184–6, 190, 196–227

London, British Library Board: 10, 231, 276

London, The Egypt Exploration Society: 1

London, Museum of London: 175–7, 181

London, Board of Trustees of the Victoria and Albert Museum: 80, 111, 116–7, 169–74

Malton Museum Foundation, Malton Museum: 129, 132, 156–7

Manchester, The Whitworth Art Gallery, University of Manchester: 233

Newcastle upon Tyne, Museum of Antiquities of the University and Society of Antiquaries of Newcastle upon Tyne: 65–8, 70–1, 188

Newcastle upon Tyne, Tyne and Wear Museums: 62–3, 133

Nottingham, University of Nottingham Museum: 195

Oxford, Visitors of the Ashmolean Museum: 34, 41, 43–4, 90, 142–3, 146–7, 150–2, 158, 178, 187, 228–9

Shrewsbury Museums Service: 64, 136

Wimborne, The Priest's House Museum Trust, Wimborne Minster: 126–8

York Museums Trust (Yorkshire Museum): 7, 9, 106–10, 130, 153, 189

CONTRIBUTORS TO THE CATALOGUE

The following have contributed to catalogue entries and are identified by their initials:

Richard Abdy [R.A.]

Lindsay Allason-Jones [L.A-J.]

Michelle Brown [M.B.]

H.E.M. Cool [H.E.M.C.]

Alex Croom [A.C.]

Thomas H. M. Fontaine [T.H.M.F.]

Karl-Josef Gilles [K-J.G.]

Hero Granger-Taylor [H.G-T.]

Elizabeth Hartley [E.H.]

Jane Hawkes [J.H.]

Hansgerd Hellenkemper [H.H.]

Catherine Johns [C.J.]

Martin Henig [M.H.]

Ralph Jackson [R.J.]

Ingo Maier [I.M]

William Manning [W.M.]

Martin Millett [M.M.]

Kenneth Painter [K.P.]

Sergio Rinaldi-Tufi [S.R-T.]

Lothar Schwinden [L.S.]

Friederike Naumann-Steckner [F.N-S.]

Roger Tomlin [R.T.]

Susan Walker [S.W.]

Winfried Weber [W.W.]

Roger J. A. Wilson [R.J.A.W.]

Conventions used in the catalogue

All dimensions are metric: H. = height, L. = length, W. = width, D. = depth, Th. = thickness, Dia. = diameter, Wt. = weight.

All dates are AD unless otherwise specified.

THE ROMAN EMPIRE

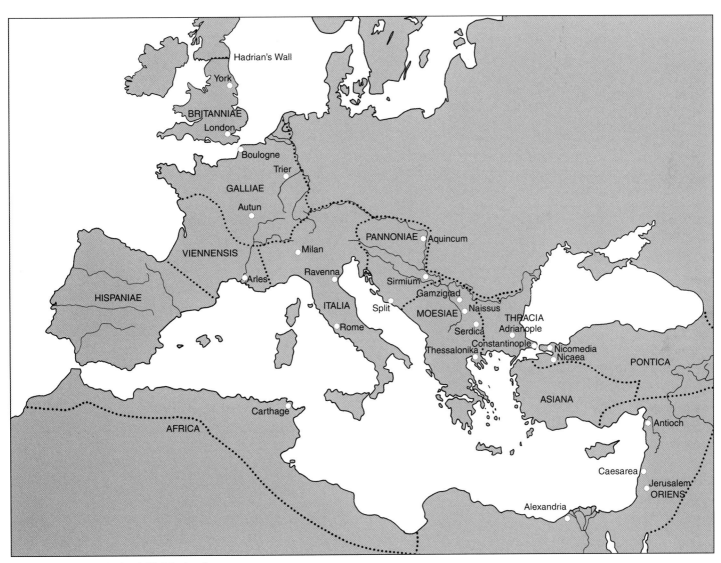

The Roman empire in the first half of the fourth century

Chronology

c.250 Birth of Constantius, father of Constantine, probably in Dacia Ripensis on the lower Danube (31 March); birth of Helena, mother of Constantine at Drepanum in Bithynia

c.272–3 Birth of Constantine at Naissus (28/27 February)

284 Diocletian proclaimed emperor at Nicomedia (20 November)

285 Diocletian defeats rival emperor Carinus in Pannonia and proclaims Maximian Caesar (Spring, early Summer); Maximian is based in the West, Diocletian in the East

286 Maximian made Augustus (1 April)

Carausius proclaims himself emperor in Northern Gaul and Britain (Autumn)

289 Constantius divorces Helena and marries Theodora, daughter of Maximian

293 First Tetrarchy inaugurated, with Constantius (at Milan) and Galerius (at Nicomedia) proclaimed Caesars subordinate to Maximian and Diocletian respectively (1 March)

Constantius captures Boulogne; Carausius murdered and replaced by Allectus

293–305 Constantine serves under Diocletian and Galerius in the East

296 Constantius recovers Britain, defeating Allectus and saving London from pillage

297 Panegyric VIII(5) delivered at Trier, celebrating Constantius's recovery of Britain (1 March)

297/8 Constantine participates in the Mesopotamian campaign of Galerius, who defeats Narses, King of Persia (Autumn) and enters Ctesiphon (28 January)

298 Diocletian captures Alexandria (Spring), and visits Upper Egypt (Summer/Autumn)

c.300 Lactantius summoned from Africa by Diocletian to be Professor of Latin Rhetoric at Nicomedia

301 Diocletian issues his Currency Decrees and Edict on Maximum Prices

301–2 Constantine accompanies Diocletian on progress through Syria, Palestine and Egypt

303 'Great Persecution' against the Christians starts at Nicomedia (23 February); enforced in Palestine from March and Africa from May

Diocletian celebrates his *vicennalia* in Rome with his colleagues Maximian and Constantius; Constantine is probably present in his entourage(20 November)

304 Diocletian collapses at Nicomedia (13 December)

305 Abdication of Diocletian and Maximian; inauguration of the Second Tetrarchy with Constantius (as senior) and Galerius promoted to be Augusti, and Severus (at Milan) and Maximinus Daza (at Nicomedia) appointed as the new Caesars (1 May)

Constantine flees from Galerius's court in the East, and meets his father at Boulogne; they cross to Britain; Constantius wins a victory over the Picts (Summer/Autumn 305)

306 Constantius dies at York and Constantine is proclaimed Augustus (25 July); he subsequently accepts the rank of Caesar from Galerius, now senior Augustus, who appoints Severus as Augustus

Maxentius usurps power in Rome (28 October); he summons his father, Maximian, from retirement to help him

c.307–316 Constantine makes Trier his principal base; campaigns against the Germans (c.307–310 and 314)

307 Severus defeated by Maxentius and Maximian; he abdicates at Ravenna (Spring)

307 Constantine is made Augustus by Maximian and marries his daughter, Fausta, at Trier; delivery of Panegyric VII(6) (September)

Severus is killed at Rome; Galerius enters Italy, but is forced to withdraw (Autumn)

Maxentius undertakes major rebuilding in the Forum at Rome after a severe fire; this is later completed by Constantine

308 Galerius holds a conference at Carnuntum, at which Maximian abdicates again, Licinius is appointed Augustus, and Constantine is re-admitted to the imperial college (11 November)

310 Maximinus proclaims himself full Augustus (May); subsequently Galerius accepts that all members of the imperial college are now Augusti; effective end of the tetrarchic system

Maximian's failed coup against Constantine, followed by his death at Marseilles (July)

Panegyric VI(7) delivered at Trier, which includes reference to Constantine seeing a vision of Apollo at Grand; Constantine claims descent from Claudius Gothicus (1 August)

311 Galerius's edict ending the persecution published at Nicomedia (30 April), and he dies soon after; Licinius and Maximinus divide his territory between them

Maximinus resumes persecution in the East (November)

311 or 312 Diocletian dies at Split (3 December)

312 Maximinus expels Christians from the cities (Spring)

Constantine invades Italy (Autumn), then wins battle of the Milvian Bridge, during which Maxentius is killed (28 October)

Constantine in Rome (October–January): he is made senior Augustus by the Senate; he grants restitution to Christians and to victims of Maxentius's rule; the Praetorian Guard is disbanded

Work begins on the Church of Christ the Saviour at the Lateran (9 November)

313 Constantine and Licinius meet in Milan and agree religious policy; Licinius marries Constantine's sister, Constantia; Constantine makes his first grant of privileges to Christian clergy (in Africa) (February)

Donatists in Africa petition Constantine (April)

313 Licinius defeats Maximinus at Adrianople (30 April)

Maximinus flees east; Licinius kills all surviving members of the other tetrarchic families (May)

Licinius publishes at Nicomedia full toleration and restitution for Christians as agreed at Milan (13 June)

Maximinus dies at Tarsus, after issuing his own edict finally ending persecution (Summer)

Council of Rome at the Lateran finds against the Donatists (October)

314 Council of Arles, with Constantine present, finds against the Donatists; the Bishop of York is one of three British bishops attending (1 August)

Constantine campaigns against the Germans

c.314–315 Lactantius writes *On the Deaths of the Persecutors*; Constantine appoints him tutor to his son Crispus in Gaul, mainly resident in Trier

315 Constantine in Rome for his *decennalia* (25 July); dedication of the Arch of Constantine

316 Constantine defeats Licinius at Cibalae (8 October); then occupies the Balkans

317 Crispus, Constantinus II and Licinius Junior proclaimed Caesars at Serdica (1 March)

321 Constantine suspends persecution of the Donatists (May)

Constantine's legislation on Sabbath/Sunday observance (July)

323 Constantine campaigns against the Sarmatians

324 Constantine defeats Licinius at Adrianople (3 July)

Constantine defeats Licinius at Chrysopolis (18 September); Licinius abdicates the next day at Nicomedia; Constantine is now sole Augustus

Foundation of Constantinople on the site of Byzantium; Constantius II proclaimed Caesar; Helena and Fausta made Augustae (8 November)

Constantine issues letter to the eastern provincials (December?)

325 Licinius executed at Thessalonica (Spring)

Constantine opens the Council of Nicaea; it fixes the calculation of the date of Easter, and makes the first attempt to settle the Arian controversy, establishing the Nicene Creed (June/July); he celebrates the opening of his *vicennalia* with the bishops at Nicaea (25 July)

325 Constantine orders excavations in Jerusalem to find the site of the Holy Sepulchre and then arranges for the construction of a church there

326 Dynastic tragedy with the deaths of Crispus (at Pola), Fausta and Licinius Junior (Spring/early Summer)

Constantine in Rome for the conclusion of his *vicennalia* (25 July)

Constantine endows St. Peter's, under construction at the Vatican in Rome, with property in the East

326–7 Helena leaves Rome (Summer 326) and journeys through the eastern provinces, including Palestine; under imperial patronage construction begins of the Church of the Nativity at Bethlehem and the Church of the Ascension at the Mount of Olives

Eutropia, Constantine's mother-in-law, travels to Palestine; her report prompts Constantine to suppress a pagan shrine and build a church at the Oak of Mamre

*c.***328** Helena dies at the court of Constantine; she is buried at Rome

Drepanum, her birthplace, is renamed Helenopolis

328–9 Constantine campaigns against the Germans

330 Dedication of Constantinople as Constantine's new Christian capital (11 May)

332 Constantine campaigns against the Goths

333 Constans, Constantine's youngest son, is proclaimed Caesar (25 December)

334 Constantine campaigns against the Sarmatians

335 Council of Tyre (July–September); immediately followed by the dedication of the Church of the Holy Sepulchre at Jerusalem, where Eusebius of Caesarea delivers his speech on the Holy Sepulchre (Tricennial Oration part 2)

Dalmatius, Constantine's nephew, is proclaimed Caesar (18 September)

Athanasius of Alexandria confronts Constantine at Constantinople, and is exiled to Trier (November)

336 Council of Constantinople; Constantine's *tricennalia* celebrated at Constantinople, where Eusebius of Caesarea delivers his panegyric (Tricennial Oration part 1) (25 July)

337 Constantine is baptized by Eusebius, Bishop of Nicomedia, and dies at an imperial property outside Nicomedia (22 May); he is buried in his mausoleum in the Church of the Holy Apostles at Constantinople; there is a hiatus in the imperial college as none of the Caesars becomes Augustus

Massacre of Constantine's brothers and nephews, including the Caesar Dalmatius (late summer)

Constantine's sons (Constantinus II, Constantius II and Constans) proclaimed Augusti (9 September)

339 Eusebius of Caesarea dies (30 May); *The Life of Constantine*, his last work, is published posthumously

Simon Corcoran

Introduction

Elizabeth Hartley

The story of Constantine the Great began in York. Had he not been in York with his father, the emperor Constantius, on 25 July 306, when the latter died, he would not have been handed the greatest prize – the right of succession to his father's title. Although we do not know exactly what happened on that day, it is clear that Constantine was extremely well prepared for the role he was taking on and he seized the opportunity offered him by fate in York.

Constantine's father had been promoted to the position of Caesar, a junior member in the imperial college, in 293 when Constantine would have been just over 20 years of age. This elevation ensured his son a place at the imperial court. But it was not his father's court at Trier in the West that Constantine joined, but that of the senior emperor, Diocletian, based principally at Nicomedia in Asia Minor. Here he would have received the training suitable for an imperial heir. He was taught rhetoric by the well-known Latin orator and poet Lactantius, campaigned with Galerius in Mesopotamia, and travelled with Diocletian through Palestine and Egypt, and probably even to Rome.

Thus trained for high office with the skills of both statesman and soldier, Constantine was fully prepared to seize the opportunity offered to him in York in 306, so that by 324 he had extended his power and become sole emperor of the Roman world. Nevertheless, Constantine attributed his success to divine favour following his decision to embrace the Christian faith in 312 before the Battle of the Milvian Bridge, just outside Rome.

In 324, in his letter to the Palestinians, he looked back on what happened:

> I, beginning from that sea beside the Britons and the parts where it is appointed by a superior constraint that the sun should set, have repelled and scattered the horrors that held everything in subjection, so that on the one hand the human race, taught by my obedient service, might restore the religion of the most dread Law, while at the same time the most blessed faith might grow under the guidance of the Supreme. (see cat.10)

Against this background it is interesting to consider the extent to which Constantine's proclamation in York in 306 might have affected the city. York, legionary fortress, *colonia*, and capital of Lower Britain for a hundred years, had become the capital of one of four provinces which made up the Diocese of the Britains in 296. This province was most likely known as Flavia Caesariensis, and hence named after Constantine's father Flavius Constantius as Caesar. It thus seems no accident that the larger-than-life-size marble head of Constantine should have been discovered in York in the area of the fortress near the headquarters building. The hall of the headquarters building was rebuilt under Constantius or Constantine and a statue of Constantine is likely to have been placed there. There are also still standing the monumental remains of the corner-tower of the fortress with its connecting curtain wall, which fronted the river. The magnificence and sheer scale of this frontage when complete suggest that it was built with imperial backing, suitable for the high status of York and its position as a place where emperors resided and major events took place.

The closest we can get to the power of Constantine is through such imperial images and monuments. From Trier, the afterglow of imperial splendour can be felt through the remains of his great audience hall, the Aula Palatina. There are also the surviving fragments from one of the painted ceilings of the palace: the portraits and figures of philosophers, dancing cupids and female personifications on this ceiling are of the highest quality, rich and strong in colouring, and strikingly three-dimensional in their modelling. From Rome, Constantine's colossal marble head, the bays and apse of his Basilica, and his magnificent arch alongside the Colosseum in Rome are lasting tributes to his power.

The personal effects of Constantine and his family, such as regalia, jewellery and arms and armour, do not survive. But associated with the emperors Constantius and Constantine are high-quality gifts, produced for those in their entourage and supporters, both civilian and military. Many of these donatives, given as public displays of largesse, were inscribed with the name of the emperor or

displayed his portrait. Among the items that survive are jewellery, medallions and plate.

For Constantine, 25 July became his 'day of power' (*dies imperii*), his accession day celebrated annually, although with special magnificence at the opening and closing of the fifth, tenth, twentieth and thirtieth years of his reign. On each occasion, there would have been great processions of the emperor and his family, speeches, chariot races in the circus and the dedication of buildings, statues and monuments. The Arch of Constantine was dedicated in 315 during his visit to Rome for the start of his tenth-year celebrations.

Although we lack details of Constantine's visits to Britain after his initial accession, coin evidence does suggest that he was there on more than one occasion during his first ten years in power. Almost certainly, York would have been one of the places to experience again an imperial *adventus* (arrival) and period of residence of emperor and court. What effect his elevation in York had on Britannia as a whole we shall never know. However, major finds in Britain provide evidence of the great wealth and prosperity sustained through the peace brought to the province by Constantius and Constantine.

The prosperity and stability evident in Britain and elsewhere throughout the empire at this time reflect the strength of leadership, commitment and vision of Constantine. He was emperor for 31 years, until his death in 337, the longest-serving emperor since Augustus, the first of the Roman emperors. Constantine chose to reinvigorate his empire by looking back to the imagery and artistic tradition of the age of Augustus. Later in his life he also looked back to the other great figure of the classical past: Alexander the Great. By choosing to model himself first on Augustus and then Alexander, Constantine was clearly expressing an image of his own destiny: he would be one of the great figures of history who would be remembered for all time.

With this sense of history and his role within it, Constantine moved with some caution during his long reign, being careful not to enforce sudden change and mindful to foster tolerance of belief. He legitimized Christianity and ordered the building of churches in Rome and elsewhere while at the same time allowing Judaism still to be tolerated and paganism with modifications to continue. The combination of endorsing new modes of thought, while allowing the classical traditions to continue, brought full expression of ideas and artistic imagery. Constantine played an active part in creating this golden age throughout the empire.

This exhibition looks as the late Roman Empire from a cultural point of view. It focuses on the art, with its richness of colour, texture and materials, and includes finely carved sculptures and cameos, medallions and decorated silver plate, brilliantly-coloured textiles and paintings and mosaics. The exhibition also takes full cognisance of all aspects of religious activity of the period. This massive cultural achievement and legacy could not have been possible without Constantine.

Figure 1 Head of Constantine (detail), Arch of Constantine, Rome

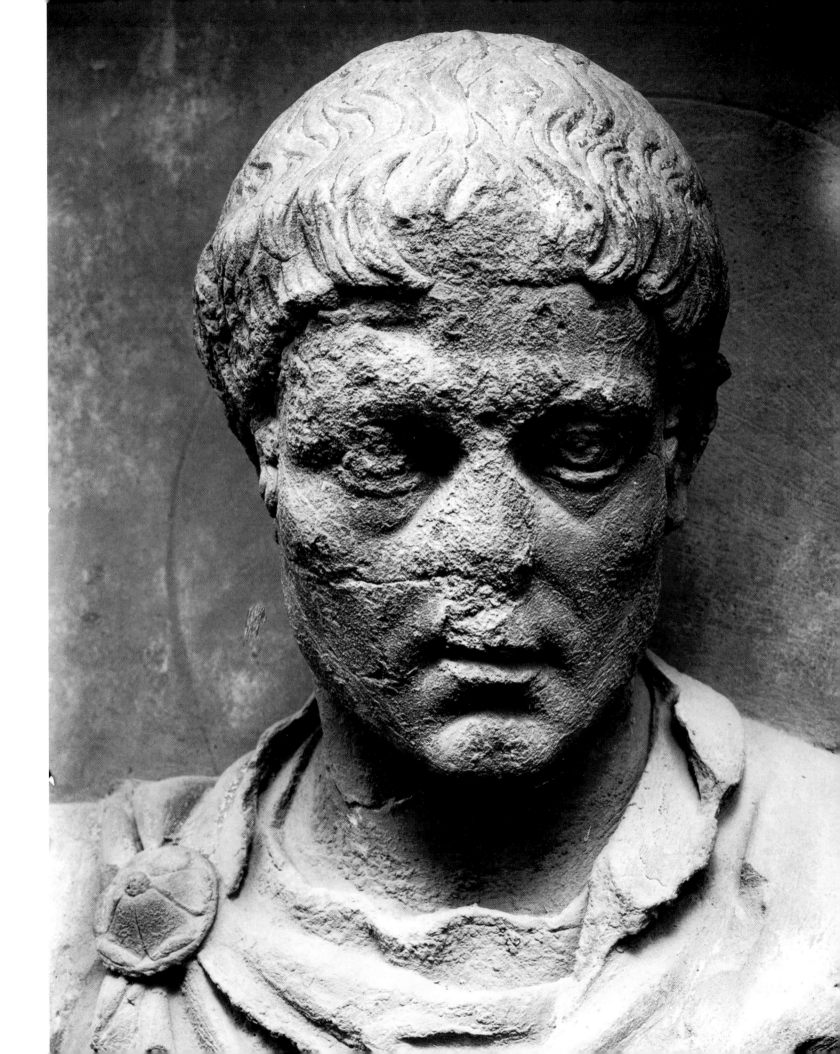

Constantius and Constantine: An Exercise in Publicity

Averil Cameron

On 25 July 306, outside the palace in York, the loyal troops of the recently dead Emperor Constantius I, known as Constantius Chlorus, hailed his son Constantine as emperor and successor.[1] Years later, when he finally became sole emperor of the whole Roman world, Constantine himself was to recall in typically ornate late Roman imperial style his proclamation in that distant territory, and the story of his own rule, 'beginning from that sea beside the Britons and the parts where it is appointed by a superior constraint that the sun should set'.[2] Eusebius, the bishop of Caesarea in Palestine, who quotes these words and who had never been to Britain, or indeed anywhere in the west, claims to have seen Constantine when the latter was travelling with the senior Emperor Diocletian through Palestine, probably in 301–2. Eusebius writes as a panegyrist: 'In handsome physique and bodily height he so exceeded his contemporaries as even to put them in fear; he took pride in moral qualities rather than physical superiority, ennobling his soul first and foremost with self-control, and thereafter distinguishing himself by the excellence of his rhetorical education, his instinctive shrewdness and his God-given wisdom'[3] (fig.2). In 310, Britain itself was imagined by a Latin panegyrist of Constantine to be blessed by Constantine's proclamation there: 'O Britain, fortunate and happier now than all lands to have been the first to have seen Constantine Caesar!'[4]

If Constantine was born in the early 270s, he would have been nearing 30 at the time of Eusebius's sighting.[5] He had been born at Naissus in Illyricum (modern Nish in Serbia), where his native language was Latin. However, he had spent the years since the age of about 20 mainly in the East, on campaign with the Roman army in Syria and Mesopotamia, and then in Egypt, with a visit to the Danube frontier in 299. He later recalled visiting the ruins of Babylon and Memphis,[6] as well as the start of the persecution of Christians in 303 in Nicomedia.[7] During this time, and until 305, he was a member of the entourage of Diocletian at Nicomedia in Bithynia and of his successor, Galerius, each of whom kept him close by his side ('a hostage', according to the *Origo*).[8] This control

over his son was perhaps a dynastic precaution designed to make sure Constantine's father Constantius stayed in line; after all, the vast geographical spread of the Roman Empire made it impossible to ensure the loyalty of a distant colleague, especially one who had spent much of the last decade suppressing usurpers in Gaul and Britain. But it also meant that the young man had an excellent training in the arts of rhetoric and in statecraft as well as in the military demands placed on future rulers.

The Christian writer Lactantius, a teacher of Latin at Nicomedia, has handed down a highly coloured tale of Constantine's 'escape'.[9] According to this version, repeated in several other sources, Constantius had become seriously ill and had written asking for his son to be sent back to him in the west. Galerius tried to prevent this and did his best to delay, but was outwitted by the young Constantine who left during the night and rode at breakneck speed all across Europe to join his father, reaching him just in time for the dying emperor to commend him and transfer imperial authority to him in person. When he wrote this account, Lactantius was already Constantine's apologist and the tutor of his son Crispus. Like Eusebius of Caesarea, he was at pains to show that Constantine had been a Christian from the earliest possible moment, and to gloss over any possible doubts about the legality of his elevation to the imperial purple by Constantius's troops. Moreover it is the purpose of the *De Mortibus Persecutorum* to blacken persecuting emperors such as Maximian and Galerius, who are portrayed as plotting against Constantius and his son. After 1 May 305, Constantius became emperor in the west, with Britain, Gaul and Spain as his sphere, while Galerius effectively controlled the whole of the east with his base at Serdica (modern Sofia) and had ambitions to become sole emperor. Constantine was conspicuously omitted from the new arrangements. It suited Christian writers to gloss over the slight and to represent Galerius, a persecutor of Christians, as attempting to deny Constantine his rightful future by refusing to reunite the son with the dying father, and thus to conceal or dissemble Constantine's own ambition.

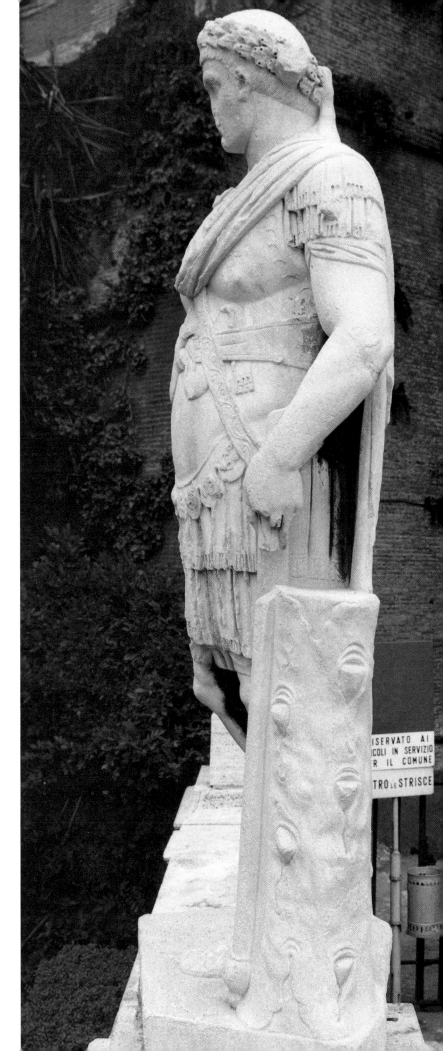

Figure 2 Statue of Constantine from the Baths of Constantine, Rome.

Constantine's panegyrist, speaking in 310, equally sought to exonerate Constantine from any charges of disloyalty, while fore-shortening Constantine's stay in Britain, though this time from a pagan perspective:

> For you were summoned even then to the rescue of the State by the votes of the immortals at the very time when your father was crossing the sea to Britain, and your sudden arrival illuminated the fleet which was already making sail, so that you seemed not to have been conveyed by the public post but to have flown in some divine chariot … Good gods, what felicity you bestowed upon Constantius Pius even on his deathbed! The Emperor, about to make his journey to heaven, gazed upon him whom he was leaving as his heir. For no sooner had he been snatched from earth than the whole army agreed upon you, and the minds and eyes of all marked you out.[10]

It was in fact clearly Constantine himself who, when he was publicly passed over as Caesar,[11] saw that his best hope of future power and future safety lay in joining Constantius in the west. Constantius's base was at Trier, and he had been occupied with campaigning in Gaul and Germany; in the winter of 304 he had been successful against German raiders who had crossed the frozen Rhine.[12] The Latin panegyric to Constantine of 310 makes it clear that Constantine did not reach his father only on his deathbed at York in 306 but that he had already joined him in 305 at Boulogne (Latin Bononia) and that they crossed from Gaul to Britain together. The *Origo Constantini* is equally clear, though it calls Constantine Caesar and not Augustus: 'he travelled with the utmost speed and came to his father Constantius at Bononia … After a victory over the Picts Constantius died at York and Constantine was made Caesar by the wish of the whole army.'[13] Constantine must have arrived at Boulogne late in 305, after a journey lasting perhaps two months. After crossing the Channel, father and son marched north in the winter of 305 and campaigned successfully against the Picts north of Hadrian's Wall, and by early January 306 Constantius and Constantine were hailed together by the title *Britannici*

Figure 3 Head of Constantius (detail), Arch of Constantine, Rome.

maximi.[14] It was months before Constantius's death on 25 July 306, and by then Constantine had had time to establish his credentials as the dutiful son and worthy successor.[15] Constantine's precaution had brilliantly succeeded. There was in any case no constitutionally established procedure whereby an emperor was made, and under the tetrarchy the succession was a matter of arrangements made behind closed doors. Constantine had been excluded from the decisions made in 305. But now he had made sure that he would be proclaimed by his father's troops, the best possible guarantee against the challenge that would certainly come.

Writing years later, Eusebius paints an affecting picture of the last moments of Constantius at York:

> he [Constantine] arrived after so long away at the very moment when his father's life was reaching its final crisis. When Constantius saw his son quite unexpectedly standing there, he rose from his couch, flung his arms round him and declared that his mind had been relieved of the only grief which had prevented him from setting life aside, which was the absence of his son; and he sent up a prayer of thanks to God, saying that he now considered death better than deathlessness, and duly set his affairs in order. He gave instructions to his sons and daughters, who gathered round him like a choir, and in the palace itself, on the imperial couch, he handed over his part of the Empire by natural succession to the senior in age among his sons, and expired.[16]

The deathbed scene over, Constantine emerged from the palace wearing the purple imperial robe and personally led the funeral procession, hailed by troops and people with the imperial title of Augustus.[17] Lactantius, writing only a few years after the event, in 314, merely says that Constantius 'commended Constantine to the troops and transmitted the imperial authority to him with his own hands'.[18] Writing decades later when Constantine was sole emperor, Eusebius has given his imagination full rein, not only emphasising the legitimacy of Constantine's succession and his filial piety but also creating a picture of close-knit family life, with Constantine's half-brothers and sisters grouped with him round their father's deathbed. When Eusebius put his last touches to the *Life of Constantine* this unity seemed fragile. The claim made here, like his statement that Constantius seemed to 'reign through' Constantine,[19] asserts a family continuity that Eusebius hoped would also extend beyond Constantine's own death into the reign of his three surviving sons.[20]

Who was Constantius? M. Flavius Valerius Constantius came from Illyricum and rose to power through the army, serving as *protector* and *tribunus* and then as *praeses Dalmatiarum* (governor of Dalmatia); by 288 he was praetorian prefect to the western Emperor Maximian. It was a classic military career for the late third century and proximity to Maximian led to adoption by him and to imperial power. Constantius cemented his relationship to Maximian by a dynastic marriage to Theodora, the latter's daughter or step-daughter, and was made Caesar to Maximian in 293.[21] The marriage to Theodora entailed putting aside Helena, who was the mother of Constantine. She had been his wife or concubine since before 270, but is said to have been of humble origin, a *stabularia*, landlady or barmaid of an inn, who came originally from Drepanum (renamed Helenopolis in her honour by Constantine) in Bithynia in Asia Minor.[22] Theodora bore Constantius six children, the younger half-brothers and sisters of Constantine.[23] In a curious parallelism, Constantius's son Constantine was also to put aside his first liaison with the mysterious Minervina, mother of his oldest son Crispus, in order to make a dynastic marriage in 307 with Fausta, the daughter of Maximian and Eutropia, by whom he had five more children.[24]

Constantius' influential position in the years before he became Caesar is revealed by a Latin panegyric of 297 in which the orator states that he owed his own introduction to the court of Maximian to Constantius, and that he had been on campaign with the latter in Germany against the Alamanni, from Mainz and across the Danube at Günzburg, perhaps in 287.[25] The panegyric itself was delivered at Trier on behalf of the city of Autun, in order to congratulate Constantius on his recovery of Britain for the Roman Empire by the defeat of the usurper Allectus in 296. The details of the events leading up to this success cover the rebellion and occupation of Britain from 286–7 by Carausius, a prefect of the fleet stationed at Boulogne and given the task of securing the Channel coast, alluded to in an earlier panegyric of Maximian from 289, and thus written when Carausius was still in control.[26] The latter rebelled against Maximian and declared himself Augustus in Britain and north-western Gaul in 286, styling himself consul in 287, 288 and 289 and minting coins.[27] The best that the panegyrist of 289 could do was to envisage the dread felt by Carausius in Britain as Maximian prepared an expedition to move north across the Channel; if this expedition did in fact take place, it did not succeed.[28]

In 293, in contrast, the new Caesar Constantius marched to Gaul and besieged Boulogne, got together a naval force and reconquered Britain, by now in the hands of Allectus. The siege of Boulogne and the campaign that followed form the set-piece of Constantius's career.[29] The panegyrist of 297 tells how he drove piles and sank stones into the water to make a mole at the entrance to the bay, effectively preventing the enemy's ships from leaving and barring

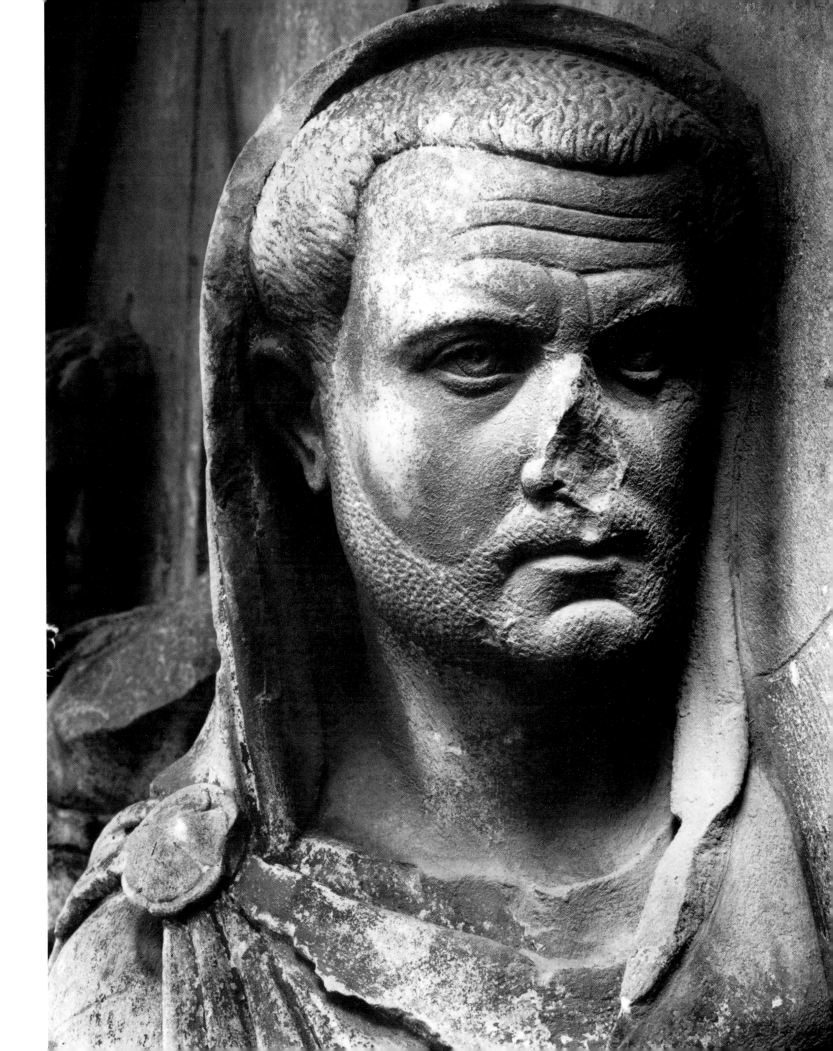

Carausius's navy from coming to the help of the city. In this way, says the orator, Ocean itself replaced conventional siege engines and became the battering ram.[30] Constantius can thus be said to have chastened the sea – a feat which Xerxes attempted and in which he failed. But then he had to pause in order to build a fleet of ships with which to cross to Britain;[31] only then could he proceed to the 'remarkable victory by which the entire State was at last liberated'.[32] Britain was a prize not to be abandoned: 'a land so abundant in crops, so rich in the number of its pastures, so overflowing with veins of ore, so lucrative in revenues, so girt with harbours, so vast in circumference.'[33] Moreover Carausius, termed a 'pirate' by Constantius' panegyrist, had evidently met with some success and brought some improvements to the people of Britain.[34] A mint was established at London which continued to operate until 326. Even Constantius' panegyrist has to admit that Carausius had gained control of a substantial number of ships, built more himself, seized a whole legion of Roman soldiers, exacted levies on merchants in Gaul and recruited barbarian troops.[35] In 293 Carausius was murdered at the instigation of his financial aide Allectus, who seized control himself. But meanwhile Constantius's ships were ready, and the new Caesar led a two-pronged expedition starting from Boulogne and the Seine, which was too effective for Allectus to withstand.

Leaving from Boulogne, Constantius sailed up the Thames to London in the second wave of the expeditionary force, though in time to prevent the remnants of Allectus's soldiers from turning back from the defeated main force and reaching the city. A later panegyrist claims that 'he sailed over such a calm sea that the ocean, astonished at such a traveller, seemed to have abandoned its customary motion'.[36] Later sources credit the final victory to the praetorian prefect Asclepiodotus who, sailing from the mouth of the Seine, nevertheless landed first,[37] but the panegyrist of 297, Constantius' protégé and writing in his interest, omits all mention of Asclepiodotus and gives all the credit to Constantius.[38] The year was 296. The scene of Constantius' entry to London, an imperial *adventus*, with symbolic kneeling citizen greeting the mounted emperor, is depicted on a gold medallion of 297 from Arras. By another remarkable parallelism, his son Constantine was to be shown entering Rome on the reliefs on the Arch of Constantine (fig.4) erected allegedly by the grateful senate and people of Rome in 315, on which see more below. The new dispensation in Britain made itself felt by dividing the existing two provinces in Britain into four, which appear as Britannia Prima, Britannia Secunda, Flavia Caesariensis and Maxima Caesariensis in the Verona List; of these, Flavia Caesariensis was clearly named after Constantius.[39]

According to Eusebius, Constantius was a man who lived a 'pious and devout life'.[40] On this view, which the Christian writer Lactantius also shared, he was utterly different from his colleagues in the tetrarchy, in particular in matters of morality and religion. The latter asserts that Galerius, made emperor when Diocletian and the elder Maximian retired from power in 305, 'despised' Constantius for his mild nature.[41] Lactantius also writes that, while Constantius now became emperor himself with Galerius, the latter thrust Constantius' son Constantine aside and made his own protégé Maximinus Daia Caesar instead.[42] The accounts of both Lactantius and Eusebius are heavily influenced by their Christian hostility to the persecuting emperors, who included Diocletian and his colleague Maximian as well as Galerius. It is often difficult to know how much to allow for this bias, when both authors claim that Constantius was so far out of step with his colleagues. Indeed, Lactantius has to defend Constantius' apparent actions against Christians, which amounted to destroying churches, by stating that he did this only because he could not openly refuse to follow orders received from Diocletian.[43] When he adds after recounting the death of Constantius that his son's first act, having been proclaimed, was to end persecution,[44] giving neither further details or context, it is fair to conclude that this assertion is part of his overall attempt to present both Constantius and Constantine as pro-Christian throughout. Nothing otherwise connects Constantine directly with Christianity until after 310, and in 307 his panegyrist has no hesitation in attributing to him the title Herculius and deriving it from Maximian.[45]

Eusebius goes much further in his portrayal of Constantius as pro-Christian. Not only was Constantius quite different from his colleagues, the only one who provided sound and paternal government within his sphere of rule; he was pious and godly, ruling by force of personality alone. Unwillingly compelled to make some gesture in the direction of persecution of Christians, the punishment he devised for those who refused to sacrifice to the gods was exclusion from the court and his own presence. He himself, in Eusebius's words, recognised only the God over all, condemned polytheism and 'fortified his house all around with the prayers of holy men'.[46] The naming of one daughter Anastasia might seem to confirm his pro-Christian sympathies, though it could also have been a name given at a later baptism.[47] To follow Eusebius again, all his family and household he consecrated to God, so that his household resembled a church, and when he died clergy were at hand to perform the appropriate rituals.[48] It comes as something of a surprise to the reader when in the context of his account of Constantine's march on Rome in 312 Eusebius states that having

decided to follow his father's God, he had to pray to be told who that God actually was.[49] Constantius may well have been less of a Christian than Eusebius would like us to believe.

Constantine's proclamation in 306 came at a critical time in the history of the tetrarchy, when such stability as had been achieved had been disturbed by the joint retirement of Diocletian and Maximian as Augusti in 305 and the new dispensation which followed.[50] The early years of Constantine were spent in securing and maintaining his own position in a changing and dangerous situation. It was confirmed by the Conference of Carnuntum in 308.[51] But it was only once he had defeated Maxentius and gained control of Rome in 312 that he could begin to address internal domestic issues in a serious way, and then only in the west;[52] again, it was only after his final defeat of Licinius in 324 that he had control of the whole empire, both east and west. By then his attention had moved eastwards. The building of Constantinople was begun as a commemoration of his victory, the refounding and renaming of an ancient classical Greek city which had a century before received the attentions of an earlier emperor, Septimius Severus, after an earlier set of civil wars. From 330 when the city was dedicated until his death in May 337, it became Constantine's permanent residence, and he was interred there in a new mausoleum of his own design.[53] As we have seen, he remained conscious of his own rise to power in the west, in furthest Britain, but direct concern on his part with Britain and the west is confined to the turbulent years 305 to 313.

In the winter following his proclamation Constantine campaigned against the Franks, and in summer 307 he was again in Britain,[54] before seeking ratification of the title of Augustus from Maximian, who had re-emerged in 306 after his abdication, and marrying the latter's daughter Fausta.[55] The panegyrist of 307 paints an affecting picture of Constantine and Fausta as children, supposedly both depicted in a painting in the palace at Aquileia, with Fausta offering Constantine a symbolic plumed helmet in a presentiment of their future marriage.[56] Constantius, as Constantine's father, is imagined as blessing the match.[57] Constantine soon resumed his military action in Germany and on the Rhine, but his position was threatened by the proclamation late in 306 of Maximian's son Maxentius. Maximian himself retired and re-emerged a second time, and came out in open opposition to Constantine in 310, whereupon Constantine marched south to Marseilles where Maximian surrendered and committed suicide.[58] Late in 310 Constantine seems to have been in Britain again.[59]

Constantine's position in these years was delicate, and he alternately played the loyal member of the tetrarchic apparatus and the dynastic successor. The panegyrist of 310, writing shortly after Maximian's death, stresses Constantine's claim to power as his father's son, and deals extremely carefully with the episode surrounding Maximian. He emphasises Constantine's clemency towards those who had rebelled against him and recounts a vision of Apollo experienced by Constantine while on this campaign, apparently at Grand, in the Vosges, seeming to offer him victory.[60] The death of Maximian was an important moment which marked Constantine's break with the tetrarchic ideology and his assertion of his own personal and dynastic claim to power. He effectively announced a break with the Herculian association of the tetrarchy and the assumption of a new divine patron. It was now also that he made his audacious claim to descent from the third-century emperor Claudius Gothicus as the basis for differentiating him from his tetrarchic colleagues;[61] his father Constantius is emphasised, as is his election by the gods, the army and the *seniores principis*.[62]

Trier was Constantine's base, as it had been for his father, and he made his own the tetrarchic complex consisting of a palace, with surviving basilica, baths, circus and walls which had been laid out by Constantius.[63] The basilica at Trier was the imperial audience chamber, and its shape became the model for the first Constantinian churches in Rome (fig.17). Painted female heads from the ceiling of another part of the Constantinian palace complex have been interpreted as portraits of ladies of the imperial family, though this now seems doubtful.[64] The palace complex belongs very well in the context of the monuments of other tetrarchic 'capitals' such as Galerius's palace complex at Salonica.[65] It was the setting for the delivery of the panegyric of 310 and others. The latter includes the eulogy of Britain, reminiscent of Tacitus's *Agricola*, already mentioned:

> a land in which neither the severity of winter nor the heat of summer is too great, in which there is such a fecundity of crops as to supply the gifts of both Ceres and Bacchus, in which there are forests without savage beasts and lands without venomous snakes, but rather there is a countless multitude of peaceful herds distended with milk and laden with fleeces. Furthermore, a thing which makes life very pleasant, the days are very long, and no night is without some light, while because of the extreme flatness of the shores no shadows are cast, and it is possible to see the sky and the stars beyond the boundaries of the night, so that the sun itself, which to us seems to set, there appears to pass overhead.[66]

The passage is hardly a reliable guide to the state of early fourth-century Britain, but it is interesting to see how this exotic conception of the faraway island is used by the orator to underline Constantine's claim to power and to the favour of the gods.

The death of Maximian left Constantine (and others) exposed: Maximin had been proclaimed Augustus by his troops in 310, as had Constantine before him, and Maximian's son Maxentius was not likely to take his father's death lightly. Maximin and Maxentius prudently allied themselves, and Lactantius tells us that Constantine also took precautionary action by betrothing his half-sister Constantia to Licinius, colleague of Galerius as Augustus in the east since 308 and sole emperor in the east since Galerius's death in 311; soon enough, Maxentius declared war on Constantine in order to avenge his father.[67] If this is true, Maxentius did not follow up his initiative but unwisely took a defensive position within the city of Rome itself, a tactic which gave Constantine's publicists great opportunities for cataloguing his supposed vices there.[68] Constantine's panegyrists were also at great pains to defend him from the charge of making war on a colleague; the truth of the matter was probably that Constantine took the offensive by marching south through Italy in the campaign that ended with his dramatic victory over Maxentius at the Battle of the Milvian Bridge over the Tiber. Maxentius and his troops took up a stand with their backs to the River Tiber and were swept into the water. Eusebius of Caesarea, writing soon after the event but from distant Palestine, likened the fate of Maxentius and his troops to that of the Egyptians at the crossing of the Red Sea, and Constantine himself to Moses.[69]

Constantine was able to enter Rome with Maxentius's head on a pike, staging an *adventus* reminiscent of his father's entry into London, and depicted on the Arch of Constantine. The Arch, set up in 315 in the context of Constantine's *decennalia*,[70] and still standing beside the Colosseum, is one of the greatest surviving late antique monuments, presenting a series of key questions about the genesis and development of late antique art (fig.4);[71] at the same time, however, it sets Constantine in the tradition of Roman emperors who had set up monuments after victories, including Trajan, Marcus Aurelius, Septimius Severus and more recently Galerius. Like the literary treatment of the same themes in the Latin panegyrics, and indeed the panegyrical Greek of Eusebius of Caesarea, the new Constantinian frieze on the Arch depicts and symbolises the great themes of imperial victory and rulership: the advance from Milan, the siege of Verona, the Battle of the Milvian Bridge, the entry into Rome, the emperor's speech from the rostra (fig.5) in the Roman forum and the giving of largesse (fig.16). In this it follows the themes of the Aurelian panels in the attic storey; other material is Hadrianic and Trajanic.[72] Constantine's defeat of Maxentius is thus placed in the context of the general theme of famous imperial victories. In the famous inscription of the Arch Constantine was able to claim that he had liberated Rome from the rule of a tyrant, in terms reminiscent of the claims of Augustus expressed in the *Res Gestae* three and a half centuries earlier.[73] Even without any Christian overtones, the moral and symbolic character of this battle and Constantine's entry into Rome was enough to place Constantine in the roll call of 'good emperors' who had relieved the city from servitude.[74]

Constantine's act in completing the Basilica Nova or Basilica of Maxentius in Rome also marked him both as legitimate victor and as still rooted in tetrarchic ideology.[75] The symbolic importance of completing and remodelling great imperial monuments started by Maxentius is obvious. Very soon – indeed as early as 313 – Constantine turned his attention to the building of churches in Rome where that was possible and around the city, drawing on and transforming the existing secular architectural idiom.[76] But there was further fighting to be done: Maximin was still a danger and Licinius was still Augustus in the east. Later in 313 Constantine was again in Britain;[77] real life went on. But the entry into Rome was deeply symbolic. It also presented a further traditional obligation for Constantine, that of showing himself to be not only capable of winning battles but also of making a settlement with the senators and people of Rome and of displaying himself as an emperor in peace as well as war. Erecting statues of himself[78] was part of the imposition of his public persona. So was the celebration in 315 in Rome of his *decennalia*, the tenth anniversary of his elevation, even though according to Eusebius he refrained from the usual sacrifices.[79]

Both Christian and pagan writers attributed Constantine's victory over Maxentius to divine intervention, though their stories differ substantially. According to the panegyrist of 313, the earliest account, Constantine's father Constantius looked down on his success from heaven and rejoiced; another panegyrist in 321 wrote of divine troops led by Constantius coming to Constantine's aid; while Lactantius in 314 describes a dream of Christ before the battle and Eusebius, in the latest and the most highly developed version, recounts a vision of the cross in the sky, experienced during the march south through Italy.[80] It was a time of heightened religious consciousness and the persecution of Christians was already on the wane. Galerius had died in 311 of a disease reported in revolting and gloating detail by the Christian writers, who saw it as a punishment for his role as a persecutor of Christians.[81] Before he died, Galerius called off the persecution,[82] confirming the Christian authors in their views. Maximin attempted to revive persecution in 312,[83] but he too died in the summer of 313, a few months after Constantine and Licinius had issued their own statement in favour of toleration. Maximin's death was treated by Lactantius and Eusebius in the

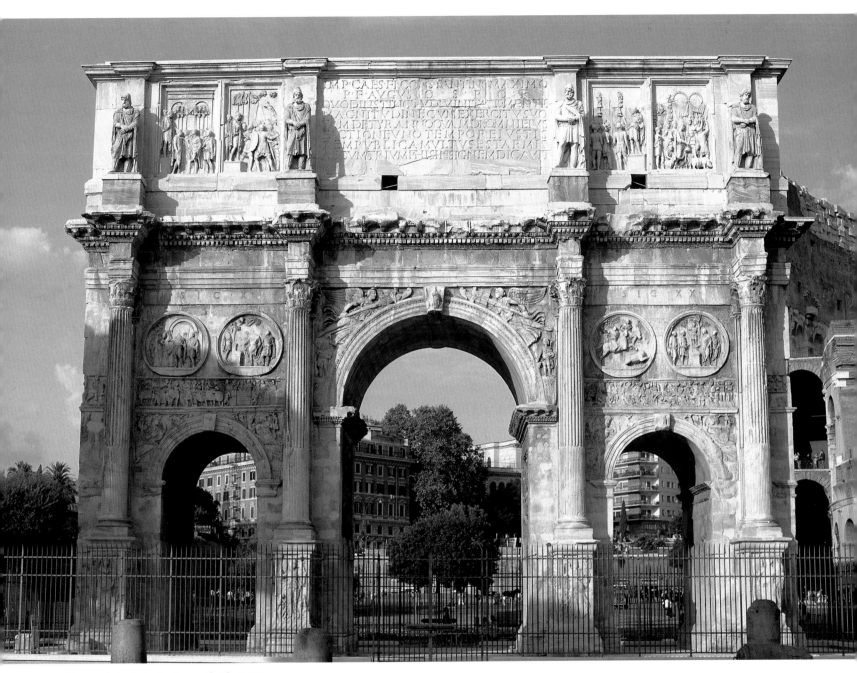

Figure 4 Arch of Constantine, south side, Rome

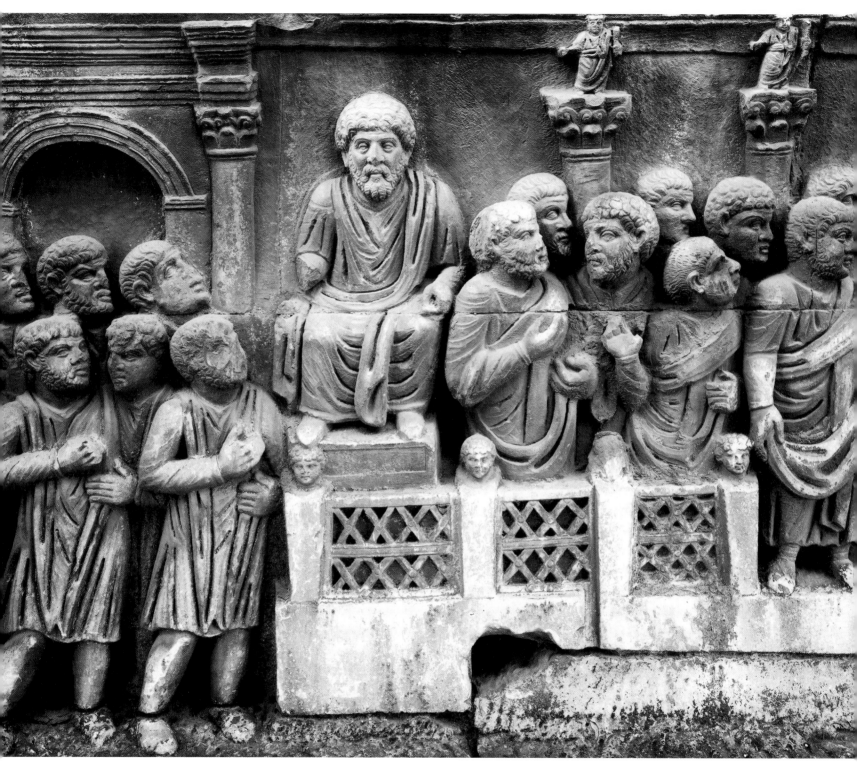

Figure 5 Emperor Constantine's speech on the rostra (detail), Arch of Constantine, Rome.

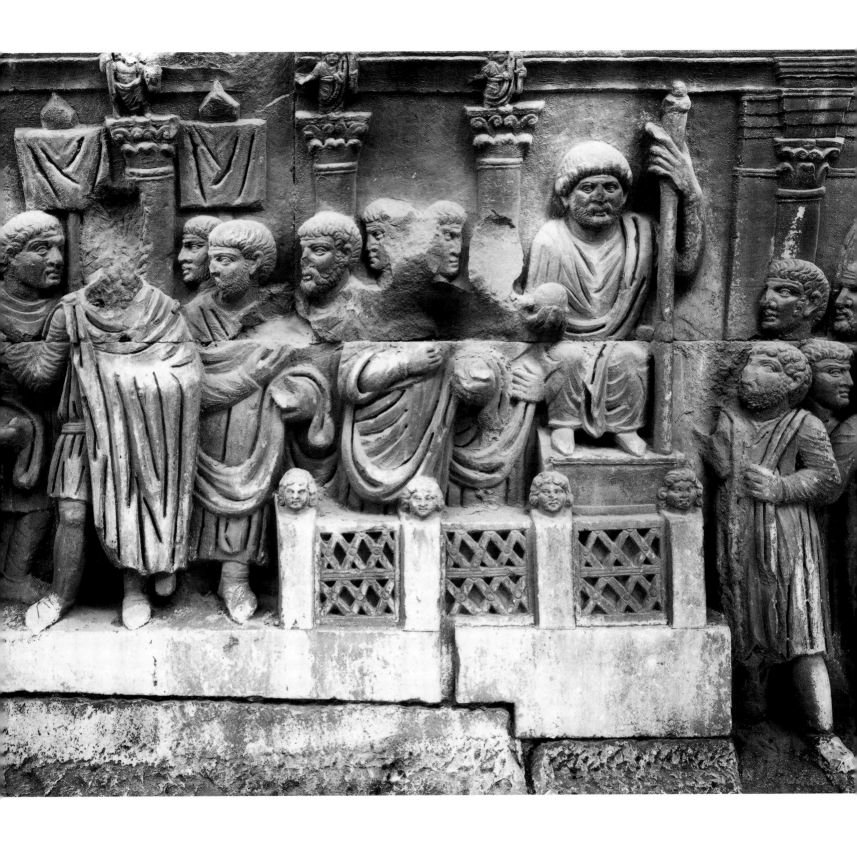

same way as that of Galerius, and he too was claimed to have recognised the punishment of the Christian God in his mortal illness; in later years, when Constantine was directing his campaign against Licinius, the latter was painted with the same colours as Galerius and Maximin, the example of whose fates Eusebius claimed he had ignored.[84]

In all these cases the issue of Christian persecution is intertwined with political interpretation. Constantine was not the first to call off the persecution, nor did he issue the so-called 'Edict of Milan' in 313 on his own initiative: rather, it was part of a political programme, again precautionary on Constantine's part, agreed at a meeting with Licinius in Milan in February 313, which also resulted in the marriage of Licinius and Constantia. The pronouncement[85] is in fact an imperial letter to the governor of Bithynia issued by Licinius after the occupation of Nicomedia subsequent to the flight of Maximin, and Eusebius's version is probably that sent to the governor of Caesarea and posted there somewhat later.[86] Nevertheless, Constantine quickly issued instructions relieving Christian clergy from civic liability, thereby unwittingly becoming involved in Christian religious divisions in North Africa;[87] he called his first church council in 313 in Rome on this matter, and thereafter never deviated from his interest in and support of Christianity.[88] This imperial involvement was translated into action and into an institutional organisation which in Britain as elsewhere in the empire was to give the church a structure and a prominence which changed its history.

The two generations or so from the rise of Constantius as a serving soldier to the formal entry of Constantine into Rome as victorious emperor saw the tetrarchic system devised by Diocletian rise and fall, destroyed not least by Constantine himself. In its first phase, prior to the abdication of Diocletian and Maximian in 305, Constantius was a loyal member of a regime which brought some much-needed stability to the empire. After his death in 306, by which time his son Constantine had taken the first steps towards securing his own future position, the system was challenged from within, and

it eventually yielded to the imperatives of personal rivalry. In this process it was Constantine who emerged as sole emperor of the Roman world from 324 to his death in 337. A similar change from collegial to dynastic rule can be viewed through the self-presentation of the principal personages.[89] The porphyry statues of the 'embracing tetrarchs' in the Vatican and in Venice are intended to convey an image of collegiality and harmony, while at the same time being indicative of military government.[90] However, in the marble portraits of Constantius one can already see personal and dynastic traits, while Constantine's portraits have moved from 310 onwards to the representation of 'an Apolline princeps that rejects the aggressive paternal militarism of third-century and tetrarchic portraits and reintroduces the idea of the emperor as a clean-shaven civilian' (figs 1 and 3).[91] Augustus was a powerful model, as he was also for the language of the inscription on the Arch of Constantine. Later, after a dozen years of sole rule, Constantine turned for inspiration to Hellenistic models and to Alexander the Great.[92]

Such a change in representation from the tetrarchy to 312 was not a feature of visual art alone. The surviving Latin panegyrists used the florid rhetorical language of imperial representation to cast first Constantius and then Constantine within a model of ruler cult in which standard imperial virtues were ascribed to whoever was the subject of their current speech.[93] We have also seen how the panegyrists gradually turned the loyal tetrarch into the dynastic ruler and recipient of divine, even Christian, favour. More surprisingly, Eusebius, Bishop of Caesarea in Palestine, far removed from the traditional language of the court, found a way to translate this panegyrical imagery into Christian and Greek dress. By the end of Constantine's reign Eusebius had evolved a Christianised ruler theory which served the eastern empire well for many centuries, but which had come a very long distance from the tetrarchic imagery associated with the career of Constantine's father. Constantine was the pivot and York the starting point for this transition from the late third-century imperial ideal to the new Christian empire of late antiquity.

Notes

1. Lactantius, *DMP* 24.8; *Pan. Lat.* VI (7).8.1; Eusebius, *Vita Const.* I.21.2–22.1, Aurelius Victor, *de Caes.* 40.2; *Ep. de Caes.* 41.3; see further below.

2. Eusebius, *Vita Const.* II.28 (Constantine's letter to the East after his defeat of Licinius in 324, quoted by Eusebius). A very early papyrus copy of this imperial letter exists in the British Library: see Jones and Skeat 1954.

3. *Vita Const.* I.19 (trans. in Cameron and Hall 1999).

4. *Pan. Lat.* VI (7).9.1. Constantine was actually proclaimed Augustus but found it more prudent to be recognised only as Caesar: see below. Galerius in 306 recognised him only as Caesar: Lactantius, *DMP* 25. The evidence of the Latin panegyrics on Constantius and Constantine is crucial: for important discussion of their techniques see Rees 2002, and extensive commentary by Nixon and Rodgers 1994.

5. For the date of Constantine's birth and the evidence for his early career see Barnes 1982, 39–42.

6. *Oratio* 16.2.

7. Lactantius, *DMP* 11; Eusebius, *Vita Const.* II.49–52; *Oratio* 25.

8. *Origo* 2.2; cf. also Eusebius, *Vita Const.* I.12.

9. Lactantius, *DMP* 24, cf. Eusebius, *Vita Const.* I.20. (comparing Constantine to Moses); Praxagoras, Jacoby FGrH II B, 219; *Origo* 2.2–4). Constantine's own ambition as a factor: Aurelius Victor, *Caes.* 40.2, Zosimus, *Hist.* II.8.2. Lactantius mentions Constantius' poor health also at *DMP* 20.1.

10. *Pan. Lat.* VI (7).7.4–8.2.

11. Lactantius, *DMP* 19.4.

12. *Pan. Lat.* VI (7).6.4, delivered at Trier, probably in 310, and addressed to Constantine but recapitulating the deeds of Constantius. The exact chronology of these years is not entirely agreed; cf. Nixon and Rodgers 1994, 212–14.

13. *Origo* 2.4.

14. *AE* 1961.240; Constantius' northern campaigns: *Pan. Lat.* VI (7).7.2, 7, with Nixon and Rodgers 1994, notes *ad locc.*; Barnes 1982, 71.

15. Barnes 1981, 27.

16. *Vita Const.* I.21 (trans. in Cameron and Hall 1999); cf. Eusebius, *HE* VIII.13.12–14.

17. Eusebius, *Vita Const.* I.22.1; *Pan. Lat.* VI (7).8.2: the panegyrist carefully explains that the soldiers merely anticipated a decision shortly afterwards approved by the 'senior rulers'. Aurelius Victor, *de Caes.* 40.2 is more laconic. For the account in *Epitome de Caesaribus* 41.3, which introduces the presence of Crocus the leader of the Alamanni who had been present in support of Constantius, for the possible role of Crocus in Constantius's campaigns and for the date and nature of the *Epitome*, see Ian Wood in this volume. Constantine's own son Constantius II similarly seized the moral high ground by organising the funeral of his father in Constantinople: Eusebius, *Vita Const.* IV.70, with notes emphasising the actual uncertainty which surrounded the moment of succession.

18. Lactantius, *DMP* 24.8.

19. Eusebius, *Vita Const.* I.22.1.

20. Cf. Eusebius, *Vita Const.* I.1.3, IV.68, 71.2. Within months of Constantine's death in May 337 his sons had set out to eliminate the descendants of Constantine's half-siblings, and soon began to fight each other.

21. For Constantius's career see Barnes 1982, 35–7.

22. Helena's humble origin: *Origo* 2; Ambrose, *De Obitu Theodosii* 42; Zos., *Hist.* II.8.2, 9.2. For Helena as concubine or wife see Barnes 1982, 36 (wife according to *ILS* 708; *CIL* 10.1483, but her low status makes this unlikely). Helenopolis: Eusebius, *Vita Const.* IV.61.1; Procopius, *De Aed.* V.2.1–5; cf. Mango 1994, 143–58.

23. For the marriages and family of Constantius see Chausson 2004, who opens the possibility that either or both of Julius Constantius and Anastasia were the children of Helena rather than Theodora, and thus Constantine's full brother and sister. Theodora as Maximian's daughter: Barnes 1982, 33, 37, cf. 125; step-daughter (daughter of Eutropia and Afranius Hannibalianus): PLRE I s.v. Theodora 1, with family tree at p.1129; against: Nixon and Rodgers 1994, 70–1.

24. *Pan. Lat.* VII (6); Barnes 1982, 43; Chausson 2004, 151–5.

25. *Pan. Lat.* VIII (5).2.1; see Nixon and Rodgers 1994, 104–5.

26. *Pan. Lat.* X (2) (Barnes 1982, 125; Nixon and Rodgers 1994, 70).

27. Barnes 1982, 11.

28. *Pan. Lat.* X (2).12; see Nixon and Rodgers 1994, 107.

29. See also *Pan. Lat.* VI (7).5.

30. *Pan. Lat.* VIII (5).6; cf. Johnson 1976, 83–5; Shiels 1977; Casey 1977, 283–301.

31. *Pan. Lat.* VIII (5).7.3–4.

32. ibid., 9.5–6.

33. ibid., 11.1.

34. See Johnson 1980, 78–81.

35. *Pan. Lat.* VIII (5).12.

36. *Pan. Lat.* VI (7).5.4.

37. Aurelius Victor, *de Caes.* 39.42; Eutropius 9.22.2.

38. *Pan. Lat.* VIII (5).14.3–17, with Nixon and Rodgers 1994, notes *ad locc.*; Todd 1981, 211.

39. Barnes 1982, 216; see Casey 1978, 191. Casey associates the name 'Maxima Caesariensis' with a presumed visit to Britain by Constantine in 314, but 313 is a more likely date for that visit (see below, n.77).

40. *Vita Const.* I.22.2; Lactantius, *DMP* 8.7.

41. Lactantius, *DMP* 20.1.

42. ibid., 19.4.

43. ibid., 15.6–7.

44. ibid., 24.9.

45. *Pan. Lat.* VII (6).8.1.

46. *Vita Const.* I.17.2.

47. Anastasia is known only from *Origo* 14 (married Bassianus, by 316); on her name see Chausson 2004, 143, and on Anastasia generally, ibid., 137–48.

48. Eusebius, *Vita Const.* I.13–18.

49. ibid., I.27–28.1.

50. Cf. Corcoran 2000, 267, 'after the abdication in 305, harmony soon became disharmony'. Corcoran 2000, 5–9, provides a succinct brief account of the tetrarchic arrangements, and see his essay in this volume.

51. Barnes 1982, 6.

52. It was generally senior emperors who had full legislative competence, though laws were issued in joint names: for a discussion see Corcoran 2000, 266–74. Lactantius claims that Galerius in 305 already behaved as though he were senior emperor: *DMP* 20.1–24.2, cf. Corcoran 2000, 267.

53. Eusebius, *Vita Const.* IV.58–9, with notes; Mango 1990, 51–61; Elsner 1998, 164–5.

54. Barnes 1982, 69. The date is based on *adventus* coins issued by the London mint, for which see Casey 1978, 183–4, who doubts whether the visit actually took place.

55. Marriage to Fausta and investiture by Maximian, late summer or autumn, 307: *Pan. Lat.* VII (6), cf. Barnes 1982, 69, n.103; Nixon and Rodgers 1994, 180–4; less likely, 25 December, Grünewald 1990, also placing these events at Arles rather than Trier (see however Nixon and Rodgers 1994, 184–5).

56. *Pan. Lat.* VII (6).6.2–3.

57. ibid., 14.3–7.

58. Barnes 1981, 40–1, emphasising the careful handling of this in Constantine's publicity. See also Lactantius, *DMP* 29.3–30.6, an account highly favourable to Constantine.

59. Again this is based on *adventus* issues from the London mint, *RIC* VI.134–5 (interpreted in *RIC* VI to refer to events in Rome), with a possible though vague reference in Eusebius, *Vita Const.* I.25 and an allusion in Zosimus, *Hist.* II.15 to troops raised in Britain for Constantine's Italian campaign: see Barnes 1982, 70; Casey 1978, 184–8. There is no mention of a visit to Britain in the panegyric of 310, so the visit if it took place is likely to post-date Constantine's presence in Trier for its delivery, perhaps on 1 August, 'the birthday of the Emperor Claudius, who made the city a colony' (Barnes 1982, 70, n.105).

60. *Pan. Lat.* VI (7).21.4–7; for the large bibliography on Constantine's 'pagan vision' see Nixon and Rodgers 1994, 248–9.

61. *Pan. Lat.* VI (7).2.1–3; see Nixon and Rodgers 1994, 219. The claim was accepted: cf. *Origo* 1; *SHA Claud.* 13.2–4.

62. *Pan. Lat.* VI (7).7.3–5, 8.2. It was more than appropriate that the claim should have been made in Trier.

63. See Elsner 1998, 130–2; Ward-Perkins 1981, 442–9.

64. Ling 1991, 195–6; see, however, Weber 1990, 5–9.

65. Elsner 1998, 128–30.

66. *Pan. Lat.* VI (7).9.1–3; cf. Tacitus, *Agricola* 12, and see Nixon and Rodgers 1994, 231nn.

67. Lactantius, *DMP* 43.3–4.

68. In the subsequent accounts of Constantine's campaign and victory, though less so by Lactantius, Maxentius is represented as a debauched tyrant and (by Christians) a persecutor: *Pan. Lat.* XII (9).3.5–7, 4.3–4, 17; IV (10).27.5, 30.1 'not a manly death but a shameful flight betrayed the tyrant himself when the bloody billows slew him in a demise worthy of his cowardice and cruelty'; Eusebius, *HE* VIII.14.1–6, 16–17; *Vita Const.* I.38.

69. Eusebius, *HE* IX. 8.5–8; for the theme of Moses in the *Vita Const.* see Cameron and Hall 1999, 35–8.

70. For the date see Buttrey 1983.

71. There is a large bibliography on the Arch: see recently Elsner 1998, 187–9; Elsner 2000; Holloway 2004, 19–53, with extensive illustrations. Recent studies and the results of Italian excavation have suggested that the extent of incorporation of earlier material was much greater than previously believed, and that the Arch represents (like the Basilica Nova) an adaptation of a monument already under construction, which was itself built on earlier foundations. *Spolia* were also extensively used in the construction of the Lateran Basilica of 313 onwards; Elsner 2000, 154.

72. For the juxtaposition of old and new see Elsner, 2000, 163–75.

73. 'quod instinctu divinitatis mentis magnitudine cum exercitu suo tam de tyranno quam de omni eius factione uno tempore iustis rempublicam ultus est armis', inscription on the Arch of Constantine, *ILS* 694; similar language in Greek at Eusebius, *Vita Const.* I.41.2, with commentary by Cameron and Hall 1999. Compare 'exercitum … comparavi, per quem rem publicam a dominatione factionis oppressam in libertatem vindicavi', Augustus, *Res Gestae* 1, with the sharp comments in Tacitus, *Ann.* I.9–10. Contemporaries of Augustus were not all taken in by this language and nor, probably, were all contemporaries of Constantine; indeed, Barnes 1981, 308, n.24, refreshingly describes the famous words *instinctu divinitatis* as 'a contemporary cliché'.

74. This traditional language is taken over by Eusebius, *Vita Const.* 39–40; see commentary by Cameron and Hall 1999.

75. See Elsner 1998, 64–5; Holloway 2004, 16, with Aurelius Victor, *de Caes.* 40.26. Among other changes was the introduction of a colossal seated statue of Constantine himself, of which the head, hands and feet survive.

76. See now Holloway 2004, 57–86.

77. Barnes 1982, 71; Casey 1978, 189–90 (314).

78. See Eusebius, *HE* IX.9.10; *Vita Const.* I.40.2 (though claimed to be a statue with an inscription recalling Constantine's Christian vision).

79. Eusebius, *Vita Const.* I.48. Constantine stayed in Rome only for about two months; for his movements in 315–16: Barnes 1982, 72–3.

80. *Pan. Lat.* XII (9); IV (10).14.1–7; Lactantius, *DMP* 44; Eusebius, *Vita Const.* I.28, with commentary in Cameron and Hall 1999, *ad locc.* Modern accounts vary, ranging from acceptance of Eusebius' version to explanations in terms of solar phenomena: see for example Weiss 2003. Constantine's religion remains a contested subject, and the bibliography is immense: see for example Walraff 2001.

81. Lactantius, *DMP* 33; Eusebius, *Vita Const.* I.56–7; for the latter account's relation to the earlier narrative in *HE* see Cameron and Hall 1999 *ad locc.*

82. Lactantius, *DMP* 34–5.

83. See Corcoran 2000, no.55, pp.149–51; Eusebius, *HE* IX.7.3–14 gives a Greek translation, and Latin epigraphic copies exist from Colbasa and Arycanda: see Mitchell 1988; Şahin 1994, no.12.

84. Eusebius, *Vita Const.* I.58–9 with commentary; ibid., I.56–9 (re Licinius); for the blackening of Licinius see also Corcoran 1993.

85. Lactantius, *DMP* 48.2–12; Eusebius, *HE* X.5.2–4.

86. For this see Corcoran 2000, no.66, pp.158–60.

87. On this see Millar 1977, 584–91.

88. See Cameron 2006.

89. See the wide-ranging discussion by Smith 1997, especially 184–7: 'Imperial styles, AD 300–25'.

90. ibid., 183.

91. ibid., 186. See also Elsner 1998, 61–2.

92. Smith 1997, 187; cf. Eusebius, *Vita Const.* IV.15.

93. The relation between the visual image and the literary treatments, often taken to be simpler and more straightforward than it actually was, is discussed by Smith 1997, 194–201. On the panegyrics and their language see also L'Huillier 1992.

Constantius and Constantine at York

Paul Bidwell

Introduction

In late 305 or early 306 the Emperor Constantius came to Britain for the second time. Ten years earlier, as Caesar, he had recovered the island from the usurper Allectus; this time he was campaigning against the Picts in northern Britain and was accompanied by his son Constantine. After achieving a great victory, Constantius died at York on 25 July 306, and Constantine was acclaimed as his successor by the army.[1] Over the next few years Constantine appears to have returned to Britain on two or possibly three occasions.[2] The 1700th anniversary of Constantine's acclamation as emperor calls for another look at York as it was in his time.

In 306 Eboracum was the largest and most important settlement in a new province which covered northern Britain up to the area of Hadrian's Wall.[3] The headquarters of the governor and the provincial administration were at York, as was the base of *legio VI Victrix*. Throughout most of the third century, and perhaps as late as 306, the governor of the province doubled as commander of the legion and had at his disposal, on Hadrian's Wall and in numerous forts to the south, the largest concentration of auxiliary troops in any province of the empire.

The effects of the presence of Constantius and Constantine at York have long been the subject of discussion. It has been said that they were accommodated in an imperial palace and that the magnificent south-west front with its series of imposing towers was begun by them.[4] These topics will be pursued further in this essay, which also examines briefly early fourth-century renovations to the buildings inside the fortress, particularly the headquarters building (*principia*).

An imperial palace at York?

Ancient accounts of the visits made to York by the Emperor Septimius Severus (between 208 and 211), and by the Emperor Constantius with his son, Constantine, mention palaces. Unfortunately, none of these accounts can really be regarded as accurate historical records. The events in 306, when Constantine was proclaimed emperor, are described by the panegyrist of 310 and by Eusebius.[5] These texts are unlikely to have been based on eye-witness accounts and will have been written to establish the legitimacy of the succession. The panegyrist refers to a formal entrance into the palace after Constantine's acclamation and Eusebius has Constantine emerging from the palace clad in his dead father's purple. These two writers were describing a developing ceremony of accession, some aspects of which would become quite rigid in Byzantine times.[6] One of these aspects was the formal entry into the palace, which at Constantinople established the link between the emperor and the people of his capital.[7] Another early reference to this part of the accession ceremonial appears in the life of Probus: when he was acclaimed in an eastern city in 276, after being saluted by the army, he is said to have been led to the palace, with the customary display of reluctance on his part.[8]

A palace would thus have played an important part in the ceremony of Constantine's accession at York. It has been suggested that it was the same *palatium* mentioned in a life of Septimius Severus[9] which might have survived long enough to be used by Constantius and Constantine, and perhaps by Constans in 343.[10] The idea of a palace at York was much influenced by the discovery in the town outside the legionary fortress at Carnuntum of a huge building complex which was claimed to be the palace built for Marcus Aurelius during the Marcomannic wars (167–80). Recently, much more of the building complex was uncovered and it was plainly a sumptuous set of baths, probably public *thermae*.[11]

Septimius Severus was in Britain in 208–11 because of a military emergency, as were Constantius and Constantine in 305–6. Severus planned a military expedition against the Caledonians. It would hardly have been his intention to stay in Britain longer than was necessary to ensure their defeat. His first campaign had seemed successful, forcing the enemy to come to terms.[12] Had there not been a renewed uprising, he might well have returned to Rome in the winter of 209. As it was, he remained in Britain until his death in February 211. The construction of an imperial palace at York by

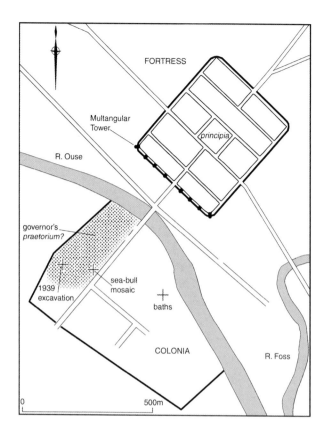

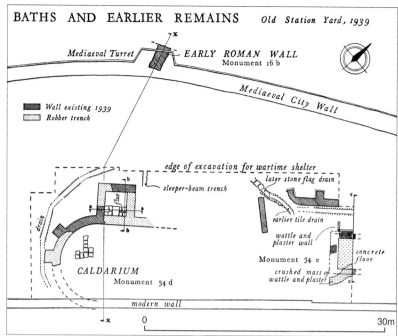

Figure 6 (left) Map of Roman York showing sites mentioned in text.

Figure 7 (above) Structures excavated in 1939, possibly part of the governor's *praetorium*.

Severus might suggest that he foresaw that he would be in Britain for several years, and that seems scarcely credible. Constantius and Constantine were in Britain for far briefer periods, and their presence was likewise required because of military emergencies. They stayed only as long as it took to obtain military victory. It is unlikely that either Severus or Constantius would have ordered the building of an imperial place at York. The term *palatium* was perhaps applied to wherever the emperor was staying when on a visit to a province.

When Severus was at York, the largest residence would have been the *praetorium* of the legionary legate in the fortress. That is where Severus and his retinue were probably accommodated.[13] York had become a far more important place by the time Constantius and Constantine had arrived there. It had been the capital of a province, probably since 216 at the latest, and was the seat of the governor. As befitted the senior provincial official, his residence would surely have been the largest and most opulent at York and the obvious place for the emperor to stay. For that brief period the governor's residence might have become a *palatium*.

The governor's praetorium[14]

In the early third century Britain was divided into two provinces, Britannia Inferior and Superior. The division had certainly been effected by 220 and probably by 216. It might well have resulted from discontent with the Emperor Caracalla which had been

expressed by the governor and army of Britain in 213.[15] The northern province, Britannia Inferior, had only one legion, *VI Victrix* at York. The notion that York was the capital of the northern province and hence the seat of the governor has no direct support from epigraphic finds or literary references, but the strategic importance of York is established by its successive use by emperors as a residence when they were in northern Britain.

Another reason for assuming that the governor was based at York is that his office would have always been combined with the command of *legio VI Victrix*. In other one-legion provinces the governor was usually based at the same place as the legion. It has been suggested that here the governor would have occupied the *praetorium* in the fortress, originally supplied for the now-superseded office of legionary legate.[16] But in other provinces the governor's *praetorium* was separated from the fortress. At Apulum (Alba Julia) in Dacia Superior, the residence was situated to the east of the fortress of *legio XIII Gemina*; to the south lay two separate towns, both of which were to attain the status of *municipium*.[17] The residence of the governor of Pannonia Superior, a two-legion province, was also separated from the fortress of *legio II Adiutrix* and the civilian settlement, occupying an island in the Danube. In Noricum, following the destruction of the *limes* in the second half of the second century, *legio II Italica* was transferred to a new fortress at Lauriacum. Command of the province was now com-

bined with that of the legion, although parts of the civilian administration were transferred from Virunum to Olivala (Wels) along with a detachment of the legion.[18] The governor was based at Lauriacum but nothing is known of his palace. It was not in the fortress: although space was allowed in its plan for the accommodation of senior officers, none of their residences was erected and it is assumed that they were outside the fortress.[19] At Lambaesis there also appears to have been no residence in the fortress of *legio III Augusta* for the governor of Numidia, another single-legion province.[20] In the province of Raetia, after the Marcomannic wars, the governor had his seat at Augsburg although he was also legate of *legio III Italica* at Regensburg; the location of the governor at some distance from his legionary command is explained by the status of Augsburg, long established as the most important centre in the province.[21]

There might have been political reasons why governors were not established in the fortresses of legions which they commanded. Perhaps it was thought better to maintain a visible separation of the military and civilian aspects of their powers. There was also probably a more immediate and practical reason. The palace at Aquincum covered an area of *c*.8–10ha and that at Apulum an area of at least 4–5ha; their extent was probably accounted for by the inclusion of parkland, gardens and colonnades within their precincts.[22]

The area behind the *principia* at York which seems to have been the site of the legionary legate's *praetorium* covers an area of *c*.0.65ha, similar to the areas of such buildings in other fortresses.[23] We should therefore expect to find a *praetorium* for the governor at York in the third century outside the fortress because of lack of space, as well as perhaps for political reasons.[24]

The possible site of the governor's praetorium *at York*
Many building remains have been recorded north-west of the main road through the *colonia* which leads to the *porta praetoria* of the fortress.[25] The largest structure was a hypocausted room or hall with an apse at its south-west end which is thought to have been part of a large bath-house. It was found with other building remains in 1939.[26] There had been earlier discoveries in the area, including a building with a heavy gritstone façade, two small apsed buildings – one of which had a fine mosaic (fig.8) showing a bull with a fish tail (cat.130) – a further apsed building and two separate ranges of rooms containing plunge baths.[27] To the south of this area was found a range of rooms with three mosaics.[28]

Two silvered bronze tablets were found in 1840 in the region of the large apsidal structure excavated in 1939. They are inscribed with dedications in Greek. One is dedicated to Ocean and Tethys

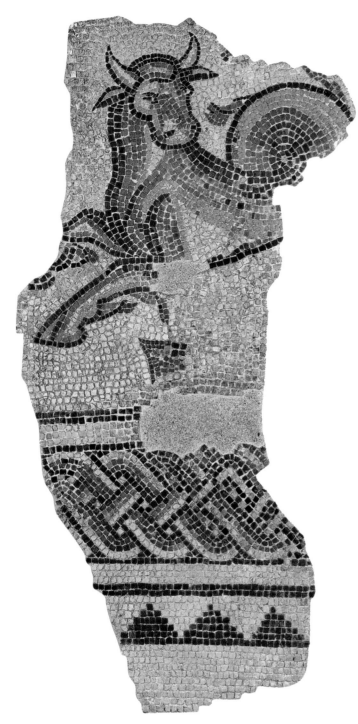

Figure 8 Mosaic with sea-bull, Toft Green, York (cat.130)

and the other to the deities of the governor's headquarters.[29] The text of the latter has been translated as: 'To the deities of the governor's headquarters, Scribonius Demetrius (set this up).' (fig.9)

The dedicator, Scribonius Demetrius, has been identified as the *grammaticus* Demetrius of Tarsus, known to have been in Britain shortly before 83–4 and almost certainly during the governorship of Agricola.[30] This has subsequently been doubted, because the name Demetrius was very common in the Greek-speaking east and the find-spot made no sense if the dedication was as early as the governorship of Agricola, who is unlikely to have had his headquarters at York.[31] If the dedication was to the deities of the governor's *praetorium*, a date after the division of Britain is indicated, when there was a governor at York.[32]

In view of the dedication on this tablet, the apsidal room excavated in 1939 deserves closer examination. Its internal width was 7.92m and its south-west end closed in an apse with external buttresses. The interior of the room had a hypocaust, but all that remained were stone flags which had formed the basement floor, with 'the marks left by each square pillar' of the hypocaust.[33] Evidently of one build with this large room was a smaller room 2.74m square internally.[34] It was described as 'a small heated room … probably a bath' but can rather be identified as a furnace-house serving the hypocaust in the larger room (fig.7). Its entire width at its east end was occupied by a narrow platform 1.2m across which was built of stone blocks. A channel described as a flue ran across the centre of the platform. The published illustrations show that the base of the channel had been worn into a deep hollow, which is characteristic of a hearth where the fire was laid to heat a hypocaust, and an unpublished letter mentions 'the reddened cheeks of the flue'.[35] The wear would have been caused by the action of heat on the stone combined with raking out of the ashes.

The identification of this smaller room as a furnace-house rather than a bath calls into question the function of the larger room. It has been described as a *caldarium*,[36] but this is not very convincing: a *caldarium* always contains a hot bath and the furnace is almost always sited next to the part of the room containing the bath, which was usually set in an apse or recess or ran across the full width of one of the narrower ends of a room. The furnace-house also lacked the large base to support the boiler which would have supplied hot water to a bath. The larger room was also not very likely to have been one of the two other types of heated room found in baths. It was too large for a *laconicum*, where a very hot, dry environment was created, and such rooms were usually square or circular in plan. Nor is it likely to have been a *tepidarium*, which is likely to have had a tepid bath.[37]

There was a second room to the north-east which was represented by a length of buttressed walling. The south-western buttress at the end of the surviving length of wall is at a pronounced angle which indicates that this room also had an apse at its south-west end. Just beyond the inner face of the wall was a channel described as an air-duct, which was 0.4m in width.[38] It looks very much like part of a channelled hypocaust, that is, a hypocaust where the hot air passes through a network of channels under the floor. Hypocausts of this type were used mainly in residential buildings rather than baths.

Remains found recently at Nos 1–9 Micklegate have been more plausibly identified as the public baths and were apparently built in the early third century.[39] The *colonia* is unlikely to have had two separate public baths, and the remains excavated in 1939 are better interpreted as part of a residential complex. The buildings might well represent two hypocausted halls or *aulae*, which might be expected in the residence of a high official of the later empire. By the fourth century an *aula*, usually taking the form of an apsed, aisleless hall, was an essential element in the establishment of an emperor, governor or senior military commander. They were audience halls which provided a setting for the increasingly formalised ceremonies of government in the later empire.[40] *Aulae* at Trier and Savaria had hypocausts, and they also had buttressed walls because of their great height, as did the *aula* at Gamzigrad.[41]

The area in which the building remains excavated in 1939 (fig.6) were situated would have been very suitable as a site for the governor's *praetorium*. The building complex would have had direct access to the road leading to the bridge over the River Ouse and to the *porta praetoria* of the fortress beyond the bridge. It could also have extended north-eastwards so that it had a frontage overlooking the river.[42] The whole of this area would have covered about 6ha, which is comparable to the areas of the governors' *praetoria* at Apulum and Aquincum.[43]

Parallels from other provinces make it very likely that a governor's *praetorium* was built at York in the early third century and that it was separated from the fortress. Although their identification is far from certain, on any map of Roman York the remains excavated in 1939 merit the label 'governor's *praetorium*', although these words must certainly be followed by a question mark.

The fortress

By 312–14 York was the capital of a new northern province which might have been created immediately after the recovery of Britain by Constantius in 296. At first the province and its army were controlled by the governor, but soon, probably under Constantine, the civil and military powers were divided, a *dux* taking over the lat-

Figure 9 Bronze tablet with dedication in Greek to the deities of the governor's *praetorium*, York

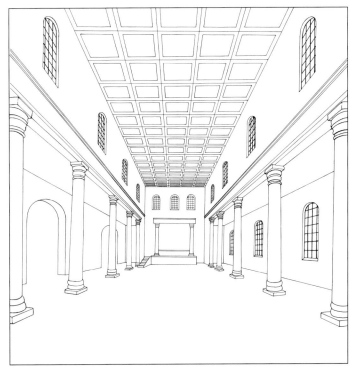

Figure 10 Reconstruction of interior of the *principia* (headquarters building), York

ter.[44] This new military command, an office later known as the *dux Britanniarum*, was (presumably) based in the fortress at York. The 'superlatively imposing form' taken by the newly built south-west front of the fortress has been connected with the institution of this new command.[45]

These changes were part of a wider transformation of the administrative structures of the Roman world which were accompanied by reforms of the army.[46] There are certainly no changes in the fortress at York in the late third or early fourth centuries which necessarily reflect alterations in the size and organisation of the legion. When the barracks were rebuilt, they retained much the same plans as before, and other buildings survived in use without major alterations. The only areas where there are few signs of activity are in the north-east part of the fortress.[47]

New fortresses, ranging in size from 2.8ha to 5.6ha, were built for the legions raised by Diocletian at the end of the third century.[48] Earlier fortresses were much larger: York at 20.8ha is standard. At the long-established fortresses along the frontier areas of the Rhine and Danube there are no signs of a reduction in the scale of occupation in the late third century and at the beginning of the fourth century.[49] Many of these sites were devastated by barbarian attacks

in the later third century, but by the early fourth century they had been rebuilt. As at York, none seems to have been radically reorganised. Change came later in the fourth century. Chester seems to conform to the general pattern.[50] Caerleon, where occupation seems to have been much reduced in scale by the early fourth century, is a marked exception.[51]

The principia

In the early fourth century the *principia* was extensively rebuilt.[52] It retained its original plan, but many of the walls were renewed from their foundations and the original columns which separated the nave and aisles of the basilica were re-erected with wider spacings, at least one with its drums in the wrong order (fig.11).[53] The dating evidence for the rebuilding was sparse,[54] and its connection with the presence of Constantius and Constantine can only be assumed.[55] It also seems that the larger than life-size statue of Constantine stood within the *principia*, possibly in the courtyard (cat.9).

The restoration of the *principia* at York, at a time when the status and size of legions was beginning to change, is remarkable (fig.10). Nevertheless, there is a parallel at the fortress at Novae in Moesia

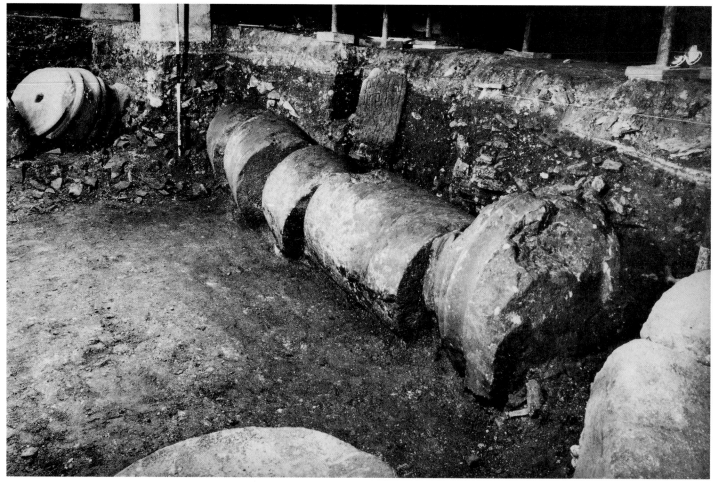

Figure 11 Collapsed column in the *principia* (headquarters building), York

Inferior (in modern Bulgaria). Despite destruction in the second half of the third century, the *principia* retained its original form, with its panoply of statues and dedications, throughout the fourth century.[56]

The south-west front of the fortress

Projecting towers were added to the defences of many fortresses on the Rhine and Danube frontiers, but none matches the towers on the south-west front at York (fig.13) in their scale and elaboration.[57] Six towers 9.4m in width with six-sided fronts projected from the curtain-wall between the *porta praetoria* and the angle towers. The *porta praetoria*, the most important gate in the fortress, seems to have had a plan typical of the second century, although there is no reason why it should not have been built at a later date.[58] Entirely exceptional are the two multangular towers at the angles (fig.12). They measure 13.7m across and, in common with the interval towers, they had large internal extensions with rectangular plans.

The towers on the south-west front were long thought to have dated to the late third or early fourth century.[59] A much earlier date

for their construction, perhaps in the Severan period, has now been proposed.[60] The whole south-west front was built in one operation, except perhaps for the gate, but the alternative view is that the new front replaced the turf rampart of the fortress and not an earlier wall. There are difficulties with this view, not least the astonishing delay in supplying the fortress with stone defences: at other fortresses founded in the later first century, in Britain and beyond, stone walls were built within a decade or so.

Now that the dating of the south-west front has been questioned, it is worth looking again at the parallels for its towers.[61] Projecting interval towers with polygonal fronts occur at a number of towns and forts in Britain, for example, at Cardiff, Cirencester and Caerwent, where they date to the late third or fourth century. There are fewer examples beyond Britain.[62] What distinguishes the interval towers at York from these other polygonal towers is their larger size and their slightly more elaborate design (their fronts are six-sided rather than five-sided). At these other sites the angle towers are merely elongated versions of the interval towers. At York the angle towers are of an entirely different and more complex plan.

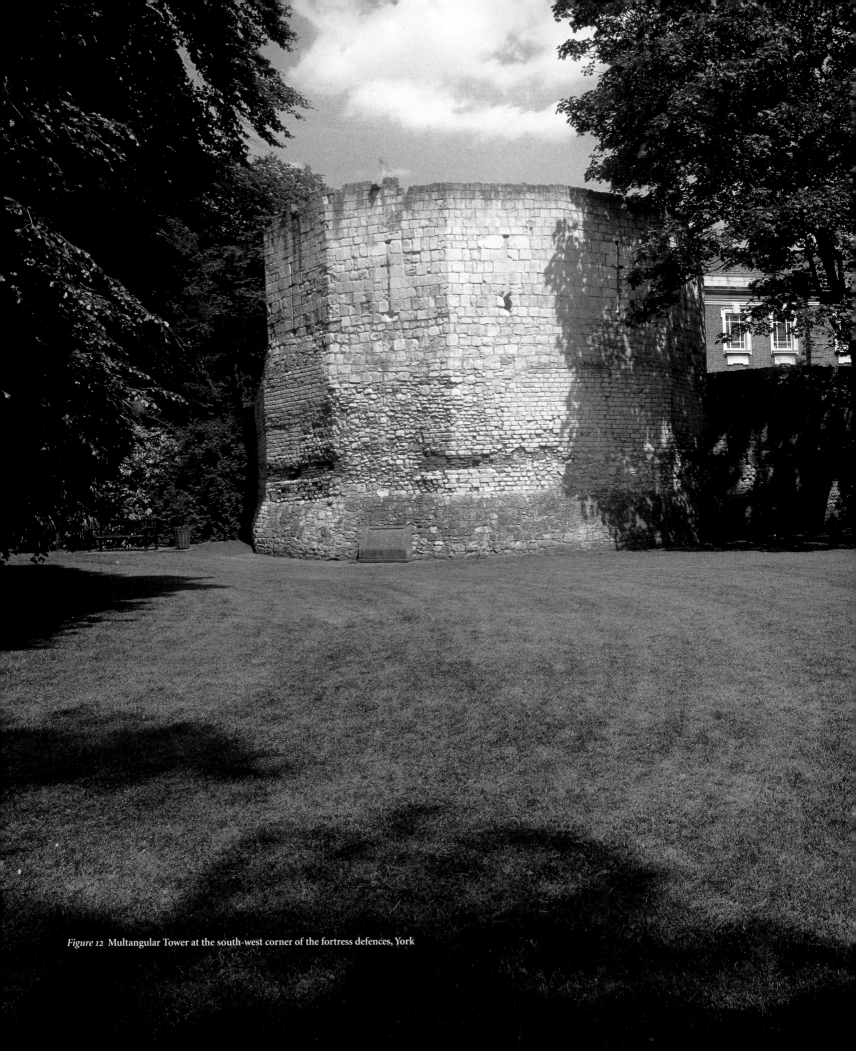

Figure 12 Multangular Tower at the south-west corner of the fortress defences, York

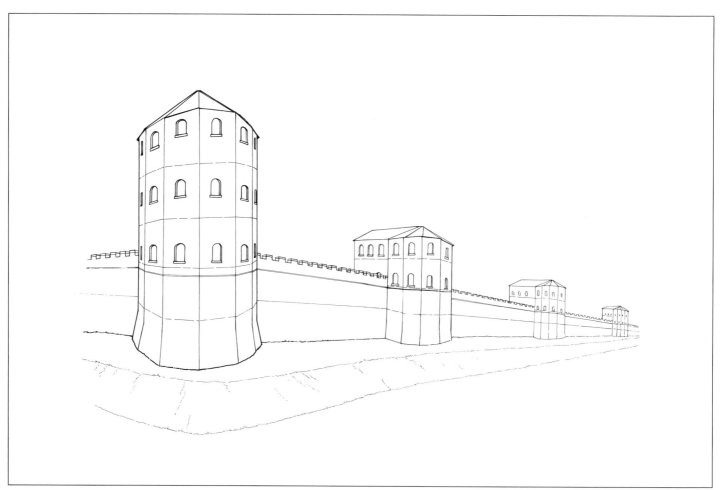

Figure 13 Reconstruction of the south-west wall and towers of the fortress at York

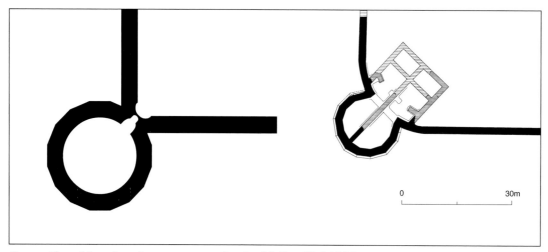

0 30m

Figure 14 Plans of the multangular corner towers at Gamzigrad (left) and York (right)

Until the extraordinary complex at Gamzigrad in Dacia Ripensis (Serbia) began to be revealed,[63] some years after the studies by Richmond and Butler, the angle towers were entirely without parallel. The walls of Gamzigrad enclosed an area of 4.5ha which was occupied by two palatial residences, temples, a huge granary and other buildings. An inscription on a pediment identifies the complex as *Felix Romuliana*, known to have been the burial place of the Emperor Galerius in 311. The complex was clearly an imperial residence and was presumably intended for Galerius' retirement, although he died while emperor. Around the circuit of the walls were 20 towers of enormous size: the gate towers and interval towers were 23.4m across and were ten-sided; the angle towers were even larger at 28.35m across and were 16-sided. All the towers were attached to the wall on only one of their sides.

The angle towers at York were based on a 14-sided rather than a ten- or 16-sided figure, and four sides rather than a single side were omitted where they were attached to the wall. Apart from these minor differences the plans of the towers at York and Gamzigrad are very similar (fig.14). They can be regarded as quite distinct from the simpler and much smaller polygonal towers and, because they are so far unique in late Roman architecture, there was probably some direct connection between them. Most obviously, they might have been designed by the same architect.

Diocletian's palace at Split, occupied by that emperor from his retirement in 305 until his death in 312, might have inspired Galerius to prepare a retreat for his own retirement, but work on the complex at Gamzigrad seems to have begun when he was still Caesar (from 293 to 305). The circuit of walls with the very large towers enclosed and superseded an earlier circuit with towers, octagonal at the gates and square elsewhere, of the usual, much smaller size. The rebuilding of the defences has been attributed to Galerius' elevation to Augustus, but this cannot be proved. Whatever their exact date, the huge towers at Gamzigrad were built at some stage between 293 and 312; the south-west front at York will surely have been of a very similar date.

One feature of the towers at York, their large rectangular extensions behind the fortress wall, remains unparalleled. Their purpose is not immediately obvious: they would not have improved the defensive capacity of the towers, nor would they have made the towers look more imposing from outside the fortress. The only useful comparison is again with Gamzigrad and is a matter of space rather than the details of architectural design. The internal area of each angle towers is about 330m square, while those at York, including their rearward extensions, have internal areas of about 200m square. Although the area at York is less than two-thirds of that at Gamzigrad, both far exceed those of most of other late Roman towers, underlining the similarities at these two sites.

Acknowledgements

I am grateful to Elizabeth Hartley and Brenda Heywood for much information and encouragement, and to the former and Nick Hodgson for commenting on drafts of this article.

Notes

1. *Pan. Lat.* vi(7).7.1–2.
2. In 312 and 314 (Casey 1978); Barnes (1981, 34, 65) had suggested different dates: in 307, late in 310 and perhaps in 313.
3. The provinces are named in the Verona List of 312–14, but it is uncertain whether the northern province was Britannia Secunda or Flavia Caesariensis (Rivet and Smith 1979, 46).
4. Richmond 1962, xxxvi; Butler 1971, 105. The main source for discoveries in Roman York up until the beginning of the 1960s is RCHMY 1; for an up-to-date account of the fortress and *colonia*, see Ottaway 2004, with bibliography; the most important reports on the fortress published since 1962 are Phillips and Heywood 1995, on excavations under the Minster, and Ottaway 1996, on the fortress defences.
5. *Pan. Lat.* vi(7).4.1 and Eusebius, *VC* 1.24; for the importance of the accession in establishing the Constantinian dynasty, see MacCormack 1981, 177–85.
6. MacCormack 1981, 181, 184.
7. *Op. cit.*, 254.
8. *SHA* Probus, x.5, an account written long after the event, probably describing what the writer assumed had happened.
9. *SHA* Severus, xxii.7.
10. Richmond 1962, xxxvi, but cf. Richmond 1969, 265, n.1, where it is conceded that that Severus might have used the legionary legate's *praetorium* in the fortress.
11. Stiglitz, Kandler and Jobst 1977, 608–11.
12. Dio lxxvii.13.
13. Cf. note 10 above; Ottaway 2004, 79–80.
14. The governor's residence is often described as a palace, but here the Latin term *praetorium*, explained below, is preferred to avoid confusion with an imperial palace.
15. Birley 1981, 168–72.
16. Richmond 1962, xxxvii.
17. Kérdö 1999, Abb. 7; the province had a single legion from the reign of Hadrian until AD 168 when the governorship was extended to include the other two Dacian provinces.
18. Friesinger and Krinzinger 1997, 167.
19. Von Petrikovits 1975, 67.
20. *Loc. cit.*
21. Dietz, Osterhaus, Rieckhoff-Pauli and Spindler 1979, 83–5.
22. Kérdö 1999, 653.

23. As in Ottaway's reconstruction of the fortress plan (2004, fig.13).
24. There is always the possibility, as in Noricum, that some sections of the administration were based elsewhere, for example at Corbridge or Carlisle, in the frontier area where the bulk of the army was concentrated.
25. RCHMY **1**, fig. on p.50.
26. ibid., monument 34d.
27. These are respectively (ibid.) monuments 34d, 31, 32, 34a–c.
28. ibid., monument 35.
29. *RIB (Corrig. Add.)*, 662–3.
30. *Op. cit.*
31. Birley 1966, 731–2.
32. Mann (1968, 307) was more definite about the third-century date of the dedication.
33. Letter to R. Perrin, 11 November 1973, from the excavator, Mary Derwas Chitty (York Museums Trust (Yorkshire Museum), YORYM 1948.12.2).
34. The junction of the south-west wall of the smaller room and the north-west wall of the larger room is shown on RCHMY **1**, pl.19.
35. RCHMY **1**, fig.47, a–c, pls 19–20; photocopy of a letter written by Mary Derwas Chitty, missing date and addressee (York Museums Trust (Yorkshire Museum), YORYM 1948.12.2).
36. RCHMY **1**, 55.
37. Cf. Nielsen 1990, 156, stating baths were a common feature of *tepidaria* in public baths in the north-western provinces.
38. RCHMY **1**, 56.
39. Frere 1990, 325–6, fig.15: Ottaway 2004, 110, figs 63–4.
40. A large apsidal hall was recently excavated in the frontier fort at Kellmünz in Raetia. It was of much the same size as the apsidal hall in Galerius' palace at Gamzigrad (see below); Mackensen (1995, 106) suggested that Kellmünz was one of the bases of the *dux provinciae Raetiae I et II* and that the *aula* was for his use when in residence.
41. Trier: Wightman 1970, 103–9; Savaria: Scherrer 2003, 65; Gamzigrad: Mayer 2002, 80–8.
42. Excavations at Tanner Row (General Accident site) and Rougier Street suggested that there had been a replanning in the area in the late second or early third century (summary in Perrin 1990, 243–8).
43. See note 22 above.
44. Frere 1978, 241–2.
45. Richmond 1962, xxxiii–xxxiv.
46. Dietz 1993; Tomlin 2000.
47. Ottaway 1996, 294–5.
48. Tomlin 2000, 33–7.
49. Kastler 2002.
50. Mason 2001, 195.
51. Boon 1972, 61–9; the fortress baths had fallen into disuse by *c.*230 (Zienkiewicz 1986, 215–610).
52. Phillips and Heywood 1995, 47–56.
53. *Op. cit.*, 53.
54. *Op. cit.*, 47
55. *Op. cit.*, 7.
56. Sarnowski 1999.
57. RCHMY **1**, 13–25; Sumpter and Coll 1977; Ottaway 1996, 279–87.
58. RCHMY **1**, 12–13, fig.6; Ottaway 1996, 247–9, fig.138.
59. Richmond 1962, xxxiv.
60. Ottaway 1996, 293–4; for an interim excavation report which provisionally dates the rampart associated with the new south-west front to the early third century, see Hunter-Mann 2005, 3.
61. Cf. Richmond 1962, xxxiii–xxxiv; Butler 1971.
62. Lander 1984, 244–6.
63. Mayer 2002, 80–8, Abb. 30–2.

Emperor and Citizen in the Era of Constantine

Simon Corcoran

A text preserved in a single manuscript of the Theodosian Code gives the following exchange between Constantine (in Latin) and a female litigant (in Greek):

> *Agrippina said*: He was not pagarch in that district.
>
> *Constantine Augustus said*: But the law provides that no-one in an administrative position is to purchase anything, so that it is of no relevance whether he purchased it in his own *pagus* (district) or another's, since it is clear that he made the purchase contrary to law.
>
> *And he added*: Are you unaware that whatever administrators purchase, all of it is made property of the *fiscus* (the treasury)?
>
> *Agrippina said*: He was not *praepositus* of that district. I made the purchase from his brother. See the deed of sale.
>
> *Constantine Augustus said*: Let Codia and Agrippina recover an appropriate price from the vendor.[1]

This text is a rare surviving example of an emperor's verbatim exchange with a litigant, but is even more unusual in that the litigant is female and speaks for herself, with no trace of an advocate.[2] The text as we have it is incomplete, with the opening missing. This would have given details such as date, place or persons present. However, given the technical terms used (for instance *praepositus*, *pagi*) and that Agrippina speaks in Greek, it is likely that she came from Egypt.[3] If we presume that the Theodosian Code did originally contain an accurate date, and since the next text (*CTh* 8.15.2) dates to May 334, the hearing must have taken place before 334 but after Constantine conquered the east from Licinius in September 324. In ignorance of location, we cannot tell how far Agrippina travelled to present her case (Constantine never visited Egypt as emperor), which is most probably an appeal from a lower court. Agrippina's rank is also unknown, although the text would probably have noted her rank had it been especially high (for example clarissimate/senatorial), but she is unlikely to have been especially poor if she was able to fight this case into the emperor's presence. Resources, patience, persistence and, if possible, connections were needed to work the judicial or administrative system. It is perhaps no surprise that two of the best-known examples from the next generation of people travelling from Egypt to petition Constantine's son, Constantius II, in Constantinople in the 340s were people of rank, familiars of the imperial *comitatus*, seeking by considerable and even repeated efforts to gain or retain offices in the emperor's gift. Thus Flavius Abinnaeus had twice to approach the emperor to have his appointment as *praefectus alae* reaffirmed (successfully),[4] while Harpocration of Panopolis sought a lucrative priesthood for his nephew (he died in Constantinople without having achieved his aim).[5]

Despite so much uncertainly about our Theodosian text, the case itself is relatively clear. The *fiscus* has confiscated property incorrectly acquired by a magistrate in office, whose brother had then sold it on to Agrippina and her co-litigant Codia. We may well imagine a third party had acted as delator to the *fiscus* in this matter, simultaneously petitioning for the confiscated property to be transferred to themselves. Something similar happened after Harpocration's death in Constantinople (348). On the grounds that he had died without heirs and his estate was forfeit to the *fiscus* under the rules of *bona vacantia* (the Crown in England has similar rights), one Eugeneios successfully petitioned for an imperial rescript granting him several of the deceased's slaves in Alexandria.[6] Whoever gained the property of Agrippina and Codia was presumably left in undisturbed possession. However, instead of letting the loss lie with the purchasers, as strict law demanded, the emperor rules that they should recover a suitable amount from the vendor. It is notable that the emperor speaks in Latin, the most formal language for an emperor, even though Constantine could probably have managed some Greek, although perhaps not with the educated polish of his nephew Julian.[7] We may suspect the petitioner did not herself speak Latin, and there is no indication of an interpreter, such as Constantine used when addressing the bishops at the solemn opening of the Council of Nicaea. So here we see the emperor in action, as the fount of justice appearing in person, at the

centre of and as an arbiter of the legal machinations of his more litigious subjects. This is precisely how a Roman emperor was supposed to behave, available and responsive to requests or demands for justice, benefits or immunities.

We can compare this to another text also uniquely preserved in the Paris Theodosian manuscript, in which Constantine is again shown interacting face to face. He enters a military headquarters building at Beauvais, being greeted by leading military figures and the praetorian prefects, and is then accosted (probably not unexpectedly) by a group of veterans, who he addresses as 'fellow veterans of mine'.[8] He hears their complaints, and then delivers a reply ensuring their privileges. Soldiers are, of course, precisely the class we would expect to enjoy relatively frequent and ready access to the emperor. Thus in 238 the villagers of Scaptopara in Thrace were probably able to petition and gain a rescript from Gordian III, because it was presented and followed through by a fellow-villager who was a praetorian.[9]

It is certainly true that the earlier imperial style adopted by Augustus and his successors, defined essentially by *civilitas*, the politeness between fellow-citizens, had been gradually modified. A specific change to a more gorgeous form of court ceremonial, marked by ornate bejewelled clothing, strict protocol and eunuch chamberlains, is ascribed in ancient sources to Diocletian and is sometimes explained as a response to the capture of the Persian king's baggage train and harem in 297. It is also true that the design of imperial buildings suggests considerable control over space. The tetrarchic period is notable for several new 'circus/palace' complexes, allowing the emperor to regulate his most public appearances.[10] The account by Lactantius of the last months of Diocletian's rule gives precisely this impression, the emperor immured in his palace with little information (if much rumour) escaping, punctuated by occasional appearances on high days. Thus Diocletian, having publicly dedicated the new circus at Nicomedia on the anniversary of his accession (20 November 304), failed to appear as expected on 13 December 304 (for some unidentified ceremony) and only reappeared in public looking very ill on 1 March 305, the anniversary of the proclamation of the Caesars.[11] We are left wondering what Lactantius really knew of the conversations between Diocletian and Galerius and other events taking place behind closed doors of which he gives detailed reports![12] Eusebius recounts the feelings of himself and the other bishops at the Council of Nicaea when they passed through the ranks of soldiers into the recesses of the imperial residence, there to recline with Constantine for the banquet celebrating his *vicennalia* (twentieth-year celebrations, July 325).[13] In about 330, a group of Melitians

(schismatic Christians from Egypt) seeking a hearing with Constantine were turned away by suspicious officials controlling access to the palace at Constantinople. The Melitians lingered in Constantinople and Nicomedia, hopeful for a later opportunity, which materialised once they came to the notice of Eusebius, Bishop of Nicomedia, who had the influence to open doors.[14] However, we should beware of exaggerating any reduction in the emperor's accessibility. For Tacitus, even the early Principate was marked by the opacity of decisions taken or trials conducted behind closed doors and not openly in the senate, and the transfer of power from Augustus to Tiberius (perhaps echoing Tacitus's observation of Hadrian's succession to Trajan) is portrayed as carefully managed within the imperial residence away from public scrutiny.[15] At the same time, we should remember that such spatial control was rather more difficult to effect in the third and fourth centuries, when emperors were highly mobile, in relentless progress around the empire and stopping in many places large and small, sometimes only briefly and where there was no specifically designed imperial residence. Such a lifestyle would give potential petitioners more chance to exploit or create opportunities to approach the emperor.[16] Constantine himself characterises the experience of his courtiers as exemplified by the dust and toil of the camp.[17] In the first ten years of his reign, despite our limited information, we can find him at York, Trier, Cologne, Beauvais, Autun, Châlons, Vienne, Arles, Aqua Viva, Sirmio (near Brescia), Milan and Rome herself.[18]

Rome, indeed, was no longer the effective imperial capital. During the third century, emperors had come to spend less time there as the needs of frontier defence or civil war kept them occupied elsewhere. But prestige still demanded that they take possession of the city and they visited when they could. Even such a busy emperor as Aurelian (270–5), traversing east and west as he reunited the fractured empire, spent time in the city and dealt with its affairs.[19] Diocletian, however, does not seem to have visited Rome when he entered Italy following his victory over Carinus in the spring of 285, so that his only visit was a purely ceremonial one (and that not entirely enjoyable) for his *vicennalia* in November 303. Even his colleague, Maximian, who was often resident in Italy, was more likely to be found in northern centres such as Milan, Verona or Aquileia[20] (see fig.15).

The reality was that Rome no longer mattered for reasons of strategy or administration. Even the senate and senators had become largely detached from imperial politics and administration. The centre of government was where the emperor was. Not only had new mobile armies coalesced, attached to the emperor rather than to a province or frontier, but the imperial *comitatus* was

no emergency 'travel-kit'; it contained all the apparatus and personnel necessary for permanent government. Further, as the number of emperors reigning jointly increased to meet military and other necessities, a series of cities developed as alternative residences, some sporadic (such as York), others virtually new imperial capitals. The most important such 'tetrarchic' capitals included Antioch and Nicomedia (Diocletian's favourite) in the east, Thessalonica, Serdica and Sirmium in the Balkans, Milan and Aquileia in Italy, Arles and Trier in Gaul. Even today, for instance, Trier boasts from this period the most monumental Roman relics of any city north of the Alps. It served as a frequent base for emperors from Maximian to Magnus Maximus, and continued as the seat of the Praetorian Prefect of the Gauls until 406. Trier was almost certainly Constantine's principal residence during his first decade of rule.[21] The exception to this trend is Maxentius, who had chosen Rome as his base on account of the local circumstances of his elevation – he was apparently already living quietly as a senator just outside the city, when tax riots and Praetorian guard dissatisfaction made him the figurehead for Roman discontent in October 306.[22] Maxentius even built his own version of a tetrarchic residence outside the city on the Via Appia.[23] His extensive building work in the centre of Rome itself (his Basilica, the Temple of Venus and Rome) was largely caused by a major fire in 307.

After his victory of 312, Constantine never contemplated basing himself in the city. He was content to flatter the wealthy and prestigious senate which, in one of its last constitutionally significant acts, made him the senior emperor.[24] He was also happy to complete Maxentius's building programme, while initiating his own rather different Christian one.[25] But, just as for Diocletian, so for Constantine Rome served as the backdrop to infrequent ceremonies (his *decennalia* in 315 and *vicennalia* in 326), not as a seat of government. Later Constantine did single out Byzantium to become his own city of Constantinople, and created a new centre of power that would in due course eclipse the other more fleeting capitals and become a permanent residence for emperors, as frenetic imperial meanderings turned into the more sedentary style of the fifth century and after.

The peregrinations of the emperors meant that many more areas and people came to enjoy the boon or endure the burden of the imperial presence. On the one hand, the sudden arrival of emperor and *comitatus* could be economically dislocating, necessitating extraordinary levies of goods or demands for billets, or causing localised inflation.[26] At Panopolis in September 298, Diocletian was expected on his return northwards from the southern frontier of Egypt. This produced a mass of correspondence from the local

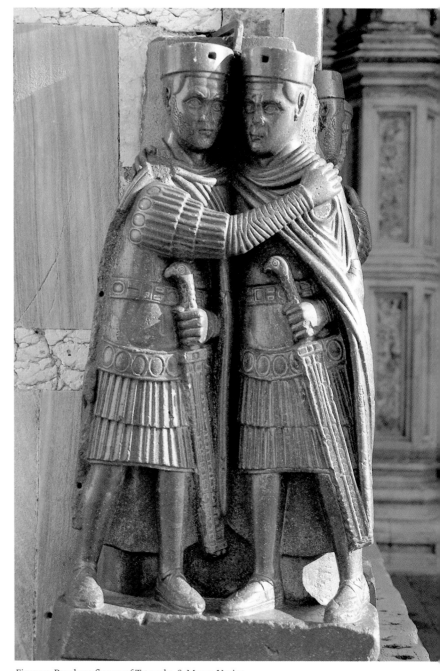

Figure 15 Porphyry figures of Tetrarchs, S. Marco, Venice

strategus to the large number of people (some frustratingly uncooperative) involved in the necessary preparations for receiving the emperor. This included the collection of food, animals for sacrifice and bedding, furnishing the *palatium*, repairing boats and fitting out a bakery solely to provide bread for the troops.[27] However, an emperor on the spot also meant that crises could be dealt with authoritatively (the best deterrence to usurpation), and benefits

could be sought and petitions presented by those unlikely to contemplate travel to an emperor far-off. In all places the arrival of the emperor provoked excitement. Crowds flocked to see the trains of Diocletian and Maximian pass by when they came together to confer at Milan in the winter of 290/1,[28] while one rabbi deemed it entirely proper for a Jewish priest to cross a graveyard (which usually incurred ritual pollution) in his enthusiasm to appear before Diocletian at Tyre.[29] On arriving at Stratonicea in Caria, Maximinus 'blazed forth' and repressed the region's endemic brigandage.[30]

The formal entry or *adventus* of an emperor into a city was a much-repeated ceremony.[31] A particular feature of this and other imperial occasions was public rhetoric, the many speeches of thanks or praise made to the emperor. There were even rhetorical handbooks, which gave guidance on how to construct a *basilikos logos* (imperial speech).[32] Given the frequency of embassies from Greek cities and the attraction of many leading Greek cultural figures to the court, the majority of formal speeches before the emperor were probably in Greek. Indeed, Millar has famously written: 'If we follow our evidence, we might almost come to believe that the primary role of the emperor was to listen to speeches in Greek.'[33] In the era of Constantine, however, surviving examples are generally in Latin, deriving from a corpus of Gallic panegyrics for the rulers in the west. The dates and occasions of these speeches well illustrate their part in the life and ceremony of the emperors.[34] Four were delivered in connection with imperial anniversaries,[35] one for an imperial birthday,[36] one for Rome's birthday,[37] one for an imperial marriage,[38] one for a victory.[39] Most were delivered at Trier in the emperor's presence, although it was common for orators to praise the emperor in other settings before other office-holders.[40] We may suppose that panegyrics were written and delivered at York to celebrate Constantine's accession, although none survives. A Greek verse panegyric written by Soterichus for Diocletian's accession in 284 does survive in part, although this seems to have been delivered before the prefect of Egypt.[41] The panegyric of 307 celebrates not just Constantine's marriage to Fausta, but his promotion to Augustus, as well as Maximian's resumption of the purple. These were constitutionally problematic topics that had to be tackled without apparent embarrassment. But such a speech was ephemeral, tailored to occasion and audience. So, as circumstances changed, so could the treatment of the same topic. Thus Maximian's reappearance as Augustus was praised (and his previous abdication rued) in the oration of 307, but condemned in 310, even though many in the audience would have been the same.[42]

Such celebrations were also the occasions for other imperial appearances, especially in the circus or amphitheatre. Diocletian's *vicennalia* at Rome was marked by a magnificent triumphal procession, games and the scattering of gold and silver coins. There were at least three *congiaria* (distributions of money) to the Roman people at this time, one by Diocletian and Maximian probably at the *vicennalia*, another perhaps by Severus at the dedication of the Baths of Diocletian in 306.[43] Constantine is depicted on the Arch of Constantine making a *congiarium* for his *decennalia* at Rome (fig.16), and liberality remained a key imperial virtue.[44] Outside Rome, Constantine celebrated victory over the Franks by throwing captives to the beasts in the amphitheatre at Trier.[45] However, circuses and theatres were also places where the populace en masse could express their views to the emperor, often with ritualised acclamations; an experience which could be unpalatable, as Diocletian found at Rome in 303.[46]

An emperor's arrival was certainly an opportunity for local petitioners. Diocletian's visit to Upper Egypt in 298, despite causing panic for the local authorities, also generated at least two rescripts. The emperor issued one to protect the rights of the inhabitants of Elephantine and Syene,[47] and, after receiving rival petitions each claiming the other to be full of lies, settled a dispute over priesthoods at Panopolis with a further rescript. Even decades later a hopeful litigant (Ammon, Harpocration's brother) claimed that nothing could prevail against it.[48]

Petitioners were not, of course, only local. Although some petitions in legal cases might be forwarded to the court, most people had to reach the emperor in person or via a willing intermediary. Many will not even have been sure where the emperor actually was.[49] One man speaks of going off 'in the footsteps of the emperors'[50] and some embassies from cities in the eastern provinces, for instance, even tracked down Severus and Caracalla in far-off Britain.[51] So onerous was serving on an embassy to the emperor considered to be, in terms of both trouble and expense, that immunities from further burdens were routine.[52] The considerable number of rescripts issued in late 294 at Nicomedia suggests that many petitioners anticipated Diocletian's arrival there in mid-November for his winter sojourn, rather than struggling to intercept him during his three-month progress from Sirmium down the Danube, through Moesia and Thrace, then crossing from Byzantium into Bithynia.[53]

At the Council of Tyre (335) Athanasius, Bishop of Alexandria, fearing condemnation by the other bishops, slipped away early and fled to Constantine, who had been in Constantinople since March. But he arrived in late October to find the emperor had recently departed. Fortunately, Constantine returned a week later (6

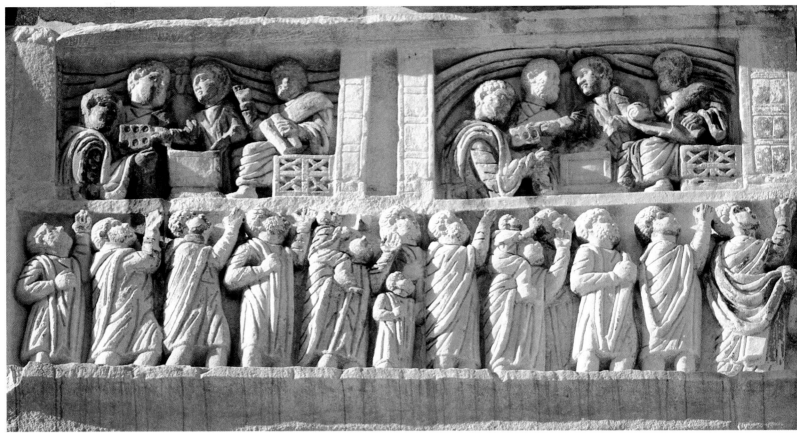

Figure 16 Constantine's *Congiarium* (detail), Arch of Constantine, Rome

November), being immediately accosted as he entered the city on horseback by a deliberately dishevelled and unrecognisable Athanasius, who thus seemed to have stolen a march over his enemies. They had followed swiftly, but arrived too late. Athanasius had twice before been heard favourably by Constantine, and now he obtained the chance of a third hearing. In this, he was then ambushed by his enemies with accusations of treason for threatening the corn supply from Egypt. He now threw away any advantage by losing his temper with the emperor, reportedly saying 'The Lord will judge between me and you, since you yourself agree with those who calumniate your humble servant'. A certain boldness was no doubt appreciated in appearing before the emperor, as we may suppose with Agrippina and the veterans in their verbal exchanges with Constantine as cited earlier. Constantine could be shocked, however, as when he realised that petitioners seeking immunities based on the number of their children were producing before his very gaze the children of others as their own (*CTh* 12.17.1)! Whether or not Athanasius spoke quite as above, he had overstepped the mark while face to face with the emperor. Constantine promptly exiled him far from Alexandria, to Trier (he was despatched the following day), although he did not formally condemn him nor allow him to be deposed from his see as the Council had wanted.[54]

For the successful, what was it like to appear before the emperor? The Constantinian *acta* already cited already give some idea of verbal exchanges. We also have some idea of personnel who might be present: the praetorian prefects and high officials, or more generally the *consilium* (later the consistory).[55] The locus is likely, for the most formal occasions and hearings, to be a magnificent hall like the surviving Aula Palatina from the palace at Trier (fig.17). Perhaps the best sense of an imperial audience can be gained from Eusebius's account of the opening of the Council of Nicaea in 325:

> On the day appointed for the Council, on which it was to reach a resolution of the issues in dispute, everyone was present to do this, in the very innermost hall of the palace, which appeared to exceed the rest in size. Many tiers of seating had been set along either side of the hall. Those invited arrived within, and all took their appointed seats. When the whole council had with proper ceremony taken their seats, silence fell upon them all, as they awaited the emperor's arrival. One of the emperor's company came in, then a second, then a third. Yet others led the way, not some of the usual soldiers and guards, but only of his faithful[56] friends. All rose at a signal, which announced the emperor's entrance; and he finally walked along between them, like some heavenly angel of God, his bright mantle

shedding lustre like beams of light, shining with the fierce radiance of a purple robe, and decorated with the dazzling brilliance of gold and precious stones. Such was his physical appearance. As for his soul, he was clearly adorned with fear and reverence for God: this was shown by his eyes which were cast down, the blush on his face, his gait, and the rest of his appearance, his height, which surpassed all those around him, by his dignified maturity, by the magnificence of his physical condition, and by the vigour of his matchless strength. All these, blended with the elegance of his manners and the gentleness of imperial condescension, demonstrated the superiority of his mind surpassing all description. When he reached the upper end of the rows of seats and stood in the middle, a small chair made of gold having been set out, only when the bishops assented did he sit down. They all did the same after the emperor.[57]

Despite Eusebius's obvious partiality and inversion of certain expectations, this conveys very powerfully the flavour of such a formal occasion: the large hall and magnificent setting, the emperor's entourage (but without the expected soldiers), the emperor's careful deportment (but eyes downcast, not imperially blazing) and rich attire, the studied protocol.[58] We may imagine how daunting in fact an emperor's presence could be. Indeed, in the consistory, the formal imperial council that replaced the old *consilium* after the time of Constantine, it was usual, as the name suggests, for all but the emperor to stand.[59]

Eusebius continues by recounting Constantine's opening speech (which was in Latin, with an interpreter relaying it in Greek) and his later interventions (when he spoke in Greek) in the often heated exchanges that marked the debates and disputes.[60] Eusebius emphasises that he displayed no resentment, but rather patience. We may suppose that an emperor was often less tolerant and flexible, although one disgruntled participant viewed the emperor's conduct as overly emollient, inhibiting important views from being heard.[61] Although Eusebius records that the bishops bandied accusations and counter-accusations, he does not explicitly record what Rufinus states: that they predictably took the opportunity to place petitions or rather accusations of their rivals in the emperor's hands. These, however, the emperor gathered up and then ordered to be burned unread.[62]

Much of the emperor's business, however, was inevitably carried out through written rather than spoken communication.[63] Each emperor had at least three senior officials concerned with his correspondence and pronouncements.[64] The *magister epistularum* (Master of Letters) handled correspondence with officials, people of high rank and cities, and any ruler of Greek speaking areas would also have a *magister epistularum Graecarum*.[65] The *magister libellorum* (Master of Petitions) dealt with petitions, being responsible for rescripts issued in reply to private petitioners. The *magister memoriae* (Master of Memory) may have been responsible for imperial edicts, *adnotationes* (usually specific grants) and other texts. Much of this correspondence was essentially responsive, replying to queries, problems or requests put to the emperor, following the traditional pattern of imperial activity. Before the fourth century, the most typical imperial letter had been one addressed in Greek to a city in the East, usually as a result of an embassy from the city to the emperor, requesting privileges or pursuing legal disputes. Although the inscriptions that are our principal source for such embassies and letters largely cease in the mid-third century, such interactions clearly continue. Thus, at Trier in 311, the rhetor from Autun gives thanks to Constantine for having reduced his city's tax burden.[66] Constantine replied to the decurions of Cologne on the immunities of Jews to civic liabilities, and to the city of Hispellum (Spello in Umbria) allowing it to hold its own festival, rather than being forced to attend that in the provincial capital.[67] Communities were still eager to acquire and were being granted the trappings of city status (their own independent council and magistrates). Galerius made such a grant to Heraclea Sintica in Macedonia in early 308,[68] and probably also to Tymandus in Pisidia,[69] while Constantine made a similar grant following a petition from the Christian village of Orcistus in Phrygia (*c*.325).[70]

The majority of Constantine's surviving pronouncements, however, are letters to office-holders, many if not most of which were probably answers to *consultationes* (queries) sent to the emperor for his guidance, although their nature is not necessarily clear from the edited versions surviving in the Theodosian and Justinian Codes. It is likely that the only text of Constantine concerning Britain is just such a reply.[71] Like our earlier texts, it survives in a single Theodosian Code manuscript (from the Vatican) and is addressed to Pacatianus, vicar of the Britains, dated 20 November 319. It reads:

> Every decurion is to be liable (for tax) only for that portion (of land) in which either he or his *colonus* or *tributarius*,[72] who is liable, collects the fruits, nor is he to be liable at all for another decurion or land. For this is clearly prohibited, and henceforward it must be observed that, in accordance with this our provision, no-one is to suffer wrong for another.[73]

This text is typically both obscure and simple. It is likely that this is only one section from a longer text that would have provided the explanatory background, perhaps the circumstances of Pacatianus's original query, although it could be a copy of a more general law

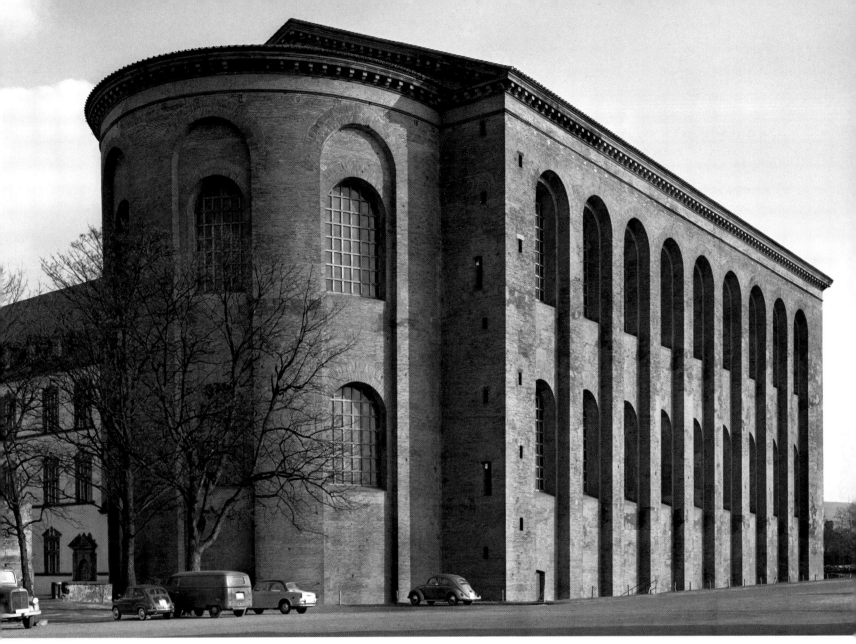

Figure 17 Constantine's Basilica, Aula Palatina, Trier

circulated to a number of officials. Stevens suggested that the source of the ambiguous liabilities might be a Celtic form of land-title, known from later Welsh laws as 'priodolder', under which rival claims could coexist.[74] But, while provinces were not identikit and Roman land law could simply overlay existing practices, there is nothing in this text to indicate a specifically British problem. Tax evasion or the attempt to off-load burdens onto others were recurrent problems and the general context seems entirely typical. Indeed, if anything, the terminology of tenancy and the tax situation demonstrate the opposite: that standard Roman administration was applied as much in the British provinces as elsewhere. Indeed, the number of documents attesting the use of the Roman civil law in Britain in at least the first 200 years of Roman rule has recently increased, although those using it cannot be proved to be 'locals'[75] and we must remember that since 212 almost all free inhabitants of the empire had been technically Roman citizens. It is also clear that in matters of the census and taxation the Roman government had a strong impact, directly projecting the authority of the state even down to the level of villages and estates. Lactantius describes the assiduousness of 'censitores' at the time of the 306 census, and two sets of inscriptions from Asiana and the Islands (listing properties and people counted for assessment) and Syria (boundary markers) suggest that his vision of an energetic process is accurate if prejudiced.[76]

The most plentiful imperial text of the third century is the private rescript, that is a ruling issued to a private petitioner.[77] While most petitioners were essentially seeking their own benefit, no doubt often property (like Eugeneios above) or immunities,[78] the

several thousand rescripts which survive do so because they embodied points of law considered instructive. Rescripts were seldom delivered directly but would be posted up in groups outside the emperor's current residence, to be copied by the recipient or by anyone else who considered them useful. The range of petitioners who receive these rescripts is wide. Senators (although they would usually receive letters), decurions, soldiers, freedmen, even slaves; most notably, between one-fifth and one-third of all recipients are women, a particularly remarkable statistic given the poor representation of women in many types of ancient evidence.[79] Few fourth-century private rescripts survive. This is not because they ceased to be issued, but rather because most extant examples derive from two collections published in the 290s (the Gregorian and Hermogenian Codes) and rescripts were never again gathered assiduously.[80] However, about a dozen Constantinian private rescripts do survive, including three to women.[81] We even know of one rescript, addressed to a decurion called Agrippinus, which was then cited in a quite different case in Egypt a decade after its original issue.[82]

It is unlikely that the emperor could have dictated, let alone written in his own hand, all his correspondence. The *magistri* mentioned above must in practice have been composers of most such material.[83] Eusebius, however, makes much of Constantine's independent composition (in Latin, then translated into Greek) and delivery of his own religious tracts instructing or rebuking his courtiers, and it is likely that his letters on Christian matters have more personal input than the general mass of texts issued in his name.[84] Yet the emperor still needed to sign everything that went out in his name. The panegyrist Nazarius already imagines of the young Constantine II in 321 that his 'fortunate right hand rejoices in bountiful subscription'.[85] The 'rescripsi' written below rescripts is the emperor's autograph authorisation.[86] Edicts or circular letters might have some posting instruction added, as with Constantine's letter to the eastern provincials, which concludes with the phrase 'Let it be posted up in our eastern regions'.[87] It is part of this text that has turned up on a contemporary papyrus.[88] Letters would end with a valediction of varying length or style, commonly of the type, 'Farewell, X, most dear to us', with newer Christian formulae such as 'God preserve you, beloved brother' appearing in texts addressed to clerics.[89] That these terminal phrases were in the emperor's own hand is sometimes indicated in copies by a phrase such as 'and in another hand'.[90] The emperor might pen entire letters if they were of sufficient importance, such as the letter from Constantine to the Persian king, Shapur II, which Eusebius states was written in his own hand.[91] One thing is certainly clear. Despite the existence of the 'palatine secretariat', the press of business upon the emperor, whether queries from

officials, appeals or the host of petitioners, was in practice overwhelming. Constantine even tried to limit the number of matters referred to him.[92]

Such pressure, of course, should have been eased by the collegiate government of the tetrarchic period.[93] Before Diocletian, third-century emperors often co-opted their sons into the imperial college (usually when they were too young to be active). Diocletian, with only a daughter, chose a different path. Once in sole control, he appointed a colleague-in-arms, Maximian, first as Caesar (285), then with full rank as an Augustus in 286. However, the primarily military crises that required attention multiplied. So in 293 Diocletian appointed the two emperors' sons-in-law, Galerius and Constantius, to the imperial college with the lesser rank of Caesar. This provided extra bodies to cope with immediate problems, so that campaigns were conducted almost simultaneously in Britain, Spain and Africa, Egypt and Mesopotamia. The arrangement also tried to settle the vexed succession question, a perennial problem for the Roman State, using the existing tutelary deities of the tetrarchs (Jupiter, Hercules), by creating a Herculian line in the west (Maximian, Constantius, later Severus and Constantine) and a Jovian in the east (Diocletian, Galerius, later Maximinus and Licinius). It is not clear that Diocletian originally envisaged a planned abdication to transfer power, as opposed to the chances of mortality, but this was probably the intention by the time of the *vicennalia* in 303, when Diocletian extracted an oath from Maximian for their joint abdication. In theory, the idea of a college of four seems admirable, with the Augusti being succeeded by their Caesars in orderly fashion and new Caesars appointed in their place. In reality, the multiplication of rulers also multiplied potential successors, and Galerius's attempt in 305 to exclude others' imperial sons (Constantine, Maxentius) as he tried to create a compliant college packed with his own candidates was a disaster. The supposedly stable tetrarchy of Diocletian staggered on in chaos for only five years after the abdication, as Galerius grasped for and lost control. It is no surprise that a ruthless elimination of surplus members of the imperial family was carried out by Licinius in 313 and Constantine's sons in 337.

Along with reorganisation of the imperial college, Diocletian also carried out wide-ranging administrative reforms, building on and giving firm shape to the work of his third-century predecessors. Provinces continued to be 'sliced and diced' and were now grouped into an intermediate territorial unit, the diocese, in the charge of a vicar (*vicarius*), that is a deputy of the praetorian prefects. Thus, after the defeat of Carausius, the two existing British provinces became four, forming a diocese with a vicar based at

London.[94] The praetorian prefects themselves emerge as the chief ministers heading the imperial government, second only to the emperors (in whose stead they could judge with an inappellable jurisdiction), although they continued to perform occasional military functions on campaigns up until 312, when the remnant of the actual praetorian guard was cashiered.

There does seem to be a change of mood in government at this time, more proactive, if still highly reactive. Constantine himself seems to have instituted a new post above all the other *magistri*, namely the quaestor. The details and timing of this development are lacking, although its origin probably lay in the role of the *quaestores Augusti* at Rome, who read out the emperor's speeches to the senate.[95] Later in the fourth century the quaestor became chiefly responsible for drafting general legislation, but what duties Constantine assigned to the post are unknown. The more aggressive, if not necessarily successful, attitude of this period is perhaps best illustrated by Diocletian's Prices Edict of 301.[96] This was issued in a vain attempt to curb rampant inflation. It consists of a lengthy edict justifying the unprecedented measure, followed by a tariff list setting maximum prices or rates for a host of goods and services reflecting every corner of the empire, even Britain.[97] The edict was probably only promulgated in the east, with the text laboriously inscribed (mostly) in Latin on stone in over forty locations in half-a-dozen provinces (and probably posted on ephemeral materials elsewhere). Although active enforcement does not seem to have endured, the ambition of this measure is clear. The trend to unsolicited Latin documents, inscribed in multiple copies in Greek-speaking areas, was short lived, perhaps deriving from the restless energy and ambition of Galerius. In particular, the Accusations Edict, often attributed to Constantine himself in 314 or 320, known from both epigraphic and manuscript copies, was perhaps part of a Galerian measure of 305.[98]

But if energetic promulgation by inscription was a temporary phenomenon, aggressive imperial policies most clearly emerge in matters of religion (see fig.18). There was the last of the empire-wide general persecutions of the Christians between 303 and 313, although this was unevenly applied and reveals the limitations of enforcement.[99] There were also the longer-lasting effects of Constantine's espousal of Christianity in 312.[100] The granting of privileges and monies to clerics and churches, including rights of jurisdiction, bound Christians and their hierarchies into the imperial system. The definition of who was orthodox, schismatic or heretical became vital, and in turn Christians had motive to approach the emperor as the ultimate arbiter. Thus disputes over Christian doctrine and discipline now became an imperial concern.

Figure 18 Nummus of Constantine: reverse showing Christogram-topped standard (cat.92)

Reference was made above to the saga of Athanasius in the 330s, but Constantine's first major entanglements arose very soon after his entry into Rome, when the proconsul of Africa forwarded petitions to him from the Donatists, one side of a bitter schism in Africa.[101] This was a legacy of persecution arising from discordant views over which acts during the crisis were reprehensible and what repercussions were appropriate. Thus, the Donatists refused to recognise Caecilian as Bishop of Carthage, as one compromised by events during the persecution. Unfortunately for them, Constantine had already written to Caecilian, sending monies for distribution to the churches in Africa and implicitly recognising him. The Donatists sought the emperor's judgment against Caecilian, but the emperor refused to judge the case directly himself; indeed later he was to say 'They seek my judgment, who myself awaits the judgment of Christ'.[102] Instead he initiated a new pattern of imperially backed church councils (even including the issue of free travel warrants for the public post), as two councils in Rome (313) and Arles (314) successively decided for Caecilian. As was to be proved time and again in the future, councils seldom settled key disputes. Disappointed parties tended to regroup, undermining decisions taken and resurrecting old issues in new ways. The Donatists proved intransigent and by 321 Constantine had discovered in his turn the limits of power and how ineffective persecution was. It is nonetheless very clear that the advent of a Christian emperor opened the floodgates for additional correspondence, petitions, appeals and every type of machination. Our rich Christian sources give us very full (if always partial!) accounts of the various disputes pursued. Indeed, in one council at least (Antioch, in 327), the bishops attempted to stem the tide of clerics visiting the court, 'who wearied the ears of the emperor'.[103] Yet such things were hardly new. The role of the emperor as giver of justice and distributor of benefits, whether largesse, offices or immunities, had hardly changed and Constantine can be seen doing all these things in full measure.

Notes

1. *CTh* 8.15.1. Best discussion in Bianchini 1984; cf. Corcoran 2000, 259–60. The manuscript is sixth/seventh century, now in Paris (facsimile: Omont 1909), the only one containing books VI to VIII virtually intact.

2. The codes supply a small number of extracts from official records (*acta*) of imperial hearings. Apart from the two Constantine texts, none preserves the words of speakers other than the emperors. These *acta* are: *CJ* 9.41.3, 9.51.1 (Caracalla); 7.26.6 (Philip); 9.1.17, 9.47.12, 10.48.2 (Diocletian); *CTh* 11.39.5 (Julian); 1.22.4 (Gratian); 4.20.3, 11.39.8 (Theodosius I). Significant numbers of non-imperial *acta* survive in the papyri, and there are possibly genuine Christian martyr *acta* (Musurillo 1972). For imperial hearings, see Millar 1992, 228–40, Corcoran 2000, 254–60.

3. *Praepositi* in charge of *pagi* were introduced into Egypt by 307–8 (Bowman, Cameron and Garnsey 2005, 321).

4. See Bell *et al.* 1962, 6–12; note especially his Latin petition to the emperors (*P. Abinn.* 1).

5. *P. Ammon* I 3 and 4 (Willis and Maresch 1997, section 2).

6. Willis and Maresch 1997, 59–67. Harpocration's brother Ammon fought against this claim, complicated by the discovery of at least two wills! For petitions to take possession of vagrant slaves, see *CTh* 10.12.1–2.

7. Compare *CJ* 10.48.2, where Sabinus addresses Diocletian in Greek (preserved as meaningless sequences of Latin and Greek letters in the medieval manuscripts, *CJ ed. maior* p.929), and the emperor rules in Latin. All other *acta* (note 2 above) are in Latin, except for a Greek ruling of Julian (*CTh* 11.39.5). For Constantine's level of Greek, see Cameron and Hall 1999, 265–6.

8. *CTh* 7.20.2 (whence *CJ* 12.46.1). The date preserved is March 320, but if the place (Civitas Velovocorum) is rightly Beauvais, an earlier date (307?) may be preferable (thus Barnes, but not generally accepted; Corcoran 2000, 257–9).

9. Hauken 1998, 74–126.

10. Humphrey 1986, ch.11. They echo the original Palatine/Circus Maximus complex in Rome.

11. Lactantius, *DMP* 17.4–9.

12. For example *DMP* 18.

13. Eusebius, *VC* III.15.

14. Epiphanius, *Panarion* III.68 (Barnes 1981, 231).

15. Note how Sallustius Crispus 'particeps secretorum' advises Livia to conceal the 'arcana domus' (Tacitus, *Annales* 1.6.3). For the Tiberius/Hadrian parallels, note the classic treatment by Syme 1958, ch.36.

16. A petitioner bribed Vespasian's muleteer to stop and shoe his animals, so giving him opportunity to approach the emperor (Suetonius, *Divus Vespasianus* 23).

17. *CTh* 6.36.1.1.

18. See Barnes 1982, 68–73.

19. Halfmann 1986, 239–40.

20. Barnes 1982, 49–60 lists the journeys and residences of Diocletian and Maximian.

21. Barnes 1982, 68. See also Cameron in this volume p.23.

22. *Epitome de Caesaribus* 40.2; Zosimus II.9; *PLRE* I Maxentius 5; Barnes 1982, 12–13.

23. Bertolotti, Ioppolo and Pisari Sartorio 1988.

24. Lactantius, *DMP* 44.11.

25. For Maxentian and Constantinian Rome, see Krautheimer 1983, ch.1 and Coarelli 1986.

26. Corcoran 2000, 215–19.

27. *P. Panop. Beatty* 1 is a register of outgoing letters, mostly concerned with Diocletian's visit, explicitly noted at *P. Panop. Beatty* 1.53–9, 108–19, 167–79, 217–24, 244–52, 256–62, 276–8, 332–7, 381–3.

28. *Pan. Lat.* XI(3).10.4–5. Mamertinus also nicely contrasts privileged access for those of high rank within the palace, with more public progresses through the centre of Milan (*Pan. Lat.* XI(3).11).

29. Smallwood 1976, 537–8.

30. *Inscriptions of Stratonicea* II.1 310, lines 22–7. The visit was probably spring 312 (Barnes 1982, 66 with *AE* 1988.1046).

31. MacCormack 1981, 17–39.

32. Note the contemporary treatises of Menander Rhetor (Russell and Wilson 1981; Heath 2004).

33. Millar 1992, 6.

34. Details from Nixon and Rodgers 1994 and Barnes 1996, 539–42.

35. *Pan. Lat.* VIII(5), *quinquennalia* of Constantius I as Caesar (1 March 297); *Pan. Lat.* VI(7) and V(8), opening and closing of Constantine's *quinquennalia* (August 310/July 311); *Pan. Lat.* IV(10) *quinquennalia* of the Caesars (1 March 321). Eusebius delivered a Greek oration at Constantinople for Constantine's *tricennalia* on 25 July 336 (Eusebius, *De Laudibus Constantini* 1–10; Drake 1976).

36. *Pan. Lat.* XI(3), Maximian's birthday (21 July? 291).

37. *Pan. Lat.* X(2), to Maximian on Rome's birthday (21 April 289); cf. VI(7) on Trier's birthday, 1 August 310.

38. *Pan. Lat.* VII(6), to Maximian and Constantine for the latter's marriage to the former's daughter, Fausta (September 307).

39. *Pan. Lat.* XII(9), victory of Constantine over the Franks (313?).

40. *Pan. Lat.* IX(4), speech of thanks by Eumenius at Autun or Lyons before a governor or vicar (298). Nazarius (*Pan. Lat.* IV(10)) was probably not speaking before Constantine, but in Rome.

41. *P. Oxy.* LXIII 4352, with Suda sigma 877 (410.11–15). The still uncertain identification is made by Livrea 1999.

42. *Pan. Lat.* VII(6).9–11 versus *Pan. Lat.* VI(7).14–16. We are fortunate that these speeches remain more or less as delivered, not retrospectively censored or rewritten.

43. Roman evidence is in the Chronographer of 354 (*Chronica Minora* I (MGH AA 9) 148). Baths dedicated: *ILS* 646. Major imperial baths were also erected at Carthage and Trier.

44. Millar 1992, 135–9; Eusebius, *VC* IV.22.2.

45. *Pan. Lat.* XII(9).23.3–4.

46. Lactantius, *DMP* 17.1–3; cf. *CJ* 9.47.12 and Corcoran 2000, 255–6.

47. *AE* 1989.754; *AE* 1995.1616. There are two texts here, with one at least of 298.

48. *P. Ammon* I 3.iv.24–5. Ammon was convinced that this would trump his brother's efforts for a fresh rescript from Constantinople!

49. Millar 2000 makes sensible observations on the effect of uncertain location upon the logistics of correspondence between Trajan (in Italy) and Pliny (in Bithynia/Pontus).

50. Millar 1992, 636 citing *P. Lond. inv.* 1589 (= *Sammelbuch* XX.14469). The emperors are the tetrarchs.

51. *Inschriften von Ephesos* III.802; *SEG* XXXVI.628.

52. A two-year exemption for a 'transmarina legatio' (Diocletian, *CJ* 10.65.3). Despite seeming a great opportunity, an ambassador had (strictly speaking at least) to get permission to present personal in addition to civic business (Modestinus, *Digest* 50.7.16).

53. Barnes 1982, 53–4.

54. For the Council of Tyre and its aftermath, see Barnes 1981, 235–40, Barnes 1993, 22–5, and Drake 2000, 3-9 and 309-15. At this same period, the rhetor Sopater was framed then executed for supposedly impeding the corn transports by magic (Eunapius, *Vitae Sophistarum* 462-4).

55. Officials listed by name: *CJ* 9.51.1 (Caracalla), *CTh* 11.39.5 (Julian); cf. *CJ* 9.47.12, *CTh* 1.22.4. The *consilium* had no fixed membership, and anyone might be asked to sit as an *assessor* (adviser). The best known of Constantine's advisers are Sopater (the rhetor), Hermogenes (possibly the first quaestor) and Hosius (Bishop of Cordoba) (Corcoran 2000, 262).

56. Possibly 'believers', i.e. Christians (Barnes 1981, 215 and Drake 2000, 252).

57. Eusebius, *VC* III.10; trans. in Cameron and Hall 1999, 125.

58. Cameron and Hall 1999, 264–5.

59. The *consilium* is still attested under Constantine (*CJ* 6.7.2, 7.1.4).

60. Eusebius, *VC* III.11–14.

61. Eustathius of Antioch in Theodoret, *HE* 1.8 (Barnes 1981, 216 and Drake 2000, 254).

62. Rufinus, *HE* X.2. Burning accusations is mentioned also in *CTh* 9.34.3 and the

Edictum de Accusationibus (*Inscriptiones Creticae* I.18.188, lines 36–45; *CIL* v.2781, lines 21–7).

63. Millar 1992, ch.5.

64. The Caesars of the first tetrarchy lacked praetorian prefects and possibly some other officials, but Constantine presumably kept his father's *comitatus* intact, even while technically only Caesar (Corcoran 2000, ch.11).

65. The page of the *Notitia Dignitatum* in the exhibition (cat.96) is for the western administration, so lacks a Master of Greek Letters. Constantine himself may well not have needed such an official until he acquired significant numbers of Greek-speaking subjects in 317.

66. *Pan. Lat.* v(8).11–13.

67. *CTh* 16.8.3 (321); *CIL* xi.5265 = *ILS* 705 (333/335).

68. Mitrev 2003. The heading names only Galerius and Maximinus, since Constantine had ceased to be recognised in the east, only becoming 'legitimate' again from November 308 (the Carnuntum Conference).

69. Tymandus: *CIL* iii.6866, *MAMA* iv.236. The text lacks date and emperor, but chimes with other Galerian activities in Pisidia (for example Christol and Drew-Bear 1999).

70. *MAMA* vii.305. See Mitchell 1998.

71. There are no known texts issued by Constantine from Britain. By contrast, several date to the sojourn of Severus and his sons in 209–11, with one explicitly stated as posted up at York (*CJ* 3.32.1).

72. *Colonus* is a (tied?) tenant, while *tributarius* is a tenant registered for the poll tax, although the exact difference is unclear. For this difficult terminology, see Mirković 1997.

73. *CTh* 11.7.2.

74. Stevens 1947.

75. Property transfer (*RIB* 2504.29); slave sale (Tomlin 2003); will (Tomlin and Hassall 2004, 347–8). For other legal texts issued in or sent to Britain, see Birley 1953, 48–52.

76. Lactantius, *DMP* 23; Corcoran 2000, 175–6 and 346–7.

77. For the rescript system, see Honoré 1994, ch.2.

78. The demand for immunity from civic or other burdens is especially insistent (Millar 1983).

79. For petitioners, see Corcoran 2000, ch.5.

80. See Corcoran 2000, ch.2, and Corcoran 2004.

81. Listed in Corcoran 2000, app.C (not all certainly rescripts or certainly Constantinian). The rescripts to women are *Fragmenta Vaticana* 33, 34 and 274.

82. *P. Col.* vii.175 (= *Sammelbuch* xvi.12692: issued 326/333, cited in court 339).

83. The basic premise of Honoré 1994, where he tries to identify individual *magistri libellorum* by their rescript style.

84. Eusebius, *VC* iv.29–33.

85. *Pan. Lat.* iv(10).37.6. Constantine II was not even five years old (Barnes 1982, 44)!

86. Honoré 1994, 45–7. For 'rescripsi' preserved on inscriptions, see *AE* 1989.721, line 11 (Caracalla; 212/13) and Hauken 1998, 64, line 168 (Gordian iii; 238); cf. 'et alia manu: scripsi' (Commodus; Hauken 1998, 10, line 9).

87. Eusebius, *VC* ii.42; cf. *VC* iii.65.3.

88. *P. Lond.* 878, Jones and Skeat 1954 (see cat.10).

89. Most of Constantine's letters from the literary sources (Silli 1987; mainly translations, not Latin originals) carry valedictory formulae, 28 'Christian', two the standard 'vale'.

90. Licinius in the Brigetio Tablet: 'et manu divina: vale, Dalmati, carissime nobis' (Corcoran 2000, 146; cf. *MAMA* vii.305 ii.15–16 to Ablabius). Four Constantinian letters in Greek versions: 'and in another hand: may God preserve you, beloved brother(s)' (Athanasius, *De Decretis Nicaenae Synodi* 38.9, 39.2, 40.43 and 42.3). Only one original imperial subscript in an emperor's own hand survives from antiquity (Theodosius II: Feissel and Worp 1988, 97–111 = *Sammelbuch* xx.14606: 'bene ualere te cupimus').

91. Eusebius, *VC* iv.8. The letter's authenticity or origin is still sometimes doubted (Cameron and Hall 1999, 313 and Carriker 2004, 294–5). Perhaps Constantine penned his private letter to Optatianus Porfyrius (Silli 1987 no.27).

92. *CTh* 11.29.1, 15.1.2; cf. 1.15.1.

93. This account follows standard treatments of the tetrarchy: Bowman, Cameron and Garnsey 2005 ch.3; Barnes 1981 chs.1–2 and 1982 chs.1–4.

94. Mann 1998.

95. Zosimus attributed the post to Constantine (5.32.6). See Harries 1988, 153–4.

96. Corcoran 2000, ch.8, with Corcoran 2002, 227–30.

97. Two qualities of rug (*tapete Britannicum*) and a hooded cloak (*byrrus Britannicus*) (*Prices Edict* 19.28–9 and 48 Giacchero = 49.28–9 and 45 Crawford).

98. See Corcoran 2002 and 2004, 65–8. The inscribed copies are from eastern provinces, subject to Galerius in 305, but not all under Constantine until 324.

99. For the persecution, see Corcoran 2000, 179–82, 185 and Bowman, Cameron and Garnsey 2005, 647–65.

100. For emperor and Church under Constantine, see Barnes 1981, Millar 1992, ch.9, Drake 2000.

101. For Constantine and the Donatists, see Barnes 1981, 54–61 and 1982, ch.15; Millar 1992, 584–9; Corcoran 2000, 167–9.

102. Optatus, I.23 and *Appendix* V.

103. Council of Antioch canons 11–12 (Mansi II.1313–14). For the date, see Barnes 1981, 385, n.38.

In the Pay of the Emperor: Coins from the Beaurains (Arras) Treasure

Richard Abdy

Discovery and disposition

On 21 September 1922 workmen at the clay pits near Beaurains, a southern *arrondissement* of Arras, broke into a world vastly remote in time to the war-ravaged part of France that their brickwork industry was helping to reconstruct. Their discovery consisted of an ancient pot containing a silver vessel (both pot and vessel now lost), full of Roman jewellery and silverware, as well as hundreds of gold and silver coins. Much of the treasure was stolen upon its discovery and years of legal action followed. Those items eventually recovered were split, some going to the city of Arras and the rest being sold on behalf of the landowner to various museums and private collections. Much information had already been lost and the subsequent scattering made the definitive 1977 catalogue of the hoard by Bastien and Metzger a great achievement of detective work as well as interpretation. The authors estimated that, of the pieces now scattered across collections in Europe and the United States, only 70 per cent remained to be catalogued (472 coins instead of the 700+ reckoned to form the initial discovery).[1]

The British Museum acquired 34 coins,[2] two medallions, the lion's share (14 pieces) of the jewellery (see cats 46–59) and the one surviving piece of silverware, the folding candlestick (figs 19, 20 and 23). The Ashmolean Museum has one medallion and three coins. The most celebrated piece in the hoard, a massive gold medallion depicting Constantius I's relief of London in 296, was acquired by the city of Arras and is known as the 'Arras Medallion'. British disappointment was somewhat mollified by the production of a limited range of superbly detailed facsimiles by Bourgey, the agent of the landowner, in the 1920s. Nowadays quite rare in themselves, the British Museum has Bourgey facsimiles of this piece and another massive medallion, of Constantine the Great (fig.20; cats 17 and 42).

Table 1: List of coins and medallions with mints, after Bastien and Metzger 1977

Period	Gold coins	Silver coins	Copper alloy coins	Medallions
First and second century	1	81	–	–
271–4 (Gallic mint)	–	–	1	–
285–315	345	19	–	25
From the following mints:				
Carthage	4	–	–	–
Alexandria	1	–	–	–
Antioch	4	–	–	–
Nicomedia	3	–	–	–
Cyzicus	16	–	–	–
Thessalonica	2	–	–	–
Siscia	3	1	–	–
Aquileia	8	–	–	–
Ticinum	2	–	–	–
Rome	60	2	–	2
Ostia	2	–	–	–
London	2	–	–	–
Lyon	1	–	–	–
Trier	237	16	–	23

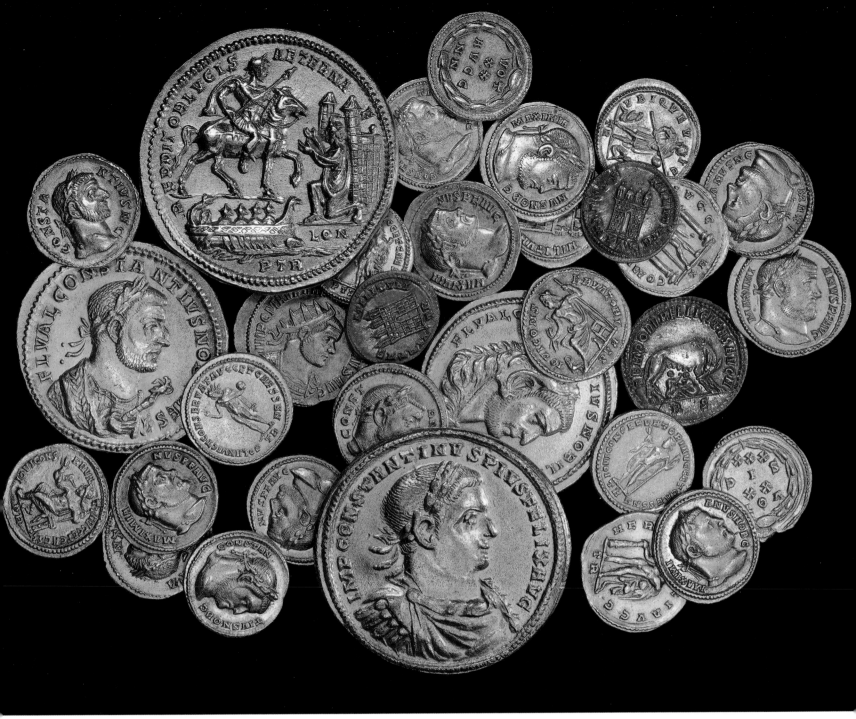

Figure 19 Beaurains (Arras) medallions and coins

Contents: the coins and medals

Bastien and Metzger list the known contents as shown in Table 1. The list shows examples from nearly every mint active in the Roman Empire in the years around 300. By this period the city of Rome itself no longer had the monopoly of producing the official state coinage. The products of the mint at Alexandria took much the same form as those produced by the mint at London. Reverse designs on the common copper alloy coins were restricted to one or two stock designs at a time, which often remained unchanged for several years. This aided the output of a standardised product throughout the empire. In addition, in an empire shared between joint emperors, the busts displayed on coins became deliberately similar, with little to distinguish the effigies of the imperial colleagues of the dominant ruler. For example, Maximian appears on coins – as does Diocletian – with a cube-shaped head and campaign-stubble beard, but is distinguished by a retroussé nose; Constantius with a cube-shaped head and stubble beard, but with a 'hooked' nose – compare cat.nos 84 (Diocletian), 23 (Maximian), and 18 (Constantius, fig.21). Everyone who wanted to conform politically was made to resemble the official image of Diocletian or,

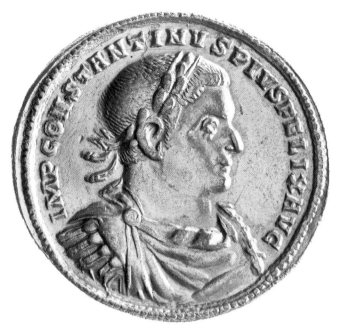
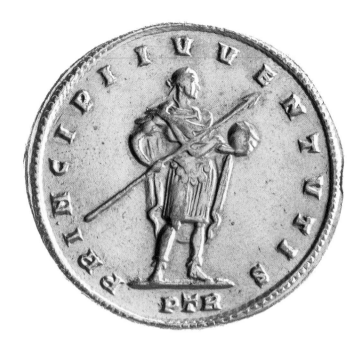

Figure 20 Medallion of Constantine, facsimile (cat.42)

subsequently, Constantine when he developed his own sleek, clean-shaven image (after his earliest coins which bore a bearded Diocletian-clone bust). This appearance of uniformity was further aided by quality control: the inclusion of mint-markings to distinguish not just the mint of origin but also its subdivision in the form of a particular workshop or production line (*officina*).

The evidence of die-links in the Beaurains Hoard

Each production line of each mint created coins from blank discs of metal by stamping them between pairs of dies to impress the front and reverse designs. Every time a new emperor appeared on the scene or a new reverse design was ordered a new die had to be engraved. Furthermore, since a die wore out after striking about 30,000 coins[3] new dies were constantly created just to maintain the current designs. No engraver could copy a design without some slight variation: the random way the folds of drapery are represented or the knot and furled ends of a wreath ribbon. Such tiny variations between the designs help distinguish between coins with ostensibly the same design but struck from different obverse or reverse dies.

Observing such details is known as 'die-linking'. One interesting conclusion drawn from studying die-links on the coins in this hoard is that many coins were from identical production batches, suggesting that they were probably received direct from the manufacturing source and were never mixed up by being circulated. The hoarder received money in discrete batches but did not spend all of it as he went along, building up the residue as savings which held a fossilised record of his income over time.

Who was the Beaurains hoarder?

Recent examination of the latest massive medallion in the hoard has revealed some interesting graffiti (see cat.42 for medallion facsimile, although little of the very faint graffiti has transferred onto this facsimile (fig.20)). This evidence had seemingly been overlooked at the time of discovery (and was not widely published until Casey 1994, 143), and since the piece has remained in private ownership there have been few opportunities to examine it since. The present author, along with Jonathan Williams and Roger Tomlin, had a brief opportunity to study the medallion in 2002 at a sale catalogued by Vagi. The reverse graffito reads almost as if intended to be a second legend below the original in the field around the standing figure of the emperor. To the left of centre, reading clockwise from the bottom, is scrawled the name *Vitaliani* (belonging to Vitalian). The graffito continues around the top of the figure down to the right of centre. Our new reading is VITALIANI PRO-TIC-TORIS (the legend interrupted by the head of the reverse figure). This appears to give Vitalian the rank of *protector* (see the essay by Roger Tomlin in this volume for an interpretation of *protector* and Vitalian's career).

Army pay

Roman army pay in the years around 300 is also relevant to the story of the hoard. It has been mentioned above that in 300 Roman coinage was of a uniform nature from Alexandria to London. It is in fact Egypt that provides the best evidence for army pay during this period. In and around 300 a set of pay records was produced on papyrus for the cavalry fort of Thmou in the vicinity of Thebes garrisoned by *ala I Hiberorum*. They survive today as part of the Beatty

collection of papyri.[4] Payments took the form of regular wages payable thrice yearly in arrears (*stipendia*), as well as direct payments in kind of various supplies (*annona*), for example fodder for the horses. Duncan-Jones has analysed the wage figures and deduced that a cavalry trooper was paid a regular wage of 1800 *denarii* a year.[5] Cavalry troopers received the same pay as legionaries in the Roman army. Remarkably, pay had probably remained at this level since 235; if so, it had certainly not kept pace with price inflation over the course of the third century.[6] Indeed, while pay levels stagnated over the course of the century, they had perhaps fallen behind rising prices by a factor of a dozen times or more. Of course the *annona* helped, but no emperor could allow his troops to become so impoverished and expect to stay in power for long.

The Beatty papyri illustrate the solution. The shortfall was made up with a new form of payment that seems to have become established over the course of the third century, cunningly designed to link the common soldier more than ever with the imperial personality cult. These took the form of bonus handouts given at propitious moments for the emperor. Most commonly special payments (*donativa*) were made for the birthday and accession day of an emperor. Further payments were made when an emperor took the office of consul (joint president of the Roman Senate for the year) or celebrated the anniversary of his reign in five- or ten-yearly intervals (*quinquennalia, decennalia, vicennalia,* etc.). Payments depended on the seniority of the emperor, bonuses in honour of a Caesar being less than those for an Augustus. However, present evidence suggests that the basic pay of a trooper/legionary would have been boosted by about 10,000 *denarii*, and this is just for an ordinary year without an imperial consulship, victory celebration or jubilee.[7] This is easily enough to make up for the otherwise apparent shortfall of wages against prices.[8]

Duncan-Jones admits that this hypothesis makes an assumption that donatives had not been a significant part of army pay during the Severan period.[9] However, numismatic evidence appears to concur. Although occasional examples are known from earlier in the third century, impressive gold 'money medallions' begin to put in regular appearances from the sole reign of Gallienus (260–8) onwards. One of the earliest known medallion hoards in the western empire is the Corsica (Golf de Lava) hoard containing 13 medallions of Claudius II Gothicus (268–70).

These objects are money medallions in the sense that they are multiples of the standard gold coin of the day (multiples of up to ten survive from the period discussed; for example, see the massive Diocletian medallion, cat.84). Their medallic (special commemorative) nature can usually be attributed to a particular donative

event.[10] The medallions in the exhibition were issued to honour the fifth anniversaries (*quinquennalia*) of Constantius (cats 17–19) and Constantine (cats 42–3) in 297 and 310 respectively. The former was a particularly auspicious occasion – the anniversary fell just when Constantius had returned in triumph from Britain and was holding the office of Consul for the second time. Cat.18 shows Constantius in the garb of Consul (fig.21), while cat.17, the celebrated Arras Medallion itself, shows the emperor as the hero of the British campaign entering London (the earliest depiction known of the city), restoring to its grateful citizens (personified by a kneeling female supplicant) the 'light' of Roman civilisation.[11] Both cats 18 and 19 carry identical reverse designs. They show Constantius raising Britannia, the personification of Britain (or perhaps a personification of London), from her knees, as her saviour from the unjust domination of rebel emperors. This is a visual shorthand for the political restitution of the Roman part of the island and its subsequent economic regeneration.[12]

Roman gold medallions

The rarity of money medallions suggests that they were issued not to common soldiers but probably only to more senior officers. Ordinary soldiers probably just received ordinary coins. Many gold coins in this hoard have common die-links, which suggests they had been received as batches of income. Some of the gold coins carry records of the official vows made at the time of the imperial anniversaries. In producing their definitive catalogue of the hoard, Bastien and Metzger deduced that the owner had received a number of handouts beginning in 285 (see Table 2).[13]

The Beaurains hoard of course represents only an unquantifiable residue of the monies received but it is clear that proportionally the recipient received much more in 303 than in 297.[14] This was probably because his career developed through successive promotions; not only did he receive more, but he was beginning to build up funds and this enabled him to spend less of what was accrued as he went along.

Spoils of war?

An intriguing component of the treasure is the 81 silver *denarii* of the first and second century. These are accompanied by one gold *aureus* of the same period.[15] Such coinage disappeared from circulation long before the end of the third century and their presence has been interpreted as the loot taken from defeated barbarians.[16] The silver *denarius* was the principal coinage of the Roman Empire for almost its first three centuries, of prime importance for taxation and army pay. It became subject to increasing debasement over this

period, the most dramatic reduction in the silver content occurring in 194/5 when the *denarius* became a coin produced from a half silver, half base-metal alloy.[17] Literary and archaeological evidence suggests that the older silver *denarii* were deliberately picked out by barbarians and retained long after they had been driven out of circulation within the empire.[18] The most dramatic archaeological evidence of this comes from Danish late Iron Age bog finds. For example, at Illerup (Jutland) about 200 *denarii*, all minted before 188, were associated with weapons that could not have entered the bog before the latest wood to make them was felled after 205.[19] The early fourth-century horizon from Nydam (Jutland), associated with the famous Nydam boat, has so far yielded 56 *denarii* minted between 69 and 217.[20] The barbarian habit of hoarding silver *denarii* has a long history. The tomb of the Frankish king Childeric (d.482) contained silver coins of the Antonine period and earlier.[21]

Coin types during the early years of Constantine's reign

The silver *denarii* in the Beaurains hoard were already ancient when they were deposited and would have had no place in the everyday coinage circulating in the Roman Empire. The Beatty papyri list sums of *denarii* but these were no longer physical coins but units of account. One of the most important numismatic documents of our period is the currency edict of 301.[22] This tells us that the two common denominations in argentiferous copper alloy were tariffed at 4 and 25 *denarii*.[23] The latter is sometimes known as the *nummus*, a term simply meaning the standard denomination. One *nummus* issue of 308 carries a mark of value confirming that the system still stood early in the reign of Constantine.[24] Another important document, the Edict of Maximum Prices (also of 301), sets the maximum

daily wage for a labourer at 25 *denarii* (i.e. 1 *nummus*). Biblical stories suggest that in the first century a fair day's wage for labouring was one *denarius*.[25] In terms of value it would seem that the *nummus* (cats 85–7) was the most direct successor to the *denarius* in the currency system of this period.

There are no examples of the base-alloy *nummus* in the hoard, but another coin type mentioned in the 301 currency edict is present. This is the *argenteus*, a pure silver coin of about the same weight the old silver *denarius* had been back in the first century. This new silver piece was however tariffed at 100 *denarii*[26] (cat.39; cats 40, 44 and 45 are half units). By tradition, a standard purse, known as a *follis* (later to become a Byzantine-period coin denomination) comprised 125 silver pieces.[27] The standard purse became an increasingly useful 'denomination' in the inflationary times of the third and fourth centuries. With the *argenteus* tariffed at 100 *denarii*, the *follis* became a sum of 125 × 100 = 12,500 *denarii*. In one scene of a mosaic from the celebrated fourth-century villa of Piazza Armerina in Sicily there are *follis* bags marked XIId (a shorthand for 12,500, with d = 500).[28]

Gold in the world of Constantine

One coin did not fit in the denominational system laid out in the currency edict in a straightforward manner: the gold piece, traditionally known as the *aureus*. In the Edict of Maximum Prices the recommended maximum price of gold is given per Roman pound, about 323g,[29] as 72,000 *denarii* which could be in the form of ingots (*in regulis*), coin (*in solidis* – 'solid bits') and jewellery (*aurum nettum* – 'spun' gold).[30] That the form of the gold made no difference meant that the face value of the gold coin was entirely dictated by

Table 2: Events occasioning major donatives

Date	Issued from	Emperor	Reason
285	Rome	Diocletian	Diocletian takes control of Italy
294	Rome/Trier	Maximian/Constantius	The Caesars take the office of consul for the first time
297	Trier	Constantius	Celebration of reconquest of Britain; fifth anniversary of the Caesars; Maximian fifth time consul; Galerius second time consul
302	Trier	Constantius	Tenth anniversary of the Caesars
303	Trier	Constantius	Twentieth anniversary of the Augusti; Diocletian eighth time consul; Maximian seventh time consul
305	Trier	Constantius	Caesars consuls for the fifth time; Caesars promoted to Augusti to create the Second Tetrarchy
307	Trier	Constantine	Constantine promoted from Caesar to Augustus
310	Trier	Constantine	Fifth anniversary of Constantine

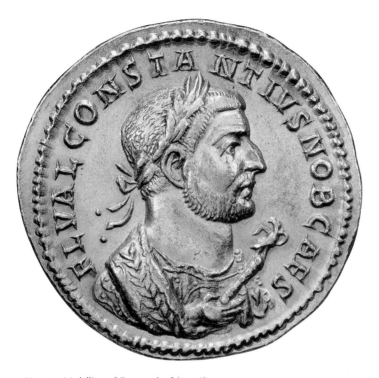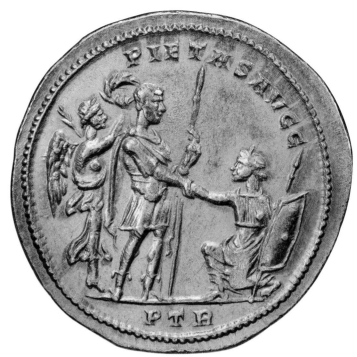

Figure 21 Medallion of Constantius I (cat.18)

the value of the metal content. In other words gold coins now 'floated' against prices on the commodity market, an inflation-proof stratagem. In the first part of this period the gold piece was struck at 60 coins to the Roman pound. With the price of a pound of gold at maximum worth 72,000 *denarii* in 301, a gold piece was worth 1200 *denarii*.[31] By 309 Constantine had changed the standard to 72 to the pound. The edict hints that the gold coin was already known as the *solidus* by 301, but by custom scholars prefer to reserve this name for the Constantinian coin, continuing to call it the *aureus* up until 309 (and later in the areas not controlled by Constantine). The reason is that the Constantinian change was so profound: it was to remain the absolute weight standard for the gold coinage in the Byzantine world up until the eleventh century.

What was the value of gold coins under Constantine? This is a harder question to answer as it depended on the market value of gold. A papyrus written between 304 and 306 suggests that the price had risen to 100,000 *denarii* per pound.[32] This is neatly confirmed by the 9-*solidus* Constantine medallion of 310 in the hoard. On the obverse it carries the graffito mark XIId (the X is barred to superimpose the traditional *denarius* symbol with the sum), the mark of the *follis*.[33] The medallion weighs one-eighth of a Roman pound of

gold = 100,000 *denarii* for the pound. Therefore an individual *solidus* = nearly 1389 *denarii* (12,500 divided by nine) or about 55½ *nummi* of the time.

The character of this hoard contrasts with another contemporary medallion hoard, probably from Sicily.[34] It belonged to an individual who seemingly remained throughout his career in the western Mediterranean, within the realm of Constantine's first great rival Maxentius. The final great Constantinian medallion hoard so far known from the western empire, the Helleville hoard, was found in a garden near Cherbourg in Normandy in 1780. The coins and medallions cover the latter part of Constantine's reign (from 326) and its aftermath, with the family of Constantine now in full control of the empire. Only one now survives (cat.79). Issued from the new capital of Constantinople, it well illustrates Constantine's ultimate imperial achievement and the fulfilment of his dynastic ambitions.

Acknowledgements
Andrew Burnett and Roger Tomlin are thanked for their comments on the draft of this essay; Michael Crawford and Jonathan Williams for their thoughts on the graffiti on the Constantine medallion.

Notes

1. There have been persistent rumours, discounted by Bastien and Metzger, of two unprecedentedly large medallions of 0.5kg of gold each melted down. See Evans 1930, 223; Toynbee 1986, 67; for their dismissal of this rumour see Bastien and Metzger 1977, 14–15.

2. The following seven coins from the Beaurains hoard are in the British Museum, Dept of Coins and Medals (BM C&M) but not in the exhibition: *aureus* of Constantius I (BM C&M 1925 4-4 5; *RIC* VI.280.7; Bastien and Metzger 1977, 44); *aureus* of Maximian (BM C&M 1925 4-4 2; *RIC* VI.164.10; *op. cit.*, 205); *aureus* of Maximian (BM C&M 1925 4-4 3; *RIC* VI.171.66; op. cit., 237); *aureus* of Maximinus II Daza (BM C&M 1925 4-4 1; *RIC* VI.204.631; op. cit., 434); *aureus* of Maxentius (BM C&M 1925 4-4 4; *RIC* VI.367.137; op. cit., 187); *argenteus* of Maxentius (BM C&M 1950 12-1 27; *RIC* VI.375.190; op. cit., 190); ½-*argenteus* of Constantine the Great (BM C&M 1949 4-3 168; *RIC* VI.216.758; *op. cit.*, 443A, i.e. omitted from catalogue).

3. Burnett 1991, 46.

4. The Chester Beatty Library, Dublin Castle, www.cbl.ie

5. Duncan-Jones 1978, 546.

6. ibid., 549–50.

7. ibid., 550.

8. ibid., 550.

9. ibid., 550.

10. Note that regular issues of Roman imperial bronze medallions have a much longer history, going back to the first century, with a heyday in the mid–late second century.

11. See Hannestad 1988, 311–13, who explores the link between the Beaurains medallion and the panegyric of 297.

12. MacCormack 1981, 29–31, considers both the iconography of this type and the relief of London medallion.

13. Bastien and Metzger 1977, 215.

14. ibid., 215.

15. ibid., nos 45–126. Bastien and Metzger estimate that there may have been around 100 *denarii* and a further 100 *aurei* in the original find.

16. ibid., 215.

17. For the silver debasement of the Roman *denarius* see Duncan-Jones 1994, 225.

18. Tacitus (*Germania* 5, 3–5), writing around the turn of the second century, mentions the German preference for old-fashioned *denarii*, which may well be due to an underlying motive of acquiring recognisably older coins with a better silver content.

19. Ilkjaer 2001, 48.

20. Horsnaes 2003, 330–3.

21. See Lasko 1971, 32.

22. The best example of this is the Aphrodisias currency inscription. See Corcoran 2000, 177 (edict no.10).

23. The 4-*denarius* coin was presumably the radiate which had been a familiar feature of the currency system before the introduction of the *nummus* in 293. Old stock, produced before the tetrarchy, continued to circulate – they were occasionally buried alongside the *nummus* in rare mixed denomination hoards of the period.

24. Issued by the mint of Lyon, *RIC* VI.263.286–265.303. The value mark reads CI HS (one *nummus* = 100 *sestertii*). The *sestertius* was another denomination long defunct by 300 and which had also become solely a unit of account. It was worth one-quarter of a *denarius*, therefore 100 *sestertii* = 25 *denarii*). See Hendy 1985, 462–3.

25. See Reece 2002, 110–11.

26. Corcoran 2000, 177. The Edict of Maximum Prices lists values in 'common *denarii*' (*denarii communes*) and it is quite possible that the *argenteus* ('silvery') was the adjective for *argenteus denarius*, a silver *denarius*.

27. For the *follis* see Jones 1959, 35–6; Hendy 1985, 339–40.

28. See Jones 1959, 34.

29. See Duncan-Jones 1994, 213–15, who calculates a figure of 322.8g from a number of weights found at Pompeii and Herculaneum.

30. Hendy 1985, 450.

31. ibid., 450.

32. *P.Oxy.* 2106. See Banaji 2001, 41, who proposes that the Diocletianic price might have been artificially low.

33. This connection was made by Professor Michael Crawford (pers. comm.).

34. See Carson 1980, 73.

The Owners of the Beaurains (Arras) Treasure

Roger Tomlin

The Beaurains Hoard contains the long-term savings of a Roman officer who received imperial donatives without spending them all.[1] 'The contents point to it having been the property of a soldier or military official, whose career was served in the west and who took part in Constantius' reconquest of Britain in AD 296.'[2] The trail of gold goes back to 285, and in 297, for example, this officer received the equivalent of 59 *aurei*, including eight gold medallions for the British campaign. In 303 he received at least 138 *aurei* for the *vicennalia* of Diocletian and Maximian: 'such a *donativum* as this can have been granted only to an officer of fairly high rank'.[3] The last medallions of all belong to the donative of 310 for Constantine's *quinquennalia*, which contained the equivalent of 15½ *solidi*.[4]

Who then was this officer, and *what* was he, besides being rich?

The hoard offers us two men's names, and an army rank. The first name is inscribed on the wedding-ring of Valerianus and his wife Paterna (fig.22). The style of this ring is most unusual and a close dating is not possible, but the best opinion suggests 'the second half of the third century'.[5] *Valerianus* is a very common name, and typical of the period: Diocletian and his colleagues all bore the nomen gentilicium *Valerius* from which it derives, and we know of at least seven late-Roman army officers called 'Valerianus', although none of them can be identified with our man.[6] But almost all the jewellery in the hoard – bracelets, earrings, neck-chains and pendants, the medallion collar – were for a woman to wear; we may indeed call her 'Paterna'. This shows that the hoard was not only an officer's savings, but also represents the portable wealth of a family.

Except for the coins, the only item perhaps of official origin is a silver candlestick (fig.23): there is another in the Kaiseraugst Treasure, and it can be argued that they were both 'official issue' like the silver plate listed in imperial letters quoted by the Augustan History.[7] These are fiction, but actual plate with imperial inscriptions survive, for example the silver dishes of Licinius in the 'Munich' treasure, as well as ingots and jewellery like the gold rings which proclaim their 'loyalty to Constantine'.[8] Comparable belt-fittings and silver dishes are illustrated among the 'insignia' of the

two finance ministers in the *Notitia Dignitatum*, no doubt because they provided the bullion and even the craftsmen. There are no candlesticks here, but if we turn to the 'insignia' of the praetorian prefects of Illyricum and Italy, we find two sets of four silver candlesticks being used to light their codicils of appointment.[9]

Even if we disregard the candlestick, the coins and medallions in the hoard are certainly 'official'. A late-Roman soldier had three sources of income: his pay proper, the *stipendium*, paid in debased coinage whose value was eroded by inflation; his rations, the *annona* and *capitus*, which multiplied as he rose in rank and sometimes were commuted for cash; and his donatives, the more or less regular bounties in gold or silver which celebrated imperial accessions and anniversaries.[10] Finding the money, even in the mid-fourth century when gold was more abundant, was an imperial problem. The Count of the Sacred Largesses remarked in 360, when he saw the ruins of Amida: 'Look how bravely the soldiers defend the cities, but the Empire's wealth is exhausted in finding them too much pay.'[11] When Constantius II, Constantine's son and successor, offered Pope Liberius a gratuity, he was told to give it to his soldiers instead.[12] His cousin Julian, Constantine's nephew, offered his men in Mesopotamia 100 pieces of silver each and, when this almost provoked a mutiny, said it was all he could afford.[13]

The Beaurains hoard is a fossil record of such payments, well worth collating with the two Beatty Panopolis Papyri which represent the paymaster's perspective. These duplicate official letters sent out in 298 and 300, including orders for the issue of pay, rations and donatives to units in Upper Egypt, but they are tantalisingly allusive.[14] The hoard, like many fossils, is incomplete; but like a papyrus it preserves a precious written detail, the second owner's name and rank.

Name and rank are given by the graffito scratched on the reverse of the last medallion, the 9-*solidus* piece of 310.[15] It is one of two graffiti, the other being on the obverse, to the right of the bust: probably XIId with a suprascript line. This reading makes such good sense that it should be accepted, but visually it is not certain.

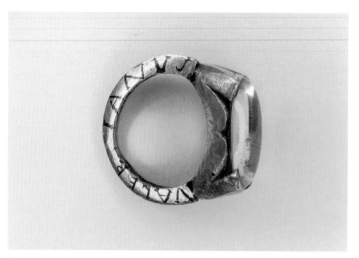

Figure 22 Finger-ring: Valerianus (left) and Paterna (right) (cat.46)

'X' is crossed by a third scratch, making it resemble the symbol for *denarii*, but the suprascript line extends above it, identifying it as part of the numeral; so the scratch must be casual. There is little sign of the final 'd', but here again the extension of the suprascript line guarantees that there is something below it, in fact part of the numeral again.[16] Barred XIId is written on the money-bags (*folles*) depicted in a contemporary mosaic at Piazza Armerina: '12,500 (*denarii*)'. This would be the cash equivalent of the 9-*solidi* medallion, one-eighth of a pound of gold, at a time when the pound was priced at 100,000 *denarii*.[17]

The graffito on the reverse begins at the bottom left of the standing figure and extends clockwise to just past the globe; it reads: VITALIANIPROTICTORIS, *Vitaliani protictoris*. P is written with an open loop like a capital letter, and S is written without lifting the stilus, a downstroke followed by an upstroke. Both these forms are typical of New Roman Cursive, the style of handwriting which superseded Old Roman Cursive towards the end of the third century. PROTICTORIS (for *protectoris*) was written with I, not E, an example of '*i* for *e* [which] is common in inscriptions of Gaul from the third century, and is thought to indicate a close pronunciation of the *e*, approaching *i*.[18] There is another example of this phonetic spelling in the epitaph of the retired *protector* Sabinus at Aquileia, *ex protictor(i)bus*.[19]

The reverse graffito asserts ownership of the medallion: '(the property) of Vitalianus, *protector*.' His name is less common than *Valerianus*, but it too is frequent and typical of the period; there happen to be two fourth-century *protectores* called 'Vitalianus', but they are both too late to be our man.[20] His rank is all we know about him. The 'protectorate' worked in the late-Roman army like the centurionate earlier, as a means of advancing able and experienced soldiers whatever their origin; it was a catalyst of social and professional mobility which developed over 200 years, from the

early third century to the early fifth century at least.[21] The first known *protectores* were, as their name suggests, ordinary bodyguards attached to generals and governors, including the emperor himself.[22] Then, in the mid-third century, Gallienus extended the term to distinguish his most important centurions and tribunes, the officers of the new 'field army' which consisted of cavalry, the Praetorian Guard and the Second *Parthica* Legion, and detachments from the old legions; these officers, to encourage and reward their loyalty, were styled 'protectors of the divine flank', bodyguards of the emperor. In view of their high rank and responsibilities, this was a title, not a literal description of their duties.[23] Succeeding emperors extended the usage downwards; this progression is not well documented, but by Diocletian's reign we find *protectores* like those of the fourth century: experienced junior officers and centurions who were seconded to the imperial court, where they served for several years as *protectores* before being promoted to regimental commands as tribunes, prefects or *praepositi*.[24] There is an example of their 'staff' duties in a papyrus which belongs to Diocletian's Egyptian campaign (297/8): at Oxyrhynchus, officers of a mobile force consisting of legionary detachments and the *Comites*, the premier cavalry unit, acknowledge receipt of fodder. They include two *protectores Augustorum*.[25] Our best-known *protector* is an Egyptian, as it happens, a generation later than Vitalianus, an officer of Constantius II called Flavius Abinnaeus: he served for 33 years in a cavalry detachment and, having risen to the senior rank of *ducenarius*, he escorted a group of foreign envoys from the Sudan to Constantinople, where he was 'ordered to adore the imperial Purple' as *protector*; during the next three years, he escorted the envoys home and brought back recruits from Upper Egypt to the imperial headquarters which were now in Syria, where he was promoted to command a cavalry regiment in Egypt again. Here by good fortune his papers have survived.[26]

Abinnaeus' long and interesting career (from 303/4 until 351) is exceptionally well documented, but we catch glimpses in inscriptions of earlier *protectores* contemporary with Vitalianus. Actually in 310, the year of the last medallion, a *protector* called Valerius Pusintulus was buried at Intercisa on the middle Danube, aged 39.[27] His career is not specified, but a good parallel is afforded by Valerius Thiumpus, an officer of Diocletian or Galerius who had been a soldier of the Eleventh Legion *Claudia* promoted *lanciarius in comitatu*, an élite infantryman in the imperial entourage; here he subsequently spent five years as *protector*, before being promoted to command the Second Legion *Herculia* at Troesmis in the Danube delta, where he died after two and a half years, aged 45.[28] Somewhat earlier than Thiumpus is Aurelius Firminus, who commanded another Danubian legion, the Second *Adiutrix* in 290, after being *protector*.[29] They both might have risen further. Constantius, the father of Constantine, was likewise *protector* before his promotion to tribune and eventually *Caesar* (in 293); and Licinius' rival Maximinus is described by a hostile witness as a shepherd who enlisted as a guardsman (*scutarius*), then was promoted *protector* and 'soon became a tribune, and the next day *Caesar*' (in 305).[30]

Examples can be multiplied, but details and close dating are often lacking. The *Caesar* Maximinus is unlikely to have been much older than Vitalianus, who in 310 might expect to be promoted to command a military unit.[31] Like Gratianus, the father of the emperors Valentinian and Valens, or Flavius Memorius, sometime Count of Mauretania Tingitana, he might even become a general (*comes*).[32] On the other hand, he might instead 'return his soul to the fates', to quote that epitaph of Valerius Pusintulus. However, his savings included eight coins of Constantine's rival Maxentius, which suggests that they were acquired in the Italian campaign of 312.[33] Since the last coins date from 315, Vitalianus evidently survived it, unlike Valerius Valens, a *protector* who 'died in the civil war in Italy' aged 50.[34] Constantine's furious advance on Maxentius and the Milvian Bridge (figs 24 and 25) was marked by the graves of three soldiers of an élite legionary detachment in his Gallic army, the *Divitenses*, which took its name from his new fort of Divitia (modern Deutz, the Cologne bridgehead).[35] The most senior of these casualties was a leading centurion promoted to *protector*, Florius Baudio, *ducenarius protector ex ordinario leg(ionis) II Ital(icae) Divit(ensis)*, who was buried at Spoleto by his son Valerius Vario, an *optio* in his old unit, at the age of 40, after 25 years' service.[36]

It is more than likely that Baudio and Vitalianus were acquainted, and that they served together in the *Blitzkrieg* which destroyed Maxentius. At all events, we can sketch a profile of Vitalianus from other men's careers: in 310 he would have been an experienced

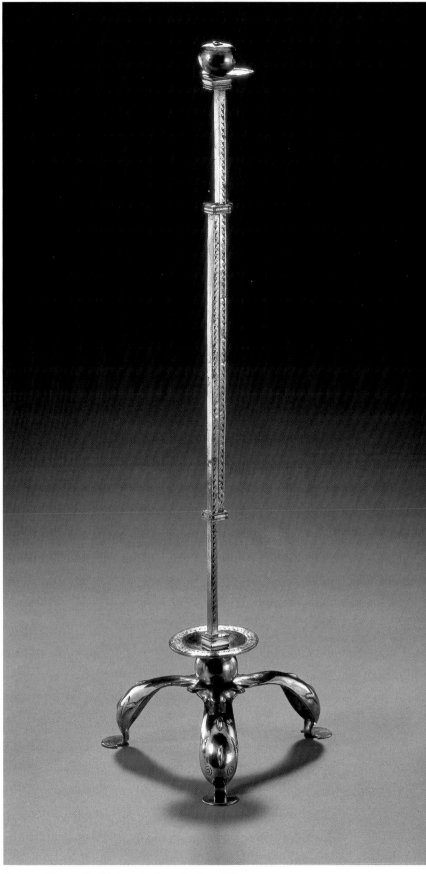

Figure 23 Silver candlestick from the Beaurains (Arras) Treasure

Figure 24 View of the Milvian Bridge from the east, before 1929, north of Rome

officer seconded to the 'imperial general staff', now in his thirties at least, but hardly more than 45, a candidate for independent command in the near future. As *protector* or perhaps a tribune in 312, he must have survived the campaign and returned to Gaul. Here he buried his accumulated wealth – not for the first time, we might suppose – unless it was actually stolen from him, and what was found in 1922 is only the robber's hoard.[37] The accident, whatever it was, that prevented him from recovering his property is now a question above Antiquarism, not to be resolved by man.

There is another question, however, which is not beyond all conjecture. The hoard contains donatives which increase in size until they peak in 303; why then does it continue on a much diminished scale until 315? Why did the owner receive 138 *aurei* in 303, but only 15½ *solidi* (almost equivalent to 13 *aurei*) in 310? It may be an accident of survival: three-tenths of the hoard has apparently been lost.[38] Perhaps Vitalianus spent most of his later donatives, or hid them elsewhere. Perhaps – and this is more likely – Constantine was simply short of money. This is understandable in 310, when he ruled only

Britain, Gaul and Spain, and was concentrating his resources for the impending struggle with Maxentius. He was evidently scraping the barrel in 310, for this donative contained many silver coins.[39] But the explanation is not convincing in 313, now that he ruled Italy and Africa as well.[40] He had the cash to distribute a *congiarium* to the Roman people: it is illustrated on his Arch at Rome (fig.16). Is it credible that he was unable, or unwilling, to reward his élite forces (a fraction of his whole army) on the scale of his own father's donative in 297 for the reconquest of … only Britain?

We do not know the scale of donatives received by a *protector*, which must have varied year by year; the donatives of 297 and 303 marked an important victory and an important anniversary respectively, but if Vitalianus was only a *protector* in 310, he would have been quite a junior officer then. The donatives are surely much too large.[41] The answer is easily conjectured: the hoard had two owners, Vitalianus and his father Valerianus. It consisted of 'the family silver' as well as cash: literally the candlestick and the (lost) silver vase which contained the late Roman coins, and figuratively the jew-

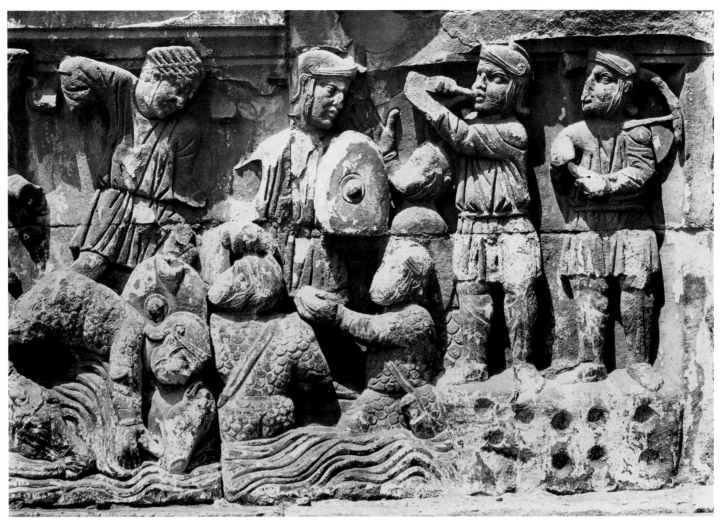

Figure 25 Battle of the Milvian Bridge (detail), Arch of Constantine, Rome

ellery which had belonged to Valerianus and Paterna, the parents of Vitalianus. The cash was largely the accumulated donatives of Valerianus, to which Vitalianus added in due course.[42] It was a two-generation hoard, perhaps one of many. When Valerius Vario buried his father at Spoleto in 312, was this all that he buried?

It follows that Valerianus was of high rank when he died: the colonel of a mobile unit, if not a general. Vitalianus meanwhile had followed his father into the army, like Roman soldiers' sons for centuries; Valerius Vario is a humbler but contemporary example. Half a century later, we certainly find generals' sons who became *protector* at quite an early age: the future emperors Jovian, Valentinian, and Valens, are the best known, and the historian Ammianus Marcellinus is likely to be another.[43] The earliest is usually thought to be Herculanus, *protector* in 354, whose father was a *magister equitum* lynched in 342.[44] He happens to be mentioned in Ammianus' first surviving book, and if we had the whole *History* no doubt we would find earlier examples. That they existed is implied by the Beaurains hoard, and we may add two officers who have already

been mentioned in a different context. They figure in Lactantius' sprightly reconstruction of the conference in March 305 at which Galerius imposed his choice of *Caesares* upon Diocletian. The first is the tribune Maximinus, who is likely to have been a *protector* in his twenties.[45] 'He is my kinsman', said Galerius. Diocletian groaned: 'You are giving me men not fit to rule.' 'I have tested them', replied Galerius, and Diocletian gave way.[46] More to the point, Maximinus was the son of Galerius' sister.[47] The second is the candidate they rejected, the western emperor Constantius' son Constantine: in 305, aged about 32, he was attached to Diocletian's court as a senior tribune.[48] We cannot be sure that he had not been directly commissioned as a tribune – a promotion more shocking than Maximinus' – but it would be unparalleled. A likelier hypothesis is that he became a *protector* aged about 20, when his father became *Caesar* in 293, and was soon promoted. There is little to choose, in fact, between his career and that of Maximinus: like Vitalianus, we may suspect, they were both 'promoted by patronage, not by imperial decision'.[49]

Notes

1. Bastien and Metzger 1977, summarised and developed by Abdy in this volume.
2. Casey 2000, 451. This is the best analysis of the hoard's ownership since Bastien and Metzger 1977, and I am grateful to John for introducing me to Vitalianus' medallion and its graffiti.
3. Bastien and Metzger 1977, 215.
4. The donatives from 285 to 315 are tabulated by Casey 2000, 450.
5. I am grateful to Catherine Johns, whom I quote.
6. *PLRE* 1, s.v. *Valerianus*, adding Aurelius Valerianus, *dux* of Arabia in 351/3 (*IGLS* 9062): they are all easterners or too late in date.
7. Bastien and Metzger 1977, 208–9.
8. Kent and Painter 1977, 20–9.
9. *Notitia Dignitatum Or.* 2 and *Occ.* 3. The insignia of other high officials display codicils on similar draped buffets, but none of them with candlesticks.
10. Bastien 1988.
11. Ammianus XX.11.5. Ammianus, one of the defenders of Amida, does not rebut the charge.
12. Theodoret, *HE* II.13.
13. Ammianus XXIV.3.3.
14. Skeat 1964, who tabulates the figures at p.xxvii; also tabulated by Jones 1964, 187–8. There is further analysis in Duncan-Jones 1978 and Tomlin 2000.
15. Vagi 2002, lot no.272, with excellent photographs of obverse and reverse. I am grateful to the auctioneers for allowing me to study the original.
16. Another possibility is S for *semis*, 'half', but the meaning would be the same.
17. Reading and interpretation are by Michael Crawford, qualified by my own autopsy.
18. Smith 1983, 901.
19. *CIL* V. 8282.
20. PLRE, s.v. *Vitalianus* 1 and 3.
21. I confine myself here to the *protectores* in *c*.300. By the mid-fourth century they were formally *protectores domestici* (thus Ammianus Marc. 15.5.22), which makes for confusion with the *domestici*. For the terminology see Jones 1964, 195, n.64, but a fuller treatment is needed.
22. Speidel 1986.
23. Christol 1977.
24. Jones 1964, 638.
25. *P.Oxy.* 43 (recto), II.7 and IV.18 (in Greek); for the date of the campaign, see Barnes 1982, 54–5.
26. Bell, Martin, Turner and van Berchem 1962, 6–12, with *P. Abinnaeus* 1; summarised in PLRE s.v. *Abinnaeus*. The chronology is refined by Barnes 1985.
27. *CIL* III 3335.
28. *ILS* 2781.
29. *CIL* III 10406 (Aquincum), *ex prot(ectoribus)*.
30. Anonymus Valesianus 1.2; Lactantius, *DMP* 19.6. See PLRE s.v. *Constantius* 12 and *Maximinus* 12.
31. They were both probably born in the 270s: see n.45 and n.48.
32. Ammianus XXX.7.2–3; perhaps the *protector* [Gr]atianus of *CIL* III 12900. *ILS* 2788 (Memorius).
33. Casey 2000, 451 (six *aurei* and two silver coins).
34. *ILS* 2776 (Dalmatia): this is not certainly the campaign of 312, but the man's name is appropriate to the date.
35. *ILS* 2777 (Spoleto), *CIL* XI 4085 (Otricoli), *ILS* 2346 (Rome), noted by Hoffmann 1969–70, II, 65 n.487. The parent-legion built the fort in Constantine's presence (*ILS* 8937).
36. *ILS* 2777. His son was adult, and his age at death is more likely to be an estimate than the years of service, so Baudio was probably in his early forties.
37. Casey 2000, 449, noting the 'domestic' content of the hoard, and that the candlestick was treated like bullion by being bent into three.
38. Bastien and Metzger 1977, 214.
39. *Op. cit.*, 153–4, nos 451–63 (13 *quinarii*).
40. *Op. cit.*, 155–7, nos 464–70 (seven *solidi*).
41. This is an impression which needs to be quantified by analysing the difficult and allusive evidence for the size of donatives (see Bastien 1988, Tomlin 2000).
42. Casey 2000, 452.
43. Jovian, the son of a *comes domesticorum*, was already *protector domesticus* in 361, aged 30; he must have served some years already, in view of his seniority (as *primicerius*) in 363. Valentinian and Valens were the sons of a *comes rei militaris*: Valentinian was already a tribune in 357, aged 36; the incompetent Valens was still *protector domesticus* in 363, aged about 35, and it may be deduced that Valentinian had been one. The *protector domesticus* Ammianus Marcellinus was *adulescens* in 355, aged about 25 (he was still active in the 390s); his origin is not known, but as an anomalous 'soldier and Greek' who wrote in Latin, he is likely to have been a senior officer's son.
44. Ammianus 14.10.2, with PLRE s.v. *Herculanus* 1. Jones 1964, 638.
45. Maximinus' date of birth is unknown, but he was *adulescens* in 305, with the implication that he was junior to Constantine (Lactantius, *DMP* 18.13). When he died in 313, he left a son aged eight and a daughter aged seven (ibid., 50.6). See further, Barnes 1982, 39.
46. Lactantius, *DMP* 18.13–15.
47. *Epitome de Caesaribus*, 40.1; Zosimus II 8.1.
48. *tribunus ordinis primi* (Lactantius, *DMP* 18.10). For the date of Constantine's birth (*c*.273) and his early career, see Barnes 1982, 39–42.
49. *ex suffragio eos pr[omotos] … me vero iudicio sacro* (*P. Abinn.* 1.12): Abinnaeus contrasts his own appointment with that of the interlopers who tried to displace him.

Art in the Age of Constantine

Martin Henig

The reign of Constantine marks a critical stage in the evolution of Roman art, just as it marks a turning point in the history of religion. In both cases, the emperor, his personality and aims had a major influence on events, but it is also true that traits which had been long observable in the evolution of Roman society crystallised around him. With regard to art, the period of Constantine marks a return to Classical ideals. Constantine broke away from the veristic traditions of third-century and tetrarchic portraiture to display softer, more idealised features reminiscent of Augustus. His was to be a decisive influence on imperial representation for two centuries, only challenged by the 'pagan' reaction of Julian (360–3), his kinsman Procopius (365–6), a usurper who rebelled against Valens and, more importantly, at the end of the century, Eugenius (392–4), whose bearded portraits deliberately evoked Hadrian and the Antonines. The same revived classicism is to be seen in other artistic media, for example in gems, coinage and wall painting.

Other innovative tendencies also come to the fore at about the same time, which are, by contrast, characterised by a love of intricate pattern and abstraction, and a use of rich colours and textures. In place of the three-dimensional realism which we associate with Graeco-Roman art, there are growing numbers of instances of two-dimensional schemes, especially in *opus sectile*, mosaic, sculptural relief and jewellery. These works are endowed with emotional intensity and seem to possess an other-worldly inner life. Figural compositions, whether carved on precious gemstones, chased on silver or laid in mosaic on floors, walls and vaults, were designed to lead the viewer beyond the everyday into a world of the imagination. Further, contemporary writers were enthused by patterns, naturally occurring in veined marbles or dextrously produced in geometrical mosaics, openwork gold-work or glass cage-cups. That is to say, there was already an art which was recognisably Byzantine. Although this culture is far better known, and of course lasted longer in the east Roman world, this tendency was certainly very apparent in the western provinces during the fourth century.

These two apparently contradictory aspects of early fourth-century art resulted in a highly creative tension, similar to that which gave rise to other great periods of artistic endeavour, such as the 30 years in the late sixth/early fifth century BC when the traditional artistic culture of late Archaic Greece vied with a growing knowledge of human and animal anatomy.

Radiance, texture and colour

Some of the most interesting manifestations of late antique art are concerned with its treatment of light, texture and colour. Light was seen as emanating from gods and from Christian saints, and was also attributed to rulers as earthly gods, possessing *numen*. Nimbed heads were by no means an invention of the early fourth century as they were already widespread as divine attributes in pagan art. Examples of nimbed deities include the splendid second-century representation of Neptune from La Chebba in the Bardo Museum, or Apollo on a third-century mosaic from Antioch, where even a representation of Narcissus is shown as nimbed.[1] The early Constantinian busts of personifications on the ceiling paintings excavated from the destroyed palace quarter under the double church in Trier provide the best-known instances from the era of Constantine,[2] though they do not stand alone and some exceptionally important paintings of nimbed deities have actually been found at a house in Malton, Yorkshire (cat.129). Such advanced work reflects the influence of the local provincial capital at York. Here we see a number of gods and goddesses, holding sceptres, depicted against a blue ground. They were of fairly high quality and invite comparison both with the Trier heads and with a group of nimbed sceptre-holding gods, comprising the principal deities in the *Aeneid* – Jupiter, Minerva, Mercury, Vulcan, Juno, Neptune, Diana, Apollo, Venus and Mars – depicted on two pages of the *Vergilius Romanus*.[3] It is not impossible that the theme of the Malton fresco was very similar, a conclave of gods associated with a mythological subject. In addition there is a floor mosaic from Brantingham whose centrepiece is a striking image of a woman wearing either a mural crown (a city-goddess) or, perhaps more probably, a crown of feathers, in

65

Figure 26 Head of Constantine from the Basilica Nova, Rome

which case she is a muse.[4] The nimbus was not confined to deities; an aureole of light could distinguish special figures – in the *Vergilius Romanus*, the protagonists in the *Aeneid* for example – but on occasion the Roman emperor was depicted thus, for example Constantius II in the calendar produced by a scribe called Furius Dionisius Filocalus in the year 354.[5]

The life of the rich, whether of emperor or villa-owner, bishop or soldier, took place against a backdrop of glittering colours and a variety of textures, soft furnishings, shining metal and veined stone. To anyone comparing a banquet of the early empire with one of the late empire, the latter would have looked more exotic and refined. This would be expressed in the ceremonial aspect. The regimented rows of serving figures as shown in a mosaic from the House of Bacchus at Alcalà de Henares (Complutum) in Spain,[6] and the boys serving Dido and Aeneas in the *Vergilius Romanus* are probably works of a century after Constantine, but there is little doubt that they reflect the formalised pattern of life in the fourth century in general. Rich textiles, marble veneers and patterned floor and wall mosaics provided a restless kaleidoscope of colour and form. The distinctive shapes of silver plate augmented this. Some, required for the toilette of aristocratic women, included richly ornamented mirrors like the outstanding example from Wroxeter (cat.136), caskets such as those in the Esquiline Treasure, ewers and fluted bowls for hand-washing. Other plate was used at table: dishes, cups, bowls, spoons and pepper pots to contain this expensive spice from south India. Methods of manufacture had been transformed. Chasing gave figural work a more precious, jewel-like quality than had been the case with early imperial repoussée work, fluting gave bowls and jugs a far richer texture, while the use of openwork, chip-carving and niello inlay emulated jewellery. Indeed, the characteristic jewellery of the time was openwork, which was used for brooches, bangles and pendants, sometimes incorporating rich jewels or coins.

Such objects demonstrate the same love of abstraction that can be observed in the growing use of decorative drilling on architectural stonework and a general delight in the abstract qualities of marble veneer (sometimes copied in paint and mosaic). Several reminiscences of early imperial art are present in the splendid panels from the Basilica of Junius Bassus in Rome, dating to the end of Constantine's reign. Cut in vibrant-coloured marbles, they include a tableau of Hylas and the Nymphs, and a rendering of a tiger leaping upon a calf, almost an *opus sectile* version of one of the vignettes in the contemporary Piazza Armerina 'great hunt'. But Junius Bassus, who constructed this great hall in his house, had himself shown in almost hieratic formality in the splendid full-dress consular robes of a Roman noble, standing in a chariot, his frontal

image evoking those of gods and emperors. An Egyptianising frieze looks back to the distant past but all in all this dazzling work of art presages the achievements of the Byzantine mosaicist.[7] Similarly, the colourful vault with myriad classical detail, including vine foliage, birds, farming scenes, vintaging cupids in the vault of the ambulatory of the mid-fourth-century mausoleum of Sta Constanza, belongs to the same context, midway between old Rome and the new art of Byzantium.[8]

If asked to select a single epithet which characterises the best art of this age, it would surely be 'jewelled'. Fourth-century jewellery designers built on the revolution of the third century in which far more elaborate forms of rings, bracelets, necklaces and pendants, as well as imaginative settings of gems within lace-like openwork, came to the fore. The most opulent examples include the jewelled diadems worn by emperors, but the pendants with openwork surrounds around portrait-medallions of Constantine virtually come into that class and were produced for men or women at the highest level of society.[9] Openwork also embellished cross-bow brooches and bracelets, some of which were set with gems. Gorgeous necklaces were, likewise, a feature of the age. The image which most readily comes to mind is the well-known figure amongst the Trier ceiling paintings, from the Dom excavations, of a woman wearing a gold wreath, a gold-coloured garment and a necklace of large amethysts each in a box-setting. She holds a jewel box from which, with her right hand, she pulls a chain of pearls.[10] The effect is meant to be gorgeous, though the splendour is not the untouchable splendour of Theodora on the sixth-century mosaic at S. Vitale. The calm classicism of the face and liquid humanity of the eyes, emphasised by their heavy lids, remind us that the classical tradition was still strong.

The same interest in texture and colour is to be seen in what survives of textiles, mainly from the East, and in such objects for the table as cage-cups, in which a vessel was cut in an intricate trellis so it would sparkle when held in the hand, perhaps reflecting or refracting light. These wonderful objects took a long time to produce and the *diatretarii* who made them were, not surprisingly, relatively well paid and accorded tax privileges. Most are abstract in design though frequently with drinking mottos around their rims but the most famous one, the Lycurgus cup in the British Museum, figures the myth of Dionysus and Lycurgus. It appears green by refracted light but a rich red when light is transmitted through it.[11] Silver tableware was likewise made to glitter, chased with elaborate patterns and enriched with black niello and gilding. Sometimes vessels were embellished with openwork frames, a feature of four handsome, rectangular monogrammed plates in the Esquiline

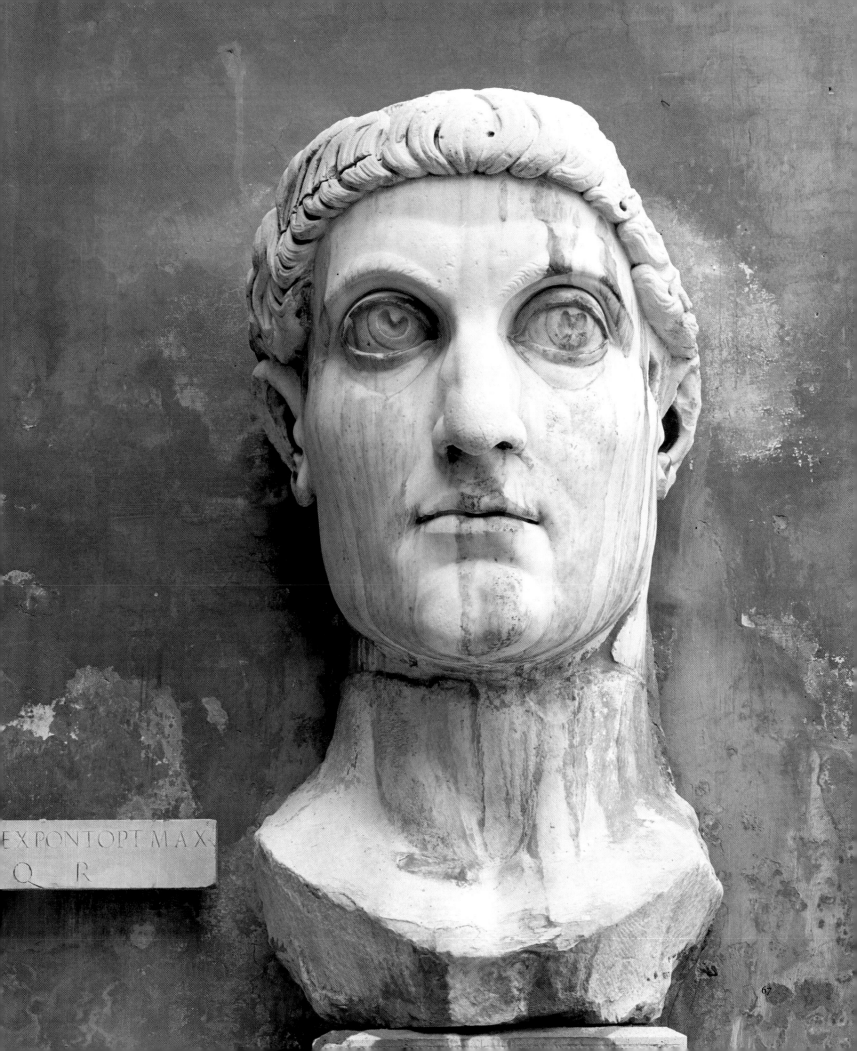

67

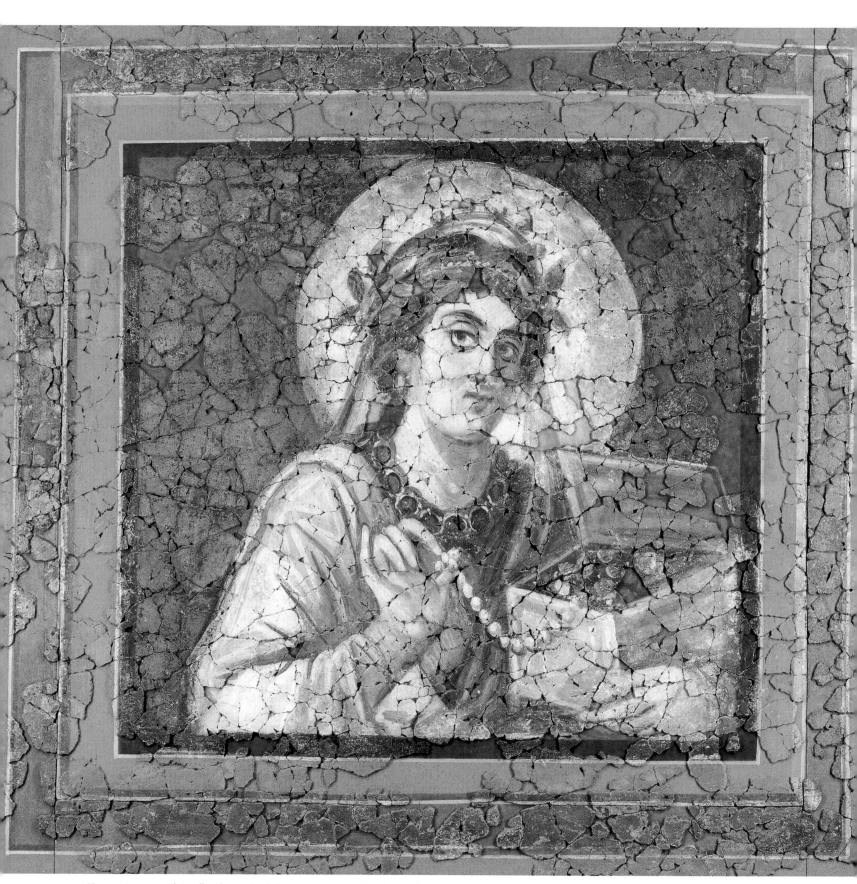

Figure 27 Woman with jewellery box, painted plaster, ceiling of royal residence, Trier, *c.*320

Treasure or the edges of the Ariadne dish in the Kaiseraugst Treasure.[12] Such treatment was even accorded to minor items like tooth-picks.[13]

Images of power

A good starting point from which to examine the art of the age of Constantine is the splendid marble head of the emperor found within the fortress at York (cat.9). It is one of the very few imperial portraits from Roman Britain and the only one in marble. Nevertheless it would have been important anywhere, despite its worn state. The large eyes, prominent nose and characteristic fringe of hair link it to such famous images of the emperor as the head from an enormous statue of Constantine in Rome (fig.26) or the more striking portraits on his coins and medallions. On the one hand these hark back to images of the first emperor, Augustus, and proclaim Constantine as the empire's second founder; on the other Constantine is shown as staring outwards, not straight ahead at men but above at the heavens. There is perhaps a hint of Alexander the Great in such a quasi-divine portrait. This is certainly emphasised on the famous gold medallion struck later in his reign in 327 which bears a striking resemblance to a gold openwork pendant depicting a profile head of Alexander again probably of the 320s.[14] Not surprisingly Constantine is the companion of *Sol Invictus* or, as his reign drew to its close, of Christ-Helios. Comparison should be made with contemporary portraits like a superb marble portrait-head, now in Leiden, of tetrarchic date, whose chiselled features and close-cropped hair and beard evoke a man who cannot spare too much time on the niceties of being shaved (cat.139).[15] The large, staring eyes, with pupils strongly emphasised, link the ruler to his subjects.

Sometimes Roman coins show full-face portraits for added effect. This was certainly true of the commemorative bowls created by the mint of Nicomedia in Asia Minor in 321/2 for Constantine's colleague and rival Licinius to celebrate the *quinquennalia*, five years of rule, of Licinius's son. The portraits of Licinius I and Licinius II, distinguished only by age, confront the viewer, doubtless an important magnate as he reclines at dinner in his *triclinium*.[16] The 'Big Brother' image demonstrated the universal longing for a saviour who could bring security. It is a reminder that for many the third century had been a terrifying time of apparently continuous disaster and, even in the first years of the fourth century, the 'Age of Anxiety' as it has been called[17] had not yet been erased from people's minds.

If the outer aspect of an imperial palace was often forbidding, the interior could be very lavish. At Split, near Spalato in Dalmatia,

the retirement palace of the Emperor Diocletian is enriched with sumptuous decorative sculptural embellishments especially in the temple and mausoleum, which are certainly meant to emphasise the status of its builder. Constantine's own palace at Trier was perhaps even more lavish (fig.27), even though not everything that survives from it is contemporary.[18] The unique ceiling decoration displaying cupids and a number of richly arrayed women, probably personifications rather than members of Constantine's family, comprises one of the most extensive areas of high-quality, classicising painting of its date in the Empire;[19] it was only in place for a short time as this part of the palace was destroyed by the building of the great double basilica-church shortly after the deaths of Crispus and Fausta in 326.

This building, which served as the cathedral, was more than simply a place of prayer. Such imperial palatine churches were inevitably settings in which imperial life and imperial ceremonial were enacted.[20] The Aula Palatina (audience hall) still stands as a building of breathtaking grandeur, (fig.17) although now much restored and stripped of its Roman period marble pilasters and veneers, wall paintings, wall and floor mosaics which were designed to create the effect of a magnificent jewel box whose centrepiece would have been the emperor and his court, all brilliantly arrayed.[21] In addition, linked to the palace there were often great public places of assembly: the amphitheatre and above all the circus, where the emperor would be seen in like majesty and acclaimed by the masses. Contemporary images on coins and medallions, as well as the cameo depicting Constantine, Helena, Fausta and the Princes Constantius and Constantine, in the Stadtbibliothek at Trier,[22] give us some idea of such occasions. They present tableaux of quasi-sacred emperors, presaged as early as the tetrarchy in wall paintings from a shrine of the imperial cult at Luxor in Egypt,[23] and continuing under Constantine and his successors down to the famous representation of the family of Theodosius I, carved in the late fourth century on the base of the obelisk in the hippodrome at Constantinople, and the brilliantly arrayed courts of Justinian and Theodora, shown on the gorgeous sixth-century chancel mosaics in S. Vitale, Ravenna. Such a scene would surely have been fully applicable to the age of Constantine, truly the founder of the Byzantine Empire.[24]

Two imperial monuments

The origins of such imperial ceremony can be glimpsed on two monuments in particular. The surviving base from the so-called Five-Column Monument, set up in the Roman Forum to celebrate the tenth anniversary of the tetrarchy in 303, is carved with reliefs

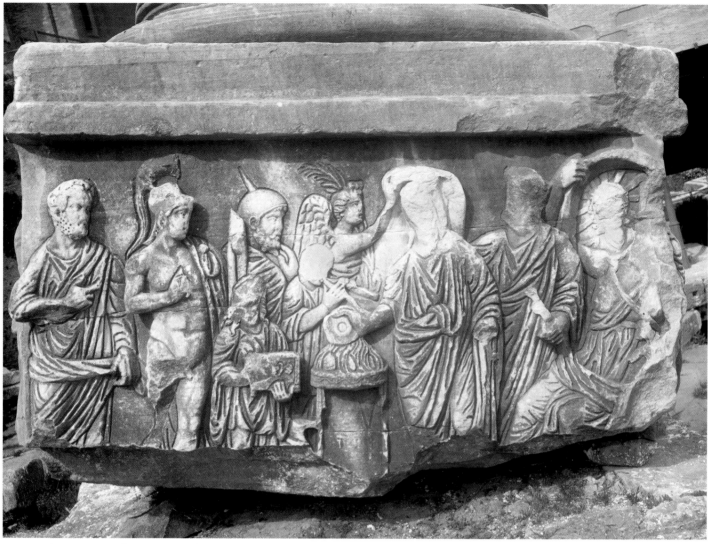

Figure 28 The Emperor sacrificing, Decennalia base, Imperial Forum, Rome

that are, for the most part, highly traditional. On one side, only the deep cutting and rather stylised placing of the two victories holding a large oval shield suggest that this is not a sculpture of the early empire. A processional frieze on another side and a *suovetaurilia* (a pig, sheep and bull prepared for sacrifice) on the third could almost be Antonine. However, in the key scene on the fourth side (fig.28) we see a divine emperor, standing full-face to the viewer, crowned by a victory and accompanied by the Genius Senatus. Mars stands on the left, while on the right is the radiate god *Sol Invictus*. The emperor could either be Constantine's father, Constantius I, or Galerius. It has been argued that the emperor is Constantius I and that the boy shown in the processional scene is none other than Constantine.[25]

The style of this relief is carried forward in the contemporary sculptures of Constantine's Arch, especially those in which Constantine is separated and elevated above the people on the ros-tra, giving an oration or distributing largess. Although both activities – addressing the populace and scattering money – go back to the first century, art now presents the emperor in a super-human role. Always, and especially in the fourth century, the emperor was the great leader in battle. Constantine is shown thus on the Great Trajanic Frieze which was incorporated in the Arch of Constantine with the head of Trajan replaced by that of Constantine. Stylistically the tableau of the Battle of the Milvian Bridge(fig.25) on the arch recalls that of the Column of Marcus Aurelius. But Constantine's was not a victory over barbarians like the battle scenes shown on the Arch of Galerius (*c*.298–303) in Thessalonica, or on the porphyry sarcophagus that was said to be that of Helena, but is more probably that of her husband Constantius I.[26] Constantine's victory was achieved over a Roman army, led by his rival Maxentius. It is sometimes seen as the victory of Christianity over paganism but nothing in the presentation of the battle scene tells us that.

The art of engraved gemstones

Cameos are especially instructive as indicators of refined taste amongst the ruling classes who appreciated the beauty of materials and delicacy of cutting. Indeed, it is highly probable that the finest examples that survive were presents to members of the dynasty and its leading supporters. Amongst the best examples of the period is the now fragmentary sardonyx cameo in the National Museum, Belgrade, which shows an emperor in Greek dress riding in triumph, like an Alexander, over a field of barbarian corpses.[27] The subject is reminiscent of the porphyry sarcophagus mentioned above and it might well also show Constantius. On the other hand, in view of its classicising style and Constantine's admiration for Alexander, it could portray his son. More certainly tetrarchic is the fragmentary Content cameo (cat.75), on which two emperors meet and shake hands, emphasising the collegiality also shown by the porphyry tetrarch groups now in Venice and Rome (though in those cases they clasp each other's shoulders). On the Content cameo the emperors are depicted accompanied by the Roman eagle, giving to the occasion an almost sacramental resonance.[28] The eagle is very similarly carved to the two eagles on the large rectangular cameo in the Stadtbibliothek at Trier (fig.29), dated between 318 and 323 presenting Constantine, his mother Helena, his wife Fausta and two imperial princes (probably the later Constantius II and Constantine II)[29] all in a theatre – or more probably circus – box, as on the base of the obelisk in the hippodrome at Constantinople where the emperors are Theodosius and his sons.

A third cameo, in the Dutch Royal Collection (cat.76), shows an imperial procession with Constantine and Fausta together with the young Crispus in a triumphal chariot.[30] Here, however, the event has been transferred to a mythological world in which centaurs replace horses and Constantine holds Jupiter's thunderbolt. Towards him flies a Victory; below the centaurs' hooves two enemies are being trampled. They should be barbarians, but their neat appearance suggests they are not; they probably symbolise Maxentius's army and his crushing defeat at the Battle of the Milvian Bridge in 313. Despite the enormous differences in scale, it is worth mentioning that the rich deep cutting of the drapery is reminiscent of the contemporary carving on the Arch; comparison of the Victory on the cameo and the Victories on the Arch is especially convincing. However, it is worth noting that on the cameo Constantine's triumph is portrayed in resolutely traditional pagan terms.

There are also surviving intaglios of this period, although these are less common. Two amethyst seal stones may be noted, both cut with imperial profile portraits. One, the head in Berlin, may depict Constantine, though it was more probably intended for his son Constantius II; the other, a rather finer cuirassed bust in the British Museum, certainly shows Constantius II (cat.78).[31] They were both probably used by important officials to seal state correspondence. The rulers wear similar jewelled diadems and have comparable hairstyles to those of contemporary coin images, but on these individually cut stones the modelling of the faces is more lively, especially in the case of the London stone, and suggests that the classical tradition continued more strongly in glyptic art. The gems, indeed, may well have been, in part, based on the portrait of Augustus by Dioskourides which was used by his successors and may have been still in use in Constantine's reign. The similarity of Constantine with the first emperor may have led later to the preservation of the cameo in the centre of the tenth-century Cross of Lothar in Aachen, which is actually a portrait of Augustus but was believed to depict Constantine.[32] The Cross of Lothar is a reminder that most of the more important gemstones which survive from antiquity, including those mentioned in this section, did so through being incorporated in precious metalwork in church treasuries.

The purple of the amethyst intaglios was significant. Colour was immensely important in this world, and the gems were clearly selected for their imperial, purple colour. The miniature figure in the round of an empress, now in the Victoria and Albert Museum, is likewise carved in amethyst (cat.80).[33] On a larger scale the porphyry figures of emperors and the porphyry sarcophagus said to be that of Helena (but, in view of its martial theme, probably that of her husband Constantius I: cat.111), and the porphyry sarcophagus of Constantina emphasise the special resonance of the imperial colour.[34]

Art and daily life: the hunt

Not surprisingly, the art of the age of Constantine reflects the lives of the wealthy men and women who commissioned it. One of the most popular activities in the Roman world had always been hunting. The hunt was a popular subject in all sorts of media from mosaics and wall paintings to silver plate. It is clear that this most aristocratic of activities continued to be patronised at the highest level, undiminished into the new, Christian century. A major feature of the Arch of Constantine, after all, is the Hadrianic hunting *tondi* with the heads of Hadrian carefully remodelled to represent Constantine or his father Constantius.

Amongst the best-known and most spacious renderings of the hunt are the mosaics from the villa at Piazza Armerina in Sicily, which are now thought to have been commissioned in the early decades of the fourth century by a wealthy senator, possibly but not

certainly Lucius Aradius Valerius Proculus Populonius, who was *consularis* of Sicily from 327 to 331, but had previous strong connections with Numidia.[35] The hunts are of two distinct types. One is the so-called Great Hunt, a hunt for wild beasts, some of them to be captured alive to be displayed in the amphitheatre (a reminder that the gory spectacles of the arena were not yet over); the other, the Little Hunt, shows a more intimate and domestic hunt for deer and hares. The splendour of the garments worn by the participants, with their distinctive coloured patches called *orbiculi* sewn onto their garments, demonstrates that this pursuit had acquired its own particular style of costume. One man portrayed in the Great Hunt is especially gorgeously dressed with highly coloured and embroidered garments, and was once thought to be an emperor; his flat cap was compared with those of the tetrarchs on their porphyry images in St Mark's Square, Venice. With his two attendants, both holding shields, he is undoubtedly important but is no longer regarded as an emperor. Other huntsmen portrayed in the mosaic are almost equally richly clad. The hunt and its associated costume is replicated on mosaics throughout the empire. A representation of two huntsmen carrying a deer slung from a pole on a mosaic from East Coker, Somerset (Taunton Museum), though not of quite the same quality, is an extract from a hunting tableau very like the Little Hunt and is certainly a surviving fragment from a larger composition of the type.[36] It is interesting to compare the scenes of the sacrifice to Diana on the Little Hunt with near-identical scenes on hunting mosaics from Antioch in Syria and Lillebonne in Gaul. In all three cases the patron, presumably, was pagan or willing to be shown as such.[37]

Amongst other examples of hunting scenes on mosaics, the ceiling mosaic of the mausoleum at Centcelles near Tarragona in Spain is of especial interest. It was possibly the tomb of Constantine's son Constans who died in 350. It seems to have juxtaposed biblical scenes in the main registers with a frieze portraying a stag hunt below, presumably reflecting the life to which Constans aspired in heaven, although as in the case of another mid-century mosaic, laid on the floor of a villa at Hinton St Mary, Dorset, by mosaicists from Dorchester, the hunting theme might have been interpreted as an allegory of the pains of the Christian's life.

Britain was very far from being a provincial backwater. In the reign of Constantine another school of mosaic craftsmen from Cirencester created one of the most remarkable mosaic designs to survive from the Roman Empire. The Woodchester pavement floored a great reception room in a large villa, palatial in size and well appointed with gardens and fishponds and, in all probability, a hunting estate. The floor mosaic depicts Orpheus, who was some-

times equated with Christ. More probably here and elsewhere in Britain, however, he is conflated with the local hunter-god, perhaps called Apollo Cunomaglus.[38] The Orpheus figure is, indeed, accompanied by a canine of rather fox-like appearance, but probably intended for a hound. Around him is a frieze of acanthus with leaves of boldly alternating colour and two other registers, the inner one of birds and the outer one of mammals, skilfully executed with bold textures and a very striking and individual feeling for pattern. Such a device could have been interpreted in two ways, which are by no means exclusive. At one level the mosaic might show the control of the lord over nature, over his estate and all who dwell there, but alternatively here is the harmony espoused by philosophical, neo-platonist pagans, as well as by Christians, in which the entire created world revolves around a still and unchanging divine centre. This composition, of which a smaller version exists from the villa at Barton Farm, just outside the walls of Cirencester, seems to be the creation of a mosaic school based in that city. Both in the harmony of their design[39] and the sophistication of their message these mosaics must rank amongst the most important works of art of their age, and yet they are far less well known than the mosaics of Piazza Armerina, to which they provide a vivid contrast. Whereas Piazza Armerina is classicising, Woodchester is dynamically abstract. Only in Britain was the Woodchester design influential, with interesting variations being produced at Horkstow and Winterton in Lincolnshire.[40]

Amongst representations of the hunt executed in other media, pride of place may be given to silver plate. A splendid representation of a hunting party on an estate beside the shore of Lake Balaton bears a Chi-Rho and was evidently a gift to a man called Seuso.[41] We also see the hunting of game animals and wild beasts, including lions, around the rim and further scenes of hunting and the preparation of game on the body of the plate, which has as a centrepiece an *al fresco* feast. Another example of show-plate, the Risley Park lanx (cat.226), depicted a boar hunt; this actually belonged to a bishop called Exuperius.[42] Other hunting scenes form the subject of cut-glass bowls made in the Rhineland, a well-known example of which was found at Wint Hill in Somerset.[43]

Art and daily life: the feast

Another central aspect of aristocratic daily life was feasting, and this again figured in most media from sarcophagi to silverware. On the former, it is not always clear whether what we see is simply a version of the very old theme, the banquet of the dead, or whether on occasion there might be a Christian (eucharistic) overtone. Sometimes, as on the great Sevso dish, the meal is represented in an entirely

Figure 29 Family of Constantine, Ada-Kameo, Trier

contemporary setting, but sometimes it is placed in a timeless world of myth. Indeed, the backdrop of the feast, the interior decor of mosaics and wall paintings, was sometimes deliberately mythologised, generally by showing the wine-god Bacchus with his retinue. There are splendid examples of Bacchus pavements from Britain to Syria. A superb painting from the villa at Tarrant Hinton, Dorset (fig.30), showing a lithe and beautiful youth holding a thyrsus and looking reflectively downwards, should be recognised as Bacchus (cat.126). He was probably pouring wine from a jug to his panther but the lower part of the painting has not survived. In quality this painting will stand comparison in its expressiveness with the famous paintings from Trier.

There is debate as to whether individual owners would necessarily attribute any religious meaning to the choice of Bacchus. Although frequently Bacchus certainly did have a pagan cult significance, as was the case of the marble group from the site of the Mithraeum at the Walbrook, London, inscribed *Hominibus Bagis Bitam* (You [Bacchus] give life to wandering men!) (cat.181), no

doubt to many aristocrats the image remained a cultural one, and modern interpreters of the mosaic at Frampton, Dorset, by the same mosaicists as those of Hinton St Mary, have to take into account the presence of Bacchus and other deities on the same floor as a Chi-Rho. The most recent attempt to explain it puts the mosaic in a Christian, albeit Gnostic, milieu.[44] Many of the silver vessels from which the rich dined would be chased with representations of Bacchus and his retinue, as in the case of the great Neptune dish from the Mildenhall Treasure and a fragment of a jug, of even finer workmanship, from the Traprain Treasure (cat.237). Bacchic themes were also popular on cut-glass vessels.[45]

An age of culture

People of education and rank were expected to know the works of classic authors such as Homer, Ovid and Virgil by heart. They interlaced their own polished speeches, letters and conservation with literary allusions, which provided an opportunity for artistic display. Amongst the rich, education at the lower levels would have been in

the hands of private tutors, but there were also institutions of higher learning. An imperial rescript issued by Gratian and Valentinian in 376, addressed to the Prefect of the Gauls, made provision for the support of Greek and Latin rhetors in certainly the most important cities in the prefecture, assuredly Trier and Bordeaux (as we know from Ausonius) and so presumably London.[46] In all likelihood that rescript was merely a restatement of what was already the position earlier in the century, and reflects a high standard of scholarship.[47] Incidentally, this heritage of Latinity appears to have survived even the political demise of the Roman state in Britain, for instance in the monastic school at Llanilltud Fawr (Llantwit Major) in South Wales.[48]

Scholarship is reflected in many works of art, for instance mosaics and wall paintings which portray scenes from myth. A mosaic from Trier dated to about 300 and signed by a mosaicist called Monnus depicts a number of Greek and Roman writers including Homer, Hesiod, Menander, Virgil and Cicero.[49] The muses, likewise figured here, seem to have been especially favoured as emblematic of culture. They also appear on mosaics from Aldborough and (probably) Brantingham in Yorkshire, the former incidentally with the individual muses identified in Greek.[50] Scenes of the loves of the gods may reflect the wide readership of Ovid and Hyginus. A masterly mosaic, signed by T. Sennius Felix of Puteoli, comes from a house in Lillebonne.[51] As well as depicting hunting scenes in its borders, it has as its central device the myth of Apollo and Daphne. Ganymede is carried up to the heavens by an eagle on a brilliantly lively mosaic at Bignor, Sussex,[52] while Europa and the Bull is one of the subjects of a very ambitious floor from the villa at Keynsham, Somerset (cat.131).

Probably dating from just after the middle of the century, a mosaic from Low Ham in the same county is unique in the empire for showing the story of Dido and Aeneas.[53] It points the way towards the existence of Virgil manuscripts like the *Vergilius Vaticanus* and the *Vergilius Romanus* being amongst the proud possessions of wealthy villa-owners in the north-western provinces, including of course Britain.[54] Although the former manuscript is often dated to *c.*400 and the other a century later, both are in a late Roman tradition that was current in the fourth. Some scholars never consider an origin for them beyond metropolitan centres such as Rome and Ravenna,[55] but there are good grounds for locating the actual production of the *Romanus,* at least, in the far west. Stylistically it seems to be related to Romano-British art, for example the Low Ham Virgil mosaic, while the text is one related to others known to come from Irish monasteries and, finally, it is known to have been in France (St Denis) during the Middle Ages.[56]

The world of Homer is represented too, in scenes such as Achilles on Scyros on a mosaic in the La Olmeda villa at Pedrosa de la Vega in Spain, Ulysses and the Sirens shown in mosaic on a fountain at Cherchel in North Africa or Ulysses proffering wine to Polyphemus at Piazza Armerina.[57] Such subjects were also found on silver plate. Achilles on Scyros provides the centrepieces of silver plates from both the Sevso Treasure and the Kaiseraugst Treasure,[58] and a fragment of a silver flagon from the Traprain Law cache shows the recognition of Ulysses on his return to Ithaca (cat.238). It is possible, however, that the scenes in these very well-known stories were taken from adaptations of Homer, perhaps theatrical.

Although the widespread use of pagan themes in art was sometimes a pointer to the owner's religious affiliation, this need not always have been the case. Classical culture (*paideia*) required the presence of pagan deities whether one was a pagan or a Christian. In the context of the dining room, Bacchus was especially important, and in the context of entertaining a certain playfulness with regard to love was allowed. Venus was naturally popular in this context, and there are excellent examples, probably datable to the period of Constantine. For example, at Bignor in Sussex the nimbed bust of Venus, which occupies the apse on one mosaic,[59] may have been intended to equate the goddess with the *domina* of the house. At Kingscote, Gloucestershire, the bust of Venus holding a mirror, which is the theme of the central roundel of the mosaic floor, is augmented by a wall painting evidently portraying Venus and Mars and is intended to make the room itself act as a sort of poetic commentary on love.[60]

The forging of a new art

As we have seen, the reign of Constantine can be viewed as marking a return to classical values in portraiture and in relief, albeit reused, but that is to miss the point. This was not a time of cultural conservatism, of nostalgia for the past. As in so many other ways, the reign of Constantine and his immediate successors was a dynamic period of transition towards a new aesthetic which we have come to call 'Byzantine'. These were years as excitingly different from what had gone before as the decades of transition from the Greek Archaic to the Classical period at the turn of the sixth to the fifth century BC or the advent of the Renaissance in the late-fifteenth century AD. Despite the continued use of traditional art forms, we really see at this time the birth of a new art. First, figural representation tends increasingly to substitute the type for the individual, whether this be a divine image (Christ) or an emperor. Second, life came to imitate art, in that images came to represent an ideal society, whether in heaven or on earth, in which ceremonial took precedence from the

moment of getting up and being dressed through a day of ceremonial, hunting and feasting. Third, colour linked to abstract forms gave imagination full rein.

It is hard to see why anyone could ever have confused this age of innovation and artistic exuberance with decadence. Elsner has characterised the imaginative use of motifs and even *spolia* from the past in a new and bold manner as a 'cumulative aesthetic', which often surpasses its models in beauty.[61] The vigour of the mainstream art of the age was remarkable not only for its quality but its geographical range, from the Atlantic to the Syrian desert. Apart from marble carving (the marble trade never spread this far north) almost every feature of the art is present in Britain, sometimes in works which are dazzlingly innovative in style. Quite rightly this is often called the 'Golden Age' of Roman Britain.[62] Maybe that description should not surprise us in the light of Constantine's continued interest in the province where he had first come to power, and also the clear evidence for imperial contacts with the British provinces under his successors. However, this has tended to be largely ignored in general works on the period, written from the standpoint of the empire as a whole. Unfortunately, the converse is true in books specifically about Roman Britain, in which the British provinces – and their art – are seen in isolation. We can be certain that Constantine, who knew from whence he came and who, like his hero Alexander the Great, had his eye fixed on his destiny, would not have made that mistake.

Notes

1. Dunbabin 1999, 111–12, fig.114; Kondoleon 2000, 196 and cf. 75, fig.8.
2. Weber 2000.
3. *Vergilius Romanus* (Vatican Library, MS. Lat. 3867) fols 234v, 235r.
4. Neal and Cosh 2002, 326–9.
5. Weitzmann 1979, 78–9, no.67.
6. Dunbabin 1999, 155, fig.159.
7. Elsner 1998, 192–3, illus.129; Dorigo 1971, 166, pl.13.
8. Oakeshott 1967, 61–2, pls 34–9.
9. Yeroulanou 1999, 84–5, 224–5, nos 116–19.
10. Weber 2000, 24–5, Abb.15.
11. Harden, Hellenkemper, Painter and Whitehouse 1987, 238–49; cf. *Codex Theodosianus* 13, 4, 2.
12. Shelton 1981, 80–1, nos 6–9; Cahn and Kaufmann-Heinimann 1984, 194–205, cat.61.
13. Cahn and Kaufmann-Heinimann 1984, 122–3, cat.38–9.
14. Kent 1978, pl.165, no.655; Yeroulanou 1999, 85–6 and 224, cat.115.
15. Walden 1990; Smith 1997.
16. Kent and Painter 1977, 20–1, nos 1–3.
17. Dodds 1965.
18. Franceschini and König 2003, 123–73.
19. Weber 2000.
20. McLynn 2004.
21. Trier 1984, 139–55.
22. Kleiner 1992, 430, 441–2.
23. Elsner 1995, 173, fig.22.
24. Elsner 1998, 78, fig.49; idem 1995, 178–9, figs 25–6.
25. Kleiner 1992, 413–17.
26. Kleiner 1992, 418–25 (Galerius Arch); 455–7 (sarcophagus).
27. Weitzmann 1979, 83, no.71.
28. Henig 1990, 105 and pl.xxxviii, no.178.
29. Trier 1984, frontispiece, no.34; Kleiner 1992, 441–2.
30. Richter 1971, 122–3, no.600.
31. Zazoff 1983, 328, Taf.100, 3 (as Constantine) though Richter 1971, 124, no.606, and Weitzmann 1979, 24–5, no.17, identify the head as, more probably, that of Constantius. The much finer London bust, Richter 1971, no.605, is certainly that of Constantius.
32. Grimme 1972, 24–8, no.22.
33. Franken 1999, 294–5, Abb.8a–c.
34. Kleiner 1992, 455–9.
35. Carandini, Ricci and de Vos 1982.
36. Scott 2000, 158.
37. Smith 1983, pls 10, 11 and 13.
38. Henig 1995, 153–4, ill.91 and 106; Scott 2000, 131–46.
39. Henig 1985, 15–16, pl.iv.
40. Neal and Cosh 2002, 148–57, 201–5.
41. Mango 1994, 55–97, pl.1.
42. Henig 1995, 166–7, ill.96.
43. Henig 1995, 143, 145, ill.87.
44. Perring 2003.
45. Harden, Hellenkemper, Painter and Whitehouse 1987, 220–1, no.122; 230–1, no.129, and see 245–9.
46. *Codex Theodosianus* XIII, 3, 11.
47. Henig 1979.
48. Thomas 1998, 56–73.
49. Hoffmann 1999, 39–46, no.9.
50. Neal and Cosh 2002, 314–18, 326–9.
51. Smith 1977, 133, pl.13.
52. Smith 1977, 115, pl.6.iib.
53. Dunbabin 1999, 96–7, fig.96.
54. Vatican, MS Lat. 3225 and MS Lat. 3867; Weitzmann 1979, 226–8, nos 203–4.
55. Cameron 2004.
56. Henig 1979, 22–3; Henig 1995, 126–7, 158.
57. Dunbabin 1999, 153 and 157, fig.160; 246–7, fig.261; Carandini, Ricci and de Vos 1982, 235–6, 238, figs 135–6.
58. Mango 1994, 153–80, no.3; Cahn and Kaufmann-Heinimann 1984, 225–307, no.63.
59. Smith 1977, 116, pl.6iii (not Juno). Henig 1995, 124, pl.xii.
60. Neal and Cosh in Timby 1998, 87–9 (mosaic); Ling in Timby 1998, 77–87 (wall-painting).
61. Elsner 2004, 304–9.
62. de la Bédoyère 1998.

The Crocus Conundrum

Ian Wood

One of the best-known accounts of the elevation of Constantine at York, that of the *Epitome de Caesaribus,* tells us that the leading figure in the event was an Alaman king called Crocus:

> Quo mortuo cunctis, qui aderant, annitentibus, sed praecipue Croco,[1] Alamannorum rege, auxilii gratia Constantium comitato imperium capit.

> When [Constantius] was dead, he [Constantine] took the imperial title with the approval of all who were present, but especially because Crocus king of the Alamans had accompanied Constantius in order to provide support.[2]

Crocus features in no other account of Constantine's elevation. Historians have, nevertheless, made much of his presence. In what follows I want to look at the interpretations of the role of the Alaman king that have been offered by scholars and also to set the epitomator's comment on him alongside what is known about the involvement of barbarians in fourth-century imperial politics, about their use in the province of Britannia and about the early history of the Alamans.

In treating the history of Constantine's elevation some scholars have been content more or less to repeat the evidence of the epitomator.[3] It is, however, rare to find a comment as neutral as 'he [Crocus] led Constantius' entourage (it was later said).'[4] More specifically Crocus has been called 'a Germanic vassal of the dead Constantius'.[5] Others have been less cautious, talking with certainty of his prominent service with the emperor.[6] Since Crocus may only be mentioned in this one source, on this one occasion, his prominent service has presumably been deduced from his presence at York and the fact that he was able to play a major role in Constantine's succession. The basis of such a deduction is clearly stated in the comment that Crocus' role 'speaks both for his high standing in the army, and for his positive attitude towards dynastic inheritance, which in the elevation of Constantine once again overrode the principles of the Diocletianic succession plans'.[7] Others

have gone so far as to say why Crocus was present in Britain: he was 'serving with the army in a campaign against the Picts'.[8] This is perfectly plausible, but can only be deduced from the fact that Constantius had come to Britain in order to deal with a Pictish threat, and indeed had won a major victory in the north just before his death.[9] On the other hand, an alternative reason for Crocus' presence in Britain has been suggested: the Germanic military unit called the *Numerus Hnaudifridi* (Notfried's Division), which is known to have been stationed at Housesteads, has been seen as foreshadowing 'Crocus and his Alemanni'.[10] It may not be appropriate to see him as the leader of a federate force already stationed in Britain,[11] but it has still been asserted that 'a king of the Alamanni, Crocus, commanding a contingent of his tribe in Britain, played an important part in the elevation of Constantine to Augustus at York in 306'.[12] The same point has been made in yet stronger terms: 'the army proclaimed Constantine as Augustus, apparently encouraged by a Germanic king, Crocus, who had been placed in command of a cohort of Alamanni serving in Britain, a fact that may have influenced him [Constantine] in his subsequent liking for German troops.'[13] Equally plausible, but closer to the words of the epitomator, is the statement that 'Epit. 41, 3 mentions (uniquely) the influence of Crocus, an Alamannic king. Presumably the Alamannic contingents implied by this passage accompanied Constantius as a result of the Romans' recent spectacular victory over these barbarians [i.e. the Alamans].'[14] Leaving aside the reason for his being in York, the type of ring that he would have worn has supposedly been identified.[15] It would have looked like the silver ring bearing the inscription *Fidem Constantino,* which was found in Augsburg (not far from Alamannic territory) in 1876. Another example of the same type is the ring from Amiens (cat.72, fig.31).

It has also been suggested that Crocus may have been the grandson of the Alamannic king C[h]rocus, who is recorded by the sixth-century bishop, Gregory of Tours, as having invaded Gaul, stirred up supposedly by his evil mother, in the time of the emperors Valerian (253–60) and Gallienus (253–68). This earlier Crocus is

said by Gregory to have destroyed the temple of *Vasso Galate* at Clermont, but to have been captured and killed at Arles.[16] Unfortunately, although there is evidence for Alamannic activity, particularly in Italy, in the days of Gallienus,[17] nothing more is known about this third-century Crocus from early sources, even though Gregory of Tours would seem to be presenting his account as reasonably common knowledge: he inserts into his narrative such phrases as 'ut aiunt' (as they say). Since Bishop Privatus of Javols was supposedly martyred in the course of the Alaman invasion, Gregory's source may have been an earlier account of the martyrdom than now survives. As it happens the surviving martyr acts of Privatus are a good deal later even than Gregory's account, although the longer of the two versions does imply the existence of an earlier record,[18] but that may have been nothing other than the brief comments by the Bishop of Tours. In the shorter version of the *Acta* the name of the Alamannic king is, rather curiously, changed to Herod.[19]

Before leaving this second Crocus it is necessary to note a further complication in the picture. A century after the Bishop of Tours, the Frankish chronicler known as Fredegar reworked part of Gregory's narrative. In doing so he retold the story of Crocus, changing him from a king of the Alamans to a king of the Vandals, Sueves and Alans, and placing his activity in the early fifth century,[20] the time of the known Vandal invasion of Gaul. Fredegar may have simply made a mistake, conflating Vandal and Alamannic activity. Such an error could have been facilitated by the fact that Sueves were included in the Alaman confederacy.[21] But Fredegar does add some details that may suggest he had access to another source.[22] It is not, therefore, out of the question that it was Gregory who misdated the invasion of Crocus, although it is perhaps easier to believe that the sixth-century bishop provided a more accurate account than the seventh-century chronicler.

The chronological problem posed by the accounts of Gregory and Fredegar, taken together with the information relating to Crocus' involvement in the elevation of Constantine, have, however, prompted an alternative reconstruction in which all the information has been thought to relate to a single individual.[23] In this reading, Crocus, having been present at York in 306, went on to cause havoc in Gaul, including the martyrdom of Privatus of Javols, before being captured and killed at Arles. The suggestion may seem far-fetched and it certainly sheds unexpected light on Constantine's reign, but it should perhaps not be dismissed out of hand. It is not impossible that a barbarian king who was present when Constantine was acclaimed as emperor subsequently went on the rampage in Gaul. Whether one accepts this reconstruction or not,

there are undoubtedly problems in any attempt to square the information. If we acknowledge the existence of two kings, probably members of the same dynasty, both called Crocus, we are left wondering why the name does not occur in Ammianus Marcellinus, who provides us with a very large number of names of Alamannic kings.[24] If, on the other hand, we do accept the historicity of two related kings called Crocus, we can reasonably note that the careers of those leaders illustrate a sharp change in the dynasty's activities, from raider to soldier of the emperor.

The range of interpretations of the position of the Constantinian Crocus is an interesting indication of just how little is actually known of the precise circumstances of the emperor's elevation and how much has been inferred. Not that any of the conjectures are impossible, though some of them are mutually exclusive. They provide an interesting entrée into what can be said about barbarians in Britain and in the service of the imperial court at the beginning of the fourth century, even if nothing for certain can be said about Crocus himself.

It is worth beginning with the doubts. We have already seen that one historian deliberately comments that the *Epitome de Caesaribus* is not contemporary with Constantine's reign.[25] It is one of a number of short histories of the Roman emperors written in aristocratic circles at the end of antiquity.[26] The most recent scholar to discuss the *Epitome* at length has argued that the author was a pagan writing in the late fourth century,[27] possibly immediately after the reign of Theodosius I, whose burial concludes the text. Despite his paganism, the epitomator is quite capable of praising Christian emperors. In fact, he makes little mention of religion, and indeed is as free in his criticism of pagan rulers as he is of Christian. His attitude towards Theodosius is generally positive.[28] In the case of Constantine, the epitomator is frosty, although not consistently so.[29] Given his normally critical stance, one might wonder whether the account of Crocus' involvement in Constantine's elevation is intended as derogatory.

Most of the passage in the *Epitome* is drawn from the mid-fourth-century historian Aurelius Victor.[30] The one obvious change is the introduction of the figure of the Alaman king.[31] Perhaps the addition was drawn from the slightly younger Greek historian Eunapius.[32] Certainly it must have been deliberate. Since the Alamans are defeated on every other occasion that they appear in the *Epitome*,[33] one might ask whether an imperial elevation in which an Alaman king is the decisive player is meant to be regarded with disdain. If the actions of Crocus recorded by Gregory of Tours were known about, the fourth-century Alaman king might have been a particularly undesirable figure to have as one's chief

supporter, especially if he and Gregory's villain were one and the same. Whether one can go further and see the introduction of Crocus into the account of the *Epitome* as a fiction is an open question. Perhaps the best one can do is to say that there is something unsettling in the role given to Crocus by the epitomator.

One might, nevertheless, go a little further and say that the epitomator's Latin seems to be deliberately suggestive while remaining imprecise. Speaking of Crocus he says: 'auxilii gratia Constantium comitato' ([Crocus king of the Alamans] had accompanied Constantius in order to provide support). A number of words here may imply more than they actually state: *auxilii gratia* strictly speaking indicates no more than help. The phrase may, however, be intended to conjure up *auxilia*, auxiliary troops. Equally, *comitato* is a participle of the verb *comito/comitor*, but *comitatu* (used admittedly in a different grammatical construction) would imply membership of the *comitatus* or imperial retinue, which seems to underlie a number of the interpretations of the role of Crocus already considered. Whether or not anyone is right to take such implications out of the epitomator's phrase is impossible to say, but the reader is apparently being invited to find more in the phrase than is actually there.

Recognition of the problems of the wording of the *Epitome* forces the modern historian back to rather more general observations about the role of barbarians in the Roman world. The interpretations that have been made of the role of Crocus have, after all, been implicitly underpinned by comparative material. This material is in fact useful in showing something of the possible contexts of Constantine's elevation, regardless of whether one accepts one or other reading of the phrase of the *Epitome* relating to the Alaman king.

We can begin with the involvement of Alaman and Frankish leaders at the heart of the fourth-century empire.[34] The subject is one that has been well studied.[35] Apart from Crocus a number of other Alamannic leaders held positions of high military office in the fourth-century empire: Gomoar[36] and Agilo[37] held the post of *magister militum*: Latinus was *comes domesticorum*:[38] Vadomar *dux*,[39] Scudilo *tribunus scutuariorum*,[40] and Hariobaudes,[41] Bitheridus,[42] Fraomarius[43] and Hortarius[44] all held the office of *tribunus* or *protector domesticorum*. A similar set of offices was held by Franks. Silvanus,[45] Merobaudes,[46] Bauto,[47] Ricomer,[48] Arbogast[49] and Charietto[50] all became *magister militum*: Mallobaudes was *comes domesticorum*,[51] while a Merobaudes[52] and a second Charietto[53] rose to be *dux*, as did Bonitus:[54] Malarichus[55] and Laniogaisus held the post of *tribunus*,[56] and Teutomeres was *protector domesticorum*.[57]

Some of these men had particularly distinguished, or at least

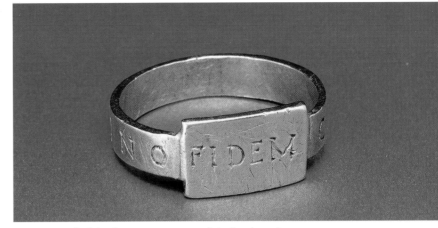

Figure 31 Inscribed ring (FIDEM CONSTANTINO), Amiens (cat.72)

notable, careers. The Alaman king, Vadomar, initially caused problems for the empire by invading Gaul.[58] Subsequently, however, he made peace with Constantius,[59] who went on to use him against Julian who, however, intercepted their correspondence and arrested and banished Vadomar. Subsequently he returned to imperial service and was appointed to a command in Phoenicia.[60] The Frank Merobaudes, who played a significant role in defending the Gallic frontier, was excluded from the politicking that followed the death of Valentinian I,[61] but was appointed consul in 377[62] and again in 383 and 388. He was also to play an important role in the usurpation of Magnus Maximus and the fall of Gratian in 384.[63] Perhaps even more influential was Arbogast, who may have been responsible for the death of Valentinian II and the usurpation of Eugenius in 392.[64] The careers of Merobaudes and Arbogast thus show that barbarians could play a role in the appointment of an emperor in the late fourth century. They would have many successors. Whether Crocus should be seen as a predecessor in such a role is a different matter. On the other hand, one should also note the career of the Frank Silvanus, tribune and *magister militum*, who went on to claim the imperial title in 355 in order to save his own skin.[65] In the mid-fourth century a general who found his position under threat could make a bid for the empire, even if he was a barbarian. This was not something that would be attempted by Germanic *magistri militum* in the fifth century. In this respect barbarian soldiers would seem to have become less rather than more ambitious.

When one looks at the chronology of the appointments of all these fourth-century barbarians, one sees quickly that most of the Alamans held office in the time of the Constantinian dynasty, notably under Constantius II, while most of the Franks were in post under the family of Valentinian or in the reign of Theodosius. Further, and perhaps more significant for an assessment of Crocus, most of the barbarians were in post in the second half of the fourth century. The only exception, leaving aside Crocus himself, is the

Figure 32 Altar dedicated by Aurelius Crotus, a German, Carrawburgh, Hadrian's Wall

sidered in this context, is no longer regarded as an indication of the presence of barbarian soldiers.[67] It is clear, however, that Germanic troops were being employed in Britain as early as the end of the first century, when the Usipites are mentioned.[68] We have already noted the presence of the *Numerus Hnaudifridi*, recorded in an inscription of the third century from Housesteads.[69] Among other inscriptions, there is one from Coventina's well relating to a Germanus called Crotus (a name intriguingly close to that of Constantine's supporter). The monument may date to the third century, but it was certainly being cared for in the fourth.[70] Another Crotus is known from an inscription of the first or second century from Templeborough, but he would seem to have been a Celt.[71] Also from Coventina's well is the votive altar of Maduhus, another soldier who identifies himself as a Germanus.[72] A further indication of the Germanic origin of those setting up votive altars is the evidence of inscriptions naming Germanic gods, such as Mars Thincsus.[73] For instance, the *Numerus Hnaudifridi* set up an altar to the *Alaisiagae* (mother goddesses), Baudihillia and Friagabis.[74] Another altar from Housesteads, now preserved at Chesters, is dedicated to Mars Thincsus, the two *Alaisiagae* – Beda and Fimmilena – and the emperor's genius.[75] The Germani who sponsored this inscription, and another also from Housesteads,[76] were *cives Tuihanti*, probably from Twenthe, just to the north of the Lower Rhine. Others, however, were Tungrians.[77] That is to say, some, perhaps most, of the Germani stationed on Hadrian's Wall originated from within the Roman Empire and not, like the Alamans, from Germania Libera (see, for example, fig.32).

These inscriptions provide us with evidence both for individual Germani and also for groups of them serving on the northern frontier. This evidence for Germanic soldiers serving in Britain can be expanded, at the highest level, with narrative information on military officials, who had clearly made their careers in the Roman army. Such men would not necessarily have had barbarians in their entourage. For example neither Fullofaudes, who would seem to have been *dux Britanniarum* in 367,[78] nor his exact contemporary Nectaridus, the *comes Litoris Saxonici*,[79] would appear to have led their own Germanic contingent. In fact, it is rare to find a clear indication that a complete squadron or *numerus* was Germanic in origin, despite the well-known example of the *Numerus Hnaudifridi*.[80] Here, once again, the narrative evidence does have a little to offer. For instance, we hear from the sixth-century pagan historian Zosimus that the Emperor Probus sent contingents of Burgundians and Vandals to Britain,[81] while Frankish mercenaries would seem to have been used by Allectus.[82] As for the use of Alamans, if we leave on one side the evidence for Crocus, we have to wait until the reign

Frank Bonitus. Indeed, Crocus stands out as being in imperial service a good decade before Bonitus. In short, there are plenty of parallels to the supposed imperial service of Crocus, but they are chronologically later. Either Crocus was a forerunner of what was to become relatively common in the second half of the fourth century – the holding of high military office by barbarian leaders – or alternatively modern historians have over-interpreted the epitomator's rather imprecise comments on Crocus in the light of later appointments.

An alternative context for the career of Crocus and his appearance at York is, as already noted, military service in Britain. Once again the evidence is suggestive, although, because much of it is derived from undated inscriptions, chronology is rather uncertain and the picture is a somewhat generalised one.[66] The evidence of supposedly Germanic-style metalwork, which also used to be con-

of Valentinian I. He appointed the Alaman Fraomar to the kingship of the Bucinobantes, and then transferred him and a troop of Alamans to Britain in 372.[83] By the time of the compilation of the *Notitia Dignitatum* in the late fourth or early fifth century, the Bucinobantes were not the only Alaman unit serving the Roman Empire.[84]

The evidence for the presence of Germanic troops in Roman Britain thus provides a set of parallels for Crocus either as a commander of a force of Germanic soldiers, or as an individual commander appointed to military office. On the other hand, clear evidence for the use of Alamans in Britain, like the parallels for the holding of high office by an Alaman, is rather later than the reign of Constantine. It is necessary to look a little more at the evidence for relations between Romans and Alamans to see if they help in any way to limit the possible interpretations of Crocus' presence in York in 306.

The Alamans emerged in the area of south-west Germany that had previously been dominated by members of another confederacy, the Suebi (fig.33). In the post-Roman period their influence would stretch into what is now northern Switzerland and Alsace. Like a number of other Germanic groups to emerge in the third and fourth centuries, they seem to have been created out of the amalgamation of previous existing tribes, including a section of the Suebi, which they seem to have absorbed.[85] That they were a hybrid group is stated by the Byzantine historian Agathias,[86] and his comment fits exactly with the fact that a number of tribes are named in our fourth-century sources as being Alaman.[87] The claim is also supported by modern linguistic study.[88] The amalgamation of tribes to form an Alamannic confederacy, however, did not mean that they acted as a united group. Throughout their history there is evidence of division and of rival kinglets. Ammianus apparently names seven kings in a single sentence,[89] and it is clear that they were not the only Alaman leaders who could claim the royal title in the mid-350s.[90] Later, in 372, Valentinian appointed Fraomar to the kingship of the Bucinobantes, an Alamannic tribe that lived to the east of the Rhine, opposite Mainz, apparently in order to limit the power of King Macrianus. At the same time he also gave Bitheridus and Hortarius, who are described as *primates* of the Alamans, posts in the Roman army.[91]

The Alamans first appear in the year 213, when they were defeated by Caracalla (188–217).[92] After this brief appearance they once again fade from the historical record. They reappear, however, in the second half of the third century. They attacked Italy (and Gaul, if one is to believe Gregory of Tours) in the time of Gallienus (253–68).[93] Thereafter, they turn up with some regularity in the nar-

rative of the *Scriptores Historiae Augustae*: they are defeated by the usurper Marius (268),[94] as well as Tacitus (275–6),[95] Probus (277–82),[96] and Proculus.[97] The epitomator who introduces Crocus into the elevation of Constantine, also mentions their defeat by Claudius II (268–70).[98] The narrative of the *Scriptores* dates, of course, from the late-fourth century, and may not be reliable. The sixth-century historian Zosimus, who occasionally provides similar information, has also to be treated with caution. We are on more certain ground when we reach the evidence of the Latin Panegyrics of the late-third and fourth centuries. These laudatory addresses are not always easy to follow, and certainly they are works of propaganda. They are, however, well dated and refer to events of the recent past. One panegyric records the defeat of the Alamans by the Emperor Maximian (285–305), following some conflict with the Burgundians.[99] The latter would continue to be hostile neighbours for another century and more. Overall it would seem that the Alamans emerged as a new people in the early third century, but that they were of little importance until the reign of Gallienus and it was not until the days of Maximian that they regularly attracted the attention of Roman authors.

Constantius' dealings with the Alamans emerge directly from those of Maximian. The panegyric on Constantius of *c.*298[100] suggests that the Caesar was present at one of the campaigns of his Augustus against the Alamans, perhaps that of 287.[101] Nor is this the only reference in the panegyrics to Constantius' involvement in fighting them,[102] although the information is such as to make any chronology very difficult to establish.[103] What is clear, however, is that Constantius had been fighting the Alamans perhaps only very shortly before his visit to Britain and his death. Indeed one victory over Germanic invaders, who had supposedly crossed the frozen Rhine, has been dated as late as 304.[104] If this were to have been the case, Crocus' involvement at York was that of a king whose people had very recently been defeated by Constantius.

Conflict between Romans and Alamans continued throughout the fourth century, even while such Alamannic leaders as Gomoar, Agilo, Latinus, Vadomar, Scudilo, Hariobaudes, Bitheridus, Fraomar and Hortarius held posts under the emperor. Loyalty (or suspected disloyalty) was a constant problem.[105] Constantine himself defeated the Franks and Alamans in *c.*313, and commemorated his victory on his coins.[106] His son Constantius II defeated them in 354.[107] Julian scored a notable victory against them in 356,[108] and he continued to ravage their territories in subsequent years, just when Constantius was using and promoting Vadomar.[109] Intermittent war would continue under Valentinian, in the 360s and 370s,[110] and also under Gratian.[111] The Alamans thus remained a problem right

up to the time of the epitomator who recorded Crocus' involvement in the elevation of Constantine.

What light does any of this shed on Crocus himself? Assuming that he is not an invention of the epitomator, there are some indications, though nothing more, about how we might interpret his role in 306. It is worth remembering that to be a king of the Alamans may not have meant much. There appear to have been lots of them at any one moment! In addition, it is important to keep in mind the fact that Crocus would have been a king of a people who had only recently emerged into the limelight. They are not known to have served the empire before the days of Crocus, although particular groups of Alamans would subsequently do so. Certainly there is nothing to suggest that any individual Alaman served in Britain before 306, and the first indication of a whole force of Alamans being stationed on the island comes with the appointment of Fraomar in 372.[112] The interpretation of Crocus as a figure who led a force of auxiliaries in Britain is thus unlikely. Although there may have been plenty of such troops before 306, there is no indication that they included Alamans by that date. Equally, although Germanic nobles would serve the empire in very high positions in the course of the fourth century, Crocus would seem to be a very early example of that tradition of service, if indeed he did hold major office under Constantius. It is perhaps safer to doubt that he held a post of any significance.

Possibly more helpful in understanding the position of Crocus is the fact that Constantius had recently defeated the Alamans. This might suggest that Crocus was effectively a hostage in the emperor's retinue. Of course, the fact of Constantius' victory does not prove that Crocus had been the leader of a force hostile to Rome. Throughout Alamannic history, there is evidence for division

among the various tribes that made up the confederacy. As we have seen, Valentinian was later to use Fraomar against Macrianus.[113] In other words Crocus could have been a pro-Roman kinglet, who had joined the retinue of Constantius while the emperor was engaged in his wars against other Alaman rulers. Crocus could equally have been a defeated ruler who had been taken hostage. In either of these cases he is not very likely to have been in a position to ensure the elevation of Constantine.

Of course, none of the caveats expressed need be valid. Someone must have been the first Germanic figure to have held major office in the empire, and Arbogast, who played a major role in the usurpation of Eugenius in 392, need not have been the first barbarian to have appointed an emperor.[114] On the other hand, given the silence of the earlier sources, one might well wonder whether the epitomator has not recast Constantine's elevation in terms which might have made more sense in his own day than in 306. All in all, it would seem that the role attributed to Crocus in the *Epitome de Caesaribus* is likely to be an anachronistic one. Certainly Crocus may have been present at Constantine's elevation, but the epitomator may well have over-interpreted genuine information. He himself was aware of Arbogast.[115] He might also have wanted to cast aspersions on the manner by which Constantine came to power. Despite such reservations, examination of Crocus' role and of the possible parallels to the various careers that have been suggested for him, can usefully serve to shed light on the slow emergence of the Alamans and on the role played by barbarians in imperial and provincial command in the third and fourth centuries. As a result, the exercise does show us something of the context in which Constantine's elevation took place.

Notes

1. Or *Eroco* in one manuscript.
2. *Epitome de Caesaribus* 41.3. I have added the word 'because' in translating *sed praecipue … comitato* deliberately in order to emphasise the fact that it is not just a gloss on *cunctis … annitentibus*.
3. For example Birley 1979, 95.
4. Barnes 1981, 27.
5. Schlumberger 1974, 196, n.57.
6. MacMullen 1969, 42.
7. Stroheker 1965a, 42.
8. Casey 1994, 135.
9. *Origo Constantini* (*Anonymus Valesianus I*), 2.4
10. Birley 1979, 95.
11. Salway 1981, 410; in general, Southern 2004, 405: 'There is no evidence that Germanic troops were brought to Britain as *laeti* and *foederati*, federate settlers with an obligation to provide recruits for the army. It has been suggested that the sections of the *Notitia Dignitatum* that might have listed *foederati* in Britain have been lost, but there is no proof for this theory.'
12. Breeze and Dobson 1976, 217.
13. Salway 1981, 322.
14. Nixon and Rodgers 1994, 229, n.34.
15. Martin 1997, 119–20.
16. *PLRE* I, s.v. Crocus, 233; Gregory of Tours, *Historiae* I.32, 34.
17. Zonaras XII.24; Eutropius, *Breviarium* IX.8.2; Aurelius Victor, *De Caesaribus* 33.3 and 35.2; also *Pan. Lat.* VIII(5).10.
18. *Passio Privati, Acta longiora* 2 (*Acta Sanctorum* August 21st).
19. *Passio Privati, Acta breviora* 1: *Alemanni cum Herode rege suo*. The change would, however, be slight if the author had before him the variant Erocus rather than Crocus, as can be found in one manuscript of the *Epitome de Caesaribus*; see above, note 1.
20. Fredegar, *Chronicle* II.60.
21. Hummer 1998, 17.
22. For example the identification of his captor as Marius. Krusch in his edition of Fredegar does comment on the fact that most of the associated material in the account does relate to the fifth century (Krusch 1888, 84 n.2).

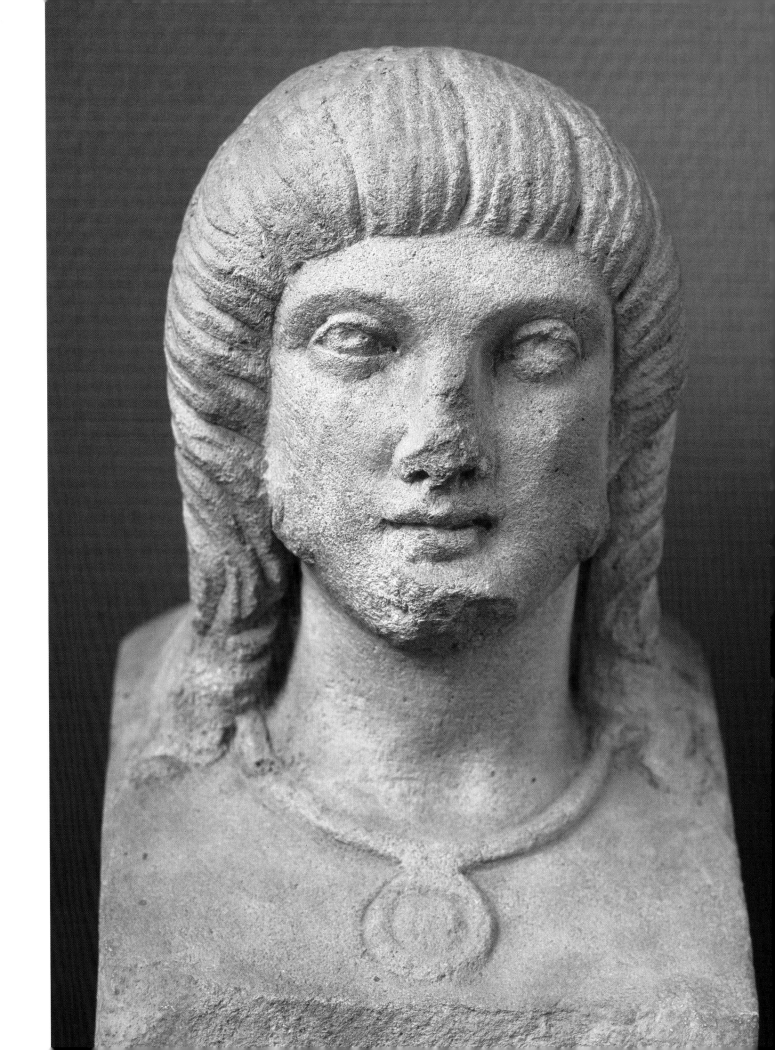

23. Duchesne 1899, 54, 124–6.
24. For the richness of Ammianus' account of the *Alamanni*, see Matthews 1989, 306–18.
25. Barnes 1981, 27.
26. For the related cluster of texts see Rohrbacher 2002, 44.
27. Schlumberger 1974, 233–46.
28. *Op. cit.* 228.
29. *Op. cit.* 201.
30. Aurelius Victor, *Liber de Caesaribus* 40.2.
31. Schlumberger 1974, 195–6.
32. Barnes 1981, 298, n.121.
33. *Epitome de Caesaribus* 34.2, 42.14, 47.2.
34. I leave on one side Fullofaudes and Nectaridus, who were probably Germanic, but whose specific ethnic attachments are unknown; see Southern 2004, 401–2.
35. See in particular Stroheker 1965a, 30–53, and also Stroheker 1965b, 9–29. A useful table that summarises much of Stroheker's case can be found in Martin 1997, 122.
36. *PLRE* I, 397–8, Gomoarius, *magister equitum*.
37. *PLRE* I, 28–9, Agilo, *magister peditum*.
38. *PLRE* I, 496, Latinus.
39. *PLRE* I, 928, Vadomarius.
40. *PLRE* I, 810–11, Scudilo.
41. *PLRE* I, 408, Hariobaudes.
42. *PLRE* I, 162, Bitheridus.
43. *PLRE* I, 372, Fraomarius.
44. *PLRE* I, 444, Hortarius 2.
45. *PLRE* I, 840–1, Silvanus 2.
46. *PLRE* I, 598–9, Flavius Merobaudes 2, *magister peditum*.
47. *PLRE* I, 159–60, Bauto.
48. *PLRE* I, 765–6, Flavius Richomeres.
49. *PLRE* I, 95–7, Arbogastes.
50. *PLRE* I, 200, Charietto 2.
51. *PLRE* I, 539, Mallobaudes. Martin 1997, 122, distinguishes Mallobaudes *comes domesticorum* from Mallobaudes *tribunus scholae*; *PLRE* sees them as a single individual.
52. *PLRE* I, 598, Merobaudes 1.
53. *PLRE* I, 200, Charietto 1.
54. *PLRE* I, 163, Bonitus. It is unclear whether there are two separate individuals or not.
55. *PLRE* I, 538, Malarichus.
56. *PLRE* I, 495, Laniogaisus.
57. *PLRE* I, 886, Teutomeres.
58. Ammianus Marcellinus (henceforth Amm. Marc.) xiv.10.
59. Amm. Marc. xv.12.17.
60. Amm. Marc. xxi.3–4.
61. Amm. Marc. xxx.10.1–3.
62. Amm. Marc. xxxi.8.2.
63. *PLRE* I, 598–9; Prosper Tiro, *Chronicle* 1183, s.a. 384 in *Chronica Minora* I, 461.
64. Zosimus, *Hist.* iv.53–4. Curran 1998, 108–9.
65. Amm. Marc. xv.5.
66. Breeze and Dobson 1976, 198, on undated inscriptions; Breeze 1981, 168.
67. Southern 2004, 403.
68. Breeze 1981, 168.
69. *RIB* 1576.
70. *RIB* 1525. See also *RIB* 1532. For the state of the monument I am indebted to Lindsay Allason Jones.
71. *RIB* 620; Birley 1979, 92, 100.
72. *RIB* 1526.
73. Breeze and Dobson 1976, 185.
74. *RIB* 1576.
75. *RIB* 1593.
76. *RIB* 1594.
77. For example *RIB* 1591; 1598.
78. *PLRE* I, 375, Fullofaudes.
79. *PLRE* I, 621, Nectaridus. Southern 2004, 401–2; Amm. Marc. xxvii.8.1.
80. The *cives Tuihanti* of *RIB* 1593–4 may be a further example. For a negative comment on the use of certain types of Germanic troops in Britain see Southern 2004, 405, quoted in note 11, above.
81. Zosimus, *Hist.* i.68, 1–3.
82. *Pan. Lat.* viii(5).16–17.
83. Amm. Marc. xxix.4.7.
84. *Notitia Dignitatum: Oriens*, v.58; vi.58: *Occidens*, v.201–2. Matthews 1989, 316.
85. Hummer 1998, 17.
86. Agathias i.6.3.
87. For example the Bucinobantes, Amm. Marc. xxix.4.7; Hummer 1998, 15–16.
88. Wenskus 1961, 500–2; Hummer 1998, 14.
89. Amm. Marc. xvi.12: Chonodomarius, Vestralpus, Urius, Ursicinus, Serapio, Suaomarius, Hortarius.
90. Amm. Marc. xiv.10: Vadomarus, Gundomarus.
91. Amm. Marc. xxix.4.
92. Dio Cassius lxxvii.13.4–6, 14.2, 15.2; *Scriptores Historiae Augustae* (henceforth *SHA*) *Caracalla*, x.6; there is a useful gathering of material in Nixon and Rodgers 1994, 62, n.23. Geuenich 1997, 74, unaccountably ignores the evidence of Dio.
93. Zonaras xii.24; Eutropius, *Breviarium* ix.8.2; Aurelius Victor, *De Caesaribus* 33.3 and 35.2; *Pan. Lat.* viii(5).10; Gregory of Tours, *Historiae* i.32, 34.
94. *SHA, Tyranni Triginta*, viii.11.
95. *SHA, Tacitus*, xv.2.
96. *SHA, Probus*, xii.3; xiii.5–7. See also Zosimus, *Hist.* i.67.
97. *SHA, Firmus, Saturninus, Proculus*, xiii.3.
98. *Epitome de Caesaribus* 34.2.
99. *Pan. Lat.* x(2).5; xi(3).17. The first of these is regarded as the earliest secure evidence (*sicheres Zeugnis*) for the name Alaman by Geuenich 1997, 74.
100. Nixon and Rodgers 1994, 105–6.
101. *Pan. Lat.* viii(5).2. Nixon and Rodgers 1994, 110–11, n.6.
102. *Pan. Lat.* vi(7).6.3. See also Eutropius, *Breviarium* ix.23.
103. Nixon and Rodgers 1994, 225–6, n.25.
104. *Pan. Lat.* vi(7).6.4; Barnes 1982, 61; Nixon and Rodgers 1994, 226, n.26.
105. For example, Amm. Marc. xiv.10.6; Matthews 1989, 317.
106. *Pan. Lat.* iv(10).17.1, 18.1–19.1. For the coinage, Nixon and Rodgers 1994, 340.
107. Amm. Marc. xiv.10.
108. Amm. Marc. xvi.2.12, 4.2; xxi.3.4–5. *Pan. Lat.* iii(11).4.5 and 6.2.
109. Amm. Marc. xvii.1, 2 and 10; xviii.2.
110. Symmachus, *Oratio* ii.29; Amm. Marc. xxvi.4.5, 5.7, 5.13; xxvii.1.1 and 2; xxviii.2.6–9; xxviii.5.8, 5.15; xxix.4.2, 4.7; xxx.3.1, 3.7.
111. Amm. Marc. xxxi.10; Zosimus, *Hist.* iv.24.4; Socrates, *HE* v.11.2; Sozomen, *HE* vii.13.1.
112. Amm. Marc. xxix.4.7.
113. Amm. Marc. xxix.4.7.
114. Curran 1998, 108–9.
115. *Epitome de Caesaribus* 48.7. Interestingly he makes no comment on the role of Flavius Merobaudes in the fall of Gratian.

Religious Diversity in Constantine's Empire

Martin Henig

Constantine's personal impact upon the religious development of the Roman Empire was profound. It resulted in the construction of enormous churches, which he endowed with gifts of precious jewels, plate and statuary, affording them such prestige that they more than rivalled the great temples of traditional pagan cults. The extent of the revolution in attitude, as much as in theological and philosophical thought over a span of 50 years, which encompassed his own reign as well as those of his sons,[1] is shown by the fact that the attempt by Constantius II's successor, Julian,[2] to abandon Christianity and revert to paganism was viewed by most people as a retreat from the natural order of things. Already, by the mid-fourth century, it was quite widely assumed that some form of Christianity was the natural religion of the State. Even so, the city of Rome retained its largely pagan, aristocratic governing class, and in Britain, Gaul, Germany and Spain there was probably also a pagan majority. Convinced Christian that he was, Constantine, who had doubtless seen something of the Diocletianic persecution, practised a policy of tolerance towards diverse faiths.

Radiance and the divine image

The momentous religious changes would not have been possible if there had not been a degree of convergence between contemporary pagan and Christian thought, often manifested in solar monotheism. This is apparent in the later third century, especially associated with the Emperor Aurelian.[3] Images of the sun-god are shown with rayed crowns, for instance on a dramatic sculptural relief from Corbridge (cat.179), depicting a facing portrait of Sol whose rays are incorporated with an encircling aureole or nimbus.[4] An altar from Carrawburgh dedicated to Mithras, there conflated with the sun-god, provides a clue about the way divine images could even be presented as actually emanating light, for three of the rays are pierced and a lamp placed in a niche behind would have transmitted a flickering light.[5] The epithet used for Sol was *invictus*: 'unconquered'. Sol Invictus was often equated with Apollo, one of whose most important Gallo-Roman sanctuaries was at Grand, visited by

Constantine in about 310. Here he was vouchsafed a vision from the god Apollo Grannus.[6] Apollo appeared in many guises around the empire and could be equated with Mithras as well as Sol. Although different rites would be performed at different shrines, exact details could be left to the priests. For the votary, imperial or otherwise, what mattered were the performance of correct ritual and the subsequent reward of a vision of the god.

It was natural to see Christ conflated with Sol, most explicitly on a vault mosaic from a tomb under St Peter's (fig.34) where Sol is depicted in his chariot, but with solar rays emanating from his nimbus lengthened into a reminiscence of a Chi-Rho or a cross.[7] Constantine wholeheartedly embraced the tradition of solar monotheism, which was both an attribute of the divine and of the ruler who represented God on earth. He is shown on coins and medallions as 'comrade of the unconquered sun'. A statuette of Sol found in Jutland may show an emperor, possibly Constantine himself, as Sol Invictus.[8] The aureole reflects the theory that superior beings, like gods, give out light, while the large staring eyes were a channel down which its rays passed from the god, or his agent the emperor, to the viewer. Constantine's continuing conflation of Christ with the Unconquered Sun is apparent in his edict of 321 which made Sunday, the day dedicated to Sol, a public holiday, a decision which was radically to alter the shape of people's lives for centuries to come.[9]

Constantine and the gods

In his public monuments Constantine was prepared to honour the long-established pantheon as a matter of course.[10] His Arch (fig.4) includes all the established symbols of power and authority, both in the reused Trajanic, Hadrianic and Antonine reliefs and in its newly commissioned sculptures. The Constantinian reliefs of Sol and Luna are not unexpected embellishments; indeed the obverse of a medallion issued after the Battle of the Milvian Bridge carries jugate portraits of Constantine and Sol.[11] More conventional aspects of traditional religion also remain prominent. One of the

Figure 34 Christ as Sol Invictus, vault mosaic, Vatican necropolis, Rome, third century

Antonine reliefs depicts a sacrifice and another shows the emperor accompanied by Mars and Dea Roma, while two of the Hadrianic hunting reliefs show the emperor actually engaged in sacrificing to Diana and Silvanus.[12] As the heads have been changed to those of Constantine, he was presumably more than prepared to have himself portrayed in this way, although in reality he actively discouraged blood sacrifice of this sort. Constantine continued to be careful to respect the privileges of traditional cults, especially the imperial cult with its associated priesthoods.[13] However, he gave particular favour to bishops, who were given the powers of civil magistrates, a position never achieved by pagan priests. Also, he seems to have withheld *active* personal support of what had been the premier cult of Rome, that of Jupiter on the Capitol, as it would have involved sacrificing to an idol.[14] However, in general his attitude was remarkably open-minded as it is expressed in a letter drawn up by Constantine and Licinius for circulation among the governors in the eastern provinces. This is the famous document often known as the Edict of Milan, whose text is recorded both by Eusebius and Lactantius:

> We grant both to Christians and to everyone freedom to follow whatever religion they want to, so that whatever divinity there is in heaven may be appeased and made favourable to us and to all who are set under our power.[15]

This freedom, incidentally, extended to Judaism, which flourished both in Palestine and amongst the diaspora throughout the empire. Some synagogues, like that at Ostia, may have reached their greatest elaboration at this time.[16]

Christians and pagans

Although it seems natural to approach the commemoration of Constantine's accession as though it were the prelude at least to the empire becoming Christian, that was not the way his contemporaries would have seen it, whatever their religious allegiances. Emperors were still very much part of a pagan world in which their divine essences (*numina*) were venerated with the gods, not just in major temples but in countless shrines throughout the empire. Indeed, priesthoods for the imperial house were inaugurated during Constantine's reign, even in Rome.[17] Everywhere religion was strongly entrenched and there was no sign that people were losing faith in the gods. In Rome, for example, the sanctuary of the Magna Mater (Great Mother) with its orgiastic rites, including the *taurobolium*, continued to flourish on the Vatican hill right down to 390, in the temple which lay in the immediate vicinity of St Peter's.[18] A sanctuary to the Syrian gods, notably Jupiter Heliopolitanus, was rebuilt on the Janiculum.[19] The cult of Isis remained visible and prominent here, alongside other traditional gods, whose festivals are noted in the Calendar of 354, and special coins were struck annually in her honour through much of the fourth century.[20]

Throughout the empire were great sanctuaries, some of them stretching back to remote antiquity. Such sanctuaries included those of Zeus at Dodona, Apollo at Delphi and Claros, Artemis at Ephesus, Athena on the Athenian acropolis, Asclepios at Epidaurus, Serapis in Alexandria and elsewhere in Egypt, and of course many urban temples throughout the empire. It is true that many of the religious images survive the second or early third centuries, and for the most part these were still being venerated in the early fourth century. Although Eusebius writes that Constantine did demolish some temples and remove their statues, the wave of iconoclasm for the most part did not begin until much later in the century.[21]

Religious images from Roman Britain and the west

In the west, as elsewhere in the Roman Empire, pagan religion was generally local. The names and identities of the gods were adapted from those of the regular Graeco-Roman pantheon but these deities were fused with Celtic equivalents and given Celtic epithets, a process we call *interpretatio Romana*. This meant that for people coming to temples far from home there was a certain familiarity in the majority of the images encountered, but at the same time the gods recognisably belonged to the region.

For instance, Jupiter was the chief god of the Roman state and of the army, a position if anything enhanced by Diocletian. In north-western Europe he had a number of local names, amongst them Taranis; in this form his cult object was a wheel which, by rolling,

would cause the sound of thunder. A statue of Jupiter was often placed on top of a column, sometimes with its shaft embellished with a scale or leaf pattern to simulate bark or leaves.[22] Frequently subordinate deities were shown on the shaft or around the base, emphasising the variety of the Roman pantheon. Such columns were later to become the targets of Christian iconoclasts even in Britain. An example in Cirencester, capital of Britannia Prima, was re-erected to *prisca religio* (the old religion), most probably in Julian's reign. This may imply a rare case of iconoclasm under Constantine or more probably one of his sons. One opportunity would have been when Constantius II sent his agent, Paulus, to arrest leading members of the British aristocracy, albeit for conspiring with the usurper Magnentius rather than for religious reasons.[23]

Other gods were also important, as a few examples will demonstrate. In military circles Mars, often called Mars Pater (Father Mars), was venerated and still figured on coins. He is well represented in York by a fine statue carved in local stone.[24] As in the case of Jupiter he too might be figured in a local guise, for instance at Stragglethorpe in Lincolnshire, where he is shown as a rider-god who, like Jupiter on his columns, tramples down and slays the malignant powers that threatened the divine order.[25] Such a deity probably had a Celtic name, such as Mars Corotiacus, whose name is inscribed on the base of a statuette of a similarly mounted Mars from Martlesham, Suffolk. Mars might preside over sacred groves (as he did in Italy) and at a sanctuary near Lincoln he was given the Celtic name of *Rigonemetos* meaning 'king of the sacred grove'.[26] Another manifestation of Mars, Mars Lenus, had his major sanctuary near Trier, while the Remi especially honoured Mars Camulus.

Mercury was at least as widespread, and was frequently depicted with a female consort called (in some instances) Rosmerta. The temple at Berthouville, Eure, in northern Gaul, from which comes one of the largest extant hoards of temple plate, was evidently abandoned in the third century, but the temple of Mercury at Uley, Gloucestershire, for example, was certainly flourishing through the fourth century; quantities of sheep and goat bones together with those of cockerels indicate that sacrifice was the normal mode of rewarding the god for favours received. Here, as at Bath, numbers of inscribed lead tablets were found, asking the deity to recover stolen property.[27]

Apollo, too, was a familiar Roman deity who in his classical form is represented by the beautiful bronze statue from Lillebonne in Gaul.[28] He could take on local aspects, for example as a hunter-god as Apollo Cunomaglus (the 'hound prince') at Nettleton Shrub and probably elsewhere in south-west Britain,[29] or Maponus in north-ern Britain.[30] Apollo Grannus, to whom Constantine paid a famous visit, probably at Grand, also had a sanctuary at Hochscheid where statues both of Apollo and of his local consort, a spring-goddess called Sirona, have been recovered.[31]

Amongst goddesses, Minerva played an important protective role in both military and civil circles and she had a number of important temples in the Roman west including that of Sulis Minerva at Bath. The name with which she is paired shows that she was here conflated with a native deity. The cult was clearly flourishing in the fourth century as is demonstrated not only from votives such as coins and metal vessels thrown into Sulis's sacred spring but from lead tablets on which the goddess was asked to punish malefactors who had stolen property from the petitioner.[32]

The Matres or mother goddesses were known regionally in Gaul, Britain and Germany under a host of native names of obscure meaning such as the Suleviae and the Aufaniae.[33] Often shown as a triad, they represented fecundity. Single deities with similar functions included the pony-goddess Epona in Burgundy and Nehalennia with her hound-familiar in the Netherlands; Nehalennia had an important temple at the mouth of the River Scheldt, visited by those merchants plying their trade in the North Sea including Britain.[34] A mother goddess, recorded at Daglingworth near Cirencester, was called Cuda and her name shows that she was probably the presiding deity of the Cotswold hills.[35] There were also goddesses of rivers, well and springs such as Arnemetia (or Arnemecta) at Buxton and Coventina at Carrawburgh by Hadrian's Wall.[36] Another deity, Sequana, is known from a large number of votive offerings of metal, stone and wood at her shrine at the source of the Seine.[37] Many of the votives depict parts of the body and were presumably presented to the deity as offerings for cures. Such pagan healing cults survived into Christian practice.

The pagan gods were clearly differentiated from the Christian Trinity both in the manner in which they might be depicted and in that they happily coexisted in all their diversity. This can be seen when looking at the multiple images carved on the bases and shafts of Jupiter columns.[38] Similarly, at Bath, Jupiter, Neptune, Apollo, Hercules, Bacchus and a local spring goddess are carved in relief on three blocks thought to be the main altar of Sulis Minerva, and consequently share her honours.[39] Small figurines and plaques embossed with figures of deities, presented to temples by worshippers, are also varied. Thus from Woodeaton near Oxford there is a plaque showing Mars, figurines of Venus, Apollo and a strange man-eating beast, half lion and half wolf. At Lamyatt Beacon, Somerset, images of Mars, Minerva and Mercury as well as a Genius have been found. At Maiden Castle a plaque depicting Minerva, a

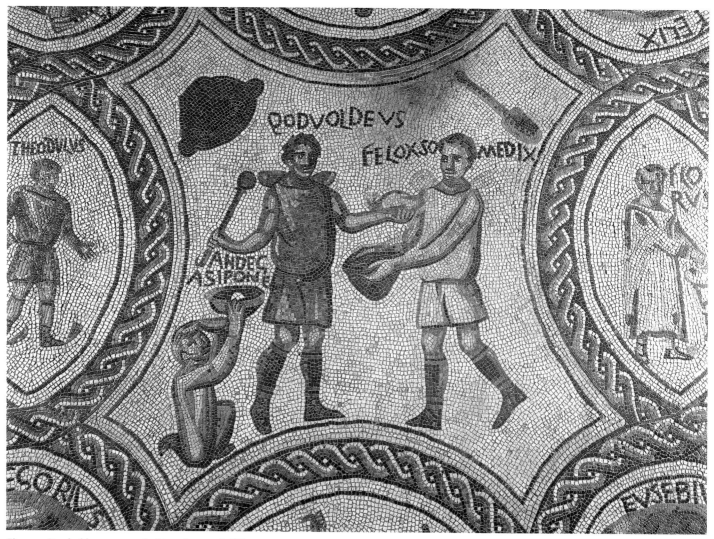

Figure 35 Quodvoldeus scene on the Mysteries mosaic, Trier

small marble Bacchus (not Diana as it was previously identified) and a strange tinned figure of a bull with harpy-like figures on its back were excavated (cat.182); the latter evokes the Celtic deity called Tarvos Trigaranus on a monument from Paris showing multiple deities.[40]

Visiting the gods

Doubtless most cult images within their temples were illuminated by torches and lamps; bronze statues, like that of Sulis Minerva at Bath, were refulgent through the application of gilding.[41] The world of the divine was very different from that of men, and this can be demonstrated even where the image of the god no longer survives. Visitors to the rural sanctuary of Nodens at Lydney, Gloucestershire, for instance, which seems to have flourished especially in the first half of the fourth century, first had to arrive as pilgrims, probably crossing the River Severn, and certainly climbing a hill, before passing through a gate into the religious compound. The

shrine was provided with a guest-house, baths (for purification) and a long building for incubation, that is, for a sacred sleep in which visions were induced. The temple itself possessed an ambulatory around which pilgrims could process, but the central part of the shrine was doubtless special, the divine images standing in the back; in front of it there was a mosaic laid by Titus Flavius Senilis the *pr(aepositus) rel(igionis)*, or priest, in association with Victorinus, the dream interpreter. Two points may be made. The first is that the presence of two temple officials shows a properly constituted cult with financial resources adequate to embellish the shrine. The second is that this spot, with a convenient collection box inserted in the mosaic, clearly marked the limit of general approach, just as a screen demarcates the sanctuary from the nave in a church. Doubtless the sea-beasts shown on the floor acted as guardians of the cult images beyond, mysterious but glowing with light.[42]

The popularity in art of themes from Classical literature was a

function of *paideia*, classical culture, but for some pagans there was real religious meaning in what was shown. For instance, on the Mysteries mosaic at Trier we see the myth of Leda and Jupiter (who seems here to be figured as an eagle rather than as a swan). The eggs laid as a result of the union, from which hatch Castor and Pollux and also Helen of Troy, are also shown. Agamemnon is depicted, evoking thoughts of the Trojan War. In this version of the myth is he her husband? Various members of what seems to be a private circle of votaries (a *collegium*) appear, carrying food or dancing: Calemerus, Eusebius, Felix, Peregorius and Theodulus. Most important is a cult scene with an explanatory inscription depicting a figure called Quodvoldeus (whose name means literally 'what the god wishes') telling Andesasus to set a bowl down and Felix to pick it up: *Q(u)odvoldeus Andesasi pone Felox dix(it)* (fig.35).[43] This is a liturgical act performed with bowls and other implements of uncertain function. A cache of jewellery, spoons and strainers from Thetford, dated late in the fourth century, provides certain evidence for a similar collegium in Britain. The ritual activity must have included eating and drinking, as at Trier, but here the cult draws on Roman rather than Greek myth, that of the Latian god Faunus. On some of the spoons there are the names of cult members, amongst them Agrestis, Ingenuus, Primigenia and Silviola, while others bear invocations to Faunus whose Celticised epithets include 'guardian of treasure' (*cranus*), 'mead-begotten' (*medugenus*) and 'prick-eared' (*ausecus*). A ring with two woodpeckers as supporters reminds us that Faunus's father was Picus ('the woodpecker').[44]

Given the late date of the Lydney mosaic, the Mysteries mosaic at Trier and the Thetford Treasure, it is more than likely that the rituals practised owed something to Christian liturgy. This liturgy was firmly in the ascendant by the mid-fourth century in much of the empire, epitomised by the bowls, strainer and other vessels in the Water Newton Treasure (cats 196–204), discussed below.

Mystery cults

While not totally separated from other cults, the so-called 'mystery religions' are often placed in a special category as demanding initiation and lifelong allegiance. For Constantine in 306 they must have been a key feature of the religious landscape, especially in York, a major fortress, *colonia* and provincial capital, a cosmopolitan place. Not many years later a bishop is attested and, even as early as 306, Constantine may have been aware of a Christian community there.

Amongst the high military circles in which Constantine and his generals moved, Mithraism is likely to have been prominent. The cult was never a serious rival to Christianity because the number of votaries in any one temple was small and select, and women were

excluded. There was a temple to Mithras at York which has yielded a good example of a small, votive bull-slaying scene (tauroctony),[45] and which might have been as richly furnished as the Mithraeum in London. Here a fine collection of marble sculptures, including another small tauroctony, a head of Mithras (cat.177) and others of Sarapis and Minerva, have been found as well as an inscription dated to the beginning of Constantine's reign and containing the formula 'ab oriente ad occidentem' (from the east to the west), a claim of universality like the Christian 'from alpha to omega' (cat.191).[46] Many other Mithraea are known, especially in the German provinces, at Heddernheim and Neuenheim, which have yielded particularly fine large tauroctonies which would have been placed in the main apse of the temple. Mithras, often described as unconquered (*invictus*), was closely allied with and sometimes associated with Sol, as for instance on an altar from Carrawburgh.[47]

Other gods offered salvation to their votaries. The cult of Isis with her consort Serapis continued to attract worshippers. Although these deities are attested in York as well as in London in the third century,[48] and a number of important Isea flourished in Italy, including Rome itself, the cult naturally attracted more adherents in the East than in the West. The cult was of especial significance in Egypt where the Serapeum at Alexandria and the Temple of Isis at Philae were major centres. Christian iconography was influenced by Isis at least in the way the goddess is portrayed, suckling her son Harpocrates, her blue robe, and such epithets as 'star of the sea' were adopted for the Virgin. Moreover the Egyptian *ankh* sign, emblem of life, influenced the form of the equal-armed Greek cross.[49]

Less influential but nevertheless very much part of the religious landscape was the cult of Cybele and of Attis, an eastern cult attested in London, Gloucester and Verulamium.[50] The orgiastic rites including ritual castration and the *taurobolium* would potentially have made this an especial target for Christian iconoclasm; but again, as we have seen, it flourished in the very shadow of one of the major Christian churches in Rome. There were centres in Gaul, for example Bordeaux and Lyons, where a number of altars recording *taurobolia* have been found.[51] The cult of the Great Mother, in the countryside near Autun, was suppressed in the late fourth century by St Simplicius.[52]

Constantine's Christian world

The most momentous change of Constantine's reign was his adoption of Christianity, which rapidly assumed the status of a favoured cult. Constantine presided over a number of important church councils. The Council of Arles in August 314 was concerned with a

dispute between the North African Donatists – Christians proud of never having surrendered their sacred books to the agents of Diocletian's persecution – and the rest of the Church, which had temporised under pressure. Delegates to the Council were drawn from the western provinces, Italy, Gaul and Britain, and included Bishop Eborius from York.[53] Constantine left the Donatists 'to the judgement of God', an inconclusive end to the meeting which, in consequence, did not resolve the schism. Constantine likewise presided over the famous Council of Nicaea in Bithynia, in May and June 325, and claimed an attendance of over 300 bishops. The Council considered the nature of the Person of Christ, that is whether He and the Father were totally distinct (as the Arians believed) or shared a single nature. Under the emperor's wise guidance, the Council settled in favour of the latter, exemplified in the Nicene Creed which is still central to Christian belief.[54]

In Rome, Constantine constructed the major Church of Christ Saviour (see the essay later in this volume 'The Legacy of Constantine in Anglo-Saxon England'). This was 333 Roman feet in length and occupied the site of a palace on the Lateran which had previously belonged to Constantine's rival Maxentius. Constantine provided it with sumptuous furnishings and it became the seat of the city's bishop.[55] He also built a major cemetery church to include the tomb of St Peter on the Vatican, even larger than the Lateran, some 360 feet in length (fig.41).[56] The focus of St Peter's was not an altar but a monument of porphyry and marble with twisted columns carved with vine scrolls. Above the triumphal arch

Figure 36 Model of ecclesiastical complex, *c.*380, Trier

separating the nave from the transepts and apse was an inscription whose language echoed secular panegyric, though this was addressed to Christ: 'Quod duce Te Mundus surrexit in astra triumphans hanc Constantinus victor Tibi condidit aulam'.[57]

After the defeat of his co-emperor and last rival, Licinius, at Chrysopolis in 324, he founded a new, largely Christian, capital at Constantinople, well provided with Christian places of worship, notably the Church of the Holy Apostles (where he was eventually buried, as the thirteenth apostle) and the Church of the Holy Wisdom (Sancta Sophia). Even so, although we generally consider Constantinople to be a Christian city, there were also pagan temples there. Constantine was also responsible for major churches in Palestine, including the Holy Sepulchre at Jerusalem, and a church at Mamre, reputedly the site of Abraham's encounter with the angels. Here, at a sanctuary venerated by Jews and pagans as well as Christians, we find a rare case of an attempt being made to appropriate a long-established sanctuary for a church, though, to judge from the images on cake moulds showing both angels and a local goddess, coexistence continued.[58] Helena, Constantine's mother, paid an imperial visit to Palestine, probably in 327, and Eusebius credits her with founding the churches at Bethlehem and the Mount of Olives, albeit under her son's inspiration.[59] Contemporary records do not, in fact, link her with excavations at Golgotha, although by the end of the century the discovery of the *lignum crucis* was being attributed to her by Ambrose.[60] Amongst other churches founded by Constantine and especially pertinent to this exhibition, so largely devoted to Britain and the north-west, is the great double basilica at Trier (fig.36). All in all, this was a most impressive programme of building throughout the empire, comparable with that of the first emperor, Augustus (though in his case the effort had gone into building temples).

Imperial patronage of Constantine's new religion is found not only in the building and adorning of churches but in the evidence for imperial benefactions recorded in the *Liber Pontificalis*. This text is considerably later in date, sixth century and onwards, but may be accurate about the gifts which comprised staggering quantities of gold, silver plate and jewels. For instance, in the account of Constantine's benefactions to the Lateran we read of 'a hammered silver fastigium – on the front it has the Saviour seated on a chair, 5ft in size, weighing 120lbs, and twelve apostles each 5ft and weighing 90lb with crowns of finest silver'. The adjacent baptistery had 'at the edge of the Font, a golden lamb pouring water, weighing 30lb; on the right, the Saviour in finest silver, 5ft in size, weighing 170lb; on the left, a silver John the Baptist, 5ft in size, bearing the inscription "Behold the Lamb of God, behold him who takes away the sin of the

Figure 37 Group of figures, wall painting, mausoleum, Poundbury, Dorset (cat.193)

world", weighing 125lb'. These staggering ensembles would in general appearance and in opulence have rivalled the finest cult images of the major Roman temples.[61] Here and at St Peter's the richest materials were used; for instance at the latter the altar itself was 'of silver chased with gold, weighing 350 pounds, decorated on all sides with prase and jacinth jewels and pearls, the jewels 400 in number' and to match 'a censer of finest gold, decorated on all sides with jewels, 60 in number, weighing 15lb'.[62]

Christianity in the Roman west

The Christian symbol most frequently employed in the early Church was the Chi-Rho, found on mosaics and wall paintings, on gravestones and portable objects of all sorts. It was, of course, the device associated with the imperial standard; but as the monogram of Christ it defined the believer. It appears on mosaics and wall paintings as well as on silverware and rings, and funerary inscriptions, of which a large number have been found in Trier. Together with the sacred monogram there are often the letters Alpha and Omega, and often there are a pair of flanking doves, probably echo-

ing the words *in pace*: the peace of the deceased.[63] However, a single dove, as featured on rings from Suffolk and Dorset, is likely to have stood for the Holy Spirit.[64]

Representations of Christian activity in the fourth century are comparatively rare, which makes what appears to be a baptismal scene moulded in relief on the front of a lead font from Walesby, Lincolnshire (cat.194), especially important.[65] Baptism was and is the defining rite of the Church, whether conducted in grand baptisteries like that in the Lateran or in the midst of the double basilica at Trier, or in more modest fonts. The wall paintings from the house-church at Lullingstone, Kent, present a row of *orantes*, that is figures with their arms raised and palms outwards in the attitude of prayer and splendidly clad in tunics and dalmatics.[66]

In place of the gods and mythological scenes there are figures of Christ, often portrayed as the Good Shepherd. There are also images taken from the Bible, both from the Old Testament and the New, frequently alluding to salvation, and a rich language of symbols such as the Chi-Rho, the palm and the dove. A limestone sarcophagus from St Maximin at Trier depicts the Good Shepherd

flanked by sheep in a central aedicule; on the left is the image of the Fall illustrated by Adam and Eve, the serpent and the Tree of Knowledge; on the right are the three young Hebrews in the fiery furnace symbolising here the salvation brought by Christ.[67] Another sarcophagus from St Matthias, Trier, portrays Noah's ark.[68] From the Les Alyscamps cemetery at Arles there are a number of Christian sarcophagi of fourth-century date, one of them showing Christ and the Apostles.[69]

In this context a painted group of figures, depicted holding sceptres, which graced the wall of a mausoleum at Poundbury, Dorchester, may be noted (cat.193; fig.37).[70] One of them is more massively built and has an ample square-cut beard; it is thus more than likely that here is another group of Apostles including St Peter, who by the fourth century was commonly identified by such a beard. Other painted fragments from the mausoleum may be representations of buildings, possibly alluding to the Heavenly Jerusalem, as in the apse mosaic of Sta Pudenziana in Rome, dating to c.400, where Christ and the Apostles appear before the backdrop of an elaborate cityscape.[71]

Minor works of art display similar scenes. Thus a silver flagon from Traprain Law (cat.234) displays Adam and Eve, Moses striking the rock and the Adoration of the Magi. A gold glass from Cologne displays Noah's ark, Moses striking the rock, Daniel in the lions' den and two scenes depicting the story of Jonah.[72] A cut-glass bowl from Trier shows Abraham about to sacrifice Isaac, prevented by the hand of God, the *manus Dei*, reaching down from heaven; a similar example from France emphasises the Christian connection by the presence below of a prominent Chi-Rho set between the sun and the moon and stars.[73] A number of fragments of bronze sheeting from *scrinia* are known, embellished in relief with biblical scenes. Typical is one from Mainz which includes the Sacrifice of Isaac, Moses striking the rock, Daniel in the lions' den and the Raising of Lazarus. Part of the bronze sheeting from such a casket was found on the site of the Temple of Mercury at Uley, Gloucestershire (cat.227); the casket was very probably rededicated to that deity by a pagan votary and depicts Jonah, the Sacrifice of Isaac, Christ with the centurion and healing the blind man.[74]

It is not surprising that, in the polytheistic, polyglot empire in which Christianity emerged, more than a link remained with the pagan past. The people who fashioned the Christian *scrinia* also made ones figuring Mercury and Diana or, in one extraordinary instance from Szentendre in Hungary, mixed pagan with Christian episodes: Daniel in the Lions' Den, the Multiplication of the Loaves and Fishes and Christ Raising Lazarus feature alongside Hercules accompanied by the legend *Invicto Constantino* and an enthroned

Jupiter.[75] A glass bowl with the scene of Adam and Eve and the legend *Gaudias in Deo* (Rejoice in the Lord) was placed in a grave in the Luxemburger Strasse cemetery at Cologne with numerous grave goods, in the pagan style.[76] Within the Water Newton treasure (cat.196–222) there is a hint of the same intermingling between Christian and pagan which continued throughout the century. The find contains a number of silver leaf-shaped plaques bearing the Chi-Rho. These are similar to others from Roman Britain and elsewhere which invoke various pagan deities, amongst them Mars, Vulcan and Jupiter Dolichenus.[77] We are reminded of one of the curse tablets from Bath where we find the phrase *seu gen(tili)s seu Ch(r)istianus* (whether pagan or Christian). While this casts light on pagan-Christian duality in Britain in the fourth century, it also, more remarkably, preserves the only contemporary inscription specifically to mention Christians in Britain.[78]

The essential role of Greek and Roman mythology in classical education at this time probably underlies the way certain scenes could be given a Christian explanation. This might be the case with Bellerophon slaying the Chimera. The scene is found on a fragment of repoussé decoration from a casket from Germersheim-Lauterburg near Speyer, together with a portrait group including the empresses Helena and Fausta.[79] Bellerophon also appears on both the Hinton St Mary and the Frampton mosaics and in the context of the former is thought to represent the heroic endeavours of Christ and his followers (fig.38). The centrepiece of the main part of the Hinton St Mary mosaic is a facing bust with a Chi-Rho behind (cat.190), which seems to be one of the earliest extant mosaics of Christ as 'Ruler of all', uniquely on a floor where it could be trodden upon, a practice later discouraged.[80] So unusual did the image appear when first found that the resemblance between the features of the face and those of contemporary emperors on coins originally made some scholars wonder whether it was a portrait of a ruler, perhaps Constantius II, rather than Christ. It is hard to think that those who looked on it would not have made some sort of connection. Nevertheless, the associated pomegranates, borrowed from the myth of Demeter, confirm that the head is associated with Salvation. The hounds pursuing deer, shown in three of the surrounding lunettes, may be intended to evoke the suffering of the faithful, perhaps the suffering of Christ in a text from the Psalms:[81] 'For many dogs are come about me: the council of the wicked layeth siege against me' (Psalm 22, 16).

The lost Frampton mosaics have the Chi-Rho on the chord of the apse of the main room, implying that the chalice within the apse is probably Christian rather than Bacchic. Other elements in the mosaics at Frampton, however, certainly included Bacchus as well

Figure 38 Drawing of floor
mosaic, Hinton St Mary,
Dorset

as Neptune and myths from Ovid's *Metamorphoses*, such as Aeneas plucking the Golden Bough and Cadmus slaying the serpent of Mars.[82] Was the patron merely presenting Christ in a pagan guise, giving him a similar status to that of other deities?[83] Another explanation is that the floor could be Christian but radically heterodox.[84] However, just as Constantine 're-invented' and Christianised the sun-god, it is likely that the Frampton mosaic was simply re-investing the pagan myths with new Christian meanings. In the light of the artistic and iconographic analogies with Hinton St Mary the scenes may well have been simply seen as Graeco-Roman cultural parallels to the new Christian revelation.

It is hard to understand the fourth century unless we realise that it was a world of shifting cultural values, in which one member of a family might remain wedded to the traditional gods, while another became a Christian yet retained some beliefs and customs of his or her parents and grandparents. This might explain the presence of both pagan and Christian wall paintings in a Roman catacomb on the Via Latina. The admixture of Old Testament scenes (Adam and Eve, Jacob's ladder; the Crossing of the Red Sea and Samson slaying the Philistine with the jawbone of an ass), New Testament scenes (the Sermon on the Mount, the Raising of Lazarus, the Multiplication of the Loaves and Fishes and Christ with the Woman of Samaria) and pagan myth, specifically the deeds of Hercules (Hercules with Minerva, Rescuing Alcestis, Slaying the Hydra and Stealing the Golden Apples of the Hesperides), is very striking.[85] Even at the very end of the fifth century the traditional race on the Lupercalia, 15 February, continued to be run in Rome by half naked young men, most of whom (like the spectators) would have claimed to be Christians.[86] By the end of the fourth century, however, many intellectuals such as the neo-Platonist Synesius of Cyrene had reformulated their philosophies in ways compatible with Christianity.[87] The shift in the religious climate of the empire took a century or longer to be complete, but it was Constantine's achievement to set the world on a new path. Although Julian, the last emperor belonging to Constantine's family, attempted to reverse the Christianisation of the empire his failure to do so shows that there could be no turning back from the revolution initiated by Constantine's accession in York in July 306.[88]

Notes

1. Constantine II (Caesar 317; Augustus 337–40), Constans (Augustus 337–50) and Constantius II (Augustus 337–61).
2. Julian (Caesar 355; Augustus 361–3).
3. Aurelian (ruled 270–5).
4. Phillips 1977, 20–1, no.56, pl.16.
5. Toynbee 1962, 154, no.70, pl.75.
6. *Pan. Lat.* VI (7).21.3–7.
7. Weitzmann 1979, 522, no.467.
8. *Spätantike und frühes Christentum*, 507–8, no.114.
9. Chadwick 2001, 207, citing *Codex Theodosianus* 2.8.1.
10. Holloway 2004, 3.
11. Holloway 2004, 33–6 (roundels); 14, fig.1.2; and Beard, North and Price 1998, 367, fig.8.1 (medallion).
12. Holloway 2004, 26–8; Curran 2000, 89.
13. Zosimus II.29.1.
14. Curran 2000, 169–81.
15. Lactantius, DMP 48.2; also cf. Eusebius, *HE* 10.5.2–14.
16. Fine 1996, 84, pls xvi–xvii, 88, fig.4.20; cf. Beard, North and Price 1998, 381.
17. Wardman 1986, 258, citing *CIL* VI.1690/1691, a *pontifex Flavialis*.
18. Vermaseren 1977, 45–51; Beard, North and Price 1998, 384, 387.
19. Beard, North and Price 1998, 384–6, fig.8.4.
20. Beard, North and Price 1998, 382–3, cf. Alföldi 1937; for the coins cf. Witt 1971, 240, pls 62, 65, 66; *LIMC* **5** (1990), 783, no.294.
21. Eusebius, *VC* III.54–8; see Sauer 2003.
22. Bauchhenss and Noelke 1981.
23. For the inscription see *RIB* **1**, no.103. Some scholars would place this earlier but, as the patron was evidently the governor of Britannia Prima, a fourth-century date remains overwhelmingly likely. Magnentius ruled from 350–3. See Ammianus *Res Gestae*, XIV.5.6, for Paulus.
24. Rinaldi-Tufi 1983, 5, no.10, pl.3.
25. Henig 1984a, 51, 53, ill.13.
26. Henig 1984a, 51.
27. Babelon 1916; Woodward and Leach 1993.
28. Espérndieu 1965, 184, no.3084.
29. Boon 1989.
30. *RIB* **1**, nos 1120–2 from Corbridge, Northumberland.
31. Kuhnen 1996, 166–7, no.23, 171–2, no.24a; Woolf 2003, 145–8, figs 31–3.
32. Cunliffe and Davenport 1985; Cunliffe 1988; for the curse tablets see Tomlin 1988.
33. Henig 1984a, 48–50.
34. Oaks 1986; Stuart 1971.
35. Yeates 2004.
36. *RIB* **1**, no.281 (inscription to Arnomecta from Brough-on-Noe); nos 1523–35 (Coventina from Carrawburgh).
37. Aldhouse-Green 1999.
38. Bauchhenss and Noelke 1981.
39. Cunliffe and Davenport 1985, 118–19, pls xlviii–l.
40. Bagnall Smith 1995, 179–80, 186–8 (Woodeaton); Henig 1986a, 277–81 (Lamyatt Beacon); Wheeler 1943, 75, 133 (Maiden Castle); cf. Espérandieu 1965, 207–17, nos 3132–6 for the Monument of the Nautae Parisiaci.
41. Cunliffe and Davenport 1985, 114 and pls xxxii–xxxiv.
42. Henig 1984a, 135–6, 155.
43. Meaning 'Q(u)odvoldeus says, Andesasus lay it down, Felix take it up'. The name 'Felix' is clearly misspelt as is that of the central figure in the drama who presumably represents the god. Cf. Henig 1986b, 165–6; Trier 1984, 286, no.150,

Abb 6; Kuhnen 1996, 243–6, no.55; Hoffmann, Hupe and Goethert 1999, no.63; Hoffmann 1999, no.21.
44. Johns and Potter 1983; Henig 1986b, 166.
45. Rinaldi-Tufi 1983, 12, no.23, pl.6 (and see pp.11–12, no.22, pl.5 for another Mithraic sculpture, that of Arimanus).
46. Cf. Shepherd 1998.
47. For Mithraeism see Clauss 2000.
48. Henig 1984a, 113–16.
49. Witt 1971.
50. Henig 1984a, 109–13, 158–9; idem 1993b, 31, nos 91–2, pl.25.
51. Vermaseren 1977, especially pp.131–8.
52. Gregory of Tours, *Liber in Gloria Confessorum*, 76.
53. Chadwick 2001, 185; cf. Munier and Gaudemet 1977, 35–67.
54. Chadwick 2001, 198–200.
55. Holloway 2004, 5 7–61; and see 73–6 for the baptistery.
56. Holloway 2004, 77–86.
57. 'Because with You as our leader the world rose to the stars, Constantine the victor in triumph founded this basilica to You.' Cf. Krautheimer 1939–77, 5: 171–2; Holloway 2004, 79–82.
58. Milburn 1988, 100; Weitzmann 1979, 583–4, no.522.
59. Eusebius, *VC* III.41–3.
60. Hunt 1982, 28–49.
61. Davis 1989, xxi, 16–17.
62. Cf. Davis 1989, 19.
63. Trier 1984, 221–2, no.104 (Marinus), 226–7, no.111 (Amantia); Merten 1990.
64. Petts 2003, 111, fig.51.
65. Thomas 1981, 221–5, pl.6.
66. Liversidge 1987; Thomas 1981, 94, fig.9.
67. Spiess 1988, 311–13, no.38, Abb.72; Trier 1984, 235–6, no.121; Kuhnen 1996, 262–3, no.66.
68. Spiess 1988, 311, no.37, Abb.71; Trier 1984, 209–10, no.96; Kuhnen 1996, 263–4, no.67.
69. Duval 1995, 118–20.
70. Davey and Ling 1981, 106–10, no.13.
71. Volbach 1961, 336–7, pl.130; cf. Revelation 21: 2 and 10–21.
72. Weitzmann 1979, 431–3, no.389, 420–1, no.377.
73. Fremersdorf 1967, 168, Taf.223 and Trier 1984, 215–17, no.99; also Fremersdorf 1967, 170, Taf.229.
74. Buschhausen 1971, 107–10, no.A54, Taf.61–5; Henig 1993b, 109–11.
75. Buschhausen 1971, 155–6, no.A83, Taf.94 (right), and 95; 125–9 no.A62, Taf.74–7.
76. Fremersdorf 1967, 168–9, no.340, Taf.226, 227.
77. Henig 1984a, 40, ill.4, 145–7; cf. Jackson 2002 for Senuna.
78. Tomlin in Cunliffe 1988, 232–4, no.98.
79. Menzel 1960, 52–3, no.90, Taf.56; Buschhausen 1971, 29–30, no.A5, Taf.7.
80. See Thomas 1981, 105–6, fig.4 and pl.5.
81. Toynbee 1964a; Eriksen 1980.
82. Henig 1984b; cf. Ovid, *Metamorphoses* xiv, 113–15 (Golden Bough); *Metamorphoses* iii, 90–2 (Cadmus).
83. Henig 1986b, 163–4.
84. Perring 2003.
85. Weitzmann 1979, 467–8, no.419; 472–3, no.423; 242–3, no.219; Ferrua 1991.
86. Beard, North and Price 1998, ix, 388.
87. See Marrou 1963.
88. Bowersock 1978.

Constantine and Christianity

Averil Cameron

In Constantine's eyes his final victory over Licinius at Chrysopolis, near Chalcedon, in 324 was part of God's saving work in the world. It demonstrated that those who keep God's law prosper, while those who have attacked and persecuted Christians receive retribution; even if that retribution is delayed, it will surely come. In just this way, each of the persecutors of Christians had met a well-deserved end: they suffer in life and also after death.[1] In contrast, he thought, God had guided and intervened in his own career:

> He examined my service and approved it as fit for his own purposes; and I, beginning from that sea beside the Britons and the parts where it is appointed by a superior constraint that the sun should set, have repelled and scattered the horrors that held everything in subjection, so that on the one hand the human race, taught by my obedient service, might restore the religion of the most dread Law, while at the same time the most blessed faith might grow under the guidance of the Supreme. (cat.10; fig.39)[2]

Nearly a dozen years earlier, after allying himself perforce with the same Licinius after the defeat of Maxentius in 312, Constantine had expressed a similar sense of religious mission in his letters about the division which came to his attention among Christians in North Africa: 'I think it is no way right that such disputes and altercations [among Christians] should be concealed from us, when they might perhaps arouse the highest deity not only against the human race, but also against myself, to whose care he has by his celestial nod committed the regulation of all things earthly.'[3] In 324, having become sole emperor, unchallenged in the whole empire from Britain in the west to the Persian boundary in the east, he looked back on his rise to power and saw it as representing the work of God.[4] In turn, he felt, it would be more than ever his duty from now on to establish a secure future for Christianity in the empire.

The imperial letter in which these sentiments are expressed was issued by Constantine for publication throughout the newly conquered eastern provinces. It is included by Eusebius of Caesarea in his admiring *Life of Constantine* and its authenticity overall is con-

firmed by the appearance of part of the document, including the passage quoted above, in a contemporary papyrus now in the British Library.[5] In the *Life of Constantine* Eusebius has written up Licinius (whom he had originally presented in his *History of the Church* as a Christian ally of Constantine) as a persecutor of Christians in order to justify Constantine's action in making war against him.[6] The whole of Constantine's campaign in 324 is presented as a war of religion: Licinius is deluded by his reliance on pagan diviners and oracles while Constantine's forthcoming success is shown to Licinius' eastern subjects in visions sent by God, and Constantine is accompanied on campaign by his Christian standard, the *labarum*, and by a tent specially constructed so that he could pray, like the tent in which Moses met the Lord face to face.[7] One might reasonably be suspicious of such claims, given Eusebius's well-known tendency to exaggerate Constantine's personal piety and pro-Christian policies.[8] Nevertheless, it is clear from his own writings that Constantine did indeed have a strong sense of his own mission. In his *Oration to the Saints*, an address by the emperor delivered on Good Friday, in a year and location variously identified by modern scholars,[9] and preserved in Greek translation, he says, 'If therefore I dare great things, I ascribe my daring to my implanted love for the divine', and later in the speech, 'The evidence [of God's work in the world] is that everything has turned out according to my prayers'.[10] The evidence of Constantine's thought in this remarkable speech has perhaps been somewhat underestimated in view of the diversity of opinion on its place and date, and therefore its position and that of the emperor's Christian faith in the development of Constantine's rise to power. But in his letter to the East in 324 Constantine's language is clear: the persecutors, he says, 'have either met their final doom in the calamity of deadly destruction, or in spinning out a life of shame have found it harder than death'.[11] Of himself, in contrast, he can write that 'my whole soul and whatever breath I draw, and whatever goes on in the depths of the mind, that, I am firmly convinced, is owed by us wholly to the greatest God'.[12]

Figure 39 Constantine's letter of 324 (Papyrus 878) (cat.10)

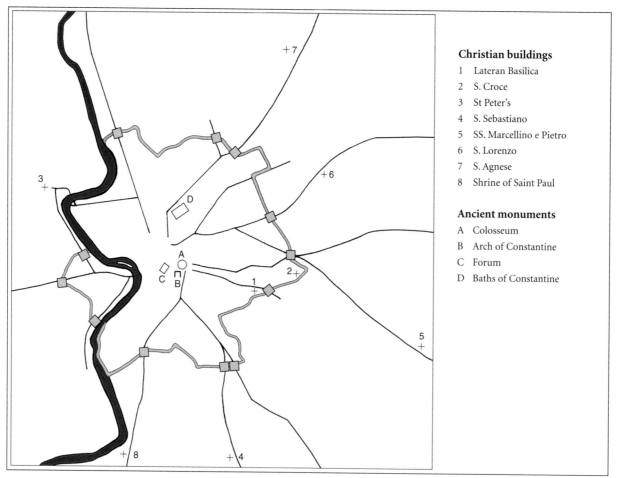

Figure 40 Constantine's Rome, c.330

Christian buildings
1 Lateran Basilica
2 S. Croce
3 St Peter's
4 S. Sebastiano
5 SS. Marcellino e Pietro
6 S. Lorenzo
7 S. Agnese
8 Shrine of Saint Paul

Ancient monuments
A Colosseum
B Arch of Constantine
C Forum
D Baths of Constantine

That such sentiments should spring to the mind of the conqueror after a victory which made him the ruler of the entire Roman world does not, of course, imply that all his actions, or even his motives, were completely consistent. After he had taken up residence in the newly refounded and renamed city of Constantinople (the city of Constantine), Constantine used to deliver weekly sermons to his courtiers, some of whom found it understandably embarrassing.[13] According to Eusebius these addresses covered the errors of polytheism, the beneficence of providence, the saving work of God in the world and the working of divine judgement.[14] Constantine did not here involve himself in doctrinal matters, but one of his first acts after his victory in 324 had been to summon the Council of Nicaea, the first ecumenical council of the Church, in order to settle not only the question of disagreements as to the date on which Easter should be kept, but also the issues about the relation of the Son to the Father which were stirring up controversy at that time. Rightly or not, he was himself credited with the 'one substance' formula (*homoousios*) which broke the deadlock and made possible what we now know as the Nicene Creed.[15] The apologetic arguments put forward in the *Oration to the Saints*, where he cites the Sibylline oracles and Virgil's

Fourth Eclogue in support of the coming of Christ, suggest a thoughtful and enthusiastic person who had a broad, even if only partly worked out, theory of the progress of history as gradually unfolding the providence of God and of his own important role as God's instrument. This is how he saw his rise to power in the letter of 324 – in terms of a steady development starting with his acclamation in Britain in 306, for which he now gave a religious explanation – and it was not surprising if bishops such as Eusebius took up similar themes in their own apologetic works.[16]

Despite this, Constantine's Christianity remains even now a highly disputed matter. In the past Constantine was discredited by rationalist historians, who found what they saw as the dishonesty of Eusebius grist to their mill.[17] According to these views the emperor could not have been sincere and, even if he were, he used his power to enforce a Christian tyranny. Edward Gibbon saw in the reign of Constantine the beginnings of a religious domination which later Christian emperors were to reinforce with increasingly repressive measures. A.H.M. Jones still has followers who wish to explain away the 'vision' of 312 as a solar phenomenon.[18] The debate centres especially on Constantine's 'conversion' in 312 after his experience

before the Battle of the Milvian Bridge, even though it is far from clear from the narratives that Constantine's religious experience in fact amounted to such a conversion.[19] The evidence is difficult to use for, while Lactantius claims that already in 306 Constantine was applying Christian principles when he took over his father's realms, Eusebius has awkwardly tried in the *Life of Constantine* to make the 312 experience the key; it was also possible for pagan contemporaries to represent it in polytheistic terms.[20] Moreover, many details of Constantine's later actions seem to undercut the notion of him as a fully Christian emperor.[21] But T.D. Barnes in his major work of 1981, *Constantine and Eusebius*, above all, set out the case for an emperor who, once he had committed himself to supporting Christians, never deviated from that aim. There may be disagreements about specific pieces of evidence or about their interpretation, but Barnes's overall view of Constantine is convincing.[22] Barnes's argument relies heavily on the evidence of Eusebius and it needed a thorough new reading of Eusebius in order for it to gain acceptance; indeed, it is striking that this rehabilitation of Eusebius occupies more than a third of the text of *Constantine and Eusebius*.

After the defeat of Maxentius in 312 Constantine immediately began to reverse the position of Christians in the empire. At this time persecution was still a contested political issue. Galerius had called off persecution in 311, two years before the joint declaration of Constantine and Licinius from Milan in 313,[23] but it had been revived by Maximian in 312 and Christians were still suffering, espe-

cially in the east; they would not be fully secure or have their properties restored until Constantine's victory over Licinius in 324. Eusebius had not suffered personally, but he had visited Christians in prison in Egypt and his mentor Pamphilus had endured mutilation. Eusebius himself had composed a treatise on the persecution in Palestine, and the experience and memory of persecution is a powerful theme in his writing, both in the *History of the Church* and the *Life of Constantine*. It was against this background that Constantine determined at once after his victory in 312 to give Christian clergy civil benefits and to declare toleration of religion. He did not know that the former act would involve him in mediating in disputes between Christians themselves in North Africa. The hardliners, who insisted against the general position that those who had compromised during the persecution must be rebaptised after repentance, and who refused to accept a bishop who had allegedly agreed to hand over the scriptures, unexpectedly appealed to the emperor for redress, and Constantine undertook to settle the matter.[24] He encountered more difficulties than he had expected; neither a meeting of bishops in Rome nor a council summoned by him at Arles persuaded the Donatists to yield. Constantine tried threats and even force, but was eventually compelled to admit defeat in the face of more pressing issues elsewhere.[25] What is striking here is not so much the fact that he could not enforce his will as his clear determination to use his position to sort out church disputes. In Rome itself he had to proceed with care, given the city's enormous prestige

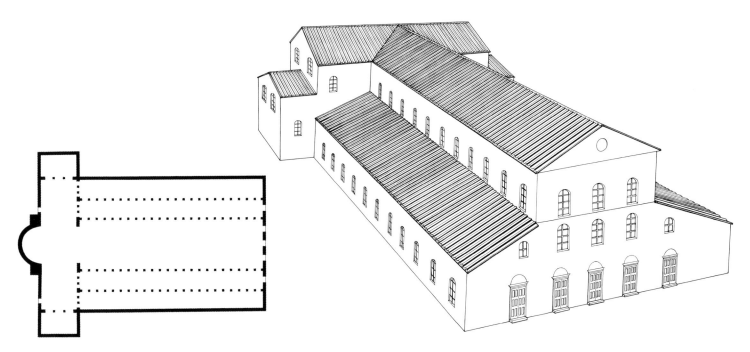

Figure 41 Plan and reconstruction of St Peter's, Rome, c.330

as the historical seat of Roman paganism. The victory arch set up in 315 is therefore ambiguous in its religious messages even while it firmly asserts that Constantine's victory had indeed been given by God.[26] Yet Eusebius tells us that in the same year (315–16) the emperor celebrated the tenth anniversary of his proclamation at York, which he counted as the anniversary of his accession, without the accustomed sacrifices.[27] He did not attempt to pull down the ancient temples in the centre of the city, but he soon embarked on a major church-building programme nonetheless. Constantine's churches made use of carefully chosen sites which were either already available to him, like the Lateran Palace, or which were cult centres commemorating apostles and martyrs, chief among them St Peter, whose ancient place of cult lay below the new church on the Vatican hill (figs 40 and 41).[28]

The Roman churches were spectacular enough, but there were more to come in the eastern part of the empire after his defeat of Licinius. An octagonal church at Antioch honoured this very early centre of Christianity and a new church at Nicomedia replaced the earlier one burned down by order of Diocletian at the start of the persecution in 303.[29] In his new city of Constantinople, dedicated in 330, Constantine made a start on the first church of S. Sophia, which was replaced by the present building erected by the Emperor Justinian in 535, as well as the Church of S. Irene and a martyr church to S. Mocius, a local martyr.[30] The most impressive part of his church-building programme, however, were the churches erected in and around Jerusalem, the very place where Christ had been crucified and resurrected. Again, the speed with which Constantine attacked the task is very striking. Once he had defeated Licinius, he called the Council of Nicaea to settle further church disputes, as he thought, once and for all; decided to build a city to be named after himself in commemoration of his victory; and began on the excavation in Jerusalem which led to the discovery of the site of the Resurrection and the building of a basilica over it. The spot on which it was believed that Christ had been crucified was on the same site.[31] Constantine's twentieth anniversary year in 325–6 proved to be a time of great personal crisis: not only his eldest son Crispus but also his second wife Fausta died or were put to death in Italy in mysterious circumstances.[32] But the building of churches in the Holy Land continued; soon afterwards Constantine sent his aged mother Helena to Palestine, and she supervised the building of the Church of the Nativity at Bethlehem and the Church of the Ascension on the Mount of Olives.[33] Constantine himself also ordered a church to be built at Mamre, where Abraham was visited by the three angels;[34] this was to be a demonstration of the power of Christianity over paganism, for the emperor had heard from his mother-in-law Eutropia that the sacred spot, with its ancient oak, had been desecrated by pagan worship and idols. As in the case of the Donatists in North Africa, Constantine did not hesitate to involve civil governors as well as bishops in religious matters, instructing the Count Acacius to make a start forthwith on the demolition so that he can start on the church-building in cooperation with the local bishops.[35]

Eusebius' narrative of this ambitious and important building programme is an account written by someone who had personal knowledge of the events and, while he devotes fulsome praise to Helena who died at an advanced age very soon after her journey to the Holy Land,[36] he makes it very clear that the initiative came from the emperor himself. In particular, he makes no mention of Helena in connection with the Church of the Anastasis (or Resurrection), or Holy Sepulchre, its usual name. This is important, in view of the later tradition, which starts with Ambrose of Milan's funeral oration for the Emperor Theodosius I in 395 and is constantly repeated thereafter, that Helena found the True Cross in the course of the excavations which preceded its building.[37] Many scholars have tried to find a mention of the Cross in Eusebius' narrative, which involves pressing his admittedly turgid and difficult Greek, or to give reasons for his apparent silence, such as that he did not approve of relics himself, or that he wished to minimise the prestige which would have gone to his rival Macarius, Bishop of Jerusalem.[38]

These 'explanations' are unconvincing: Eusebius does not mention the finding of the True Cross because nothing like that happened when he wrote, and he does not mention Helena because she was not involved in the church built over the burial cave of Christ. The legend that the True Cross itself had been found at the site of Golgotha grew up later, though perhaps not much later, and Helena's name was first associated with it, at least in our sources, by Ambrose. By the sixth century Constantine and Helena were also linked in a thick cloud of legend which had them converting Jews and Constantine being baptised in Rome by Pope Sylvester.[39] In seventh-century England Aldhelm, Bishop of Sherborne (d.709), who had visited Rome, knew the story of Sylvester curing Constantine of leprosy and had clearly been influenced by the *Vita* or *Actus Sylvestri*;[40] he also knew of the founding of Constantinople, which he ascribes to Constantine's having been instructed by Sylvester in a dream. Needless to say, further confusion crept in on other matters; indeed, later medieval sources had Helena as a native of England. In fact Constantine was not generally highly regarded in Anglo-Saxon England. Bede (d.735) wrote only briefly about him in a notice explicitly citing the uncomplimentary fourth-century pagan epitomator Eutropius, and which calls

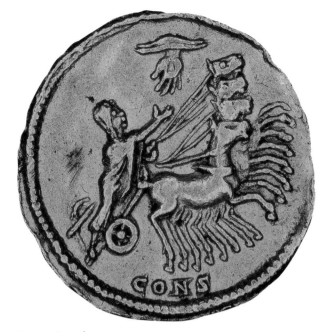

Figure 42 Consecratio coin of Constantine: obverse with veiled head of emperor; reverse depicting his ascension to heaven

Constantine's mother Helena Constantius' concubine.[41] Bede here reflects the prevailing Anglo-Saxon view of Constantine's relative unimportance in British history and the greater stress that was laid on the usurper Magnus Maximus and which is found in Gildas's *De excidio Britanniae*. In the East a mass of legends had grown up by the sixth century about Constantine; however, Eusebius's *Life of Constantine* had been forgotten and was not rediscovered until the eighth century. Thus, while great importance was attached to Constantine, the historical Constantine receded into legend.[42] It is essential to cut through this to the reliable historical evidence for the building in Jerusalem. Constantine never visited the Holy Land himself. But, despite all the legend and the cult which later built up around the figure of Helena, it was he, not Helena, who was behind the church-building programme in the Holy Land.

However determined he might be about his own desire to promote Christianity, it was not to be expected that Constantine could achieve complete success or that he would carry everyone with him. There were critics, both during his lifetime and later.[43] This critique has been partly obscured by subsequent Christian attitudes, but some of it has survived in the highly critical account of his reign in the work of the early sixth-century pagan historian Zosimus, who was drawing on the earlier hostile pagan Greek account by Eunapius. According to this version, Constantine converted only to expiate his guilt over the death of Crispus and Constantinople was so badly built that its inhabitants' houses kept collapsing; so far was it from being a Christian city that Constantine even built new temples there himself.[44] The fourth-century Latin text about Constantine known as the *Origo Constantini* did not depict him as a Christian emperor until it received later revisions.[45] Eusebius'

account of Constantine in the *Life of Constantine* is probably reliable in general terms, but the work is written as a panegyric and every individual detail needs to be carefully scrutinised.[46] The speech which Eusebius delivered in Constantinople for Constantine's thirtieth anniversary is even more expansive, for example in its claims about the emperor's assault on pagan temples, yet few actual examples were cited.[47] Constantine's legislation is not by any means unequivocally Christian in emphasis, and there are cases where Eusebius claims to be reporting laws with a Christian purpose but has been shown to be guilty of selective and partial interpretation.[48] Constantine might surround himself with bishops and involve himself in doctrinal disputes, he might order the books of pagan authors to be burnt[49] and promote Christians to high office,[50] but the overwhelming majority of the population he ruled was pagan and remained so. Wider Christianisation in the empire took longer and happened after Constantine.

Eusebius tells us that on Easter Day 337 Constantine became ill; he first took the waters in Constantinople, then travelled to the city of Helenopolis (named after his mother Helena) to pray at the martyr's shrine there.[51] Realising that the end was coming, he reached Nicomedia and decided to be baptised. The emperor dressed in white, received the sacrament of baptism and made his dispositions for the succession. He died on the day of Pentecost and his body was taken to Constantinople by his son Constantius for a lying-in-state and for Christian burial in his newly built mausoleum.[52] The fact that Constantine was baptised only on his deathbed has often been found surprising, or taken as an indicator that he had remained uncertain about his faith until then. But delaying baptism in this way was the surest guarantee that the newly baptised person would

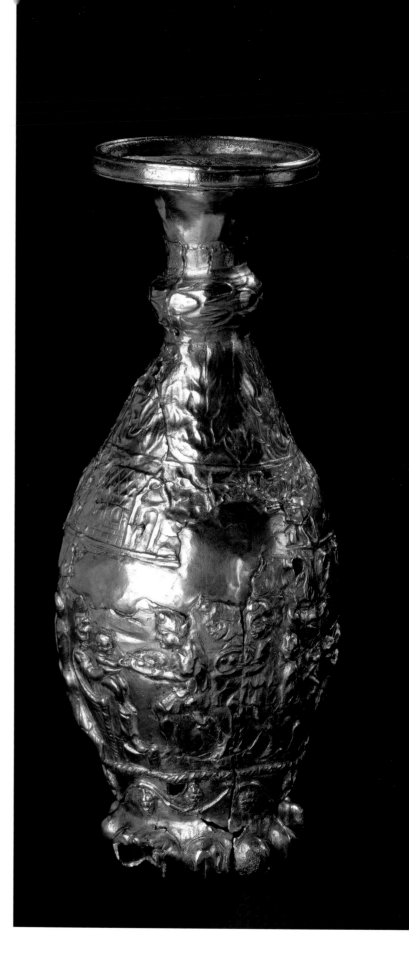

go straight to heaven, all their sins forgiven. Dressed in his white garments, Constantine told his court: 'I know that I am in the true sense blessed, that now I have been shown worthy of immortal life, that now I have received divine light.'[53] The emperor was sure of himself, even if his subjects were not. Indeed, it seems that a traditional imperial funeral in Rome had been expected by some;[54] coins were struck drawing on the traditional iconography of the imperial *consecratio*, and Constantine was given the epithet *divus* on inscriptions of 337 (fig.42).[55] The wheels of empire were slow: many had not realised, or did not want to know, that Constantine was different from the emperors who had gone before him.

Constantine has often been misunderstood. He did not make Christianity the state religion or the official religion of the Roman Empire. Nor was he the cynical manipulator or the semi-pagan of many modern accounts. He was also far from being the kind of Christian that other modern writers seem to think he should have been. Instead, he had the enthusiasm of a convert and he did not deviate from his feeling that God had given him the task of using his imperial position to promote Christianity in the empire. This he tried to do to the best of his ability. He could not make the Roman Empire Christian in his own lifetime: no Roman emperor possessed the mechanisms to bring such a change about. It was not until the end of the fourth century, under Theodosius I, that legal penalties were imposed on adherents of other religions, thus effectively making Christianity the official religion of the State. Even then the laws could only be sporadically enforced and Justinian was still legislating against pagans in the sixth century. Yet Constantine had set the momentous precedent of putting the weight of the imperial power behind Christian policies. He also set a personal example by demonstrating and, indeed, arguing for his religious preference. Perhaps even more importantly for the future, he changed the status of the Church from persecuted minority to privileged institution, and gave its bishops status, judicial privileges and influence. His lavish gifts to secure the future of the churches he founded and his measures to enable the Church to inherit and receive gifts made possible the flow of wealth towards the Church which lay behind its development into a powerful and important institution. By the late-fourth century many bishops were themselves powerful figures and controlled significant wealth. Upper-class families vied with each other not only in their wealth but also in their piety, and were able to commission for their houses the silverware and mosaics with Christian motifs which can be found in Britain and all over the empire (cat.234; fig.43). How sure can we be that this would have happened had it not been for Constantine?

Notes

1. Eusebius, *VC* II.25, 26.1–2, 27.1–2.
2. ibid., II.28.2.
3. Optatus, *Appendix* 3 (trans. Edwards 1997, 183–4; letter to Aelafius, see Corcoran 2000, 331).
4. See Pietri 1998.
5. Jones and Skeat 1954; see Cameron and Hall 1999, 239; Corcoran 2000, 315.
6. For this see Cameron and Hall 1999, 227–31; Eusebius quite deliberately expanded on and enhanced his earlier narrative in the *History of the Church* so as to bring this out. He also altered some of his references to Licinius in revisions of the *History of the Church* itself; see Van Dam 2003, 130–1. From a modern perspective this seems deplorable, and some have drawn the conclusion that Eusebius is completely shameless and unreliable as a historian (for example Burckhardt 1949 [1853]).
7. *VC* II.4.2–3; 6.1; 7–9; 12.1–2, cf. Cameron and Hall 1999, 231–4.
8. The *Life of Constantine* is a panegyric: see Cameron 2000; Barnes 1989.
9. For example 315 in Rome (Edwards 2003); 321 at Serdica (Barnes 1976, 1981).
10. *Oratio* 2, 22.
11. *VC* II.27.1.
12. ibid., II.29.1; on Constantine's sense of mission see Cameron and Hall 1999, 42–6; Barnes 1981, 275.
13. *VC* IV.29–30.
14. ibid., 30.3.
15. See Cameron 2005.
16. See Frede 1999 and, on the *Oratio*, Edwards 1999.
17. Burckhardt 1949 [1853]; Grégoire 1939.
18. Weiss 2003; visions were in any case the order of the day: see below for Constantine's 'pagan vision' in 310.
19. Barnes 1981, 43; though see 275 'a religious conversion which profoundly affected his conception of himself'.
20. Lactantius, *DMP* 24; see below, with Cameron and Hall 1999, 204–13; Cameron 2005.
21. For further discussion see Van Dam 2003.
22. Cf. Barnes 1986; 1998.
23. Lactantius, *DMP* 48; Eusebius, *HE* x.5.
24. Barnes 1981, 56–61.
25. Optatus, *Appendix* 10.
26. Above, p.24.
27. Eusebius, *VC* I.48.
28. Barnes 1981, 49.
29. *VC* III.50.
30. Barnes 1981, 222.
31. See Eusebius, *VC* III.25–47.3, with Cameron and Hall, 1999; Biddle 1999.
32. Barnes 1981, 220–1; understandably, Eusebius entirely omits this episode, which is told in the pagan tradition (Zosimus, *Hist.* II.29).
33. *VC* III.42–3.
34. *VC* III.51–3; cf. Genesis 18: 1–33.
35. *VC* III.53.2.
36. *VC* III. 43.5–47.
37. See Borgehammar 1991; Drijvers 1992.
38. Rubin 1982.
39. For the legendary Constantine and Helena see Lieu and Montserrat 1996, 1998.
40. Lieu 1998, 136–40; Stevenson 1998.
41. Bede, *HE* I.8; see Lieu 1998, 142; Stevenson 1998, 190; she was a 'low woman' according to Zosimus, *Hist.* II.8.
42. Constantine and Helena became saints of the Orthodox church with their feast day on 21 May. They are depicted in countless icons, usually flanking the Cross.
43. See Barnes 1981, 272; Fowden 1994.
44. Zosimus, *Hist.* II.29–39; Barnes 1981, 273.
45. English translation in Stevenson 1996.
46. For the form of the work see Cameron 2000.
47. English translation in Drake 1976.
48. See Cameron and Hall 1999, 321–3; historians are still divided as to the reliability of Eusebius's claim (*VC* IV.23) that Constantine banned sacrifice, and the law itself if it existed does not survive.
49. Socrates, *HE* I.9.30–1; the books of schismatics were to be 'hunted out', Eusebius, *VC* IV.66.1.
50. See Barnes 1995; Salzman 2002.
51. *VC* IV.60–1.
52. *VC* IV.62–70.
53. *VC* IV.63.1.
54. *VC* IV.69.
55. *VC* IV.73, with Cameron and Hall 1999, commentary, 348–50.

The Legacy of Constantine in Anglo-Saxon England

Jane Hawkes

Constantius, a man of exceptional kindness and courtesy, who had governed Gaul and Spain during the lifetime of Diocletian, died in Britain. His son, Constantine, the child of Helena his concubine, succeeded him as ruler of Gaul. Eutropius writes that Constantine, proclaimed Emperor in Britain, succeeded to his father's domains.[1]

Thus it is that Constantine is invoked in Anglo-Saxon England, in the early eighth century, in Bede's *Ecclesiastical History of the English People*. However, beyond outlining the events surrounding the proclamation of 306, the context of the statement is telling. It is inserted into an account of how the Church in late Roman Britain became 'tainted' by the 'deadly poison' of Arianism, despite its being 'exposed and condemned by the Council of Nicaea'.[2] The implication is that, despite his failure to eradicate 'the poison' of Arianism at Nicaea, Constantine is to be regarded as an exemplary ruler because he was someone who battled heresy. It is in this guise that Bede presents him elsewhere in his *History*: in his account of Pope Gregory's letter to Æthelbert of Kent (*c.*597), which exhorts the Anglo-Saxon king to convert to Christianity and fight paganism. Here Constantine is invoked as a royal exemplar for, with his acceptance and promotion of Christianity, he turned the Roman State from its 'false worship of idols'.[3]

As part of this broader undertaking Constantine's church-building activities were also important to Bede. Towards the end of his *History*, where he sets the English Church within the wider context of the Earthly Church, he describes some of the churches in Palestine visited by the Merovingian bishop, Arculf, recorded by Adomnán of Iona (*c.*703). Among these only two are described in detail: the Churches of the Resurrection and Ascension in Jerusalem.[4] Although Constantine was responsible for both these buildings, he is credited only with 'the Church of Constantine', the complex incorporating the Churches of the Holy Sepulchre and Resurrection and the Altar of the Cross. These, Bede says, were 'erected by the Emperor Constantine in a magnificent royal style, because ... here his mother Helena found the Lord's Cross'.[5] Here,

Bede's narrative deliberately highlights Constantine's connection with the specific sites of Christ's Crucifixion, Burial and Resurrection, and so associates him with the places and events of Easter, the festival central to the liturgical calendar, and the focus of the doctrine of salvation.

Overall, therefore, Bede presents an Anglo-Saxon view of Constantine as an exemplary ruler who combated false doctrine, who raised churches whose function was central to the commemoration, promotion and implementation of salvation in his newly established Christian empire, and whose endeavours brought him everlasting fame. Accomplishing this, 'he transcended in renown the reputation of former princes, and surpassed all his predecessors as much in fame as he did in good works'.[6]

It is an attitude that seems to have characterised much of the understanding of Constantine and his activities throughout the Anglo-Saxon period, being repeated in Cynewulf's ninth-century Old English poem on Helena and the tenth-century vernacular homily on 'The Finding of the True Cross'. In both cases, Constantine is presented as a victorious ruler: *riht cyning, guð weard gumena,*[7] and *se mære casere ... eawfæst on þeawum and arfæst on dædum.*[8] He is also intimately linked in these texts with the sign of the cross, his vision of the Cross of Victory being recounted in some detail in both poem and homily,[9] and the church erected over the find-site of the Cross of the Crucifixion being described in the poem as built by *þa selestan, þa þe wrætlicost wyrcan cuðon stangefogum* (the best, those who knew how to build most exquisitely in stone-bondings), while the great silver cross set on the altar is *þæt lifes treo, selest sigebeama* (the tree of life, the most excellent sign of victory).[10]

These literary accounts, so varied in their nature and function, and spanning the Anglo-Saxon period, provide valuable insight into attitudes concerning Constantine in early medieval England. They also provide insight into the views of early Christian Rome that seem to have pervaded the intellectual milieu of Anglo-Saxon ecclesiastical culture. For, while Constantine was regarded as the

exemplary Christian ruler, he was always the emperor of Rome. For Cynewulf *he Romwara in rice wearð ahæfen* (he was elevated to ruler of the Roman people);[11] while to the late Anglo-Saxon homilist, he was *se mære casere on Roma byrig* (the glorious emperor in the city of Rome),[12] and according to Bede he was *piissimus imperator* (the most pious emperor) whose reputation was established throughout the Roman world.[13] It is this association of Church and imperial Rome through the person of Constantine that seems to pervade the understanding of 'Rome' current in the Anglo-Saxon world and which seems to have infused much of its public art.

This is particularly the case with the stone sculpture of the region, but it is also apparent in the documented motives underlying the construction of the earliest stone churches. Indeed, Cynewulf's description of the manner in which *þa selestan* (the best) of those trained in building in stone were gathered together *on þam stedewange girwan godes temple* (to prepare the temple of God, in that very place);[14] aptly encapsulates the church-building enterprises of the early Anglo-Saxon churchmen. To these founders stone-building materials, the sites selected and even the builders themselves were all important.

When Gregory's papal mission first arrived in England in 597 it was with the hopes of establishing metropolitan sees in the Roman provincial capitals of London and York, the latter perhaps being selected for its association with Constantine.[15] While York was indeed established as the seat of the northern metropolitan, Canterbury (Æthelbert's capital) replaced London in the south.[16] However, the initial foundation of the see at York and the establishment of the first Anglo-Saxon church there did not take place much before 630, three decades after the arrival of the mission in Kent and some 30 years of church-building activity there.[17] This, along with the selective nature of the documentary sources and the subsequent exigencies of survival, means that it is the remains from Canterbury that provide the clearest insight into the motives underlying the church-building activities of the early Anglo-Saxon ecclesiastics, and the way in which the selection and setting of their churches seem to carefully mirror the Constantinian foundations of Rome (fig.40).[18]

Thus, the Church of SS Peter and Paul, which was consecrated outside the walls of the old Roman city of Durovernum Cantiacorum, encapsulates in its single foundation what were, by the late sixth century, the two pre-eminent martyrium churches of Rome, dedicated to Peter and Paul, which had been established by Constantine to contain their human remains *fuori le mura* (outside the walls).[19] Later, the martyrian nature of these foundations was further echoed at Canterbury with the flanking *porticus* of SS Peter

and Paul being used to bury the archbishops of Canterbury and the kings of Kent,[20] imitating the use of the eastern *porticus* of St Peter's in Rome for papal burials from Leo I (440–61) onwards.[21] Within Canterbury itself the papal mission established its cathedral church, dedicated to Christ Saviour, very close to the old city walls. This was a dedication and setting that, in its peripheral location within the walls adjacent to one of the city gates, quite remarkably invoked Constantine's first (cathedral) basilica in Rome. Dedicated to Christ Saviour and also known as *Basilica Constantiniana*,[22] this was one of only two churches that he was able to build within the city itself, on the imperial estate of the Lateran just inside the city walls between the Porta Asinaria and Porta Praenestina. It was, furthermore, intended as the place of residence for the then bishop of Rome;[23] that in Canterbury was similarly established by Augustine as 'a dwelling for himself and all his successors'.[24]

The other churches erected in and around Canterbury in the early seventh century were less overtly associated with Constantine himself, but still evoked the imperial and papal city of Rome. The building initially utilised by the papal mission, for instance, was a small church dedicated to St Martin located to the east of the monastery. In Rome, the monastery of St Martin, incorporating a chapel of the same dedication, was located by the apse of St Peter's.[25] Nearer to SS Peter and Paul at Canterbury another church was erected before 620, dedicated to Mary.[26] The significance of the coincidence of this consecration with the rededication of the Pantheon in Rome in 609 to the Virgin (the first pagan temple to be rededicated on papal initiative to Christian purposes)[27] is unclear. However, the multiplicity of churches at Canterbury (and indeed elsewhere in Anglo-Saxon England: at York, Hexham, Wearmouth and Jarrow),[28] while recalling the landscape of Christian Rome, also points to the manner in which these complexes mirrored the liturgical geography of that city: they replicated the churches involved in the papal processions, churches that included St Peter's and St Paul's, Christ Saviour and the fifth-century foundation of Sta Maria Maggiore.[29]

These associations were further extended to include the materials used in the construction of the churches. In Canterbury this involved using recycled Roman brick,[30] but for Bede such structures were regarded as 'stone'. Apart from any symbolic intentions he may have had concerning Peter as 'the rock' (*petrus*) on which Christ's Church was founded (Matthew 16, 18), such inconsistencies are best explained by the fact that, for Bede, Roman building material *was* stone, a legacy of the predominantly military nature of the north of England. Because it was the Roman nature of the English Church that Bede sought to emphasise, he described the early

churches in terms familiar to him as Roman, setting stone against the wood and thatch of vernacular, Germanic and Irish building traditions.[31] Nevertheless, while the reuse of Roman material might be construed as a matter of economics and logistics (given the accessibility of earlier Roman building material), the availability of local craftsmen able to build in stone or brick at the turn of the sixth century has to be questioned; it may well imply that the mission included, alongside those whose task it was to promote papal orthodoxy in the region, artisans with the skills necessary for building 'in the Roman manner'.[32]

Regardless of such considerations, the construction and dedication of the only other church to be set up within the city of Canterbury suggests that the decision to use materials identifiably 'Roman' was more than a case of exigency. This was the church dedicated to Coronati Quattuor, an unusual dedication which, apart from a church in Pannonia where the saints in question had been martyred, existed only in Rome. Here a fourth-century *titulus* on the Coelian Hill was rededicated to Coronati Quattuor in the early decades of the seventh century by Boniface IV to mark the translation of the relics of the Pannonian martyrs.[33] While it has been suggested that the dedication in Canterbury may mark the further translation there of some of these relics, what is important is that the crowned martyrs in question were stonemasons. A new 'stone' church dedicated to these specific saints, set up *within* the confines of the Romano-British cantonal capital of Canterbury, whose landscape had been systematically redefined by its new churches to reflect Constantinian and papal Christian Rome, cannot have been coincidental. Rather it would have been understood as a highly symbolic construct, its setting, dedication and appearance serving to encapsulate all that was perceived to be Christian Rome within the new Anglo-Saxon setting, preserving in a very clear and public way the legacy of Constantine on which the mission was founded.

The early stone churches set up in the north of the country replicate these Roman-Constantinian ecclesiastical activities in many ways. That at York, initially established by Paulinus (in 627) as the seat of the northern metropolitan in fulfilment of Gregory's initial plan, was dedicated to Peter, as was Wilfrid's rebuilt monastic church at Ripon (taken over from the Columban Irish foundation and re-established on Roman principles) and Benedict Biscop's basilica at Wearmouth, the sister church at Jarrow being dedicated to Paul.[34] With these latter churches Bede states unequivocally that the use of stone in their construction was what made them Roman.[35] And, despite the stone-building activities ongoing in Kent during the seventh century (the church at Reculver, for instance, being dedicated in 669), suggesting that stonemasons were

available in England at this time, Wilfrid saw fit to send to Italy for the expertise to construct his churches at Ripon (665–72) and Hexham (672–8), while Benedict famously imported his labour from Gaul for the construction of the basilicas at Wearmouth (674) and Jarrow (682).[36]

Visually, the Roman nature of these churches would have been clear.[37] The *opus signinum* work of their flooring is a feature long identified with Roman structures, while their long, narrow dimensions with high-set, round-headed windows emulated those of a number of early churches in Rome, such as Sta Maria in Cosmedin. While not achieving its current distinctive design until the eighth century, this church incorporates the *loggia* of an earlier temple which was enclosed *c.*600, to create an ecclesiastical hall which established the dimensions of the current basilica and which served as a *diaconia* providing for the needs of, among others, travellers disembarking from the adjacent port of Tiber Island.[38] In addition, the covered walkway at Wearmouth linking St Peter's with the Chapel of St Laurence and the monastic complex to the south would have replicated the covered walkways in Rome set up by Constantine to shelter those moving between the city and the churches of St Peter, St Paul and St Lawrence.[39] These are features that would have been encountered by almost all those travelling between Rome and England throughout the seventh and eighth centuries, whether from Canterbury or elsewhere. For those travelling from the north (such as Wilfrid and Benedict), their sojourns in Canterbury en route to and from Rome and Northumbria would have provided a clear indication of how Christian Rome could be physically established in England.

While the details of such specific Constantinian and papal references may not have been appreciated by all who viewed the Anglo-Saxon churches, it seems they were consciously intended by their patrons and it is hard to overestimate their grandiose appearance within a local setting. Being multi-storeyed and built of stone with lead roofs and stained glass windows as part of large complexes containing other stone-built structures, they would have stood out impressively, dominating a landscape in which the only other stone structures were the remains of imperial Rome. Furthermore, these ecclesiastical complexes were not the only stone constructs set up in such deliberate acts of *imitatio romae*. Freestanding, large-scale stone monuments were also erected which, in their setting, decoration, form and iconography involved very conscious associations with Rome and Constantine.

The setting of many of these monuments makes the connections clear, being erected adjacent to or within the confines of Roman sites. Thus, the monument at Bewcastle (Cumbria) was set up

within the fort of Fanum Cocidii, north of Hadrian's Wall, in the early eighth century; while at Ilkley (Yorkshire) three stone shafts were erected within the fort of Olicana during the ninth century, with others being erected nearby at Otley.[40] In none of these instances does it seem that the Roman sites were selected for easy access to materials, for in each case the stone for the Anglo-Saxon monuments was transported from elsewhere, that at Bewcastle being quarried at sites close by.[41] Thus the places selected for these distinctive monuments seem to have been deliberately chosen in order to reclaim that which was Rome and re-establish it as part of the new Rome of Christ.[42]

It also seems that the images employed to decorate the stone monuments set up in this way were used deliberately to display association with the world of Christian imperial Rome. Thus, the rider that filled the uppermost panel of the shaft erected at Repton, Derbyshire (fig.44), *c.*800, displays the use of late antique art to articulate the aspirations of Anglo-Saxon rule. Here, the iconography of the imperial *adventus* was selected, as opposed to the closely related image of the victorious warrior, active in battle, trampling the body of the defeated enemy underfoot (a motif that was particularly popular on funerary monuments in the north-west of the empire).[43] The dependence is indicated by the comparatively static pose of the horse and the manner in which the Repton rider sits astride his mount, three-quarter turned to face the spectator; by the mid-fourth century *adventus* images depicted the emperor in just this way.[44]

The Repton rider does, however, display some notable differences to the late antique type. Most of the imperial versions depict the rider wearing a cloak and do not show him in the type of body armour depicted at Repton. Nor do the imperial riders sport leg gaiters or carry two swords and a shield, and neither do they brandish their weapons in the manner of the Repton rider. These differences, the Anglo-Saxon nature of the weapons,[45] and the impressive moustache worn by the Repton rider, all suggest the *adventus* model was adapted to depict a local figure. The diminutive shield held aloft by the Repton rider is particularly remarkable as it features a lightly incised cross rather than the central boss essential to such equipment in the Anglo-Saxon period.[46] This suggests that the accoutrement of the Germanic warrior was redeployed to display the religious affiliation of the rider, while the manner in which it is held aloft and displayed was intended to proclaim the triumphant status of those fighting and ruling under this sign. It seems that the designers of the stone appropriated the well-established prototype of the imperial *adventus* in order to portray a local secular figure as a victorious ruler, using the upraised shield to

Figure 44 Anglo-Saxon ruler as Imperial Rider, cross shaft, Repton, Derbyshire

Figure 45 Reconstruction of cross-slab, Jarrow, Tyne and Wear

display and promote the role of Christianity in his triumphant leadership.

This was a theme that had been associated with *adventus* images from the time of Constantine, and it was one that was actively promoted in Christian art in the early ninth century. The tendency of Anglo-Saxon sculpture, from the early eighth century onwards, to display figural images based on late antique models has long been noted,[47] but during the course of the ninth century it also came to characterise the art of Carolingian Gaul and it is was here that the motif of the victorious rider was utilised: to associate Charlemagne with Constantine on the now lost 'Einhardt Reliquary'.[48]

Such Constantinian references are also visible even earlier in an Anglo-Saxon context, at centres such as Jarrow, Wearmouth and Escomb (Co. Durham) where, during the later seventh and eighth centuries, stone slabs decorated with a large, high-relief cross were set up.[49] One of these, at Jarrow (fig.45), is particularly illuminating: apparently built into the wall of the church (dedicated in 685) as a reredos, it bears the inscription 'IN HOC SINGULARI SIGNO VITA REDDITUR MUNDO' (In this unique sign life is returned to the world).[50] It is generally accepted that the opening words were taken from Rufinus's translation of Eusebius's account of Constantine's vision of the Cross of Victory, and it has been suggested that its placement over the altar at Jarrow was intended to replicate the setting of S. Croce in Gerusalemme. This, the only other church founded by Constantine within Rome, was understood to have been erected to contain a relic of the Cross brought from Jerusalem by Helena. By the seventh century it was the focus of papal liturgical activity on Good Friday when the pope processed 'to Jerusalem' from Christ Saviour bearing the Lateran's relic of the Cross, which, being placed on the altar 'in Jerusalem', was worshipped at the hour of Christ's death.[51] Resonating with such visual, textual and liturgical associations, the inscription and cross of the Jarrow stone provide clear evidence for devotion to the cross as the sign of victory and salvation that was intended to recall to the mind of the congregation the story of Constantine's vision, the Triumph of the Cross and the establishment of the Church associated with him.

This symbolic potency of the sign of the cross in Anglo-Saxon ecclesiastical contexts may go some way towards explaining the presence of the monumental freestanding stone crosses, carved with relief ornament, that were set up across the countryside from the early eighth century onwards. Unique to the early Christian world of Britain and Ireland until the eleventh century, this distinctive monument form has been most popularly considered an amalgam of the 'Roman' techniques developed in the production of carved architectural stonework, with the large gem-encrusted

metalwork altar and processional crosses, the growth of the cult of the cross in the liturgy of the eighth century and the Columban tradition of erecting wooden crosses.[52] The introduction to Anglo-Saxon England of this latter practice is attributed to the Northumbrian king, Oswald, who, in an act of Constantinian imitation, set up a large wooden cross prior to his victory over 'apostates' and 'idolators' at Heavenfield, Northumberland, in 634.[53] Indeed, Bede's explanation of the place-name implicitly echoes Constantine's vision, for 'it signified that a heavenly sign was to be erected there, a heavenly victory won'.[54]

It is perhaps also relevant to consider, in relation to the genesis of the monumental stone crosses, the triumphal monument forms that would have been encountered by those visiting Rome, such as Benedict (who arrived in 653) and Wilfrid (who followed in 654). Of these, the obelisks, with their squared tapering monolithic forms, were monuments that had become ubiquitous in Rome as signifiers of imperial victory, and by the early middle ages would have included in their number that which stood to the south-west of St Peter's (fig.41). With this particular obelisk any visitor to the basilica in the early middle ages would have encountered a monument that was both distinctive in its form and one that was inextricably linked by its setting with St Peter and Constantine.[55] Given these connections and the association of Constantine with the 'victory sign' of the cross in Anglo-Saxon England, it is not inconceivable that the triumphal form of the obelisk in Rome may have played a part in the development of the form of the squared and slightly tapered monumental stone crosses that were set up in northern England during the eighth and ninth centuries. Indeed, such connections may have influenced the contemporary references to these crosses. The runic inscription on the monument at Bewcastle, for instance, refers to it unequivocally as 'this victory sign' (*þis sigbecn*).[56]

Regardless of such considerations, it does seem that other triumphal monument forms encountered in Rome (namely, the triumphal column) may well have informed the production of another type of monument erected in Anglo-Saxon England: the freestanding, carved stone columns. Again unique to Britain in the early medieval period, these comprise a small but distinct group of monuments produced throughout the region during the ninth century: at Dewsbury and Masham (Yorkshire) in the north; at Wilne (Derbyshire) and Wolverhampton in the West Midlands; and at Reculver (Kent), Wantage (Berkshire) and Winchester (Hampshire) in the south-east.[57] Of these, the fragments at Dewsbury (cat.273–5) and Reculver (cat.267–72), and the more complete column preserved at Masham (fig.46), stand out as a remarkably distinct group

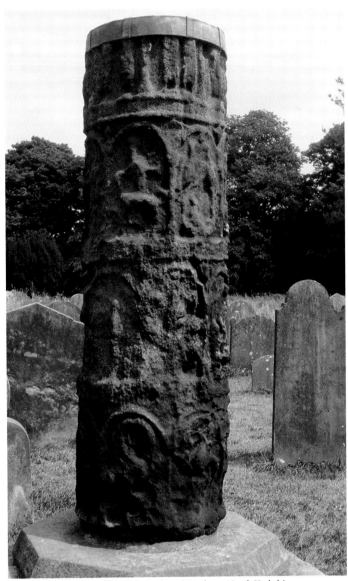

Figure 46 Anglo-Saxon 'triumphal column', Masham, North Yorkshire

linked, not just by their columnar form and their common date, but most significantly by the manner in which they are decorated: with relief figural carving arranged in horizontal registers running the length of the column. It is in this latter aspect that they differ so appreciably from the other cylindrical monuments, whose decoration is limited to non-figural (animal, foliate and interlace) motifs, and is not necessarily organised in horizontal registers.[58] Thus these three columns invoke, in form and decorative layout, the triumphal columns of Rome that are filled with registers of figural decoration which encircle their entire length (fig.47).[59]

They may also have imitated the imperial monuments in the way that these were crowned, for the remains of the three Anglo-Saxon columns preserve the vestiges of their uppermost registers, which indicate that they supported terminal features. The column at Masham, for instance, preserves a socket hole that is set slightly

off-centre, indicating that it is a primary rather than secondary feature, and demonstrates that the column was originally a composite monument. At Dewsbury, strands of rope moulding preserved at the top of one of the fragments (cat.273) are arranged in such a manner that they mark the transition of the monument from cylindrical to squared form. In fact this detail, along with the survival of fragmentary cross-heads at both Dewsbury and Masham,[60] has encouraged the perception of these two monuments, not as columns, but as full-length square cross-shafts evolving out of truncated round bases.[61] This perception is now generally considered highly improbable, as the proposed monument form would have been extremely unstable.[62]

Conversely, the monument at Reculver, due to Leland's sixteenth-century description of it standing 'lyke a fayr columne' approximately nine feet high with 'the figure of a crosse' set on it,[63] has been reconstructed very differently: as a tall, slightly tapering column[64] and, alternatively, as a straight cylinder with a cross-head set immediately into the uppermost drum.[65] The variation in diameter of the Reculver stones does indeed suggest that it was originally a composite monument of tapering cylindrical form. However, the manner in which one of the stones (cat.267) preserves a thin band of interlace underneath suggests that it was placed at the top of the monument and, standing proud of the column, was viewed from below. This indicates that the uppermost drum of the column functioned in a manner analogous to the capitals crowning the imperial triumphal columns, which supported the figure of the victorious emperor whose deeds were depicted on the column itself. At Reculver it seems likely that the imperial figure of victory was replaced by the Christian sign of victory, the cross, set on the distinctive upper drum of the column. If this is indeed the case, it may be that the monument which stood at Dewsbury can be reconstructed in an analogous manner: the transition from the cylindrical form of the column marked by the rope moulding may indicate the original presence of a cross-head, rather than a cross-shaft, that was square in section set at the top of the column (cat.273). Likewise, the socket hole in the top of the Masham Column, suggesting that something further was attached to it, may indicate that a cross-head was originally set into its upper register.

While such reconstructions must necessarily remain extremely speculative, it is interesting to note that the earlier (eighth-century) accounts of the Holy Land record the presence of a column standing to the north of the Holy Sepulchre complex in Jerusalem.[66] Identified by Adomnán of Iona and Bede as the column marking the centre of the world, this bore the *imago clipeata* of Christ at the top and was crowned by a cross.[67] Here, in one of the most central

and emotive of Christian settings, one that was associated in Anglo-Saxon literature with the person of Constantine,[68] it would seem that the form of the imperial triumphal column may well have been appropriated and adapted to mark (victorious) Christian purposes in a manner analogous to the monumental forms that were apparently being erected in the ninth century in England.

Certainly the iconographic significance of the images carved on the Anglo-Saxon columns articulates these associations. The overall programme filling the columns at Reculver and Dewsbury cannot, of course, be recovered in any detail; but that at Masham can be partially reconstructed, despite the considerable weathering and current accelerated erosion suffered as a result of the lead cap installed in an unfortunate attempt to protect it from the elements. For here, it is still possible to identify in the upper register the figure of Christ enthroned and flanked by the standing figures of the 12 apostles. In the register below, images of the Old Testament figure David (dictating the psalms and combating the lion) survive alongside that of Samson, bearing the gates of Gaza, and a pair of peacocks. The panels of the third register cannot be deciphered, but the lowermost is filled with beasts set against a plant scroll. Together, the images refer to Christ's victories over death and the establishment of his Church on Earth.[69]

Within the programme, David and Samson serve iconographically to prefigure Christ's redemptive death. Thus David slaying the lion signifies the manner in which Christ, in overcoming death, delivered Christians from the power of evil,[70] while Samson's deeds at Gaza (Judges 16, 1–3) foreshadow Christ's Harrowing of Hell,[71] this particular event being regarded as having been foretold by David in the psalms.[72] As such, it is perhaps not surprising that the image of David Dictating his Psalms at Masham is preserved next to Samson. Images such as this conveyed a matrix of ideas surrounding the salvation of Christ, largely because the biblical description of the House of David as a God-given institution (II Samuel 7) meant that prophetic messages concerning humanity's future salvation were inextricably linked with him. Thus scenes of David Dictating the Psalms illustrated not only the king of Israel who was the forefather, prophet and embodiment of the Son of God, but that the psalms, which collectively celebrate the soul's triumph over evil, represented the words of Christ and his Church.[73] The Masham image thus functions as a powerful visual mnemonic recalling Christ and his salvation. The relevance of this for the individual Christian is further expressed in the panel depicting the pair of peacocks flanking an urn or chalice. This is a scheme that, having been established early in Christian art, refers to the Eucharist and the immortal life to be gained through regular participation in its

mystery (*sacramentum*), dispensed by the Church, that institution being represented by the composite image of Christ and his apostles.[74] It is possible that this set of references may also have included the beasts in the plant scroll at the base of the column, for these comprise a scheme that commonly signified the Christian community receiving spiritual sustenance from the Church.[75] Considered overall, therefore, the iconography of the Masham Column reveals that Christ's victory over death, figured by Old Testament events, ensures immortality for each Christian through regular participation in the liturgy of the Church.

While such iconographic detail cannot be recovered from the fragments at Dewsbury and Reculver, what does survive of these columns indicates that they too displayed in their uppermost registers the iconographic scheme of Christ and his Apostles, the scheme that refers most explicitly to the Church founded in Christ. At Reculver, the remains of the scheme can be seen in the two fragments (cat.267–8) carved with standing figures separated by Corinthian-style columns; it is the underside of one of these (cat.267) which preserves the band of interlace, indicating that it was set at the top of the column.[76] At Dewsbury, two of the fragments (cat.273, 275) are bound across the top by a plain horizontal moulding, under which are the enthroned figure of Christ (fig.48) and the remains of full-length standing figures. It is above the horizontal moulding on cat.273 that the remains of the rope moulding marking the transition between the round column and its squared terminal are preserved. This indicates that, like Masham and Reculver, the Dewsbury Column displayed the scheme of Christ enthroned and flanked by his apostles in its uppermost register. All three thus presented at the crown of the column a scheme that was intended to represent the Church founded on Christ and his apostles.

This scheme had a particular resonance in early Christian art, largely under the influence of the solid silver *fastigium* that was donated by Constantine to the Basilica of Christ Saviour. From the nave, this arcade was seen to frame life-size silver statues of 'the Saviour seated on a chair, 5ft in size, weighing 120lb, and the 12 apostles each 5ft and weighing 90lb with crowns of finest silver'.[77] The prominence of this object, as well as its association with Constantine and his first church in Rome, ensured the popularity of the scheme up to the late sixth century (when it was reproduced and extended by Gregory at St Peter's). After this it dropped out of use, only to be reintroduced in the later eighth century when it was invoked, most notably, in the mosaics of the central apse of the *Triclinium* (triconch hall) of the papal palace attached to the Constantinian Lateran Basilica by Leo III (798–9). Here the scheme

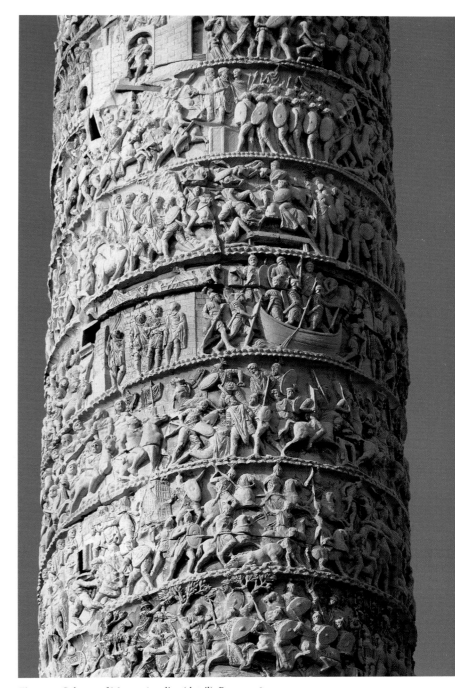

Figure 47 Column of Marcus Aurelius (detail), Rome, *c.*180

was reproduced and accompanied, in the surrounding triumphal arch, by Christ, Peter and Constantine on one side, and Peter, Leo III and Charlemagne on the other – a grouping of figures that visually articulated the contemporary policy of spreading the faith and strengthening the position of the papacy in the West.[78]

By setting Christ and his apostles in the upper registers it is clear that those responsible for the production of the Anglo-Saxon columns intended to display, very prominently, Christ's divine authority and the establishment of his Church. This was in keeping with contemporary developments in Rome when, through self-conscious acts of imitation, Church and State sought to associate themselves with Constantine. More importantly, these concerns are emphasised by the type of monument on which the iconographic schemes are displayed. While the earlier imperial columns celebrated the victories and triumphal rule of the emperors, that at Masham clearly celebrates Christ's victories and the triumphal establishment of his Church, while those of Dewsbury and Reculver echo these themes with their shared use and placement of the iconographic scheme of Christ and his apostles. At Reculver, moreover, the column displaying this scheme was originally set up inside the church (itself established in the Roman fort of Regulbium) where it stood before a triple arcade separating nave from the sanctuary.[79] This is an architectural feature that clearly replicated the triple openings of the imperial triumphal Arch of Constantine (fig.4), a monument form that was itself probably echoed in the portals of the Roman Constantinian basilicas of St Peter's and Christ Saviour.[80]

At Masham and Dewsbury the Constantinian associations invoked by the Carolingian popes would have had a particularly strong resonance given their location near York, with its historical connection to Constantine – a connection that may well have been invoked by other ecclesiastical means in the region. For, by the end of the eighth century, the centre at York, (re-)promoted to metropolitan status in 735, contained not just the Basilica of St Peter, but also churches dedicated to Mary and Holy Trinity (arguably synonymous in the early middle ages with Christ Church) and, most significantly, the church dedicated to Alma Sophia in 780.[81] The unusual nature of this dedication at this time would inevitably have recalled Constantine's foundation of Hagia Sophia in Constantinople.

Certainly, in their distinctive monumental form, their variously evocative imperial settings and their specific iconographic programmes, the columns would have provided impressive visual testament to the ambitions of their ecclesiastical patrons, and their intentions to articulate and proclaim their identity as part of the Church triumphant, a Church that, at the turn of the ninth century, regarded itself as a very real part of the legacy of Constantine. They thus stand as testimony to the idea of Rome in Anglo-Saxon England which, from the turn of the seventh century, seems consciously to have been invoked by the Anglo-Saxon Church, in its literature, buildings and monuments, in attempts to re-establish the Christian Rome of Constantine and his heirs in what had once been the outpost of empire.

Figure 48 Christ in Majesty, column fragment, Dewsbury, West Yorkshire (cat.275)

Notes

1. 'His temporibus Constantius, qui uiuente Dioletiano Galliam Hispaniamque regebat, uir summae mansuetudinis et ciuilitatis, in Brittania morte obiit. Hic Constantium filium ex concubina Helena creatum imperatorem Galliarum reliquit. Scribit autem Eutropius quod Constantinus in Brittania creatus imperator patri in regnum successerit.' *HE* I.8.
2. 'Cuius temporibus Ariana heresies exorta, et in Nicena synodo detecta atque damnatia, nihilominus exitiabile perfidiae suae uirus, ut diximus, non solum orbis totius sed et insularum exxlesiis aspersit.' *HE* I.8.
3. 'Sic enim Constantinus quondam piissimus iimperator Romanam rempublicam a peruersis idolorum cultibus reuocans omnipotenti Deo Domino nostro Iesu Christo secum subdidit, seque cum subiectis populis tota ad eum mente con uerbit.' *HE* I.32.
4. *HE* v.16–17; cf. Bede, *DLS*, and his main source, Adomnán, *DLS* I.11.
5. '... primum de locis sanctis pro condicione platearum diuertendum est ad ecclesiam Constantinianam, quae Martyrium appellatur. Hanc Constantinus imperator, eo quod ibi crux Domini ab Helena matre repert a sit, magnifico et regio cultu construxit.' *HE* v.16.
6. '... Unde factum est, ut antiquorum principum nomen suis uir ille laudibus uinceret, et tanto in opinione praecesores suos quanto et in bono opere superaret.' *HE* I.32.
7. 'just king, battle-protector of the people', *Elene* lines 13b–14a.
8. 'the glorious emperor ... pious in conduct and virtuous in deeds', *Finding of the True Cross*, lines 5–7.
9. *Elene*, lines 69–98; *Finding of the True Cross*, lines 19–31.
10. *Elene*, lines 1026b–1027a; lines 1017–1032 for full account of the church.
11. *Elene*, lines 9–10a.
12. *Finding of the True Cross*, lines 5–6.
13. *HE* I.32.
14. *Elene*, lines 1020b–1021a.
15. For example Scullard 1979, 68–9.
16. *HE* I.26.
17. The (arch)episcopal status of York in this early period is notoriously unclear, despite Bede's description of Paulinus's receipt of the *pallium* in 633/4 (*HE* II.17).
18. Hawkes 2003, 72–6, especially notes 2, 9, 10.
19. *LP*, 176–8.
20. *HE* I.32, II.3; cf. Levison 1946, 34–5; Taylor and Taylor 1965 1, 134–45; Morris 1989, 18; Gem 1997, 20–1, 90–107.
21. Ó Carragáin 1999.
22. *LP*, 172–4; cf. Krautheimer 1965, 46–7.
23. Krautheimer 1980, 21–4; Noble 1984, 189–91.
24. '... atque ibidem sibi habitationem statuit et cunctis successoribus suis', *HE* I.33.
25. Ó Carragáin 1994, 18.
26. *HE* II.6.
27. *LP*, 317; *HE* II.4.
28. Taylor and Taylor 1965 1, 297–312, 338–49, 432–46; Cramp 1976; Morris 1986, 82–5; Cramp 1994; Cambridge and Williams 1995; Bailey 1996b.
29. Morris 1986; Ó Carragáin 1994, 11–12.
30. Gem 1997, 17–20.
31. Hawkes 2003, 69–76.
32. 'iuxta Romanorum quem semper amabat morem facerent', Bede, *HA* 5.
33. *LP*, 317; *HE* II.4; cf. Levison 1946, 34–5; Krautheimer 1980, 35, 87; Cambridge 1999, 231; Hawkes 2003, 72–3.
34. *HE* II.14, v.19, 24; *HA* 5–7, 368–71; *Vita Wilfridi* 17; see below, note 81.
35. *HA* 5.
36. *HA* 6.
37. Higgitt 1973; Cramp 1974, 34–5; idem 1976; idem 1994; Ó Carragáin 1999; Hawkes 2003, 75–6.
38. Giovenale 1927, 17–36; Krautheimer 1980, 77–8, 105, fig.125.
39. Krautheimer 1980, 25, 28; Ó Carragáin 1994, 58.
40. Hawkes 2002a, 344; idem 2003, 81–3 for examples.
41. Bailey and Cramp 1988, 71, 162.
42. See also the Anglo-Saxon practice of establishing churches in relation to earlier Roman settings (Morris and Roxan 1980, 182; Phillips and Heywood 1995; Norton 1998; Hawkes 2003, 72–3, especially n.10).
43. MacCormick 1981, 1–84; Biddle and Kjølbye-Biddle 1988, 254–8; Mackintosh 1986; Hawkes 2002a, 344; idem 2003, 83.
44. MacCormick 1981, 46–8.
45. Underwood 1999, 47–72; Halsall 2003, 164–7.
46. Halsall 2003, 167–8; Dickinson and Härke 1992.
47. Clapham 1930, 58–74; Kendrick 1938, 116–25; Saxl and Wittkower 1948, 12–18; Lang 1993; Hawkes 1996; idem 2002a.
48. Hubert, Porcher and Volbach 1970, 224, fig.29.
49. For example Escomb 7, Jarrow 16, Monkwearmouth 5 (Cramp 1984, 79, 112–13, 124).
50. Cramp 1984, 112–13; Ó Carragáin 1994, 12.
51. Krautheimer 1980, 24; Ó Carragáin 1994, 11.
52. Cramp 1965, 1–5; Bailey 1996a, 23–41.
53. Mac Lean 1997.
54. 'significans nimirum quod ibidem caeleste erigendum tropeum, caelestis inchoanda uictoria', *HE* III.2.
55. Ó Carragáin 1994, 40; Hawkes 2003, 76–9.
56. Bailey and Cramp 1988, 65.
57. Dewsbury (Collingwood 1915, 162–3); Masham (Lang 2002, 168–71); Wilne (Routh 1937, 39–40); Wolverhampton (Rix 1960); Reculver (Tweddle, Biddle and Kjølbye-Biddle 1995, 46–61, 138, 151–61); Wantage (*op. cit.*, p.268); Winchester (*op. cit.*, 331, 333–4); cf. the eleventh-century fragment at Melbury Bubb, Dorset (Cramp 1975, 198).
58. Cf. the ninth-century inscribed (but undecorated) 'Elsieg Pillar' in Wales (Nash-Williams 1950, 123–5).
59. For example columns of Trajan and Marcus Aurelius (Richardson 1992, 95–6, 176–7).
60. Collingwood 1915, 166; idem 1927, 59; Lang 2002, 171–2.
61. Collingwood 1927, p.7, fig.13.
62. Tweddle, Biddle and Kjølbye-Biddle 1995, p.156.
63. Smith 1964 4, 59–60.
64. See Tweddle, Biddle and Kjølbye-Biddle 1995, 155–7.
65. Kozodoy 1986, 83–7, figs 3–4.
66. Adomnán *DLS*, 57; Bede *DLS*, 256.
67. See Werner 1990, 202–5 for summary of the evidence.
68. For associations with Constantine, see above notes 4, 10.
69. Hawkes 1997, 156; idem 1999, 207–11.
70. See, for example, Augustine, *Ennarationes in Psalmos VII, IX*; Cassiodorus, *Expositio Psalmorum XXVII*; cf. Bailey 1978.
71. See, for example, Gregory the Great, *Homelia in Evangelia XXI*, Hawkes 2002a, 343–4.
72. See Psalm 24 and the *Gospel of Nicodemus*; see Hawkes 2002a, 343 for the circulation of these ideas in Anglo-Saxon England.
73. Bailey 1978, 20.
74. See Hawkes 1999, 210, for summary.
75. See, for example, Greenhill 1954; O'Reilly 1992; Hawkes 2002b.
76. Tweddle, Biddle and Kjølbye-Biddle 1995, 138, 151–62.
77. 'fastidium argenteum battutilem, qui habet in fronte Salvatorem sedentem in sella, in pedibus V, pens. lib. CXX, et XII apostolos qui pens. sing. in quinos pedibus libras nonagenas, cum coronas argento purissimo' (*LP*, 172; trans. Davis 1989, 16).
78. Krautheimer 1980, 128–37, 256–7; Noble 1984, 323–4.
79. Fernie 1982, 35–6, fig.13; Hawkes 2003, 72 and fig.1.
80. Krautheimer 1980, 26–7.
81. Morris 1986, 82–4. This is currently the subject of extensive new research by my colleague Dr Christopher Norton which is soon to be published, and I am grateful to him for discussions on the topic.

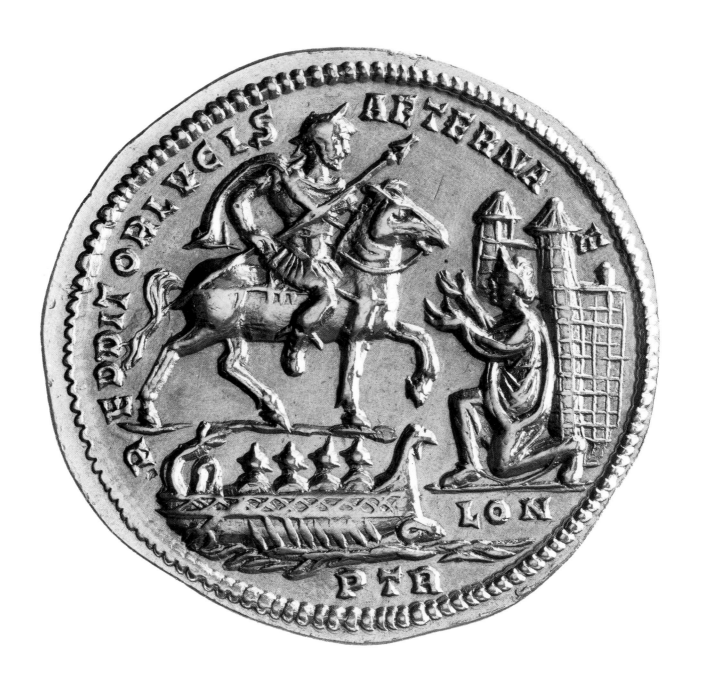

1

1 Papyrus fragment

Oxyrhynchus, Egypt
Papyrus; H. 230mm, W. 260mm
Latin, end of 3rd century
The Egypt Exploration Society, P.OXY 2950
Bibl. P. Oxy. XLI, no.2950.

The fragment is about one-quarter of a papyrus strip of uncertain purpose. It has been interpreted as a 'cartoon' for a stone-cut inscription, but more likely it was a temporary caption or public notice written on the equivalent of paper. It is inscribed with a brush or soft reed pen in 'Rustic Capitals' of calligraphic quality: '[Imp(eratori) Caes(ari) Gai]o Aur[el(io)] Val(erio) Dioc[letiano pio fel(ici) invicto Augusto] | [Imp(eratori) Caes(ari) Marc]o A[u]r(elio) Val(erio) Max[imiano pio fel(ici) invicto Augusto] | [...] vexill(atio) leg(ionis) V M[ac(edonicae) ...]' (For the Emperor Caesar Gaius Aurelius Valerius Diocletianus, Dutiful (and) Happy, Unconquered (and) August, (and) for the Emperor Caesar Marcus Aurelius Valerius Maximianus, Dutiful (and) Happy, Unconquered (and) August, the detachment of the Fifth Legion *Macedonica* ...). The Fifth Legion *Macedonica* and the Thirteenth Legion *Gemina* were the legionary garrison of the Danubian province of Dacia Ripensis, but they each provided a detachment to Diocletian's mobile army. In 297/8 he was campaigning in

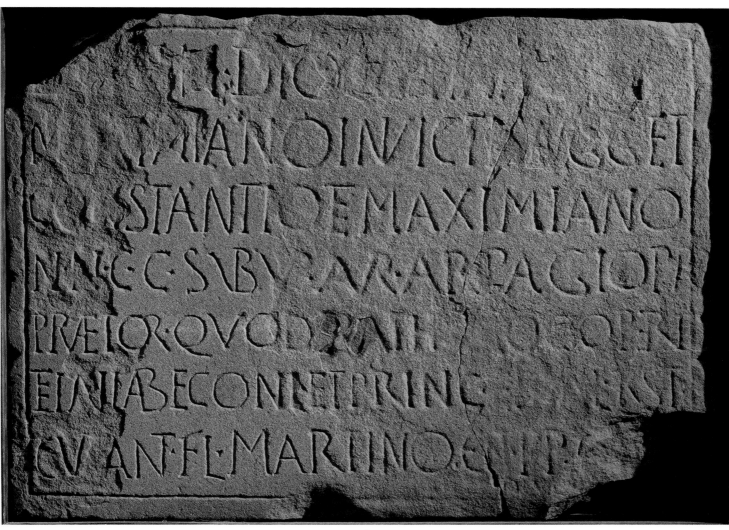

2

Egypt, where he visited Oxyrhynchus in May or June 298, and this is the likely date of the papyrus. It was probably dedicated by both legionary detachments, and accompanied by another dedicated to the two Caesars, Constantius and Galerius. [R.T.]

2 Building slab

Birdoswald, Cumbria
Sandstone; H. 635mm, W. 840mm
Latin, 297/305
Museum and Arts Service, Carlisle, CALM 1929.31
Bibl. *RIB* I, 1912.

'[D(ominis)] n(ostris) Dioc[letiano] et M[axim]iano Invictis Aug(ustis) et Constantio et Maximiano n(obilissimis) C(aesaribus) sub v(iro) p(erfectissimo) Aur(elio) Arpagio pr(aeside) praetor(ium) quod erat humo copert(um) et in labe(m) conl(apsum) et princ(ipia) et bal(neum) rest(ituit) curant(e) Fl(avio) Martino cent(urione) p(rae)p(osito) c(ohors) […]' (For our Lords Diocletianus and Maximianus, Invincible (and) August, and for Constantius and Maximianus [i.e. Galerius], Most Noble Caesars, under His Perfection Aurelius Arpagius, the governor, the […] Cohort restored the commandant's house which had been covered with earth and had fallen into ruin, and the headquarters building and the bath-house, under the charge of Flavius Martinus, centurion in command). The stone is dedicated by the garrison of Birdoswald, which was probably still the First Aelian Cohort of Dacians, to the four emperors of Diocletian's 'tetrarchy'; it thus expresses the reassertion of central authority after the defeat and death of Allectus in 296. It was subsequently reused as flooring in a barrack block. [R.T.]

7

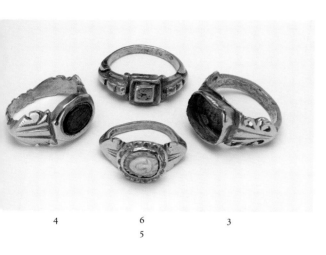

4 6 3
 5

3 Finger-ring

Sully Moors, near Cardiff
Gold; internal Dia. 20mm, Wt. 11.4g
3rd–4th century
British Museum, London, P&E 1900.11.23.1
Bibl. Grueber 1900, 64, no.3, pl.III, 10; Marshall 1907, no.797;
Kent and Painter 1977, 59, no.123.

Found in October 1899, with gold and silver
coins down to *c*.306. Keeled hoop with
triangular shoulders bearing pierced and incised
decoration. There is an oval box setting on the
rectangular bezel. The stone is lost. [C.J.]

4 Finger-ring

Sully Moors, near Cardiff
Gold and nicolo; internal Dia. 21mm, Wt. 12.4g
3rd–4th century
British Museum, London, P&E 1900.11-23.2
Bibl. Grueber 1900, 63, no.1; Marshall 1907, no.796; Kent and
Painter 1977, 59, no.124.

Found in October 1899, with gold and silver coins
down to *c*.306. Ring of keeled form with
triangular shoulders, and incised decoration on
shoulders and hoop. The raised bezel is octagonal
externally and contains a plain setting described
by Marshall as a nicolo paste (i.e. glass imitating
the appearance of banded microcrystalline quartz
in black and grey-white). [C.J.]

5 Finger-ring

Sully Moors, near Cardiff
Gold and onyx; internal Dia. 18mm, Wt. 6.9g
3rd–4th century
British Museum, London, P&E 1900.11.23.3
Bibl. Grueber 1900, 63, no.2, pl.III, 9; Marshall 1907, no.544;
Kent and Painter 1977, 59, no.125; Henig 1978b, 273, no.729,
pl.LII.

Found in October 1899, with gold and silver
coins down to *c*.306. Narrow hoop of keeled
form with triangular shoulders bearing only
simple, incised linear decoration. The bezel is a
raised oval setting with a carved petalled or egg-
and-tongue border. The gem is an onyx (pale
chalcedony) carved in cameo with a stylised
head of Medusa. [C.J.]

6 Finger-ring

Sully Moors, near Cardiff
Gold; internal Dia. 20mm, bezel 9mm square,
Wt. 11.3g
3rd–4th century
British Museum, London, P&E 1900.11-23.4
Bibl. Grueber 1900, 64, no.4, pl.III, 11; Marshall 1907, no.203;
Kent and Painter 1977, 59, no.126; Henig 1978b, 279, no.781,
pl.XXII.

Found in October 1899, with gold and silver
coins down to *c*.306. The ring has a plain hoop,
with raised ridges on the shoulders bearing
transverse mouldings. The square bezel is
engraved with a figure of a cockerel walking to
the left. [C.J.]

7 Tuscan capital

York, from the cross-hall of the *principia*
Gritstone; H. 860mm, W. of abacus 1220mm,
Dia. of shaft 820mm, total H. of column (base,
seven drums of shaft and this capital) 7750mm
Early 4th century

York Museums Trust (Yorkshire Museum),
YORYM: 2005.51

Bibl. Phillips and Heywood 1995, **1**, 40–5, pl.5 and cf. pp.7–8 for Constantius's work on the fortress; **2**, 223, 226–7, fig.94, i.2; Blagg 2002, 141–2, fig.40, York 42.

This is the capital of a complete column of the Tuscan order, from the north-east colonnade of the basilica, which was one of the first main columns from a major building in Britain to be found virtually intact. It was excavated under York Minster, 1966–73. The capital has a lewis hole in the top with a dowel hole inside it in order to secure it to the architrave. It is embellished with very bold and heavy cyma mouldings, finished on a lathe, but white plaster render, of which traces remained on another capital. It would have lightened the somewhat oppressive utilitarian starkness of capital and column. One side of the *abacus* was sheered off during the digging of an Anglian grave.

Although the headquarters building was originally laid out in the second century, it was remodelled in the early fourth century, possibly at the behest of Constantius I or Constantine. [M.H.]

8 Milestone

Crindledykes, near Vindolanda
Sandstone; H. 940mm, W. 305mm
Latin, 306/7
English Heritage (Trustees of the Clayton Collection), B198 CH274
Bibl. *RIB* 1, 2303.

'Imp(eratori) Caes(ari) Flav(io) Val(erio) Constantino Pio F(elici) nob(ilissimo) Caesari divi Constanti Pii Augusti filio' (For the Emperor Caesar Flavius Valerius Constantinus, Dutiful (and) Happy, Most Noble Caesar, the son of the deified [i.e. late Emperor] Constantius, Dutiful (and) August). The formulation belongs to the first year of Constantine's reign (from 25 July 306), before he was promoted from *Caesar* to *Augustus* in about September 307. The stone belongs to a group of seven milestones found at a point on the Stanegate road one Roman mile east of the Vindolanda milestone still *in situ*, including another which gives Constantine the enhanced rank of *Augustus*. Both stones may have formally recorded road repairs, but in fact they advertised his accession and subsequent promotion to passers-by. [R.T.]

8

9 Head of Constantine

Stonegate, York
Marble; H. 420mm, W. 240mm, D. 300mm
4th century
York Museums Trust (Yorkshire Museum),
YORYM: 1998.23
Bibl. Richmond 1944, 1–5; Toynbee 1962, 125, no.6, pl.12;
RCHMY 1, 112, no.8; Toynbee 1964b, 55–6; Rinaldi-Tufi 1983,
23, n.38; Rinaldi-Tufi 2005, 288–9, no.131.

Carved in the round, the head is in good condition apart from weathering externally due to water over a large part of its surface, particularly on the nose and around the right ear. Only the upper part of the crown is seriously damaged. The head, which is twice life-size, was intended to be fitted to a statue. It is turned slightly to the left and downwards with respect to the axis of the neck. There are some significant traces of an oak-leaf crown on the left side of the head. The hair is cut short over the back of the neck and at the temples, and in a fringe combed forward on the forehead. It is not worked on the top inside the crown, which would not have been visible. The forehead is smooth, the cheekbones somewhat pronounced and the chin round and tending towards plumpness. The ears, partly covered by hair, are small and close to the head; the eyes not excessively large, beneath not too pronounced brows. There are slight traces of incisions on the pupils and the irises, with indications of the use of a drill in the depth of the lachrymal caruncle. The tip of the nose has been damaged, so that it is difficult to say anything precise about its shape. The corners of the rather fleshy mouth have also been drilled. The neck is thick. On the whole, the head is well made: the modelling is rather soft and passages from one plane to another smooth. It was perhaps executed in Britain, but by an able craftsman, probably of continental origin and connected with the imperial workshops.

Richmond has proposed that this is one of the earliest-known portraits of the Emperor Constantine, if not the earliest. The portrait is certainly from the late empire if one considers certain details, such as the drilling of the corners of the eyes and the mouth, and the evidence of the robust masses (note the neck in particular). The accuracy of the execution and the over-life-size dimensions show that it is the portrait of someone important. The identification with Constantine is supported not only by historical factors (Constantine was declared emperor at York in 306) but also by stylistic and iconographic considerations. There is a definite classicising trend in the development of Constantine's portrait, which, in the first phase at least, actually took the iconography of Augustus as a model, particularly for the locks combed forward over the forehead and the slightly aquiline nose. Constantine was also the first emperor after Trajan who did not wear a beard. The crown of oak leaves (*corona civica*) is another element in favour of this interpretation: it was used by Constantine and his immediate successors and was another conscious return to the early imperial period, for the attribute of the emperor in the third century was a crown with rays or laurel leaves and in the rest of the fourth century a diadem. Despite the damage to the nose, one of the most important features for identifying portraits of Constantine, Richmond's hypothesis is acceptable.

With regard to the discovery of the head there is only the scant record of its being found in excavations in Stonegate before 1823, not far from the site of the *principia* of the fortress of Eboracum, beneath the Minster. It is probable that the statue, to which the head belonged, was placed in the *principia*. [S.R-T.]

10 Document on papyrus

Greek; Papyrus; 243 × 165mm
3rd–4th century
British Library, London, Papyrus 878
Bibl. Kenyon and Bell 1907; Baynes 1930, 40–9; Skeat 1953, 71–3;
Jones and Skeat 1954, 196–200; Winkelmann 1962; Cameron
and Hall 1999, 104–5, 239.

Illustrated on p.97
The poor state of preservation of this papyrus is such that its true significance was lost for many centuries. It formed part of a miscellaneous collection of papyri bequeathed to the British Museum by Myers in 1901. When Kenyon and Bell compiled their *Catalogue of Greek Papyri in the British Museum* in 1907 they accordingly paid it scant attention, simply noting that the text on the recto was an official document or petition written in the third or fourth century in a tall cursive hand, its meaning largely lost through damage; and that on the verso a literary text in a small cursive hand, perhaps an oration, had been added in the fourth century. In 1951 Jones announced at a congress held in Oxford the astounding discovery that the text on the verso was in fact a contemporary copy of a letter from the Emperor Constantine to the provincials of Palestine which was in effect a proclamation to the eastern provinces of his empire restoring to Christians the freedom, status and property taken from them during the preceding era of persecution. It also expounded on the moral poverty of paganism. This highly significant edict marked Constantine's newly assumed role as sole ruler of the Roman world, following his defeat of his one remaining competitor, Licinius, at the Battle of Chrysopolis in 324. The existence of such a proclamation had been asserted by Eusebius in his *Life of Constantine*, but its veracity had been questioned – until the discovery of the content of this scrap of papyrus.

Ironically, all that remains of the damaged text is the passage referring to the British origin of what Constantine evidently regarded as his divinely predestined mission. Constantine's words were translated by Skeat in 1953 as follows:

It is not vainglorious, for one who acknowledges the beneficence of the Almighty to make boast thereof. It was He who sought out my service, and judged it fitting for the achievement of His own purpose. Starting from that British sea and those lands where the sun is ordained to set, He repulsed and scattered by His divine might the encompassing powers of evil, to the end that the human race might be recalled to the worship of the supreme law, schooled by my helping hand, and that the most blessed faith might be increased with the Almighty as Guide.

This unprepossessing papyrus fragment was thus a landmark in the foundation of the Byzantine State and in the adoption of Christianity as the official religion of the late Roman Empire. It also gives a valuable insight into how Constantine came to present his proclamation as emperor in one extreme outpost of empire – at York in Britain – as the inevitable start of a divinely appointed career that would lead him to establish a new focus of *imperium* and faith at its eastern extremity – in Constantinople. [M.B.]

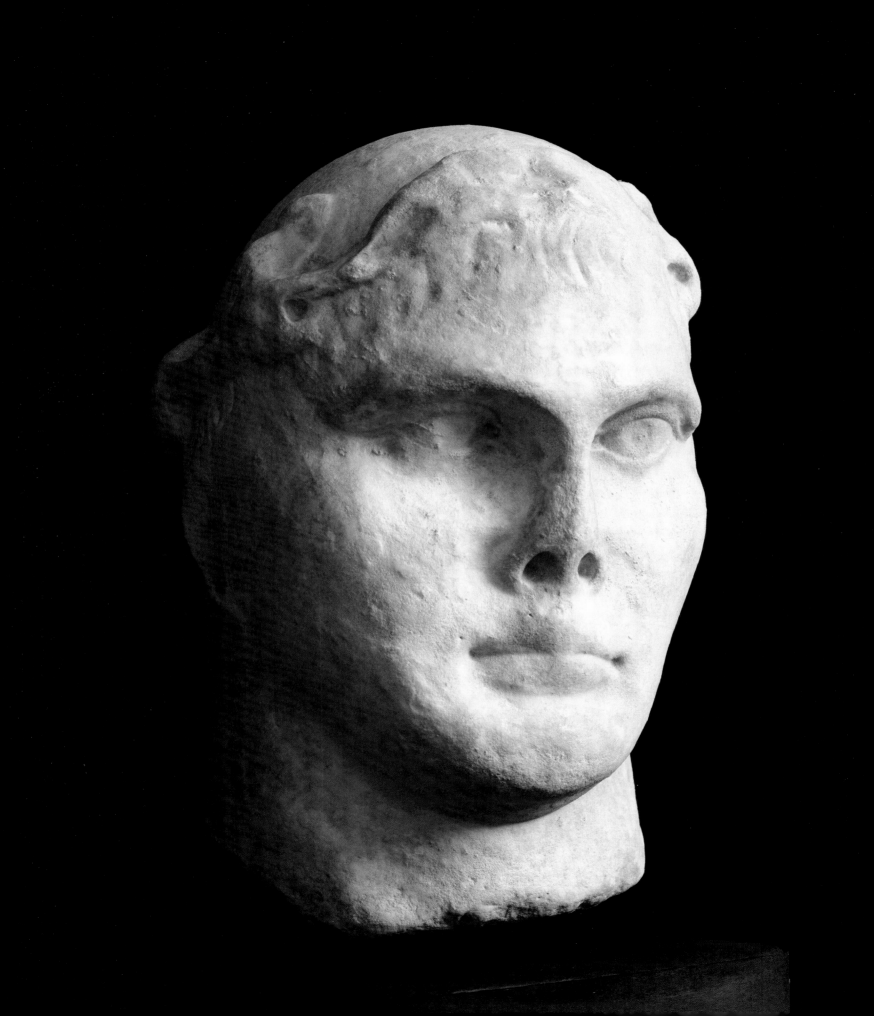

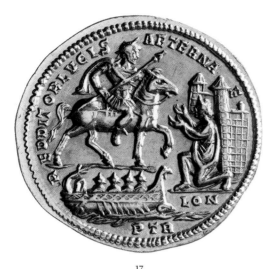

17

11–59: *The Beaurains (Arras) Treasure*

11 *Aureus* of Maximian

Beaurains, Arras
Gold; Dia. 23mm, Wt. 5.33g
Mint of Ticinum (Pavia), 286
British Museum, London, CM 1924 1-3 3
Bibl. *RIC* v.282.541; Bastien and Metzger 1977, 43.

Obverse: IMP C M AVR VAL MAXIMIANVS AVG.
Bust representing Maximian with upper part of
cuirass visible and wearing diadem emanating
solar rays.
Reverse: IOVI CONSERVAT AVGG. Jupiter
brandishing a thunderbolt.
Mint mark: SMT.

This coin was possibly minted as part of
Maximian's accession donative after 1 April 286.
[R.A.]

12 *Aureus* of Maximian

Beaurains, Arras
Gold; Dia. 20mm, Wt. 5.45g
Mint of Rome, 291
British Museum, London, CM 1924 1-3 2
Bibl. *RIC* v.275; Bastien and Metzger 1977, 158.

Obverse: MAXIMIA–NVS P F AVG. Wreathed
head representing Maximian.
Reverse: HERCVLI PACIFERO. Hercules 'the
pacifier' (holding out branch of peace).
Mint mark: PR.
This coin may have been produced to
commemorate Maximian's sixth imperial
acclamation in 291 or it may have formed part of

the regular annual imperial birthday or
accession anniversary donative. [R.A]

13 *Aureus* of Galerius

Beaurains, Arras
Gold; Dia. 18mm, Wt. 5.68g
Mint of Rome, 294
British Museum, London, CM 1924 1-3 19
Bibl. *RIC* vi.351.8b; *PCR* 1178; Bastien and Metzger 1977, 180.

Obverse: MAXIMIA–NVS CAES. Wreathed head
representing Galerius (Galerius Valerius
Maximianus, distinguished from Maximian by
his junior rank at this period).
Reverse: VIRTVS MILITVM. Reverse shows a fort
gateway.
Mint mark: PR. [R.A.]

14 *Aureus* of Constantius I

Beaurains, Arras
Gold; Dia. 19mm, Wt. 4.99g
Mint of Trier, 294
British Museum, London, CM 1924 1-3 12
Bibl. *RIC* vi.165.19; Bastien and Metzger 1977, 199.

Obverse: CONSTA–NTIVS N C. Wreathed head
representing Constantius I.
Reverse: IOVI CONSERVATORI. Jupiter 'the
protector' enthroned, brandishing a
thunderbolt, with his eagle at his feet.
Mint mark: PT. [R.A.]

15 *Aureus* of Maximian

Beaurains, Arras
Gold; Dia. 18mm, Wt. 5.00g

Mint of Trier, 295/6
British Museum, London, CM 1924 1-3 4
Bibl. *RIC* vi.170.55; Bastien and Metzger 1977, 206.

Obverse: MAXIMIA–NVS P F AVG. Wreathed
head representing Maximian.
Reverse: IOVI CONSERVATORI. Jupiter 'the
protector' enthroned, brandishing a
thunderbolt, with his eagle at his feet.
Mint mark: PTR. [R.A.]

16 *Aureus* of Constantius I

Beaurains, Arras
Gold; Dia. 19mm, Wt. 5.39g
Mint of Trier, 295/6
British Museum, London, CM 1924 1-3 13
Bibl. *RIC* vi.172.71; Bastien and Metzger 1977, 217.

Obverse: CONSTA–NTIVS N C. Wreathed head
representing Constantius I.
Reverse: PIETAS AVGG. Pietas (in the sense of
duty towards family and the state) shown as a
woman holding a baby between two children.
Mint mark: PTR. [R.A.]

17 Medallion of 10 *aurei* of Constantius I (facsimile)

Beaurains, Arras
Electrotype gold; Dia. 42mm, Wt. of gold
original 52.88g
Mint of Trier, for 1 March 297
London, CM, original in Musée d'Arras
Bibl. *RIC* vi.167.34; Bastien and Metzger 1977, 218; Toynbee
1986, pl.VIII, no.4; Casey 1994, pl.7.4; Nixon and Rodgers 1994,
106.

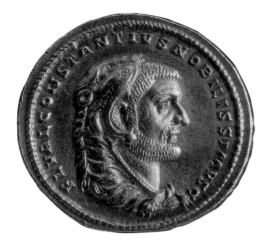

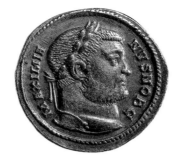

19

22

Obverse: FL VAL CONSTA—NTIVS NOBIL CAES.
Wreathed and draped bust representing
Constantius I with shoulder of cuirass visible
showing the *pteryges* (protective leather
shoulder-straps).
Reverse: REDDITOR LVCIS AETERNA. Grateful
London is represented by a kneeling woman
(labelled LON) with arms outstretched in
welcome as the emperor rides towards the gates
of the city.
Mint mark: PTR.

The reverse scene is visual shorthand for the
events described in the *Panegyric* for
Constantius (*Pan. Lat.* VIII), performed during
or not long after the celebrations of 1 March 297.
The invasion of Britain and defeat of Allectus is
presented as the liberation of Britain (*Pan. Lat.*
VIII.9.5–6). In the aftermath, Constantius's
soldiers saved London from rampaging
barbarian mercenaries (*Pan. Lat.* VIII.17.1).
Constantius arrives in London by a mixture of
transportation, alighting on horseback from a
ship. The legend proclaims Constantius as 'the
restorer of the eternal light' of Roman
civilisation to Britain. [R.A.]

18 *Medallion* of 5 *aurei* of Constantius I

Beaurains, Arras
Gold; Dia. 35mm, Wt. 26.79g
Mint of Trier, for 1 March 297
British Museum, London, CM 1928 2-8 1
Bibl. *RIC* VI.167.33; Bastien and Metzger 1977, 220; Toynbee
1986, pl.VIII, no.6; Casey 1994, pl.7.3;
www.thebritishmuseum.ac.uk/compass.

Illustrated on p. 57
Obverse: FL VAL CONSTANTIVS NOB CAES.
Wreathed bust representing Constantius I in the
garb of Consul holding the traditional *scipio*
(eagle-tipped sceptre). Constantius held this
office for the second time during his British
expedition.
Reverse: PIETAS AVGG. Constantius raising
Britannia from her knees; a winged figure of the
goddess Victory crowns him from behind.
Legend emphasises the pious duty of the
emperors in helping a beleaguered province.
Mint mark: PTR. [R.A.]

19 Medallion of 5 *aurei* of Constantius I

Beaurains, Arras
Gold; Dia. 34mm, Wt. 26.84g
Mint of Trier, for 1 March 297
British Museum, London, CM 1928 2-8 2
Bibl. *RIC* VI.167.32; *PCR* 1152; Bastien and Metzger 1977, 221;
MacCormack 1981, 31–2; Toynbee 1986, pl.VIII, no.5; Casey
1994, pl.7.2.

Obverse: FL VAL CONSTANTIVS NOBILISSIMVS
C. Bust representing Constantius I wearing the
lion-scalp of Hercules. In tetrarchic ideology the
western emperors were assigned the divine
patronage of Hercules while the eastern
emperors were assigned Jupiter, hence the
proliferation of coin reverse types below to
Hercules and Jupiter as guardian gods or
conservatores.
Reverse: same die as cat.18.
Mint mark: TR. [R.A.]

20 *Aureus* of Diocletian

Beaurains, Arras
Gold; Dia. 19mm, Wt. 4.91g
Mint of Trier, for 1 March 297
British Museum, London, CM 1924 1-3 1
Bibl. *RIC* VI.168.36a; *PCR* 1153; Bastien and Metzger 1977, 231.

Obverse: DIOCLE—TIANVS AVG. Wreathed head
representing Diocletian.
Reverse: COMES AVGG. Mars standing in a
shrine. Legend labels the god as the 'companion'
of the emperors.
Mint mark: TR. [R.A.]

21 *Aureus* of Constantius I

Beaurains, Arras
Gold; Dia. 20mm, Wt. 5.43g
Mint of Trier, 302
British Museum, London, CM 1924 1-3 10
Bibl. *RIC* VI.169.42; Bastien and Metzger 1977, 241.

Obverse: CONSTAN—TIVS NOB C. Wreathed head
representing Constantius I.
Reverse: HERCVLI AVGG. Hercules holding club
and lion-skin.
Mint mark: TR. [R.A.]

22 *Aureus* of Galerius

Beaurains, Arras
Gold; Dia. 19mm, Wt. 5.02g
Mint of Trier, for 1 March 302
British Museum, London, CM 1924 1-3 17
Bibl. *RIC* VI.173.82; *PCR* 1156; Bastien and Metzger 1977, 245.

Obverse: MAXIMIA—NVS NOB C. Wreathed head
representing Galerius.

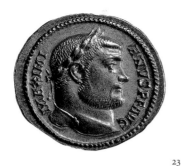

23

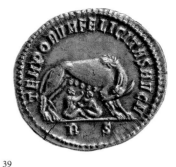
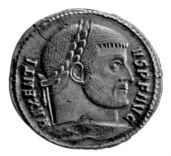

39

Reverse: SIC X SIC XX COS IIII. Legend within wreath: 'as ten [years] so twenty, Consul for the fourth time'. [R.A.]

23 *Aureus* of Maximian

Beaurains, Arras
Gold; Dia. 20mm, Wt. 5.24g
Mint of Trier, 302/3
British Museum, London, CM 1924 1-3 7
Bibl. *RIC* VI.169.46; *PCR* 1159; Bastien and Metzger 1977, 254.

Obverse: MAXIMI–ANVS P F AVG. Wreathed head representing Maximian.
Reverse: HERCVLI CONSERVATORI. Head of Hercules 'the protector' wearing lion-scalp.
Mint mark: TR. [R.A.]

24 *Aureus* of Galerius

Beaurains, Arras
Gold; Dia. 19mm, Wt. 5.18g
Mint of Trier, 302/3
British Museum, London, CM 1924 1-3 16
Bibl. *RIC* VI.173.83; Bastien and Metzger 1977, 271.

Obverse: MAXI–MIANVS N C. Wreathed head representing Galerius.
Reverse: SOLI INVICTO. Bust of Sol Invictus, the 'unconquered' sun-god.
Mint mark: TR. [R.A.]

25 *Aureus* of Constantius I

Beaurains, Arras
Gold; Dia. 19mm, Wt. 5.21g
Mint of Trier, 302/3
British Museum, London, CM 1924 1-3 11

Bibl. *RIC* VI.171.64; Bastien and Metzger 1977, 274.

Obverse: CONST–ANTIVS N C. Wreathed head representing Constantius I.
Reverse: MARTI PROPVGNATORI. Mars 'the defender'.
Mint mark: TR. [R.A.]

26 *Aureus* of Maximian

Beaurains, Arras
Gold; Dia. 19mm, Wt. 5.25g
Mint of Trier, for 20 November 303
British Museum, London, CM 1924 1-3 5
Bibl. *RIC* VI.174.97; Bastien and Metzger 1977, 299.

Obverse: MAXIMI–ANVS P AVG. Wreathed head representing Maximian.
Reverse: VOT XX SIC XXX. Legend within wreath is a record of the public vows for the well-being of the emperor that had been kept up to the twentieth anniversary (*vicennalia*). In addition, SIC XXX (so 30) indicates that new vows were offered up to take the emperor to his thirtieth anniversary (*tricennalia*). [R.A.]

27 *Aureus* of Galerius

Beaurains, Arras
Gold; Dia. 18mm, Wt. 5.54g
Mint of Trier, 20 November 303
British Museum, London, CM 1924 1-3 20
Bibl. *RIC* VI.174.94b; Bastien and Metzger 1977, 306.

Obverse: MAXIMIA–NVS NOB C. Wreathed head representing Galerius.
Reverse: VOT XX AVGG NN. Legend within wreath records the vows upheld at the twentieth

anniversary (*vicennalia*) of the Augusti (Diocletian and Maximian). [R.A.]

28 *Aureus* of Galerius

Beaurains, Arras
Gold; Dia. 18mm, Wt. 5.35g
Mint of Trier, 303
British Museum, London, CM 1924 1-3 18
Bibl. *RIC* VI.170.53; Bastien and Metzger 1977, 318.

Obverse: MAXIMI–ANVS NOB C. Wreathed head representing Galerius.
Reverse: IOVI CONSERVAT AVGG ET CAESS NN. Jupiter 'the protector of our Augusti and Caesars' enthroned, brandishing a thunderbolt.
Mint mark: TR. [R.A.]

29 *Aureus* of Maximian

Beaurains, Arras
Gold; Dia. 17mm, Wt. 5.12g
Mint of Trier, 303
British Museum, London, CM 1924 1-3 6
Bibl. *RIC* VI.169.43; Bastien and Metzger 1977, 338.

Obverse: MAXIMIA–NVS P F AVG. Wreathed head representing Maximian.
Reverse: HERCVLI CONSER AVGG ET CAESS NN. Hercules 'the protector of our Augusti and the Caesars'.
Mint mark: TR. [R.A.]

30 *Aureus* of Constantius I

Beaurains, Arras
Gold; Dia. 18mm, Wt. 4.83g
Mint of Trier, 303

British Museum, London, CM 1924 1-3 8
Bibl. *RIC* VI.169.45; Bastien and Metzger 1977, 357.

Obverse: CONSTAN–TIVS NOB C. Wreathed head representing Constantius I.
Reverse: HERCVLI CONSER AVGG ET CAESS NN. Hercules 'the protector of our Augusti and Caesars'. Same reverse die as cat.32.
Mint mark: TR. [R.A.]

31 *Aureus* of **Constantius I**

Beaurains, Arras
Gold; Dia. 18mm, Wt. 4.56g
Mint of Trier, 303
British Museum, London, CM 1924 1-3 9
Bibl. *RIC* VI.169.41; Bastien and Metzger 1977, 383.

Obverse: CONSTAN–TIVS NOB C. Wreathed head representing Constantius I.
Reverse: CONSERVATORES AVGG ET CAESS NN. Jupiter and Hercules 'protectors of our emperors' hold a Victory on globe statuette.
Mint mark: PTR. [R.A.]

32 *Aureus* of **Galerius**

Beaurains, Arras
Gold; Dia. 19mm, Wt. 5.20g
Mint of Rome, for 1 May 305
British Museum, London, CM 1924 1-3 22
Bibl. *RIC* VI.363.113; *PCR* 1242; Bastien and Metzger 1977, 184.

Obverse: MAXIMIA–NVS P F AVG. Wreathed head representing Galerius. Maximian was retired at this point so the legend identifies Galerius (Galerius Valerius Maximianus) as Augustus.
Reverse: IOVI CONSERVAT AVGG ET CAESS. Jupiter 'the protector of the Augusti and Caesars' enthroned, brandishing a thunderbolt.
Mint mark: PR. [R.A.]

33 *Aureus* of **Galerius**

Beaurains, Arras
Gold; Dia. 18mm, Wt. 5.21g
Mint of Trier, for 1 May 305
British Museum, London, CM 1924 1-3 23
Bibl. *RIC* VI.203.618b; Bastien and Metzger 1977, 402.

Obverse: MAXIMIA–NVS P F AVG. Wreathed head representing Galerius.
Reverse: CONCORDIA AVGG ET CAESS NN. Concordia (harmony – that is, between the members of the newly formed Second Tetrarchy) as an enthroned woman holding a libation dish (*patera*) and cornucopias.
Mint mark: TR. [R.A.]

34 *Aureus* of **Constantius I**

Beaurains, Arras
Gold; Dia. 17mm, Wt. 5.40g
Mint of Trier, for 1 May 305
The Ashmolean Museum, Oxford, Arthur Evans Bequest 1941
Bibl. *RIC* VI.205.634a; Bastien and Metzger 1977, 408.

Obverse: CONSTAN–TIVS P F AVG. Wreathed head representing Constantius I as Augustus.
Reverse: VBIQVE VICTORES. Emperor standing in full military dress holding spear and globe, between captive barbarians. For most of this period up until his death at York (25 July 306) Constantius was campaigning in northern Britain and the coin probably includes British victories (which earned him the title 'Britannicus Maximus' for the second time) as at least part of its message of 'victories everywhere'.
Mint mark: TR. [R.A.]

35 *Aureus* of **Galerius**

Beaurains, Arras
Gold; Dia. 18mm, Wt. 5.47g
Mint of Trier, for 1 May 305
British Museum, London, CM 1924 1-3 15
Bibl. *RIC* VI.205.634b; Bastien and Metzger 1977, 410.

Obverse: MAXIMIA–NVS P F AVG. Wreathed head representing Galerius.
Reverse: VBIQVE VICTORES. Same reverse die as cat.34.
Mint mark: TR. [R.A.]

36 *Aureus* of **Constantius I**

Beaurains, Arras
Gold; Dia. 19mm, Wt. 5.19g
Mint of Trier, for 1 May 305
British Museum, London, CM 1924 1-3 14
Bibl. *RIC* VI.203.620a; Bastien and Metzger 1977, 419.

Obverse: CONSTAN–TIVS P F AVG. Wreathed head representing Constantius I.
Reverse: HERCVLI CONSER AVGG ET CAESS NN. Hercules, 'the protector of our Augusti and Caesars'.
Mint mark: TR. [R.A.]

37 *Aureus* of **Maximinus II Daia**

Beaurains, Arras
Gold; Dia. 18mm, Wt. 5.38g
Mint of Trier, for 1 May 305
British Museum, London, CM 1924 1-3 21
Bibl. *RIC* VI.204.625b; Bastien and Metzger 1977, 425.

Obverse: MAXIMI–NVS NOB C. Wreathed head representing Maximinus II Daia.
Reverse: IOVI CONSERVATORI AVGG ET CAESS NN. Jupiter, 'the protector of our Augusti and Caesars', brandishing a thunderbolt.
Mint mark: TR. [R.A.]

38 *Aureus* of **Severus II**

Beaurains, Arras
Gold; Dia. 18mm, Wt. 5.57g
Mint of Trier, for 1 May 305
British Museum, London, CM 1924 1-3 24
Bibl. *RIC* VI.204.630a; Bastien and Metzger 1977, 429.

Obverse: SEVERVS NOB CAES. Wreathed head representing Severus II.
Reverse: SOLI INVICT CONSERVAT AVGG ET CAESS NN. Sol Invictus, the 'unconquered' sun-god and 'protector of our Augusti and Caesars'.
Mint mark: TR. [R.A.]

39 **Argenteus of Maxentius**

Beaurains, Arras
Silver; Dia. 22mm, Wt. 3.03g
Mint of Rome, 307
British Museum, London, CM 1924 1-3 25
Bibl. *RIC* VI.375.190; Bastien and Metzger 1977, 190A (i.e. omitted from catalogue).

Obverse: MAXENTI–VS P F AVG. Wreathed head representing Maxentius.
Reverse: TEMPORVM FELICITAS AVG N. Wolf and twins (Romulus and Remus), the emblem of the city of Rome.
Mint mark: RS.

It is unlikely that the Arras hoarder received direct payments from Maxentius and this was probably acquired through the general coinage circulation. [R.A.]

40 Half-*argenteus* of Constantine the Great

Beaurains, Arras
Silver; Dia. 15mm, Wt. 1.72g
Mint of Trier, for 25 December 307
British Museum, London, CM 1924 1-3 27
Bibl. *RIC* VI.216.760; Bastien and Metzger 1977, 444.

Obverse: IMP CONSTANTINVS AVG. Wreathed bust representing Constantine with upper part of cuirass visible.
Reverse: VIRTVS MILITVM. Fort gateway.
Mint mark: TR.

This is an unusual denomination, which in itself may indicate that it was issued as a special bonus payment, probably for Constantine's adoption of the title of Augustus (25 December 307). [R.A.]

41 *Solidus* of Constantine the Great

Beaurains, Arras
Gold; Dia. 17mm, Wt. 4.41g
Mint of Trier, for 25 July 310
The Ashmolean Museum, Oxford, Arthur Evans Bequest 1941
Bibl. *RIC* VI.223.821var; Bastien and Metzger 1977, 445.

Obverse: CONSTAN–TINVS P F AVG. Wreathed head representing Constantine.
Reverse: VOTIS V MVLTIS X. Winged Victory in the act of inscribing a shield marked VICTORIA AVG ('the emperor's victory'). Main legend records the public vows for the well-being of the emperor marking the fifth anniversary (*quinquennalia*); the vows for five years had been upheld, and new vows were offered up to take the emperor to his tenth anniversary (*decennalia*).
Mint mark: PTR. [R.A.]

42 Medallion of 9 *solidi* of Constantine the Great (facsimile)

Beaurains, Arras
Electrotype/Gold; Dia. 42mm, Wt. of gold original 40.26g
Mint of Trier, for 25 July 310
British Museum, London, CM 2004.11-11.1
Bibl. *RIC* VI.220.801; Bastien and Metzger 1977, 446; Toynbee 1986, pl.IX, no.5; Casey 1994, pl.7.5; Vagi 2002, 272.

Illustrated on p.54

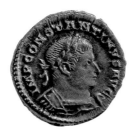

40

Obverse: IMP CONSTANTINVS PIVS FELIX AVG. Wreathed and draped bust representing Constantine with shoulder of cuirass visible, showing the *pteryges* (protective leather shoulder-straps).
Reverse: PRINCIPI IVVENTVTIS. Constantine standing in full military dress holding spear and globe.
Mint mark: PTR.

This medallion carried the graffitoed value of gold on the front, just before the bust: XIId (12,500 *denarii* for a medallion representing 1/8 of a Roman pound of gold). The reverse graffito around the figure appears to read VITALIANI PRO–TICTORIS. The graffiti have not transferred well onto the electrotype facsimile in the exhibition. [R.A.]

43 Medallion of 1½ *solidi* of Constantine the Great

Beaurains, Arras
Gold; Dia. 23mm, Wt. 6.60g
Mint of Trier, for 25 July 310
The Ashmolean Museum, Oxford, Arthur Evans Bequest 1941
Bibl. *RIC* VI.221.802; Bastien and Metzger 1977, 448.

Obverse: IMP CONSTANTINVS P F AVG. Draped bust representing Constantine with shoulder of cuirass just visible and wearing diadem emanating solar rays.
Reverse: PRINCIPI IVVENTVTIS Constantine standing in full military dress holding spear and globe.
Mint mark: PTR. [R.A.]

44 Half-*argenteus* of Constantine the Great

Beaurains, Arras
Silver; Dia. 15mm, Wt. 1.72g
Mint of Trier, for 25 July 310
The Ashmolean Museum, Oxford, Arthur Evans Bequest 1941
Bibl. *RIC* VI.224.827; Bastien and Metzger 1977, 459.

Obverse: IMP CONSTANTINVS AVG. Wreathed bust representing Constantine with upper part of cuirass visible.
Reverse: VIRTVS MILITVM. Fort gateway.
Mint mark: PTR.

An unusual denomination, which in itself may indicate it was issued for a special bonus payment. [R.A.]

45 Half-*argenteus* of Constantine the Great

Beaurains, Arras
Silver; Dia. 15mm, Wt. 1.79g
Mint of Trier, for 25 July 310
British Museum, London, CM 1924 1-3 26
Bibl. *RIC* VI.224.828; Bastien and Metzger 1977, 462.

Obverse: IMP CONSTANTINVS AVG. Wreathed bust representing Constantine with upper part of cuirass visible.
Reverse: VIRTVS MILITVM. Fort gateway.
Mint mark: PTR. [R.A.]

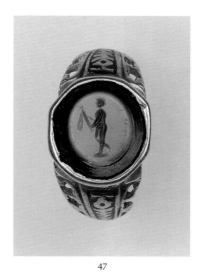

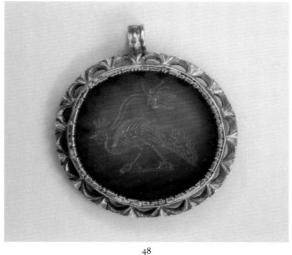

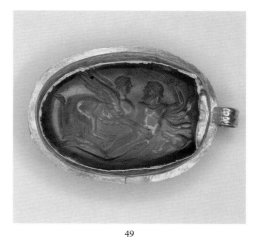

47

48

49



46 Finger-ring

Beaurains, Arras

Gold, aquamarine; internal Dia. 18mm, gem 21 × 12mm, Wt. 12.6g

Late 3rd–early 4th century

British Museum, London, GR 1924.5-14.3

Bibl. Bastien and Metzger 1977, 170–2, B12, pl.VII.

Illustrated on p.60

Gold ring with a large gem in an open-backed setting with curved lobes. The hoop is laterally flattened and carries a niello-inlaid inscription on each side, in somewhat irregular letters with serifs. One side has the name VALER … IANVS, and the other, PATE … RNA, each with a gap in the centre of the word. The surface of the gold is extensively scratched.

The setting is a large, slightly irregular narrow oval stone, very pale blue-green, with a good vitreous lustre. It has been identified as an aquamarine (beryl). [C.J.]

47 Finger-ring

Beaurains, Arras

Gold and nicolo; internal dimensions 19 × 15mm, setting 12 × 14mm, Wt. 6.6g

Late 3rd–early 4th century

British Museum, London, GR 1924.5-14.4

Bibl. Walters 1926, 202, no.1909*; Bastien and Metzger 1977, 170–1, B11, pl.VII; Guiraud 1988, 140, no.556, pl.XXXI; for the type of Theseus see Henig 1970, 250–2.

Ring of keeled form with pierced ornament and niello inlay on the shoulders. The latter takes the form of a narrow panel on each shoulder with a branched pattern, bordered by simple

openwork. The latter is very worn and has broken in several places: the surface of the gold shows wear throughout.

In a plain rub-over setting, an almost round intaglio in black and grey nicolo (a variety of chalcedony, which is a microcrystalline quartz) with a flat table. The motif of the gem, which is probably second century in date, is Theseus standing, facing right and holding the sword that had belonged to his father Aegeus. [C.J.]

48 Pendant

Beaurains, Arras

Gold and carnelian; 24 × 22mm (26mm including suspension ring); Wt. 3.5g

3rd–4th century, earlier gem

British Museum, London, GR 1924.5-14.5

Bibl. Walters 1926, 245, no.2453, pl.XXVIII; Richter 1971, 78, no.381; Bastien and Metzger 1977, 172–4, B14, pl.VIII; Guiraud 1988, 174, no.748, pl.L; cf. Walters 1926, no.2452 for the type.

The gold setting is a simple openwork egg-and-tongue border, the gem retained with a ring of milled wire at the front and a series of triangular claws at the back. There is a simple ribbed suspension ring. There seems to be little or no wear on the gold.

The gem is a disc about 3mm thick, flat front and back. It is translucent, cloudy and a warm orange colour, but there is no trace of the clear colour-banding of white and reddish-brown seen in the variety of chalcedony (microcrystalline quartz) known as sardonyx. The published description as 'sardonyx' is therefore hard to explain: the stone is a translucent reddish-orange form of chalcedony

and is better referred to as 'carnelian', or possibly as 'sard'. The intaglio is a very elegantly engraved peacock with trailing tail, walking to the left on a single ground-line. A butterfly hovers above the bird, and two lines connect the insect with the bird's beak, intended to depict reins. The gem is of the Republican period, dating to the second or first century BC, and was therefore of some antiquity when reused in its present setting. [C.J.]

49 Pendant

Beaurains, Arras

Gold and amethyst; 29 × 19mm (including suspension loop), Th. 6mm, Wt. 4.9g

3rd–4th century, earlier gem

British Museum, London, GR 1924.5-14.6

Bibl. Walters 1926, 203, no.1918*, pl.XXIV; Richter 1971, 53, no.247; Bastien and Metzger 1977, 171–2, B13, pl.VII; Guiraud 1988, 178–9, no.796, pl.LIII.

The gold setting is completely plain with a flat, undecorated flange and a ribbed suspension loop. It is noteworthy for being an upright (portrait-format) setting for a horizontal, landscape-format intaglio. A chip has been lost from the edge of the gem at its right-hand end, now at the top of the setting.

The gem, convex front and back, is a pale mauve amethyst (macrocrystalline quartz) with a slight band of deeper colour across the upper right area. The intaglio is of exceptionally high quality, and depicts a fallen warrior struggling with a sphinx. The warrior is naked, apart from a cloak, folds of which swirl behind and beneath him. He is bearded, and brandishes a sword with



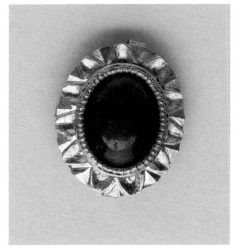

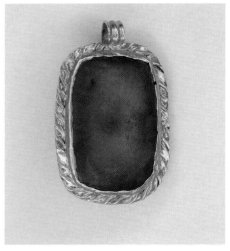

50

51

52

a leaf-shaped blade. The sphinx – depicted in fine detail, especially the feathers of her wings – has pounced upon him. The proportions of both figures are accurate. The subject, style and quality of the engraving recall Greek work of the Classical period, but it is probably an Augustan product (first century BC to first century AD) in a consciously archaising and hellenising style. [C.J.]

50 Pendant

Beaurains, Arras
Gold and citrine; 34 × 20mm, Th. 10mm, Wt. 8.1g
3rd–4th century
British Museum, London, GR 1924.5-14.7
Bibl. Bastien and Metzger 1977, 173–4, B16, pl.VIII.

The gold setting is a narrow flange with an impressed egg-and-tongue pattern, and the suspension ring is of the usual ribbed type.

The stone is a long oval, convex front and back, a deep golden yellow colour, with some internal colour variation and a large, striped feather-like inclusion. The gem is well polished, but bears a number of surface scratches. Though still generally described in print as a topaz, the gem was identified in 1974 as citrine, a yellow variety of quartz. While it is rarer than amethyst, citrine can be artifically produced by heat-treating amethyst. This example is an unusually deep golden colour. [C.J.]

51 Setting

Beaurains, Arras
Gold and amethyst; 22 × 17mm, Th. 6mm, Wt. 4g
3rd–4th century
British Museum, London, GR 1924.5-14.8
Bibl. Bastien and Metzger 1977, 173–4, B15, pl.VIII.

This object is a component from a piece of jewellery, perhaps from a necklace or bracelet. The gold mount, which is in very fresh condition, consists of a wide flange worked into an egg-and-tongue pattern. At the front, the plain gem is retained by a bezel of milled gold wire; at the back, there is a simple rub-over setting, and four plain rings are soldered to the reverse side of the decorated flange at the top, bottom and both sides of the gem.

The stone is an oval amethyst (quartz), convex front and back; a good shade of purple, but very cloudy and with areas of paler colour. The front surface is somewhat scratched. [C.J.]

52 Pendant

Beaurains, Arras
Gold and peridot; 25 × 18mm (max. L. with suspension ring 28mm); Wt. 4.8g
3rd–4th century
British Museum, London, GR 1924.5-14.9
Bibl. Bastien and Metzger 1977, 173–5, B17, pl.VIII.

The pendant is of long, sub-rectangular form. The gold setting is a simple flange with oblique crimping and a ribbed suspension ring.

The gem is a translucent light green, extremely scratched and worn, so that its surface

is completely matt. It has previously been published as glass, but was identified in 1974 as peridot, the gem-quality variety of the mineral olivine. Though most modern sources of peridot are in Asia and the New World, there was a source near the Red Sea coast of Egypt, which would have supplied specimens in antiquity. Peridot is softer than quartz (6½ on the Mohs scale), but even so the surface wear is severe and this, combined with the light green colour, makes it understandable that the gem has been assumed to be glass. [C.J.]

53 Link

Beaurains, Arras
Gold; 24 × 9mm, Wt. 0.9g
3rd–4th century
British Museum, London, GR 1924.5-14.10
Bibl. Bastien and Metzger 1977, 165–6, B5.

Two links of gold wire, each an uneven figure-eight shape, connect to form a knot of Hercules. The link is likely to be from a necklace. [C.J.]

54 Necklace

Beaurains, Arras
Gold and emerald; L. 1250mm, Wt. 27.6g
3rd–4th century
British Museum, London, GR 1924.5-14.11
Bibl. Bastien and Metzger 1977, 163, B1, pl.IV.

The long chain is incomplete, without its clasp. It consists of 52mm-long lengths of very fine loop-in-loop chain only about 1.5mm square in cross-section, connected by plain straight links intended to carry pierced beads. There are 19

such links, of which ten still have the emerald (beryl) beads in their natural hexagonal crystalline form. All are the usual cloudy but vividly coloured emeralds normally found in Roman jewellery.

Very long chains of this kind were probably worn looped twice around the neck. [C.J.]

55 Necklace

Beaurains, Arras
Gold and emerald; L. 423mm, cross-section of chain *c*.2mm, Wt. 16.2g
3rd–4th century
British Museum, London, GR 1924.5-14.12
Bibl. Bastien and Metzger 1977, 163–4, B2, pl.IV.

The fine loop-in-loop chain has seven bead-links, of which three still retain the natural emerald (beryl) beads. There is a simple hook-and-eye clasp, and the lengths of chain between the beads are about 40mm, with the two end lengths being shorter. A necklace of this length forms a circle of around 130mm diameter when fastened: a suitable length to encircle the base of the neck quite closely.

The central emerald bead is a very fine one, 9mm in length and of a beautiful deep green. [C.J.]

56 Bracelet

Beaurains, Arras
Gold and gemstone; L. 265mm, Wt. 9.9g
3rd–4th century
British Museum, London, GR 1924.5-14.13
Bibl. Bastien and Metzger 1977, 164–5, B3, pl.IV.

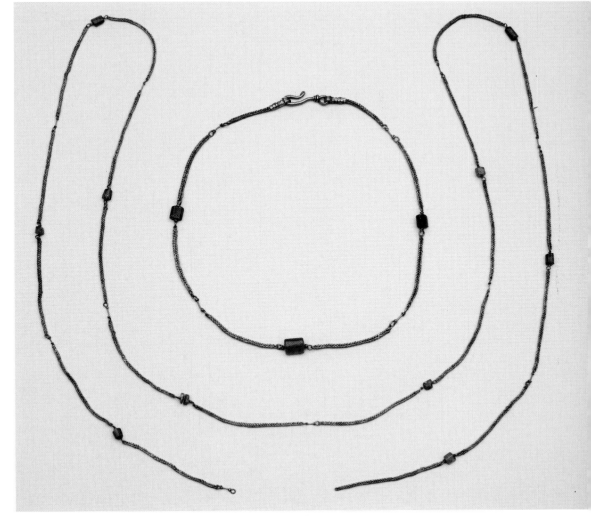

54, 55

53

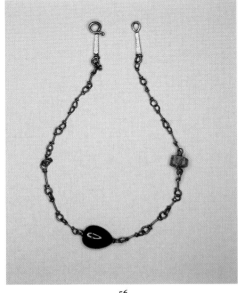

56

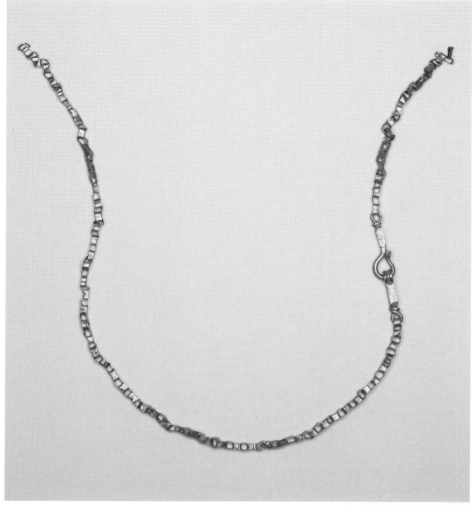

57

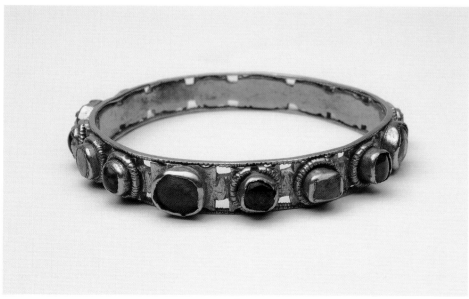

58

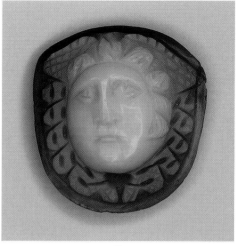

59

The chain consists entirely of plain straight wire links, probably all intended for small beads. There would have been 16 beads in all. The clasp is a hook and eye, on long, tapering square-sectioned terminals. Only two gemstone beads survive, a somewhat damaged emerald at one side and, in the centre, a long (13mm) almond-shaped bead with a high vitreous lustre, which appears opaque black. It is definitely not a garnet, as suggested in Bastien and Metzger. Two small translucent areas can be detected and in transmitted light they appear blue to blue-green. Attempts to obtain and read a spectrum from these small patches were not entirely successful, but sapphire (corundum) is a possible identification.

A chain of this length forms a circle of about 85mm diameter when closed: it cannot be a necklace, but must be a loosely fitting bracelet. [C.J.]

57 Bracelet or necklace

Beaurains, Arras
Gold; L. (incomplete) 194mm, Wt. not recorded
3rd–4th century
British Museum, London, GR 1924.5-14.14
Bibl. Bastien and Metzger 1977, 164–5, B4a, pl.IV.

The chain is formed of distinctive links made of flat gold strips only 1mm wide, creating a 'paper-chain' effect. The clasp survives, and is a tiny hook-and-eye construction. The chain forms a closed circle about 65mm in diameter, appropriate as a bracelet; however, there are breaks in the links and it is not impossible that there were additional lengths of chain and/or

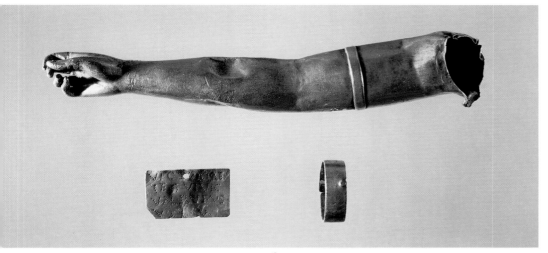

60

other elements, so the possibility that this is an incomplete necklace cannot be excluded. [C.J.]

58 Bracelet

Beaurains, Arras
Gold, emerald, almandine garnet and glass; external Dia. 74.5mm, internal Dia. 62mm, Wt. 72.3g
3rd–4th century
British Museum, London, GR 1986.11-15.1
Bibl. Bastien and Metzger 1977, 166–7, B8, pl.v; Bailey 1988.

The bracelet is a rigid circlet of rectangular gold elements on which are set round or oval mounts for gems. Heavily worn beaded wire forms the outer borders of the circlet. There are four settings in pale blue glass with slightly convex surfaces, four emeralds, with tables polished flat, and, between them, eight smaller cabochon almandine garnets. The metal is pale in colour, and its composition is 86 per cent gold, 10 per cent silver and 4 per cent copper.

This ornament was known only from a photograph when the Beaurains treasure was published in 1977, but later came to light in a private collection and was acquired by the British Museum in 1986. [C.J.]

59 Cameo

Beaurains, Arras
Chalcedony (onyx); 27 × 23mm
Late 3rd century
British Museum, London; GR 1924.5-14.2
Bibl. Walters 1926, 334, no.3549*; Bastien and Metzger 1977, 174–5, B18, pl.VIII; Guiraud 1988, 201, no.991, pl.LXIII.

The unmounted gem is roughly oval, wider at the top than the bottom, and is carved from chaledony (microcrystalline quartz) banded in bluish-white and very dark bluish-grey. Though described in the literature as 'sardonyx', onyx is a more appropriate term. The back of the gem is flat.

The cameo depicts a head of Medusa turned a little to the left, with spread wings at the top of her head and the locks of her hair forming a regular pattern of S-shaped serpents surrounding her face. The two serpents at her chin are larger than the others, but they are not intertwined in a Knot of Hercules as is so often the case. Cameos of onyx depicting Medusa were very common in the third and early fourth centuries, set in brooches, earrings, finger-rings (see cat.5) and pendants to provide protection against malignant spirits. Jet Medusa pendants were manufactured in Britain and the Rhineland for the same purpose. [C.J.]

60 Silver right arm

Tunshill Farm, near Rochdale, Lancashire
Silver; arm of statuette L. 224mm, plate 42 × 25mm
Late 2nd or early 3rd century
British Museum, London, P&E 1983.10-1.1
Bibl. Macdonald 1926, 9–16; Potter and Johns 1986; RIB (Corrig. Add.), 194, no.582; Potter and Johns 1992, 124–5; Henig 1995, 60.

Silver right arm of a statuette of Victory, the hand clenched to hold an object now missing. Arm: sheet silver. Hand: cast. Found with the statuette were a silver band, inscribed ID, and a

small rectangular silver plate with a punched inscription was originally attached by a chain of four links to the band.

The inscription reads: 'Victoriae leg(ionis) VI Vic(tricis) Val(erius) Rufus u(otum) s(oluit) l(ibens) m(erito)' (To the Victory of the Sixth Legion Victrix Valerius Rufus willingly and deservedly fulfilled his vow).

The arm is straight and must have held an object such as a victor's crown in the closed hand; thus the reconstruction of the statuette as Victory, suggested by Potter and Johns, must be correct. The identification is confirmed by the inscription on the plate, which makes sense only if the statuette was a Victory. The goddess would have been poised on a globe, with her wings spread, a crown held up in her right hand and a palm in her left. The reconstructed form of the statuette on a globe is that used for most representations of Victory. It goes back to the famous early Hellenistic statue from Tarentum, erected on a pillar by Augustus in the Curia Julia (Senate House) in Rome in thanks for his victory at Actium in 29 BC (Dio Cassius, 51, 22). The plate and the statuette may have been set up together; but who Valerius Rufus was, and what victory of the Sixth Legion he was commemorating, unfortunately cannot now be established.

The statuette has been reconstructed by Potter and Johns to be about 830mm high to the tips of the wings, about half life-size. To this must be added the height of the globe on which the goddess stood, as well as a base, giving a total of about 1500mm. No other silver statuette of this size has been found in Britain and the only other known large statuette in precious metal is a Gorgoneion of gold, from a third-century hoard found at Wincle in Cheshire, which was probably part of a half-life-size bust of an emperor wearing a cuirass. The size of the Tunshill statuette does not in itself demonstrate whether it came from a public or a private shrine. The fact that the goddess is Victory does not exclude it being in a private shrine: there were many such statuettes in Gallo-Roman domestic shrines. The addition of the dedicatory plaque, however, suggests that, when the plaque was added, it was in a public shrine.

From the second to the fourth century the headquarters of the Sixth Legion were in York. Why was the statuette found so far from there?

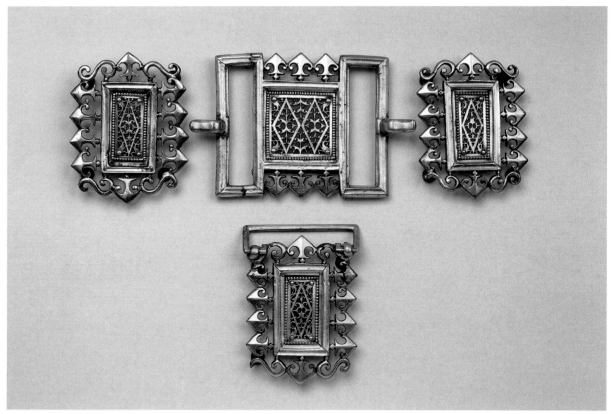

61

There are several possibilities. One is that the Victory was in the legionary shrine inside the fortress headquarters and that it was looted, hidden and not recovered, on the other side of the Pennines. There are possible dates for such a disaster at York. The *principia*, the headquarters building which contained the legionary shrine, was burned down three times: at the end of the second century, at the end of the third century and around the end of the fourth century. Macdonald argued strongly that this was what happened. He added to this the hypothesis that a gilded bronze leg, probably from an imperial statue, was also from York and that a bronze globe found with the leg was possibly a mount for the silver statuette. The leg and the globe were found at Milsington in Roxburghshire.

There is no evidence to connect the silver arm from Tunshill or the other objects mentioned above with any disaster in York. It is far too distant from the find-places to be a convincing source. Also, soldiers of the Sixth Legion were based not only at York, but also at Corbridge, on the Antonine Wall and at the fortress at Carpow.

The complete statuette could have come from a shrine at or near the place where it was found. Given that the arm was clearly wrenched from the statue, what we have may well have been part of the stock of a dealer in old metal or the result of theft. There is another possible reason why the Tunshill statuette was initially removed from its shrine – to protect the valuables of the shrine against a threat in the neighbourhood. That is perhaps the most likely explanation of all; but, unfortunately, in the end it did not succeed. [K.P.]

61 Four-part set of belt-fittings

Cologne, Germany
Silver, parcel-gilt; L. of belt buckle with tongues/prongs 95mm; *opus interrasile* panel 29 × 18mm; other mounts L. 50mm, W. 63mm; combined Wt. 155.86g
End of the 3rd century
Römisch-Germanisches Museum der Stadt Köln, inv. Metall 1345, a, b, c, d

Bibl. Kisa 1896, 45, Taf.I, 2–5; La Baume 1964, 293–5, Bild 278, col.pl.xv; La Baume 1967, 311, no.F1, col.pl.xvi; Hellenkemper 1979, 82–3, no.10; Schulze 1980, 65, no.54; Naumann-Steckner 1990, 63–4 no.I.e.8a.

The set of four metal belt decorations consists of a double buckle with two prongs, and three additional mounts, one of which has a movable attachment bar. On each of them, a profiled border surrounds an inset panel of pierced (*opus interrasile*) work in silver sheet. On the mounts, the borders consist of heart-shaped leaves and S-shaped motifs, while the clasp is flanked by two plain upright rectangles, between which are three heart-shaped elements.

The treatment of the openwork panels consists of upright lozenges filled with symmetrical vegetal ornament, with similar foliate ornament occupying the surrounding spaces. The borders are fire-gilded, while the foliate ornament appears silver in colour against a darker background.

The mounts were originally attached with four rivets each to a leather belt. The two free ends hung down from each side of the buckle and were bent back and secured by the prongs. As an extra security measure against loss, the buckle was riveted to another, thinner, leather strap.

The Cologne set of belt mounts belongs to a Norico-Pannonian tradition, based in the

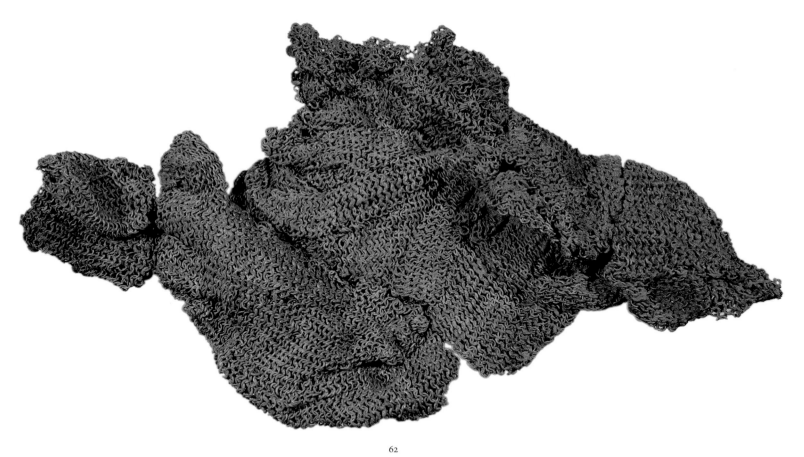

62

Roman provinces of Noricum and Pannonia, which correspond roughly to modern Austria and Hungary. Another variant is the bronze buckle without a tongue or prong, which was in use throughout the Rhine–Danube frontier areas and also in Britain. In Regensburg, a buckle of that kind was found with an *antoninianus* of Gallienus (253–68). As a parallel to the pierced (*opus interrasile*) work of the decorative panels, a silver mount with the inscription *Ausonius vivas* should be mentioned; it was found in a lead sarcophagus in the Luxemburger Strasse in Cologne, together with a silver coin of the Emperor Gordian III (238–43). [F.N-S.]

62 Mail suit

Arbeia Roman Fort, South Shields
Iron; H. 510mm, W. 340mm
Late 3rd or early 4th century
Tyne and Wear Museums, TWCMS 2002.1311
Bibl. Croom 2001.

Complete mail suit belonging to an auxiliary soldier of the Fifth Cohort of Gauls, found in the debris of a barrack block that had burnt down in a fire. This is one of only two complete Roman ring-mail suits in the country and is certainly the best preserved. As it was lost in a fire and then sealed within a thick layer of burnt daub, the preservation of the individual links is remarkable. The links are only 7mm across, but the rivets closing alternate rows of links can be seen, and even the occasional hole where a rivet has been lost. [A.C.]

63 Greave fragment

Arbeia Roman Fort, South Shields
Copper alloy; H. 140mm, W. 60mm
Late 3rd or early 4th century
Tyne and Wear Museums, TWCMS 2002.1372

Fragment of a greave (lower leg armour) with embossed decoration. The top part of the surviving piece shows the standing figure of a winged Victory, holding a palm leaf over her shoulder, and the lower section has a triangular, stylised leaf. A greave, even in fragmentary condition, is a very unusual site find from Britain. It was found in a barrack block belonging to the Fifth Cohort of Gauls that had burnt down (see also cat.62). [A.C.]

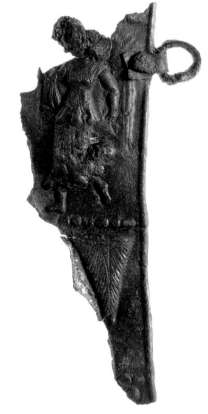

63

64

65

64 Plumbata

Wroxeter, Shropshire
Iron and lead; L. 135mm
4th century
Shrewsbury Museums Service, SHYMS:
A/2004/025

Bibl. Musty and Barker 1974; Barker 1979; Bishop and Coulston 1993, 162, fig.115, no.16.

Barbed and tanged iron projectile with the junction of the shank or tang and wooden shaft encased in an ovoid jacket of lead.

This is an example of a *plumbata mamillata* or 'breasted javelin' of the type described in the anonymous *De Rebus Bellicis*, written *c*.368–9. According to Vegetius (1.17; 3.14), two legions, both with Illyrian origins, used this type of *plumbata*; indeed, took their name from the weapon. They were also referred to as *mattiobarbuli* or *martiobarbuli*, possibly linking them with the German Mattiaici or with the fourth-century units of Mattiarii. Each soldier carried five or six in the hollow of his shield, ready to be thrown at the start of battle. Using reconstructions of the Wroxeter *plumbatae*, Eagle (1989) has found that the weapons are most accurate at 60m if thrown underarm. He further discovered that it was possible to throw the weapons whilst one's body remains protected by one's shield and that the enemy's wounds would mostly be to his head or shoulders. Six examples of the *plumbata mamillata* have been found at Wroxeter. Others have been found in both towns and forts, the dated examples being of fourth- to fifth-century date. [L.A-J.]

65 Spear

(*Magna*) Carvoran, Northumberland
Iron; L. 549mm
Museum of Antiquities of the University and Society of Antiquaries of Newcastle upon Tyne, 1956.265.A

Bibl. Richmond 1940; Swanton 1973, 30, figs 4a, 146; Manning 1976, 21, no.22.

Long, barbed spearhead with a square-sectioned shank that becomes rounded as it merges into the socket.

Barbed spearheads, although rare in Britain, are known to have been in use by the mid-second century. This spearhead differs from the earlier examples in the length of its neck. Manning (1976, 20) has described it as 'a formidable and vicious weapon, which invites comparison with the *angon* of the Migration period, a weapon especially favoured by the Franks'. It is thought to have developed from a type of barbed spearhead found in late Iron Age Scandanavia (for example in the late-fourth-to-early-fifth-century Nydam hoard). In Britain, a small group of this type of spearhead was found on Hadrian's Wall, and it also appears in Anglo-Saxon graves in Kent and the Thames Valley, but it is considered unlikely that the two groups were connected although the Hadrian's Wall group may relate to the use of Germanic troops on the frontier.

The spearhead was found in 1833 in a well inside Carvoran Fort on Hadrian's Wall. [L.A-J.]

66 Arrowhead

Vercovicium (Housesteads), Northumberland
Iron; L. 49mm
Museum of Antiquities of the University and Society of Antiquaries of Newcastle upon Tyne, 1903.1

Bibl. Manning 1976, 23, no.43.

For description and history, see cat.67. [L.A-J.]

67 Arrowhead

Vercovicium (Housesteads), Northumberland
Iron; L. 80mm
Museum of Antiquities of the University and Society of Antiquaries of Newcastle upon Tyne, 1903.1

Bibl. Manning 1976, 23, no.38.

Arrowhead with a tang and a plain triangular blade.

This arrowhead, along with nos 66 and 68, comes from the largest hoard of such arrowheads (more than 800 in all) found in Britain. It was discovered in Room 12 in the north-west corner of the *principia* of Housesteads Fort, Hadrian's Wall. The excavator stated that 'there was some reason to think that they might have been arranged in bundles' (Bosanquet 1904, 225). It is presumed that part of the Housesteads *principia* had been demoted to a weapons store and workshop in the third century. The upper storey of the building collapsed into the store during or just after the time of Constantine. [L.A-J.]

66 67 68

68 Arrowhead

Vercovicium (Housesteads), Northumberland
Iron; L. 60mm
Museum of Antiquities of the University and
Society of Antiquaries of Newcastle upon Tyne,
1903.1
Bibl. Manning 1976, no.40.

For description and history, see cat.67. [L.A-J.]

69 Dice-tower

Vettweiss-Froitzheim, Germany
Copper alloy; H. 225mm, W. 95mm, D. 95mm
4th century
Rheinisches Landesmuseum Bonn, 85.269
Bibl. Horn 1989; May 1991, 186–7, cf. 178–85; Zehnder 1999,
72–3; cf. Huelsen 1904, 142–3; Austin 1934, 30–4.

The object, found in 1985 on the site of a *villa
rustica*, is in the form of a rectangular tower of
thin sheet-metal all of whose sides are of pierced
geometric openwork. Running along the sides
and back at the top are three words in capitals:
VTERE FELIX VIVAS (Use happily; may you live).

In the front are six words, one above the
other, which arrange themselves into phrases of
two words each:
PICTOS VICTOS (The Picts are conquered)
HOSTIS DELETA (The enemy has been destroyed)
LVDITE SECVRI (Play with security)

Dice were dropped into the top of the tower
and deflected by three inclined plaques each at
an angle of 45°. They emerged at the front,
falling down a flight of steps flanked on each
side by a dolphin.

The tower was employed for the game *ludus
duodecim scriptorum*, a version of backgammon
very popular in the Roman period. A tower of
the same sort but not inscribed comes from
Qustul in Nubia, and a tower and dice are
portrayed with the figure representing the
month of December in the Filocalus Calendar of
354. The inscriptions are paralleled on marble
boards used for the same game. For example,
one from the Catacomb of SS Marco e
Marcellino in Rome, is inscribed PARTHI OCCISI
(The Parthians are killed); BRITTO VICTVS (The
Briton conquered); LVDITE ROMANI (Romans
play). One from St Matthias, Trier, is inscribed
VIRTVS IMPERI (The virtue of the Empire);
HOSTES VINCTI (The enemy is subdued);
LVDANT ROMANI (The Romans play).

Clearly the idea presented by the legends is
that the game is designed to be played in the
security of winter (Filocalus Calendar) or when
there are no enemies left to fight.

The disciplined openwork of the design dates
the tower to the late third or fourth century. The
reference to the Picts (of Scotland) is interesting
and may refer to the northern campaigns of
Constantius I in 296, or even putative later
conflicts (of 343 or 368). However, the Picts were
a very popular *topos* at the time and it would be
unwise to insist on linking the object with any
particular historical episode. [M.H.]

70 Gaming Board

Chapel House (Milecastle 9, Hadrian's Wall),
Tyne and Wear
Sandstone; L. 186mm, W. 130mm, D. 16mm,
squares 15 × 20mm
2nd century
Museum of Antiquities of the University and
Society of Antiquaries of Newcastle upon Tyne,
1930.44

Incomplete gaming board of micaceous
sandstone, possibly a reused roofing slate. A
minimum of 91 squares have been lightly incised
on one face.

It is likely that this board was used for a
game called *ludus latrunculorum* which,
according to Varro (x.22), was played on a board
marked into squares with playing pieces (*calculi,
latrones* or *milites*) made from materials of
different colours. A piece was taken by being
surrounded by two opponents in rank or file
(Ovid, *Ars Amatoria* II.358–9) and the winner
was the person who captured the most pieces.
The game was often referred to as 'the soldier's
game' and its military connections are shown by
the name of the pieces (see the mid-first-century
poem *Laus Pisonis*, lines 192–205). Complete
ludus latrunculorum boards found in Britain are
usually marked with 8 × 8 squares, so this
example is unusual. Its small size also suggests it
was part of a portable set. See Bell 1960, 84–7, for
the rules of the game. [L.A-J.]

71 Dice shaker

Vercovicium (Housesteads), Northumberland
Wood; H. 44mm
3rd century
Museum of Antiquities of the University and
Society of Antiquaries of Newcastle upon Tyne,
1956.151.47

Wooden dice shaker originally in the shape of a
waisted cylinder but now distorted. The species
of wood is so far unidentified but is probably
oak.

The most popular dice game in the Roman
period was throwing three dice together to get
the highest score. Dice were also used in *ludus
dudecim scriptorem, tabula* (later replaced by
alea) and in the Roman equivalent of Three
Men's Morris. See Bell 1960, 30–7. [L.A-J.]

69

70 71

72 Inscribed ring

Amiens, France
Gold; internal Dia. 25mm, bezel 16 × 10mm, W.
hoop 5mm, Th. hoop 1mm, Wt. 10.92g
Metal composition: gold 81.4 per cent; silver 13.1
per cent; copper 5.4 per cent
4th century
The Fitzwilliam Museum, Cambridge, GR. 1.1975
Bibl. Danincourt 1886, 88; CIL XIII.3, no.10024, 29b; Ogden
1992, fig.3, 263–4.

Illustrated on p. 79
Large, plain gold ring with rectangular bezel,
type and inscription as Henkel 1913, nos 100–2.
The inscription FIDEM CONSTANTINO is deeply
engraved, *fidem* on the bezel and *Constantino*
around the hoop. The engraving is deep enough
to have held niello inlay, but there is no sign of
its presence. The exterior, especially the bezel, is
heavily scratched. On the interior back of the
hoop, upside-down in relation to the main
inscription, a lightly but neatly incised graffito
of the four letters ILIX. The meaning of this
graffito is unknown, but it may be a name or
part of one.

The ring was found at Amiens in 1884. It is
one of a considerable number of rings and
fibulae known with this inscription. [C.J.]

73 Gold brooch with inscriptions

Piesport-Niederemmel, Germany
Gold; surviving L. 112mm, Wt. 75.5g; gold
content *c*.87 per cent
315/316
Rheinisches Landesmuseum Trier, inv.
no.1972.296
Bibl. Trier 1984, no.31 g.

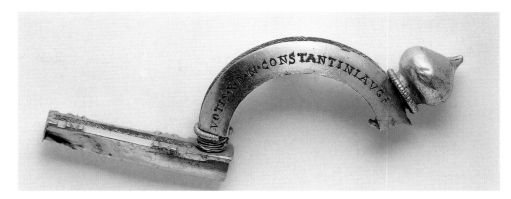

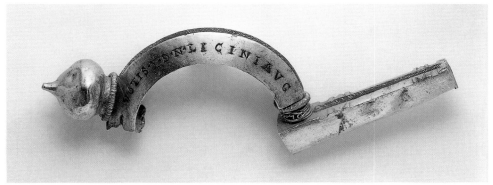

The fibula is a very large example of the late Roman crossbow type. The pin and cross-bar are missing. Engraved and niello-inlaid decoration runs centrally down the bow and foot, and each sloping side of the bow bears a neatly lettered inscription, also inlaid with niello.

(a) VOTIS·X·D·N·CONSTANTINIAVG

(b) VOTIS·X·D·N·LICINIAVG

These inscriptions permit the fibula to be dated precisely to the year 315/16, when Constantine I and Licinius I celebrated their *decennalia*, the tenth anniversary of their accession. This brooch is the largest example yet known of the 'Kaiserfibeln' presented by the emperor to high-ranking civilian and military officials on special occasions such as imperial anniversaries. The original owner, and presumably recipient, of this brooch was evidently named Servandus: this name is lightly incised on the underside of the bow.

The fibula may, like the glass cage-cup found at Niederemmel in 1950, have been part of a grave-group. Both objects provide evidence that a family with close connections to the imperial court lived in the locality, though the exact location remains unknown. [K-J.G.]

73

74 Pewter bowl

Aquae Sulis (Bath), 1878–9
Pewter, set with a coin in the centre of the bowl;
Dia. 150mm, H. 40mm
4th century
Roman Baths Museum & Pump Room, Bath and North East Somerset Council, BATRM 1983.14.C5

74

Bibl. Sunter and Brown 1988, 10–11 no.14; see also Kent and Painter 1977, 20–2.

This is a shallow, hemispherical bowl with beaded rim, possibly originally with a soldered footstand. Set in the centre is a bronze coin of Constantine depicting his laureate head and the legend: CONSTANTINVS AVG.

Although this cannot have been the product of any government directive, the bowl does resemble the silver bowls in the Munich Treasure made on the occasion of the *quinquennalia* (five-year anniversary) of Licinius II in 321/2. Vessels of this type must have been made for emperors (including Constantine) on other occasions for circulation amongst influential and important people. The Bath bowl is surely an unofficial, cheap version of such a vessel, made in Britain from the locally produced alloy, pewter, and exhibited by a supporter of Constantine who later dedicated it to Sulis Minerva in her sanctuary at Bath.
[M.H.]

75 Cameo

Provenance unknown
Agate; H. 100mm, W. 45.6mm, Wt. 94.3g
3rd–4th century
The Content Family Collection of Ancient
Cameos. Property of Philippa Content, PVC1-178
Bibl. Henig 1990, 105 and pl.xxxviii, no.178; Henig 1993a, 37, 38, fig.2.1.

This is a fragment, cut down from a major state-cameo and possibly set in the Middle Ages into a piece of ecclesiastical metalwork. It portrays two figures in full-length coats. Little of their bodies remains but they shake hands in token of their concord. That on the left is accompanied by an eagle, which stands to the right with its head turned left. An inscription below, probably of the Renaissance period, reading SEMPER . I . AVGVSTVS / FELIX . M . ANTONIVS identifies them as Augustus and Antony. The cameo has been ascribed to the Severan period; however comparison with the carving, especially of the eagle, with the Ada-Kameo in the Trier Stadtbibliothek (Trier 1984, 117–18, no.34) (fig.29) suggests a late third- or early fourth-century date during the Tetrarchy or the succeeding period when Constantine still had Licinius as a colleague.

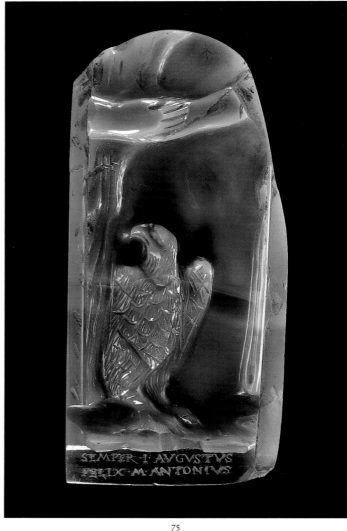

75

Large cameos such as this were often presents to supporters of the dynasty, and would perhaps have been set in frames and kept in their owners' private closets.
[M.H.]

76 Cameo

Provenance unknown
Agate; H. with frame 205mm, W. with frame 290mm; H. without frame 180mm, W. without frame 255mm
Second decade of 4th century; enamelled frame 17th century
Geld en Bankmuseum, Utrecht
Bibl. Zadoks-Josephus Jitta 1966, 9–97 and 101–3; Bastet 1968; Richter 1971, 122–3 no.600; *Spätantike und frühes Christentum*, 435–7, no.47.

Formerly in the Rubens collection and engraved by Paulus Pontius after a drawing by Rubens, for Fabri de Peiresc in 1624. It was lost in the wreck of the *Batavia* but recovered. Acquired for the Dutch Royal Collection in 1823.

Known as the Great Cameo, it shows Constantine standing in a chariot pulled by two bearded centaurs, in profile to the right. He is laureate and holds the thunderbolt of Jupiter in his right hand. Before him, facing left, is Constantine's wife Fausta, her head veiled as a bride and in the character of Juno Pronuba, or perhaps Ceres, holding the corn-ear and poppy head in her left hand. Behind Constantine is a woman, probably representing his grandmother Claudia, pointing at young Crispus, who stands in front, wearing cuirass and helmet, his left hand holding his sword scabbard.

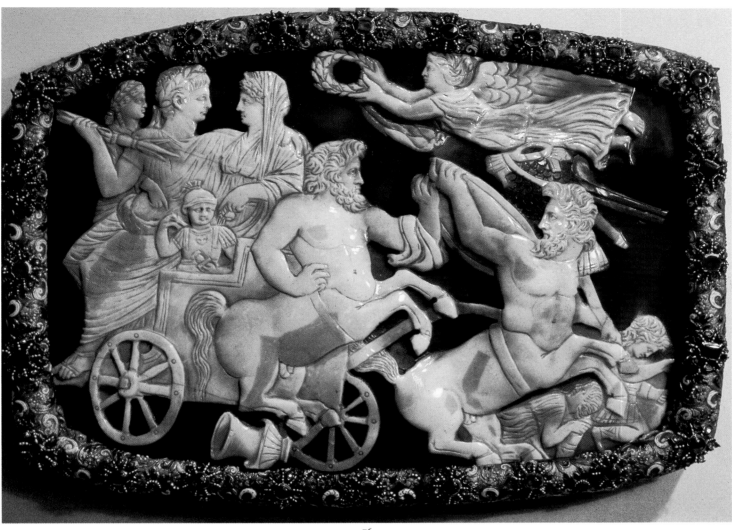

76

The centaurs are strikingly characterised. The foremost bears a trophy on his left shoulder and tramples two youthful figures. Both of these figures appear to be clean-shaven and the one lying beneath the belly of the centaur seems to be clad in a tunic. Thus they do not appear to be barbarians and may represent the supporters of Maxentius slain at the Battle of the Milvian Bridge. A cantharus, lying on its side, its neck and upper body plain, its lower part fluted, places the scene in a bacchic context; Constantine is thus, in a sense, also Neos Dionysos.

In the field above, a Victory flies towards Constantine holding out a laurel wreath. The deeply carved drapery and wings are reminiscent of the Victories on Constantine's Arch (fig. 4).

The manner in which the dynasty has been placed in a mythological context deliberately recalls the cameos of the Augustan and Julio-Claudian period, but the unevenness of the gem and the much later style of the carving leave little doubt that this is a work of Constantinian date and can probably be placed around the time of his *decennalia* in 315. [M.H.]

77 Cameo of Constantius I

Provenance unknown
Onyx; H. 40mm, W. 27mm
End of 3rd–early 4th century
British Museum, London, GR 1867.5-7.542

Bibl. Walters 1926, 342 no.3620; Miescher 1953, especially 101, pl.xviii, 2; Donati and Gentile 2005, 222–30, no.29; cf. Kleiner 1992, 406–7, fig.373.

The cameo, carved in high relief on a flat ground, depicts the draped bust of a clean-shaven man, distinguished by a high forehead, slightly furrowed brow, somewhat haggard cheeks, large eyes with drilled pupils, aquiline nose, slightly pouting lips and a prominent adam's apple. Above a fringe of short hair he sports a laurel wreath, identifying him as an emperor. His tunic is fastened by a brooch on the right shoulder.

The head is paralleled by alabaster heads, likewise laureate, in London, Oslo and Autun (this last from near Lyons); a fourth alabaster head was found at Riez. All are very close to images of the tetrarchs, and the western provenance of two of them is suggestive. Only the lack of beard militates against a confident identification with Constantius or (less

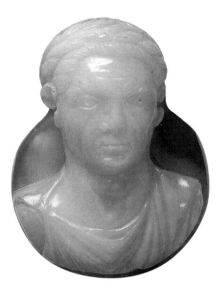

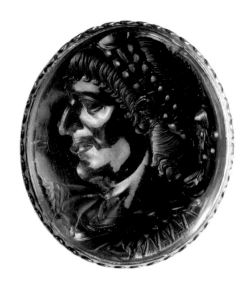

77

78

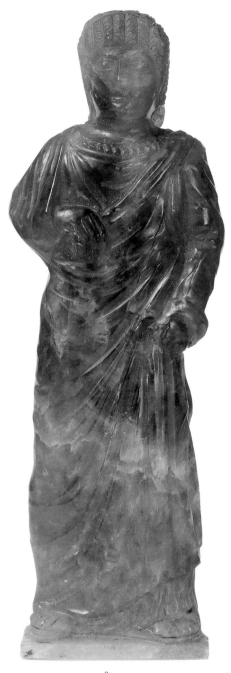

80

probably) one of his colleagues, but it should be noted that on sculpture, for instance the portrait in the Ny Carlsberg Glyptotek, this feature is only very lightly indicated and the gem-cutter may have been hesitant about roughening the polished surface of such a fine stone. The rather aged appearance suggests that if it is Constantius it shows him late in life, perhaps as Augustus in 305–6, immediately prior to the accession of Constantine. [M.H.]

78 Intaglio

Provenance unknown
Amethyst; H. 33mm, W. 28mm
4th century
British Museum, London, GR 1907.5-14.1

Bibl. Walters 1926, no.2032; Richter 1971, no.605; Donati and Gentile 2005, no.30 (and see no.31).

Bust of an emperor in profile to the left, wearing a jewelled diadem, cuirass and *paludamentum*. His hair, held in place by the diadem, ends in a fringe framing his face; at the back it is long and swept forward over the nape of his neck. His face is clean-shaven, with prominent nose and jutting chin, characteristic of the features of Constantine's son, Constantius II (337–61).

The gem follows a tradition of Constantinian portraiture on gems. A second amethyst intaglio in Berlin, with somewhat less pronounced features, is variously attributed to Constantine and Constantius II, though like the London

intaglio it was probably intended for the latter. What is certain is that it was Constantine and his advisers who decided on the general form of the imperial image appearing on these special gems, owned by people with close connections with the ruler. Doubtless the rich imperial purple of these jewels was of the utmost significance.

In the fourth century intaglios carved in hardstones increasingly fell out of use as signets, but the symbolic significance of certain types (imperial images or, in the religious sphere, Christian devices) remained high. [M.H.]

79 Medallion of 9 *solidi* of Constantine the Great

Helleville (Normandy) hoard, 1780
Gold; Dia. 48mm, Wt. 40.50g
Mint of Constantinople, 330
Geld en Bankmuseum, Utrecht, AM 11094

Bibl. *RIC* VII.577.44; Babelon and Van Kerkwijk 1906; MacCormack 1981, pl.47; Toynbee 1986, pl.v, no.6, n.198; Deperot 1987, 77.

Obverse: CONSTANTI–NVS MAX AVG. Diademed bust representing Constantine with draped shoulders.
Reverse: SALVS–ET SPES REIPVB–LICAE. Dynastic scene of Constantine haloed and enthroned in the centre, flanked by his sons Constantine II and Constantius II.
Mint mark: CONS.

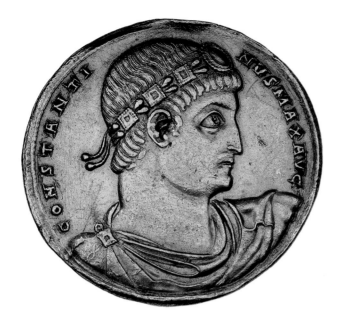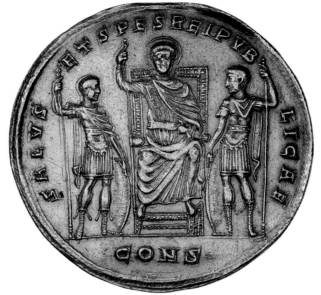

79

This may have been minted for 11 May 330 upon the formal consecration of the new capital. The attitude of the shoulders of the bust suggests the left arm is raised in salutation or benediction. Such a gesture may indicate oratorical contact of the emperor with his people in the form of a public address (*adlocutio*); it is also reminiscent of Sol's attitude of benediction (see cat.89). [R.A.]

80 Figurine of empress

Pontine Marshes, near Rome
Amethyst; H. 91mm
3rd–4th century
Victoria and Albert Museum, London, 281-1874
Bibl. Urlichs 1844; Franken 1999, 294–5, Abb 8a–c.

This figurine, carved in the round in a hard stone, probably amethyst, almost certainly portrays an empress for whom the purple colour is eminently suitable. She has long hair descending in ringlets down her neck and fringing her brows and face. Her coiffure is held in a place by a simple diadem. Low on her neck she wears a string of large stones, similar to some of the jewellery in the Beaurains Treasure (nos 48–58). She wears a full-length tunic with her sandalled feet projecting. Over the tunic she wears the *palla* from which her right hand emerges; her left arm is held close to her side.

It is not possible to be certain of the identity of this miniature carving, which is, however,

likely to date to the time of Constantine. [M.H.]

81 Glass bust of a prince of the imperial house

Cologne, Germany
Glass; H. 83mm, W. 63mm
Second half of the 3rd to first half of the 4th century
Römisch-Germanisches Museum der Stadt Köln, inv.no. RGM N 157
Bibl. Loeschcke and Willers 1911, 18, no.157, Taf.21; Fremersdorf 1967, 43, Taf.73; La Baume 1967, 271, no. D89, pl.XII; Hellenkemper 1987, 24, no.4; Salzmann 1990, 209–12, no.19, Abb.127–30; Hellenkemper 1990, 43–4, no.1c.3b

The small sculpture in opaque deep-blue glass is a portrait of a boy wearing the *toga contabulata*, an official state costume, and a *tunica*. The *balteus* (hemmed edge of the toga) is decorated with a stylised vegetal scroll with bunches of fruit. In the smooth back surface of the bust is a hollow, perhaps for locating an attachment. The broad oval head is carried on a thick neck and the facial features are fairly coarsely formed: he has wide, full cheeks with marked cheekbones, a long nose, heavy eyelids and widely spread eyebrows, a convex forehead and large, slightly projecting ears. On the back of his head, short strands of hair radiate from the crown.

The form and style of the glass bust suggests that it may have been intended as an *emblema*, a decoration in the round mounted in a bowl or

on a *phalera*, probably intended for presentation as an official gift (*largitio*). The opaque, brilliant blue glass might have been selected as a substitute for gemstone.

Many suggestions as to the boy's identity have been made, but the facial features are not distinctive enough to support certain identification. There is general agreement that the style indicates a date in the second half of the third century or the first half of the fourth. [H.H.]

82 *Aureus* of Carausius

Provenance unknown
Gold; Dia. 20mm, Wt. 4.31g
Mint of London, 293
British Museum, London, CM R11200
Bibl. *RIC* v.463.1; *PCR* 1137; Casey 1994, pl.4.6.

Obverse: CARAVSIVS P F AVG. Laureate bust, with shoulders of cuirass visible, representing Carausius.
Reverse: CONSERVAT AVG. Jupiter 'the protector' holding thunderbolt and sceptre, eagle at feet.
Mint mark: ML. [R.A.]

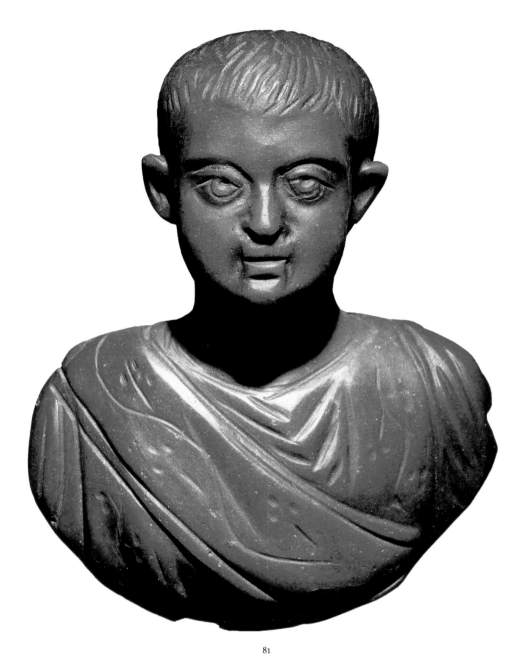

81

83 *Aureus* of Allectus

Provenance unknown
Gold; Dia. 20mm, Wt. 4.46g
Mint of London, 293
British Museum, London, CM 1864 11-28 179
Bibl. *RIC* v.558.4; *PCR* 1145.

Obverse: IMP C ALLECTVS P F AVG. Laureate bust, with drapery round shoulder visible (seen from back), representing Allectus.
Reverse: ORIENS AVG. Sol the sun-god and a captive.
Mint mark: ML. [R.A.]

84 Medallion of 10 *aurei* of Diocletian

Provenance unknown
Gold; Dia. 37mm, Wt. 53.5g
Mint of Nicomedia, 294
British Museum, London, CM 1867-1-1-865
Bibl. *RIC* vi.553.1; *PCR* 1202; Toynbee 1986, pl.xlviii, no.1; www.thebritishmuseum.ac.uk/compass.

Obverse: IMP C VAL DIOCLETIANVS P F AVG. Bare head representing Diocletian.
Reverse: IOVI CONSERVATORI. Jupiter 'the protector' holding statuette of Victory on a globe, eagle at feet.
Mint mark: SMN.

This is an example of the largest size of gold medallion known from tetrarchic times. The size enables the creation of a particularly powerful 'portrait' in the tetrarchic style. Shorn of any imperial regalia such as a laurel wreath, Diocletian is starkly presented as a forceful-looking but depersonalised caricature.

Like the ordinary gold coins of this year the reverse honours one of the guardian gods of the newly established tetrarchy, that of the eastern house of Diocletian and Galerius: the 'Jovians'. Minted at Diocletian's capital, it was possibly distributed for the occasion of the appointments of the new Caesars (1 March 294). [R.A.]

85 *Nummus* of the deified Constantius I

Provenance unknown
Argentiferous copper alloy; Dia. 26mm, Wt. 5.44g
Mint of Trier, 307–8
British Museum, London, CM B0475
Bibl. *RIC* vi.218.789; *PCR* 1232.

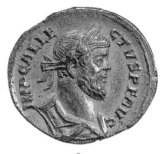

82

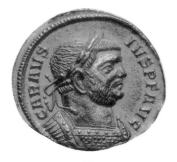

83

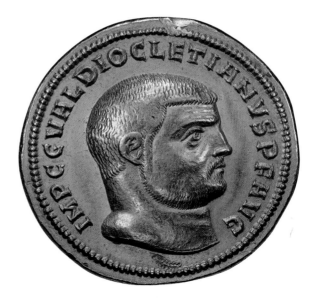

84

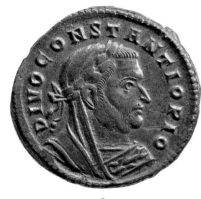

85

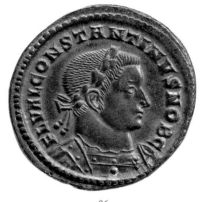

86

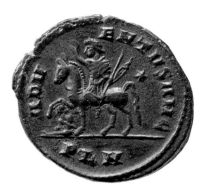

87

Obverse: DIVO CONSTANTINO PIO. Laureate bust representing Constantius with fold of toga drawn over head.
Reverse: MEMORIA FELIX. Eagle-flanked altar.
Mint mark: PTR.

Traditional deification followed the emperor's death at York on 25 July 306. During the following year Constantine issued the traditional memorial coinage showing the altar for the new god. His own death in 337 would mark the final example of this pagan practice, when his 'portrait', deified like his father, was to be coupled with a reverse of his chariot-propelled ascent to heaven (see fig.42). [R.A.]

86 *Nummus* of Constantine the Great

Provenance unknown
Argentiferous copper alloy; Dia. 26mm, Wt. 6.98g

Mint of Trier, 307
British Museum, London, CM B0488
Bibl. *RIC* VI.212.734.

Obverse: FL VAL CONSTANTINVS NOB C. Laureate bust representing Constantine with shoulders of cuirass visible.
Reverse: PRINCIPI IVVENTVTIS. Constantine as 'prince of youth' holding army standards.
Mint mark: S A // PTR.

Constantine is shown as Caesar, just prior to his elevation to Augustus later in the year. [R.A.]

87 *Nummus* of Constantine the Great

Provenance unknown
Argentiferous copper alloy; Dia. 24mm, Wt. 4.55g
Mint of London, 310–12
British Museum, London, CM B0095

Bibl. *RIC* VI.134.138; Casey 1978, 180, ill.5.

Obverse: CONSTANINVS P AVG. Bust representing Constantine, helmeted, upper part of cuirass visible and holding spear and shield.
Reverse: ADVENTVS AVG. Constantine on horseback, hand raised in greeting.
Mint mark: – * // PLN.

The arrival (*adventus*) of an emperor to a local community was marked with much pomp and ceremony. The most likely date for an imperial visit to Britain within the period of this particular mint mark is regarded by Casey as the summer of 312. London *adventus* coin types are also known for the summer of 307 (*RIC* VI.129.82), as well as 313–14 (*RIC* VII.97.1) and 314–15 (*RIC* VII.98.21), probably indicating a third visit in the good sailing months (April–October) of 314. [R.A.]

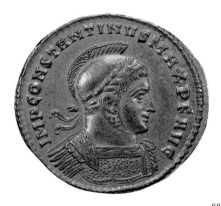

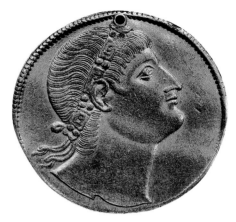

88

91

88 Medallion of 2 *solidi* of Constantine the Great

Provenance unknown
Gold; Dia. 25mm, Wt. 8.56g
Mint of Ticinum (Pavia), for 25 July 315
British Museum, London, CM 1896 6-8 99
Bibl. *RIC* VII.362.25; *PCR* 1294; Toynbee 1986, pl.XXXI, no.3.

Obverse: IMP CONSTANTINVS MAX P F AVG.
Laureate, cuirassed and helmeted bust
representing Constantine.
Reverse: VICTORIAE LAETAE AVGG NN. Two
Victories holding a shield inscribed VOT X over
an altar inscribed VOT XX.
Mint mark: SMT.

Contemporary with the famous Arch of
Constantine at Rome (fig.4), this medallion
contains similar messages. The reverse records
vows upheld over the past ten years (up to 25
July 315) and those offered up to take the
emperor to the twentieth anniversary. The
legend commemorates the 'joyful victories' of
'our emperors'. The Arch tacitly recognised
Constantine's then partner Licinius. [R.A.]

89 *Solidus* of Constantine the Great

Provenance unknown
Gold; Dia. 18mm, Wt. 4.48g
Mint of Ticinum, 316
British Museum, London, CM 1863 7-13 1
Bibl. *RIC* VII.368.53; *PCR* 1295.

Obverse: COMIS CONSTANTINI AVG. Busts of Sol
the sun-god (emanating solar rays) and
Constantine (laureate) shoulder to shoulder.
The latter holds a globe and raises other hand in
salutation.

Reverse: LIBERALITAS XI IMP IIII COS PP.
Liberalitas (imperial largesse).
Mint mark: SMT.

Constantine is shown and described as the
'companion' of the sun-god on a coin minted
nearly four years after his reported vision on the
eve of the Battle of the Milvian Bridge. The
emperor copies Sol's characteristic gesture of
benediction seen on the most common coins
(copper alloy *nummi*) of Constantine until 317.
[R.A.]

90 *Solidus* of Constantine the Great

Provenance unknown
Gold; Dia. 19mm, Wt. 4.28g
Mint of Ticinum, 1 January 316
The Ashmolean Museum, Oxford, Arthur Evans
Bequest 1941
Bibl. *RIC* VII.366.41; Howgego 1995, no.176.

Also illustrated on p. 00

Obverse: CONSTAN−TINVS P F AVG. Haloed,
facing bust representing Constantine.
Reverse: FELICIA TEMPORA. The four seasons
represented as small boys. Legend = 'happy
times'.
Mint mark: ·T·.

Although from the seventh century it came to be
associated exclusively with representations of
Christ and Christian saints, the halo (or
nimbus) first appears as imperial iconography
on coins of the pagan Diocletian and his
associates. The *Panegyric of Maximian* (*Pan.Lat.*
x(2).3.2) flatters the emperor with the
suggestion of 'that light which surrounds your
divine head with a shining orb'. However, the
nimbus should be seen as an equally traditional

alternative to the more familiar 'radiate' image
used by Hellenistic kings and Roman emperors
(for example cat.89) which suggests solar rays
emanating from the head in a visual
demonstration of divine power. The seasonal
reverse suggests the occasion of the New Year,
with its opportunity for imperial largess. [R.A.]

91 Medallion of 2 *solidi* of Constantine the Great

Provenance unknown
Gold; Dia. 28mm, Wt. 8.14g (pierced for
suspension)
Mint of Nicomedia, 327
British Museum, London, CM 1853 5-12 218
Bibl. *RIC* VII.622.133; Toynbee 1986, pl.XXXV, no.3.

Obverse: diademed head of Constantine looking
upwards.
Reverse: GLORIA ROMANORVM. Roma holding
Victory statuette and sceptre.
Mint mark: SMN.

Constantine's coinage indicates the adoption of
the diadem in 324. It first appeared in its
classical Greek form as a simple cloth strip,
borrowed from the iconography of Alexander
the Great (see also cat.94), but quickly
developed into jewel-encrusted regalia. The
upward glance of the head, with its straining
neck, is another quotation from images of
Alexander. In a Constantinian context the image
was reinterpreted as the emperor in the *orans*
position of early Christian prayer, with upcast
face. This 'praying Constantine' coin design is
mentioned in the contemporary writings of
Eusebius (*VC* IV, 15). [R.A.]

92 *Nummus* of Constantine the Great

Provenance unknown
Argentiferous copper alloy; Dia. 18mm, Wt.
2.96g
Mint of Constantinople, 327
British Museum, London, CM 1890 8-4 11
Bibl. *RIC* VII.572.19; *PCR* 1309; Bruun 1997, pl.19, no.7.

Obverse: CONSTANTINVS MAX AVG. Laureate
head representing Constantine.
Reverse: SPES PVBLIC. Christogram-topped
standard (*labarum* or *vexillum*) with shaft
piercing serpent. Legend: 'public hope'.
Mint mark: A –//CONS.

Constantine's standard pierces a serpent
representing his defeated rivals. This is the first
coin type where the design explicitly proclaims
Constantine's new faith, showing his
Christogram standard. Christograms had made
a subtle appearance prior to this as an
occasional mint mark of Ticinum of 319–20.
(There is also a rare silver medallion type of
about 315 from this mint, *RIC* VII.364.36, which
on some examples appears to show a tiny
Christogram badge on the emperor's helmet.)
See also the Christogram coin of Magnentius,
cat.95.

The standard's banner bears three discs that
would have carried imperial images (described
by Eusebius: *VC* I, 28–31). These represented
Constantine himself and his two sons,
Constantine II and Constantius II, who were
junior emperors at the time. The mint of
Constantinople had already begun by about 326,
in advance of the city's official foundation in
330. [R.A.]

93 Medallion of Helena

Provenance unknown
Copper alloy; Dia. 38mm, Wt. 41.93g
Mint of Rome, 324–6
British Museum, London, CM 1872 7-9 430
Bibl. *RIC* VII.323.248.

Obverse: FLAVIA HELENA AVGVSTA. Diademed
and draped bust representing Helena.
Reverse: PIETAS AVGVSTES. Pietas and children.

This medallion was probably distributed to
commemorate Helena's promotion to the rank
of empress, after Constantine became sole
master of the Roman world in 324. [R.A.]

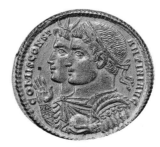

89

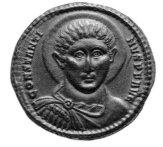
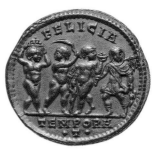

90

92

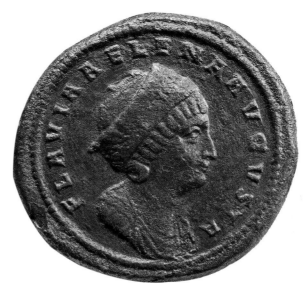

93

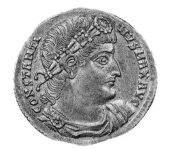
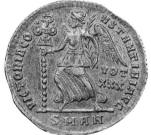

94

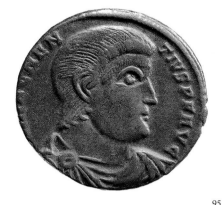
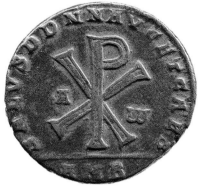

95

94 *Solidus* of Constantine the Great

Provenance unknown
Gold; Dia. 19mm, Wt. 4.45g
Mint of Antioch, for 25 July 335
British Museum, London, CM 1863 7-13 2
Bibl. *RIC* VII.694.96.

Obverse: CONSTANTINVS MAX AVG. Diademed
bust representing Constantine with shoulders of
cuirass and cloak visible.
Reverse: VICTORIA CONSTANTINI AVG // VOT
XXX. Victory.
Mint mark: SMAN.

This coin records Constantine's thirtieth
anniversary (*tricennalia*). In his final 'portrait'
type his hair is now shown longer, a fashion
possibly inspired by Alexander the Great. [R.A.]

95 *Nummus* of Magnentius

Provenance unknown
Argentiferous copper alloy; Dia. 26mm, Wt.
9.30g
Mint of Amiens, 350
British Museum, London, CM 1935 11-17 770
Bibl. *RIC* VIII.123.34.

Obverse: D N MAGNENTIVS P F AVG. Bust
representing Magnentius with shoulders of
cuirass and cloak visible.
Reverse: SALVS DD NN AVG ET CAES.
Christogram.
Mint mark: AMB.

The Christogram is shown as the whole
design on a coin of the short-lived usurper
Magnentius, hoping to exploit the popularity
of Constantine and his victorious symbol.
The cipher is shown in its fullest form: the
first two letters of Christ's name in Greek, Chi
and Rho, are superimposed to form the main
symbol. Flanking this are A and ω (an
alternative to Ω): Alpha and Omega,
symbolising God. See also the *labarum* coin,
cat.92. [R.A.]

Centres of administration

96 Fragment of the *Notitia Dignitatum*

Italian, Neapolitan?
Vellum; 260 × 205mm
Latin; 13 July 1427
The Fitzwilliam Museum, Cambridge, MS 86-
1972
Bibl. Omont 1891; Alexander 1976; Wormald and Giles 1982;
Alexander 2002; Maier 2005.

These five single folios are fragments of a
manuscript book that Antonius Angeli, from
Aquila, copied in 1427 from a manuscript
belonging to the library of the cathedral chapter
at Speyer. Angeli's copy subsequently belonged
to Cardinal Giordano Orsini (d.1438), the royal
library in Naples, the Carthusian Monastery of
Aula Dei at Zaragoza (before 1580), Gaspar de
Guzman (from 1626 to 1645), Gaspar de Haro y
Guzman (d.1687), the Convento del Angel de los
Carmelitos Descalzos at Sevilla (after 1687) and
the Couvent des Augustins déchaussés de la
Croix-Rousse at Lyon (before 1715). Around 1715,
it was obtained either by Thomas Coke
(Holkham Hall) or his tutor Thomas Hobart
(Cambridge) or by Henry Lee-Warner
(Walsingham Abbey) and brought to England.
The five leaves were sold by Puttick and
Simpson in 1861 to Guglielmo Libri and again by
Sotheby's in 1862 to Sir Thomas Phillipps. They
were acquired by Francis Wormald in 1948 who
bequeathed them to the Fitzwilliam Museum,
where they arrived in 1972.

The five leaves are a copy of the so-called
Notitia Dignitatum, which was ultimately
derived from an original compilation assembled
about 400. The page on display (fol.3r) contains
the picture and text relating to the western
*magistri scriniorum memoriae, epistolarum,
libellorum* (masters of the palace bureaus of
memorials, correspondence and records) who
managed imperial correspondence,
appointments to civil and military offices in the
imperial service below the rank of provincial
governor and associated registry functions.

The picture has the caption *Magister
scriniorum* and the upper part shows three pairs
of covers (front and back?) each representing
the *codicilli* (appointment document) of one of
the three masters identified by the subscript
caption *memoriae, epistolarum, libellorum*. One
cover in each pair is inscribed *FL. INTall.
COMORD. PR.*, the alternate cover either *FL.*

Memoriae epistolax rlibellox:

97

uale. COSTRL: iuss. dd: (first) or *FL. uale. mag. ep. iussu. dd:* (second and third). In the lower part of the picture are four sets of documents, each comprising a book and scrolls, with the fourth set showing Greek lettering on an open book and open scroll.

These four sets of documents illustrated correspond closely to four such sets in the almost identical picture preceding the text relating to the four eastern *magistri scriniorum*, where the first three masters are the same as those in the west but are augmented with a fourth, a *magister epistolarum graecarum* (master of Greek correspondence), whose existence is reflected in the four *codicilli* in the upper part of the picture.

Thus, while the eastern picture shows four *codicilli* covers and four sets of documents which, therefore, clearly represent the activities of the four masters listed in its text, this western picture shows the same four sets of documents, but only three *codicilli* covers and three masters in its text – there is no master of Greek correspondence despite the fourth set of documents containing a book and scroll with Greek inscriptions.

This apparent discrepancy arose either because the western text is now deficient (it has no equivalent to the last item in the eastern text which mentions the assistants that the masters selected from the palace departments) or because the artist of the western picture simply copied the eastern one, reducing the number of *codicilli* but not the sets of documents. In either case, the artist saw no conflict between the three *codicilli* and the four sets of documents and there is probably a simple organisational explanation.

While all four masters, in both east and west, are called *magistri scriniorum*, there is no reference to a *scrinium epistolarum graecarum* anywhere within the so-called *Notitia* itself nor within any of the law codes, leading to the conclusion, first, that the master of Greek correspondence must have been a subordinate within the department of correspondence in the east and, second, that this department was represented in the eastern picture by two sets of documents.

The western picture suggests that the department of correspondence there carried out the same two functions as in the east, but,

because of the lesser volume of translations, no subordinate master of Greek correspondence was required, as attested by the number of *codicilli*.

The text below the picture states:

Magister memori*ae* annotat*io*n*es* om*nes* dictat et emittit respond*et* tam*en* et precibus.
'The master of memorials: formulates and issues all *adnotationes* (imperial notes in the margins of petitions) and responds to petitions.'

Magister epistolar*um* legati*o*n*es* civitat*um et* con*su*l*t*ationes et preces tractat.
'The master of correspondence: manages deputations from cities and *consultationes* (imperial answers to officials about legal matters) and petitions.'

M*agiste*r libell*o*r*um* cogniti*o*n*es* et preces tractat.
'The master of records: manages *cognitiones* (records of imperial judgements) and petitions.'

[I.M.]

97 Fragment of sarcophagus lid

Mertesdorf, near Trier
Local sandstone; H. 320mm, L. 720mm, D. 360mm

98

99

*c.*300

Rheinisches Landesmuseum Trier, G 37P

Bibl. Hettner 1893, 137, no.314; Cüppers 1969, 290, Abb.12; Trier 1984, 97, no.19.

The fragment comes from the central section of the sarcophagus lid. A rectangular block projects from the sloping top of the cover and forms a niche for the portraits of a man and wife carved in high relief. Their right hands are clasped (*dexterarum iunctio*) to symbolise the union of marriage.

The woman wears a *stola*, and her hair is dressed in the *Scheitelzopffrisur*, a style made fashionable by Helena, the mother of Constantine. It consists of a wide plait drawn together at the nape of the neck, brought up over the back of the head to the forehead, and then tucked under. This version of the hairstyle, which leaves the ears uncovered, was popular from about 270 to 310.

The man wears a toga with a somewhat inaccurately depicted *contabulatio*, a broad, very stiff panel of cloth crossing from the right armpit to the left shoulder. The fact that the man is represented in the official formal dress, the toga, indicates he was of high social and political standing. In his left hand he holds a scroll. His beard and hairstyle date the relief to around 300.

The style of the late Antique sarcophagi in the Rhine–Mosel region is closely related to that of earlier Gallo-Roman funeral monuments and is quite different from south Gaulish and Italian work. Decorated sarcophagi, and those with inscriptions, were often reserved for members of the upper levels in society. [L.S.]

98 Corinthian pilaster capital

Trier, Basilica of Constantine
Marble; H. 385mm, W. 250mm
First half of the 4th century
Rheinisches Landesmuseum Trier

Bibl. Trier 1984, no.56c e.

The Corinthian capital, made of a coarse-grained white marble, is part of the inner decoration of Constantine's audience hall. Together with other parts of the original wall covering it was found at the beginning of the nineteenth century during the restoration of the building. It remains uncertain whether it belonged to the decoration of the vestibule or the throne hall itself. Only the left half of the pilaster capital is preserved. From an eight-leaved blossom beside the central axis emerges a small hare with long ears. The graphic and less plastic form of the lance-shaped acanthus leaves is typical for the art of the early fourth century in Trier. [T.H.M.F.]

99 Acanthus frieze

Trier, Basilica of Constantine
Marble; H. 310mm, W. 180mm
First half of the 4th century
Rheinisches Landesmuseum Trier

Bibl. Trier 1984, no.56c f.

The fine-grained white marble of the acanthus wreath testifies to the high quality of the inner decoration originally adorning the imperial audience hall in Trier. The fragment of acanthus scroll is bordered by an angled moulding. It is impossible to say whether the fragment is from a horizontal frieze on the wall or whether it was part of the embrasure of a window or niche. [T.H.M.F.]

100

100 Ceremonial lance with inlaid decoration

Trier, found in the River Mosel
Iron with copper and brass inlay; L. 315mm, Dia.
of socket 34mm
4th century
Rheinisches Landesmuseum Trier, EV 1978, 5
Bibl. Trier 1984, no.155 c.

The almost complete lancehead is decorated
with inlaid ornament in copper and brass.
Around the socket the upper of two inscribed
brass bands is preserved; it bears the words
ANBIANIONI·VIVAS. On the spearhead itself,
ring-and-dot and triangular leaf motifs are
inlaid in brass on either side of the midrib.
Above these are two curved lines in copper and
two very stylised human busts, looking inwards
towards each other. Their torsos are inlaid in
copper and their heads in brass. It is uncertain
whether they are intended to represent tetrarchs
or two pairs of emperors.

It would seem that the owner of this display
weapon belonged to the tribe of the Ambiani,
from which, according to the *Notitia Dignitatum*
(cat.96) special cavalry units were recruited at
this period. [K-J.G.]

101 Glass vessel

Trier, from a Roman house south of the
Kaiserthermen
Glass; rim Dia. *c*.220mm
4th century
Rheinisches Landesmuseum Trier, 914
Bibl. Trier 1984, no.83.

The fragment from a very thick glass vessel is
decorated with an engraved representation of a
chariot race in the circus. Below the four
grooves that encircle the rim are the spectators,
sitting beneath an arcade decorated with
garlands. A charioteer, wearing protective
clothing and helmet and brandishing his whip,
drives his four-horse chariot (*quadriga*) to the
left. The driver and horses of a second chariot,
which has already passed the turning posts
(*metae*), appear below; the *metae* are small
obelisks surmounted with spheres. To the right
is shown the beginning of the wall that marks
the centre line of the arena (*spina*), on which
stands a statue of a naked dancing satyr, one of
the sculptures that often embellished these

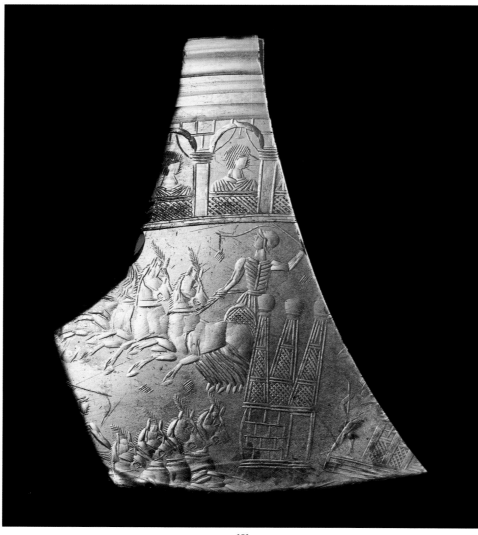

101

features of the ancient arena. The outstanding quality of the workmanship of this vessel suggests it was manufactured in an Italian workshop. [T.H.M.F.]

102 Contorniate with inlaid decoration

Trier, found in the amphitheatre
Brass with silver, copper and niello inlay; Dia. 43mm
4th century
Rheinisches Landesmuseum Trier, 09,864
Bibl. Trier 1984, no.81.

Unlike the majority of contorniates, which are struck or carved, this example is decorated on both sides with inlay work in contrasting metals. The obverse depicts a charioteer with a whip standing between two large containers of palm branches. In a *tabula ansata* (label with triangular projections) on the upper right is engraved the name PORFYRI. On the reverse is a frontal representation of a four-horse chariot (*quadriga*). The charioteer has a whip and palm branch. He has lost his helmet, which appears to the right of the scene. A silvered *tabula ansata* in the upper left reads PVRFYRI, and another, below the scene and along the ground-line, is inscribed FONTANVS. The name Porphyrius appears frequently as the name of a victorious charioteer; Fontanus may well have been the name of the lead horse of the team. [K-J.G.]

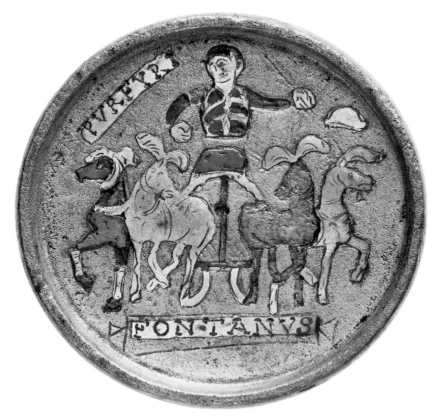

102

103 A Christian funerary inscription, for the palace official Probatius

Trier, Church of St Maximin
White marble; H. 580mm, surviving L. 590mm (originally *c.*950mm); D. 25mm
4th century
Rheinisches Landesmuseum Trier, 53,167
Bibl. Gose 1958, 66, no.454; Gauthier 1975, 384f., no.148; Trier 1984, 225ff., no.110.

This funerary inscription for a palace official, Probatius, is one of the most spectacular of its kind from Trier, outstanding in terms of its size, its elegant lettering and the formula of the text:

In hoc [sepul-]	In this grave
cro i[acet]	lies
Proba[tius]	Probatius,
palati[nus]	the palace officer,
v(ir) p(erfectissimus)	the *vir perfectissimus*

The strictly symmetrical layout is helpful in reconstructing the full text. In general, the opening formula using the term *sepulcrum* is known in the Rhineland only in funeral poetry prior to the seventh century. By the fourth century, inscriptions from the area surrounding the imperial residence refer only to public professions in the civil administration, the military or the religious life. It was no longer usual, as it was in the third century, to mention other, private, trades and professions on gravestones.

Beneath the inscription, part of a series of Christian symbols is preserved. On the left is a dove or peacock facing right and holding a branch in its beak. In the centre is an A (alpha), two small six-pointed stars and part of a Constantinian Chi-Rho monogram. The group would have been completed with an omega and corresponding bird facing inwards on the left.

More than half of the early Christian inscriptions from Trier include a Chi-Rho monogram and/or doves. In Rome the sacred monogram is recorded from 323. The earliest Trier inscriptions from the southern cemetery often lack the symbols.

Probatius evidently belonged to the large group of *palatini* employed in the imperial court. His exact position is not specified, but his post may have been involved in the administration of Constantine's family's private property or in the financial administration. The abundance of early Christian inscriptions from Trier has provided us with information about a series of officials at the imperial residence. Most of the inscriptions are from the cemetery around St Maximin, in the north of the city; from about 320 this was the most important of the Trier cemeteries. [L.S.]

103

104

104 A Christian funerary inscription, for Amantia

Trier, Church of St Maximin
White marble; H. 550mm, L. 930mm, D. 40mm
4th century
Rheinisches Landesmuseum Trier, Reg. 90
Bibl. Gose 1958, 50ff., no.406; Gauthier 1975, 284ff., no.99; Trier 1984, 226ff., no.111.

Like others in the extensive group of early Christian inscriptions from Rome, North Africa and southern Gaul, early Christian inscriptions in Trier normally follow a standard wording with a formulaic introduction and indication of the age of the deceased. It is obvious that the inscription to Amantia does not conform to that pattern. The large size of the marble slab, the elegant lettering and the well-proportioned panel lend the inscription a monumental character.

The unusual text demonstrates an attempt to achieve a trochaic verse metre: *Hic Amant/iae in pace / hospita c/aro iacet*. 'Here lies in peace the body that granted Amantia hospitality' or 'Here lies in peace the body of Amantia, as though a guest'.

The distinctive and individual concept of the inscription implies personal authorship, rather than the reproduction of a set pattern of words. Two slightly different meanings can be read into the verse, no doubt consciously and deliberately. The second interpretation, that of the body resting only temporarily in the grave, is a Christian idea. The first meaning, on the other hand, corresponds with the ancient pagan belief that the body provides a home for the soul only for the short period of life. With its implied musings on the roles of body and soul, as with its visual presentation on the marble slab, the inscription has a highly individual air.

Below the lettering is an arrangement of Christian symbols that, like the inscription itself, is of unusual type. It depicts two doves flanking a monogram cross enclosed within a stylised wreath.

The deceased woman, Amantia, and the person who commissioned this monument to her would have belonged to the educated upper class that was close to the imperial court. [L.S.]

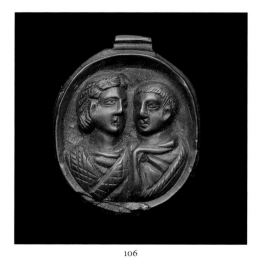

106

105

105 Plaster fragment with Chi-Rho

Trier, Germany: from the south-east basilica
Plaster H. 560mm W. 460mm
Bischöfliches Dom- und Diözesanmuseum Trier,
418,13-14
Bibl. Kempf 1965, 230, no.24 II 13–14; Binsfeld 2004, 235–52.

Two large fragments, not conjoined, of plaster
from a screen wall in the early Christian south-
east basilica associated with the Trier
Liebfrauenkirche. Together with a smaller third
fragment, they can be reconstructed to show a
double line forming a Chi-Rho monogram,
scratched on the plaster while it was still partly
damp.

Mounted with these pieces are other, similar
examples, together with graffiti of names,
invocations to Christ and *vivas* inscriptions.
These must be counted amongst the most
important testimonies of Christian belief from
the extensive complex of early Christian
buildings in Trier. This older screen wall was
probably erected in the middle of the fourth
century, and divided the chancel of the south-
east basilica from the nave. Around AD 380 it
was replaced by a new screen on which members
of the congregation also scratched graffiti.
[W.W.]

106 Pendant

York
Jet; H. 50mm, W. 39mm
Late 3rd–4th century
York Museums Trust (Yorkshire Museum),
YORYM: H2442
Bibl. Allason-Jones 1996, 25, no.5.

Oval pendant with a polished back; the front has
faded to a dull, deep brown finish. A rectangular
suspension tube with two transverse grooves
runs along the top. The front edge of the
pendant is raised to enclose the busts of a man
and a woman facing slightly towards each other.
The woman is the larger of the two figures and
wears her hair in a manner reminiscent of the
Medusa pendants. Her back hair is caught at the
nape and cross-hatched lines may suggest she
wears a snood or hair net. She is wearing a
draped garment under an outer coat, the
decorated edges of which cross over her chest.
The man stands to her left and wears a cloak
apparently fastened by a disc brooch. A
decorated band runs across his chest from his
left shoulder.

 This is the only jet pendant from Roman
Britain to show a posed couple rather than an
embracing couple and can be compared to a
number from Germany (Hagen 1937, nos E23,
E25, E26, Taf.31). One couple on a pendant from
Cologne has a laurel bough between them,
which may be an interpretation of the band on
the chest of the York man (Hagen 1937, no.E24).

 Three types of jet pendant are known in
Roman contexts: those with the head of Medusa;
those with a portrait of an individual, couple or

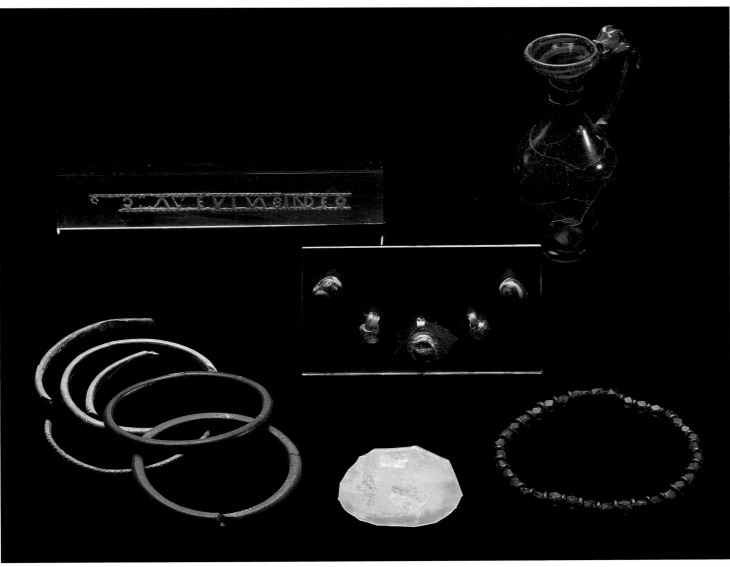

107

family group; and a third with a mythological scene. The pendants showing a couple, usually embracing, are often referred to as 'betrothal pendants'; the York couple, however, are rather stiffly posed and this may record a special occasion, such as a wedding anniversary, rather than a betrothal. It is possible that the recognised magical powers of jet were being invoked in order to keep evil away from the couple but, equally, this may be the Roman equivalent of carrying a family photograph in one's locket. Although the majority have been found in graves, the evidence of wear indicates that these were worn for considerable periods of time by their owners and were not simply made for the grave.

The rarity of jet pendants in the Roman world may imply that they were all the product of a single workshop; however, recent analysis has shown considerable variation in the sources of the material used as well as considerable individuality in style and skill of manufacture (Allason-Jones and Jones 2001). [L.A-J.]

107 Sycamore Terrace, York

The following items were found in 1901 in a grave at the north end of Sycamore Terrace, York. The stone coffin contained the skeleton of an adult, presumably female given the jewellery that accompanied it and the greeting on the bone mount. The principal publication of this

group is RCHMY 1, 73, fig.58, with colour illustration of complete groups in Ottaway 2004, pl.13. The bibliographies given below relate to the particular items.

107a Funnel-mouthed jug

Deep-blue glass with many tiny bubbles; H. 123mm
4th century
York Museums Trust (Yorkshire Museum),
YORYM: H12
Bibl. Harden 1962, 140, pl.67.

It has a fire-rounded rim edge and a trailed base ring.

107b Mirror

Greenish colourless glass; Dia. *c*.58mm
4th century
York Museums Trust (Yorkshire Museum),
YORYM: H11

Slightly convex with chipped edges.

107c Bracelet

Deep-blue glass; bead sections 5mm
4th century
York Museums Trust (Yorkshire Museum),
YORYM: H10.5

Thirty-seven diamond- and triangle-faceted
cubic beads and 34 short cylindrical beads.

107d Bracelets (two)

Jet; internal Dia. 68mm and 65mm
4th century
York Museums Trust (Yorkshire Museum),
YORYM: H9.1 and H9.2
Bibl. Allason-Jones 1996, 34, no.105; 35, no.127.

Both are plain annular bracelets.

107e Bracelets (four)

Elephant ivory; internal Dia. of most complete
example 68mm
4th century
York Museums Trust (Yorkshire Museum),
YORYM: H10.1, H10.2, H10.3, H10.4

Fragments of four examples now extant, but five
recorded originally. One (H10.1) with diagonal
grooves on outer face.

107f Earrings (two)

Light-yellow/brown glass; L. 14mm and 12.5mm
4th century
York Museums Trust (Yorkshire Museum),
YORYM: H8.1 and H8.2
Bibl. Allason-Jones 1989, 135, nos 581–2.

These have a looped trail with one end spiralling
around the other.

107g Two pendants

One silver, one copper alloy; L. 20mm and
18mm
4th century

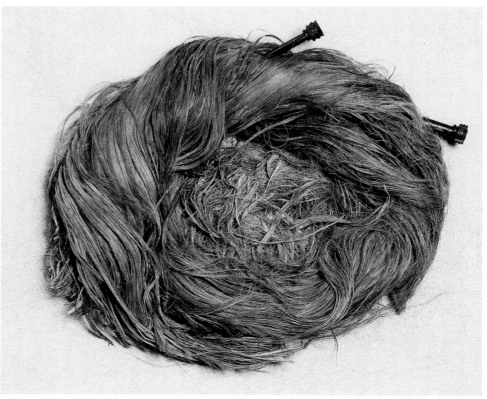

108

York Museums Trust (Yorkshire Museum),
YORYM: H6.1 and H6.2

Each consists of a flattened hemisphere at either
end of the strip, bent in half to form a closed
amulet.

107h Two beads

Glass; Dia. 15mm
4th century
York Museums Trust (Yorkshire Museum),
YORYM: H8.3 and H8.4

Very dark glass appearing black with opaque
yellow marvered trails. One also has three slices
of blue canes acting as eyes.

107i Openwork mount

Bone; L. 134mm, H. 9mm
4th century
York Museums Trust (Yorkshire Museum),
YORYM: H5
Bibl. *RIB* II.3, no.2441.11, with references to earlier
publications.

Letters spell out the words
S(OR)ORAVEVIVASINDEO (*Soror ave vivas in deo*).

This burial has attracted attention because of the
inscription on the bone mount. This translates as
'Hail sister, may you live in God', an eminently
Christian sentiment. The presence of the other
items, though, is thought to be at odds with the
identification of the woman as a Christian. She
was clearly wealthy, as not only was she buried in
a stone coffin but she also had access to
uncommon and probably costly items. She had
several elephant ivory bracelets, and ivory is a
rare material in Britain with well under a
hundred items recorded from the whole of
Roman Britain (Greep 2004). The glass earrings
are unique in Britain, while the little blue jug was
probably an import from the Rhineland. The
only places where similar jugs have been found
in any numbers are Cologne and Trier, though
this example has self-coloured trails and handle
as opposed to the opaque white details of the
German examples (Haberey and Röder 1961,
137–8). Given the other items in the grave are
jewellery and toilet equipment, it is likely that it
was a container for cosmetics or perfumes.

Late in the fourth century there are major
changes in female jewellery fashions, with
bracelets outnumbering hairpins for the first
time. Bone bracelets and unusual beads are also

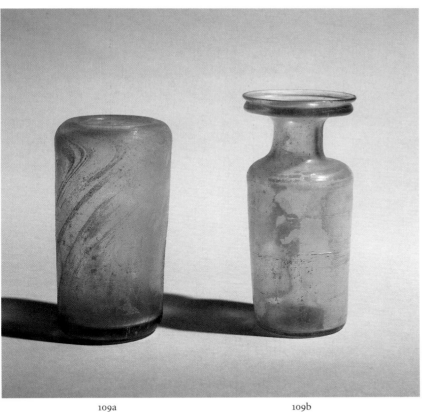

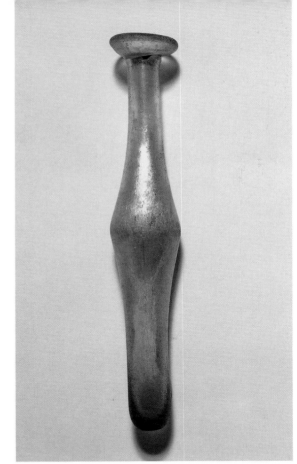

109a 109b 110

often found at this period (Cool 2000, 48–51). The Sycamore Terrace woman's parure includes ivory bracelets and unusual black beads, and she did not dress her hair with the aid of hairpins. This suggests she lived in the second half of the fourth century. Interestingly, the fact that she did not dress her hair in an elaborate style requiring hairpins may provide an additional clue to her religious allegiance. The early Church Fathers were obsessed by the way women wore their hair. Taking their authority from various passages in the Epistles of St Paul (for example I Corinthians 11. 5–15; I Timothy 9, I Peter 3.3), authors such as Tertullian and Jerome raged against elaborate hairdressing styles and commended veils (for example Tertullian, *On the Apparel of Women* 2.5; *On the Veiling of Virgins* 18; Jerome, *Letter to Marcella* 38 4.2). One explanation for the decline in the use of hairpins in the later fourth century may well be the spread of Christianity as more women wore veils. The Sycamore Terrace woman would definitely have been wearing her hair in a way the local bishop would have approved of, even if he lamented that a member of his flock was still so wedded to worldly goods that she took her jewellery and toilet items with her to the next world. [H.E.M.C.]

108 Hair and jet pins

York, Railway Station Booking Office site
Human hair and jet; L. of pins 63mm, 86mm, heads 8 × 5mm
Late 3rd–early 4th century
York Museums Trust (Yorkshire Museum),
YORYM 1995.248–9
Bibl. RCHMY **1**, 83; Allason-Jones 1996, 22, 39, nos 180–1.

Bun of auburn hair found with two jet hairpins *in situ* in a stone coffin orientated north–south with its head facing south. The coffin was lined with lead sheet, which would have aided the survival of the hair, as would the gypsum filling. The lid of the lead lining was decorated with a cord pattern (RCHMY **1**, 83). The body was that of a young girl who was probably in her mid-teens when she died.

The pins are both of the 'cantharus head' type. A *cantharus* was a two-handled drinking cup of Greek origin, which was considered during the Roman period to be sacred to the god Bacchus, the god of wine, who was also worshipped as a saviour god who could lead the dead to an afterlife of triumph. The *cantharus* was also used as a motif in early Christian art, signifying the fount of eternal youth or, more

specifically, the Christian eucharist (Hutchinson 1986, 179). Unfortunately it is not possible to differentiate between a Christian and a Bacchic cantharus motif.

This type of pin is almost entirely confined to the late Roman burials in York with only a few examples being found elsewhere in Britain (see Allason-Jones 1996, 39). The lack of examples on the Continent may suggest that they were a local product and the motif of particular importance to the population of York.

The women of the Roman Empire were always changing their hairstyles; indeed, the writer Ovid observed that it would be easier to count the acorns on an oak tree than to list the number of different hairstyles in vogue in the first century (*Ars Amatoria* III, 149). However, this basic hairstyle of a bun wound round at the back seems to have been common throughout the empire amongst the less fashion conscious from the first century to the fifth, becoming particularly popular during the Christian period when it was the only female hairstyle to be approved of by the early Christian Fathers (Tertullian, *On Female Apparel* VII).

The hairstyle, the use of *cantharus*-headed pins, and the gypsum filling of the coffin may

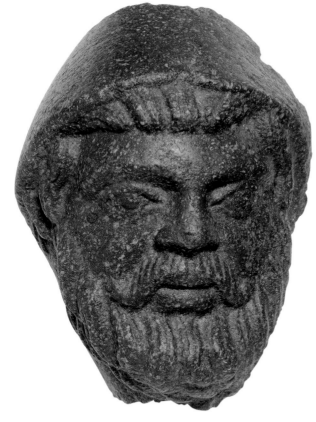

111

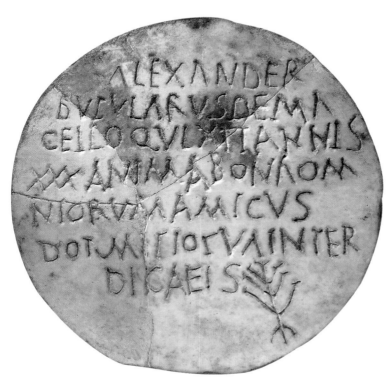

112

all point to the deceased being a Christian. [L.A-J.]

109a Hole-mouthed flask

Old Railway Station, York
Pale-greenish colourless glass with many bubbles; H. 103mm
4th century
York Museums Trust (Yorkshire Museum),
YORYM: HG146.1
Bibl. Roach Smith 1880, 174–7; Harden 1962, 140, fig.90.

It has a fire-rounded rim and abraded decoration.

109b Funnel-mouthed flask

Old Railway Station, York
Green bubbly glass; H. 114mm
4th century
York Museums Trust (Yorkshire Museum),
YORYM: HG146.3

It has a fire-rounded rim edge and abraded decoration.

Flasks such as (a) are very rare. They have been found in graves in northern France, the Rhineland and England, frequently with flasks like (b) as if the deceased was going to need the contents of both in the after-life. This pair was accompanied by a second identical pair in a lead coffin, with the skeleton of an adult and some cremated remains possibly of a child. At Colchester similar vessels came from the grave of two adolescents, probably girls given their jewellery (Anon. 2003). Since the hole-mouthed flasks are so rare, it is interesting that a high proportion have been found in graves with female jewellery, for example at St Aldegund (Haberey and Röder 1961), Strasburg (Straub 1881, 105–6) and Reims (Morin Jean 1923, 58). This suggests they were seen as a feminine possession. The Reims flask had been used as a container for hairpins and one of the York examples had a ring in it; so possibly the hole-mouthed forms were a type of jewellery box. [H.E.M.C.]

110 Pipette flask

The Mount, York
Pale greenish colourless glass, rim edge rolled in;
L. 217mm
4th century
York Museums Trust (Yorkshire Museum),
YORYM: HG6
Bibl. Harden 1962, 140, fig.89; HG6; Cool 2002, 147, no.1, fig.10.1.

Flasks like this are unusual because they are found throughout the empire at a time when vessel types normally had more limited distribution. In the western empire they are found almost exclusively in the graves of wealthy individuals, most of whom appear to be women. Other items placed in their graves often suggest that they may have worshipped the saviour gods Bacchus or Sabazius and looked forward to a new life after their death. Analyses of the contents of pipette flasks found early in the twentieth century in France suggested they might have contained wine. We need to be cautious about the results of such old analyses; but if they did contain special wine for funerals, that would be especially appropriate for Bacchus, god of wine. [H.E.M.C.]

111 Sculptured head

Possibly Rome
Porphyry, light reddish-purple in colour; H. 155mm
Early 4th century
Victoria and Albert Museum, London,
A 102.1956
Bibl. Vermeule and von Bothmer 1956, 336; cf. Delbrueck 1932, 215, Taf.101; Kleiner 1992, 455–6; Donati and Gentile 2005, 286 nos 127a–c.

The head, clearly detached from a relief, figures a male head slightly turned to the left; he is bearded and moustachioed and wears a conical cap. The subject was perhaps intended for a Goth or even a Persian. The type, in any case, is very much that of a barbarian and can be compared with the surviving lower half of a porphyry head in the Vatican, likewise richly bearded and which, when complete, would have been almost exactly the same size as this head. The Vatican head, together with an arm and foot, comes from the porphyry sarcophagus,

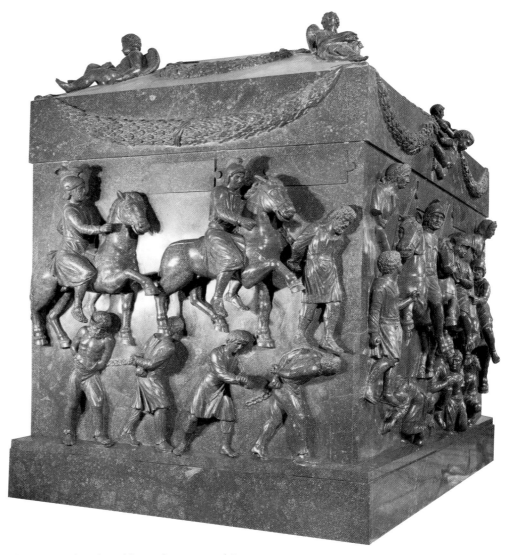

Figure 49 Porphyry imperial sarcophagus, restored, Rome

traditionally believed to be that of Helena, which showed battles between Romans and barbarian (fig.49). The sarcophagus was thoroughly renewed between 1778 and 1787, and in the process some fragments were clearly detached, if they were not already broken off. Vermeule and von Bothmer thought it likely that this head of a 'bearded eastern barbarian' too was once part of this important imperial sarcophagus.

The military subject of the sarcophagus has long suggested to scholars that it was intended for a warrior emperor, either Constantius I or very possibly even Constantine himself, though in the event he was buried in Constantinople. [M.H.]

112 Tombstone of Alexander

Rome
Marble circular panel; Dia. 327mm
Latin, 3rd/4th century
Governors of the Dr Pusey Memorial Fund, The Principal and Chapter, Pusey House, Oxford, Wilshire Collection
Bibl. *JRS* **19** (1929), 151, no.5.

Alexander butularus de macello qui vixit annis XXX anima bona omniorum amicus dormitio tua inter dicaeis (Alexander, a sausage-maker from the market, who lived 30 years, a good soul, the friend of everyone. May your sleeping be among the Just). This epitaph, in crude capitals highlighted with red, was written in substandard

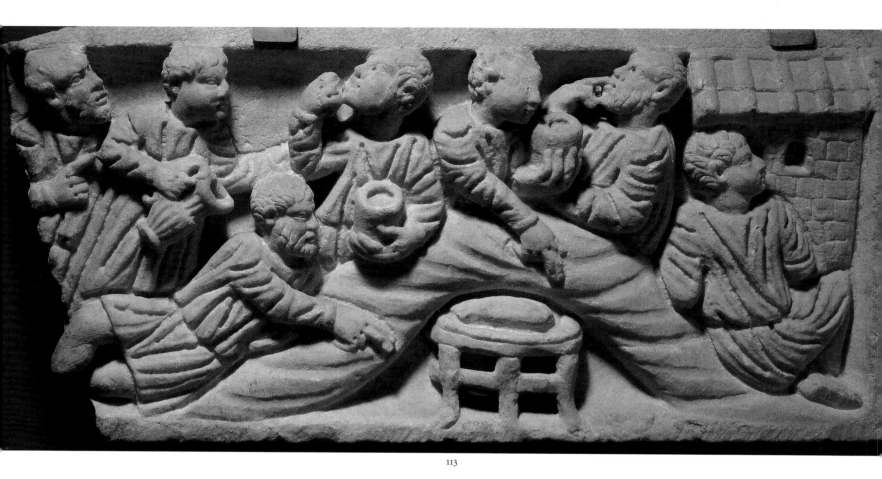

Latin, possibly by a bilingual, who transcribed *dicaeis* from Greek but gave it a Latin termination (in the wrong case). The stylised Menorah indicates Alexander was Jewish, despite making a sausage (*botulus*) that would have contained pig's meat and blood. [R.T.]

113 Sarcophagus lid

Probably from Rome
White marble; H. 300mm, W. 700mm
4th century
Governors of the Dr Pusey Memorial Fund, The Principal and Chapter, Pusey House, Oxford, 65.4

Bibl. Webster 1929, 152; Buckton 1994, 44–5 no.23; cf. Himmelmann 1973, 57–66, especially p.66, no.56, Taf.49b.

This fragment from the left side of a sarcophagus lid depicts a banqueting scene, clearly in the open air as a small building is shown on the right, abutting the edge of the inscription panel that would have occupied the centre of the lid. Seven men, four clean-shaven, three bearded, stand or recline around a sigma-

shaped couch. The man standing with a jug and the one behind him might have been servants. However, there is no obvious distinction in dress or status from two of the reclining figures who hold beakers. All wear identical tunics.

In front of the couch is a small circular table on which is a fish. Two of the diners seem to be reaching out towards it. Alfresco dining is shown in many works of art, especially those associated with the feast at the end of the hunt, but of course the fish (or, in other reliefs, loaves of bread) would most probably have assumed a Christian connotation in the context of a Christian burial as, indeed, would the wine. The scene belongs to a well-known type of sarcophagus carving depicting sigma-couches. [M.H.]

114 Statuette

Rome, Esquiline Hill, 1793
Silver gilt; H. 180mm, W. 60mm, D. 84mm, Wt. 706g
4th century
British Museum, London, P&E 66,12-29.23

Bibl. Dalton 1901, 74–5, pl.xx no.333; Weitzmann 1979, 176–7, no.155; *Spätantike und frühes Christentum*, 481–3, no.84, 2; Shelton 1981, 86–7, no.30, pls 36–7; Shelton 1985, 147–55, pl.30, 6; Buckton 1994, 36–7, no.14; cf. Zwierlein-Diehl 1997, 85.

This is one of a set of four statuettes in the form of personifications of major cities of the later Roman Empire, the others being Rome, Antioch and Alexandria. Each personification sits upon a rectangular socket that capped the end of the horizontal frame of a *sedes gestatoria* (chair of state), something like a sedan chair. Together, the images comprise a group that is unified in design and decoration. Constantinople was paired with Rome and Antioch with Alexandria. Gilding embellishes draperies and attributes but the flesh areas are left plain.

Constantinople was founded in 324 and was

almost immediately personified in a statue, reproduced with variations on countless coins and works of art, in the long-established Graeco-Roman manner of personifying cities in the form of goddesses. However, Constantine was determined from the first that Constantinople was to be a Christian city and her image was only offered 'bloodless sacrifice'. Here Constantinopolis wears a double-crested helmet and is dressed in a mantle and tunic, the latter embellished with two stippled stripes or *clavi*. On her right arm she sports an armlet and a bracelet. She holds a cornucopia full of grapes, larger fruit and sheaves of corn in her left hand and a patera in her right hand. Below the figure is a palmately lobed leaf enriched with stippling.

The nature of the ornaments suggests that they were designed for the use of a high official, and the association of the Proiecta Casket in the Esquiline Treasure with the Turcii, as suggested by a monogram upon it, may signal that the furniture fittings and statuettes all belonged to a functionary of the same family, either to the L. Turcius Apronianus who was *praefectus urbi* in 339 or a successor who was prefect in 362–3. [M.H.]

115 Life-sized statue of a goose

Constantinople (?)
Bronze; H. 580 mm
Probably 4th century
British Museum, London, GR 1859.6-1.1

Bibl. Walters 1899, 287, no.1887; Keller 1913, 223, fig.84; Toynbee 1973, 264; Roberts 1996, 50–1; www.thebritishmuseum.ac.uk/compass.

A pipe through the goose's beak forks into two sections within its body, suggesting that the goose could have emitted steam, smoke or even sound.

The central spine of the Hippodrome was adorned with sculptures illustrating imperial victories and the defeat of monsters. The goose is not listed in surviving accounts (Malalas, *Chrom. Pasch*, 320, 1528). Some contemporary mosaics illustrate parodies of imperial chariot races, with geese among other birds pulling the chariots. The 'twisted silver necklace' mentioned by Walters and now lost may have represented a harness for this goose, though it may have been the remains of modern consolidant used to secure the removable neck. [S.W.]

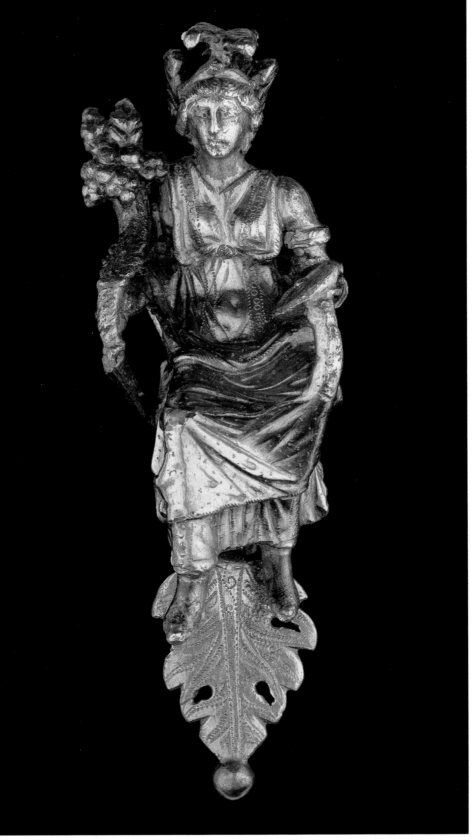

114

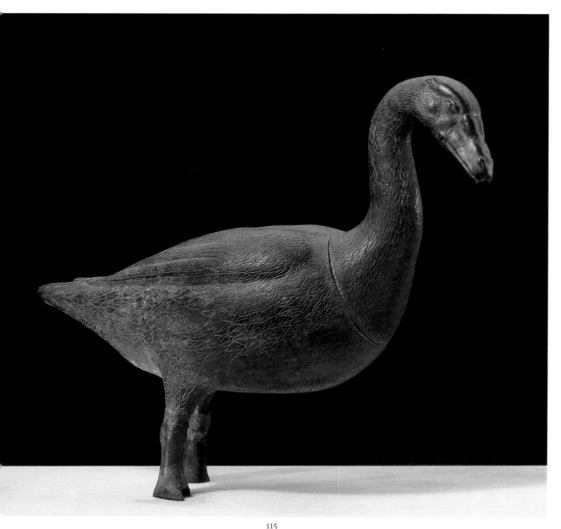

115

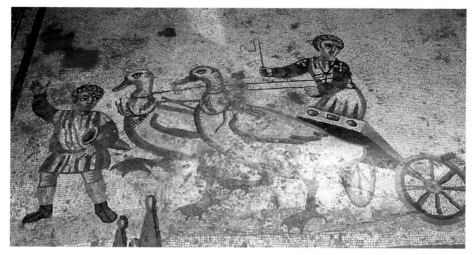

Figure 50 Circus mosaic with bird-drawn chariots showing the white faction with geese (detail), Piazza Armerina, Sicily, c.315–325

Dress and ornament

116 Dalmatic

Akhmim, Egypt
Undyed linen and purple wool, mounted on modern cloth; as mounted L. 1300mm, W. 2060mm including sleeves; as woven 2060 × 2600mm
First half of the 4th century
Victoria and Albert Museum, London, T.361-1887
Bibl. Kendrick 1920, 40, cat.1, pl.1; Walker and Bierbrier 1997, 178–9, no.227; Schmidt-Colinet, Stauffer and al-Asàd 2000, cats.267–9, 355 and 466–7.

A *dalmatica* was a tunic with very broad sleeves (presumably originally *tunica dalmatica*) that combined features of the traditional sleeveless Roman *tunica* and the 'Gallic coat' of the western Roman provinces. Dalmatics first became common at the same time as other sleeved tunics, that is, around the mid-third century, and for the following two centuries were widely worn by men and women. After this time, they continued to be worn by clergy in the western church and dalmatics survive to this day, in a much more decorated form, as a church vestment. This example, from a Christian burial, can be dated on the basis of the style of the geometric decoration within the bands. This type of linear decoration had come in also around the mid-third century (the earliest examples are from Palmyra, a city destroyed in 273). The simplicity of the patterning in this case, with squares of meander separated alternately by a twisted strap motif and a stylised stem with circular leaves, points to a relatively early date.

This dalmatic was made in what was then the conventional manner, that is, it was 'woven to shape' as a single piece with an opening left for the head. The tunic has been worn and repaired and there is a sizeable patch on one shoulder. The relatively short length (only 1040mm with the tuck), together with the undyed ground, suggest it was a man's garment.

The distribution of the bands, with two shoulder stripes (*clavi*) and two bands on each cuff, is the normal arrangement for dalmatics. The dye on the wool yarn has been analysed and found to be the famous true purple, derived from sea snails. This dark blue-purple was the least expensive of the various grades of true purple but, because the tunic is large and the

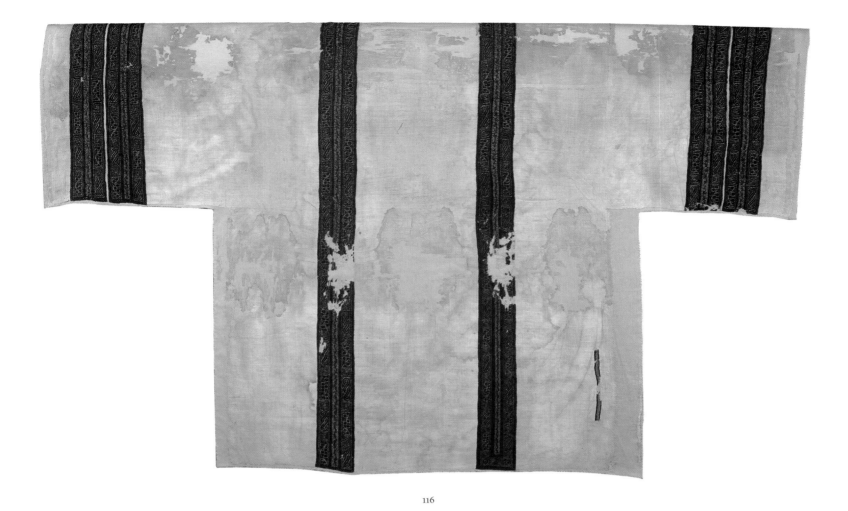

116

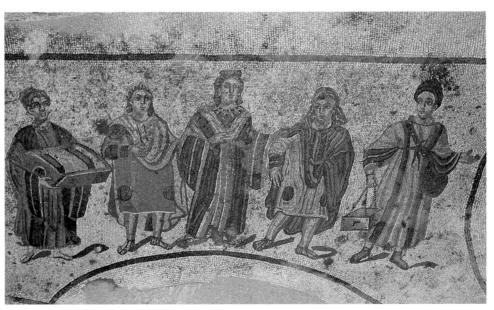

Figure 51 Mosaic showing the Lady of the house (*domina*) with her sons and female servants (detail), Piazza Armerina, Sicily, c.315-325

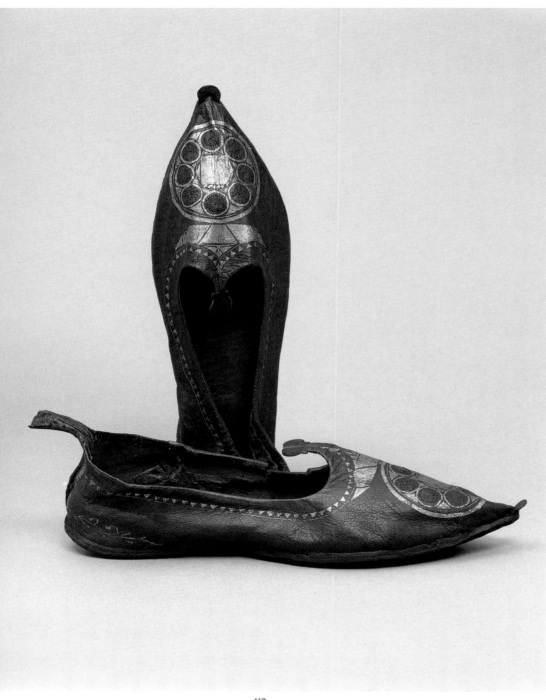

117

bands unusually wide, the total quantity of dyed wool is considerable. Confirmation that this was a high-quality product, of the sort that would have been traded over long distances, comes from an additional detail: a 'weaver's mark' placed near one corner. This narrow bar is a woven detail and has a chevron design formed by weft yarns of purple wool, undyed silk and gold thread (the latter a cut lamella of pure gold wound around a silk core). The exact significance of this mark is not known – it has parallels in less complete finds from Palmyra – but it must denote origin or quality, perhaps a combination of these two.

We cannot be certain where this dalmatic was made. Egypt itself was an exporter of linen clothing. But this garment seems too fine to have been made where it was found, at Akhmim in Middle Egypt. Alexandria is a possible source. The purple-dyed wool must have been imported, most probably from the Levant.

Diocletian's Edict of Maximum Prices of 301 lists maximum prices for various dalmatics. For example, a man's linen dalmatic, without purple bands but of the best quality Scythopolitan linen, is listed at 10,000 *denarii*. This compares with dalmatics of coarse linen 'for the use of common people or slaves', which ranged from 500 to 800 *denarii* (Ch.26, 39a and 75–7). Silk was, of course, more expensive than linen and a man's all-silk dalmatic with purple bands using 1lb of wool dyed red-purple was listed at 50,000 *denarii* (Ch.19, 15). The cheapest dalmatics were of poor quality wool: a woman's hooded dalmatic of very coarse wool with bands using 2lb of imitation purple is given at 200 *denarii* (Ch.19, 8). The section of the Edict on linen clothing with purple ornaments is unfortunately not well preserved but it ends with a useful warning: '[garment] types of linen for which proportions have not been defined are to be sold [only] after a reckoning has been agreed between the buyer and seller of the quality of the purple and of the linen, and of the weight, and of the workmanship, and of the dimensions' (Ch.27, 34).

Men wore the dalmatic unbelted. They could wear a cloak over it and a narrow neck scarf, but neither men nor women appear ever to have combined the dalmatic with the draped mantle that typified civic dress – the Roman toga or its Greek equivalent, the rectangular *himation*.

Because of its generous proportions, the dalmatic was essentially a luxury garment. [H.G-T.]

117 Pair of woman's shoes

Egypt
Leather with gilding and embroidery; each L. 250–60mm, W. 80mm, H. 60–70mm
5th–6th century
Victoria and Albert Museum, London, 837-1903 and 837A-1903

Flat shoes of leather, constructional sewing in linen, with a high front coming up to a double-lobed extension, finishing at the heel with a high tab; at the toe an additional small disc of leather. Perhaps originally purple or red, extensively embellished with gold leaf; a disc-shaped motif on the front encloses eight smaller circles, these decorated further with embroidered stars, the embroidery thread possibly of silk.

The many shoes found in Egypt have so far been little studied. Although exceptionally well preserved, this pair cannot at present be closely dated. [H.G-T.]

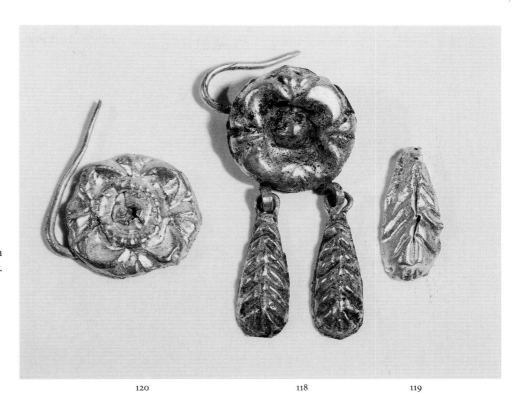

120 118 119

118 Earring with pendants

Brougham, Cumbria
Gold; Dia. 13mm, L. of leaf motifs 15mm, total L. 33mm
Late 3rd–early 4th century
Museum and Arts Service, Carlisle, CALMG 1971.15.309
Bibl. Allason-Jones 1989, Type 14, no.10; Cool 2004, 101, M1, fig.4.267.

Composite earring, consisting of a circular rosette with repoussé petal motifs around a plain central boss (see also cat.119). A plain back plate is brazed into position. The hook is formed from block-twisted gold wire, the spiral seam being clearly visible. The end of the hook is flattened and soldered to the back plate before forming a smaller hook below the rosette. A second flattened length of wire is soldered to the first and forms another hook at the base of the plate: from each of these hangs a hollow, pear-shaped, gold leaf motif with a repoussé convex front plate brazed to a plain back. The faces have a central rib with oblique grooves running down the edge. A loop of circular-sectioned wire with flattened ends is welded to the back of each leaf.

There are similar earrings in Istanbul which have a single pendant and a bead held by wire in the centre (Ergil 1983, no.20). There is no indication that the Brougham example had any additional elements. The matching earring pendant (cat.119), another pendant from Vindolanda and the earring from Bewcastle (cat.120) form a tight distribution in the area of Hadrian's Wall and may suggest a common workshop. The type of earring has a wide date range in the eastern provinces. The Roman cemetery at Brougham has revealed a link between the local population and Pannonia; it may be this link which explains the presence of these earrings in Britain. [L.A-J.]

119 Earring pendant

Brougham, Cumbria
Gold; L. 15mm, W. 6mm
Late 3rd–early 4th century
Museum and Arts Service, Carlisle, CALMG 1971.15.313
Bibl. Allason-Jones 1989, Type 14, no.11; Cool 2004, (Grave 75) 101, no.2, fig.4.75, no.1.

Pear-shaped leaf motif with a convex repoussé face, with a central rib and oblique grooves, brazed to a plain back plate. This is of the same type as cat.118 and may have come from its matching pair. [L.A-J.]

120 Earring

Bewcastle, Cumbria
Gold; Dia. 14mm, H. 2mm
Late 3rd–early 4th century
Museum and Arts Service, Carlisle, CALMG 1987.34
Bibl. Allason-Jones 1989, Type 14, no.4; Allason-Jones in Gillam, Jobey and Welsby 1993, 28.

Earring consisting of a hollow rosette with a flat backing plate, similar to cat.118. The rosette has a central boss which has broken open but there is no sign that it contained an inset, wire bead or any pendants (cf. Ergil 1983, no.120). The boss is surrounded by a pelleted ring which, in its turn, is surrounded by four petal shapes that extend to the edge of the disc. A hook of twisted wire of circular section is fixed to the back at its flattened end. The hook is bent so that the rosette would be held against the ear-lobe. [L.A-J.]

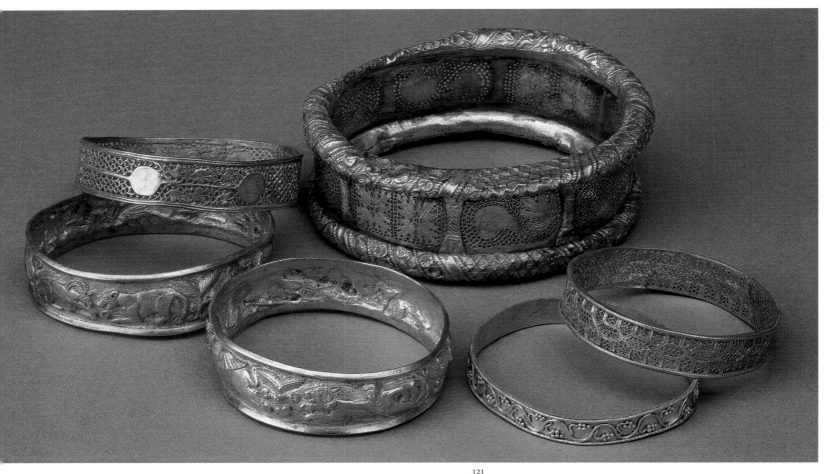

121

121 Armlet

Hoxne, Suffolk
Gold; external 103 × 95mm, Wt. 139.2g
4th–5th century
British Museum, London, P&E 1994.4-8.26
Bibl. Yeroulanou 1999, no.222.

The gold armlet is constructed of an elaborately
pierced gold band with tubular borders in thick
gold sheet with repoussé and engraved
decoration. This decoration takes the form of
diagonal bands incorporating leaves and birds,
imbricated leaf patterns, shells, small dolphins
and an overall diaper pattern of square
quatrefoils.

The pierced band features eight panels (four
designs, with one repeat) each c.35mm long,
ornamented in openwork of very fine
craftsmanship and design. Between the panels
the gold has been left intact and covered on the
outside by applied 'twisted columns' in gold
sheet. The piercing includes leaf designs,
quatrefoils and spiral patterns. [C.J.]

122 Late Roman armlet with relief decoration

Cologne (?)
Gold; external Dia. 102>91mm, internal Dia.
81>71mm, W. 69.55g
4th century
Römisch-Germanisches Museum der Stadt
Köln, Metall 1500
Bibl. La Baume 1967, 312, no.F9; Hellenkemper 1979, 100, no.19.

The armlet is a large tubular ring manufactured
from a strip of relief-decorated gold sheet, its
edges overlapping on the inner surface, which
has been shaped into a complete circle. On the
outer curve, the bangle is divided into eight
sections decorated in repoussé with alternating
patterns of imbricated leaf tips and oblique
fluting. The latter creates the visual effect of
twisted, spiralling wires. The panels of relief
decoration are demarcated by wide concave
grooves bordered with bead rows. A small gem is
set in one of the leaf-decorated sections.

This ornament entered the Reimbold

Collection, to which it belonged prior to its
acquisition by the museum in 1913, alongside
another gold armlet decorated with alternating
plain and relief-decorated 'beads'; in all
probability the two were found together,
perhaps in a grave, in the Cologne district. Two
similar gold bracelets made of decorated gold
sheet were found in 1931 in the Bonn legionary
fortress (see nos 123–4).

The technical characteristics of the armlet
and its decoration, when compared with the
parallels, indicate manufacture in the fourth
century. The decorative motifs on the armlet,
especially those on the 'beaded' armlet probably
found in association, indicate Alexandrian
prototypes. The actual size of armlets of this
kind and representations of them on statuettes
suggest they were worn in pairs on the upper
arm. [H.H.]

123 Armlet

Bonn
Gold; external Dia. 93 × 87mm, Wt. 62.2g
4th century
Rheinisches Landesmuseum Bonn, 34 278
Bibl. Oelmann 1932a, 306, Taf.LXIV, Abb.2; Oelmann 1932b, 323;
Von Petrikovits 1963, 82–3.

The tubular armlet is made from a strip of gold
decorated in repoussé and engraved designs in
oblique panels, creating a spiralling effect when
rolled into a tubular ring. The design consists of
eight sections of imbricated leaf tips separated
by concave mouldings with beaded borders. The
technique and the style are related to the borders
of the large Hoxne armlet, cat.121.

This armlet and cat.124 were found in 1930 in
the Römerstrasse in Bonn, within the precincts
of the legionary fortress. The hoard contained
gold jewellery and coins up to 353; unfortunately
it was dispersed into private hands when found,
and the full inventory remains unknown. [C.J.]

124 Armlet

Bonn
Gold; external Dia. 85 × 80mm, Wt. 51.3g
4th century
Rheinisches Landesmuseum Bonn, 34 279
Bibl. Oelmann 1932a, 306, Taf.LXIV, Abb.2; Oelmann 1932b, 323;
Von Petrikovits 1963, 82–3.

The bangle is made of a strip of gold, decorated
in simple repoussé and formed into a tubular
ring. A small hole, perhaps used for filling the
tube with a substance such as sulphur to give it
greater strength, has been sealed with a blue
glass bead. The design consists of simple oblique
fluting creating a twisted effect, separated into
six sections by deeper channels bordered by
relief bead rows.

For details of provenance and context, see
cat.123. [C.J.]

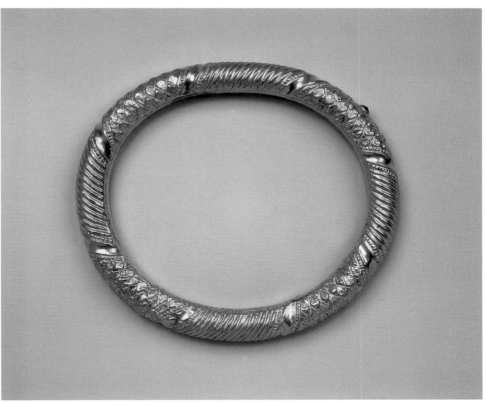

122

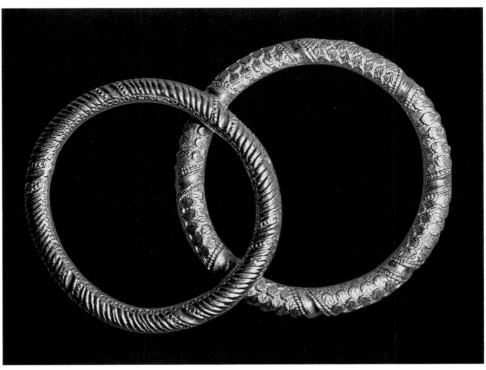

124 123

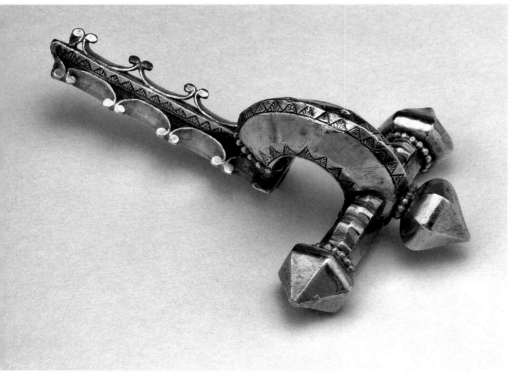

125

125 Crossbow brooch

Moray Firth, Scotland
Gold; L. 79mm
4th century
British Museum, London, P&E 1962.12-15.1
Bibl. Kent and Painter 1977, no.22; Deppert-Lippitz,
Schürmann, Theure-Grosskopf, Krause, Würth and Planck
1995, 150, B2.

Crossbow brooch with six-faceted terminals.
The bow and foot are decorated with engraved
hatched triangles inlaid with niello, the cross-
bar has raised decoration in gold, and
ornamental gold volutes are attached along the
sides of the foot. The pin is lost. One terminal
screws into position. The screw consists of a rod
with a spiral of square-sectioned gold wire
soldered around it. It has a left-hand thread.
[C.J.]

Art and design

126 Wall painting

Tarrant Hinton, Dorset
Plaster; H. 760mm, W. 620mm
Early 4th century
The Priest's House Museum Trust, Wimborne
Minster, WIMPH: ARC003
Bibl. Davey and Ling 1981, 165–6, pl.cxi, assemblage B; Henig
1995, 90, 119, 162, pl.iv.

Illustrated on p.75

A large quantity of painted plaster was recovered
in fragments from a room in the Roman villa at
Tarrant Hinton in 1970–1 and, to judge from
what has been reconstructed, it comprises the
most accomplished fresco painting yet seen in
Roman Britain.

This assemblage consisted of the head and
right shoulder of a youth, somewhat effeminate
in appearance with deep-set, soulful eyes. His
head is tilted slightly downwards. The
naturalistic flesh colours with lighter highlights
contrast with darker hair. The background is
blue. Behind his head is a long staff, purple in
colour, but yellowish along the left edge. Beyond
is another smaller head, likewise evidently male,
in profile to the left.

Previously identified as Narcissus looking
down at his reflection in the water, the figure
may be actually Bacchus, a popular deity in
domestic contexts in Roman Britain, especially
in the context of dining. The top of the long
staff or sceptre is not apparently preserved, but
the object could well be the shaft of the thyrsus
that he holds. The smaller head looks like that of
a young satyr.

Although very different as a subject, the
expressiveness of the main head is close to that
of the paintings of women from the imperial
palace at Trier and, like them, it reflects the best
work of the 'Constantinian Renaissance'. If it is
surprising to find work of this quality from a
normal villa in the province of Britannia Prima,
the wall painting is a reminder that Britain was
no backwater but in wall painting, as in the
other arts, linked to the major centres of power
and patronage. [M.H.]

127 Wall painting

Tarrant Hinton, Dorset
Plaster; H. 660mm, W. 1300mm
4th century
The Priest's House Museum Trust, Wimborne
Minster, WIMPH: ARC002

Bibl. Davey and Ling 1981, 165–6, pl.lxxviii, assemblage A; for
Nicias see Ling 1991, 129–31.

This is the lower left corner of a figural scene,
showing the lower leg and left foot of a standing
male figure and the right foot of the same figure
raised on a pedestal. The background is blue as
is the case of the previous fragment (cat.126).
However, while on grounds of scale and quality
this painting could be part of the Bacchus
composition, the pose is more suggestive of
other deities, notably Neptune and Mercury, and
of various heroes such as Argos and Perseus.
Paintings of the latter, based on work by the
classical Greek artist Nicias, are recorded from
Pompeii. The Tarrant Hinton painting may be a
fourth-century copy of such a work. [M.H.]

127

128 Wall painting

Tarrant Hinton, Dorset
Plaster; H. 720mm, W.940mm
4th century
The Priest's House Museum Trust, Wimborne
Minster, WIMPH: ARC001

Bibl. Davey and Ling 1981, 166–7, pl.lxxix.

This depicts a panel, imitative of a wall veneer in
coloured marble (*opus sectile*). The central
tondo is purple-red, imitative of imperial
porphyry. A circular frame of imitation green
Spartan marble between white bands surrounds
it. Beyond there is infilling of grey, mottled with
pink and white patches, enclosed in a square
frame of porphyry between white bands.

Although such schemes based on marble
veneers are known throughout Roman times,
for example in the décor of the second-century
basilica in London, such decoration was very
much a feature of the fourth century, as was the
use of expensive coloured stone itself, for
instance in the houses of Ostia. Cf. Dunbabin
1999, 260–2, figs 275, 278. [M.H.]

128

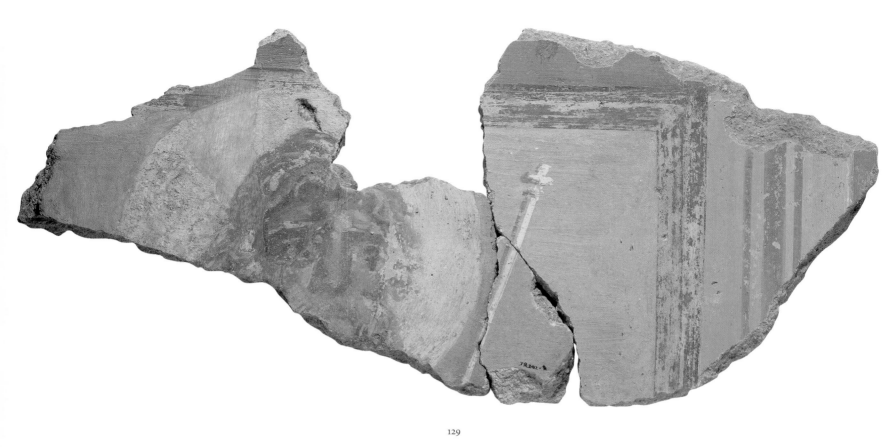

129

129 Wall painting

Malton, North Yorkshire
Plaster; L. 500mm, H. 220mm
Early 4th century
Malton Museum Foundation, R32.2912
Bibl. Davey and Ling 1981, 145–6, no.29A, pl.lx.

The fresco, of which this is a fragment,
decorated the 'mosaic room', the principal room
of an official building which has also yielded a
sculpted console (cat.132). The detail is from the
top right-hand corner and shows, within an
outer red and inner black border, a bearded
male head surrounded by a pale blue nimbus,
set against a sky blue surround. The nimbus is
suggestive of a god, and this is confirmed by the
presence of a sceptre with a pronounced cross-
bar at its apex. The sceptre is brown on the left
side and pale on the right.

The painting is expressive, the eyes deep-set
and bold, the nose fairly large and the beard full.
It could depict Jupiter or Neptune, but probably
the former as Neptune would be expected to
carry a trident. Amongst other nimbed heads
from the room is a goddess, so what may have

been portrayed was an assembly of Olympians.
While this painting is more or less
contemporary with the early fourth-century
paintings from the imperial palace at Trier, they
are less carefully done and far more
impressionistic. They do not attain the quality
of the Tarrant Hinton wall paintings.
Nevertheless, they demonstrate that wall
painting of some pretension was obtainable in
Malton. [M.H.]

130 Mosaic

Toft Green, York
Stone tesserae; H. 1340mm, W. 670mm
3rd or 4th century
York Museums Trust (Yorkshire Museum),
YORYM 1998.24
Bibl. RCHMY 1, 53–4, no.32, pl.22; Toynbee 1964b, 288; Neal
and Cosh 2002, 368 and 372, no.149.4.

Illustrated on p. 33
This fragment from a marine pavement depicts
a sea-bull swimming to the left, but with his
head turned to the front or slightly to the right.
His front legs are stretched out before him and

his tail is tightly curled. The creature's body is
attractively shaded in bands of dark grey, red
and yellow tesserae, a successful attempt at
three-dimensional modelling. The mosaic was
bordered by a band of guilloche and a row of
stepped triangles. The tesserae are small,
especially the carefully shaped black tesserae
around the bull's eyes and mouth, which are laid
with especial care and skill. As mosaics in
Britain, for all their imaginative designs and
subject matter, seldom attain this level of
technical competence, the work should probably
be attributed to a mosaicist from outside Britain
who was brought over for the purpose. It
certainly cannot be assigned to any of the
suggested mosaic workshops of Roman Britain.

Neal and Cosh tentatively ascribe this
mosaic, which came from a building of some
importance, to the early third century, but other
mosaics from the structure are dated by them a
century later and it is just as likely laid in the
period of Constantius I and Constantine's stay
in York. In any case this is part of a floor that
Constantine may have walked upon. [M.H.]

131 Mosaic

Keynsham, Somerset
Stone tesserae; figured panel without frame
910 × 910mm
First half of 4th century
Roman Baths Museum & Pump Room, Bath
and North East Somerset Council

Bibl. Bulleid and Horne 1926, 128, pl.xvii, fig.1; Toynbee 1964b,
240–1, pl.lvii b; Smith 1977, 141, pl.xix b; Russell 1985, 10–11;
LIMC **4** (1988), 84, Europe no.145 and cf. p.85, no.162 for
Lullingstone.

Within a square frame, two women are depicted,
both of them half draped, with the upper parts
of their body bare. One stands in front of a
placid, seated bull and proffers a basket
(possibly of flowers); the other is seated on the
bull's back and hangs a garland over its head.
The bodies of the women and bull are suggested
in pale outline while darker tesserae are
employed for the basket, garland and draperies.

The scene, as Bulleid and Horne realised,
probably illustrates Ovid's *Metamorphoses* (11,
846–75), in which Europa first offers flowers to
the bull, then garlands him and finally sits on his
back. Thus the two women represent Europa in
consecutive stages of the story. Ovid's work was
immensely popular in the Roman world and the
poem accompanying the mosaic at Lullingstone,
Kent, showing the rape itself, is composed in an
Ovidian metre.

Europa and the bull is one of six myth scenes
that embellished the imposing *triconch
triclinium* built in the form of a hexagon at
Keynsham. Two other panels partially survive,
one showing Achilles discovered hidden
amongst the daughters of Lycomedes on Scyros
and the other Minerva inventing the double
pipes (*tibia*), both of which are described or
alluded to in the same work. The aim of this
veritable picture gallery was to display the villa
owner's taste and erudition.

The mosaic was executed by mosaicists from
south-west Britain, probably centred on
Ilchester (Lindinis). Although evidently drawing
on earlier Graeco-Roman prototypes, they
invested the composition with their own
individuality, characterised by a subtle
understanding of line and spare use of infilling,
which is one of the hallmarks of much of the
best fourth-century Romano-British mosaic art.
[M.H.]

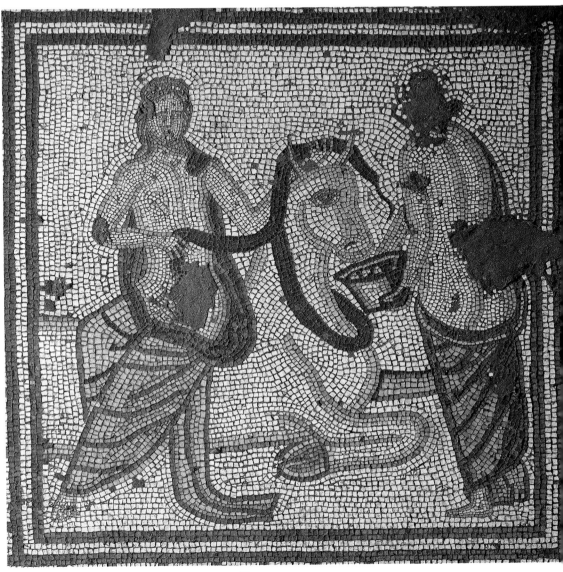

131

132

133

134 (opposite)

132 Console

Malton, Yorkshire
Sandstone; H. 490mm, W. 470mm, D. 160mm
3rd–4th century
Malton Museum Foundation, R32.42 OFC 49/C

Bibl. Mitchelson 1964, 219, pl.xvi; Wenham 1974, 37, pl.iii; Rinaldi-Tufi 1983, 59–60, no.100, pl.27.

The piece, although battered, is of very high quality. The block is carved on three sides. Its narrow front displays a winged figure, a Victory or a winged genius, whose arms are raised as though to support a lintel above. The quality of the carving, especially the figure's hair and the feathers of the wings, is very high. Unfortunately the bottom of the figure is lost, but it is almost certainly female and thus a Victory.

The left side is carved with a vertical thyrsus, its shaft carved with leaves. The right face is ornamented with a heavy garland.

While it is possible that the stone was originally from a funerary monument, it is far more likely that it comprised part of one side of a formal entrance to the building known as the 'town house' at Malton, which doubtless had an official function of some sort. The rather heavy style of the swags is suggestive of quite a late

date, tetrarchic or, indeed, Constantinian. The latter would certainly agree with the date of the rest of the décor of the house. [M.H.]

133 Painted plaster fragment

Arbeia Roman Fort, South Shields
Plaster; H. 360mm, W. 180mm
Late 3rd or early 4th century
Tyne and Wear Museums, TWCMS 2002.1329

Fragment of wall plaster with a figure of a cupid in a marine environment. Only part of his face survives, with one wing and arm, and parts of two nearby sea creatures. It was part of the original decoration of a room within the commanding officer's house, constructed when the fort was rebuilt after a fire, and was removed during later redecoration or remodelling. A marine theme was commonly used in bath-houses, and one including a cupid was found in the baths of Southwell villa, so it is likely that this fragment originally came from the baths in the commanding officer's house. This is the only piece of figurative wall plaster yet recovered from the Hadrian's Wall frontier zone. [A.C.]

134 Cylindrical beaker

Unknown, possibly Bonn
Greenish colourless glass, rim cracked off, linear wheel-cutting and abrasion; rim Dia. 118mm
Mid-4th century
Römisch-Germanisches Museum der Stadt Köln, N.326

Bibl. Fremersdorf 1967, 174–5, Taf.235; La Baume 1967, 274, no.D99; Harden, Hellenkemper, Painter and Whitehouse 1987, 234–5, no.131.

This beaker probably shows Constantine's Christian German bodyguards. The large oval shields are typical of those being carried by the emperor's bodyguards on the Arch of Constantine (Bishop and Coulston 1983), and there is an eight-pointed star on each of the standards and forming the blazon on one of the shields. It has been doubted that a simple motif like this can be taken as a Christian symbol, but another contemporary glass-cutting workshop was certainly using it in this way. It occurs as the base motif on several bowls with explicitly Christian scenes and in one case has an elaboration that could be seen as the Rho of a Christian monogram (Cool and Price 1987, 116; see also cat.135 here). [H.E.M.C.]

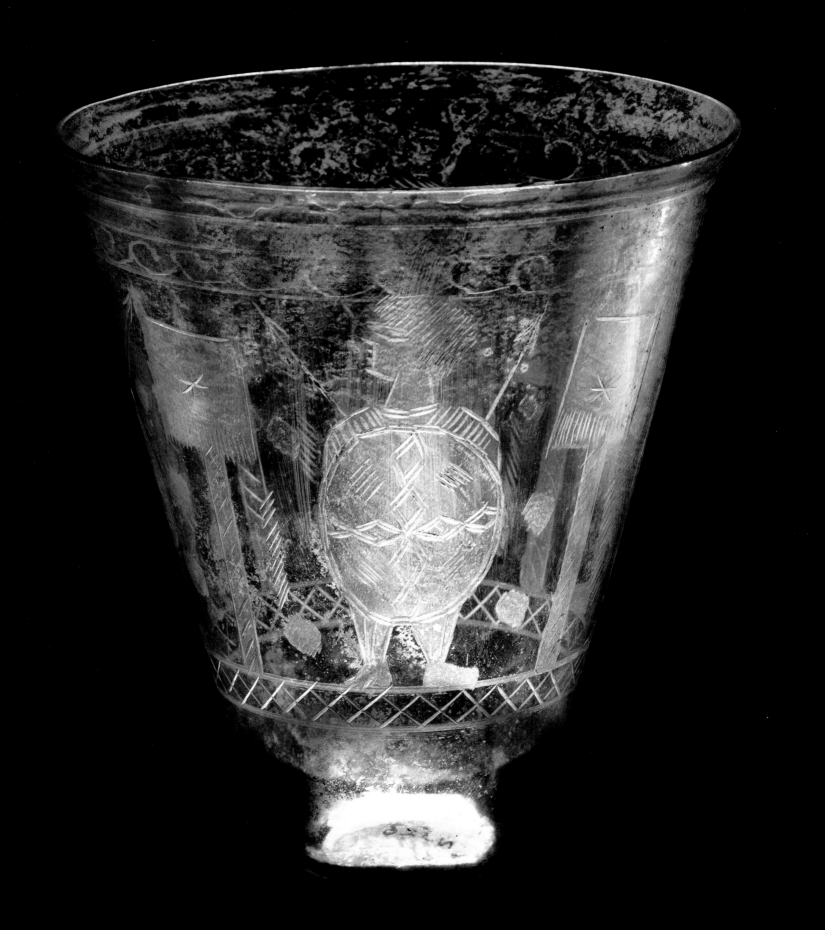

135 Hemispherical bowl

Colliton Park, Dorchester
Pale greenish colourless glass, rim cracked off, linear wheel-cutting and abrasions; rim Dia. 190mm
Mid-4th century
The Archaeological Collections of the Dorset Natural History and Archaeological Society at the Dorset County Museum, Dorchester, 1973.7

Bibl. Drew and Collingwood Selby 1938, 55–6, pl.III; Toynbee 1962, pl.159; Fremersdorf 1967, 177, Tafn.242–3; Price 1995, 27, fig.10.

The scene on this bowl, found in 1938, depicts five figures dancing around a central bust. The figures are clearly maenads and satyrs as the females hold *thyrsi* (a wand with a pine cone finial and ribbons), the symbol of the god Bacchus who may be represented by the central bust.

This bowl and the beaker (cat.134) probably came from the same workshop and may even have been cut by the same person. Various individual styles of cutting figured scenes can be recognised in the north-western provinces in the mid-fourth century (Cool and Price 1987, 113–18). These two vessels are characterised by the use of short wheel-cut lines and areas of matt abrasion. The eyes of the figures are very distinctive, being formed of six lines arranged in a lozenge. An interesting feature of all the workshops, which were probably in the Rhineland, is that they seemed to cater for a very varied clientele happily producing scenes relating to the worship of a variety of different gods and faiths including Bacchus and other pagan gods, Christianity and the Jewish faith. These workshops clearly indicate that whatever the emperor might have preferred to be the religion of the empire, the people worshipped a much wider range of gods. [H.E.M.C.]

136 Mirror

Wroxeter, Shropshire. Found in excavations on the site of the forum
Silver, with traces of gilding; Dia. 285mm, L. handle 150mm, Wt. 1445g
Late 3rd–early 4th century
Shrewsbury Museums Service, SHYMS A/2004/024

Bibl. Atkinson 1942, 196–8, pl.46; Toynbee 1964b, 334–5, pl.lxxviii c; Strong 1966, 179; Lloyd-Morgan 1981, 146–51; see also Wightman 1970, 245, pl.14b; Shelton 1981, 73–4 pls 2a, 4b, 10d, 11b; Weber 2000, 34–5, Abb.24.

This spectacular mirror, probably the finest example of its type in existence, was cast in one piece, the detail being finished by chasing. The front is slightly convex and shows signs of polishing; the back is ornamented around its edge with a vegetal wreath in six sections, two of oak, two of apple and two of pine, which are separated by six flowers likewise of three types. The outer rim of the wreath is beaded. The handle soldered to the back was crafted from two thick lengths of grooved silver wire, tied in a reef knot and terminating in leaf-shaped plates. Near each leaf is a six-petalled rosette (one of them was lost in antiquity and has been replaced by a modern copy). Some traces of the gilding which embellished the ornament remain, for instance on the flowers of the wreath.

Toynbee's second-century date is certainly too early, and Lloyd-Morgan cites comparanda from third- and fourth-century contexts. Indeed, a mirror of this type (although with simpler handles) is held by one of the women portrayed on the famous Constantinian wall painting from the part of the imperial palace at Trier, demolished in order to build the great double basilica (fig.52). Mirrors such as this were heavy and normally held by servants for the benefit of the patroness (*domina*), as is seen on the well-known third-century toilet-relief from Neumagen near Trier as well as on the mid-fourth-century Proiecta Casket from the Esquiline Treasure. [M.H.]

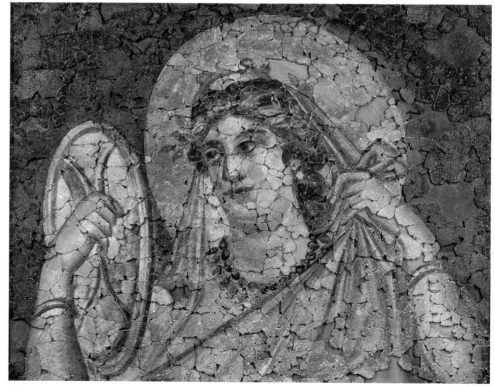

Figure 52 Woman with mirror, painted plaster, ceiling of royal residence, Trier, *c.*320

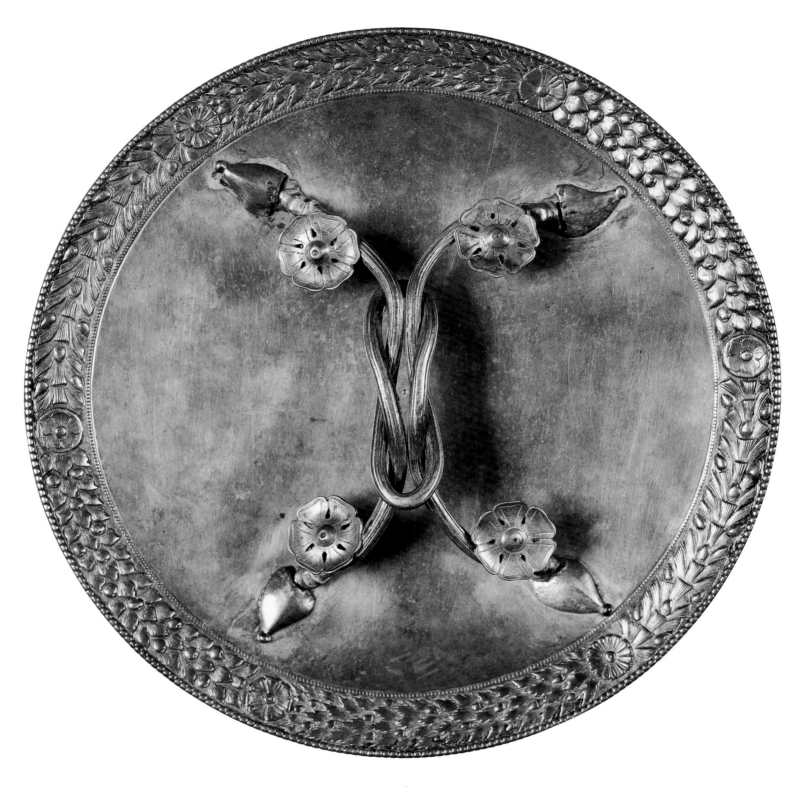

136

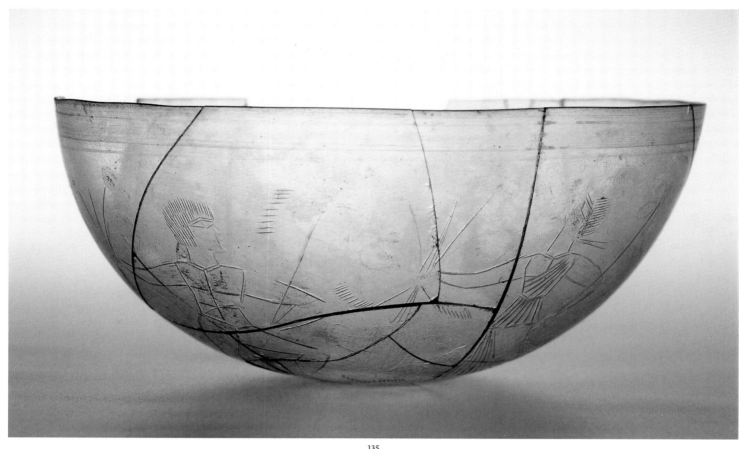

135

137 Bone plaque

Provenance not known; probably Egypt
Bone; 174 × 114mm
4th century, perhaps the 330s
National Museums Liverpool (World Museum
Liverpool), M10035
Bibl. Gibson 1994, 4–5, no.2; cf. Stern 1953, pl.XI, 1; Neal 1981,
58–61, pl.25a.

A thin panel of bone, incised with the figure of a
winged boy running to the right. His head,
shown partially turned to the front, has large
eyes and his neat fringe of hair is very much in
the style of Constantine and especially his sons.
He wears a cloak that billows out behind him, a
long-sleeved tunic and knee-length leggings. In
his hands he holds a hare. A gable frames his
head and shoulders.

The subject is close to that of the hare-
holding youth representing the month of
October in the Roman calendar produced by
Furius Dionysius Filocalus in the year of the
consulate of Constantius II and his Caesar,
Gallus, 354, though there are major differences

in the composition, not least that on the
Calendar the youth is nude, while the figure on
the Liverpool plaque, more reasonably for a
month when the weather is beginning to turn
chilly, is dressed for the season. However, both
this and the Filocalus drawing belong to the
same early fourth-century tradition, ultimately
dependent upon the same archetype, which is
surely that of manuscript illumination.

Although the hare was thought by Stern and
Gibson to have been included as the enemy of
the vineyards, it is more probably a symbol of
fecundity, thus of a fruitful harvest; this is why a
hare was used as the centrepiece of the major
segment of a fine mosaic from Cirencester,
dating to the time of Constantine. [M.H.]

138 Stile of a cupboard door

Hayton, East Yorkshire
Oak with bone inlay; L. 1030mm, W. 67mm, D.
37mm
Before mid-4th century
Hull and East Riding Museum, Hull Museums
and Art Gallery, KINCM 1020.1995 1088 A, B
Bibl. Frere 1972, 150, no.194, fig.54; Crummy 1983, 152–8; Mols
1999, pl.145; Arena *et al.* 2001, 494–7; Halkon and Millett 2003,
303–9.

This item of furniture was recovered during the
excavation at Hayton, near Pocklington, East
Yorkshire, in 1997, of part of a rural settlement
site. It was found almost upright in a well, with
the result that, although one end is very well
preserved through waterlogging, the other is
degraded (Halkon and Millett 2003).

The object comprises two pieces of wood,
originally joined to make one using a scarf joint
affixed with a small wooden peg; analysis shows
that the whole thing is made of oak. Together,
the two pieces form a straight bar 1030mm long
by 67mm wide and 37mm deep (see fig.53). The
well-preserved end is square cut and is clearly
the original terminal. One face is decorated with
inlay, and has various other surviving features.
Near the preserved end is a lap joint shaped as a
right-angled triangle cut right across the face of
the piece and with its hypotenuse away from the
squared terminal. This has a wooden peg
surviving *in situ*. A second lap joint coincides

138

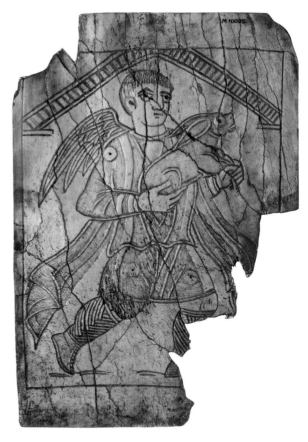

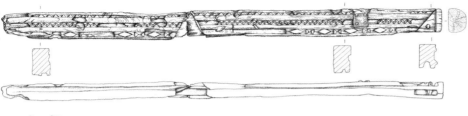

0 __ __ __ 5cm

Figure 53 Drawing of stile of cupboard door

137

with the scarf joint, *c.*500mm from the corner of the first. This is in the form of an equilateral triangle which thus mirrors the first. Between the two, *c.*170mm from the terminal is a square iron plate, 30mm by 30mm, fixed in place with four nails, and clearly a hinge plate. The adjacent narrow face has a rebate 10mm wide by 5mm deep running its full length, about a quarter of the way in from the decorated face. Into this face are cut two blind mortise joints coinciding with the triangular lap joints on the decorated surface. That nearest the terminal is 12mm wide by 50mm long, whilst the other is the same width but 70mm long. Damage at the terminal end means that it is not clear whether the rebate continued beyond the mortise although it is assumed that it terminated here.

The broad upper surface is decorated with three strips of inlay. These are set in a shallow rebate with triangles and diamonds of bone separated by triangles and rectangles of wood between. The bone varies in colour and, although there is no trace surviving, it is likely that an adhesive was used to set the inlay. Taking

the outer edge as being that from which the hinge opens, the decoration takes three forms. The outer strip (*c.*5mm wide) is filled with opposed triangles of bone and wood, each *c.*10mm long. The central strip (*c.*10mm wide) is also filled with opposed triangles of bone of the same size, but separated by lozenges of wood *c.*5mm in width, set forming a zig-zag line but with the grain perpendicular to the rebate. Finally, the inner rebate (*c.*12mm wide) has large bone lozenges alternating with opposed pairs of smaller triangles of bone inlay all set between wooden inlays.

This author knows of no parallel for this decoration from the ancient world (see below). However, bone inlay of similar type is frequently found on excavations, for example at Verulamium. Other, more elaborate inlaid furniture is also attested by fragments of bone or horn inlay from Colchester, whilst considerably more prestigious inlaid furniture survives from the early middle ages (for example the chair from the Crypta Balbi excavations in Rome).

The basic reconstruction of the object is

reasonably clear. It is apparent that it is the *stile* from one side of a door, presumably from a cupboard as it is too slight to have been from a building door. On the decorated outer face of the door, the triangular lap joints show that they were mitred, both for strength and for decorative effect. Such mitred joints are clearly seen on an early eighth-century manuscript illustrating a cupboard with books alongside the Prophet Ezra. This cabinet is coincidentally also shown decorated with paint, or perhaps inlay (*Codex Amiatinus*, Biblioteca Medicea Laurenziana, Florence: MS Amiatino 1, fol.vr). The manuscript was created at the Jarrow-Monkwearmouth monastery. The broader dimensions of the door cannot be known with any certainty.

Whatever form the Hayton door took, it is clear that it was already well used by the time it was deposited in the mid-fourth century. It was riddled with woodworm and had lost part of its inlay before being discarded. The absence on other fragments also shows that it had been broken up. [M.M.]

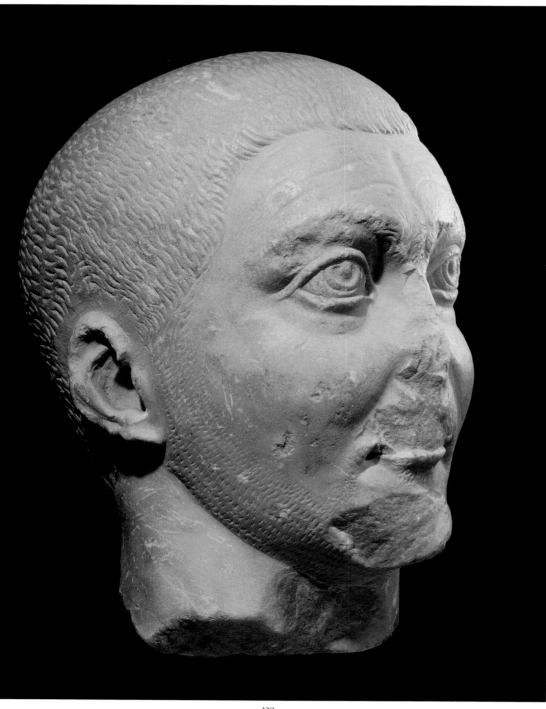

139

139 Portrait head

Constantinople?
Marble; H. 280mm
Early 4th century
Rijksmuseum van Oudheden, Leiden, 1.1961/3.1

Bibl. Salmonson 1964; Von Sydow 1969, 114–19, Taf.7; Bergmann 1977, 161–3; Inan and Alföldi-Rosenbaum 1979, 312–13, no.309, Taf.219; Bastet 1979, 57, no.60; Bastet and Brunsting 1982, 214–15, no.397, pl.118; Smith 1997, 189, pl.VI, I.

Although the nose, mouth and chin of this striking portrait of a young man are damaged and there is further chipping around the ears and eyebrows, this is a distinctive carving. The subject's close-cropped hair, with its receding brow line, is composed of short engraved notches in almost parallel rows while the incipient beard framing the face was executed with even shorter chisel cuts. His eyebrows appear to have been rather more carefully modelled and a prominent feature is the vertical groove between them which also divides the lines of the forehead. The eyes themselves, which display very well-defined pupils and lids, gaze piercingly at the viewer. There is the hint of a smile around the mouth.

The head is only life-size and lacks any obvious imperial attributes; it might, therefore, be merely a private portrait of about 300. However, Smith relates it to a head from Ephesus, now in Vienna, which with some plausibility he identifies as that of Licinius I. If correct, both portraits are characterised by smiling features indicative of *facilitas* (accessibility), while the stubbly beard is expressive of a soldier-emperor whose constant watchfulness prevented him from shaving every day. Although possibly contemporary with the Constantine portrait from York (cat.9), the Leiden head exhibits the old-fashioned and rugged virtues of the tetrarchy whereas Constantine's images set out to recreate Augustan classicism. [M.H]

140 Fragment of ceiling decoration with *putto*

Trier, Germany; Church of St Maximin, southern side aisle
Plaster; H. 403mm, W. 208mm
Bischöfliches Dom- und Diözesanmuseum Trier, MA 52

Bibl. Trier 1984, 236–7, no.122c; Neyses 2001, 4, 1–2.

The impressions of wooden laths on the reverse side of the plaster show that it comes from a painted ceiling, of which many additional fragments were hidden in the rubble. The ceiling with its figural decoration belonged originally to a rectangular funerary monument of the third or early fourth century, from which a larger early Christian edifice developed in the middle of the fourth century.

The paint is thickly applied and depicts a *putto*; part of his head and upper body, his right

arm and his right wing are preserved. We cannot infer the subject of the whole scene of which he formed part, but the mosaics from the Mausoleum of Constantia in Rome, for example, might provide parallels. The outstanding quality of the fragments from St Maximin is reminiscent of the so-called Constantinian ceiling paintings from a house beneath Trier Cathedral. Because of that stylistic similarity, this painting may be dated to the first quarter of the fourth century. [W.W.]

141 Plate

Katharinenengraben, Cologne
Colourless glass with sheet gold and enamelled decoration; estimated Dia. 200mm
4th century
Rheinisches Landesmuseum Bonn, LXVIII
Bibl. Bracker 1976.

Glass vessels decorated by gold sheet were a luxury item in the third and fourth centuries. The sheet was applied to the glass and then the design was scratched away to reveal the glass below. A large group is known from Rome, these vessels often having been found in the catacombs. These are characterised by having a second thin layer of glass applied over the gold which preserves the design. Another group is known primarily from sites in the Rhineland, but these vessels lack the protective second layer of glass and so the gold has often flaked away, as here. The difference in technique suggests that there were probably two different centres of manufacture (Harden, Hellenkemper, Painter and Whitehouse 1987, 263–8).

This vessel, found in 1857, has an unparalleled design depicting a Roman city. Certain features depicted, such as the street pattern at the gate (left) and the harbour scene (bottom right), suggest it may have been Cologne. Some of the streets and walls were clearly labelled (see 'Aureliana' bottom right) but unfortunately the piece is now too fragmentary for us to be able to identify the city with certainty. [H.E.M.C.]

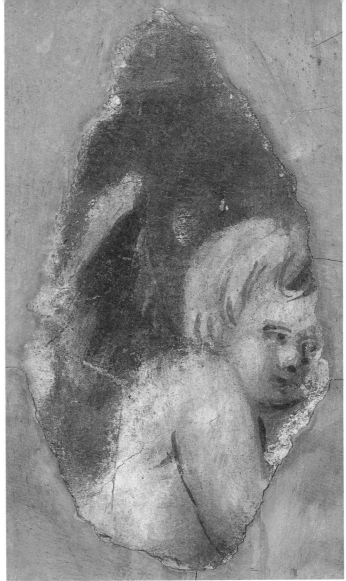

140

141

Economy

The survival of the tools discussed below is primarily the result of the custom of the ritual deposition of large hoards of ironwork, which reappears in the fourth century some two centuries after the cessation of a series of similar deposits in the late Iron Age and early Roman period. What this means in terms of the religion of the period is uncertain, but it is not the only evidence for a resurgence of native paganism in the final years of Roman Britain.

Whatever the reasons for their deposition, these tools confirm that the late Roman farmer was exceptionally well equipped with iron tools, and indirectly they support other archaeological and historical evidence which suggests that agriculture in southern Britain was flourishing for much of the fourth century. This is the period when the majority of the villas, so characteristic of southern England, were turned from farmhouses into country mansions; a development which may indicate a movement of capital from the towns to the country. That British agriculture was highly productive at this time is confirmed by the fact that in 360 the Emperor Julian was able to send 600 shiploads of British grain to the Rhineland, then suffering from barbarian incursions. This action appears to have been founded on an existing trade rather than being a new idea. The Rhineland, with its great cities and armies, easily accessible across the North Sea, would have provided an excellent market for British traders, particularly for grain easily transported by water.

No doubt it was the absence of barbarian attacks on any scale for the first two-thirds of the fourth century that allowed British agriculture to be so productive. The evidence for animal husbandry is less clear, but there is little doubt that the woollen industry flourished at this time. The cropping shears from Great Chesterford (cat.149) and the discovery of large iron carding combs, like the shears of types which accord with the commercial production of cloth rather than a domestic industry, as well as a reference in the *Notitia Dignitatum* (cat.96) to a State weaving works at Venta (probably Caistor by Norwich or Winchester) all indicate that sheep farming, at least, was highly productive.

Whether agriculture continued to flourish after the barbarian conspiracy, which appears to

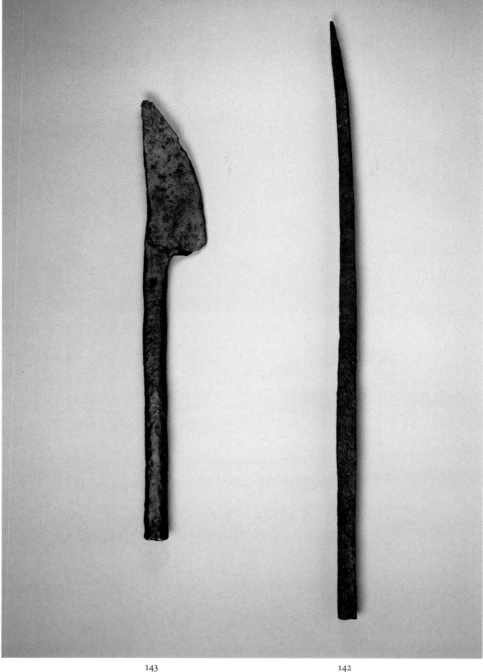

143 142

have led to a major disaster in Britain in 367, is more doubtful, but agriculture is resilient and, even if many of the villas went into decline in the last years of the fourth century, the same may not have been true of their fields.

142 Plough share

Dorchester, Oxon.
Iron; L. 933mm
Late 4th century
Ashmolean Museum, Oxford, AN 1967.1244

Bibl. Manning 1964, 54ff; Rees 1979, 57ff; Manning 1984, 144, fig.32, no.28.

A long rectangular-sectioned bar which narrows slightly as it approaches its tip, which has an asymmetrical, D-shaped cross-section, characteristic of such shares. Bar shares of this type are essentially iron replicas of the wooden fore-shares used in Iron Age and Roman bowards. They are mainly known from the late Roman ironwork hoards where they are often, but not invariably, associated with the same number of plough coulters.

This is one of a number of pieces from a small hoard of iron artefacts found buried in silting from the bank behind the city wall of the small town at Dorchester on Thames. The hoard

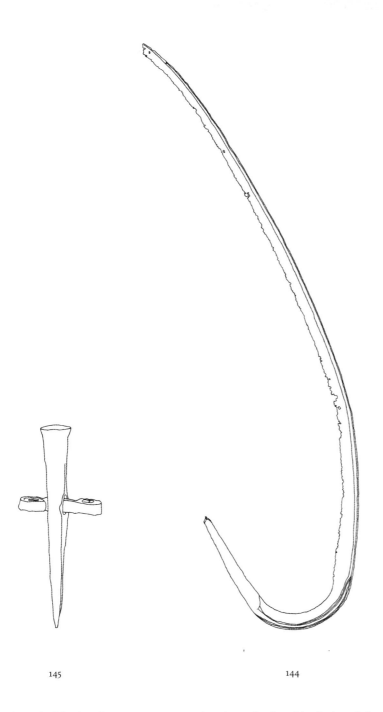

145

144

144 Scythe blade

Great Chesterford hoard
Iron; L. 1410mm
4th century
University Museum of Archaeology and
Anthropology, Cambridge, 1948.1093E

Bibl. Neville 1856, 10, pl.3, no.29; Manning 1972, 235; Rees 1979, 475ff; Manning 1985, 49.

The long, gently curving blade is surprisingly narrow for its length, although a ridge on one side of the back of the blade gives it additional strength. The tip of this example is broken, but the tips of complete examples from the hoard narrow evenly to a point. At its top the blade curves back on itself to form a tapering tang with a short, upturned tip.

This was one of 12 such scythes in a hoard of iron artefacts discovered in a pit at Great Chesterford, Essex, in 1854.

This type of scythe appears to be a late Roman form, apparently found only in Britain and rare even here. The Great Chesterford examples remained unique for over a century until two more were discovered at Barnsley Park, Gloucestershire; a discovery that confirmed the type was not confined to East Anglia. Since then fragments of others have been found elsewhere in southern England. This type of scythe appears to have replaced a form with a shorter but wider blade used in the early Roman period.

Experiments in 1967 with a replica made for the Museum of English Rural Life in Reading showed these tools were perfectly practical for cutting both grass and cereals despite their great size. [W.M.]

145 Mower's anvil

Great Chesterford hoard
Iron; L. 232mm
4th century

University Museum of Archaeology and
Anthropology, Cambridge, 1948.1073D

Bibl. Neville 1856, 3, pl.1, no.8; Manning 1972, 235; Rees 1979, 480ff; Manning 1985, 59.

The spike-like body tapers from a rounded head to a pointed, square-sectioned stem. A strip runs through the stem, its ends coiled in opposite directions.

dates from the end of the fourth century or possibly slightly later. [W.M.]

143 Plough coulter

Dorchester, Oxon
Iron; L. 690mm
Late 4th century
Ashmolean Museum, Oxford, AN 1967.1240

Bibl. Manning 1964, 54ff; Manning 1984, 144, fig.32, no.29.

It has a massive, square-sectioned stem and a strong blade with a convex edge ending in a curved tip. Such coulters were commonly, although not invariably, used with the type of bar share also found in the hoard. In this case there is little doubt that the two formed a pair and were used on a bow-ard, a relatively simple type of plough used throughout northern Europe in the later prehistoric and Roman periods. In Britain coulters of this type are only found in the late Roman period but, while they were probably unknown in Britain in the first and early second century, it is possible that they were in use here for some time before they appear in the archaeological record in the great ironwork hoards of the fourth century. [W.M.]

149

148

This was one of five field anvils from the Great Chesterford hoard. Neville identified them as small anvils or anvil pegs and assumed that they were used in working metal. Their real function was to act as anvils that could be pushed into the ground and used to support a scythe when dents were beaten out in the field. It is a relatively common type, particularly in the large late Roman hoards, and first appears in Britain in the first century, probably being introduced by the Roman Army along with the early form of scythe. These anvils are not unique to Britain. [W.M.]

146 Pruning or leaf hook

Shakenoak
Iron; L. 120mm, W. 50mm
4th century
Ashmolean Museum, Oxford, AN 1968.174
Bibl. Brodribb, Hands and Walker 1968, 102, fig.34, no.22; Manning 1985, 57, Type 2.

This has a hooked blade that runs into a conical socket. It is an example of a relatively common type that could have been used for pruning or stripping leaves for fodder. [W.M.]

147 Ox-goad

Shakenoak
Iron; L. 600mm
4th century
Ashmolean Museum, Oxford, AN 1968.168
Bibl. Brodribb, Hands and Walker 1968, 104, fig.35, no.48.

It has a short spiral socket, from which projects a relatively long, tapering spike. Such goads are common finds on Roman sites. In use they were mounted on the end of a staff and used to control draught oxen, which in most of the northern provinces were probably the most commonly used traction animals. [W.M.]

148 Model wool-bale

Broch of Dun an Iardhard, Isle of Skye, Scotland
Buff-coloured terracotta, hollow; 60 × 45 × 43mm
2nd–4th century
National Museums of Scotland, Edinburgh, GA 1013
Bibl. Macleod 1914–15, 66–7, fig.11; Curle 1931–2, 289–90, fig.2a, b; Wild 1970, 23, pl.xiic.

This object is a naturalistic portrayal of a bale of raw wool, securely corded both longitudinally and transversely. It preserves traces of green paint over a layer of stucco. It appears to be Roman and, indeed, is recorded as having been excavated in association with Roman-period beads at the broch. It belongs to a class of votive designed for deposition in a shrine.

The model epitomises the importance of wool, generally, within the economy of the north-west provinces in the Roman period, especially in the latter part of the Roman period. It also suggests that wool was often dyed before weaving. The bale attests trade well beyond the imperial frontiers, throughout the Roman period, by enterprising entrepreneurs. [M.H.]

149 Cropping shears

Great Chesterford hoard
Iron; L. 1350mm
4th century
University Museum of Archaeology and Anthropology, Cambridge, 1948.1092
Bibl. Neville 1856, 10, pl.3, no.30; Espérandieu 1965; Manning 1972, 235.

The U-shaped spring continues into round-sectioned arms ending in long rectangular blades that widen slightly towards their ends. They were designed for cropping the knap of newly woven cloth. Although an apparently unique survival, cropping shears must have been a familiar sight in areas where weaving was undertaken on a semi-industrial scale, but were probably too expensive to have been used for cloth woven in the household. A Roman relief from Sens shows that such shears were held with both hands at the junction of the blades and spring, the remainder of the spring being pressed against the body, with the blades held against the cloth that was hung from a beam. Similar shears continued to be used in the medieval period. [W.M.]

150 Saw blade

Shakenoak
Iron; L. 600mm
3rd or 4th century
Ashmolean Museum, Oxford, AN 1968.177
Bibl. Brodribb, Hands and Walker 1968, 102, fig.34, no.28; Manning 1985, 21.

Fragment of wide, parallel-sided saw blade with the remains of five teeth and a large rivet hole. It is probably part of the blade of a bow-saw or, less probably, a frame-saw. The size of the teeth, approximately 10mm, indicate that it was intended for heavy work, the equivalent of the modern rip-saw which is used for rapidly cutting along the grain of the wood. The teeth have a pronounced slope rather than being symmetrical; this would suggest they were intended to cut on the back-stroke when the drag of the wood put the blade under tension, but too few teeth survive for certainty. Nor can we tell whether the teeth were set, given the small number that survive. Fragments of bow-saw blades, with teeth of varying fineness, are not uncommon finds on Roman sites in Britain and other Roman provinces.

It would be difficult to overestimate the importance of the carpenter in Roman Britain. Not only were most dwellings largely constructed of timber, but so were their fittings and furniture; while on farms most of the equipment was either wholly or largely made of wood. All of the late Roman ironwork hoards contain carpenter's tools, in particular chisels and gouges. Along with smithing, carpentry must have been one of the most important and ubiquitous crafts in the Roman world. [W.M.]

151 Chisel

Dorchester, Oxon
Iron; L. 229mm
Late 4th century
Ashmolean Museum, Oxford, AN 1967.1245
Bibl. Manning 1984, 144, fig.33, no.30.

Mortice chisel with a solid, octagonal handle and a strong blade with a long chamfer to the edge. Such chisels were used in heavy carpentry rather than cabinet making and often have a solid iron handle rather than a wooden one. Although this one comes from a late Roman hoard, such chisels are found throughout the Roman period and are not confined to Britain. [W.M.]

152 Spearhead

Shakenoak
Iron; L. 120mm
4th century

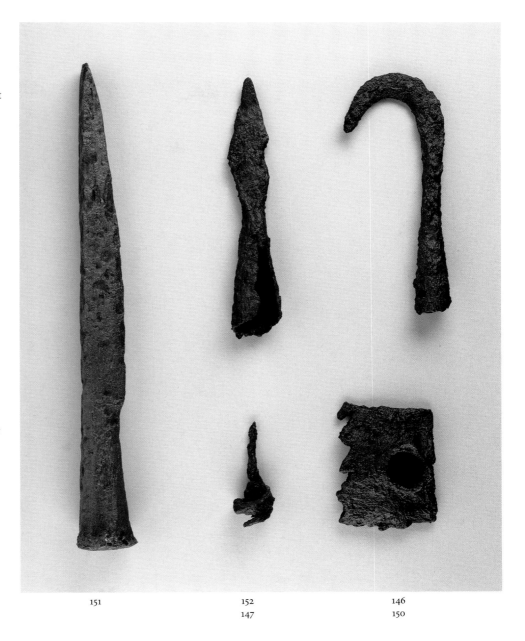

151 152 146
 147 150

Ashmolean Museum, Oxford, AN 1968.172
Bibl. Brodribb, Hands and Walker 1968, 102, fig.34, no.32; Manning 1985, 161.

This has a lozenge-shaped blade and a conical socket, which is almost as long as the blade, with a wide gap between its edges. It is a small example of a type commonly found throughout the Roman world, most examples, not surprisingly, coming from military sites. This one, however, comes from a civilian context. Civilians were most likely to have used spearheads for hunting; such a small spearhead would probably have been used for relatively

small animals, perhaps deer, rather than for larger and more ferocious quarry such as boars, which would have required a more specialised spearhead.

Hunting was the rural sport *par excellence*. It is the subject of innumerable mosaics in the Mediterranean provinces and is constantly referred to in the literary sources. By its very nature it leaves few archaeological traces, but the spearheads that are regularly discovered in civilian contexts, as well as the rarer arrowheads, were almost certainly intended for that sport. [W.M.]

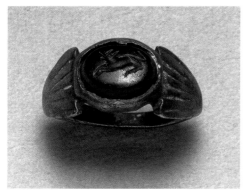

153

153 Silver ring with intaglio

Helperthorpe, Yorkshire
Debased silver ring, cornelian intaglio; W. max.
21mm, front to back 12.5mm, intaglio 11.5 ×
10mm
Late 3rd–early 4th century (*c.*250–320)
York Museums Trust (Yorkshire Museum),
2002.571

The ring has the keeled hoop and triangular
shoulders typical of this period. The bezel is
rectangular and the dark cornelian setting rises
proud of its surface.

The subject, a hound, is a common device on
signet rings, either shown by itself or coursing a
hare or deer. Like so many other contemporary
works of art, including mosaics (such as the
example in the Town House Malton) and cut-
glass vessels (of the type of the Wint Hill bowl), it
almost certainly attests its owner's love of the
chase, though it cannot be ruled out that, as is the
case with the Hinton St Mary mosaic (cat.190),
the dog is employed symbolically. [M.H.]

154 Six-sided seal

Kingscote, Gloucestershire
Heavy-leaded tin bronze; each side *c.*19 × 19mm,
Wt. 55.99g
3rd–4th century
Cotswold Museum Services, Corinium Museum,
Cirencester, B761
Bibl. Henig 1977; Henig in Timby 1998, 185–7, fig.89; *RIB* **2.1**,
no.2409.19.

Found in a room of the 'villa', five of the sides of
the cube display an intaglio device within a
beaded surround. The most diagnostic is a bust
of Sol in profile to the right with the retrograde
legend: INVICTVS SOL. Other devices are Sol in
a facing *quadriga*, the god holding up one hand
in salutation and clutching his whip in the
other; the goddess Roma seated on a cuirass;
Mars accompanied by an eagle; and the clasped
hands of concord. The final side has a less
formal device not contained within a beaded
border, showing a huntsman with his hound
chasing a stag, the most characteristic outdoor
pursuit of the upper classes in late Roman
society.

It is possible that the first five devices of the
cube seal were employed on pieces of soft lead to
seal packages. [M.H.]

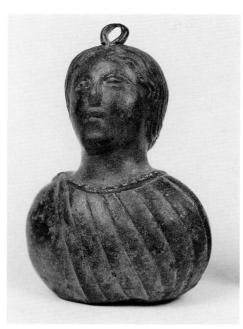

155

155 Steelyard weight

Kingscote, Gloucestershire
Hollow cast bronze, filled with lead; H. 90mm,
Wt. 1.01g
4th century
Cotswold Museum Services, Corinium Museum.
Cirencester, 1998/196/7/1
Bibl. Henig 1978a; Henig in Timby 1998, 183–6, fig.88.

Found in a room of the 'villa', the steelyard
weight is cast in the form of the bust of a young
woman and was attached to the steelyard by
means of a separately made loop of copper alloy
attached through a small hole in the forehead.
The subject is almost certainly Constantine's first
wife, Fausta. The triangular nose, protruding
almond-shaped eyes and simply rendered mouth
suggest a provincial workshop. The *stola*, pleated
in diagonal grooves both front and back, is
likewise probably an insular style. It has a pleated
edging around the neck and is fastened on the
left shoulder by means of a circular brooch. A
series of beads shown just above the top of the
garment on the front might be part of a fringe
but is more probably a stylised attempt to show a
necklace. The hair swept back to a bun at the
back was adopted from the much earlier fashions
of the Antonine period.

The use of an imperial portrait for weighing
would imply government sanction for the
transactions undertaken. [M.H.]

156 Fragment of building tile

Langton, East Riding of Yorkshire
Fired clay; L. 210mm, W. 175mm, D. 40mm
4th century
Malton Museum Foundation, R31.118
Bibl. Corder and Kirk 1932.

The flat tile from the villa at Langton has an
imprint of a child's foot impressed on the
surface. The footprint is about 140mm long,
which would be about the length one would
expect of a three-year-old. The print was made
by stepping on the top of the tile before it was
fired in a kiln, presumably when the tile was left
to harden. [E.H.]

156

157

157 Building tile

Langton, East Riding of Yorkshire
Fired clay; L. 350mm, W. 215mm, D. 40mm
4th century
Malton Museum Foundation, R31.337.8

Bibl. Corder and Kirk 1932.

The rectangular tile from the villa at Langton
has an imprint of a dog's paw as well as the
signature of the tiler in the shape of a backward
'S' at the other end. The maximum width of the
dog's paw is 80mm. The dog must have strayed
onto the tile as it lay flat before being fired in the
kiln. [E.H.]

158 Two-part mould

St Just, Penwith, Cornwall
Greisen, a granitic rock very rich in mica; upper,
smaller piece H. 48mm, Dia. 135mm; lower,
larger piece H. 48mm, Dia. 145mm; total H. of
two parts fitted together 72mm
Late 3rd or 4th century
Ashmolean Museum, Oxford, AN 1836.147
(larger), AN 1836.148 (smaller)

Bibl. Borlase 1769, 310 and pl.xxv, figs vi–ix; Brown 1970;
Brown 1976, 34, fig.32; Penhallurick 1986, 213–14, fig.123a.

The lower part of the mould is darker than the
other, probably the result of burning.

The two objects, thought by Borlase to be
paterae 'from which they poured out the libation
of wine, either upon the Altar, or between the
horns of the Victim' are in fact (as Brown
recognised) two parts of a stack of turned stone
moulds used for casting small pewter bowls. The
larger (lower) section has a lathe-turned foot-
rim for the bowl being cast, cut on the inside.
The base of the smaller (upper) section and its
everted outer sides are smooth, though a casting
channel for the molten pewter to be poured into
the mould may be observed. A turned foot-rim
on the inside shows that another section of
mould was slotted in above. The larger lower
piece of mould has a foot-rim carved on the
underside, presumably for use in a different
assembly of mould pieces.

Although stone moulds are quite widespread
in southern Britain and further east, for instance
in the Bath region, they are often carved in
oolitic limestone. Cornwall was crucial as it was
the only insular source of tin, an essential
ingredient of pewter.

Evidence for official Roman activity in
Cornwall, as evinced by milestones, suggests that
the late third century and the period of the reign
of Constantine marked a peak of activity in the
peninsula. [M.H.]

158

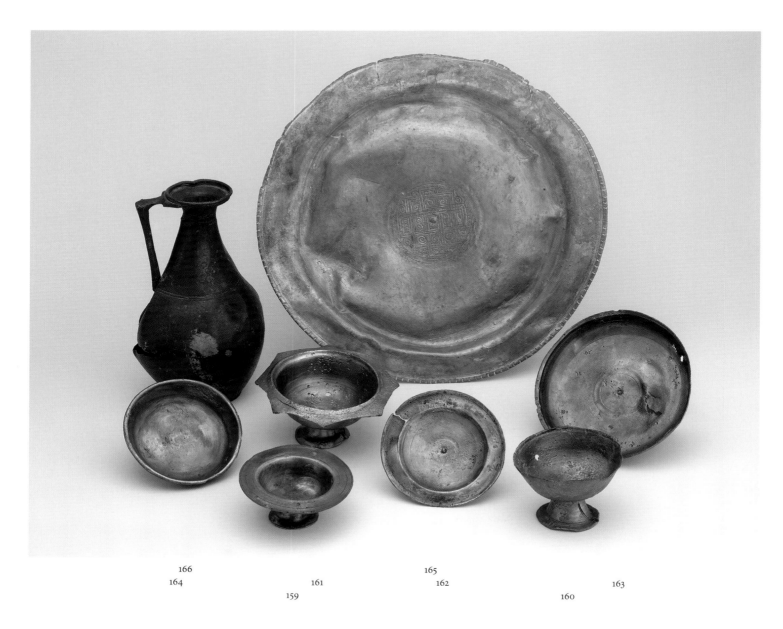

166
164
165
161 162
159 163
160

159–68: Romano-British pewter tableware

Roman pewter was an alloy of tin and lead that could be cast at the relatively low temperature of 300°C and could then be polished to resemble silver. The ratio of tin to lead has been found to vary widely but was normally somewhere between 80:20 and 70:30. Pewter appears to have been made almost exclusively in Britain, where both tin and lead ores were available, and to have reached its maximum period of production in the late third and fourth centuries.

The principal use of pewter was in the manufacture of tableware for those prosperous enough to aspire to ostentatious dining in the villas and town-houses of late Roman Britain but lacking sufficient wealth to afford silver plate. In consequence, pewter vessels were often made in imitation of their silver counterparts, though they also took their inspiration from contemporary vessels in bronze, glass and fine pottery. The survival in southern Britain of many pewter hoards provides evidence for the size and composition of pewter table services. They seem usually to have combined large plates with flagons or jugs and a range of dishes, bowls, cups and platters in a variety of sizes. Decoration, other than turned rings applied when the cast vessels were finished on a lathe, was rare and restrained, and it is mostly to be found at the centre of plates. However, the relative softness of the metal made it easy to mark, and many pieces have graffiti incised on their underside, usually personal names, presumably of owners, but occasionally the Christian Chi-Rho monogram.

The group assembled here comprises pieces from hoards of the fourth century found at Icklingham, Suffolk, and Appleshaw, Hampshire, together with a jug of the second century from London and an ornamental mount from Alcester, Warwickshire. Together they give an indication of the potential for sophisticated dining in wealthy, if not elite, households in Roman Britain at the time of Constantine. [R.J.]

159 Bowl

Part of a hoard of metalwork found at
Icklingham, Suffolk in 1849
Pewter
Dia. 105mm, H. 54mm, Wt. 190g
4th century
British Museum, London, P&E 1853.4-11.5
Bibl. *RIB* **2.2**, 2417.22.

Found as part of a hoard of metalwork in 1849.
A small pedestal bowl with simple incised rings
on the flanged rim. On the underside of the rim
is the neatly incised name LICINIVS. [R.J.]

160 Bowl or cup

Icklingham, Suffolk
Pewter; Dia. 99mm, H. 74mm, Wt. 242g
4th century
British Museum, London, P&E 1852.6-26.14

A small plain-rimmed bowl on a high tapering
pedestal, part of a hoard of metalwork found in
1849. [R.J.]

161 Bowl

Icklingham, Suffolk
Pewter; W. 149mm, H. 76mm, Wt. 358g
4th century
British Museum, London, P&E 1853.4-11.2

A pedestal bowl with incised and dot-punched
decoration on the eight-point flange. Found as
part of a hoard of metalwork in 1849. [R.J.]

162 Platter

Icklingham, Suffolk
Pewter; Dia. 119mm, H. 19mm, Wt. 135g
4th century
British Museum, London, P&E 1853.4-11.14

A small circular platter with low foot-ring and
flanged rim, found as part of a hoard of
metalwork in 1849. [R.J.]

163 Dish

Icklingham, Suffolk
Pewter; Dia. 164mm, H. 31mm, Wt. 405g
4th century
British Museum, London, P&E 1853.4-11.16
Bibl. *RIB* **2.2**, 2417.19 (where the dish is erroneously attributed
a pedestal).

Found as part of a hoard of metalwork in 1849.
A circular dish with low foot-ring and simple
incised mouldings below the rim. On the
underside, within the foot-ring, is the incised
graffito IXARINVS. [R.J.]

164 Dish

Icklingham, Suffolk
Pewter; Dia. 118mm, H. 225mm, Wt. 180g
4th century
British Museum, London, P&E 1853.4-11.17

Found as part of a hoard of metalwork in 1849.
A small plain dish with low foot-ring and simple
everted rim. On the underside, within the foot-
ring, is a lightly incised graffito comprising a
cross within a rhombus. [R.J.]

165 Plate

Appleshaw, Hampshire
Pewter; Dia. 373mm, Wt. 1880g
4th century
British Museum, London, P&E 1897.12-18.10

Part of a hoard of 32 pewter vessels found
buried in a building in 1897. A large circular
plate, with low foot-ring and flanged rim, its
edge decorated with nicking, perhaps a
rudimentary imitation of the more
accomplished beading found on silver vessels.
The engraved design in the centre roundel
comprises interlaced rectangles enclosing spiral
and other curvilinear motifs. [R.J.]

166 Jug

Moorfields, London
Pewter; H. 237mm, Wt. 1034g
2nd century
British Museum, London, P&E 1959.5-3.1

Found near the base of a Roman well-shaft
excavated in 1959. Pewter jug with bulbous body,
low foot-ring, narrow tapering neck, flat mouth
and moulded rim. The handle and its
escutcheon are unelaborate and decoration of
the body is restricted to incised girth and neck
rings. This was a popular form of jug in pewter
that continued in use in the third and fourth
centuries. [R.J.]

168

167 Dish

Appleshaw, Hampshire
Pewter; Dia. 108mm, H. 23mm, Wt. 144g
4th century
British Museum, London, P&E 1897.12-18.28
Bibl. *RIB* **2.2**, 2417.36.

Part of a hoard of 32 pewter vessels found
buried in a building in 1897. A small plain dish
with low foot-ring and simple everted rim. On
the underside, within the foot-ring, is a lightly
incised Chi-Rho motif. [R.J.]

168 Model dish with fish

Alcester, Warwickshire
Pewter; L. 73mm, Wt. 66g
Probably 4th century
British Museum, London, P&E 1935.11-7.1

Found with Roman coins, pottery and a
fragment of a bronze statuette about 1929. A
miniature oval dish laden with three fish, the
lowermost cast in one with the dish, the two
above being separate castings. There is incised
decoration on the rim and within the dish. The
carefully modelled fish may have been intended
to represent three different species. There is a
hollowing of the long axis of the underside and
a possible fragment of solder beneath the rim of
the dish indicating that the object was originally
fastened to something larger. It was, perhaps, a
self-referencing decorative mount on a full-size
oval fish dish. [R.J.]

169 Fragments from a mattress cover

Egypt, Akhmim
Wool tapestry weave; 1630 × 495mm
4th century
Victoria and Albert Museum, London 267-1889
Bibl. Kendrick 1920, 46–7, cat.20, pl.vi; *Textiles* 1995, 47, cat.48; Wood 1996, 54; see Trilling 1982, cat.1, cat.108 and 109 for Washington covers.

This textile fragment is from a mattress cover, probably for a marriage couch, and has large birds between bands which are based on wreaths and garlands. The fragment, from a Christian burial, is from the lower left side of the textile, preserving the selvedge and part of the 'starting border' (the horizontal border where weaving began). The tapestry weave, continuous throughout, is even but relatively coarse (*c*.7 warp ends per cm). The large scale of the design confirms the furnishing use. Another fragment, in the Metropolitan Museum of Art, New York (90.5.807; 640 × 500mm), also with part of the left selvedge, appears to have joined on directly above this larger fragment. The second fragment in the Victoria and Albert Museum (268-1889; 380 × 380mm) is from the centre of the textile. The original overall dimensions can be calculated as *c*.2720 × 2100mm.

The decoration is based on a symmetrical arrangement of bands. In the central area, wreath-like bands in threes alternate with broad bands with birds set on a cherry-red ground. The birds perch on green branches and originally were arranged in pairs, with a basket of grapes between them. Looking at the three fragments together, we can deduce that this paired bird motif repeated twice across the width of the textile and three times down its length. The birds vary from one another in colouring but are all of the same exaggerated style, with tiny eyes set very close to their beaks, thick necks and short tails. They resemble small game birds, but are much enlarged (*c*.300mm high).

Above and below the bands with birds is a broad band made up from five sub-bands: the middle and outer sub-bands are again based on wreaths or garlands and the two sub-bands in between are derived from jewellery – a gold necklace set with almond-shaped gemstones. The textile finished at each end with a wider individual band, a garland of leaves and occasional roses, the leaves and flowers seen in profile in the lighter borders. Many conventional tapestry techniques are employed, notably hatching for the birds' plumage and simplified 'shading' for the plain borders within the multiple bands. But a comparatively late date is indicated first by the quantity of decoration in general and second by the use of the jewellery motif.

Transverse bands, grouped and single, are typical of cushion and mattress covers. The style of decoration in this case is very different from the mattress covers in *polymita* weave (see cats 170 and 171), but can be compared to mattress covers depicted on a type of stone sarcophagi produced in Attica in the third century and where the technique represented is surely also tapestry. On each of the sarcophagi, a deceased married couple is represented reclining as if in bed. It is hard at first to reconcile the large size of the actual textile (*c*.2720 × 2100mm) with this use. Two complete *polymita* mattress covers in Washington are considerably smaller, measuring 2390 × 1290mm and 2390 × 1330mm, while a more complete cover also in tapestry weave, again in Washington, is longer but still narrower, at 3250 × *c*.1850mm. The two tapestry examples, however, are surely intended for double rather than single beds (the design of the exhibited textile supports this, through the organisation of the paired bird motif into two columns). The Attic sarcophagi and other representations also illustrate how covers were tucked in around the mattresses, which evidently were often quite thick. Little information on the actual size of beds is available but Wood's study of the remains of wooden beds at Herculaneum shows that in the first century they were around 2300 × 1200mm, by our standards rather long.

The imagery of the exhibited cover, and its probable association with marriage, is best understood by comparing it with the Washington tapestry cover which has the medallioned heads of Aphrodite/Venus and her consort Adonis (Textile Museum 71.118). Its similarity with the textile here lies first of all in the layout, overall colouring and style. But many details are also very close. In particular, hidden in the garland are birds perched on twigs very similar to the much bigger birds on the exhibited textile. The iconographic message of this textile is less direct, but the non-figurative bands, derived from wreaths, garlands and jewellery, by themselves carry the idea of ceremony and celebration, while the motif of the paired birds with their basket of grapes would have been immediately recognised as a symbol of fruitfulness. Aphrodite herself is here understood, even if she is not depicted.

The Washington textile has a woven inscription inside the left-hand wreath: *Herkleias* (at Herekleia). From this it has been argued that, although found in Egypt, the textile might have been woven at Herakleia Perinthos, near Constantinople. The Victoria and Albert textile fragments do not have an inscription and it is not known where the cover was woven. It might be understood as a copy of an imported type since the yarns are all S-spun, a circumstance which fits a provenance within Egypt. On the other hand, the prominence of a khaki-coloured weft yarn, perhaps the product of an iron mordant, is unusual in an Egyptian textile. [H.G-T.]

170 Fragment from a mattress cover

Akhmim, Egypt
Wool, weft-faced compound tabby weave (*polymita*); 180 × 115mm
Mid-3rd to mid-4th century
Victoria and Albert Museum, London, 899-1886
Bibl. Kendrick 1921, 75, cat.547.

From a Christian burial. Cut in modern times from the remains of a larger textile (other fragments are known). As with cat.171, another example of *polymita*, we can recognise this as a mattress cover. In both cases the decoration is composed of repeating bands, but in detail the design is very different in the two fragments and here complex chequers take the place of the simple motifs in contrasting colours that are typical of this weave. In fact the design is extremely close to that of the silk fragments from Cologne (cat.233) and we can conclude that this much heavier textile has been inspired not only by the designs of the contemporary *scutulatus* silks but, in its use of two colours close in tone, also by their damask effect.

Certain technical characteristics, in particular the fact that the compound structure continues on through the plain cherry-red bands, also set this textile aside from the majority of finds in this weave. Although

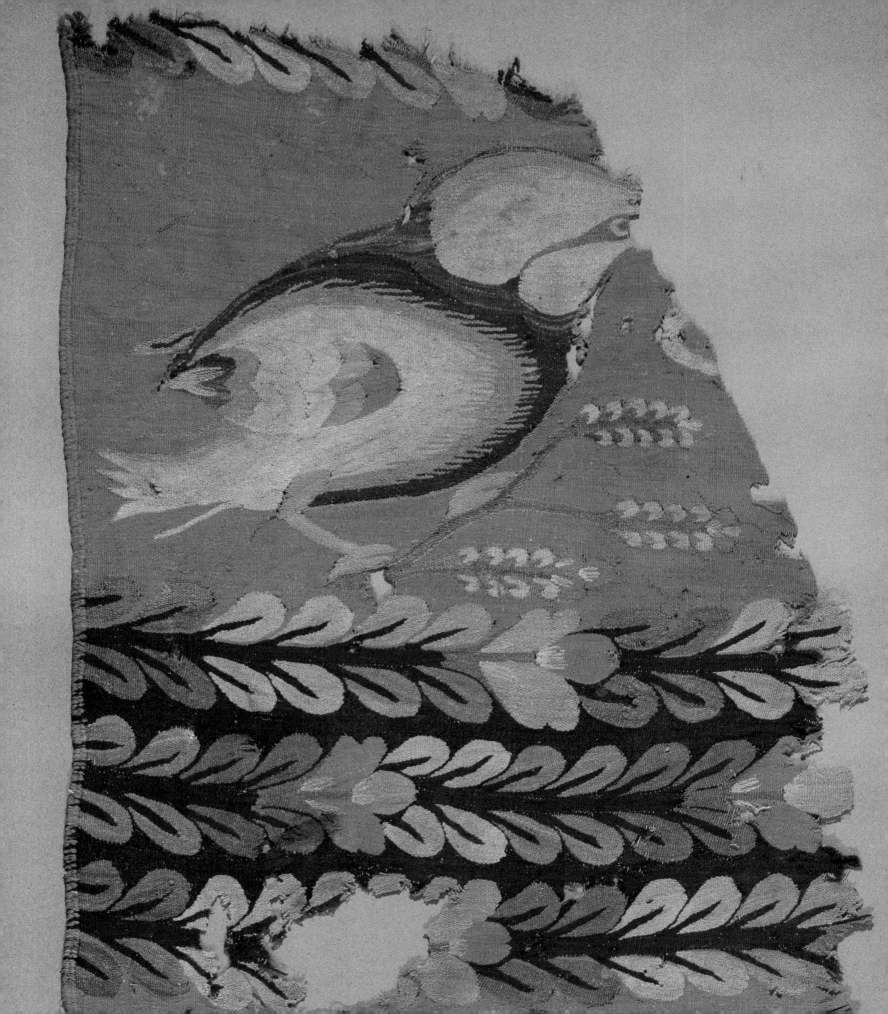

170

171

discovered in Egypt, it may have been made elsewhere. [H.G-T.]

171 Fragment from a mattress cover

Akhmim, Egypt
Coloured and undyed wool, weft-faced compound tabby weave (*polymita*); 405 × 320mm
3rd–4th century
Victoria and Albert Museum, London, 449-1887
Bibl. Kendrick 1921, 74, cat.542; Lamm and Charleston 1939, pl.III.

From a Christian burial. Fragment from a much larger textile. The type of textile is known to have been used for cushion and mattress covers and here, as with cat.170, the thickness points to the latter. The weave, known in antiquity by the Greek term, *polymita,* literally '[woven with] many heddles', was the first with mechanically repeating designs to have been developed in the western world and may have had its origins in Alexandria. It had been known since the first century and this example, with three field designs and three border designs, each in two contrasting colours, provides a small repertoire of typical patterns: the various bands would have been arranged symmetrically down the length of the cover. [H.G-T.]

172 Fragment from a curtain

Akhmim, Egypt
Linen embroidered in coloured wool (chain stitch and couching); 205 × 215mm
c.5th century
Victoria and Albert Museum, London, 1262-1888
Bibl. Kendrick 1921, 15, cat.318, pl.IV; Buckton 1994, 112.

From a Christian burial. Fragment, probably from the upper centre of a curtain, with a jewelled cross and paired doves within a wreath. The fragment has been cut in modern times from the remains of a much larger textile. Where the wool embroidery thread is missing (eaten by moths in antiquity) the drawing of the design can be seen on the linen ground.

The motif of a cross within a wreath is common in early Christian art. Its use is symbolic – the cross represents Christ and the wreath His victory over death – but here the individual components are each represented realistically. The wreath, of green and red leaves or petals, is covered at its base by a basketry

sleeve, serving as a handle; a jewel or brooch is missing from its apex. The cross, with slightly flared equal arms and suspended by a chain, is apparently of gold and is embellished with square and round gemstones and pairs of pearls. Jewelled pendants hang from the cross itself and from the chain. The doves are represented in shades of blue, with yellow-ringed eyes and pink legs and beak.

The realistic treatment points to a comparatively early date. Most textiles recovered in Egypt are decorated in tapestry weave rather than embroidery. In the case of furnishings, however, embroidery seems to have been an established alternative. [H.G-T.]

173 Fragment from a curtain or wall hanging

Egypt, Akhmim
Linen, resist painted and dyed in blue; 550 × 680mm
4th century
Victoria and Albert Museum, London, 723-1897
Bibl. Kendrick 1922, 64–5, cat.785, pl.xix; Woolley 2001.

The fragment of wall hanging or curtain, from a Christian burial, shows the Annunciation and, on the right, the Virgin Mary on her own. It has no woven edges, but the weave shows that there was a selvedge a little way above the present upper edge and the organisation of the borders suggests that the fragment comes from the top right of the decorated area. The larger textile was divided into horizontal registers by borders and into individual scenes by twisted columns.

In this fragment the main scene is the Annunciation. The angel appears before the seated Virgin, identified by the inscription *Maria*. The scene is as described in the apocryphal Book of James (x.1–xi.11): Mary had been allotted true purple and scarlet wool to spin into yarn to be used in weaving a new Veil for the Temple. She 'took the purple and sat down upon her seat and drew out the [wool]. And behold an angel of the Lord stood before her saying: Fear not, Mary …'. Mary is shown in the fragment preparing a rove, the stage of yarn production that preceded spinning proper. In her left hand she holds up the mass of combed purple wool fleece. With her right hand she draws this out into a continuous rove that drops into the wool basket at her feet.

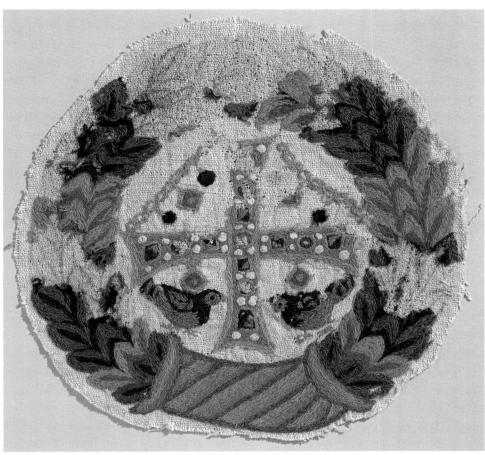

172

Another fragment in the Victoria and Albert Museum undoubtedly comes from the same textile, and again from the upper edge (1103-1900; Kendrick 786, 455 × 850mm). Here the subject is the Nativity. A third fragment in the Victoria and Albert Museum (722-1897, Kendrick 787, 780 × 850mm), which has parts of two registers with biblical scenes, is believed to have come from the same textile as the first two. If so, the Life of Mary must have acted as a preamble to the main subject, the Life of Christ accompanied by appropriate Old Testament scenes, and the whole must have been divided into at least three registers.

A distinctive style is more or less common to all the resist-dyed textiles of this period from Egypt. Its signature is really the treatment of the heads, which have exuberantly curly hair and very large eyes set in simplified but expressive faces. But the whole figures are lively and full of movement, especially in comparison with the rather solid and impassive figure style of most

late Roman art. The boldness of the painting is suited to textiles intended to be seen from a distance. Certainly some of the surviving examples are very large.

As discussed by Kendrick, the technique of these textiles, with a design painted in resist medium and the whole textile afterwards dyed either blue or red, is undoubtedly of Indian origin. The orthographic details of the various inscriptions, along with the character of the linen cloth itself, make clear that they were actually executed in Egypt, but it is possible that they were produced by Indian craftsmen working there. They must have been quick to produce and relatively cheap, but the dyeing of such large pieces of cloth would have been a highly specialist undertaking.

In a letter written to a colleague in 394, Epiphanius, Metropolitan of Cyprus, related that while travelling in Syria he had seen, at a place called Anablatha, a dyed and painted curtain hanging in the doorway of the church

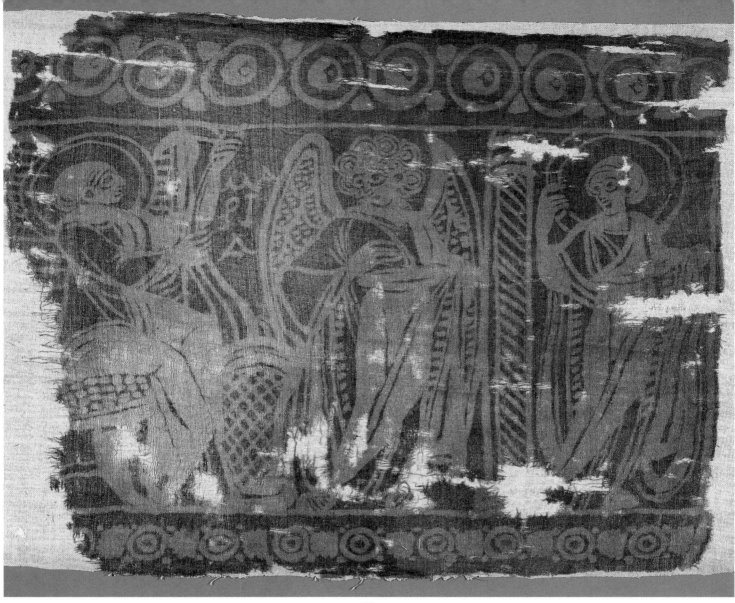

173

('inveni ibi velum pendens in foribus ejusdem ecclesiae tinctum atque depictum'). This had on it:

the image as of Christ or some saint: I do not recall exactly whom it represented. Seeing this, therefore, and abominating the idea of a human image hanging in the church, contrary to the authority of the scriptures, I rent it asunder and recommended the custodians of the place to use it to wrap the body of some poor man for burial. (Epistula, 263–4)

Epiphanius is certainly describing a textile in the resist technique.

The use of curtains and awnings over doorways was well established in antiquity and Epiphanius would have known of the Veil that had hung in the front of the Temple of Jerusalem for which Mary was preparing wool yarn. The technique of the Veil must have consisted, as with most surviving curtains from Egypt, of motifs tapestry woven in coloured wool within a ground of undyed linen. According to Josephus's account (*Jewish War*, 209–15) at the time of the Second Temple the decoration of the Veil had a cosmological theme. We can safely assume that no human figures were depicted.

Because the resist-dyed textiles have more or less their own style it has been difficult to date them. A comparison with early Christian art in Italy is useful, however, particularly in terms of composition and subject matter. The twisted columns and horizontal registers of this textile make it close to the reliefs on certain Italian sarcophagi of the mid- to late fourth century (Gough 1973, 105–8). Indeed, the manner in which the Life of Mary occurs above the Life of Christ can be compared to the way the decoration on the lid of some sarcophagi relates to the main scheme of decoration on the box itself.

The early dating of this textile is supported by the clothing depicted. The garments the figures are wearing are very plain and consist of draped mantles over tunics that are very wide but still sleeveless. In reality, people had been wearing sleeved tunics from the mid-third century. The change in the garments depicted in biblical scenes came somewhat later. Taking the mosaics at Ravenna as a guide, it can be observed that in the mosaics of the fifth century at the Mausoleum of Galla Placidia and the Baptistery of the Orthodox the tunics are sleeveless, while in the sixth-century mosaic in Sant'Apollinare Nuovo they have tight sleeves from elbow to wrist. [H.G-T.]

174 Square panels with portrait busts, appliqués from a furnishing textile

Akhmim, Egypt
Wool with small quantities of linen, tapestry weave; each 230 × 215mm
4th century
Victoria and Albert Museum, London, 269-1889 and 270-1889

Bibl. Kendrick 1920, 64–5, cats 58–9, pl.xiv; Trilling 1982, cat.1.

These two panels, from a Christian burial, undoubtedly come from a furnishing of some sort. This must have been intended to be viewed at some distance as the design is very bold and the use of colours quasi-abstract (note in particular the pale turquoise used on the bridge of the noses of both subjects). The texture is also relatively coarse (only *c.*7 warp ends per cm). Nevertheless, a large number of different colours of weft yarn have been used with great skill. The aim has not been to create smooth gradations of tone, or 'shading', as would have been the case in earlier and finer tapestry weaving, but for effects that are both contrasting and three dimensional; the heads stand out from the dark background and the large features are clearly defined within the faces. The style is essentially that which was current throughout the Roman Empire at this time and can be compared with the paintings from Trier (cat.40 and figs 27 and 52). In these Egyptian images, however, the tendency for the head to be shown as disproportionately large in relation to the shoulders is particularly marked. This mannerism was to continue in Egypt as a key element in the later 'Coptic' style.

The panels were made to be sewn to another cloth, almost certainly of plain linen. The normal practice was for areas of tapestry decoration to be woven as part of the larger textile (cat.116 demonstrates this technique). The fact that, in this case, the panels have been woven separately on a wool warp indicates that they are the product of a specialist tapestry workshop.

The female figure is surely Aphrodite. Unusually, she is shown with dark rather than blonde hair, but her jewellery is typical, as is her semi-nakedness. Once she has been identified, her partner is recognisable as Adonis; these two are often found paired on textiles from Egypt. Essentially Adonis has been included to provide symmetry. His lower status is shown by the fact

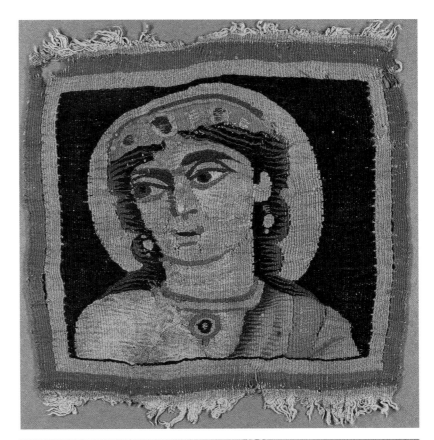

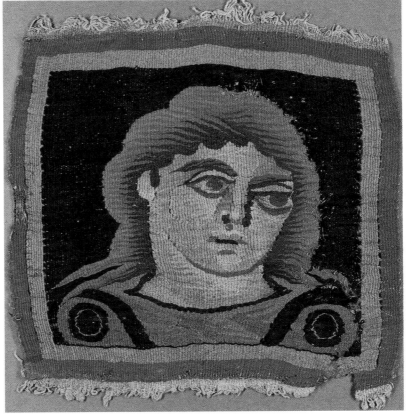

174

that he has no halo, nor diadem or wreath of any kind. His long wavy hair at first sight might seem to be an attribute of the mythical hero, but is perhaps more likely to be a contemporary fashion. It can be compared, for example, to the long hair of the owner's two sons in the mosaic in the vestibule to the baths at Piazza Armerina (fig.51). Here the young man on the left wears a narrow-sleeved tunic in green. The roundels on the shoulders of Adonis's green tunic show that his tunic would have been of the same type.

Aphrodite's principal role was as goddess of human sexuality and of fruitfulness in general. As such, she presided over marriages and, on a large textile in Washington that appears to have been a cover for a marriage couch, the heads of Aphrodite and Adonis are again found together (see cat.169). Aphrodite was also the deity of concord and civil harmony, and because of this was associated with magistrates. A court scene gives us the best idea of how these two panels might have been used. This is depicted on two folios in the Rossano Gospels, a manuscript produced in the sixth century, perhaps in Jerusalem, where the subject is Christ before Pilate (fols 8r and 8v). Here Pilate sits behind a writing table covered with a white fringed cloth. There are two portrait busts on the front of this textile where it hangs down in front of the table and where the images would have been visible to the whole assembly.

The panels of Aphrodite and Adonis are pagan images found in a Christian burial. Textiles with pagan subjects continued to be made in Egypt in the fourth century and beyond. [H.G-T.]

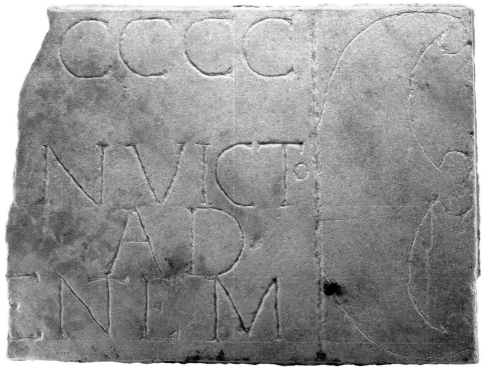

176

175 Casket and infuser

London
Silver with traces of gilding; casket: H. 63mm, Dia. 254mm, infusor: H. 45mm, Dia. 64–70mm
Late 3rd century
Museum of London, 21579
Bibl. Toynbee 1962, 173–4, no.110, pls 111–12; Toynbee 1986, 42–52, no.16, col.pl.XIII, pls 22–5, 9, figs 2–4; Strong 1966, 170, pl.46a; Shepherd 1998, 179–81, figs 208–10; cf. Merrifield 1998.

The casket, which is hinged, is ornamented on both lid and sides with scenes connected with the capture of exotic animals. In the centre of the lid is an elephant; other animals portrayed here are leopards, a snake attacking a boar, and eagle-griffins attempting to lever open box-like objects. A third box-like object has a man emerging from it so this must be some sort of decoy to capture these ferocious beasts.

The sides show a griffin confronting a snake, an ichneumon (one of the mongoose family) likewise facing a serpent, an elephant in combat with a leopard, a hippopotamus likewise fighting a feline, a lion devouring a quadruped and scenes of human combat suggestive of the arena.

The infuser, which is too small to fit its container snugly, is plain apart from perforations on the base in the form of an eight-petalled rosette with surrounding vegetal frieze.

It has been suggested that the infuser could well have been for liquids used in the Mithraic mysteries. The considerable wear on the casket and signs of repair suggest that it was being used many decades after manufacture, probably into the middle decades of the fourth century. The subject matter of the casket, which could be seen to allude to Bacchus's Indian triumph, would suit a Bacchic use and indeed the object may be regarded as an example of the *cista mystica* like that held by the maenad on the statuette group (cat.181). Hallucinogenic drugs were very probably used in Bacchic ritual. With the casket and strainer were the fragmentary remains of a silver bowl, ornamented with punched, geometric ornamentation, very probably the container for the drink.

Here, then, is evidence for the same sort of pagan ritual, involving sacramental feasting, indicated by the Trier Mysteries mosaic (fig.35) and the Thetford Treasure. [M.H.]

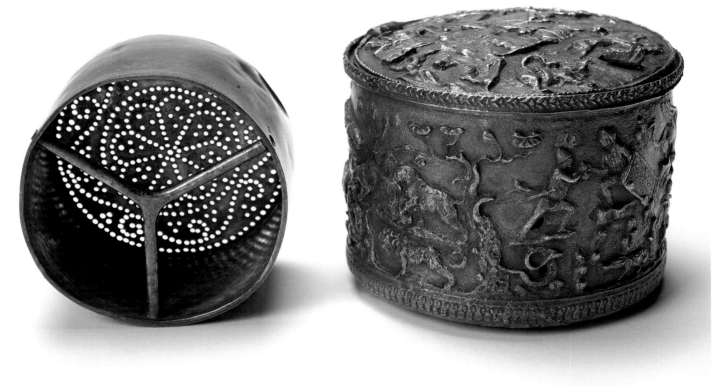

175

176 Dedication panel

London, Walbrook Mithraeum
Imported marble; H. 255mm, W. 320mm, T. 16mm
Latin, *c*.September 307/November 308
Museum of London, 18499
Bibl. *RIB* 1, 4; Shepherd 1998; Henig 1998.

The right-hand portion of quite a wide panel intended for insertion into a building structure, whose find-spot and surviving letters suggest a dedication to Mithras and the Unconquered Sun on behalf of four senior emperors (*Augusti*). The text can therefore be restored with reasonable certainty: *[Pro salute d(ominorum) n(ostrorum) Au]g(ustorum) [et nob(ilissimi) Caes(aris) deo Mithrae et Soli] Invicto [ab oriente] ad [occid]entem* (For the welfare of our Lords the [four] Augusti and the Most Noble Caesar, to the god Mithras and the Sun Unconquered from East to West). This combination of emperors belongs to the period of about a year in which Constantine and Maxentius had secured their recognition as western *Augusti* by Maximian, Maximian himself had resumed power, Galerius

was eastern *Augustus*, and Maximinus was *Caesar*.

The Mithraeum beside the Walbrook stream in the City of London was excavated in 1954 by Grimes. The many finds from the temple included marble sculpture of high quality which, together with others, recovered from building work at the site about sixty years earlier (in 1889) give it a place amongst the most richly appointed Mithraea in western Europe. The temple was of the usual basilican shape and evidently in use for the worship of Mithras from the time of its construction in the late second or early third century until the first decade or so of the fourth century, when disaster struck. However, contrary to the suggestion previously advanced, this does not appear to have been the result of Christian iconoclasm but of the structural weakness of the building. It was constructed on the shifting gravels and silts of the stream bank and this led to its partial collapse. Subsequently the Mithraic sculptures were collected and buried. The temple was eventually rebuilt, but the worshippers during the entire remainder of the fourth century were

very probably a collegium of worshippers of Bacchus. The statuette of Bacchus and his companions (cat.181) found on the latest floor should be assigned to this *Bacchium* and so, very probably, should the casket and strainer and faceted silver bowl recovered from a recess in the temple's north wall, though unfortunately there is no stratigraphical proof of the date of the cache. [R.T.; M.H.]

177 Head of Mithras

London
Marble, probably Carrara; H. 369mm
3rd century
Museum of London, 20005
Bibl. Toynbee 1962, 141–2, no.36, pl.42; Toynbee 1986, 5–10, no.1, col.pl.1, pls 1–3; Shepherd 1998, 165–6, figs 180–3.

The youthful head that characteristically wears a Phrygian cap is framed by richly carved locks of hair. The lips are slightly parted, and the eyes gaze upwards, their pupils deeply drilled and situated just below the eyelids. These features emphasise the god's ecstatic union with the heavens. The head and neck terminate in a

roughly shaped tenon intended for slotting into a body, presumably a tauroctony (bull-slaying scene).

Although originally highly polished, the surface has suffered abrasion, and there is physical damage to the side of the neck which may be the consequence of the collapsing temple building (see cat.176).

The carving is of very high quality. It is powerful evidence of Mithraism in London in the period immediately before and during Constantine's reign. [M.H.]

178 Circular brooch

Ostia, 1899
Bronze; Dia. 70mm
3rd century
Ashmolean Museum, Oxford, AN 1927.187
Bibl. Vermaseren 1948; Weitzmann 1979, 195, no.174; *Spätantike und frühes Christentum*, 435–7, no.47; *LIMC* **5.i** (1992), 606, Mithras no.229.

The subject portrayed upon this disc brooch is the Mithraic tauroctony (bull-slaying scene). Mithras, characteristically arrayed in Phrygian cap, short tunic, trousers and shoes, has leaped upon the back of the primeval bull, which is shown in profile to the right, and plunged his dagger into the animal's neck. Mithras is here equated with Sol by virtue of the rays, nine in number, which project from his nimbus and the raven perched upon his cloak that billows out behind him.

On the right is a cockerel while, on the left, standing upon the bull's tail, is another bird, similar in appearance to the raven but probably intended for a nightingale, in which case the nightingale and raven are emblematic of day and night, here standing in place of the usual *dadophori*, Cautes and Cautopates. Below a hound and snake, beneficent creatures which were believed to lap the bull's blood, the source of all life. Meanwhile a scorpion attacks the bull's testicles.

The brooch is hinged with a pin and back plate, and slightly convex. Most of the detail is engraved but some is lightly incised, especially the bull and Mithras's nimbus.

A number of Mithraea are recorded in Ostia, where the cult would have had a particular appeal to merchants. Although differing from Christianity in many respects, the emphasis on

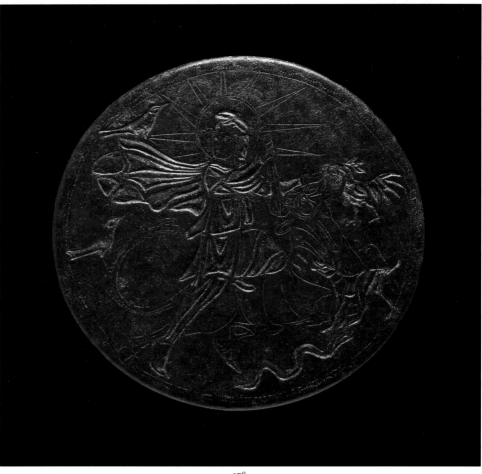

178

the sun provides an interesting parallel to the Solar monotheism which was so striking an aspect of Constantine's Christianity. [M.H.]

179 Relief carving of Sol

Corbridge, Northumberland
Buff sandstone; H. 520mm, W. 560mm
Probably late 3rd century
English Heritage (Trustees of the Corbridge Excavation Fund), CO 23342
Bibl. Toynbee 1964b, 140; Phillips 1977, 20–1, no.56, pl.16.

Found reused in the fourth-century floor of the east granary, the relief depicts a fully frontal radiate bust of Sol, nimbed with protruding rays of which only eight out of perhaps ten remain as a result of damage to the top right corner of the stone. The shoulders are not fully shown but drapery extends almost up to the chin. Behind his left shoulder is his whip.

The face is distinctly ovoid with a rounded chin, and the god's hair is rendered in a fairly

decorative manner as a mass of curls, worn as a sort of topknot. The eyes are large and rather almond shaped with boldly emphasised lids, the nose is wedge shaped and the lips small and pouting.

Although clearly a local carving, it is an expressively powerful image which attempts to create the same overwhelming effect that more classically accomplished renditions of the Sun achieved in more metropolitan centres. Outward-facing images of the Unconquered Sun (Sol Invictus), like this, may have influenced the way in which the head of Christ came to be shown in fourth-century art, as at Hinton St Mary (cat.190), where the solar rays were replaced by the Chi-Rho.

From the end of the third century the veneration of the sun was a feature of a number of cults and this relief at Corbridge was presumably still displayed well into the fourth century. [M.H.]

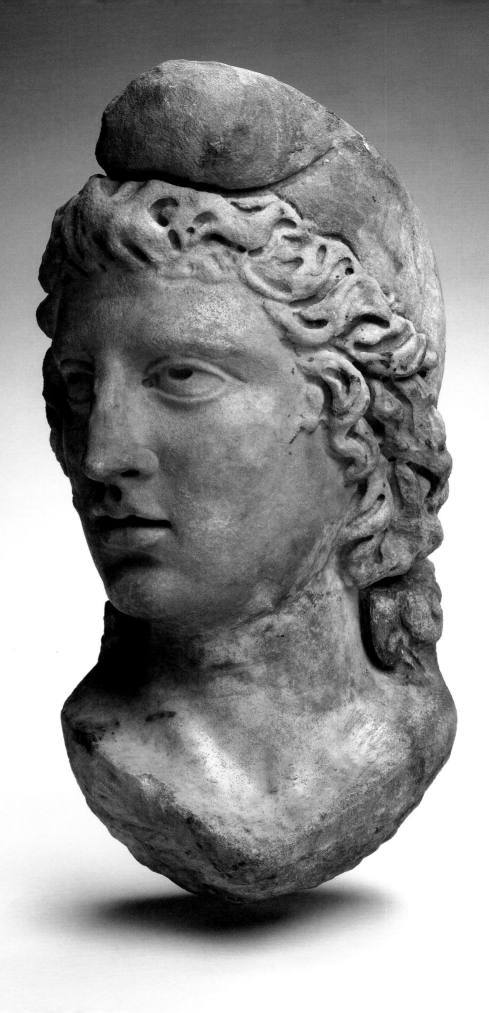

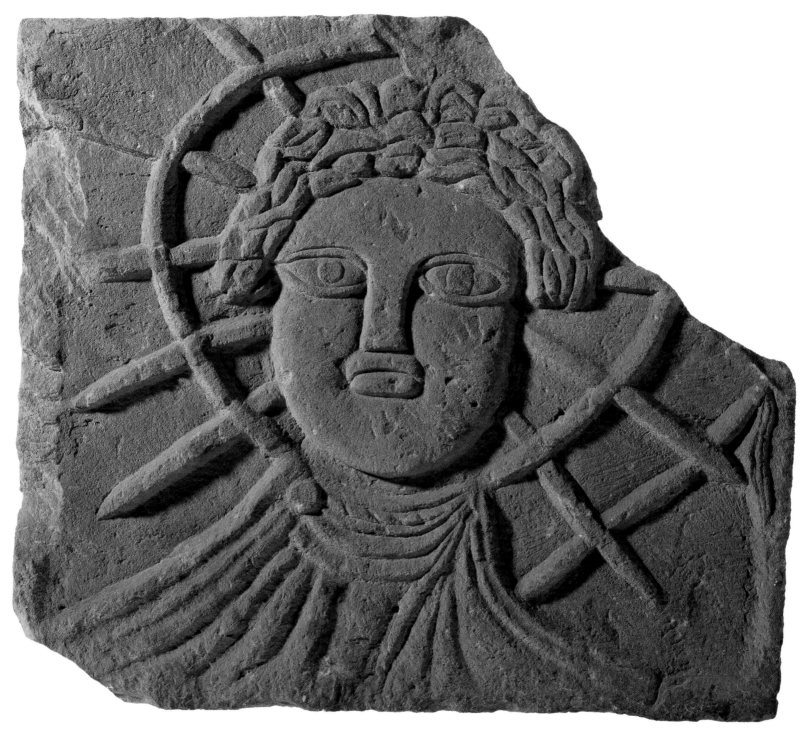

179

180

180 Dedication slab

Chesters Fort, Hadrian's Wall
Sandstone; H. 480mm, W. 320mm, Th. 210mm
Latin, 286
English Heritage (Trustees of the Clayton
Collection), CH 6841
Bibl. *Britannia* **36** (2005), forthcoming.

The stone is the middle portion of a dedication
to the eastern god Jupiter Dolichenus and
mentions his temple, for which there is other
evidence at Chesters. The stone is dated by a
fragmentary consulship in the bottom line, that
of Maximus and Aquilinus in 286. This is the
latest consular date to be yet found in a
Romano-British inscription, and it happens to
be the year of Carausius' accession. It is also
evidence that worship of Jupiter Dolichenus in
Britain survived the sack of his cult centre at
Doliche (now Dülük in south-eastern Turkey)
by the Persians in 252. [R.T.]

181 Statuette of Bacchus with his companions

London
Marble; H. 343mm, W. 293mm
3rd–4th century
Museum of London, 18496
Bibl. *RIB* **1**, no.1; Toynbee 1962, 128–30, no.12, pl.34; Toynbee
1986, 39–42, no.15, col.pl.XII, pl.21; Shepherd 1998, 110, 189–91,
figs 221–2; Stirling 2005, 193–4, fig.63.

Bacchus stands in the centre of the group, nude
with a lithe, somewhat effeminate, body and
long locks which cascade down to his breast. On
his head he wears a diadem. His right arm is
raised and characteristically bent over his head,
his hand grasping a large snake. Behind is a vine
from which hang clusters of grapes. On his right
is a tree trunk upon which sits a diminutive
figure of Pan; below is an equally diminutive
Silenus on a donkey. On the other side Bacchus
is partly supported by a satyr, and on the far left
is a maenad holding a *cista mystica*. Most of the
figure of Pan and the heads of the satyr and
maenad are missing.

On the low base is an inscription:
HOMINIBVS BAGIS BITAM (You give life to
wandering mortals).

Traces of paint remain including green
among the grapes and the tree and blue behind
the head of Silenus. There are traces of red on

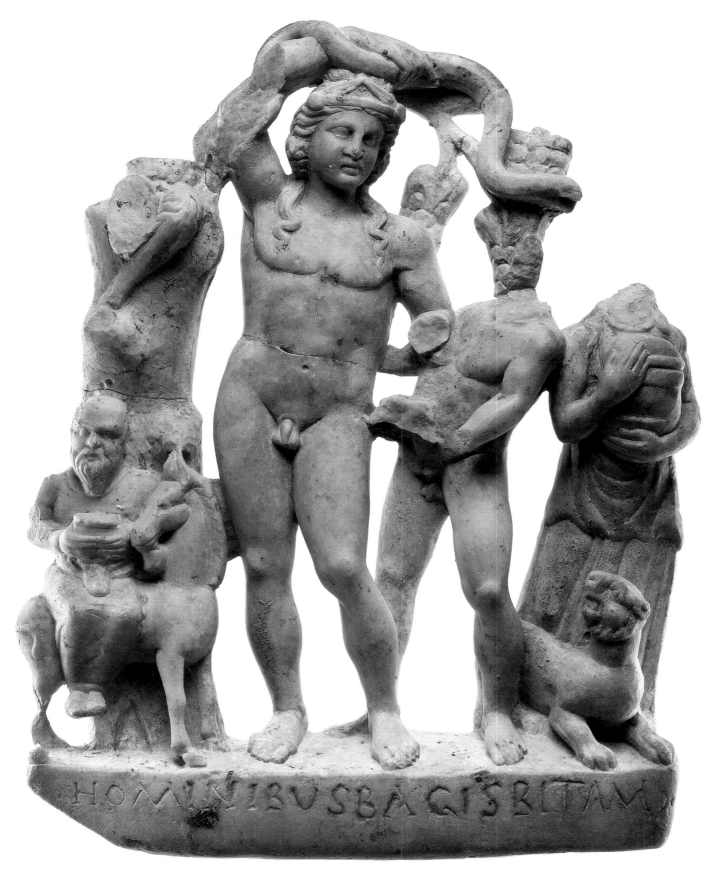

181

182

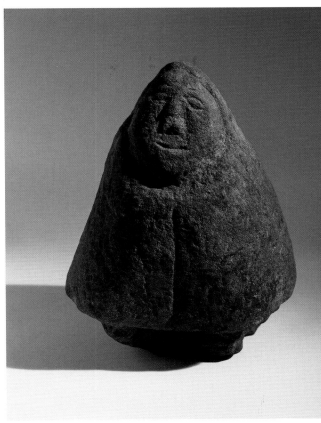

183

183 Statuette of a Genius Cucullatus

Birdoswald
Local sandstone; H. 176mm, W. 132mm
3rd century
Museum and Arts Service, Carlisle, L29-26
Bibl. Coulston and Phillips 1988, 62, no.154, pl.43.

This small carved figure with a conical head and body and simply indicated facial features probably represents a local godling, a *genius cucullatus*, so called from the cloak or *cucullus* which envelops his body. This would have opened at the front as indicated by a vertical line scored down its centre. *Genii Cucullati* are generally shown as a triad, so this figure may well have had companions.

Although the Greco-Roman healing god Aesculapius is often associated with a small hooded deity, Telesphorus, the lack of sophistication in this carving renders that possibility unlikely. The Birdoswald figure is thus an indication of the pagan conception of deity at its most basic and probably survived the advent of Christianity under Constantine.
[M.H.]

the flesh, and more remains within the letters of the inscription.

It has been suggested that the inscription may in fact be secondary, converting an essentially genre piece into an item of religious devotion, presumably in the fourth century.
[M.H.]

182 Tinned-bronze figurine

Maiden Castle, Dorset
Copper alloy, tin plated; H. 95mm
3rd or 4th century
The Archaeological Collections of the Dorset Natural History and Archaeological Society at the Dorset County Museum, 1939.55
Bibl. Wheeler 1943, 75–6 and 133, pl.xxxi B; Ross 1967, 290 pl.72c; see *LIMC* 7 (1994), 848–50.

This unique figurine depicts a three-horned, dewlapped bull with its tail curved over its back, surmounted by three female busts. The one to the rear, above the bull's tail, clearly has an avian body; that in the centre seems to be heavily draped. Between the bull's horns is another bust, now headless. The composition must be a version of *Tarvos Trigaranus,* 'the bull with three egrets [or cranes]' depicted in the first-century monument of the Nautae Parisiaci at Paris. It shows the persistence of such Celto-Roman iconography right through the empire.

The figurine is also of interest for its manufacture. It was clearly intended to look as though it was cast in silver and this effect was achieved by the use of tin, mined in Cornwall.
[M.H.]

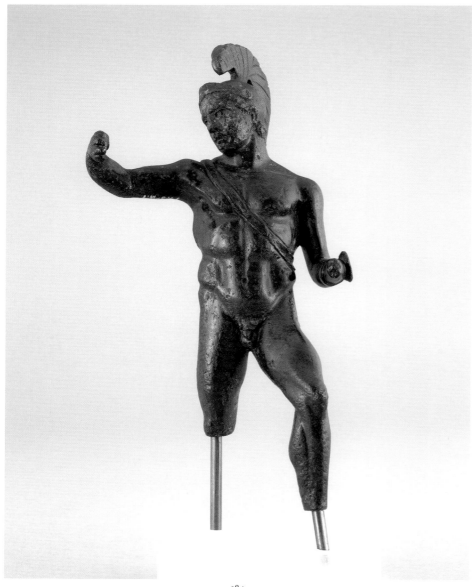

184

184 Statuette of Mars

Barkway, Hertfordshire
Copper alloy; H. 189mm
Probably 3rd century
British Museum, London, P&E 1817, 3-8.1

Bibl. Lysons 1817, pl.xlii, figs 1–2; Taylor 1914, 149, pl.x (left); Toynbee 1964b, 66; Pitts 1979, 51, no.13, pl.7; Lindgren 1980, 108–9, pl.78; Henig 1984a, 50–2, ill.12; Kaufmann-Heinimann 1998, 228n, GF2, Abb.176; cf. Bruun 1966, 179, no.192, pl.IV (solidus of Trier mint, 317–18).

This statuette portrays Mars, nude apart from a plumed helmet and a baldric which passes over his right shoulder and under his left arm. His right arm is raised, probably in order to brandish a spear, now lost. His right leg is missing below the knee and so are his hands and feet. This is an example of the striding Mars (Mars gradivus) type, common on gems and on coins including issues of Constantine. The modelling is very adept but there is no reason why it should not have been cast in a British workshop on commission for presentation to Mars at this particular temple, just as the votive leaves certainly were. [M.H.]

185 Plaque of Mars

Barkway, Hertfordshire
Silver gilt; H. 180mm, W. 100mm
Probably 3rd century
British Museum, London, P&E 1817, 3-8.3

Bibl. Lysons 1817, pl.XLI, 2; Taylor 1914, 149–50, pl.x (right); Walters 1921, 60–1, no.231; Toynbee 1964b, 328–9, pl.LXXVI; Toynbee 1978, 140–1, no.27, fig.7.1; Simon and Bauchhenss 1984, 568, no.495; Henig 1984a, 40–1, ill.4; Henig 1990b, 159, fig.11.12; Kaufmann-Heinimann 1998, 228, GF2, Abb.176; *RIB* 1 218.

The plaque is gilded to resemble gold from which such votive plaques were occasionally made. It is of oblong form with two finials curving outwards. In the centre Mars is shown, helmeted and cuirassed and looking to the left, holding a spear in his right hand and supporting a shield in his left hand. He is portrayed within an aedicule with twisted columns and leafy (Corinthian) capitals, and a triangular pediment containing a wreath. Below within an ansate plaque is the inscription: D . M . ALATORI/DVM . CENSORINVS/GEMELLI . FIL/V.S.L.M (To the god Mars Alator Dum[…] Censorinus, son of Gemellus paid his vow freely and willingly). The epithet *alator* may mean 'huntsman'. [M.H.]

184–6: Barkway assemblage

A small assemblage of objects comprising a statuette of Mars (cat.184), a handle and five silver votive leaves, one of which was gilded, dedicated to Mars (see cats 185–6) and two leaves to Vulcan were found together in Rookery Wood near the village of Barkway, Hertfordshire, in 1743 or 1744. Another collection of silver plaques was found at Stony Stratford, Buckinghamshire, with plaques depicting Vulcan, Apollo, Mars and Victory. A third collection of silver and gold plaques was recently discovered near Baldock, Hertfordshire, depicting a Minerva-type goddess evidently called Senuna. All three groups were doubtless connected with temples or shrines and may have come from *favissae*, temple repositories where sacred objects, which had been dedicated to the god but were no longer required for display within the shrine, were laid to rest. They demonstrate the flourishing state of pagan cults, dedicated to a wide variety of deities, in the British countryside. The late third- or early fourth-century date for the deposition of the Baldock group may be applicable to the others, showing that the tradition of giving votive leaves to deities was very much alive at the time of Constantine. Silver leaves like those from Barkway were familiar throughout the empire.

186 Plaque

Barkway, Hertfordshire
Silver; H. 200mm, W. 110mm
Probably 3rd century
British Museum, London, P&E 1817, 3-8.4

Bibl. Lysons 1817, pl.XLI, 1; Taylor 1914, 149–50, pl.x (right);
Walters 1921, 60–1, no.232; Toynbee 1964b, 328–9, pl.LXXVI;
Toynbee 1978, 140, no.28, fig.6; Kaufmann-Heinimann 1998,
228, GF2, Abb.176.

The plaque is rectangular with two pairs of
volutes. In the centre Mars is portrayed,
helmeted and cuirassed and looking to the right,
holding a spear in his right hand and supporting
a shield in his left hand. He stands within an
inner aedicule, representing the sanctuary of the
temple. There is a larger outer aedicule, with
herringbone-patterned gable, suggestive of the
temple as a whole. Both inner and outer pairs of
columns have twisted shafts. [M.H.]

187 Intaglio

Provenance unknown
Cornelian ringstone; 13 × 10.5mm, Wt. 0.84g
2nd–4th century
Ashmolean Museum, Oxford, AN Fortnum 75

Bibl. Henig 1983, 10–12, fig.1a; Henig and MacGregor 2004, 128
and 132, no.14.26.

The seven-branched candlestick was widely used
as a Jewish symbol in wall paintings, funerary
monuments and small objects such as seal-
stones which were originally set in finger-rings.
In this example the three central branches are
depicted with decorative disc attachments in the
style of religious standards used in various cults
including that of Serapis.

Judaism, one of the parents of Christianity,
was widely disseminated in the empire, and was
amongst the religions to which Constantine
accorded favour. [M.H.]

188 Finger-ring with intaglio

Aesica (Great Chesters), Northumberland
Silver and heliotrope; intaglio 15 × 12mm, H.
2.5mm, Dia. of ring 24–8mm
Late 3rd century–4th century
Museum of Antiquities of the University and
Society of Antiquaries of Newcastle upon Tyne,
1956.150.20.6.A

Bibl. Henig 1972; Charlesworth 1973, 233, pl.xxxi; Henig 1978b,
no.367.

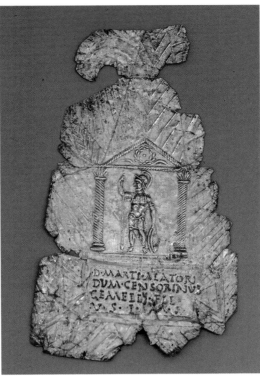

185

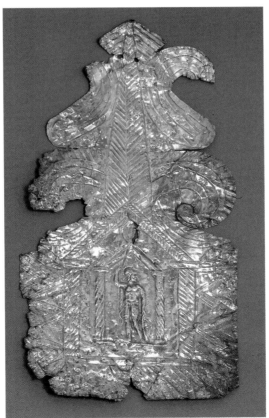

186

187

188

189

The ring has triangular shoulders, fluted and decorated with volutes, which are also employed lower down on the hoop. This is an elaborate example of a ring type characteristic of the third century (Henig type VIII).

The intaglio, cut on a stone whose material was believed to have solar connotations, depicts a figure with the head of a cockerel and two serpentine legs. His body is that of a soldier, clad in a cuirass and holding a circular shield in his left hand. In his right hand he holds a whip, the attribute of Sol. The figure probably represents Iao, a Hellenised version of the Hebraic supreme god, whose name was very probably engraved on the underside of the gem, as it was on similar amulets from Silchester (Hampshire) and in the Thetford Treasure. Iao is invoked in an oracle of Apollo, reported by the fourth-century pagan writer Macrobius, as 'the supreme god of all gods' (Macrobius, *Saturnalia* I, 18, 20).

Amulets such as this demonstrate the way in which some Judaic concepts permeated the Roman world even before Christianity became widespread. It is possible that the Great Chesters hoard, found in the fort strong-room, was buried around the time the usurper Allectus was defeated, but a later date is possible. [M.H.]

189 Gold amulet with Greek inscription

York, Old Railway Station
Gold; H. 19.5mm, W. 15mm
Probably 3rd or 4th century
York Museums Trust (Yorkshire Museum),
YORYM H20
Bibl. RCHMY **1**, 133, no.139, pl.65; *RIB* **1**, 236–7, no.706; cf. *RIB* **1**, 144, no.436 (Caernarfon); *RIB* **2.3**, no.2430.2 (Woodeaton); Biddle and Kjølbye-Biddle 2001, 57–60, fig.10 (St Albans); Tomlin 2004 (Billingford); for amulet cases MacGregor 1976, 10–11, no.72 (York); Johns and Potter 1983, 98–9, no.30 (Thetford).

This is a rectangular gold leaf inscribed with two lines of text, the upper line consisting of a mixture of letters and other characters that defy easy interpretation; the lower line is an Egyptian demotic text in Greek characters, apparently reading ΦΝΕΒ ΕΝΝΟΥΘ(Ι) (The lord of the gods).

Such texts, inscribed on sheets of precious metal, often blend Greek, Egyptian and Hebrew elements and were designed to obtain the help of divine powers in overcoming life's problems. They are particularly common in the east of the empire and only three other gold charms of this sort have been found in Britain. The earliest may be the example recently found at Billingford near Dereham, Norfolk, written partly in Latin. It was evidently owned by a person called Tiberius Claudius Similis, who probably came from Lower Germany in the late second or early third century and expected it to bring him 'health and victory'. It introduces the Hebraic Ἰαώ (Iao) and Αβρασαχ (Abrasax), both protective deities. The Caernarfon *lamella* and another from a native temple at Woodeaton near Oxford, both incorporate the similarly Hebraic name 'Adonai' in their invocations. Such charms were used widely, well into the period of the late empire. Thus, in the late Roman cemetery on the site of St Albans Abbey, tightly rolled thin pewter scrolls (which, when fresh, would have looked like silver), evidently inscribed, were associated with two fourth-century burials, which may have been Christian.

These *lamellae* would have been worn on the person in phylacteries amulet cases like a (probably) third-century specimen from the drain of the Fortress Baths at York or a late fourth-century example from the Thetford treasure.

This use of invocations and words of power is also found on magical or 'gnostic' gemstones, like the example exhibited here from Great Chesters (cat.188), depicting the god Ἰαώ. [M.H.]

190 Central roundel of floor mosaic

Hinton St Mary, Dorset
Stone tesserae; central roundel (without borders) 850mm, mosaic 8100 × 5200mm
Mid-4th century
British Museum, London, P&E 1965.4-9.1
Bibl. Toynbee 1964a; Eriksen 1980; Neal 1981, 87–9, mosaic 61.

The central roundel from the larger section of the Hinton St Mary mosaic, a masterpiece by the Durnovarian (Dorchester) school of mosaicists, is a roundel depicting a draped male with clean-shaven features looking towards the viewer. Behind his head is a Chi-Rho, carefully executed, though the mosaicist has omitted the serif on the bottom left branch of the Chi. The bust is flanked on either side by a pair of pomegranates trimmed with leaves. Despite some resemblance to images of Constantine and particularly his sons, this is not an image of the emperor but of Christ himself. Pomegranates, with their numerous seeds, were potent life symbols; associated in pagan myth with Demeter, but here applied to Christ.

190

The mosaic as a whole (fig.38) is an example of scriptural exegesis which cannot be understood without reference to Psalm 22, on which it is a commentary. The psalm falls into two parts of which the first (vs 1–18) is despairing, while from v.20 the mood changes and becomes increasingly ecstatic. The psalm, which begins with the line quoted by Jesus at his death, 'My God, my God, why have you forsaken me?' (Matthew 27, 46; Mark 15, 34), has always been taken by Christians to reflect first the suffering of Christ, and then the salvation he brings to mankind through his heroic sacrifice. All the figural elements in the mosaic allude to aspects of this poem.

The superscription to Psalm 22 is 'To the leader: according to the Deer of the Dawn. A Psalm of David'. The enigmatic 'Deer of the Dawn' was perhaps a melody but the mosaicist has taken it literally and combined the deer motif with v.16 'For dogs are all around me; a company of evildoers encircles me' and v.20 'Deliver my soul from the sword, my life from the power of the dog'. A reference may also have been intended to Psalm 42.1, 'As a deer longs for flowing streams so my soul longs for you, O God'.

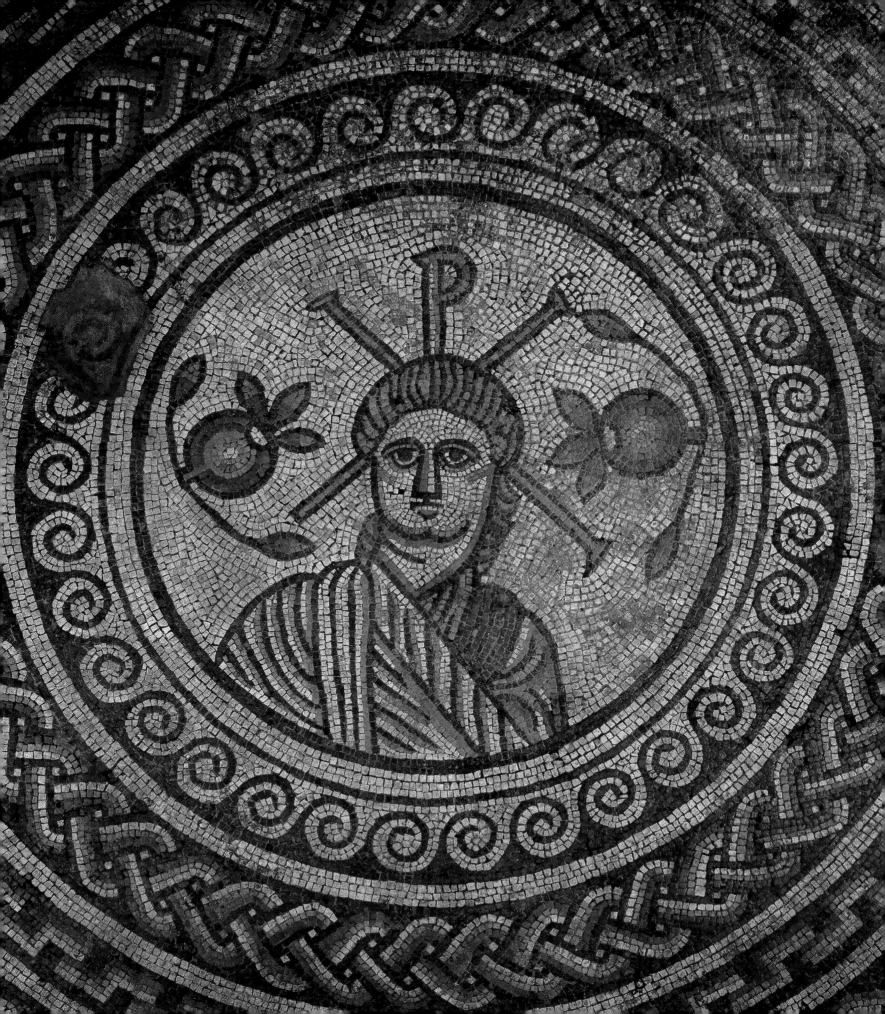

191

191 Pewter bowl

Sutton, Isle of Ely, Cambridgeshire
Pewter; H. 95mm, Dia. 210mm
4th century
University Museum of Archaeology and
Anthropology, Cambridge, 1922.753
Bibl. *RIB* **2.2**, 2417.29 with *Britannia* **29** (1998), 444; Clark 1931;
Toynbee 1962, 176, no.121, pls 137–8; Toynbee 1964b, 328;
Thomas 1981, 124–5; Mawer 1995, 20, c2.Pe.2; cf. Brown 1973,
188–9, fig.1, no.7; Sunter and Brown 1988, 10–11, fig.5 no.15.

The bowl is of a well-known form, with
octagonal flange and normally a high foot. Plain
examples are recorded, for example, in the
hoard of pewter from Appleford, Oxfordshire.

The incised decoration of the octagonal
flange is unusual. It consists of a large Chi-Rho
flanked by Alpha and Omega and with a small
crescent above. The figural decoration consists
of a peacock, two peahens, an owl and four
tritons. The peacock symbolises immortality;
the nereids in pagan contexts symbolise the
passage of the soul to felicity after death, but for
a Christian they could signify rebirth at baptism;
the owl, Minerva's bird, may have been
borrowed from pagan iconography to represent
Holy Wisdom.

Scratched underneath is a graffito in New
Roman Cursive: *superti … patientia*, perhaps for
superstitis patientia (a [*or* the] survivor's
patience). The allusion is obscure, and it may be
that *Patientia* and *Superstes* are personal names
otherwise unattested; 'Patience' would then be
the owner's name and 'Survivor' (in the genitive
case) that of her father or husband.

Plate used for the Eucharist would, as at
Water Newton (cats 196–204), most probably
have been of silver. In any case the flange would
have rendered the object unsuitable for a
chalice, and it is the wrong shape for a paten. In
an ecclesiastical setting it could have been an
oblation dish. The inscription, however, suggests
it was in private possession, and it may well
simply have been used domestically albeit by a
Christian family, though the dividing line
between sacred and secular is not always clear:

In the smaller section of the mosaic, there is
only an oblique allusion to the theme of the
psalm. A central roundel, unfortunately
damaged and crudely repaired in antiquity,
portrays a pagan mythological hero,
Bellerophon, on the winged horse Pegasus, in
the act of slaying the chimera. On either side is a
rectangular panel showing a hunting dog
coursing a stag in a wooded background. For a
Christian these trees would bring the Cross to
mind, and Bellerophon is a metaphor for Christ.

All becomes explicit in the larger part of the
mosaic. In three lunettes to the left and right of
Christ and above him the same elements of
hound, deer (in two cases a stag and in the third
a hind) and tree are seen. Immediately below the
Christ roundel a huge spreading tree is an
explicit reference both to the Cross and to the
Tree of Life. We go indeed from the sacrificial
'they divide my clothes among themselves, and
for my clothing they cast lots' in v.18 to the
Eternal Life opened up for us by Christ's
Passion, 'and I shall live for him' (v.29). With the
Chi-Rho behind him, Constantine's famous
'sign' is evoked. Here is Christ as *Cosmocrator*
(World-Ruler), as in v.28: 'For dominion belongs
to the Lord, and he rules over the nations'. This
concept is backed up by the four draped half-
length figures in the corners of the room, two
flanked by pomegranates (like Christ) and two
by rosettes. In a pagan mosaic we might have
expected personifications of the Seasons or
wind-gods here, but perhaps they simply
represent humankind, as in v.28: 'For dominion
belongs to the Lord, and he rules over the
nations'.

The disciplined layout of the mosaic and its
many attractive decorative elements such as the
stylised folds of the garments of Christ and the
other figures and the typical Durnovarian fleshy
leaf scrolls proclaim this a masterpiece. It also
indicates that at least one villa owner had a
highly sophisticated knowledge of the Bible.
[M.H.]

many of the silver and pewter plates from Bath (which incidentally include a flanged pewter bowl) were probably first used in the home before being consigned to the sacred spring of the goddess Sulis Minerva. [M.H. and R.T.]

192 Tombstone of Papias

Carlisle
Sandstone; H. 530mm, W. 810mm
Latin, 4th century
Museum and Arts Service, Carlisle, CALMG 1889.127/1892.1
Bibl. *RIB* **1**, 955.

D(is) M(anibus) Fla(vius) Antigon(u)s Papias civis Grecus vixit annos plus minus LX quemadmodum accomodatam fatis animam revocavit Septimia Do … (To the spirits of the Dead. Flavius Antigonus Papias, a Greek citizen, lived more or less 60 years, in the way that he recalled his soul resigned to the fates. Septimia [?Domina, his wife …]). The letter forms and the bold setting-out lines support a fourth-century date, when Christianity was spreading rapidly, and it is possible that Papias was a Christian. The qualification of his age at death as 'more or less' is typical of Christian epitaphs, but not exclusive to them. The heading D M and the idea of 'the fates', both pagan in origin, are conventions which are also found in Christian epitaphs. Embedded in the text is a metrical fragment whose grammatical subject is apparently Papias, [who] 'recalled his soul resigned to the fates'. Almost the same phrase occurs in a non-Christian epitaph of 310 found in Hungary (*CIL* **3** 3335). [R.T.]

193 Wall painting

Poundbury, Dorchester
Plaster; 870 × 630mm
Mid-4th century
The Archaeological Collections of the Dorset Natural History and Archaeological Society at the Dorset County Museum, 1994.5
Bibl. Davey and Ling 1981, 106–11, no.13; Sparey Green 1993, 135–9; cf. Dorigo 1971, 126, fig.85 and 227, pl.27.

Illustrated on p.91
This is a section of fresco from the western part of the south wall of the mausoleum. The fragment shows the upper part of a group of five figures (there were certainly originally more),

192

turned slightly to the east and evidently, in at least three instances, holding staves, shown in black but with a white highlight along the left edge. One of them, wearing a purple tunic, has a massive, rather rectangular head terminating in a dark beard. Better preserved is an elderly, ruddy-faced man, again bearded, wearing a white dalmatic (see cat.116).

The staves bring to mind the sceptres carried by gods in, for instance, the Tarrant Hinton and Malton paintings. These figures seem to be wearing everyday costume and do not look like gods. A clue to their identity is provided by a small Chi-Rho in white on its side, above and on the extreme left of the composition. If it is interpreted as a Christian scene, it is reasonable to see these as Apostles and the massively built man, maybe, as Peter, 'the Rock'. Sparey Green cites examples of double rows of Apostles wearing white dalmatics in the Catacombs, as in the Cemetery of the Jordani and in the apse mosaic of the Chapel of San Aquilino in Milan.

It is more than likely that Christ was shown somewhere in the centre of the group at Poundbury too.

There seems to have been a figural composition on the east and west walls as well. The west wall preserved traces of an architectural composition, plausibly interpreted by Sparey Green as revealing the Heavenly Jerusalem.

Although they are tantalisingly fragmentary and a good deal lower in quality than, for example, the Tarrant Hinton paintings, as examples of Christian art the décor of the Poundbury mausoleum ranks in importance with the church paintings from Lullingstone, Kent, revealing that fourth-century Britain had its own vigorous tradition of Christian art. [M.H.]

194

194 Tank

Walesby, Lincolnshire
Lead; H. 460mm, W. 480mm, D. 140mm, figured
panel, surviving L. 200mm (originally
*c.*290mm); H. 85mm
4th century
The Collection: Art and Archaeology in
Lincolnshire, LCNCC: 67.59.1

Bibl. Wright 1960, 238–9, no.16, pl.xxv; Petch 1961; Toynbee
1962, 181–2, cat. no.133, pl.143; Toynbee 1964b, 353–4; Thomas
1981, 88, 122, 221–4, pl.6; Guy 1981; *RIB* **2.2**, 71, no.2416.14.

The surviving remains of this lead tank consist
of two pieces cut in antiquity. One piece lacks
decoration save for two vertical strips of double
cable moulding and the herringbone ornament
along the rim.

The other preserves on the left a figural
scene. On the right are three men, evidently
clean-shaven with neatly-indicated short hair;
they are clad in belted tunics and cloaks and
stand between two Tuscan columns. The plough
has gouged a tear in the surface and distorted
the column separating this group from their

female companions on the left. Those on each
side wear long dresses; the sex of the figure on
the left is manifest from her breasts, but damage
has removed much of the detail of the woman
on the right. Between them is a girl shown nude
but carrying a long drape in her hands which on
her right reaches the ground and on her left to
the knee.

Below the figural panel is a large Chi-Rho,
executed in moulded lead strips, decorated with
herringbone zig-zag hatching, the longest
transverse strip 180mm in length, the others of
80mm strips. On the right between two vertical
strips of double-cable moulding is a group of
three reversed lunulae.

The Chi-Rho indicates the object was
Christian. The scene evidently shows a
candidate for baptism (who has just removed
her clothes) between sponsors, and in the
presence of the congregation, symbolised by
three people on each side. Presumably, there
were three further figures beyond another
column (of which a trace may remain) on the
left to complete the scene. The tank, like similar

examples from Roman Britain, albeit without
figural decoration, was presumably part of a
font in which baptism was by affusion.

The reason for the later deliberate
destruction of the vessel is uncertain. It may
have occurred because the Christian authorities
wished to prevent unauthorised use of the font
after it was no longer regarded as fit for use.
[M.H.]

195 Front part of tank

Flawborough, Nottinghamshire
Lead; W. 740mm max., H. 480mm max.; D. front
to back 600mm max.
4th century
University of Nottingham Museum, 2001/01

Bibl. Elliott and Malone 1999.

The tank was found in two pieces in 1998,
deposited one on top of the other in a pit. The
tank is not in good condition: prior to its
deposition an unsuccessful attempt had been
made to dismantle it. It was partly folded and at
the same time the base was sawn into two

halves. It had originally been made in three pieces: a flat round base and the two curving sides of the tank with mould-made decoration, all of which were welded together with rounded strips of lead. The tank originally measured approximately 1000 by 850mm, with sides when vertical about 550mm high. Gratuitous damage done at the time of dismantling includes slash marks, holes and lesser abrasions.

The top edge of the tank consists of a plain rounded lip; below it is a narrow frieze edged at top and bottom with a simple cable moulding. To left and right the frieze is decorated with a running ivy tendril in relief, replaced in the centre by the inscription: VTERE FELIX ('use happy', in other words 'good luck' to the user) (Tomlin and Hassall 2000, 442–3, no.42). To the left of the legend the border is interrupted by an *orans*, with hands raised vertically in prayer. It was clearly matched by another *orans* to the right of the inscription, almost entirely lost in one of the deep folds of the tank – the head and one upraised hand can just be made out.

The field below the frieze is taken up by a series of rectangular panels, now about 255mm across and 280mm high. The panels are divided by vertical strips 35mm wide, with a raised cable border on either edge and two vertical grooved lines between. Each panel is occupied by cable-patterned decoration in the form of a saltire. In the upper part of the central panel only is a Chi-Rho monogram set within a wreath, flanked by two *orans* figures, one on either side. The face and hands of the figure on the left have been worn flat and the legs damaged by scoring. The right *orans* is better preserved: the eyes and nose and some fingers of the figure's right hand can still be seen. Both *orantes* in the central panel appear to be male; the surface condition of the outer pair is too worn to ascertain their sex.

The tank belongs to a class of objects of which 21 examples, including this one, are now known (Watts 1991, 158–73; Watts 1995; Watts 1998, 147–53; Looker 1998–9). The distribution of the tanks shows a strong concentration in the East Midlands and East Anglia, where all but five of the tanks have been found. The presence of the chi-rho monogram on nine examples, including the one from Flawborough, indicates Christian ownership for some (and perhaps all) of them, and raises the possibility that they were used in Christian liturgy. It seems most likely

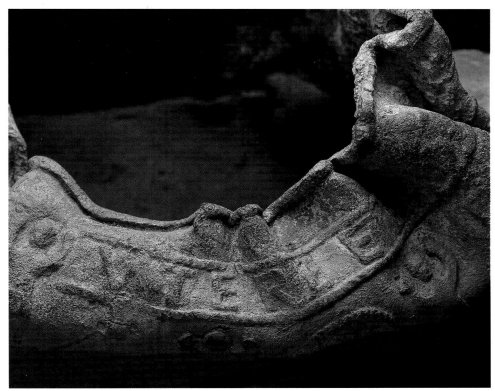

195

that they were used for Christian baptism, the new convert standing in the tank and having water poured over him or her; the alternative theory that they were used in the preparatory rite of foot-washing, *pedilavium,* seems less likely (Watts 1988; Watts 1991, 171–2).

Of all the 21 tanks, Flawborough's is the most highly decorated as well as being one of the largest: only one other example, from Walesby (Lincolnshire: cat.194), has human figures, and Flawborough is unique in combining a Chi-Rho, *orantes* and an inscription. The position interrupting the frieze of the two outer *orantes*, deliberately set at a level higher than the central pair flanking the Chi-Rho, also calls for comment. Are they meant to be shown heading heavenwards, and so hinting at the resurrection of the body and the promise of eternal salvation for Christians? While the Flawborough tank is so far without parallel in Britain, it is closely related to a flat lead panel from East Stoke (Ad Pontem), a small settlement five miles away from Flawborough on the Fosse Way. The panel (*RIB* **2.2**, 2416.8) likewise bears a Chi-Rho and the inscription VTERE FELIX, both framed by identical borders of cable pattern. Indeed it is clear from the letter forms and the spacing and

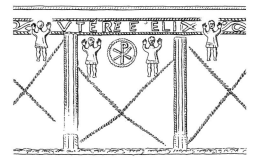

Figure 54 Decorated area of tank (cat.195)

size of the letters on the Flawborough tank, and in particular the mistaken use of an E instead of an F at the beginning of FELIX, that both objects were made using the same mould, both for the inscription and (probably) the Chi-Rho. The East Stoke piece is also accompanied by two figures (but not *orantes*; they may be angels), and was no doubt part of a container, perhaps also used for liturgical purposes. The tank was apparently not destroyed before the late fourth century as the pit where it was found contained pottery of that date (Elliott and Malone, pers. comm.). [R.J.A.W.]

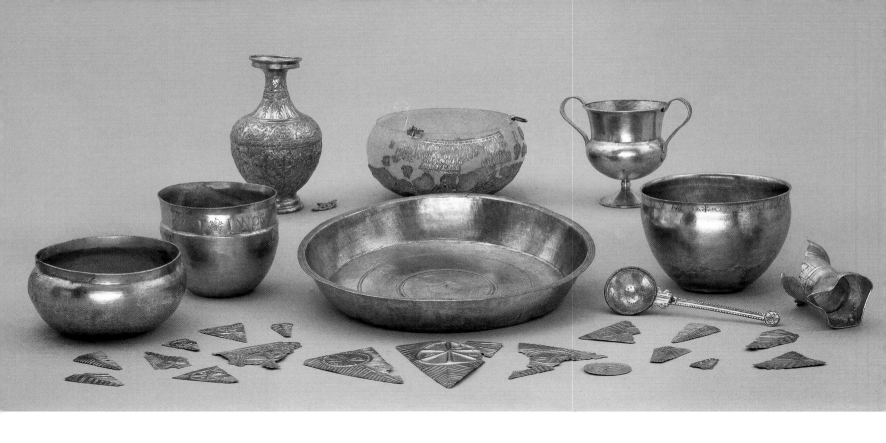

196–222: The Water Newton Treasure

Bibl. Painter 1975b; Wright, Hassall and Tomlin 1976; Kent and Painter 1977, 29–33, nos 26–51; Painter 1977; Thomas 1981, 117–18; Henig 1984a, 123–6; Frend 1984–5; Potter and Johns 1992, 129–30, 209, pl.IX; Künzl 1993; Henig 1995, 77, 93; Brenk 1999; Painter 1999; Guggisberg and Kaufmann-Heinimann 2003, 272, 278, Abb. 260, 341 HF 69.

The Water Newton Treasure of one gold and 27 silver objects was found early in 1975, within the south-east angle of the enclosed area of the Roman town of Durobrivae (near Chesterton, Cambridgeshire). The archaeological context is unknown, but marks on the vessels show that the objects were stored in the large dish (cat.202) when hidden. All were in a usable condition when they were put away in antiquity.

Because of the Christian inscriptions and symbols, the treasure cannot be earlier than the second half of the fourth century. None of the vessels or plaques needs to be earlier than the late fourth century and some may even be early fifth century, as suggested by the occurrence on two small vases in the Hoxne Treasure, buried between 407 and 450, of the same decoration found on the jug (cat.196). Further, the inscription on one of the deep cups (cat.200) incorporates reminiscences of the Old Latin Bible and of the Mass. Ambrose's lectures on the Mass for the newly baptised in Milan show that

these were used in the west in the last decades of the fourth century and the Water Newton Treasure cannot have been buried until then.

The plaques are remarkable because they are clearly part of the same tradition as plaques dedicated to gods at pagan shrines (see cats 185–6). The Water Newton plaques, however, are the only surviving examples carrying Christian symbols and dedications, demonstrating how early Christians adapted pagan practices to express devotion to their own God. Although they were valuable gifts to God, the difference in weight and value between the vessels and the plaques is so great that there were clearly two groups of donors, of whom the richer ones gave vessels and the poorer ones gave the less expensive plaques.

The vessels also carry dedications. The inscription on one of the cups (cat.199), for example, reads, 'Innocentia and Viventia gave this offering to Christ'. Similarly, on the other inscribed cup (cat.200), the inscription makes

clear that Publianus, whose name is on the base, is presenting this vessel to Christ. In the cases of the large dish (cat.202), and strainer (cat.204), a Chi-Rho and Alpha and Omega might in other circumstances have been regarded as decoration of secular objects, as pagan religious decoration was demonstrably used in this way; but in the context of the treasure, these objects too can be regarded as dedications.

The vessels were also used during the liturgy. On cup or bowl cat.200 the general sense of the inscription *Sanctum altare tuum Domine subnixus honoro* is clear: 'O Lord, I Publianus, relying on you, honour your holy altar [or 'sanctuary']'. A new Mass was introduced after the Council of Trent in 1545–63, and the phrase *Introibo ad altare Dei ad Deum qui laetificat iuventutem meam*, the Old Latin version of Psalm 42.2, is the formula at the very beginning of the Fore-Mass, marking the celebrant's arrival at the altar. As with all matters to do with the Mass, it is difficult to know when this was

Figure 55 Inscription on cup or bowl (cat.200) (bowl shown on right in illustration above)

introduced. The only Order of the Mass surviving from the latter part of the fourth century, in the last book of the *Apostolic Constitutions*, does not include it. This work, however, is almost certainly of Syrian provenance, and so the question is whether the formula could have been used in the west. We shall probably never know whether *introibo ad altare Dei* was used in the Roman Mass at this time, but it was certainly present in the liturgy of Milan at the end of the fourth century. Ambrose's catechism of about 390 to the adult newly baptised attests that the whole sentence, in the Old Latin version, was used at the end of Lent, in the Paschal night, when they processed from the baptistery into the church and to the sanctuary for the Mass (Ambrose, *De Mysteriis* 8, 43; *De Sacramentis* 4, 2, 7). It is plausible that the formula might also have been used in other forms of the Mass and at other places, including Water Newton.

There is further support for the view that the Water Newton text recalls the Mass. First, Ambrose's description of the Mass for the newly baptised also includes the phrase 'holy altar', *sacrosanctum altare*, which might well have been in the relevant rubric in the Ordo for the Milan Mass. Alternatively, one might turn to the use of *sublime altare*, for the use of which during the offertory Ambrose again bears witness (*De Sacramentis* IV, 6). *Sanctum altare* in the Water Newton inscription might be a reminiscence of either of these. Second, the *Supplices* in the post-Tridentine Mass, the prayer following the *Offerimus*, was accompanied by the kissing of the altar. It is recorded in the sixth-century *Primus Ordo Romanus* (*salutat altare*), and goes back to pagan practice, attested by Minucius Felix for the third century (*Octavius* 2, 4). The Water Newton word *honoro* may well refer to this action and to the same point in the Mass.

These elements, therefore, could be the direct source for the Water Newton inscription. If the Water Newton inscription is a reference to the Mass or is a quotation from an alternative version of the Mass, the bowl itself could well have been used in celebrating the Mass. If the reference was more specifically to the Ambrosian Mass, then the inscription on the Water Newton bowl might refer to the introduction of the *catechumenoi* (the initiates) after baptism. Did Publianus present the bowl to mark the occasion of his own baptism, with its first use at the subsequent Mass? Alternatively, the Water Newton inscription may have refered to the offertory, the high point of the Mass when the officiating priest honoured the altar.

If the group of vessels comprised a liturgical set, the possible liturgical function of the *sanctum altare* vessel would be confirmed. The problem is to know what constitutes such a set. The only fourth-century documentary help is the inventory of 303 from a church at Constantine in Numidia. The list includes many of the sorts of object that might be expected in a church; but there is no way of being sure that any of them was specifically devoted to the liturgy and not to other, social, activities of the church. At a later date a set clearly included specially fashioned chalices, patens, jugs, strainers, spoons, processional crosses, fans etc., but this later evidence cannot be transferred back to the fourth century.

The form of some of the vessels might help to solve the problem. To most modern eyes the two-handled cup (cat.201) resembles a chalice. Moreover, it is reasonably closely matched in form by the sixth-century chalices in the only other church treasure found in the west, at Gallunianu in Italy. Again, the large Water Newton dish (cat.202), with Chi-Rho, Alpha and Omega, is of the same form as undoubted patens of the sixth and seventh centuries – for instance the 12 examples in the treasure from Kaper Koraon in Syria, all but one of which were dedicated for church use. In the third and fourth centuries, however, there is no certain example of such a cup being anything other than a drinking vessel or of a bowl being anything other than a bowl. The concept of exclusively liturgical silver had not been formed clearly in the fourth century. The Water Newton cup and bowl, therefore, could only become what we would call a chalice and paten by virtue of their owner or user.

The almost entirely Christian decoration of the Water Newton silver vessels (i.e. excluding the merely decorative vegetable ornament of jug cat.196) might support the idea that they were used for liturgical purposes. The objects of the sixth-century find from Canoscio in Umbria were long held to be a church treasure for just that reason. Nevertheless, Christian decoration or similarity to later ecclesiastical types is not sufficient proof of liturgical purpose, any more than pagan representations on other vessels means that they were necessarily used in pagan rites.

What does distinguish the Water Newton vessels from finds such as Canoscio are the dedications in the hoard, both on the plaques and particularly on the two vessels. The dedications, combined with the possibility that the vessels are noticeably lacking in decoration and may be in forms specially suitable for religious purposes (see discussion of cat.200), suggests the treasure can be nothing but a church hoard. The possibility that the *sanctum altare* inscription alludes to or even quotes from the Bible and the liturgy makes it more than likely that the cup, bowls, jugs and strainer will have been used in the Mass, while the faceted bowl, which may well have been a hanging lamp, could also have been used at the altar and certainly in the church.

A further problem has been raised: did the treasure come from a church or a private chapel? Brenk (1999) suggested that the Water Newton Treasure was used for a celebration of the Eucharist in a private chapel in a house, but considered it an open question whether the Water Newton Treasure belonged to a church community or a private individual. This suggestion, however, takes no account of the facts that the plaques in the hoard suggest they were deposited at a place of pilgrimage, that two socially distinct groups of donors were present at Water Newton and that there is no demonstrable family link between the named donors of any of the votive gifts (except the pair of Innocentia and Viventia). In conclusion, it is most unlikely that the Water Newton Treasure belonged to an individual or a single family or was used in a private chapel. Therefore the community church is the likely owner.

Who put the Water Newton Treasure in the ground? Was it the original owners? Was it local robbers or was it plunderers from outside the province? The treasure does not have the iron and bronze normally found in a group which has been plundered (Künzl 1993). Non-coin hoards inside the empire are overwhelmingly of precious metal and show what was useful and of value to Roman robbers. These hoards are either what owners were trying to protect from theft or what was hidden by the robbers themselves. The

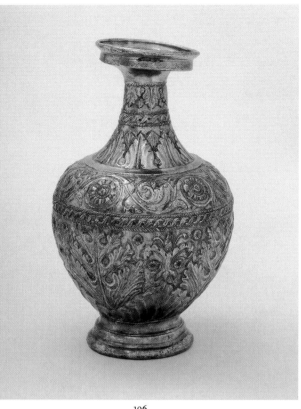

196

Water Newton Treasure belongs with the former group. There was no bronze or iron, and so the danger was local. The handles of the two-handled silver cup in the treasure were detached before the hoard was hidden; but all the objects were usable and this may point to them having been concealed to prevent theft, rather than having been 'swag' hidden by thieves.

The Water Newton Treasure, therefore, is important evidence of the transition from paganism to Christianity; above all it includes vessels which are probably the earliest surviving liturgical plate from the early Church from anywhere in the Roman Empire. [K.P.]

196 Decorated jug

Water Newton, Cambridgeshire
Silver; vessel: D. max. *c*.116mm, H. 203mm, Dia. of rim 65mm, Wt. 534g; handle: L. 48mm, Wt. 9.3g
End of 4th century or early 5th century
British Museum, London, P&E 1975.10-2.1
Bibl. Painter 1975b, 335, no.5; Kent and Painter 1977, 29–30, no.26; Painter 1977, 12–13, no.5, pl.5; Engemann 1984, 127–9; Baratte 1993, 75, 155; Donati 1996, 226, no.78.

Silver jug; handle: damaged and detached, cast and pierced, foliate design, and originally

fastened at two points on the neck; body: everted and upstanding rim; spout formed by angling of rim; slender neck; ovoid body; high foot-ring. The jug seems to have been raised rather than cast (Barker, Cowell, Craddock, Hughes and Lang 1977). The surface is rather worn. The base was folded inwards and is hollow on the underside. The handle, which was soldered on, had been worked to shape and the design inscribed with a gouge-shaped tool.

Decoration, in relief: the neck – (1) upper zone of pendant leaf forms below a roped border, giving an ovolo-like effect, (2) a narrow, middle zone of an S-meander between roped lines and (3) a lower zone of upright leaves of acanthus form; a narrow plain zone on the shoulder; the body decoration in three zones – (1) the upper, on the shoulder, a scroll with acanthus leaves and rosettes in alternate curves, the centres of the flowers being decorated with tiny rings; (2) below, at about the point of maximum diameter, a narrow dividing border (cf. neck zone 2), an S-meander between roped lines; (3) the lowest zone, 75mm deep, with upright acanthus buds and fully opened leaves alternating with small, simple rosettes.

This jug belongs to a group that has a marked shoulder between the neck and the ovoid body and no separate foot. Engemann has shown that the few parallels for this form, both late Roman and Sassanian, lie in the fifth to seventh centuries. Examples are known in silver from Viminacium (Serbia) and in silver and in bronze from Qustul (Sudan), while another bronze example, in Berlin, is decorated with encrusted hunting scenes. Brass examples of the fifth, sixth and seventh centuries are known from the eastern half of the empire.

Although the plant motif with which the jug is decorated has good parallels in the first half of the fourth century, the date of the jug itself, because of the connections of its form, is probably no earlier than the second half of the fourth century and might even lie in the early part of the fifth century. This date is supported by the presence of two small vessels with similar decoration in the Hoxne Treasure, deposited between 407 and 450 (Bland and Johns 1993, 26), and the decoration on the body is also paralleled on a sixth-century silver hanging lamp in the Kaper Koraon Treasure (Mundell Mango 1986, 155–8, no.33). [K.P.]

197 Hanging lamp

Water Newton, Cambridgeshire
Silver; H. *c*.100mm, Dia. *c*.180–90mm, Wt. 220.4g
4th century
British Museum, London, P&E 1975.10-2.2
Bibl. Painter 1975b, 335, no.4; Kent and Painter 1977, 30, no.27; Painter 1977, 11–12, no.4, pl.4; Martin-Kilcher 1984, 396; Bird 1986; Baratte 1993, 233–4; Donati 1996, 227, no.79.

Fragmentary bowl in thin sheet silver, elaborately decorated with repoussé worked from the outside so that the inside decoration is in relief. The base is slightly dished, and the profile is slightly incurved towards the top, with a plain, upright rim. The bowl has two rings, with overlapped ends, and fragments of chain. One of the rings is decorated with a seven-petalled rosette and is riveted to a portion of the plain rim.

The zones of decoration of the bowl, from the rim downwards, are: (1) astragalus border between dotted lines; (2) zone of four rows of leaf tips in scale pattern; (3) astragali between dotted lines; (4) deep zone of circles with dotted borders, containing five central dots, divided by (a) upright leaf tips, and (b) opposed peltae with leaf tips (once only); (5) astragali between dotted lines; (6) as 4, except for pelta motif; (7) three rows of astragali; (8) herringbone pattern; (9) astragali.

The lamp was made by raising with frequent anneals; the surface was then scraped, using a lathe to rotate the bowl, after which it was decorated using a series of different sized punches. A chain made from wire which had not been drawn but possibly hammered or swaged from a strip of sheet, was attached by means of decorated rivets (Barker, Cowell, Craddock, Hughes and Lang 1977).

The vessel was very damaged and was in about 50 pieces when found. The bowl probably had a total of three suspension rings. The rings and chain show that it was meant to be viewed from the outside and that it was the outer surface, not the inner, which was meant to be looked at. The same kind of decoration punched in from the outside is found on a number of types of bowl of the third and fourth centuries. In the Chaourse Treasure, dated about 270, there are two bowls so similar in shape and decoration that they may even have been made in the same workshop.

It is occasionally possible to be sure that a type of silver vessel is an imitation of the same form and decoration in glass. This is the case here, where third- to fourth-century glass vessels decorated with rows of cut facets have been copied in silver. There are two types of such silver bowls, one being a hemispherical bowl decorated with embossed geometric motifs in rows one above the other, the second being wider bowls, decorated with bosses which alternate with incised or dotted motifs of stylised plants. The Water Newton bowl belongs to the second group which includes close parallels from Notre-Dame d'Allençon and St Pabu (Finistère) in Gaul and from the London Walbrook Mithraeum in Britain (Baratte and Painter 1989, 102–4, no.32). It is clear, however, that the form goes on to the fifth century, because the deposit of the example in the Coleraine hoard from Ireland is dated by coins to the beginning of the fifth century (Walters 1921, 55, no.223).

The more open form to which the Water Newton bowl belongs is matched in glass by vessels which have similar form and decoration and which must be hanging bowls intended as lamps. Such a fourth-century dark-green, cast and cut bowl with facet-cut decoration was found in a grave at Horrem in the Rhineland, and a second bowl, apparently from the same mould, comes from Cologne itself. It may be conjectured that facet-cutting of glass developed into cutting which left an openwork 'cage' of glass surrounding the main vessel. Two such openwork bowls, probably of the early fourth century, now recognised as hanging lamps, are the Constable Maxwell cage-cup and another openwork bowl in the Corning Museum of Glass which still has the remains of its bronze collar and lamp-hanger (Whitehouse 1988). Vessels such as these are the closest parallels in form, decoration and function to the Water Newton bowl. [K.P.]

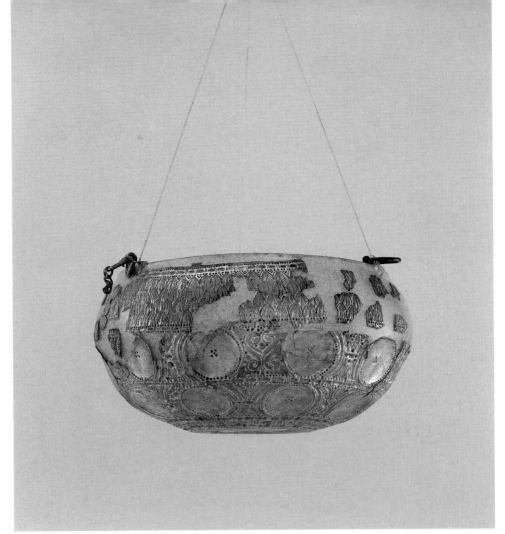

197

198 Plain bowl

Water Newton, Cambridgeshire
Silver; L. *c.*160mm, W. *c.*90mm, Wt. (bowl and fragments) 258.3g
4th century
British Museum, London, P&E 1975.10-2.3.

Bibl. Painter 1975b, 335, no.1; Kent and Painter 1977, 30, no.28; Painter 1977, 10, no.3, pl.3; Donati 1996, 227, no.80.

198

199

Damaged silver bowl with a vertical rim and dished base. Raised and then scraped on a lathe; the outer surface was then polished; the rim was hammered down to neaten and thicken it (Barker, Cowell, Craddock, Hughes and Lang 1977). A pair of lines, close together, has been drawn just below the edge of the rim.

This bowl, the hanging lamp (cat.197) and one of the inscribed bowls or cups (cat.200, inscribed *Sanctum altare tuum, Domine, subnixus honoro*) belong to a group of deep bowls, with a simple, slightly everted or vertical rim and with a rounded, scarcely flattened base, which is found particularly in glass across the empire from the second to the fifth century (Harden 1936, 100–1). The shape is natural in glass, since it is easily made by inflating a paraison, knocking off part of the globe of glass, cutting round the hemisphere to form the edge, and slightly flattening or pushing in the base. Particular examples include colourless glass bowls of the second century from graves at Leuna, Germany. They include one with faceted decoration, and another with a facet-cut figured scene showing Artemis and Actaeon (Harden,

Hellenkemper, Painter and Whitehouse 1987, 196–7, nos 106–7).

These glass bowls were imitated in pottery, as is demonstrated by Samian bowls with wheel-cut decoration from sites such as Cologne (La Baume 1964, 18–19). The silver bowls from Water Newton are also imitations of glass. It might not be obvious from this plain, undecorated example; but its shape is clearly matched by that of the hanging lamp, and the decoration and shape of the hanging lamp are matched by glass bowls such as the faceted bowl from Leuna.

The possible religious function of this vessel and its use as a dedication is discussed with the inscribed bowl cat.199. [K.P.]

199 Inscribed cup or bowl

Water Newton, Cambridgeshire
Silver; H. *c*.124mm, Dia. *c*.150mm, Wt. including 11 fragments 260.5g
Late 4th century
British Museum, London, P&E 1975.10-2.4

Bibl. Painter 1975b, 335, no.8; *Britannia* 7, 1976, 385, no.32; Kent and Painter 1977, 30, no.28; Painter 1977, 13–15, no.8, pl.8; Thomas 1981, 115–16; *RIB* **2.2**, 30, 2414.1.

Deep cup or bowl, with a slightly dished base; rim everted, with a flat zone beneath, about 25mm deep, bearing partly lost inscription, with lettering in double-line neat letters, about 13mm high; Chi-Rho of elaborate form, with an open Rho: (Chi-Rho with Alpha and Omega) INNOCENTIA ET VIVENTIA ... RVNT: *Alpha Chi-Rho Omega: Innocentia et Viventia ... dedicaverunt* or *dederunt.*

The bowl was raised, scraped on a lathe and finally polished, probably on the lathe (Barker, Cowell, Craddock, Hughes and Lang 1977). The letters were engraved using a sharp tool that cut a crisp-edged round-bottomed groove. There are signs of a previous rough-out of the inscriptions. The vessel is badly damaged and only about half remains. One of the broken fragments is from the rim and bears part of the inscription.

This form of cup or bowl is rare in silver but is known in glass (Isings 1957, 133–4, form 107a). The measurement of the body is more than that of the diameter; the rim bulges, while the edge is turned out slightly. A mould-blown example from a grave at Cologne is dated *c*.350, and the shape is also that of a number of cage-cups, such as the Lycurgus cup, the cups from Trivulzio and Varese, Italy, and that from Köln-Braunsfeld, Germany, all dated to the fourth century (Harden, Hellenkemper, Painter and Whitehouse 1987, 238–49 nos 134, 135, 137 and 139).

The incomplete inscription characterises the cup as a dedication. The final letters of the word ... RVNT are part of a verb, probably 'dederunt', 'dedicaverunt' or 'offerunt'. The meaning in each case is that Innocentia and Viventia presented the vessel to Christ, who is represented by the Chi-Rho. The closest parallel to this Water Newton cup in silver, in form and function, is a cup from a small hoard of late fourth- or early fifth-century silver found on the site of the *domus* of the Valerii on the Coelian Hill, Rome. The fragmentary cup is 79mm high, and round the rim has an inscription in double-line capitals which reads, '[cross] PETIBI ET ACCIPI VOTVM SOL, peti(v)i et accepi (et) votum sol(vi)' (I prayed and my request was granted and I paid my vow [*sc.* to Christ]) (Brenk 1999, 83). [K.P.]

200 Inscribed cup or bowl

Water Newton, Cambridgeshire
Silver; H. 115mm, Dia. 170mm, Wt. including
fragments, 662.9g
Late 4th century
British Museum, London, P&E 1975.10-2.5
Bibl. Painter 1975b, 336, no.9; *Britannia* 7, 1976, 385, no.33;
Britannia **8**, 1977, 448 corrigendum; Kent and Painter 1977, 30,
no.30; Painter 1977, 15–16, no.9, pl.9; Thomas 1985, 116, 149; *RIB*
2.2, 31, 2414.2; Donati 1996, 228, no.82.

Illustrated on p.210, right
Deep cup or bowl, the base dished, with a
slightly concave rim; damage to one side and to
part of the base. A name, facing inwards, is
inscribed on the exterior of the base in neat
letters *c.*7mm high: PVBLIANVS. These letters
have serifs and are not a rough, scratched
graffito. Round the rim is an inscription in
letters of the same type and size: '[Chi-Rho with
Alpha and Omega] SANCTVM ALTARE TVVM D
[Chi-Rho with Alpha and Omega] OMINE
SVBNIXVS HONORO or *Sanctum altare tuum,
Domine, subnixus honoro* (Prostrating myself,
Lord, I honour your sacred altar or sanctuary).

The original casting may have been of poor
quality (Barker, Cowell, Craddock, Hughes and
Lang 1977). The bowl was raised, possibly using
the technique of crimp raising, and then scraped
on a lathe. It was pre-polished radially and
circumferentially, and finally polished. A punch
was used for the inscription on the rim and
base, probably a bar with a trumpet shape at the
either end. Where this (or half of it) could not
be used the letters were chased.

The shape of the bowl and its relation to
glass vessels is discussed together with the plain
bowl (cat.198). On this bowl the craftsman has
made clever use of the upright rim for the
inscription. The shape was thus particularly
suitable for its purpose at this site. We may
speculate that whoever provided the vessels may
well have had this purpose in mind. This is not
at all to suggest that all vessels of this type were
produced for religious purposes; but the shapes
of the vessels found at Water Newton may have
been picked deliberately for their suitability, just
as in some pagan religious hoards there are
types of vessel which seem to be particular to
the site, as for example in the treasure of
Notre-Dame d'Allençon, in which there are
types of vessel which were not for the most part

fashionable in groups of vessels intended for the
dining table. Baratte has suggested that at such
sanctuaries there must have been craftsmen who
offered pilgrims vessels like the conical bowls
found there; these were less expensive than
figured vessels, but nevertheless pleasing to the
eye as well as being appreciated as votive objects
(Baratte and Painter 1989, 104, nos 34–5). It may
be for similar reasons that four out of the seven
vessels found at Water Newton have little or
minimal decoration. Three worshippers offered
decorated objects; but the others either had
nothing added or commissioned only an
inscription to make plain their adherence to
the cult.

The inscription characterises the cup as a
dedication. The words round the rim are a line
of verse, a dactylic hexameter. On the base is the
name 'Publianus', in the nominative. This makes
it clear that Publianus presented this vessel to
Christ. The significance of the inscription is
discussed in the introduction to the Water
Newton pieces. [K.P.]

201

201 Two-handled cup

Water Newton, Cambridgeshire
Silver; H. 125mm, Dia. 110mm, Wt. including
handles 315.7g
Late 4th century
British Museum, London, P&E 1975.10-2.6
Bibl. Painter 1975b, 335, no.6; Kent and Painter 1977, 30–1,
no.31; Painter 1977, 13, pl.6; Donati 1996, 229, no.83; Baratte *et
al.* 2002, 49.

Cup of cantharus form: body carinated; upper
half almost cylindrical, lower half more globular
and of a larger diameter, the upper part turning
in to meet the upper edge of the lower section;
short stem; outsplayed foot; two ogival handles,
fastened to rim, rising above rim, turning down
to meet lower section of cup at greatest diameter.

No decoration; but the external surface
appears to have been burnished; the interior
shows hammer marks and the position of the
handles is indicated by solder marks; rim
thickened and neatly finished; foot of a low
conical form, also with a thickened rim, and
attached to the body by a square-ended rivet;
slight knop between base and cup; handles of

simple, flat section (found detached, but now re-attached); but basal attachment formed to a simple drop shape.

The cup was raised, scraped and polished (Barker, Cowell, Craddock, Hughes and Lang 1977). The rim was thickened and may have been sawn or filed towards the inside to neaten it. The top and bottom are attached by means of a rod passing through from one to the other via a hollow bead with flared ends. This may be of different composition from the rest of the cup.

Silver drinking vessels, whether cups or bottles or jugs, were a particular feature of Roman silver from the first century BC. Nevertheless, during the late third and early fourth century craftsmen seem to have reduced the use of silver for these vessels in favour of glass. This makes all the more noticeable the apparent return to favour of silver in the second half of the fourth century. Drinking cups on a stem and foot now took on fantastic forms, as can be seen in the Mildenhall and Traprain Law Treasures (cats 234–55). The Water Newton cup differs from these in having a short stem, a deep carinated bowl and two handles. The general name for the shape is *cantharus*. The form with a taller section above the carination is often referred to in the archaeological literature as a *carchesium*; but this name does not go back to Roman times (Hilgers 1969, 48, 140–1, no.87).

Canthari were popular in silver in the first century BC to the first century AD, when good examples are found in the treasure from Hildesheim in Germany (Boetzkes, Stein and Weisker 1997, 45–9, nos 11–17). The form does not disappear, for it is known in pottery and glass in the second and third centuries. A green-glazed pottery *cantharus* was found in a sarcophagus of about 200 in the Luxembergerstrasse in Cologne; while in Trier, the potteries area of St Barbara produced a third-century black-glazed *cantharus*, painted in barbotine with the gods of the days of the week (La Baume 1964, 123–4). A large third-century *cantharus* in colourless glass, with trailed decoration in blue, white and gold, was found in Aachenstrasse in Cologne, and another bright green example of the same date, with similar decoration, was found in a grave in the Weyerstrasse (Harden, Hellenkemper, Painter and Whitehouse 1987, 123, no.55). Silver reappears in the fourth century, with the Water

Newton cup, and then goes on being used for the form. From the fifth century a *cantharus* of silver and glass is known from Mzechta in Georgia (Kisa 1908, 602–4, figs 208–9), and from the end of the fifth century the cup given to a church probably in Syria, by Ardaburius and Anthousa in fulfilment of a vow, is of the same shape and differs only in having a pair of horizontal handles (Ross 1962, 4–5, no.5, pl.IV). The shape goes on being used in the sixth and seventh centuries, though with a ring foot instead of a stem and foot. In the Kaper Koraon Treasure there are two hanging lamps, one of 574/576–8, and the other of 602–10 (Mundell Mango 1986, 102–3, no.13, 155–8, no.33). Mundell Mango points out that this type of lamp, because of its *cantharus*-like shape, is mentioned frequently as a *farum cantharum* in the *Liber Pontificalis* (biographies of early popes, from the fourth to the eighth or ninth centuries, including accounts of named churches, their foundations and endowments).

Despite the cup's superficial resemblance to medieval and modern chalices, this vessel was not made for use in the liturgy. As far as can be determined at present, no such 'liturgical' vessels existed at this period. Vessels needed for church use were those used domestically. The discovery of this cup, however, in the context of this treasure, with its links to the Bible and the Mass, makes it likely that it was used with the other vessels (also originally domestic in purpose) in a church at Water Newton. [K.P.]

202 Large dish

Water Newton, Cambridgeshire
Silver; H. 53mm, Dia. at rim 335mm, Dia. at base *c*.270mm, Wt. 1.30kg
Late 4th or early 5th century
British Museum, London, P&E 1975.10-2.7

Bibl. Painter 1975b, 335, no.3; *Britannia* 7, 1976, 386, no.34; Kent and Painter 1977, 31, no.32; Painter 1977, 10–11, no.3, pl.3; Thomas 1981, 115; Frend 1984–5, 146–7; Mundell Mango 1986, 80; *RIB* **2.2**, 32, 2414; Donati 1996, 229, no.84; Painter 1999, 3.

Large, deep dish with straight, everted walls and a small, flat, horizontal rim, about 8mm wide; rim grooved; a central depression, 3mm in diameter, presumably a lathe mark made when turning the vessel, and a second, smaller point closer to it, which is the centre of a broad

scribed circle, 112mm in diameter (Barker, Cowell, Craddock, Hughes and Lang 1977).

Decoration: concentric, very light turning marks over whole internal base; in the central 112mm circle is a large, lightly incised Chi-Rho, the Rho being of the open form; to the left and right an Alpha (not visible until after first conservation and cleaning) and an Omega. Made by raising and finished on the inner surface by scraping and polishing; decorated with scribed lines, two centres being used.

This dish is one of a type with high sloping sides with a flat rim (some broad, some narrow), a flat bottom and no foot-ring. The others, 12 in number, are dated to the sixth and seventh centuries and almost all come from hoards found in Syria. The exception is a dish in the Gallunianu Treasure from Italy. Mundell Mango recognised the connection of the Water Newton dish with this group. She went on to suggest that, since the later dishes are all explicitly dedicated for church use, they must all, including that from Water Newton, be patens, and that they are distinct from later domestic plates, 'which have a flatter profile and a very small, niello inlaid cross in the centre'.

Mundell Mango must of course be right about the later dishes; but it cannot be demonstrated that a particular type was made for use as a paten in the late fourth or early fifth centuries. It is far more likely that the Water Newton dish belongs to a type normally used for domestic purposes, like the other vessels in the hoard. It should be noted that it is very similar to late fourth-century dishes in the Esquiline, Traprain Law and Hoxne Treasures, which differ only in having had a foot-ring added. The Water Newton dish has been adapted for use in the church by having the inscription added. [K.P.]

203 Mouth and neck of spouted jug

Water Newton, Cambridgeshire
Silver; H. (rim to break) 105mm, Dia. across rim 63mm, Wt. (jug and fragment) 151g
Late 4th or early 5th century
British Museum, London, P&E 1975.10-2.8

Bibl. Painter 1975b, 335, no.2; Kent and Painter 1977, 31, no.32; Painter 1977, 10, no.2, pl.2; Donati 1996, 230, no.85.

Mouth and neck of a large spouted jug, broken from the body. Two holes in the rim were for the

attachment of a handle. One small detached fragment survives from the neck.

Raised; anvil marks can be seen on the inside surface; the outer surface was finished on a lathe and polished (Barker, Cowell, Craddock, Hughes and Lang 1977). Decorative lines inscribed on the surface of the neck, possibly on a lathe, before the final anneal. Holes near the top made by a round-ended punch from the outside; the top edge of the jug seems to have been filed and the pouring lip worked outwards on an anvil.

Jugs are known in hoards of silver from Chaourse (France; buried about 260), Sisak (Croatia; buried *c.*300) and Taraneš (Macedonia; buried *c.*324). In general, however, the use of silver for drinking vessels, whether cups or pouring vessels, seems in the third century to have fallen out of fashion, presumably in favour of the use of glass (Baratte 1993, 73). The preference for glass for drinking vessels, including jugs, bottles and amphorae, seems to have continued until at least the middle of the fourth century. There are no jugs, for example, in the Mildenhall and Kaiseraugst Treasures. In the later fourth century, however, there was a renewed interest in silver for this purpose. In the treasure from the Esquiline Hill in Rome, for example, there are two jugs, and the early fifth-century Seuso Treasure (probably from the Balkans) has at least six vessels of this type (Mundell Mango 1994). For this reason it is with these last two treasures that the Water Newton Treasure, with its two jugs, belongs.

The fragmentary state of the jug makes it difficult to be sure of the original shape. In addition to this the fact that the handle was apparently fixed relatively crudely by means of rivets also makes classification difficult. There are, however, a number of jugs with the mouth extended into a spout, for example from Rome (in the Esquiline Treasure), southern Italy, Syria and Kertch in the Crimea (Baratte 1993, 76). Besides the extension of the mouth into a spout these jugs all have a relatively tall neck, a globular body and a handle which from the neck rises above the body and then curves down to be fastened at the centre of the body. This is probably the type of jug represented here. If so, its date, like that of the comparanda, is probably to be placed at the end of the fourth or the beginning of the fifth century. [K.P.]

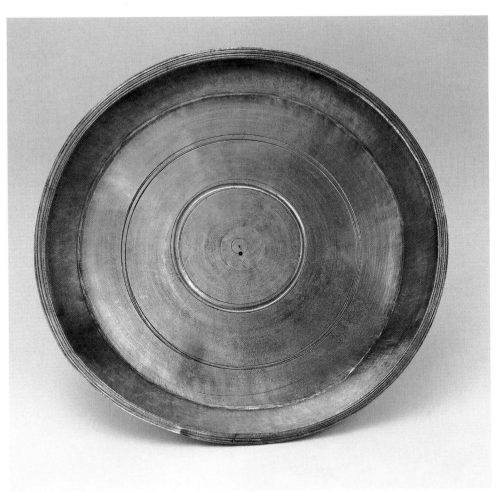

202

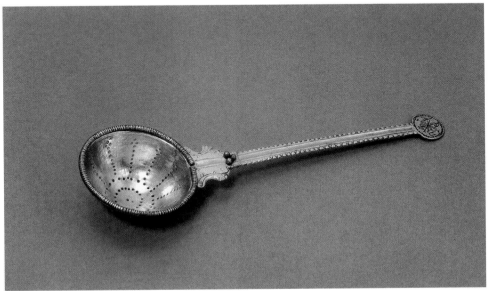

204

204 Strainer with handle

Water Newton, Cambridgeshire
Silver; L. 202mm, Dia. of bowl 60mm, Dia. of
disc 19mm, Wt. 64.4g
Late 4th century
British Museum, London, P&E 1975.10-2.9

Bibl. Painter 1975b, 335, no.7; *Britannia* 7, 1976, 386, no.34; Kent
and Painter 1977, 31, no.35; Painter 1977, 13, no.7, pl.7; Thomas
1981, 115; *RIB* **2.2**, 31, 2414.3; Martin 1984, 102, 111–13, 119,
Taf.31,1; Donati 1996, 230, no.86.

Strainer, its bowl pierced with two circles and 12
radiating lines of small holes, each radiating line
ending in a group of four holes; rim of bowl
formed of a separate ring of silver with a
segmented pattern on the surface; handle, partly
gilt, broken and repaired with three large rivets
in antiquity; handle engraved, decorative
notches along the edges, and at the end a disc,
19mm in diameter, bearing an engraved Chi-
Rho and Alpha and Omega within a circle of
punched dots.

The strainer is closely comparable in shape
and size with the partly gilded strainer from
Traprain Law (cat.253). About a hundred similar
strainers, some combined with toothpicks as, for
example, in the Kaiseraugst Treasure (Martin
1984), are known which date from the third to
the seventh centuries. Only two date from the
third century; but 20 are of the fourth to fifth
century, including those from treasures such as
Thetford, Traprain Law and Kaiseraugst.

The strainers from the church treasures of
Water Newton, Canoscio and Kaper Koraon
allow us to suppose that in the fourth to sixth
centuries they were used for church purposes.
This is demonstrated not by the Christian
inscriptions and symbols on them but by their
association with objects or contexts that must be
liturgical. Nevertheless, unlike the wine used in
services, it is open to doubt whether there was
any significance in the act of straining the wine,
as there is no record of the use of sieves in any
liturgy before the tenth century, in the sixth
Ordo Romanus (Martin 1984, 111–12). The
straining will have been simply a matter of
practicality, as it was in domestic contexts.
[K.P.]

205–22: The Water Newton plaques

The Water Newton plaques are the only
Christian examples of leaf plaques so far known.
Most, though not all, of the pagan plaques, are
of silver, though a few are known in gold and
bronze, and most have been dated to the second
or third centuries. They come from numerous
shrines in the Roman Empire, from Britain,
France, Germany, Switzerland, Austria and Italy,
and a small number are from Hungary, the
Balkans, Romania and Turkey (Toynbee 1978;
Künzl 1993, 85–9). The distribution shows that
most come from Britain and the northern
provinces, Germany, Switzerland and Austria. Of
these 270 or 77.4 per cent come from Britain (48
plaques), the Four Gauls (222 plaques) and
Germany (11 plaques). The other main area
where they were used in considerable numbers
was the Danube provinces (20 examples).

Previously it was thought that the similarity
of the leaf-shaped plaques to palm branches
meant their origin was in the Oriental cults
(Noll 1980). The distribution, however, makes it
more likely that they recall the Celtic worship of
trees. This is true, however, only of the leaf-
shaped plaques of the Roman period, not of
those of the late Classical and Hellenistic
examples from the Mediterranean area. Some of
the latter are square, and in the Roman period
there are some plaques in the shape of little
shrine buildings.

The plaques were votive objects, for many of
the pagan examples were found on or near the
sites of temples. The Chi-Rho monogram,
representing Christ himself, takes the place on
the Water Newton plaques of the deities
depicted or named in inscriptions on the pagan
plaques. In the Water Newton Treasure one of
the pieces (cat.207) has a text ('*Anicilla*' or
'*Amcilla votum quo(d) promisit conplevit*'),
combined with a Chi-Rho, confirming in this
context the votive function of all the plaques of
this class, pagan as well as Christian.

The manner in which these plaques were
dedicated in temples and churches probably
varied. As at Water Newton, some have small
holes near the bases or at the centre, suggesting
that the plaques were mounted, by means of tiny
rivets, on walls or on a now-vanished
strengthening backing, perhaps of wood or
leather or linen; but most show no signs of

having been attached to anything. It has been
suggested that they may have been propped up
in sand or placed in slits on shelves or brackets
fixed to the inside walls of religious buildings.
Alternatively they may simply have been piled
on plates, offered at altars, whether pagan or
Christian, or before pagan statues, and then
stored away in treasuries. In the case of the hot
springs at Vicarello in Italy the plaques were
simply thrown into the sacred waters.

The Water Newton plaques are quite
exceptional, and dedicating such things may at
the time have been exceptional for Christians. A
particular group of Christians probably
imitated a pagan practice that they had seen in
a local temple. It remains possible, however,
that the use of the silver plaques was part of a
tendency for many people to continue to follow
long-established religious practices, no matter
which particular cult was currently in fashion.
In other words, in contrast to those of the
vessels, the dedications of the Water Newton
plaques may be not the acts of adherents of
Christianity, transferring their loyalty
deliberately or in confusion from Mars to
Christ, but rather a general expression of
religious behaviour, traditional in the north-
west provinces and therefore appropriate for
the worship of any of a wide variety of eastern,
Roman and Celtic gods. Whether this was true
or not in the fourth century, the practice of
dedicating plaques became fully Christianised
and continued into the sixth and seventh
centuries. The Ma'aret en-Noman Treasure,
from Syria, for example, included not only two
silver crosses, a spoon and a spherical box, but a
plaque, 296mm high, and 14 small plaques
(Mundell Mango 1986, 237–45, nos 67–72). The
large plaque showed St Symeon on his column
and an inscription shows that it was offered to
him. The small plaques, ranging in height from
26 to 48mm, carry prayers to God asking that
the prayers of the dedicant may be acceptable
(*euprosdekta* in Greek, perhaps recalling a
passage in the Epistles (Romans 15.16): '… that
the offering up of the Gentiles may be
acceptable, being sanctified by the Holy
Ghost'). Some of these show female praying
figures, while five have representations of eyes,
perhaps being ex-votos in recognition of
healing. Whatever the precise interpretation,
however, there is no doubt that the Water

Newton plaques are Christian dedications to God, the earliest of their kind.

Silver plaques were votive gifts of great value, as were spoons dedicated at other sites such as Thetford. The difference, however, in weight and therefore value between each of the vessels and each of the plaques is so great that the more prosperous donors of the vessels should be distinguished from the less affluent and less sophisticated donors of the plaques.

205–6 Plaque and disc with Chi-Rho

Water Newton, Cambridgeshire
Silver; plaque: H. 131mm, W. *c.*90mm, Dia. of Chi-Rho roundel 48mm, gold; disc: Dia. 49mm, Wt. 4.5g
Late 4th century
British Museum, London, plaque: P&E 1975.10-2.10; gold disc: P&E 1975.10-2.11

Bibl. Painter 1975b, 336–8; *Britannia* 7, 1976, 386, no.34; Kent and Painter 1977, 32, nos 36–7; Painter 1977, 16–17, nos 10–11, pls 10, 11; Thomas 1985, 115; *RIB* **2.3**, 2430.3 (disc); *RIB* **2.3**, 11 (plaque); Donati 1996, 231, nos 87 and 89.

Plaque

An inverted triangle with a central rib and lines in relief, like a leaf or feather; at the upper end a medallion, demarcated by small repoussé beads, embossed within the roundel: 'Alpha Chi-Rho Omega', the Chi-Rho being ligatured; in the centre a small hole, punched from the front; the Chi-Rho, and possibly the background, gilt. The gold disc (cat.206) fits on the back of this plaque.

Disc

Disc of very thin sheet gold with a central hole 2mm in diameter, punched from the side on which the decoration is concave; from this side the Chi-Rho reads correctly. Embossed: 'Alpha Chi-Rho Omega', the Chi-Rho being ligatured, the open Rho having a slight tail, the Omega inverted; round the monogram a plain circle and a ring of punched dots at the edge.

This and the other leaves were made from thin sheet that was cut and further worked (Barker, Cowell, Craddock, Hughes and Lang 1977). The designs were inscribed from the back, except cat.208, which was inscribed from the front. In some cases a compass was used to inscribe the circle. The metal was not of sound

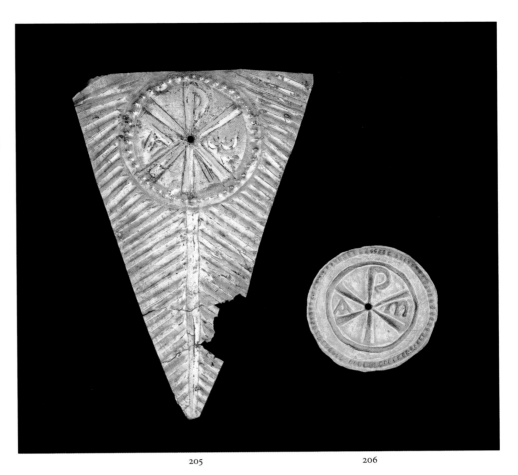

205 206

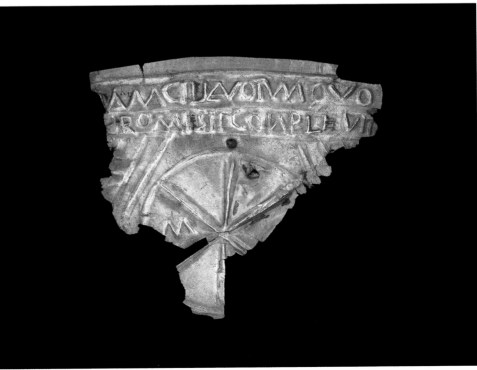

207

appearance in the cases of cats 205 and 211, due to bands of impurities which resulted in spalling. Usually only the front surface was polished. The metal tends to be thinner at the most acute angled point. Holes near the point might be for suspending the leaves, but those at the centre of the circle seem to be constructional. Leaves cats 205 and 213 were gilded.

The gold disc fits exactly over the reverse of the central roundel of the plaque, and the holes match. It therefore seems certain that the two belong to each other. A consequence is that this plaque was meant to be seen from both sides and cannot have been mounted on any backing such as wood or leather. [K.P.]

207 Plaque with Chi-Rho and inscription

Water Newton, Cambridgeshire
Silver; W. 100mm, H. 87mm, Dia. of roundel 55mm
Late 4th century
British Museum, London, P&E 1975.10-2.12

Bibl. Painter 1975b, 336–8; *Britannia* 7, 1976, 386, no.35; *Britannia* 8, 1977, 448; Kent and Painter 1977, 32, no.38; Painter 1977, 17–18, no.12, pl.12; *RIB* **2.3**, 2431.1; Donati 1996, 231, no.88.

About two-thirds of a triangular plaque; along the upper edge a two-line inscription in relief, the letters uneven, an initial letter perhaps being mostly missing, the ligatured N in *conplevit* and the Q in *quod* written retrograde: '… AMCILLA VOTVM QVO(D) PROMISIT CONPLEVIT'. Below this is a hole, nearly 3mm in diameter, pierced from the front, and a simple circle in relief, containing a Chi-Rho; the open Rho having a distinct tail, the Omega interchanged with Alpha and so on the left, and inverted, in the form M. The left edge of the Alpha can be distinguished, but the letter is mostly broken away.

Wright saw an initial 'I' before the name 'Amcilla'. Painter read the name as 'Anicilla'. The name is most likely Amcilla, and they were both probably wrong. Frere and Tomlin (*RIB* **2.3**, 70) note that, 'a personal name *Iamcilla*, and a name in *–amcus*, of which it would be a diminutive, is improbable, but compare *Iamius*' (*CIL* **2**, 767). They continue, 'Painter's *Anicilla* (compare *CIL* **2**, 767), presumably a diminutive of *Anicius*, is plausible but faces two objections: the initial letter I read by Wright and the difficulty of reading M as NI ligatured.' Painter and Wright examined the plaque and its broken left edge

together. Painter could not see the fragmentary and broken right edge of an 'I' which Wright observed, and he still does not think it exists.

Frere and Tomlin note that the silversmith reversed 'Q' and one 'N' and inverted the Omega in error. They suggest that the mistake resulted from embossing the letters from behind. The mistakes are also vivid evidence that the plaques were prepared at the place where they were dedicated and only when they were needed. [K.P.]

208 Plaque with Chi-Rho

Water Newton, Cambridgeshire
Silver; H. 112mm, W. 105mm, Dia. of roundel 55mm
Later 4th century
British Museum, London, P&E 1975.10-2.13

Bibl. Painter 1975b, 336–8; Kent and Painter 1977, 32, no.39; Painter 1977, 18, no.13, pl.13; *RIB* **2.3**, 2431.9; Donati 1996, 232, no.90.

Plaque of inverted triangle form with 'leaf' or 'feather' pattern radiating to each corner, embossed retrograde within the roundel: 'Alpha Chi-Rho Omega'; suspension holes in the centre of the Chi-Rho and near the lower point. [K.P.]

209 Plaque with Chi-Rho

Water Newton, Cambridgeshire
Silver; H. 67mm, W. 59mm, Dia. of roundel 38mm
Late 4th century
British Museum, London, P&E 1975.10-2.14

Bibl. Painter 1975b, 336–8; Kent and Painter 1977, 32, no.40; Painter 1977, 18, no.14, pl.14; *RIB* **2.3**, 2431.7; Donati 1996, 232, no.91.

Small triangular plaque with leaf patterns in the corners only, embossed within the roundel: 'Alpha Chi-Rho Omega', the Chi-Rho being ligatured; no suspension hole; the outlines of the Alpha sharpened by scratches on the right side; a slightly yellowish patina over the whole surface, which may be tarnish or the remains of thin gilding. [K.P.]

210 Plaque

Water Newton, Cambridgeshire
Silver; H. 74mm, W. *c.*45mm
Late 4th century
British Museum, London, P&E 1975.10-2.15

Bibl. Painter 1975b, 336–8; Kent and Painter 1977, 32, no.41; Painter 1977, 18, no.15, pl.15; Donati 1996, 232, no.92.

Narrow triangular plaque, presumably broken, with central rib and lines in a leaf or feather pattern. A hole, *c.*3mm in diameter, has been pierced from the back. [K.P.]

211 Plaque with Chi-Rho

Water Newton, Cambridgeshire
Silver; H. 68mm, W. 52mm, Dia. of roundel 25mm
Late 4th century
British Museum, London, P&E 1975.10-2.16

Bibl. Painter 1975b, 336–8; Kent and Painter 1977, 32, no.42; Painter 1977, 18, no.16, pl.16; *RIB* **2.3**, 2431.10; Donati 1996, 233, no.94.

Small triangular plaque, with relief 'leaf' patterns in the corners, embossed within the roundel: 'Chi-Rho'. A small hole in the centre of the Chi-Rho is pierced from the back. [K.P.]

212 Plaque

Water Newton, Cambridgeshire
Silver; H. 78mm, W. *c.*40mm
Late 4th century
British Museum, London, P&E 1975.10-2.17

Bibl. Painter 1975b, 336–8; Kent and Painter 1977, 32, no.43; Painter 1977, 18, no.17, pl.17; Donati 1996, 233, no.95.

Small, broken triangular plaque with leaf pattern in relief, and a hole in the central rib, pierced from the back. [K.P.]

213 Plaque with Chi-Rho

Water Newton, Cambridgeshire
Silver; H. 157mm, W. 113mm, Dia. of roundel 70mm
Late 4th century
British Museum, London, P&E 1975.10-2.18

Bibl. Painter 1975b, 336–8; Kent and Painter 1977, 32, no.44; Painter 1977, 18, no.18, pl.18; *RIB* **2.3**, 2431.8; Donati 1996, 233, no.93.

Triangular plaque with repoussé leaf or feather pattern. Within a large gilt medallion embossed: 'Alpha Chi-Rho Omega'. [K.P.]

214 Plaque with Chi-Rho

Water Newton, Cambridgeshire
Silver; H. 49mm, W. 30mm
Late 4th century

217 214 216

British Museum, London, P&E 1975.10-2.19

Bibl. Painter 1975b, 336–8; Kent and Painter 1977, 32, no.45; Painter 1977, 19, no.19, pl.19; *RIB* **2.3**, 2431.5; Donati 1996, 233, no.96.

Small triangular plaque with leaf pattern, embossed within the roundel: 'Alpha Chi-Rho Omega'. The Chi-Rho is a simple one, the Rho lacking the added tail, and the Alpha having a dot rather than a cross-bar. There is no hole pierced in the plaque. [K.P.]

215 Plaque

Water Newton, Cambridgeshire
Silver; H. 58m, W. 38mm
Late 4th century
British Museum, London, P&E 1975.10-2.20
Bibl. Painter 1977, 19, no.20, pl.20; Donati 1996, 234, no.97.

Damaged triangular plaque, with repoussé ribs in leaf or feather pattern. There is no hole pierced in the plaque. [K.P.]

216 Plaque with Chi-Rho

Water Newton, Cambridgeshire
Silver; H. 60mm, W. *c.*45mm, Dia. of roundel 28mm

Late 4th century
British Museum, London, P&E 1975.10-2.21
Bibl. Painter 1975b, 336–8; Kent and Painter 1977, 32, no.47; Painter 1977, 19, no.21, pl.21; *RIB* **2.3**, 2431.6; Donati 1996, 234, no.98.

Triangular plaque with the point upwards, decorated with leaf pattern, inscribed within the roundel: 'Alpha Chi-Rho Omega'. There is a border of small beads round the edge of the plaque near the roundel, in which the Chi-Rho is in intaglio but the Alpha and Omega are in relief. [K.P.]

217 Plaque with Chi-Rho

Water Newton, Cambridgeshire
Silver; H. 80mm, W. 64mm, Dia. of roundel 42mm
Late 4th century
British Museum, London, P&E 1975.10-2.22
Bibl. Painter 1975b, 336–8; Kent and Painter 1977, 33, no.48; Painter 1977, 19, no.22, pl.22; *RIB* **2.3**, 2431.4; Donati 1996, 234, no.99.

Triangular plaque, point upwards, embossed within the roundel 'Alpha Chi-Rho Omega'. The upper part has repoussé ribs in a leaf pattern.

The Chi-Rho roundel is in relief, but has no bold outer circle, merely a line incised on the back. The open Rho has a tail; the Alpha is of a somewhat distorted form. In the lower two corners of the plaque are two small fronds or leaves, and there are beaded borders following the plaque edges in the lower area. [K.P.]

218 Plaque

Water Newton, Cambridgeshire
Silver; H. 70mm, W. 60mm
Late 4th century
British Museum, London, P&E 1975.10-2.23
Bibl. Painter 1975b, 336–8; Kent and Painter 1977, 33, no.49; Painter 1977, 19, no.23, pl.23; Donati 1996, 235, no.100.

Triangular plaque with ribbed pattern based on lines into each corner. [K.P.]

219 Plaque

Water Newton, Cambridgeshire
Silver; H. 38mm, W. 29mm
Late 4th century
British Museum, London, P&E 1975.10-2.24
Bibl. Painter 1975b, 336–8; Kent and Painter 1977, 33, no.50; Painter 1977, 19, no.24, pl.24; Donati 1996, 236, no.101.

223

225

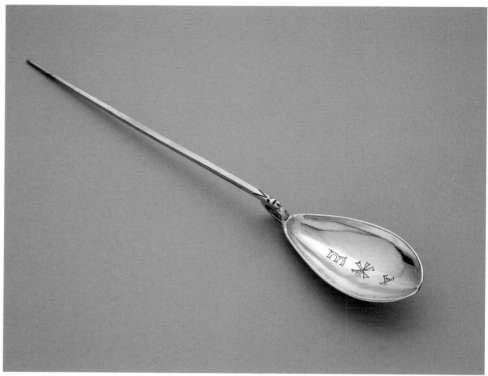

224

Fragment of triangular leaf or feather plaque with ribs. [K.P.]

220 Plaque

Water Newton, Cambridgeshire
Silver; H. 80mm, W. 45mm
Late 4th century
British Museum, London, P&E 1975.10-2.25
Bibl. Painter 1975b, 336–8; Kent and Painter 1977, 33, no.51; Painter 1977, 19, no.25; Donati 1996, 236, no.102.

Triangular plaque with rather faint leaf pattern. [K.P.]

221 Plaque

Water Newton, Cambridgeshire
Silver; H. 56mm, W. 24mm
Late 4th century
British Museum, London, P&E 1975.10-2.26
Bibl. Painter 1975b, 336–8; Kent and Painter 1977, 33, no.52; Painter 1977, 19, no.26, pl.26; Donati 1996, 236, no.103.

Small triangular plaque with bold centre rib and lines. There is a small hole pierced near the base of the triangle. [K.P.]

222 Plaque

Water Newton, Cambridgeshire
Silver; H. 70mm, W. 40mm
Late 4th century
British Museum, London, P&E 1975.10-2.27
Bibl. Painter 1975b, 336–8; Kent and Painter 1977, 33, no.53; Painter 1977, 19, no.27, pl.27; Donati 1996, 236, no.104.

Damaged triangular plaque with ribs in leaf or feather pattern. [K.P.]

223 Finger-ring

Suffolk, England
Gold; internal Dia. 21mm, Wt. 27.55g; metal (semi-quantitative XRF analysis) gold 96 per cent, silver 4 per cent, copper 0.6 per cent
4th century
British Museum, London, P&E 1983.10-3.1

Bibl. Johns 1984.

A large ring of the late Roman Brancaster type (Johns 1996, 53–5), with a raised octagonal bezel deeply engraved with a Chi-Rho monogram beneath two branches. In one of the branches a bird is depicted pecking at fruit, a Bacchic image widely adopted in early Christianity. The design is enclosed within a plain line following the form of the bezel. The sacred monogram is reversed and, as there is no evidence of inlay, it may be assumed that the ring was intended for use as a seal. [C.J.]

224 Spoon

Biddulph, Staffordshire
Silver; L. 194mm, L. of bowl 57mm, W. of bowl 31mm, Wt. 27.8g
Probably early 5th century
British Museum, London, P&E 1971.5-1.1

Bibl. Painter 1973; Sherlock 1973, 206; Painter 1975a; Hauser 1992, 23; *RIB* **2.2**, 142, no.2420.56; Guggisberg and Kaufman-Heinimann 2003, 280, 338, HF 42.

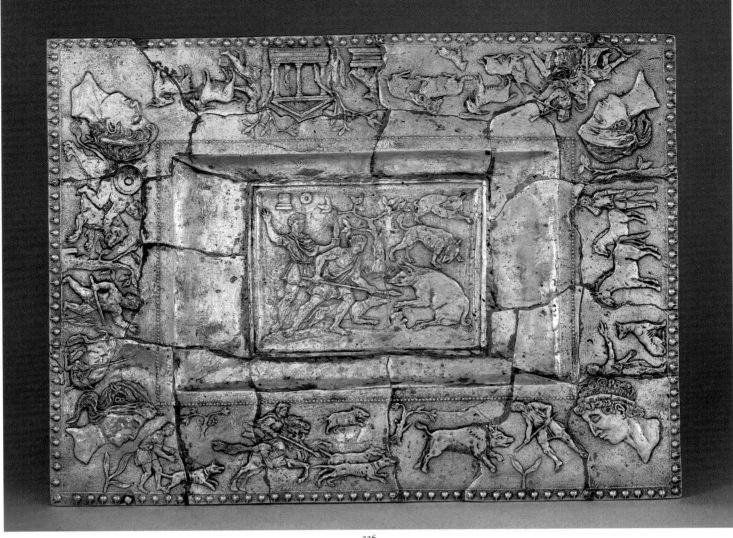

226

Silver spoon; elongated, pear-shaped bowl; long, thin handle, square in section, the junction with the handle pierced in the form of a scroll; tip of bowl worn. In bowl a Chi-Rho monogram between Alpha and Omega, inscribed in double-stroke letters.

The spoon was found before 1885 in a hoard with three or four other spoons just south of Congleton, Cheshire. This type of spoon seems to be later than those, for example, from Canterbury (after 311), Thetford (380–90) and Dorchester (after 395). The Biddulph spoon is therefore likely to date to the early fifth century.

The Christian symbols on the bowl of the spoon may perhaps suggest the owner's religious inclination; but the spoon had no religious purpose. Its primary function was as an eating implement. Equally important, however, was its role, because it was a piece of precious metal with a standardised metal content, in enabling the owner to save. Spoons of this type were often made at this period in groups of 12, which

weighed one Roman pound. Individual spoons varied slightly; but they weighed about one Roman ounce. [K.P.]

225 Disc

Provenance unknown, bought in Alexandria, 1881
Green glass, moulded decoration; Dia. 44mm
4th century
British Museum, London, P&E 81.7-19.35
Bibl. Buckton 1994, 29, no.5.

The cross was not a Christian symbol in the fourth century in the way it was to become later. Crucifixion was a shameful death for criminals, and so the forms of the cross adopted combined the shape with the Greek letters Chi (χ) and Rho (ρ) which were the first two letters of 'Christ' in Greek. The *crux monogrammatica* used here has the Rho forming the upper arm of the cross and was popular in the fourth century. Whether this piece was an amulet or served some other

function is unknown. [H.E.M.C.]

226 Lanx

Risley Park, Derbyshire
Silver, recast; L. 490mm, W. 383mm, H. 25mm, Wt. 4764.2g
Late 4th century
British Museum, London, P&E 1992.6-1.1

Bibl. Stukeley 1736; Odobesco 1889–1900, I, 119–20, fig.41; Morin 1898; Cabrol and Leclerq 1914, col. 1405; Jullian 1921; Dohrn 1949, 2, 100–2, 117–18, 129, 133, pl.20.4; Pirzio Biroli Stefanelli 1965, 97; Strong 1966, 185–6; Vieillard-Trogekouroff 1978; Johns 1981; Fischer-Heetfeld 1983; Toynbee and Painter 1986, 41–2, pl.xxc, no.50; Johns and Painter 1991; *RIB* **2.2**, 42–3, no.2414.40; Baratte 1993, 7, 193, 199, 238, 284; Johns and Painter 1995; Guggisberg and Kaufmann-Heinimann 2003, 16, 275, n1092, 341, HF 62.

Rectangular silver dish with beaded rim and rectangular foot, broken into 26 pieces, now soldered together. Decoration, reported to have been gilded: figured frieze, facing outwards, two sides with hunting scenes, two sides with

pastoral scenes, divided by heads at the four corners; scene in the centre showing a wild boar hunt. On the back an inscription, parallel to one long side of the rectangular foot, scratched in vertical capitals: EXVPERIVS EPISCOPVS ECLESIAE BOGIENSI DEDIT [Chi-Rho] (Exuperius the bishop gave [this dish] to the Bogiensian church).

The Risley Park lanx, discovered in 1729, is the first piece of Roman silver plate known to have been found in Britain. When found, the lanx was broken into pieces by the finders and distributed between them; but 26 fragments were collected together by 1754, and after the middle of the nineteenth century moulds were made from them. The original fragments were then probably melted down and used to cast the new pieces into a new dish, which were soldered together.

Details of the beading on the rim suggest that the original was cast by a craftsman accustomed to working in pewter. Pewter plate appears to have been made only in Britain, and so the method of manufacture suggests that the lanx may have been made there. Comparative vessels in pottery and silver probably date the dish to the second half of the fourth century.

The lanx was made originally as a piece of table plate, to be used in dining. On its back, however, it has an inscription, which says that Bishop Exuperius gave the dish to a church. It therefore establishes what (at least in some circumstances) a bishop could afford or was prepared to pay for. There is, however, no evidence that the dish was used in the liturgy.

Most interpretations of the personal name and of the name of the church in the inscription have favoured one out of a range of possible identifications in France. There is, however, no reason why the personal name and the place name should not occur in Britain. The *ec(c)lesia Bogiensis* may therefore be the episcopal church of Exuperius at Bogiacum or Boiana, the estate of Bogius. If so, the estate and bishopric should probably be sought first in the vicinity of the find-place. [K.P.]

228

229

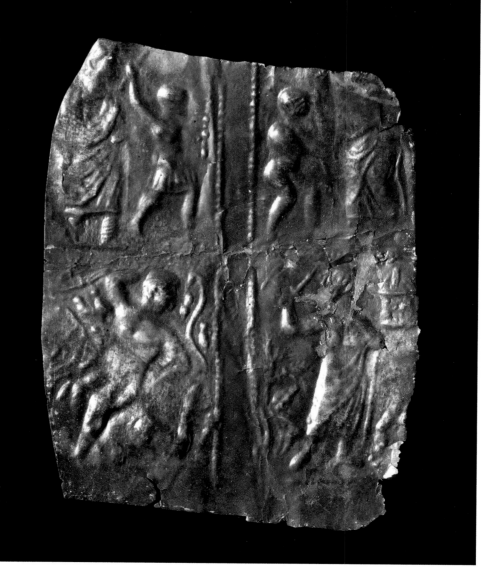

227

227 Sheeting from casket

Uley, Gloucestershire
Copper alloy; H. 85mm, W. 67 mm
First half of 4th century
British Museum, London, P&E 1978.1-2.70
Bibl. Henig 1993b, 107–10, figs 95–6; Petts 2003, 124–5, fig.62; cf. Buschhausen 1971, 132–6, A65, pls 80–1 (for the Intercisa *scrinium*).

This is a fragment from the sheeting covering a wooden casket, probably used as a box for letters and papers (*scrinium*). It is ornamented *en repoussée* with four scenes, produced by hammering the metal into a die matrix. The two superimposed scenes on the left are separated from the two on the right by two parallel rows of beading. The two episodes above are drawn from the New Testament, those below from the Old Testament.

On the left, above, is the episode of the centurion's servant. The centurion identified by his vine staff (*vitis*) is leaving Christ having been told his servant has been healed (cf. Matthew 8, 5–13). Below, Jonah reclines under the gourd. On the right, above, Christ is shown healing a blind man (see Mark 8, 22–5 or John 9, 6). Below is the Sacrifice of Isaac (Genesis 22), with Abraham brandishing a knife, while an altar is shown on the right.

Caskets such as this are quite common, depicting both pagan and Christian scenes. Indeed, one from Intercisa, Hungary, depicts Jupiter, Minerva, Mars and Mercury as well as Orpheus charming the beasts, the Chi-Rho and biblical scenes, including two of those (Jonah and Christ healing the blind man) shown on the Uley example.

The Uley sheeting was folded, presumably to 'kill it', making it acceptable as an offering to Mercury; this shows that even in the fourth century Christians might sometimes lapse or else that pagans who found themselves in possession of Christian objects might treat them in a manner that was not intended by those who had them made. [M.H.]

228 Intaglio

Risinium (Risano), Dalmatia
Cornelian ringstone; 11.5 × 8.5mm, Wt. 0.39g
3rd–4th century
Ashmolean Museum, Oxford, AN Fortnum 109
Bibl. Middleton 1991, 143–4 no.284; Henig and MacGregor 2004, 128 and 131–2, no.14.25.

On the left is a countryman holding a shallow basket in front of him as though to broadcast seed, a sheep looks up at him and beyond is a large amphora. In the field above the Chi-Rho (for 'Christos') or more probably the 'Iota-Chi' (Iesus Christos) monogram. In addition there are the conjoined letters, 'I' with 'H' (for Iesous). The devices can probably be interpreted as the parables of the sower and of the lost sheep and also the miracle of the marriage feast at Cana.

Although the use of such Christian iconography certainly precedes the Peace of the Church, for example in the catacombs, overtly Christian intaglios such as this could be used with far greater confidence from the accession of Constantine. [M.H.]

229 Intaglio

Find-spot not known
Cornelian ringstone; H. 15.1mm, W. 12mm, Wt. 3.45g
3rd–4th century
Ashmolean Museum, Oxford, AN Fortnum 71
Bibl. Henig and MacGregor 2004, 128, 129, no.14.8.

The intaglio depicts Jesus standing in the River Jordan with John the Baptist standing beside him. Both, unusually, are clothed. The dove of the Holy Spirit is shown perched on Jesus' head. This important and explicit portrayal of a crucial event at the beginning of Jesus' ministry is likely to date from the reign of Constantine, when explicit references to the major events in Christ's life would not have risked persecution. For the wearer of the signet the baptism scene would have evoked the rite that initiated postulants into the Church. [M.H.]

Christian imagery in the fifth and sixth centuries

230 Figurine

Egypt, possibly carved in Alexandria
Ivory; H. 101mm, W. 50mm, D. 25mm
3rd or 4th century
National Museums Liverpool (World Museum Liverpool), 56.20.330
Bibl. Weitzmann 1979, 520, no.464; Gibson 1994, 2–3, no.1; for Christ-Orpheus cf. Weitzmann 1979, 520–1, no.465 (red slip plate) and 466 (marble statuette); for the Good Shepherd in sculpture see Weitzmann 1979, 518–19, nos 462–3; on gems, see Henig 1978b, 230, no.361, pls xxxii and xli; Krug 1980, 191 and Taf.80, no.93; Rizzardi 1996, 50–1, 215–16, pls 23–7.

Figurine of a shepherd. On his head, which is inclined to the left, he wears a Phrygian cap, strapped under his chin. His body is clad in a short belted tunic, its top covering his right shoulder leaving his left breast bare: this is the way artisans and countrymen normally wore the tunic. The garment is pleated below and has an embroidered hem. He carries a sheep over his shoulders and is flanked by two other sheep, the animal on his left standing and that on his right squatting on its haunches. Behind him there is a tree with spreading branches. The statuette stands on a circular base, pierced by four dowel holes. Two of the holes still contain pegs, showing that the statuette was once affixed to another object.

This *criophoros* (man carrying a sheep) belongs to a widespread Graeco-Roman pastoral convention. The cap identifies the subject as a shepherd from Asia Minor, and possibly as Orpheus. Other examples include a similar ivory *criophoros* in Dumbarton Oaks and a marble statuette, perhaps from Egypt. He was probably reinterpreted as the type of Christ, the Good Shepherd, as is confirmed by a similar figure being associated with Jonah on a North African red earthenware plate.

The Good Shepherd was in widespread use as the type of Christ, 'the good shepherd who lays down his life for the sheep' (cf. John 10, 11–16), in early Christian art from the third to the fifth century, appearing in works of art in all media. [M.H.]

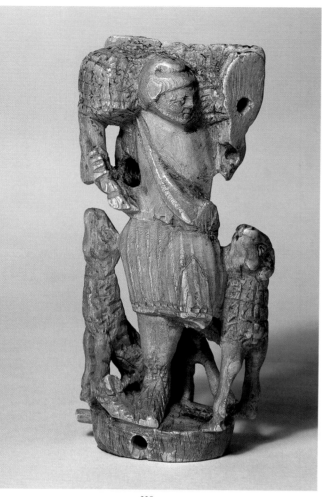

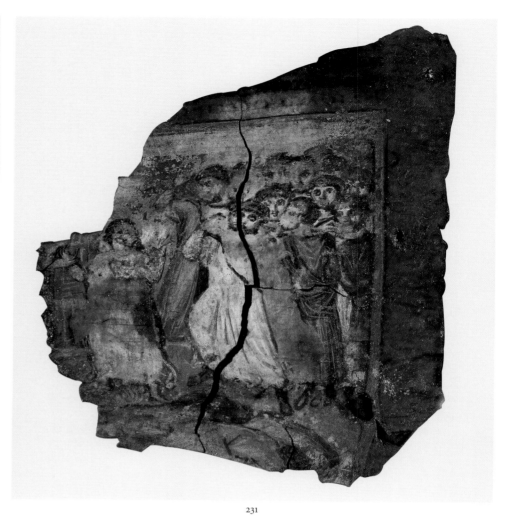

230

231

231 Cotton Genesis: Bristol Fragment

Eastern Mediterranean, perhaps Egypt
(Alexandria)
Greek; vellum, fragment of a codex (originally
of *c*.220 folios); 110 × 94mm (originally *c*.330 ×
250mm)
Late 5th or early 6th century
British Library, London, Cotton Genesis Otho
B vi 4

Bibl. Nersessian 1978, no.1; Weitzmann and Kessler 1986;
Lowden 1992, 40–53; Evans and Wixon 1997, 74–6.

The Cotton Genesis is a rare example of a fully
illustrated late antique/early Christian book. It
was severely damaged in a fire that destroyed
part of the Cotton Library at Ashburnham
House in 1731 and the surviving fragments have
shrunk to half their original size. During
antiquity bibliophiles did not greatly favour
illustrated works, but their didactic function
seems to have been valued by the early

Christians. When Christianity became more
publicly practised during the fourth century,
following Constantine's conversion and the
subsequent edicts of toleration, books
containing scripture became better made and
grander, some featuring cycles of images
designed to elucidate the text, until debates
concerning idolatry plunged Byzantium into a
period of iconoclasm during the seventh and
eighth centuries. Few such early Christian
illustrated books were probably made; fewer still
have survived, hence the continued importance
of the charred remnants of one of the most
opulent volumes of them all, the Cotton
Genesis. This contained some 339 miniatures,
illustrating the text (of the Septuagint edition)
in a remarkably full fashion. This image depicts
the story of Lot and the angels (Genesis 19, 7–11).
Lot's angelic visitors have smitten the Sodomites
with blindness and they besiege his home,
demanding that he hand the angels over. Lot can

be seen on the left, his waist seized by the hand
of an angel who pulls him back into the house.

The manuscript had reached Venice by the
thirteenth century and was in England by 1575,
where it is said to have belonged to Henry VIII,
Elizabeth I and John Fortescue (d.1607). It had
entered the collection of the parliamentarian
Robert Cotton by 1611. It was lent to Thomas
Howard, fourteenth Earl of Arundel (d.1646),
and bought back from his heirs by John Cotton
who bequeathed the Cotton collection to the
nation in 1702. It became part of the collections
of the British Museum on its foundation in 1753.
In 1756 this, and three other fragments, were
removed by Andrew Gifford, assistant librarian
in the British Museum's Department of
Manuscripts, who bequeathed them to Bristol
Baptist College in 1784. It was returned on loan
to the British Museum in 1928 and purchased
1962. [M.B.]

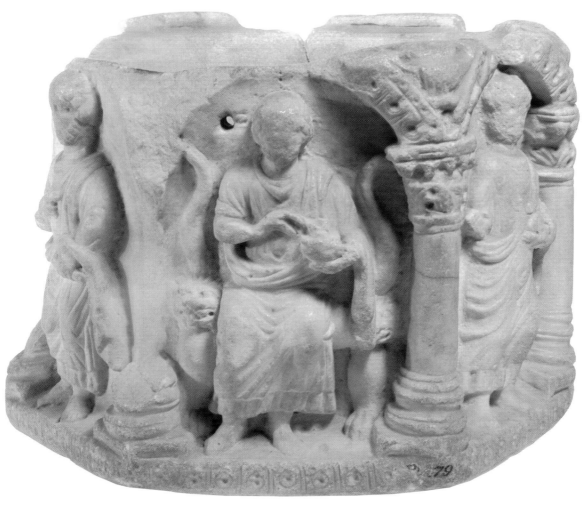

232

232 Casket

Provenance unknown (Papenbroke Collection)
6th century
Marble; H. 215mm, Dia. 300mm
Rijksmuseum van Oudheden, Leiden, Acc. Pb 79
Bibl. Bastet and Brunsting 1982, 175.

Slightly damaged six-sided casket, with circular interior, articulated by round columns with richly profiled bases and Corinthian-style capitals supporting round-headed arches decorated with simple pierced foliate motifs. *Canthari* of sixth-century form fill the spandrels, and single figures are set under the arches: five standing and one enthroned. A border of pierced work set out in metope-style arrangement encircles the base. A recessed rim around the top indicates the casket was originally lidded.

The six bearded figures are naturalistically posed and wear full-length tunics under long over-garments, with the *loros* draped over their shoulders and arms. All except one carry attributes in their left hands while their right hands are variously posed, either gesturing towards the attribute or raised in speech/blessing. The enthroned figure, seated on an elaborate throne in the late antique style with lion-head and claw terminals and a lyre-shaped back, carries a ewer. The figure next to him, moving right, carries a cloth purse; the next, a jar. The third standing figure is empty-handed, but the position of his left arm and the scarring of the marble above indicate he originally held an attribute. The next figure carries a bowl, while the fifth bears a scroll.

The architectural features, the rendering of the figures and the overall scheme indicate a date of production between the fourth and sixth centuries when such arrangements were popular in Christian art, but the style of the *canthari* suggests a sixth-century date. The enthroned figure can be identified as Christ, suggesting the other figures may be apostles; the nature of their attributes makes specific identification uncertain. The scroll-bearing figure on Christ's right might be identified as Peter, but in a Byzantine context would be more likely to be Paul, the Apostle of the New Law. The figure with the purse may be Matthew, the tax collector, but this is unlikely as he is generally identified as a gospel writer. Furthermore, the containers held by the other figures, along with the unusual presence of the *canthari* in the spandrels, point to the attributes as indicators of the casket's function, suggesting its use in the rituals of baptism. From an early date the *cantharus* was, through its identification with the laver that stood outside the Tabernacle of Solomon's Temple, a symbol of the purification of the priesthood and indeed all Christians, baptised into the Church, a ritual that involved anointing with holy oil as well as water. [J.H.]

233

233 Fragment of silk

Shrine of the Three Kings, Cologne Cathedral,
previously Church of Sant' Eustorgio, Milan
Undyed silk, *scutulatus* weave; 85 × 100mm
Mid-3rd to mid-4th century
The Whitworth Art Gallery, University of
Manchester, T.13722 (Franz Bock Collection)
Bibl. Wild 1964; Schulten 1980; Granger-Taylor 1983; Fiorio
1985; Wild 1987; Wild 1989; Schrenk 2000; Pritchard 2001;
Bédat *et al.* 2005.

The fragment, of fine cultivated silk, has a
woven geometric design and probably comes
from a tunic. In recent times it has been possible
to identify it as part of a larger piece of
scutulatus silk from the Shrine of the Three
Kings in Cologne Cathedral. A second fragment
in Cologne is from the same textile or from a
similar one. This smaller fragment has, in
addition to the undyed silk ground, part of a
tapestry band in gold thread and wool dyed with
true purple.

The weave of the silk areas, in modern
terminology, is 3/1:1/3 geometric twill damask.
As is generally the case with damasks, no colour
has been used and the design is visible only as a
result of the contrast between the warp-faced
and weft-faced effects. The design in this case
plays subtly on the relationship between small
squares and larger squares built up from them.

The connection between the twill damasks with
geometric designs and the Latin term *scutulatus*
was made by John Peter Wild (Wild 1964; the
same term also originally covered the traditional
Celtic and Germanic wool textiles in 2:2 lozenge
twill weave). Because the designs and technique
of the silk examples evolved over the two
hundred or so years during which they were
made, they can be dated comparatively closely.

The fragments are most likely to have come
originally from a dalmatic. A cushion cover is
another possibility. Diocletian's Edict of
Maximum Prices of 301 lists a loom for this
technique: *tela holosericis vestis scutulatae*,
literally 'a loom of [*sic*] a pure silk garment [in]
twill damask [weave]' (12.32a, discussed by Wild
1987). The loom was probably vertical,
something like that still in use in Iran for
weaving *polymita*-type floor coverings called
zilu.

With the exception of two from Palmyra in
Syria, virtually all the finds of *scutulatus* silk
have been made in western Europe. Recent
discoveries include a burial at Naintré in western
France where the silk fragments may be from
the same garment as tapestry bands with plant
designs in gold thread (Bédat, Desrosiers,
Moulherat and Relier 2005). A less well-
preserved burial in London has traces of similar
textiles. These finds illustrate how very wealthy

some families in the western Roman empire
were at this period.

Emerging as the most likely places for the
production of this type of textile are the
prosperous and expanding cities of the western
provinces, perhaps Milan, also Mainz and
Cologne along the Rhine, and Trier (Granger-
Taylor 1983, 143–4; Wild 1989). Wherever
established, this was an industry based on an
imported raw material since cultivated silk of
this quality must have come from China at this
date.

The history of the fragments from the Three
Kings shrine in Cologne is a long one. They were
probably removed at the opening of the shrine
in July 1864. Franz Bock, who was present,
recorded seeing a great heap of bones wrapped
with torn strips of 'byssus' and perceiving
among these 'a small squared pattern,
continually repeating' (Schulten 1980, 11). This
opening celebrated the seventh centenary of the
transfer to Cologne of the relics of the Three
Kings. These had been given to Reinald von
Dassel, then Archbishop of Cologne and
imperial chancellor, following the sack of Milan
by Frederick I Barbarossa in 1162.

It is known that the earlier place of
deposition of the bones and their wrappings was
a very large late Roman sarcophagus in the
Church of Sant' Eustorgio, near to the Porta
Ticinese in Milan. Beyond this we know very
little. The sarcophagus survives today in the
chapel of the *Re Magi* in the church, but the
building itself is largely of the eleventh to
twelfth century. On the other hand Eustorgius,
by tradition the founder of the church, is a
historical figure, the ninth Bishop of Milan who
probably succeeded Bishop Protasius in 344–6.
And under the crypt of the present church are
the remains of a late antique building with a
semicircular apse, perhaps Eustorgius's original
church. Excavations also revealed traces of a
pagan and Christian cemetery, dating from the
third century onwards (Fiorio 1985, 11). One
possibility is that the textiles, which are
contemporary with Eustorgius or somewhat
earlier, were placed in the Magi sarcophagus in
his time. Whatever the exact details, the textile
fragments are particularly interesting because of
their link with the early period of the established
church. [H.G-T.]

End of Empire

234–66: Traprain Law Treasure

The native hill fort of Traprain Law, some 32km (20 miles) east of Edinburgh, lies in the territory of the tribe of the Votadini and was the major centre of their power. Finds of Roman material at the site show that there was considerable contact between them and the Romans, although the nature of this contact is not well understood and is a matter of current research and debate (Rees and Hunter 2000; Edrich, Giancotta and Hanson 2000).

The Traprain Law Treasure, found during excavations by Curle in 1919 within the hill fort, consists of 152 pieces of silver. About 140 are fragments of Roman silver plate, most of which had been cut into pieces, while the rest are small objects such as belt-fittings, jewellery and coins. From the time of its discovery the treasure has frequently been interpreted as pirates' loot which had been divided up for distribution between the participants, presumed to be members of the Votadini tribe. Other ideas, suggested by a comparable hoard from Gross Bodungen in Germany, published in 1954, indicate that broken silver plate was used as a means of exchange. A fresh look at the material has begun to suggest a third possibility.

The objects cut up were originally fine pieces of table plate, as fine as any found in the most impressive late Roman hoards of silver from across the empire, originally used by high-ranking citizens to impress guests at dinner; but they were also an important means of saving wealth. We do not know whether the Traprain Law pieces belonged to a single family before they were cut up, but they might have been. Whether the original vessels were previously in Britain or elsewhere cannot be known for certain; but there is no reason to suppose that the plate did not come from Britain, as the few associated coins certainly did.

Whatever the source of the silver plate, some very fine pieces are represented and a number of them have been reconstructed by the National Museum of Scotland. The importance of the hoard can only be hinted at here. One of the most remarkable vessels is a jug decorated in relief with four scriptural scenes: two with miracles of Moses, one showing Adam and Eve in Paradise about to be expelled from the Garden of Eden and the fourth with the Adoration of the Magi. Quite apart from the quality of the workmanship, this jug is unique in being the only surviving silver vessel of the period to show these scenes. The relief on another fragmentary jug shows a Bacchic procession including figures of the highest quality. The figurework is to be compared with a bowl from the eastern Roman Empire (now in Washington, DC), with two jugs in the Seuso Treasure, possibly from Hungary, and with the great dish and two plates with Bacchic scenes from the Mildenhall Treasure, which are the three finest pieces of surviving Roman silver plate. The Traprain Law pieces were made in the best workshops of the late Roman period, along with the treasures mentioned above, as well as those from Hoxne, Trier, Kaiseraugst and the Esquiline Hill in Rome.

Curle interpreted the Traprain Treasure as 'booty' and 'ready for the melting pot', since most of it had been cut up and it was found outside the frontier. Other hoards of chopped-up silver (also known as 'hacked silver') have been found beyond the imperial borders, for example at Balline and Coleraine in Ireland, at Høstentorp in Denmark and at Gross Bodungen in north Germany. It was previously supposed that hacked silver hoards were restricted to the barbarian lands beyond the Roman frontiers. Another study, by Grünhagen, based on the Gross Bodungen hoard, concluded that silver might well have been used in exchange, and that in this role it was prized in the barbarian world as a means of payment. It has since become clearer that hacked silver circulated also inside the empire. Good examples are in the fourth-century hoard from Water Newton, which includes two pieces of hacked silver weighing one and two Roman pounds respectively, and the Kaiseraugst Treasure, which contained not only plate and ingots given as donatives, but also a piece of hacked silver which had been prepared in a mint in Mainz. In these cases the silver was one of the ways in which soldiers and officials received special bounties as part of their pay. By the fifth century, when the Traprain Law Treasure was deposited, we seem to have passed, at least in some areas, to a situation where donatives consisted entirely of cut-up silver plate handed out to soldiers by weight. The cut-up plate seems itself to have become the official gift.

If the cut-up plate at Traprain Law was an official gift to a Roman official or soldier, who was he? The silver belt buckles and strap-ends seem to have belonged to a soldier who was enrolled and served in the Roman army in the east European provinces, those bordering on the Danube, where units were staffed mainly by east Germanic troops, many of them Goths. These Germanic troops crossed the frontier into the empire to do military service as regular troops. The Traprain brooch is a type worn by women from the same east European provinces. This implies that the owner of the brooch may have been his wife.

Böhme has suggested that this evidence means that the soldier was probably part of a unit of Goths serving in Britain in the middle third of the fifth century. There are other such men. At Gloucester the man in a burial of the early fifth century was a 20–25-year-old, identified as an eastern German by the objects in his grave, namely silver shoe buckles and strap-ends, a matching silver belt buckle and a knife, paralleled in graves in south-east Europe and southern Russia. The fact that he was buried without weapons suggests that he was a Goth. At Whorlton in Yorkshire a hoard of about 7000 coins included the silver tongue of a buckle, perhaps from the same sort of buckle as was found at Traprain Law. It was deposited in the first or second quarter of the fifth century. And from St Albans comes a mid-fifth-century woman's trapezoidal silver brooch of eastern European type with parallels in Poland. Its owner was probably the Germanic wife of another Germanic soldier, possibly a Goth. This and other evidence suggests that in Britain in the fifth century organised bands of Roman soldiers included not only locally raised troops but various units of barbarian troops who were originally recruited into the Roman army and equipped in Gaul or the Danubian provinces and were later posted to the northern provinces of the empire. The Goth whose equipment was at Traprain Law therefore crossed the frontier with his wife, joined the army, received local Danubian equipment and was promoted at some point here to a senior rank, receiving the silver buckles.

During his service in the Roman army the Goth must have been awarded one or more donatives. If the donative was the cut-up plate

owned by the Goth, then, at the end of his
service, he and his wife presumably took their
savings and retired. If the four surviving coins
were his, the two clipped examples show that
they circulated in Britain and that the Goth
served at least the last part of his service there.
His belt buckles suggest that this happened in
the middle third of the fifth century. It is likely
that the Goth went to Traprain Law with his
wife, his equipment and the silver plate. The
reason why he went there, buried his valuables
and failed to recover them is hard to imagine.

234 Silver jug with scenes from the Old and New Testaments

Traprain Law
Silver; H. 216mm, Dia. *c.*76mm
Late 4th century
National Museums of Scotland, Edinburgh,
GVA 1

Bibl. Curle 1923, 13–19, no.1, 94–5; Dohrn 1949, 100; Edinburgh
1958, no.24; Toynbee 1962, 171–2, no.107; Toynbee 1964b, 313;
Pirzio Biroli Stefanelli 1965, 100, 102, 112; Strong 1966, 182–6,
pl.35A; Beckwith 1970, 22, fig.41; Kent and Painter 1977, 123,
no.193; Kötzsche 1979; Stutzinger 1983; Mundell Mango 1994;
Del Moro 2000.

Silver jug, with partial gilding, reconstructed
from fragments; handle missing. Decorated in
repoussé with scenes showing the Adoration of
the Magi; the miracle of Moses striking water
from the rock of Horeb; the Fall, with Adam and
Eve in Paradise next to the tree with the serpent;
and, probably, a second miracle of Moses – the
quails in the desert.

 The jug is likely to have been made in the
western half of the empire. It is one of very few
such vessels of this date with Christian scenes.
Scenes from the Old Testament were often
deliberately placed with scenes from the New
Testament in order to give extra meaning to the
latter. The four scenes may therefore be seen as
linked in a narrative. Because Man fell (scene 3),
Christ was incarnated on earth to save him
(scene 1), and this salvation was prefigured by
the types of miracles from the Old Testament
(scenes 2 and 4). These meanings are
undoubtedly present in the scenes on the jug;
but we cannot know whether it was known to
the craftsman who copied the scenes or the
customer who bought the jug.

 There is no inscription which would identify

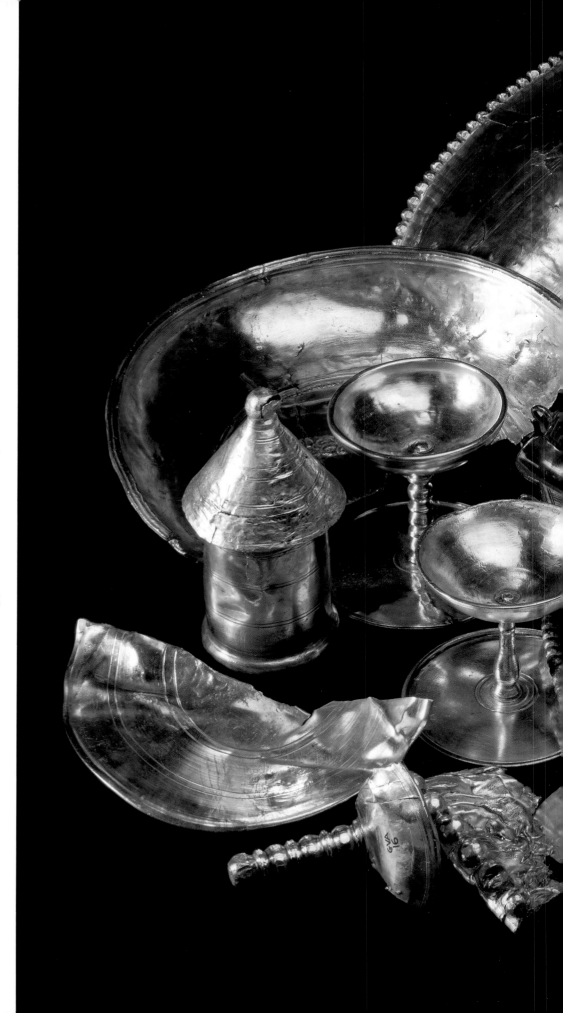

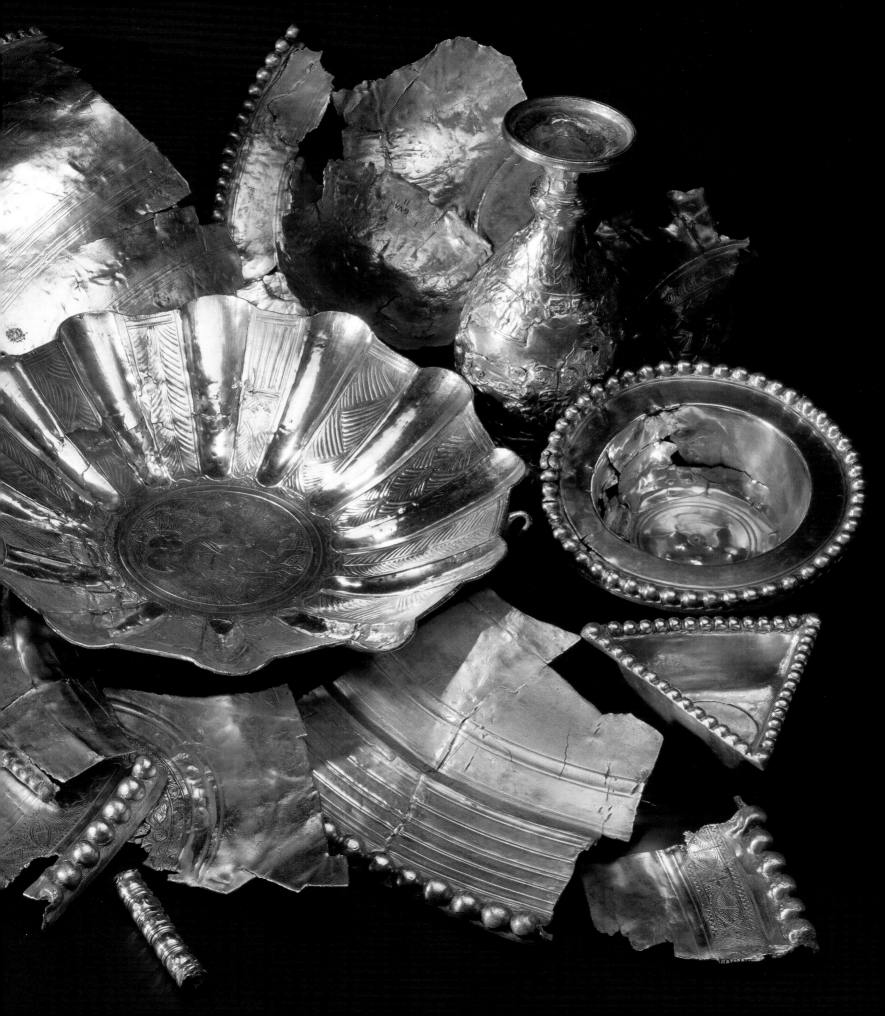

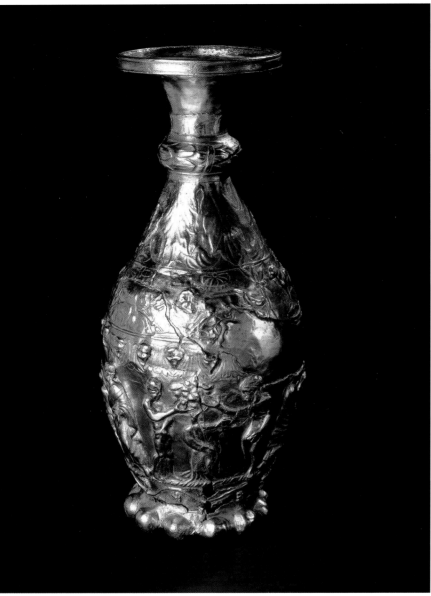

234

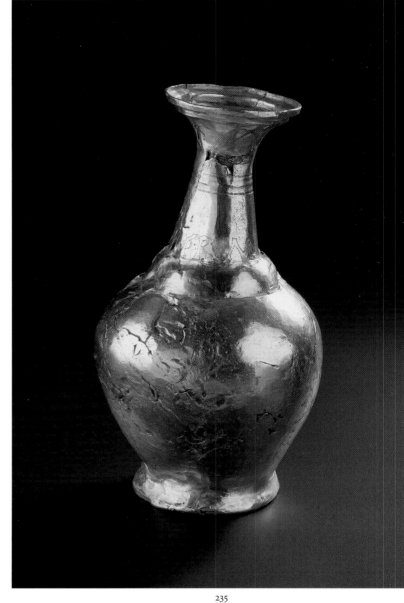

235

the jug as being for use in a church. In the absence of evidence such as an inscription confirming such a use, this vessel could well be Christianised domestic silver, comparable to contemporary works with pagan representations, and for use at the table. [K.P.]

235 Silver jug

Traprain Law
Silver; H. 154mm
Late 4th century
National Museums of Scotland, Edinburgh,
GVA 2

Bibl. Reinach 1921; Curle 1923, 19–21, no.2, pls VI–VII, fig.5; *PSAS* lxii (1928), 162, fig.1; Pirzio Biroli Stefanelli 1965, 113–14; *RIB* **2.2**, 36, no.2414.20; Provost 1988, 65; Baratte 1993, 79, 115.

Silver jug or bottle, with partial gilding, reconstructed. On the neck is an inscription in dotted capitals, with a Chi-Rho and Alpha and Omega, reading FRYMIACOEISIAFICT.

This vessel was probably a jug (with a handle) rather than a bottle. A misunderstanding of the inscription suggested that it meant that the jug was from a church in France, and from this it was concluded that the jug and the treasure were stolen from Gaul by 'Irish' pirates in 406. In fact the inscription most probably means 'Alpha Chi-Rho Omega' and 'Eisia made [this] for Frymiacus' (or 'at Frymiacum').

Curle thought that the Christian emblems implied that the jug might have been used in the communion service. But this is a jug for table use, as with so many other objects with Christian symbols. [K.P.]

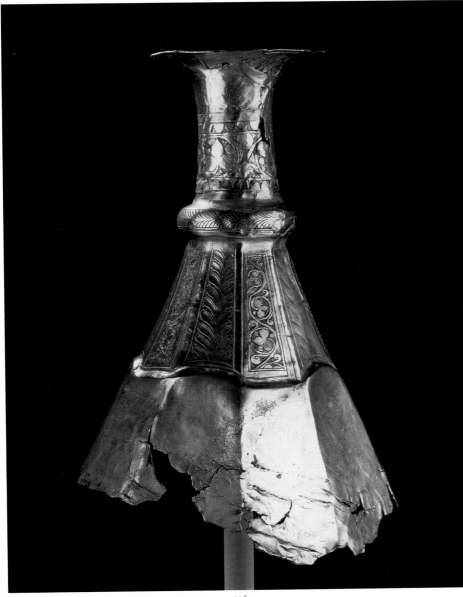

236

237 Silver jug with Bacchic procession

Traprain Law
Silver; H. 162mm
4th century
National Museums of Scotland, Edinburgh,
GVA 7
Bibl. Curle 1923, 25–6, no.7, pl.XI, fig.8; Dohrn 1949, 129; Toynbee 1964b, 313; Pirzio Biroli Stefanelli 1965, 111, 115; Cahn and Kaufmann-Heinimann 1984, 146, 283; Baratte 1993, 80, 181.

Part of a jug, decorated with a Bacchic relief of figures in high relief in repoussé: on the left, part of a female figure, including one hand, parts of draperies and a flaming torch; to the right, a nude satyr; to his right a pedestal or altar; to the right a figure, moving right, its sex uncertain.

 This fragmentary fourth-century jug is, artistically, the finest in the hoard. The scene shows part of a Bacchic procession or *thiasos*. The Bacchic theme is to be seen everywhere in Roman silver work, used for purely decorative purposes, for the atmosphere of well-being and pleasure that it evoked or for real religious reasons. In the fourth century Bacchic processions and jugs both come into fashion, though without any particular emphasis on triumphs or worship. There is no reason to think that the *thiasos* here is anything more than decorative. [K.P.]

238 Fragment of a silver jug with Odysseus

Traprain Law
Silver; H. 142mm
4th century
National Museums of Scotland, Edinburgh,
GVA 8
Bibl. Curle 1923, 27–8, no.8, pl.XII, fig.9; Dohrn 1949, 92; Pirzio Biroli Stefanelli 1965, 102, 115; Cahn and Heinimann-Kaufmann 1984, 239, fig.123; Baratte 1993, 80, 188.

Part of a jug or bottle, with figures in repoussé, from the left: a single, large right foot; Eurykleia, her left arm stretched out towards Odysseus' foot; female facing the front; female facing right; female facing front, holding a spindle in her left hand; fragment of the lower legs of a female, facing right.

 The vessel, probably a jug, with a globular body, belongs in the fourth century. The scene illustrates a key moment in Homer's story of Odysseus' return home after the end of the

236 Fragmentary large silver jug

Traprain Law
Silver; H. 255mm
Second half of 4th century
National Museums of Scotland, Edinburgh,
GVA 3
Bibl. Curle 1923, 21–2, no.3, pls VIIB and VIII, fig.6; Toynbee 1962, 171–2, no.107, pl.123; Toynbee 1964b, 313; Pirzio Biroli Stefanelli 1965, 104, 113, 114, 116; Baratte 1993, 80.

Upper portion of a large pear-shaped jug; ten-sided body; reconstructed. Decorated with gilded and nielloed panels.

 This vessel is distinctive for its ten faceted sides. It was in the fourth and early fifth century that faceted jugs and other vessels came into fashion in the fourth and early fifth century. The technique of niello decoration was used all over the western empire, and this jug is likely to have been produced in Gaul or the Rhineland or the Danube area, rather than further east. [K.P.]

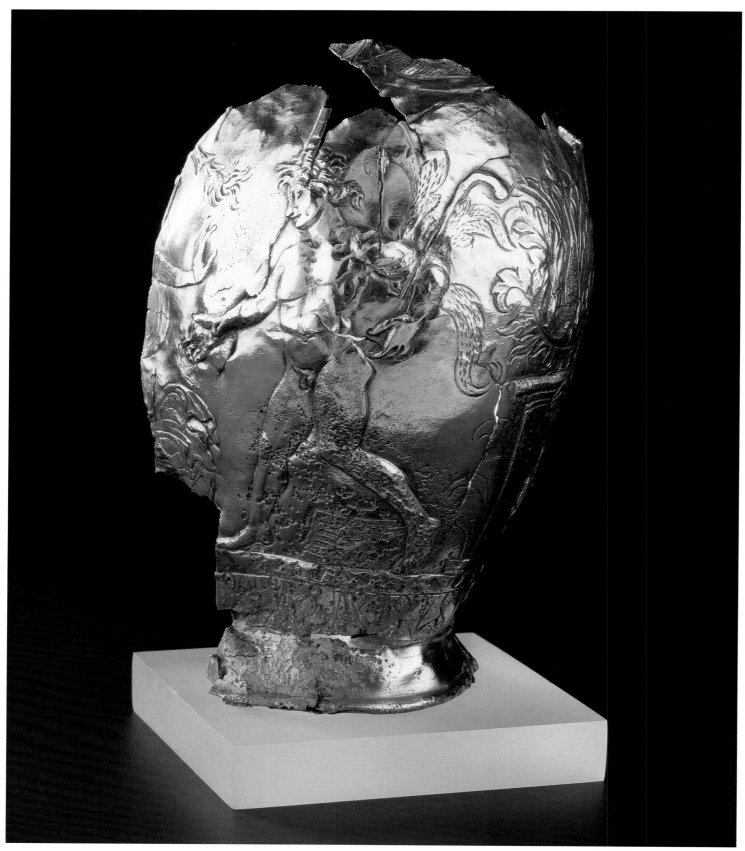

237

Trojan War. After many adventures he arrived to find his wife besieged by suitors who believe Odysseus dead. In disguise as a filthy beggar, Odysseus talks to his wife, who does not recognise him but makes him welcome as a guest. Eurykleia, his old nurse, prepares to wash the guest's feet, but recognises his true identity. She is sworn to secrecy, and on the following day Odysseus, with his son, kills the suitors and is reunited with his wife. Here the Odyssey ends.

Another vessel in the Traprain Law Treasure, a large silver dish (GVA 67), has on the underside of the base a fragmentary graffito inscription TALAS ITHA[…]. This may be another reminiscence of the Odyssey, whose theme is the return of Odysseus (regularly ταλασίφων – 'stout-hearted') to Ithaca. The repertoire of scenes on Roman silver vessels in the fourth century reflect the intellectual and literary interests of the aristocratic classes. In the fourth century this same repertoire is found across the decorative arts, using analogous images which are fruits of a single culture. [K.P.]

239 Silver cup

Traprain Law
Silver; H. 105mm
Mid- or late 4th century
National Museums of Scotland, Edinburgh,
GVA 13

Bibl. Curle 1923, 29, no.13, pl.XIII, fig.10; Dohrn 1949, 111–12; Pirzio Biroli Stefanelli 1965, 115–16; Kent and Painter 1977, no.194; *RIB* **2.2**, 35, no.2414.16; Baratte *et al.* 2002, 48–9.

Silver cup with a gilded shallow bowl, a stem formed of four vase-shaped sections, and a wide, flat foot. On the underside of the base is a graffito, CON, possibly a personal name, Constantius or Constantinus.

This is one of five or six similar cups represented in the treasure. The only parallels in silver are two cups from the Mildenhall Treasure. There is a similar cup in pewter in the fourth-century hoard from Appleshaw in Hampshire. The beading round the rims of the Mildenhall cups, not present on the Traprain Law cups, suggests that such vessels may not have been intended for drinking. The bases, decorated on the Mildenhall cups, may show that the cups were turned upside down when not being used for drinking. These conclusions may also apply to the Traprain Law cups. [K.P.]

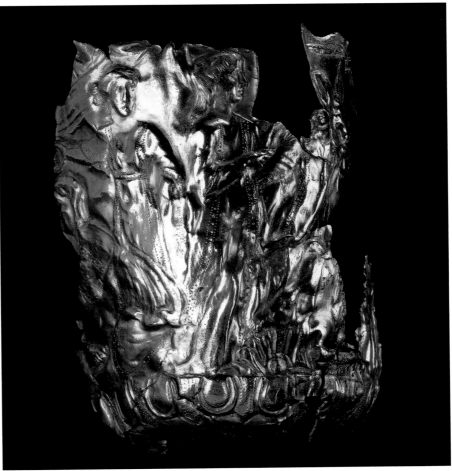

238

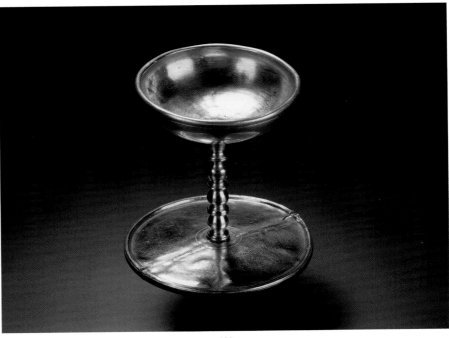

239

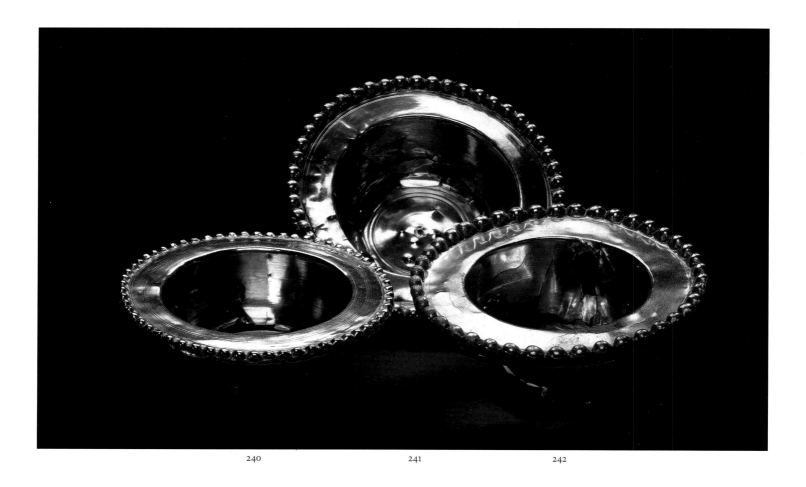

240 241 242

240 Small silver bowl

Traprain Law
Silver; Dia. 164mm
Late 4th or early 5th century
National Museums of Scotland, Edinburgh,
GVA 23

Bibl. Curle 1923, 34, no.23, pl.xiv; Pirzio Biroli Stefanelli 1965, 102; Baratte, Lang, La Niece and Metzger 2002, 28–9.

Silver small bowl; flat rim; hemispherical body; foot-ring.

 This is one of eight matching small hemispherical bowls in the treasure. Two more (cats 241 and 242) are included in the exhibition.

 Other bowls of the same sort have been found in the treasures from Mildenhall and Hoxne in Suffolk, and Šabac and Viminacium/Kostolac in Serbia. Individual bowls from Syria, Russia and perhaps Constantinople have stamps which suggest a date of the end of the fourth century or the beginning of the next for the whole group. Some of the bowls in the Traprain Law Treasure have

inscriptions indicating different ownerships, and this may rule out their having been made as a set. The distribution shows that bowls of this type were made all over the empire; but the Traprain Law bowls are likely to have been made in the western half of the empire and the inscriptions in Latin show that they were used there. [K.P.]

241 Silver small bowl

Traprain Law
Silver; Dia. 143mm
Second half of 4th century or early 5th century
National Museums of Scotland, Edinburgh,
GVA 22

Bibl. Curle 1923, 33–4, no.22, fig.11; *RIB* **2.2**, 34, no.2414.13.

Silver small bowl; flat rim; hemispherical body; foot-ring. Graffito on the side, in capitals except for 's', which is in fourth-century new Roman cursive: AMABILIS. When found, the base was detached. Restored. [K.P.]

242 Silver small bowl

Traprain Law
Silver; Dia. 151mm
Second half of 4th or early 5th century
National Museums of Scotland, Edinburgh,
GVA 27

Bibl. Curle 1923, 35, no.27, pl.xiv, fig.15.

Silver small bowl; flat rim; hemispherical body; foot-ring. Graffito on underside: DIG – probably an abbreviated personal name, *Dignus* (or similar). [K.P.]

243 Silver fluted bowl

Traprain Law
Silver; Dia. 302mm
Second half of 4th century
National Museums of Scotland, Edinburgh,
GVA 30

Bibl. Curle 1923, 36–9, no.30, pl.xvii, pl.xviiib, figs 17–18; Pirzio Biroli Stefanelli 1965, 105, 111, 116; Baratte 1993, 125, 178.

Large silver bowl; flat circular medallion in

centre and 24 radiating panels; three of four original escutcheons to attach two swing-handles. Central medallion decorated with nereid riding a panther-headed sea monster; by its tail the head and tail of a fish; between the sea-monster and the nereid three shellfish; below, a dolphin, a fish and another shell.

One of three fluted bowls in the treasure, dating to the second half of the fourth century. It was made somewhere in the western or northern provinces, during the second half of the fourth century. Similar bowls occur in the major finds of the period, such as the treasures from Mildenhall, Kaiseraugst and the Esquiline Hill in Rome. It was probably used for toilet purposes, including the washing of hands at banquets. [K.P.]

244 Triangular silver bowl

Traprain Law
Silver; L. of sides 116, 114 and 117mm, H. 52mm
4th century
National Museums of Scotland, Edinburgh,
GVA 35
Bibl. Curle 1923, 41, no.35, pl.xxii; Pirzio Biroli Stefanelli 1965, 102, 104; Strong 1966, 203.

Silver triangular bowl; horizontal, projecting rim, decorated with beading; circular foot-ring. The treasure includes a surprising variety of shapes of vessels. The shape of this bowl seems to be unmatched; but unusual shapes were probably more common than the surviving silver suggests. The lack of parallels means that the dish cannot be dated more precisely than to the fourth century. [K.P.]

245 Fragmentary silver bowl with head of Hercules

Traprain Law
Silver; Dia. when complete 254mm, H. 76mm
Probably late 4th century
National Museums of Scotland, Edinburgh,
GVA 36
Bibl. Curle 1923, 41–3, 94, no.36, pls xx–xxi; figs 21, 69; Dohrn 1949, 100, 102, 121, 129; Pirzio Biroli Stefanelli 1965, 118; *RIB* ii.2, 38, no.2414.29; Guggisberg and Kaufmann-Heinimann 2003, 146, n.338.

Portion of a silver bowl with a high foot-ring; decorated outside with a frieze of three groups of animals pursuing each other in a landscape of

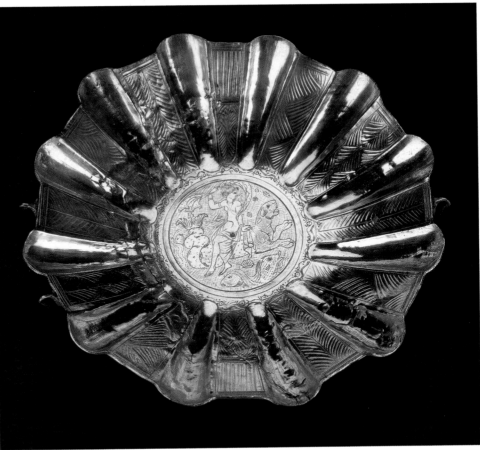

243

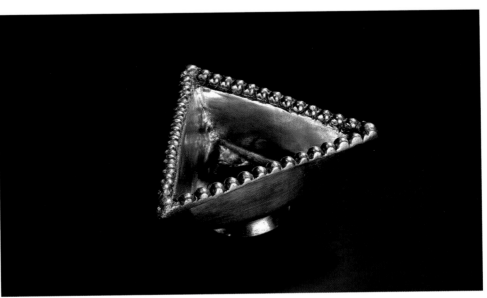

244

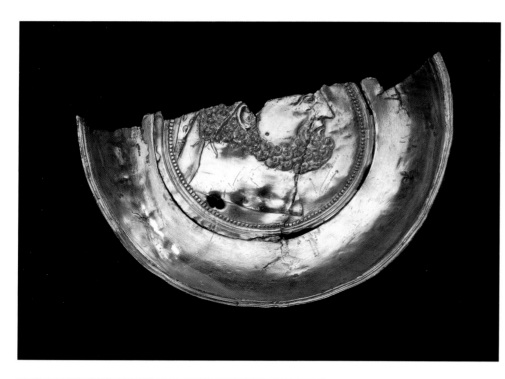

trees and plants, separated by masks of Mercury and a female. On the underside of the base an inscription: [...].III (uncial symbol) SI (Three (pounds?) seven ounces).

The distinctive shape of this bowl is paralleled by two bowls found at Kostolac/ Viminacium in Serbia, dated by stamps to the fifth or sixth century. All three are related to other bowls with high foot-rings, which in turn are closely connected to Sassanian silver vessels made in Persia. In spite of these connections it is most likely to have been made in the northern or western provinces.

The style and content of the decoration date this bowl to the fourth century. Although the frieze on the outside wall of the bowl is Bacchic, Hercules, like Mercury in the frieze, does not belong to the traditional Bacchic scene. Non-Bacchic divinities, however, do occur in other Bacchic contexts. Most dramatically, Hercules appears, drunk, on the Mildenhall great dish. [K.P.]

246 Silver shallow bowl

Traprain Law
Silver; Dia. 210mm
Late 4th century
National Museums of Scotland, Edinburgh,
GVA 40
Bibl. Curle 1923, 48, no.40, pl.xviiia, fig.24; *RIB* **2.2**, 36–7, no.2414.24.

Silver bowl with curved sides and flat thickened rim, standing on a vertical foot-ring. Graffiti on the underside of the base, including ROM and RO, probably for the name Romanus or Romulus.

A close parallel for this bowl is a bowl probably found in the treasure from the Esquiline Hill in Rome (Shelton 1981, 82, no.14). [K.P.]

247 Fragment of a silver cylindrical vessel

Traprain Law
Silver; H. 124mm
Late 4th century
National Museums of Scotland, Edinburgh,
GVA 92
Bibl. Curle 1923, 62–3, no.92, pl.xxv; Pirzio Biroli Stefanelli 1965, 120.

Fragment of the upper portion of a silver vessel:

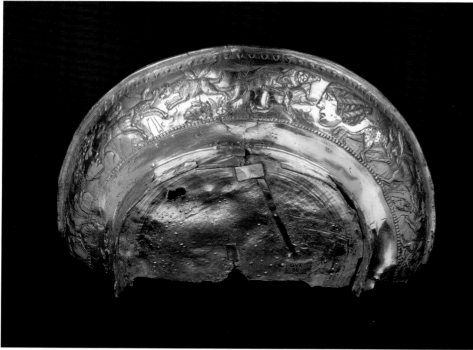

245

body cylindrical; slightly turned out rim. This is one of four such vessels in the treasure. It is doubtful whether the wall turned inwards or was vertical. There are two possibilities for the use of this vessel. If the wall turned in and then out, it may have been part of a cup or beaker, similar to examples in glass. If the wall was vertical, then the only surviving similar vessels are four vertical-sided beakers found in Italy; but they are of the first century and so not relevant. There are no surviving fourth-century silver beakers of this shape. A second possibility is that the fragment and its fellows are from small, cylindrical boxes, of the sort discussed below under cat.254. Parallels in the Esquiline Treasure, from Rome, show that they were used for holding cosmetics. [K.P.]

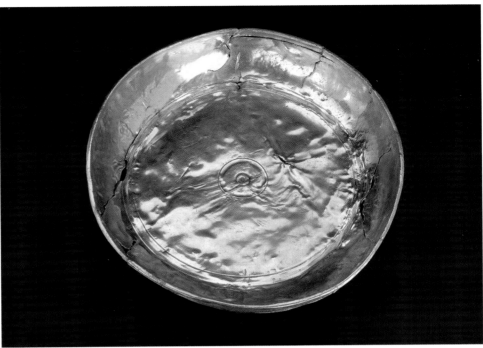

246

248 Long-handled silver spoon

Traprain Law
Silver; L. 213mm
Late 4th or early 5th century
National Museums of Scotland, Edinburgh,
GVA 97
Bibl. Curle 1923, 63–4, no.97, fig.41; Martin 1984, 76; *RIB* **2.2**, 143, 2420.59.

Silver spoon; bowl rounded, fluted on the back, and fastened to the tapering handle by an openwork offset. Bowl inscribed with Chi-Rho.

This is a characteristic late Roman spoon, of a type in use until the sixth century. This and another spoon in the treasure (GVA 98) have very similar Chi-Rho symbols engraved in the bowl. Almost all spoons are private table plate, increasingly important socially, with increasing weight, more complicated shapes and increased decoration, as part of the table luxury of the period. In spite of Christian symbols, spoons were not used in the Eucharist in the Latin rite, and not in the eastern rite before the eighth century. Christian decorations or inscriptions are no more significant than similar pagan wishes for good luck on other spoons (for example VIVAS OR VIVAS IN DEO), just as both pagan and Christian scenes on vessels are little more than interesting decoration. Only rarely can it be suggested that spoons might have played a role in religious activities, as for example in the case of the Thetford spoons, where it is the find as a whole that dictates the circumstances of the interpretation. [K.P.]

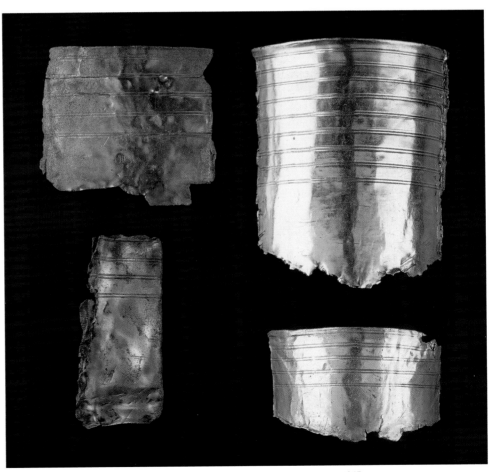

247

248

249

249 Silver swan-handled spoon

Traprain Law
Silver; L. 84mm
Mid-4th century
National Museums of Scotland, Edinburgh,
GVA 103

Bibl. Curle 1923, 68, no.103, pl.xxvi, figs 48, 49; Pirzio Biroli
Stefanelli 1965, 110; Martin 1984, no.97.

Silver spoon; handle wrongly extended,
terminating in a bird's head.

There is a concentration of this type of
spoons in the second half of the fourth century
and the beginning of the fifth, and they are
found in hoards buried in the sixth century.
Their distribution is almost exclusively in the
west of the empire, where it is widespread, as
British finds from Traprain Law, Thetford and
Canterbury show. This western bias might be
because few silver hoards of the fourth and fifth
centuries are known from the east; but in fact
the almost complete lack of this form, even
among chance finds, cannot be a matter of
chance. Close parallels for this spoon are in the
Kaiseraugst Treasure of the mid-fourth century.
This example can therefore also be assigned to
this date. [K.P.]

250 Silver ladle or spoon

Traprain Law
Silver; L. 133mm
Late 4th century
National Museums of Scotland, Edinburgh,
GVA 106

Bibl. Curle 1923, 70–1, no.106, pl.xxvi, fig.53; Pirzio Biroli
Stefanelli 1965, 111; Baratte, Lang, La Niece and Metzger 2002,
68–9.

Ladle or spoon with a circular bowl and a
handle in the form of a dolphin.

This object belongs to a type that was part of
a fashion beginning in the second half of the
fourth century. Implements of this sort found in
Italy at Pavia, Desana and Canoscio are usually
dated to the end of the fifth or the sixth century;
but there is no independent dating evidence for
them. Nine such 'ladle-spoons' occur in the
Carthage Treasure. These are dated on the style
of their decoration to not earlier than the
second half of the fifth century. The closest
parallels for the Traprain Law example are found
in the Mildenhall Treasure of the mid-fourth
century and the Hoxne Treasure, buried
between 407 and 450.

The function of these ladles or spoons is not
clear. They certainly do not take the place of
spoons, as the discovery of normal spoons with
them demonstrates. They were certainly not
some sort of liturgical spoon, as has been
suggested for those found at Canoscio and
Pavia. [K.P.]

251 Fragment of a small silver platter

Traprain Law
Silver; L. 171mm
Late 4th century
National Museums of Scotland, Edinburgh,
GVA 108

Bibl. Curle 1923, 72, no.108, fig.55, pl.xxvii, pl.xxxviii; Pirzio
Biroli Stefanelli 1965, 116, 120; Cahn and Kaufmann-
Heinimann 1984, 172–3, pl.78, 1.

Fragment of small silver dish; on the left-hand
edge there is a fragment of the rim turning
outwards, most likely the beginning of an equal
second curve, suggesting that the dish was in the
form of a double oval, the two ovals being
contiguous along a long edge.

Inside the rim, a border of curved, gouged
grooves; in the centre of the dish, an engraved
fish, facing left; round the fish, groups of wavy
lines indicating water.

Curle misinterpreted the vessel as a heart-
shaped dish, with the fish pointing upwards.
Such a form is unparalleled and unlikely. The
fragment can be completed to give the vessel the
shape of a double oval. This is not a common
form in surviving silver hoards; but there are
three examples in the Hildesheim Treasure, close
in size to the Traprain Law fragment. There will
probably have been a second fish or some other
sea-creature in the lost half of the dish.

The fish and parallels on vessels in pewter
from Appleshaw, Icklingham and Alise-Sainte-
Reine and in silver on two from Kaiseraugst,
near Basel, are clearly the work of craftsmen and
not works of art; but they are more richly
decorated, more directly and better observed
than the small drawings on the older bronze
dishes. Overall, however, the drawing on the
Traprain Law dish, which is regular and careful
but without great contrasts, may be compared
with the fish on the front of the Lipsanothek,
the most important ivory early Christian
reliquary, dated to the Theodosian period. The
Traprain Law dish may therefore be dated to the
late fourth century.

Oval and rectangular dishes for serving fish,

250

251

fowl and meat are relatively common in groups of plate of the late Roman period. Representations of fish on serving vessels are often claimed to show a reference to the Christian symbol of the fish (*ichthys*); but they are in fact direct descendants of older representations of fish on bronze vessels from Gaul (themselves reductions of pictures of the sea and of fish) and without intellectual content. [K.P.]

252 Silver base of a circular dish and a fragment of silver network

Traprain Law
Silver; Dia. of base of circular dish 127mm
Late 4th or early 5th century
National Museums of Scotland, Edinburgh,
GVA 109

Bibl. Curle 1923, 73–5, no.109, pl.xxviii; Pirzio Biroli Stefanelli 1965, 121; Kondoleon 1979, 45; Boyd 1988, 194–5.

Silver fragment of the base of a circular dish, decorated on the underside with a series of concentric grooves and a plain band of gilding around the edge, fragments of network attached; a detached part of a network mounting. Underside of base decorated with a series of concentric grooves and a plain band of gilding; on the upper side with attached fragments of network and studs.

The fragments are a version in metal of a glass openwork vessel, thus linking it with the most spectacular vessels of the period in glass. Glass cage cups, or *diatreta*, have delicate openwork designs, meticulously cut from a thick blank of glass. It is likely that coloured glass was used for the liner of the Traprain Law vessel in order to contrast more vividly with the silver of the mounting. It is not known whether the openwork technique originated in a metal or glass workshop. The earliest such vessel is a small vase, in the British Museum, dated to the first century. A more elaborate example is the late second- or early third-century cup, found in Tiflis and now in St Petersburg. The third example is a fragmentary third-century vessel found at Varpelev in Denmark. The technique continues into late antiquity with objects like a third- or fourth-century gold cup with Bacchic scenes, and the so-called Antioch Chalice, a fifth-century openwork gilded silver cup showing Christ and the Apostles.

The fragments were most probably part of a suspended silver lamp. Another silver suspended lamp in the exhibition forms part of the treasure from Water Newton. There are only two other finds of silver suspended openwork lamps known. One is of the late fourth or early fifth century and comes from Rome. The other find is a group of eight lamps, part of the furnishings, known as the Sion Treasure and from a sixth-century church in Turkey. The lamps from the Water Newton and Sion treasures are from churches. It does not follow, however, that the Traprain Law lamp was necessarily from a church. Lighting devices were needed in all types of buildings, whether religious or secular. [K.P.]

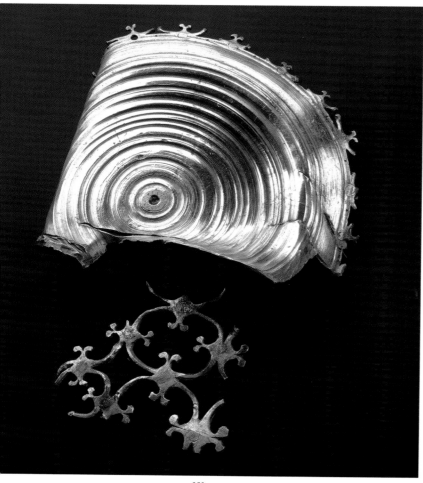

252

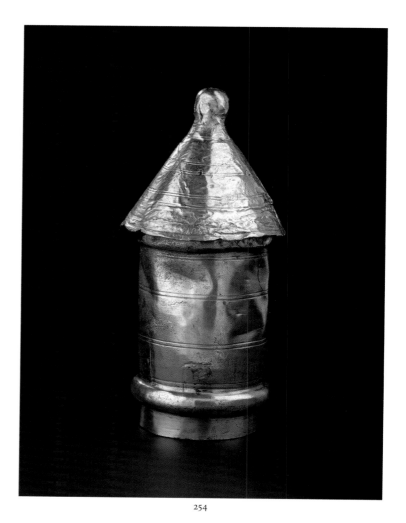

254

253 Silver strainer

Traprain Law
Silver; Dia. of bowl 51mm
Late 4th or early 5th century
National Museums of Scotland, Edinburgh,
GVA 111
Bibl. Curle 1923, 75–6, no.111, pl.xxviii, figs 59–60; Pirzio Biroli
Stefanelli 1965, 121; *RIB* **2.2**, 36, no.2421; Johns and Potter 1983,
53–5; Martin 1984, esp. 111–21.

Silver strainer, with circular bowl and portion of
handle and handle-support. Traces of gilding; a
miniature dolphin on either side of the handle.
In the bowl two perforated inscriptions, both
designed to be read from the outside: IESVS
CHRISTVS; XP (monogram Chi-Rho).

There is enough of the handle to show that it
was a rod, widened and strengthened next to the
bowl by a support in the form of two dolphins.
The closest parallel for this support is to be
found on a combined strainer and toothpick
from Kaiseraugst. Dolphins are also found as

handle-supports on a second example from
Kaiseraugst, on one of the two strainers in the
Thetford Treasure and on the Water Newton
strainer (which has its Chi-Rho at the end of the
handle). The Traprain Law strainer belongs, as
do a substantial number of such finds, to the
second half of the fourth century or the
beginning of the fifth.

Strainers of this sort are found regularly with
spoons and other table implements used
regularly in the course of dining. They were used
particularly for removing spices floating in the
wine. Since wine was also used in churches,
strainers of the same sort were needed there, and
we know from documentary evidence that they
were there from the fifth century onwards. It is
tempting, therefore, to suppose that a strainer
with Christian symbols might have been
reserved for this purpose. In fact, however, there
is no reason to suppose that Christian decoration
carries this implication, any more than that
pagan decoration or mottoes carries is similarly

significant. In practice, we can only surmise that
a strainer was used for religious purposes when
the whole context of a find suggests it, as, for
example, with the Christian finds from Water
Newton or the pagan finds from Thetford or the
Walbrook Mithraeum in London. The Traprain
Law strainer was most probably used as part of a
set of domestic silver. [K.P.]

254 Silver cylindrical box

Traprain Law
Silver; H. 97mm, Dia. 60mm
Late 4th or early 5th century
National Museums of Scotland, Edinburgh,
GVA 115
Bibl. Curle 1923, 77, no.115, pl.xxii.

Silver cylindrical box; encircled by moulding
just below the top and by a smaller moulding
just above the base; lid missing, base detached;
decorated with four pairs of parallel lines.

This object closely resembles four cylindrical

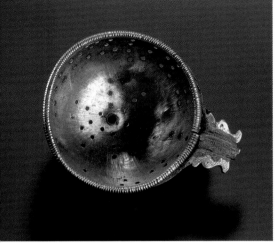

253

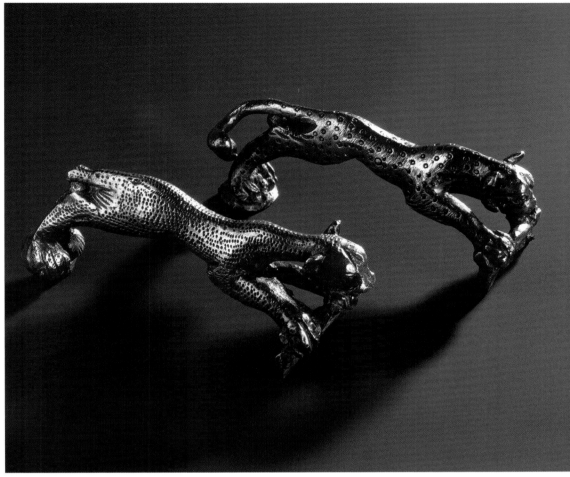

255

containers placed around a silver bottle in a pierced bronze disc within a circular lidded box in the Esquiline Treasure of the late fourth century. The four cylinders are identical and have tightly fitting lids. There are boxes similar to that in the Esquiline Treasure in the late fourth- or early fifth-century Seuso Treasure and there are fifth-century such boxes from Phrygia and Syria. The Traprain Law cylinder, designed for a similar box, is therefore of the late fourth or early fifth century.

Both the Esquiline box and the Seuso box are clearly toilet caskets and so their cylinders must have been used to contain ointment or other toilet preparations. It is unlikely, however, that the type was restricted to this purpose. The boxes are likely to have been used for anything for which they were convenient, in a variety of contexts, just like all small boxes, whatever their shape and design. In churches, for example, small boxes were used to hold bread, incense, precious offerings or relics. Secular uses for

small boxes will have been just as numerous. [K.P.]

255 Two silver handles in form of a leopard and a panther

Traprain Law
Silver; leopard, L. 73mm, panther, L. 83mm
Late 4th century
National Museums of Scotland, Edinburgh,
GVA 123
Bibl. Curle 1923, 79–80, no.123, pl.XXXI; Pirzio Biroli Stefanelli 1965, 121–2; Baratte *et al.* 2002, 68.

Silver handles modelled in the forms of an upright leopard and an upright panther.

Silversmiths of late antiquity had a taste for the use of animal forms for handles. Some of the spoons (for example cat.249) have swan's heads for handles, while the small strainer (cat.253) has a dolphin. The size and design of this leopard and panther are so close that there is little doubt that they were made as a pair. This, however,

does not resolve the question of whether they are from one vessel or two, for they could have been single handles on each of a pair of vessels.

There are examples of such handles in place on vessels: a pair of panthers on a big amphora in the Seuso Treasure; a greyhound on a fourth-century silver jug in the Louvre; leopards on the fourth- or fifth-century gold openwork cups in the treasure found at Petrossa, in Romania; and two centaurs as handles on the amphora of the late fourth century in the hoard found at Conceşti in Romania. Other examples of animal handles survive separated from their vessels: the single tigress in the Hoxne Treasure; two panthers in the lost fourth-century Trier Treasure. These examples in silver and gold suggest that the Traprain Law pair of animals come from a single amphora. Some Roman and Sassanian contemporary jugs in semi-precious stone, however, have animal-shaped handles. The lack of metal jugs with one animal handle may, therefore, be a matter of chance. [K.P.]

256 Silver brooch

Traprain Law
Silver; L. 48mm
Late 4th to first third of 5th century
National Museums of Scotland, Edinburgh,
GVA 145
Bibl. Curle 1923, 84–5, no.145, pls XXXII, XXXIII; Pirzio Biroli
Stefanelli 1965, 122; Böhme 1986, 488, fig.15, 2; 491; 563, Liste 1,
no.23.

This silver bow fibula is a well-known type of
east German women's jewellery. Examples are
known in the homeland of Dacia, but also in
Gaul and Spain. It represents the presence of a
woman Goth at Traprain Law. The grave of a
woman found at Windisch-Oberburg (Aargau,
Switzerland), included a two-buckle belt parallel
to cat.258, a belt buckle similar to cat.257 and a
silver brooch. The brooch was similarly of a type
found in eastern and central Europe. Both
women are to be regarded as the wives of their
Germanic soldier-husbands. [K.P.]

257 Silver buckle

Traprain Law
Silver; L. 48mm
Mid-5th century
National Museums of Scotland, Edinburgh,
GVA 146
Bibl. Curle 1923, 86, no.146, pls XXXII, XXXIII; Dohrn 1949,
68–9; Clarke 1979, 272; Böhme 1986, 497, fig.21, 2; 564, Liste 1,
no.1.

Silver buckle consisting of D-shaped loop;
tongue; rectangular plate.

There are two buckles and two strap-ends in
the hoard. They are probably from two late
Roman military belts. This buckle, from a
single-strap belt, is likely to date from the
middle of the fifth century and to have been
made in the area of the Danube for the Goth
who also owned the other buckle (cat.258) and
the chip-carved strap-end (cat.261), which are
from the same area. There is a close parallel in a
tomb of the fifth century, found at Vindonissa
(Windisch-Oberburg, Switzerland). A woman
was buried with a belt which had a buckle
similar to this, though the square plaque had
one rivet, not two, and also a two-buckle belt
which is a parallel for the Traprain Law buckle
cat.258. [K.P.]

258 Silver-gilt buckle

Traprain Law
Silver; L. 58mm, W. 32mm
Second third of 5th century
National Museums of Scotland, Edinburgh,
GVA 147
Bibl. Curle 1923, 86–7, no.147, pls XXXII, XXXIII; Böhme 1986,
497, fig.21, 1; 502–3; 564, Liste 2, no.1; Böhme 1987.

Silver buckle with square decorated loop; on
either side of the base of the tongue a dotted
Alpha and Omega; attached to lower part of
plate are three ridged bars, gilt and richly
ornamented, kept in position by three dome-
headed studs and holding the end of the strap,
part of which remains, within the plate.
Detached: a group of six similar bars, with studs
still fastened to a piece of leather, and another
single bar.

Almost identical rectangular buckles and
stiffening plates have been found at Lyon
(France), Windisch-Oberburg (Aargau,
Switzerland), Komitat Tolna and Dombóvár
(Hungary) and Kanatas and Kapulovka
(Kazakhstan). Closed grave-finds and stylistic
parallels date these buckles to the middle third
of the fifth century. The Alpha and Omega on
the Traprain Law brooch are paralleled by a Chi-
Rho on the Dombóvár brooch. The finds from
Lyon, Windisch-Oberburg and Komitat Tolna all
included pairs of buckles. The Traprain Law
buckle is therefore likely to have had a pair, and
so to have been part of a two-strap military belt.
It is worth noting that the Windisch-Oberburg
find, the grave of a woman, included a silver
buckle similar to the other Traprain Law buckle
(cat.257), while the two-buckle belt matching
this find (cat.258) was folded up on her chest.

Rectangular buckles are typical equipment
for troops in the Illyrian diocese. The
distribution of these finds shows that, besides
other barbarian mercenaries such as Huns,
eastern Germanic recruits and Goths served in
the Roman army on the Danube and in the
Balkans. The Traprain Law buckle therefore
suggests that the owner was from one of the
eastern Germanic tribes, recruited and armed in
the Danubian area. The Gothic brooch (cat.256)
suggests that the soldier too was a Goth. [K.P.]

259 Leather strap with gilded silver studs

Traprain Law
Leather and silver; W. of strap c.14mm, L. of
lozenge-shaped studs 19mm, Dia. of circular
studs 6mm
5th century
National Museums of Scotland, Edinburgh,
GVA 148
Bibl. Curle 1923, 88, no.148, pls XXXII, XXXIII, fig.68.

Leather strap, with seven lozenge-shaped studs
with bevelled sides and with 16 dome-shaped
studs.

The round-headed studs are of the same
character as those on the plates connected with
the large buckle (cat.258). They are smaller but
may nevertheless be connected with it. Similar
studs were found in position on a two-strap belt
found in grave 376 at Lankhills, Winchester
(Clarke 1979, 268–9). The Traprain Law studs
probably also lined one edge of a two-strap
military belt, on the side where the buckle was
mounted; the opposite side of the strap would
have been decorated with a matching set of
studs. [K.P.]

260 Silver strap terminal

Traprain Law
Silver; L. 54mm
Second third of 5th century
National Museums of Scotland, Edinburgh,
GVA 149
Bibl. Curle 1923, 88–9, no.149, pls XXXII, XXXIII; Clarke 1979,
283; Böhme 1986, 473; 475, Abb.5.9; 562, Liste 1, no.2.

Silver strap terminal, lancet-shaped, ending in a
circular disc. In the catch-plate at the head there
still remains a portion of the original leather
strap. Decorated: the upper surface gilt; on the
plate with two groups of small dotted markings;
around the tongue and the terminal disc with a
nielloed border, the surface within the border
with chip-carving.

This strap-end is part of a military belt.
There are parallels from Richborough, Ixworth,
Beadlam and Leicester. This type of strap-end
occurs frequently with chip-carved buckles, and
here it may be linked with the square-looped
buckle cat.257 as part of the military belt from
the Danubian area. [K.P.]

261 Silver strap-end

Traprain Law
Silver; L. 73mm
Second third of 5th century
National Museums of Scotland, Edinburgh,
GVA 150
Bibl. Curle 1923, 89–90, no.150, pls. XXXII, XXXIII; Böhme 1986, 497, Abb. 21, 6; 498–9; 564, Liste 2, no.1.

Silver strap-end: a circular disc with a short quadrangular plate projecting from it. Decorated on one side with chip-carving; opposite side polished and unornamented.

The only finds strictly comparable to this strap-end have been made in Germany, on a moor at Ejsbøl near Hadersleben and in an early Alamannic woman's grave at Kirchheim am Neckar. They are, however related to the luxury disc-shaped strap-ends with dotted decoration of the late fourth and early fifth century, found in the provinces of Germania I, Maxima Sequanorim and Raetia, but particularly in south-west Germany. Units in this area, wearing equipment decorated in this way, included east German mercenaries from across the frontier, particularly Goths. [K.P.]

262 Silver stud

Traprain Law
Silver; L. 19mm
5th century
National Museums of Scotland, Edinburgh,
GVA 151
Bibl. Curle 1923, 90–1, no.151, pls XXXII, XXXIII.

Silver stud with a globular head, flattened on opposite sides and with a small, bent, circular shaft (the point missing).

Curle suggested that this object might be an earring and quoted Frankish examples with spherical or cube-shaped heads. If he is right, then it may be a second piece of women's jewellery, to be connected with the brooch (cat.256), and a second piece of evidence for the presence of a Germanic woman, probably a Goth. [K.P.]

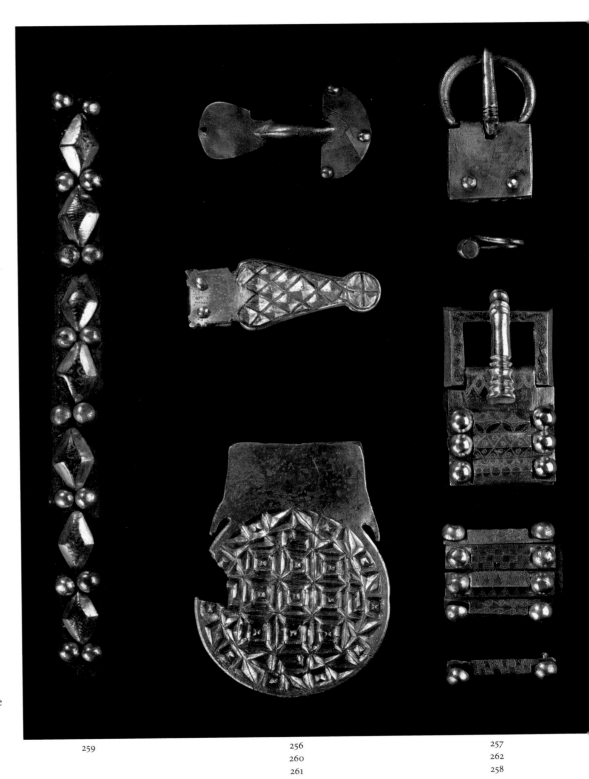

259

256
260
261

257
262
258

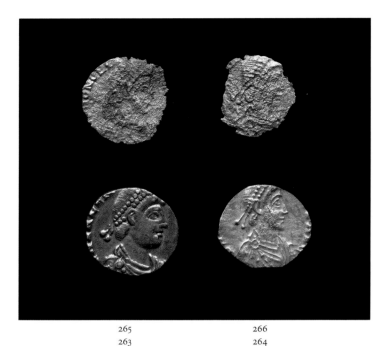

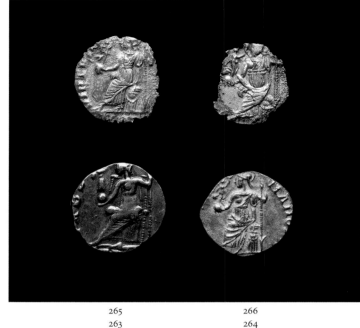

265 266 265 266
263 264 263 264

263–266: *Four silver coins*

263 *Siliqua* **of Valens**

Traprain Law
Silver; Dia. 12.8–13.2mm, Wt. 1.05g
364–78
National Museums of Scotland, Edinburgh,
GVA 152 A

Obverse: DNVALEN-(SPFAVG).
Reverse: VRBS-(ROMA).
Mint mark: TRPS (Trier).

This coin was worn and clipped.

264 *Siliqua* **of Arcadius**

Traprain Law
Silver; Dia. 12.0–13.1mm, Wt. 0.73g
388+
National Museums of Scotland, Edinburgh,
GVA 152 B

Obverse: DN(ARCADIVSP)FAVG.
Reverse: (VIRTVSRO)-MANORV(M). cf. *RIC* IX, Tr
106b.

This coin was slightly worn and clipped.

265 *Siliqua* **of Honorius**

Traprain Law
Silver; Dia. 11.9–12.8mm, Wt. 0.50g

393+
National Museums of Scotland, Edinburgh,
GVA 152 C

Obverse: DNHNORI-(VSPFAVG).
Reverse: VIRTVS(ROMANORVM].
Mint mark: MDPS (Milan).

Obverse corroded; reverse slightly worn.

266 *Siliqua* **of Honorius?**

Traprain Law
Silver; Dia. 10.2–11.8mm, Wt. 0.46g
393+
National Museums of Scotland, Edinburgh,
GVA 152 D

Bibl. Curle 1923, 2–5, 91, no.152; Dohrn 1949, 90; Robertson
1975, 419; Sekulla 1982, 289, 291; Robertson, Hobbs and Buttrey
2000, 402–3, no.1617.

These four coins have long been quoted as the
main evidence for dating the deposit of the
treasure. The nature of the hoard was deduced
from the supposed circumstances as being
plundered in the early fifth century. This has
been upset by two factors. First, study by Böhme
of the military metalwork (cats 257–62) has
shown that the treasure cannot have been
deposited before the middle third of the fifth
century. Second, the coins have been re-
examined.
 Curle described the discovery of the coins
(1923, 2–5):

When the treasure was unearthed, two coins were
found, and in the washing of the soil which came from
the pieces, when the rough dirt was removed from
them, two more were discovered. These were all of
silver – one each of Valens and Valentinian II, and two
of Honorius. The last-named were in good condition,
and it was, therefore, evident that the date of the
deposit lay in the reign of Honorius.

 Sekulla and Robertson have both identified
the 'coin of Valentinian II' as being of Arcadius.
Sekulla further identified the coins:
263 as Roman Imperial Coinage IX, Tr 27b/e;
264 as Roman Imperial Coinage IX, Tr 106b;
265 as Roman Imperial Coinage IX, Mil 32;
266 as Roman Imperial Coinage IX, Mil 32?.
Nick Holmes of the National Museums of
Scotland, however, has kindly noted that he
thinks that, while cats 263 and 265 are fourth-
century *siliquae*, they are not closely identifiable.
Sekulla commented that such coins may have
been in use in Roman Britain until about 425
but that this need not preclude a later date of
burial for the hoard.
 The coins thus do not date the deposit of the
hoard. Their small number, however, may be a
reflection of the scarcity of coin when the
Gothic soldier was being paid for his service in
the Roman army. [K.P.]

Legacy

267–72: Reculver Column, in six pieces

The six stones exhibited are part of a collection of eight fragments of Anglo-Saxon sculpture from Reculver, two of which (pieces of a cross-head and a circular drum) have been misplaced. All but one of the stones emerged from the church, but cat.267, found in Canterbury, was reputedly moved there when Reculver Church was demolished in the nineteenth century. Their dating has attracted some debate, but a number of factors together suggest a ninth-century date is most appropriate, namely the use of the distinctive monumental columnar form with the decoration arranged in horizontal registers, paralleled elsewhere in Anglo-Saxon England in the ninth century; the scheme of apostolic figures, a feature of early ninth-century Anglo-Saxon sculpture; and the manner in which a late antique figural type has been rendered, paralleled in ninth- and tenth-century Anglo-Saxon art.

It has been assumed that these stones represent the remains of a column seen at Reculver by John Leland, c.1540, but considerable doubt has been cast on this assumption. This is due to the lack of scenes mentioned by Leland, the different diameters of the stones and the varying styles of drapery. Nevertheless, although there are some variations in the details of the figural style, there are also many features linking them. Furthermore, differentiation of figural detail is a characteristic of late antique art, and the well-modelled nature of the faces and bodies, the way in which the bodies are clearly defined under the coherently rendered classical garments and the manner in which the poses of the figures have been naturalistically conveyed all indicate dependence on just such a prototype. Differences in the stones' diameters can be explained by tapering, a feature of other Anglo-Saxon columns, and by the fact that the guilloche under cat.267 indicates that at least one of the drums making up the column was intended to stand proud of its surface. The fragmentary nature of the stones also means that the lack of scenes mentioned by Leland is not entirely surprising. Equally, the presence of images not mentioned by Leland cannot be taken as evidence that these fragments represent some other column from Reculver. Knowledge of Anglo-Saxon sculpture was

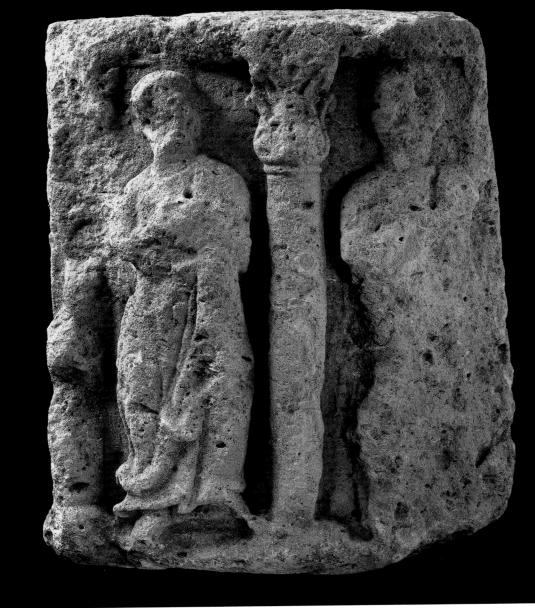

267

comparatively limited in the sixteenth century, while discussion of 'idolatrous' images was not characterised by great observational accuracy in the period following the Reformation in Britain.

What Leland does describe is 'a fayr columne' surmounted by a cross and 'curiously wrought and paynted' with figures and narrative images, something not inconsistent with the extant remains from Reculver. He further identified two registers of standing figures, one at the base of the column, the other at the top. Cat.272, which has the largest diameter and so was probably from the lower part of the column,

preserves the remains of four standing figures and would originally have held six. The shared setting of the standing figures in cats 267–8 and the guilloche underneath cat.267 suggest they were from the upper part of the column. Together this provides evidence for two registers of standing figures (some identifiable as the apostles), at the top and base of the column – a scheme popularly associated with Constantine in Christian art of the later eighth and ninth centuries – supporting the assumption that the fragments are indeed from the column seen by Leland and that this was of ninth-century date.

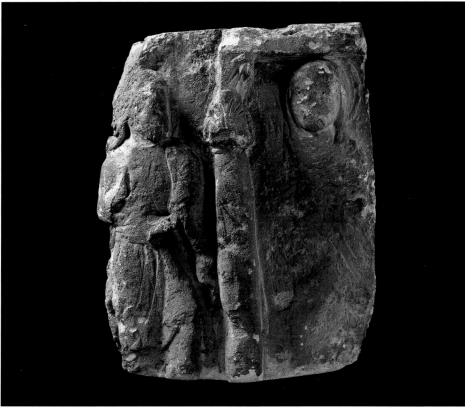

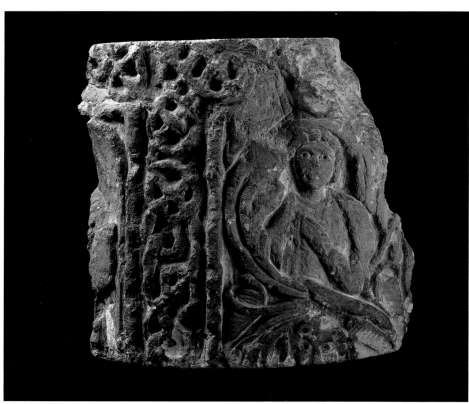

269

267 Column fragment

Old Dover Road, Canterbury
Limestone; H. 340mm, W. 240mm, D. 240mm,
Dia. *c*.460mm
9th century
Dean and Chapter of Canterbury and the
Parochial Church Council of Reculver, 1197

Bibl. Peers 1927, 250–6, fig.7, pls XLII–XLIV; Kozodoy 1976;
Backhouse, Turner and Webster 1984, 40–1, cat.22; Tweddle,
Biddle and Kjølbye-Biddle 1995, 46–61, 138, 151–61, ills 108–20.

The carving preserves two standing figures
separated by round columns with Corinthian-
style capitals supporting a square entablature.
Both figures half turn towards each other. That
on the left is clean-shaven with short hair, and
holds a book across his chest. He wears a full-
length robe that falls in fluttering folds
encircling the legs; a long over-garment is
gathered over the left arm. Underneath the
stone, around the edge, is a band of two-strand
twist, indicating it was designed to stand proud
of the column and be viewed from below. [J.H.]

268 Column fragment

Reculver Church
9th century
Limestone; H. 295mm, W. 200mm, D. 200m,
Dia. *c*.460mm
Dean and Chapter of Canterbury and the
Parochial Church Council of Reculver, 1197

The carving preserves two figures, half turned to
face each other and flanking a column, like those
of cat.267. The left-hand figure, bearded with
long hair, wears a long robe under a knee-length
tunic with a sash at the waist. Drapery falls from
his left shoulder in S-shaped folds. He raises one
hand over his chest. The second, veiled, figure is
haloed and has a well-modelled face with drilled
eyes that would have held paste glass. Red
pigment adheres to the background and the
halo. [J.H.]

269 Column fragment

Reculver Church
Limestone; H. 290mm, W. 270>220mm, D.
140mm, Dia. *c*.380mm
9th century
Dean and Chapter of Canterbury and the
Parochial Church Council of Reculver, 1197

The carving is framed across the top and bisected vertically by a band of interlace. Extensive traces of plaster survive with red pigment adhering. On the left are the remains of a winged figure with a rectangle protruding at chest height. This is best understood as an angel holding either a tablet that may have borne an inscription or a large open book which was held to one side. A plant scroll crosses the field on the right, the branches framing two figures set above and below the main stem. Both have short curled hair and well-modelled faces with deeply drilled eyes. The upper is clean-shaven and wears a plain garment with a cloak over his shoulders. The left arm emerges from the cloak with the hand held over the chest. Human figures entwined in a plant scroll are a rare, but not unknown, feature of Anglo-Saxon sculpture and can be understood (through the biblical text of John 15, 1–5) to refer to the Christian community sheltered within the Church and receiving spiritual sustenance from its teachings and sacraments. [J.H.]

270 Column fragment

Reculver Church
Limestone; H. 325mm, W. 240>170mm, D. 185mm, Dia. *c*.460mm
9th century
Dean and Chapter of Canterbury and the Parochial Church Council of Reculver, 1197

The carving consists of two profile figures separated by a curved moulding that traverses the stone and bifurcates near the top. The left-hand figure strides to the right, his bare feet placed naturalistically on the ground (represented by a series of rounded features on the lower edge). He wears a full-length robe that falls in fluttering folds encircling his calves under a knee-length tunic tied at the waist. A strip of drapery extends from his right hand, which is stretched out before him and drilled with a deep hole. To the right the second figure, wearing a full-length robe, reaches over towards him, the body passing behind the curved moulding. A drilled hole pierces the foot resting on the ground. These holes would have held metal attachments, possibly attributes held by the figures, and would have contributed to the bright polychrome effect of the monument. Further evidence of this can be seen in the traces

270

271

272

of blue pigment preserved in the drapery folds and the red pigment laid over plaster in the background. The figures themselves depict the Ascent of Christ, who strides towards heaven, reaching up to the Hand of God. In early Christian versions of this scene Christ is assisted in his ascent by an angel reaching over to support him on the right, as does the second figure on this stone. [J.H.]

271 Column fragment

Reculver Church
Limestone; H. 295mm, W. 220>205mm,
D. 165mm, Dia. *c*.460mm
9th century
Dean and Chapter of Canterbury and the
Parochial Church Council of Reculver, 1197

Red paint and plaster survive in the background and blue pigment is preserved in the drapery folds. The carving consists of the remains of two profile figures turned away from each other. That on the left is indicated only by the edge of a full-length robe that falls in windswept folds around the ankles. The other figure wears a similar robe under a long over-garment gathered across the body to the right; a narrow

fold of drapery hangs down his back. He leans over a block on which is set a curved feature, cupped by a hand on the right. Another hand, in very low relief, crosses the block horizontally. Between the two figures is a large circular boss with a pair of triangular features above. These have been interpreted as wings, identifying the figures as angels. However, it should be noted that they are distinctly less tapered than the wing featured on the figure on cat.269, and their identity thus remains uncertain. If the right-hand figure is not an angel, he can be identified as Abraham in the act of sacrificing Isaac, his hand pulling back the hair of his son on the block, which Isaac grasps with his outstretched hand. [J.H.]

272 Column fragment

Reculver Church
Limestone; H. 380mm, W. 430>360mm,
D. 160mm, Dia. *c*.530mm
9th century
Dean and Chapter of Canterbury and the
Parochial Church Council of Reculver, 1197

Coloured pigment is applied on a thin plaster ground: red in the background, red and blue in

the drapery folds. The carving preserves the remains of four figures separated by vertical mouldings drilled with pairs of holes and rebated for narrow metal fittings. All four figures stand with their legs naturalistically relaxed. They wear full-length robes that fall in pleated folds around the ankles under long garments, gathered up to one side to fall in S-shaped folds around the legs. The third figure from the left holds a half-opened scroll at an angle across the body. [J.H.]

273–5: Dewsbury Column, in three pieces

Three fragments form part of the same monumental column carved in high relief with registers of figural decoration. The dimensions of the figures, the size of the heads and feet, the depth of the relief and the rendering of the garments are features shared by these stones, but not by other Anglo-Saxon carvings from Dewsbury. It seems that the stones formed part of the upper register of the column, bounded by a horizontal moulding with rope-moulding above, marking a transition between the round column and a terminal, square in section (possibly a cross-head). Set within this register were the figures of Christ enthroned and flanked by his apostles, a scheme popularly associated with Constantine in Christian art of the later eighth and ninth centuries. The influence of a late antique model is indicated by the manner in which the varied turning poses of the figures have been naturalistically rendered, by the well-modelled nature of their faces and bodies, and the way the bodies are defined under the coherently rendered classical garments.

273 Column fragment

Dewsbury, Yorkshire
Sandstone; H. 600mm, W. 260mm, D. 200mm
Early 9th century
The Minster Church of All Saints, Dewsbury
Bibl. Collingwood 1915, 162–71; Collingwood 1927, 6–8, 73–4.

The carving preserves two figures, turned slightly to the left, standing under a plain moulding. Above, the remnants of two strands of rope moulding sweep up to the left, forming a triangle containing the remains of a leaf. The figure on the left is badly damaged, but the outline of the head and shoulders suggest he was

bearded. His eyes are deeply drilled, as are those of the figure on the right, whose well-modelled head is clean-shaven with short hair. He wears a full-length, long-sleeved robe under a long over-garment, with a high collar round his neck that extends in bands down the front. This suggests liturgical garb, but there is no sign that the figure was tonsured. He holds a scroll over his chest in his left hand. [J.H.]

274 Column fragment

Dewsbury, Yorkshire
Sandstone; H. 0.57m, W. 390mm, D. 220mm
Early 9th century
The Minster Church of All Saints, Dewsbury

The carving preserves the remains of three figures standing over an arcade containing pairs of figures, the heads and shoulders of which survive. At least one of these had a well-modelled face with deeply drilled eyes. Although damaged, the figures standing above the arcade wear long garments over full-length robes whose hems are slightly upswept between the legs, emphasising the limbs underneath. All three are coherently positioned on the arcading, those on the left and right facing forwards and the one in the centre being three-quarter turned left. The figures set within the panels below possibly depicted narrative events, as occurs on the early ninth-century column at Masham, Yorkshire (fig.46). [J.H.]

275 Column fragment

Dewsbury, Yorkshire
Sandstone; H. 600mm, W. 230mm, D. 160mm
Early 9th century
The Minster Church of All Saints, Dewsbury

Illustrated on p.113
This stone preserves the figure of Christ Enthroned in Majesty. An incomplete inscription in the moulding above reads I IHS XLVS, incorporating an apparently incorrect rendering of the abbreviation for *Iesus Christus*. The halo is undecorated except for a narrow moulding round the rim, but the drilled eyes set in the well-modelled face would have contained paste glass and point to the originally polychrome nature of the sculpture, indicating the halo could once have displayed a cross. Like many Anglo-Saxon images of Christ, he is clean-

273

274

shaven with long hair knotted by the ears. The folds of his robe are stylised but coherently rendered with his left hand, holding a scroll, emerging from the over-garment draped across his arm. The right hand, held palm outwards, is disproportionately large, a characteristic of other carved images of Christ from Dewsbury that suggests the designers wished to emphasise Christ blessing. The moulding to the right of Christ suggests he was framed and so separated from the flanking apostles. [J.H.]

276 Constantine and the Cross

Manuel Malaxos, *Synopsis Historiarum Constantinopoleos*
Greek; paper, ff. 498; 214 × 155mm (135 × 75mm)
1574
British Library, London, Harley 5632 f.3

Bibl. *Harley Catalogue*, III, 283; Istrin 1897, 135–9; Evans and Wixon 1997, 366–7; Pattie and McKendrick 1999, 142–3.

This image of Constantine the Great holding the Cross introduces an autograph copy of an abbreviated history of Constantinople by the scribe Manuel Malaxos (fols 3–492, dated April 1574, with the *Last Vision of Daniel* added on the remaining folios). It contains one other image of the stars assuming the form of the cross (fo.6) – the vision that convinced Constantine to fight the Battle of the Milvian Bridge in its name. The ensuing victory was a stimulus to his conversion to Christianity. He is depicted wearing the garb of a medieval Byzantine emperor, in eastern fashion, recalling images of Constantine and Helena with the Cross found in Syrian lectionaries of the first half of the thirteenth century (such as that made in 1226 and owned by the Orthodox Bishopric of Midyat, fol.302; see Evans and Wixon 1997, 366–7). It was rare for secular texts to be illuminated in Byzantium, which may explain why this ruler image was probably based upon one found in liturgical lectionaries illustrating the feast of the Invention of the Cross.

Purchased by Demetrios Pekiolos (?) from his brother-in-law, Manolis, 1651; owned by John Covel DD (his Greek MS xxix) and purchased from him for the Harleian Library, 27 February 1715/16, according to the diary of the Duke of Oxford's librarian, Humphrey Wanley. [M.B.]

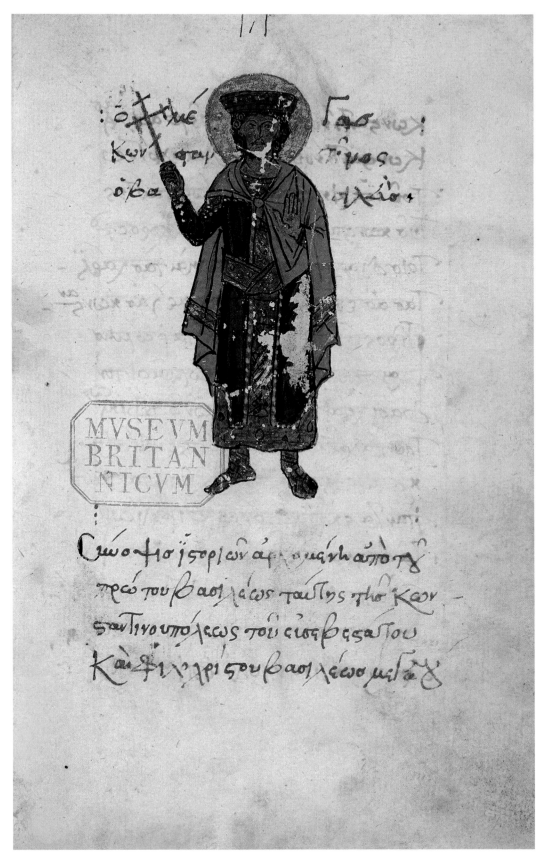

276

GLOSSARY

aedicule: 'little building', pedimented niche esp. for an image

Alpha and **Omega:** first and last letters of the Greek alphabet, hence the Beginning and End: 'I am the Alpha and the Omega', says the Lord God, who is and who was and who is to come (Revelation 1.8)

ankh: Egyptian life-symbol resembling the Cross, but with a loop in place of the upper arm

ansate: 'having handles', esp. of an inscribed plaque with wedge-shaped mounts

astragalus: 'knuckle', architectural moulding of semicircular section, often decorated with a bead-and-reel motif

Augustus: 'august', imperial title used by Diocletian and Constantine to mark a senior emperor

bow-ard: plough, not having a mould-board

Caesar: imperial title used by Diocletian and Constantine to mark a junior emperor

calathus: tall basket, or beaker of basket-like shape

cameo: gem cut in relief, often having two or more layers of contrasting colour, designed to display an image in relief on a ground of the other

Chi-Rho: first two (Greek) letters of the name 'Christ', used as a sacred monogram

clarissimate: 'most distinguished', used of senatorial rank

collegium: 'college', association esp. of craftsmen or priests

colonia: chartered settlement of Roman citizens esp. veterans, but later a title awarded to important cities like York

comes domesticorum: 'Count of the Domestics', imperial court general ranking after the commanders-in-chief

comes rei militaris: 'military Count', general commanding a mobile army

comitatus: 'entourage' of the emperor, the imperial court

congiarium: cash largesse distributed to civilians by the Emperor

consecratio: 'making sacred', esp. the deification of a deceased emperor

consularis: 'consular', ranking with ex-consuls; the title of some provincial governors

contorniate: 'grooved' medallion, usually of brass or bronze, probably distributed at circus games

cornelian: red translucent stone, named from the fruit of the cornel tree

coulter: iron blade fixed in front of a plough-share for cutting vertically into the soil

criobolium: 'ram-sacrifice' in the cult of Cybele, in which the votary was drenched in the animal's blood

cuirass: (armour) breast-plate

cyma: architectural moulding with S-like profile

dadophori: 'torch-bearers', the two companions of Mithras: Cautes with raised torch representing day; Cautopates with lowered torch representing night

decurion: member of a town council

decennalia: celebrations of an emperor's tenth year of rule

diaconia: Christian centre run by deacons of the Church

diaspora: 'dispersion' of a whole people, esp. the Jews

diatretarius: filigree worker, esp. a maker of 'cage-cups' (*diatreta*) in glass or sometimes crystal / hardstone, where the surface is under-cut to enclose the core vessel in a 'cage'

dominus, domina: 'lord' and 'lady', esp. the owner of a landed estate and his wife

dowel hole: hole in a block of wood or stone for the pin which attaches it to another

ducenarius: 'two-hundred (thousand) man', a senior non-commissioned officer, but originally the pay-grade of certain major officials

dux: general commanding a frontier army

Eboracum: Roman York

fastigium: 'gable', hence pedimented structure in a church, denoting honour for the person, image or object below it

foederati: barbarians in treaty-relationship with the empire, esp. if settled on imperial territory in return for providing military service

grammaticus: 'grammarian', a professional teacher of language and literature

guilloche: running ornament of two or more bands plaited together to form a border, esp. in mosaic

heddle: the cords in a loom which separate the warp-threads, so that the shuttle bearing the weft can pass between them

hippodrome: race-track for horses and chariots, a 'circus'

iconoclasm: deliberate destruction of statuary, for religious or political motives

imago clipeata: image (usually portrait) within an oval- or round-shaped frame

intaglio: figure incised in a gem or metal die, usually in reverse so that the impression will be positive; hence seals are often called intaglios.

interpretatio Romana: 'identification' of a non-Roman deity with a Roman one. The term is employed by Tacitus in *Germania* 43

invictus: 'unconquered', an epithet of deities (e.g. Sol, Hercules, Mithras) and emperors

jacinth: reddish-orange gemstone, a variety of zircon, different from ancient 'hyacinth', which was blue

laeti: barbarians settled on imperial territory under Roman supervision, used as a source of recruits

lamella: thin metal sheet, esp. inscribed tablet addressed to a deity

lanciarius: 'lancer', infantryman armed with a lance

Lewis hole: wedge-shaped incision in a block of stone, for insertion of lifting-prongs

limes: 'boundary', hence the Roman frontier

lorus: scarf-like vestment derived from the embroidered edge of a consul's robe, worn by the Emperor as a symbol of religious authority

magister equitum: 'Master of the Cavalry', either commander-in-chief of cavalry at the imperial court, or commander-in-chief of a major regional army (including infantry)

magister militum: 'Master of the Soldiers', general term for a commander-in-chief

maver: to roll glass in order to have decoration embedded in the surface of the glass

niello: black silver-sulphide, used as a decorative inlay on silverware

nimbus: bright disk surrounding the head, a halo

numen (plural **numina**): divine spirit(s) of a place or person, esp. the emperor

opus sectile: 'cut-work', patchwork of stone or marble veneer decorating a wall or floor

opus signinum: concrete made of mortar and crushed tile, used for flooring

orans (plural **orantes**): human figure(s) shown in the attitude of prayer with hands raised and palms outwards

orbiculi: 'small discs' of decorated material sewn onto clothing

pagarch: administrator of a *pagus* ('village')

paideia: 'culture', esp. literary

palatium: 'palace', the seat of the emperor and the central administration; from the Palatine hill in Rome, site of the first imperial residence

paludamentum: military cloak, esp. of generals and the emperor

panegyric: speech of praise, esp. of the emperor

pelta: crescent-shaped shield used as a decorative element, esp. to flank an inscribed panel

phalera: decorative metal disc worn by horses and soldiers, esp. a military decoration

porphyry: 'purple', a hardstone quarried in the Egyptian Eastern Desert, used in veneers and sculpture, esp. of emperors

praefectus alae: officer commanding a cavalry regiment

praepositus (plural **praepositi**): officer commanding a military detachment

protector domesticus: senior non-commissioned officer seconded for service at the imperial court with the prospect of a commission

prisca religio: 'the old religion', pre-Christian cult

quinquennalia: celebrations for an emperor's fifth year of rule

rescript: 'reply', written by the emperor to an inquiry or petition

scrinium (plural **scrinia**): container(s) for documents, hence the imperial secretariat

spolia: 'spoils', material salvaged from earlier buildings and re-used

strategus: in Egypt, the deputy-governor of a 'district' (*nome*)

taurobolium: 'bull-sacrifice' in the cult of Cybele, in which the votary was drenched in the animal's blood

tetrarchy: 'rule of four', modern term for Diocletian's division of imperial power between two *Augusti* and two *Caesares*

titulus: house of the Church in Rome (pre- and post-Constantine)

tribunus scholae: officer commanding a regiment of mounted guards (*schola*)

tribunus scutariorum: officer commanding a regiment of mounted guard esp. equipped with shields (*scutarii*)

tricennalia: celebrations for an emperor's thirtieth year of rule

triclinium: room with 'three couches', esp. a dining-room

tri-conch: building-end formed of three apses

triglyph: stylised beam-end in an architectural frieze

vicennalia: celebrations for an emperor's twentieth year of rule

ANCIENT AUTHORS AND WORKS

Abbreviations used below:

ACW Ancient Christian Writers
CCSL Corpus Christianorum Series Latina
CSEL Corpus Scriptorum Ecclesiasticorum Latinorum
ECF The Early Church Fathers
GCS Die griechischen christlichen Schriftsteller der ersten
 Jahrhunderte
MGH Monumenta Germaniae Historica (AA: Auctores Antiquissimi;
 SRM: Scriptores Rerum Merovingicarum)
NPNF Nicene and Post-Nicene Fathers. On-line at:
 http://www.ccel.org/fathers2/
OCT Oxford Classical Texts
OWC Oxford World's Classics
PC Penguin Classics
TTH Translated Texts for Historians

AUTHORS, WORKS

Acta Sanctorum
> Collection of acts of saints and martyrs made by the Bollandists, ordered by feast-day starting in January (December is not complete). Publication started Antwerp, 1643. Modern reprint, 67 vols., Brussels, 1902–1970

Adomnán (or **Adamnán**), **Abbot of Iona** (*c.*625–704)
DLS *De Locis Sanctis* (*On the Holy Places*)
> Text and translation: D. Meehan, *Adamnan's De Locis Sanctis* (Scriptores Latini Hiberniae 3), Dublin, 1958, repr. 1983. Text only in J. Fraipont, *Itineraria et Alia Geographica* vol. 1 (CCSL 175), Turnhout, 1965, 175–234

AE *L'Année épigraphique*, Paris, 1888 onwards

Agathias, historian and poet (*c.*532–*c.*580)
Historiae
> Text: R. Keydell, *Agathiae Myrinaei Historiarum libri quinque* (Corpus fontium historiae Byzantinae, Series Berolinensis 2), Berlin 1967. English translation : J.D. Frendo, *Agathias: The Histories* (Corpus fontium historiae Byzantinae, Series Berolinensis 2A), Berlin 1975

Ambrose, Bishop of Milan (*c.*338–397)
De Obitu Theodosii (*On the Death of Theodosius*)
> Text: O. Faller, *Sancti Ambrosii Opera VII* (CSEL 73), Vienna, 1955, 371–401. English translation: J.H.W.G. Liebeschuetz, *Ambrose of Milan: Political Letters and Speeches* (TTH 43), Liverpool, 2005
De sacramentis and *De mysteriis*
> Text of both in O. Faller, *Sancti Ambrosii Opera VII* (CSEL 73), Vienna, 1955, 15–85 and 89–116. English translation: R.J. Deferrari, *Saint Ambrose: Theological and Dogmatic Works* (The Fathers of the Church, Patristic Series 44), Washington DC, 1963; *De*

mysteriis only in B. Ramsey, *Ambrose* (ECF), London/New York, 1997, 145–60

Ammianus Marcellinus, historian (died after 391)
Res Gestae
> Text and translation: J.C. Rolfe, *Ammianus Marcellinus* (Loeb), 3 vols., Cambridge MA and London, 1935–1940. Translation (abridged): W. Hamilton, *Ammianus Marcellinus: The Later Roman Empire (A.D. 354-378)* (PC), Harmondsworth, 1986

Anonymus Valesianus
> See *Origo Constantini*

Athanasius, Bishop of Alexandria (*c.*299–373)
De Decretis Nicaenae Synodi
> (Letter on the Decisions of the Council of Nicaea), includes copies of Constantine's letters.
> Text: H.-G. Opitz, *Athanasius Werke* vol. 2, Leipzig, 1934–1941; Constantine's letters also appear in vol. 3/1, Leipzig, 1934–5. English translations (lacking the letters) in NPNF ser. 2 vol. 4 or K. Anatolios, *Athanasius* (ECF), London/New York, 2004, 176–211. Translations of Constantine's letters on Christian matters can be found in P.R. Coleman-Norton, *Roman State and Christian Church*, London, 1966, vol. 1

Augustine, Bishop of Hippo (354–430)
Enarrationes in Psalmos
> Text: E. Dekkers and J. Fraipont, *Sancti Aurelii Augustini: Enarrationes in Psalmos I–L* (CCSL 38), Turnhout, 1956 or C. Weideman, *Sancti Augustini Opera: Enarrationes in Psalmos 1–32* (CSEL 93/1A), Vienna, 2003 . English translations: S. Hebgin and F. Corrigan, *St. Augustine on the Psalms vol. 1* (ACW 29), New York, 1960, or J.E. Rotelle, *Saint Augustine: Expositions of the Psalms vol. I* (The Works of Saint Augustine, a Translation for the 21st Century III/15), New York, 2000; also NPNF ser. 1 vol. 8

Augustus, emperor (63BC–AD14)
Res Gestae (AD14)
> Text: J. Gagé, *Res Gestae Divi Augusti* (Budé), rev. ed., Paris, 1977. English Translation: P.A. Brunt and J.M. Moore, *Res Gestae Divi Augusti : The Achievements of the Divine Augustus*, rev. ed., Oxford, 1986

Aurelius Victor
> See under Victor

Bede, church historian and biblical scholar (672/3–735)
DLS (*De Locis Sanctis*)
> Text in J. Fraipont, *Itineraria et Alia Geographica* vol. 1 (CCSL 175), Turnhout, 1965, 249–80. English translation by W.T. Foley in *Bede: A Biblical Miscellany* (TTH 28), Liverpool, 1999, 5–25

Bede

HA (*Historia Abbatum*)

Text in J. Plummer, *Venerabilis Baedae Opera Historica vol. I,* Oxford, 1896, 364–87. English translation by D.H. Farmer as 'Lives of the abbots of Wearmouth and Jarrow' in *The Age of Bede* (PC), rev. ed., Harmondsworth, 1998, 187–210

HE (*Historia Ecclesiastica*)

Text and translation: R. Mynors and B. Colgrave, *Bede's Ecclesiastical History of the English People* (Oxford Mediaeval Texts), Oxford, 1969; Colgrave's translation only in OWC, rev. ed., 1999

Cassiodorus, office-holder then monk (*c.*487–*c.*580)

Expositio Psalmorum

Text: M. Adriaen, *Magni Aurelii Cassiodori Expositio Psalmorum* (CCSL 97–8), 2 vols., Turnhout, 1958. English translation: P.G. Walsh, *Cassiodorus: Explanation of the Psalms* (ACW 51–53), 3 vols. New York, 1990–1991

Chronica Minora I

Text: Th. Mommsen, *Chronica Minora I* (MGH AA 9), Berlin, 1892

CIL *Corpus Inscriptionum Latinarum*, Berlin

CJ (*Codex Iustinianus/Justinian Code*)

Authoritative compilation of edited excerpts from imperial legislation between Hadrian and Justinian; second edition promulgated by Justinian in 534.
Text: P. Krüger, *Codex Iustinianus* (*editio maior*), Berlin, 1877 (repr. Goldbach, 1998); also *editio minor* (= *Corpus Iuris Civilis* vol. 2), Berlin, 1877

Councils of the Church

Cited from the edition of G.D. Mansi, *Sacrorum conciliorum nova et amplissima collectio* Florence/Venice, 1759–1798, repr. Paris 1901–1927 and Graz, 1960–1962. English translation: NPNF ser. 2 vol. 14

CTh (*Codex Theodosianus/*Theodosian Code): authoritative compilation of edited excerpts from imperial legislation between Constantine and Theodosius II; promulgated by Theodosius II in 437–8.
Text: Th. Mommsen and P. Meyer, *Codex Theodosianus*, 2 vols, Berlin, 1905. English translation, C. Pharr, *The Theodosian Code,* Princeton, 1952

Cynewulf, poet (*c.*750/850)

Elene

Text: G.P. Krapp, *The Vercelli Book* (The Anglo-Saxon Poetic Records 2), New York, 1932, 66–102 or P.O. Gradon, *Cynewulf's Elene* (Exeter Medieval English Texts and Studies), 3rd ed., Exeter, 1996

Digest Authoritative compilation of edited excerpts from the Roman jurists between Augustus and Diocletian; promulgated by Justinian in 533.
Text: Th. Mommsen, *Digesta Iustiniani, editio maior,* 2 vols., Berlin, 1868 (*editio minor* in *Corpus Iuris Civilis* vol. 1, Berlin, 1872). English translation, A. Watson (ed.), *The Digest of Justinian,* 4 vols., Philadelphia, 1985; rev. ed. in 2 vols. 1998

Dio Cassius, historian (died after 229)

Text: U.P. Boissevain, *Cassii Dionis Cocceiani historiararum romanarum quae supersunt,* 5 vols, Paris, 1895–1931. Text and English translation: E. Cary, *Dio's Roman History* (Loeb), 9 vols., Cambridge MA and London, 1914–1927

Diocletian's Prices Edict

Edict setting maximum prices for goods and services, known principally from inscriptions, promulgated by Diocletian in 301.
Text: M. Giacchero, *Edictum De Pretiis Rerum Venalium Diocletiani et Collegarum,* 2 vols, Genoa, 1974. English translation (based on a less complete older edition) by E. Graser in T. Frank, *An Economic Survey of Ancient Rome V,* Baltimore, 1940, 310–421. Note that a new definitive numeration of the sections will be used by M.H. Crawford in his as yet unpublished edition of the Prices Edict text from Aphrodisias, to be accompanied by a TTH translation by S. Corcoran

Eddius Stephanus, monk at Ripon (*c.*710/720)

Vita Wilfridi

Text and translation: B. Colgrave, *Eddius Stephanus: The Life of Bishop Wilfrid,* rev. ed., Cambridge, 1927, repr.1985. Translation only by J.F. Webb in *The Age of Bede* (PC), rev. ed., Harmondsworth, 1998, 107–84

Elene See Cynewulf

Epiphanius, Bishop of Constantia (Salamis in Cyprus) (*c.*315–403)

Epistula ad Ioannem Hierosolymitanum

(Letter to John, Bishop of Jerusalem) = Jerome, Letter 51. For text and translation, see under Jerome

Panarion Haireseon

Text: K. Holl (rev. J. Dummer), *Epiphanius, Panarion Haeresium* (GCS), 2nd ed., 4 vols, Berlin, 1980–2005. English translation: F. Williams, *The Panarion of Epiphanius of Salamis* (Nag Hammadi Studies 34–5), 2 vols, Leiden, 1987–1994

Epitome de Caesaribus (late 390s)

Anonymous summary account of emperors from Augustus to Theodosius I, based on Aurelius Victor.
Text in F. Pichlmayr (ed.), *Sexti Aurelii Victoris Liber De Caesaribus* (Teubner), rev. ed., Leipzig, 1970, 131–76. French translation and commentary: M. Festy, *Pseudo-Aurélius Victor: Abrégé des Césars* (Budé), Paris, 1999, repr. 2002

Eunapius of Sardis, rhetor and historian (*c.*345/6–*c.*414)
Vitae Sophistarum
> Text and translation: W.C. Wright, *Philostratus and Eunapius, Lives of the Sophists* (Loeb), Cambridge MA and London, 1922

Eusebius, Bishop of Caesarea (in Palestine) (*c.*260–339)
HE (*Historia Ecclesiastica*)
> Text, E. Schwartz, Th. Mommsen and F. Winkelmann (eds.), *Eusebius Werke II: Die Kirchengeschichte* (GCS new series 6), 2nd ed., Berlin, 1999. English translation, H. J. Lawlor and J. E. L. Oulton (eds), *Eusebius, Ecclesiastical History and Martyrs of Palestine*, 2 vols. London, 1927–1928, or G. Williamson, *Eusebius, The History of the Church* (PC), rev. ed., Harmondsworth, 1989
De Laudibus Constantini
> Two part work containing the Tricennial Oration and the Oration on the Holy Sepulchre.
> Text: I.A. Heikel, *Eusebius Werke I* (GCS), Leipzig, 1902, 195–259. English translation: H.A. Drake, *In Praise of Constantine: A Historical Study and New Translation of Eusebius' Tricennial Orations*, Berkeley, 1976
VC (*De Vita Constantini*)
> Text: F. Winkelmann, *Eusebius Werke I.1: Über das Leben des Kaisers Konstantin* (GCS), 2nd ed., Berlin, 1975. English translation: Averil Cameron and S.G. Hall, *Eusebius: Life of Constantine* (Clarendon Ancient History Series), Oxford, 1999

Eutropius, historian (died after 390)
Breviarium
> (History of Rome to 364)
> Text: C. Santini, *Eutropii Breviarium Ab Urbe Condita* (Teubner), Leipzig, 1979; also H. Droysen, MGH AA 2, Berlin, 1879, repr. 2000. English translation: H.W. Bird, *Eutropius, Breviarium* (TTH 14), Liverpool, 1993

Finding of the True Cross
> ('In Inventione Sanctae Crucis') (11th C.)
> Text and translation: M.-C. Bodden, *The Old English Finding of the True Cross*, Cambridge, 1987; also R. Morris, *Legends of the Holy Rood* (Early English Text Society 46), London, 1871, 2–17

Fragmenta Vaticana
> (Juristic work *c.*324, revised 370s)
> Text (ed. Th. Mommsen) in P. Krüger, Th. Mommsen and W. Studemund, *Collectio Librorum Iuris Anteiustiniani* vol. 3, Berlin, 1890, 1–106, repr. Hildesheim, 2001

'Fredegar', chronicler, true name unknown (*c.* 660)
Chronica
> Text: B. Krusch, *Fredegarii et aliorum Chronica. Vitae Sanctorum* (MGH SRM 2), Hannover, 1888, repr. 1984, 18–168. Selections in English: A.C. Murray, *From Roman to Merovingian Gaul: A Reader* (Readings in Medieval Civilizations and Cultures 5), Peterborough, Ontario, 2000, 448–90 and 591–621

Gildas, monk (6th C.)
De Excidio Britanniae
> Text and translation: M. Winterbottom, *Gildas: The Ruin of Britain and Other Works* (Arthurian Period Sources 7), London and Chichester, 1978

The Gospel of Nicodemus
> (*Evangelium Nicodemi*; also called *The Acts of Pilate*) (versions from 6th C. onwards)
> Latin text (10th C.): H.C. Kim, *The Gospel of Nicodemus: Gesta Salvatoris* (Toronto Medieval Latin texts 2), Toronto, 1973. English translations of various versions: M.R. James, *The Apocryphal New Testament*, Oxford, 1924, 94–146 or J.K. Elliott, *The Apocryphal New Testament*, Oxford, 1993, 164–225

Gregory the Great (Pope 590–605)
Homiliae in Evangelia
> Text: R. Etaix, *Gregorius Magnus: Homiliae in Evangelia* (CCSL 141), Turnhout, 1999. English translation: D. Hirst, *Gregory the Great: Forty Gospel Homilies* (Cistercian Studies 123), Kalamazoo, 1990

Gregory, Bishop of Tours (*c.*539–594)
Historiae (*Historia Francorum*)
> Text: B. Krusch and W. Levison, *Gregorii Turonensis Opera I: Libri Historiarum X* (MGH SRM 1.1), Hannover, 1937–1951. English translation: L. Thorpe, *Gregory of Tours: The History of the Franks* (PC), Harmondsworth, 1974
Liber in Gloria Confessorum
> Text: Book 8 of B. Krusch. *Georgii Florentii Gregorii episcopi Turonensis libri octo miraculorum* (MGH SRM 1.2), Hannover, 1885, repr. 1988 . English translation: R. van Dam, *Gregory of Tours: Glory of the Confessors* (TTH 5 = Latin Series 4), Liverpool, 1988

IGLS *Inscriptiones grecques et latines de la Syrie*, Beirut/Paris, 1929 onwards

ILS H. Dessau, *Inscriptiones Latinae Selectae*, 3 vols. Berlin, 1892–1916

Inschriften von Arykanda
> See S. Şahin 1994

Inschriften von Ephesos
> See Engelmann, Knibbe, and Merkelbach 1980

Inscriptiones Creticae
> See Guarducci 1935

Inscriptions of Stratonicea
> See M.Ç. Şahin 1981

Jerome (Hieronymus), biblical scholar (*c.*347–420)
Epistulae (Letters)
> Text: I. Hilberg, *Hieronymi Epistulae* (CSEL 54–6), rev. ed., 3 vols., Vienna, 1996. English translation: NPNF ser. 2 vol. 6; also F.A. Wright, *Select Letters of St. Jerome* (Loeb), Cambridge MA and London, 1933

Josephus, historian and Jewish apologist (37–*c.*100)
De Bello Iudaico (The Jewish War)
> Text and translation: H. St.-J., Thackeray, *Josephus: The Jewish War* (Loeb), 2 vols, Cambridge MA and London, 1927–1928, repr. 3 vols, 1997. Translation only: G. Williamson, *Josephus: The Jewish War* (PC), rev. ed., Harmondsworth, 1981

Justinian Code
> See *CJ/Codex Iustinianus*

Lactantius, rhetor and Christian apologist (*c.*260–*c.*330)
DMP (*De Mortibus Persecutorum*: On the Deaths of the Persecutors)
> Text and translation: J.L. Creed (ed.), *Lactantius, De Mortibus Persecutorum* (Oxford Early Christian Texts), Oxford, 1984

Laus Pisonis (In Praise of Piso; before 65)
> Text and translation in J.W. and A.M. Duff, *Minor Latin Poets* (Loeb), Cambridge MA and London, 1935, 287–315

LP (*Liber Pontificalis*)
> Text: L. Duchesne, *Le Liber Pontificalis*, 2 vols, Paris, 1886–1892, repr. 1957. English translation: R. Davis, *The Book of Pontiffs: the ancient biographies of the first ninety Roman bishops to AD 715* (TTH 6), rev. ed., Liverpool, 2000

Macrobius, grammarian and philosopher (*c.*430)
Saturnalia
> Text: J. Willis, *Ambrosii Theodosii Macrobii Saturnalia* (Teubner), rev. ed., Leipzig, 1970. English translation: P.V. Davies, *Macrobius: The Saturnalia*, New York, 1969

John Malalas, chronicler (*c.*490–*c.*570)
Chronographia
> Text: J. Thurn (ed.), *Ioannis Malalae Chronographia* (Corpus fontium historiae Byzantinae, series Berolinensis 35), Berlin/New York, 2000. English translation: E. and M. Jeffreys and R. Scott, *The Chronicle of John Malalas* (Byzantina Australiensia 4), Melbourne, 1986, repr. 2004

MAMA Monumenta Asiae Minoris Antiqua
> (see Buckler, Calder and Guthrie 1933, and Calder 1956)

Mansi See Councils of the Church

Minucius Felix, Christian apologist (early 3rd C.)
Octavius
> Text and translation by G.H. Rendall in T.R. Glover and G.H. Rendall, *Tertullian and Minucius Felix* (Loeb), Cambridge MA and London, 1931

Notitia Dignitatum (late 4th/early 5th C.)
> Gazetteer of the military and civil administration of the empire. Text: O. Seeck, *Notitia Dignitatum*, Berlin, 1876. English translation by P. Brennan forthcoming in the TTH series, Liverpool

Optatus, Bishop of Milevis (d. after 384)
> Text: K. Ziwsa (ed.), *S. Optati Milevitani Libri VII* (CSEL 26), Vienna, 1893. English translation, M. Edwards, *Optatus: Against the Donatists* (TTH 27), Liverpool, 1997

Oratio (*Oratio ad Sanctos: Oration to the Saints*)
> Good Friday address given by Constantine (*c.*320) Text: I.A. Heikel, 'Konstantins Rede an die heilige Versammlung,' in *Eusebius Werke I* (GCS), Leipzig, 1902, 149–92. English translation: M. Edwards, *Constantine and Christendom* (TTH 39), Liverpool, 2003, 1–62

Ordines Romani/Ordo Romanus
> (Roman liturgies; dating from mid 8th C. onwards) Text: M. Andrieu, *Les Ordines Romani du haut moyen âge. 2, Les textes (Ordines I–XIII)* (Spicilegium sacrum Lovaniense. Études et documents 23), Louvain, 1931

Origo Constantini
> Also known as *Anonymus Valesianus I* (mid-4th C., revised early 5th C.) Brief anonymous account of the life and reign of Constantine. Text: I. König, *Origo Constantini, Anonymus Valesianus* (Trierer historische Forschungen 11), Trier, 1987. Text and English translation: J.C. Rolfe, *Ammianus Marcellinus III* (Loeb), Cambridge MA and London, 1939, 509–31. Translation only by J. Stevenson, 'The Origin of Constantine', in S.N.C. Lieu and D. Montserrat, *From Constantine to Julian: Pagan and Christian Views*, London/New York, 1996, ch. 1

Ovid, poet (43BC–AD17)
Ars Amatoria
> Text: E.J. Kenney, *P. Ovidii Nasonis Amores etc.* (OCT), 2nd ed. Oxford, 1994. English translation in P. Green, *Ovid: The Erotic Poems* (PC), Harmondsworth, 1982 or A.D. Melville, *Ovid: The Love Poems* (OWC), Oxford, 1990

Ovid

Metamorphoses

Text: R.J. Tarrant, *P. Ovidi Nasonis Metamorphoses* (OCT), Oxford, 2004. English translation: D. Raeburn, *Ovid: Metamorphoses* (PC), Harmondsworth, 2004

P. Abinn.

Papyri from the Abinnaeus archive (*c.*340–351). See Bell, Martin, Turner and van Berchem 1962

P. Ammon

Papyri from the archive of Ammon Scholasticus (*c.*300–360). See Willis and Maresch 1997

Pan. Lat. (*Panegyrici Latini*) (dating between 100 and 389)

Text: R. Mynors, *XII Panegyrici Latini* (OCT), Oxford, 1964. English translation: C.E.V. Nixon and B.S. Rodgers, *In Praise of Later Roman Emperors*, Berkeley, Los Angeles and London, 1994 (includes reprint of Mynors's text).

The currently accepted dates of the Panegyrics are as follows: I, 100; II(12), 389; III(11), 362; IV(10), 321; V(8), 311; VI(7), 310; VII(6), 307; VIII(5), 297; IX(4), 298; X(2), 289; XI(3), 291; XII(9), 313.

NB: The first numeral (Roman) in each reference denotes the traditional number for the panegyric, the bracketed Arabic number the chronological sequence (according to Mynors).

Passio Privati (Passion of Privatus)

Text: *Acta Sanctorum* August vol. 4, Antwerp, 1739, repr. Brussels, 1970, 433–41

P. Col. Columbia Papyri (see Bagnall and Lewis 1979)

PG J.-P. Migne, *Patrologia Graeca* (*Patrologiae Graecae Cursus Completus*), 2nd series, 166 vols., Paris, 1857–1866 [and later reprints]

PL J.-P. Migne, *Patrologia Latina* (*Patrologiae Latinae Cursus Completus*), 221 vols., Paris, 1844–1864 [and later reprints; including on CD-ROM, Chadwyck-Healey, 1995 (http://pld.chadwyck.co.uk/)]

P. Lond.

Papyri from the British Museum, London (see Jones and Skeat 1954; and Souris 1989)

P. Oxy. *The Oxyrhynchus Papyri* (Graeco-Roman Memoirs series), London, 1898 onwards

P. Panop. Beatty

Panopolis papyri (298–300). See Skeat 1964

Praxagoras of Athens, historian (mid-4th C.)

Fragments in F. Jacoby, *Die Fragmente der griechischen Historiker IIB*, Berlin, 1929, 948–9 no. 219

Prices Edict

See Diocletian's Prices Edict

Procopius of Caesarea, historian (d. after 554)

De Aedificiis (Buildings)

Text and translation: H.B. Dewing, *Procopius vol. VII* (Loeb), Cambridge MA and London, 1971

De Rebus Bellicis (military pamphlet; later 4th C.)

Text: R.I. Ireland, *Anonymi auctoris De rebus bellicis* (Teubner), Leipzig, 1984. English translation: E.A. Thompson, *A Roman Reformer and Inventor*, Oxford, 1952

Res Gestae (*Divi Augusti*) see Augustus

RIB *The Roman Inscriptions of Britain*, 2 vols., Stroud, 1990–1995

Rufinus, church historian and theologian (*c.*345–*c.*410)

HE (*Historia Ecclesiastica*)

Latin translation of Eusebius, *HE* with new books 10 and 11. Text, E. Schwartz, Th. Mommsen and F. Winkelmann (eds.), *Eusebius Werke II: Die Kirchengeschichte* (GCS new series 6), 2nd ed., 3 vols., Berlin, 1999. English translation, P.R. Amidon, *The Church History of Rufinus of Aquileia Books 10 and 11*, Oxford, 1997

Sammelbuch

Sammelbuch griechischer Urkunden aus Aegypten, Wiesbaden, 1913 onwards

Scriptores Historiae Augustae (*SHA*); also known as the Augustan History. Anonymous set of imperial biographies from Hadrian to Carus and his sons (117–285), purportedly written under Diocletian and Constantine, but in fact a coded spoof of the 390s.

Text: E. Hohl, *Scriptores Historiae Augustae* (Teubner), 2 vols., rev. ed., Leipzig, 1965; text and English translation in D. Magie, *Scriptores Historiae Augustae* (Loeb), 3 vols., Cambridge, MA and London, 1921–32

SEG *Supplementum Epigraphicum Graecum*, Amsterdam, 1923 onwards

Socrates Scholasticus, church historian (*c.*379–*c.*440)

HE (*Historia Ecclesiastica*)

Text: G.C. Hansen, *Sokrates: Kirchengeschichte* (GCS new series 1), Berlin, 1995. English translation: NPNF ser. 2 vol. 2. French translation (incomplete): P. Périchon and P. Maraval, *Socrate de Constantinople: Histoire ecclésiastique* (Sources Chrétiennes 477, 493), 2 vols., Paris, 2004–5

Sozomen, church historian (died after 443)

HE (*Historia Ecclesiastica*)

 Text: J. Bidez and G.C. Hansen, *Sozomenus: Kirchengeschichte* (GCS new series 4), rev. ed., Berlin, 1995. English translation: NPNF ser.2 vol.2. French translation (incomplete): A.-J. Festugière, B. Grillet and G. Sabbagh, *Sozomène: Histoire ecclésiastique* (Sources Chrétiennes 306, 418), 2 vols, Paris, 1983–1996

Suetonius, imperial biographer (*c.*70–*c.* 130)

 Text: M. Ihm, *Suetonii De Vita Caesarum Libri VIII* (Teubner), Leipzig, 1908. English translation: C. Edwards, *Suetonius, Lives of the Caesars* (OWC), Oxford, 2000

Suda or Suidas (10th C. encylopaedia)

 A. Adler, *Suidae Lexicon* (Lexicographi Graeci 1), 5 vols., Leipzig, 1928–1938. Translation: http://www.stoa.org/sol/

Symmachus, orator and epistolographer (*c.*340– *c.* 402)

Orationes (Speeches)

 Text in O. Seeck, *Q. Aurelii Symmachi quae supersunt* (MGH AA 6.1), Berlin, 1883, repr. 2002

Tacitus, historian (*c.*56–*c.*120)

Agricola

 Text: R.M. Ogilvie and I. Richmond, *Cornelii Taciti De Vita Agricola*, Oxford, 1967. English translation: H. Mattingly, *Tacitus: The Agricola and The Germania* (PC), rev. ed., Harmondsworth, 1970 or A.R. Birley, *Tacitus, Agricola and Germany* (OWC), Oxford, 1999

Annales

 Text: C.D. Fisher, *Cornelii Taciti Annalium ab excessu divi Augusti Libri* (OCT), Oxford, 1906. English translation: A.J. Woodman, *Tacitus, The Annals*, Indianapolis and Cambridge, 2004

Germania

 Text: M. Winterbottom in *Cornelii Taciti Opera Minora* (OCT), Oxford, 1975, 35–62. Translation: J.B. Rives, *Tacitus, Germania* (Clarendon Ancient History Series), Oxford, 1999

Tertullian, theologian (*c.*160–*c.*240)

De cultu feminarum (*On the Apparel of Women*)

 Text: A. Kroymann in either CSEL 70, Vienna, 1942, 59–95 or CCSL 1, Turnhout, 1954, 341–370. English translation in E.A. Quain, *Tertullian: Disciplinary, Moral, and Ascetical Works* (The Fathers of the Church Patristic series 40), Washington DC, 1959, 117–52

De virginibus velandis (*On the Veiling of Virgins*)

 Text by E. Dekkers, CCSL 2, Turnhout, 1954, 1207–26 or V. Bulhart, CSEL 76, Vienna, 1957, 79–103. English translation: G. Dunn, *Tertullian* (ECF), London/New York, 2004,135–61

Theodoret, Bishop of Cyrrhus (*c.*393–466)

HE (*Historia Ecclesiastica*)

 Text: L. Parmentier, *Theodoret: Kirchengeschichte* (GCS new series 5), rev. ed., Berlin, 1998. English translation by B. Jackson in NPNF ser. 2 vol. 3

Theodosian Code

 See *CTh/Codex Theodosianus*

Varro, antiquarian and grammarian (116–27BC)

LL (*De Lingua Latina*)

 Text and translation: R.G. Kent, *Varro: On the Latin Language* (Loeb), 2 vols., Cambridge MA and London, 1951

Vegetius, military writer (late 4th C.)

Epitoma Rei Militaris

 Text: M.D. Reeve, *Vegetius: Epitoma Rei Militaris* (OCT), Oxford, 2004. English translation: N.P. Milner, *Vegetius: Epitome of Military Science* (TTH 16), 2nd ed., Liverpool, 1996

Verona List of provinces (*c.*314)

 Text and translation: T.D. Barnes, *The New Empire of Diocletian and Constantine*, Cambridge MA and London, 1982, ch. 12

Aurelius Victor, historian (d. after 390)

De Caesaribus

 (Summary account of emperors from Augustus to Constantius II)

 Text: F. Pichlmayr (ed.), *Sexti Aurelii Victoris Liber De Caesaribus* (Teubner), rev. ed., Leipzig, 1970. English translation: H.W. Bird, *Aurelius Victor, De Caesaribus* (TTH 17), Liverpool, 1994

Vita Wilfridi

 See Eddius Stephanus

John Zonaras, historian and canonist (d. *c.* 1160)

Epitome tôn Historiôn (*Epitoma Historiarum*)

 Text in *Patrologia Graeca* vol. 134 or by L. Dindorf (Teubner), 6 vols., Leipzig, 1868–1875. English translation (Bks XII.15–XIII.19 covering 3rd and 4th centuries) forthcoming by T. Banchich, Routledge

Zosimus, historian (early 6th C)

Historia Nova (New History) (history of Rome to 410)

 Text: F. Paschoud, *Zosime, Histoire Nouvelle* (Budé), 3 vols, Paris, 1971–2000. English translation, R.T. Ridley, *Zosimus, New History* (Byzantina Australiensia 2), Sydney, 1982, repr. 2004

ABBREVIATIONS

Antiq.J. *Antiquaries Journal*

Arch.J. *Archaeological Journal*

BABesch *Bulletin Antieke Beschaving*

BAR British Archaeological Report

CASSS *Corpus of Anglo-Saxon Stone Sculpture*

CBA Council for British Archaeology

CSIR.GB *Corpus Signorum Imperii Romani. Great Britain*

Edinburgh 1958 *Masterpieces of Byzantine Art*, Exhibition Catalogue, Edinburgh

Harley Catalogue *A Catalogue of the Harleian Collection of Manuscripts Preserved in the British Museum*, commenced by H. Wanley, and successively continued by D. Casley, W. Hocker and C. Morton, with an index by T. Astle, 4 vols, London, 1808–12

JBAA *Journal of the British Archaeological Association*

JRA *Journal of Roman Archaeology*

JRS *Journal of Roman Studies*

JTS *Journal of Theological Studies*

LIMC *Lexicon Iconographicum Mythologiae Classicae*

MAMA *Monumenta Asiae Minoris Antiquae*

MGH *Monumenta Germaniae Historica*

OUCAM Oxford University Committee for Archaeology Monograph

PCR Carson, R.A.G., *Principal Coins of the Romans:* **2**, *The Principate 31 BC–AD 296*, London, 1980; **3**, *The Dominate AD 294–498*, London, 1981

PLRE 1 A.H.M.Jones, J.R. Martindale and J. Morris, *The Prosopography of the Later Roman Empire Vol I: AD 260–395*, Cambridge, 1971

PSAS *Proceedings of the Society of Antiquaries of Scotland*

RCHMY 1 Royal Commission for Historic Monuments (England). *An Inventory of the Historical Monuments in the City of York* 1, *Eburacum, Roman York*, London, 1962

RIB 1 Collingwood, R.G. and Wright, R.P. *The Roman Inscriptions of Britain* 1, *Inscriptions on Stone*, Oxford, 1965

RIB 2 Frere, S.S., Roxan, M. and Tomlin, R.S.O. (eds), *The Roman Inscriptions of Britain* **2**, *Instrumentum Domesticum*, Fascicule 1, Gloucester, 1990

RIB 2.2 Frere, S.S. and Tomlin, R.S.O. (eds), *The Roman Inscriptions of Britain* **2**, *Instrumentum Domesticum*, Fascicule 2, Stroud, 1991

RIB 2.3 Frere, S.S. and Tomlin, R.S.O. (eds), *The Roman Inscriptions of Britain* **2**, *Instrumentum Domesticum*, Fascicule 3, Stroud, 1991

RIB *(Corrig. Add.)* Collingwood, R.G. and Wright, R.P., *The Roman Inscriptions of Britain* 1, *Inscriptions on Stone*, Oxford 1965 (reprinted with *Addenda and Corrigenda* by R.S.O. Tomlin, Stroud, 1995)

RIC *The Roman Imperial Coinage*, 10 volumes, various editors, London, 1923–94. Coin reference is given by volume number (in Roman numerals), then page number and item number

Spätantike und frühes Christentum *Spätantike und frühes Christentum. Ausstellung im Liebieghaus Museum alter Plastik*, Exhibition Catalogue, Frankfurt am Main, December 1983–March 1984

SPAW *Sitzungsberichte der preussischen Akademie der Wissenschaften*

Textiles 1995 Stauffer, A. (ed.), *Textiles of Late Antiquity*, Exhibition Catalogue, Metropolitan Museum of Art, New York

Trier 1984 *Die Stadt in Spätantiker und Frühchristlicher Zeit, Trier – Kaiserresidenz und Bischofssitz*, Exhibition Catalogue, Mainz

BIBLIOGRAPHY

Aldhouse-Green, M. (ed.), 1999. *Pilgrims in Stone. Stone Images from the Gallo-Roman Sanctuary of Fontes Sequanae*, BAR International Series **754**, Oxford

Alexander, J.J.G., 1976. 'The Illustrated Manuscripts of the *Notitia Dignitatum*' in R. Goodburn and P. Bartholomew (eds), *Aspects of the Notitia Dignitatum*, BAR Supplementary Series **15**, Oxford, 11–49

Alexander, J.J.G., 2002. *Studies in Italian Manuscript Illumination*, London

Alföldi, A.A., 1937. *A Festival of Isis in Rome under the Christian Emperors of the Fourth Century*, Budapest

Allason-Jones, L., 1989. *Ear-rings in Roman Britain*, BAR British Series **201**, Oxford

Allason-Jones, L., 1996. *Roman Jet in the Yorkshire Museum*, York

Allason-Jones, L. and Jones, J.M., 2001. 'Identification of "Jet" Artefacts by Reflected Light Microscopy', *European Journal of Archaeology* **4.ii**, 233–51

Anon. 2003. 'The Western Suburb: Excavations on the Site of the Former Victorian Workhouse at St Mary's Hospital', *The Colchester Archaeologist* **16**, 10–15

Arena, M.S., Delogu, P., Paroli, L., Ricci, M., Saguì, L. and Vendittelli, L. (eds), 2001. *Roma dall' antichità al medioevo. Archaeologia e storia nel Museo Nazionale Romano Crypta Balbi*, Rome

Atkinson, D., 1942. *Report on Excavations at Wroxeter (the Roman City of Viroconium) in the County of Salop 1923–1927*, Oxford

Austin, R.G., 1934. 'Roman Board Games I', *Greece and Rome* **4**, 24–34

Babelon, E., 1916. *Le trésor d'argenterie de Berthouville près Bernay (Eure)*, Paris

Babelon, E. and Van Kerkwijk, A.O., 1906. 'La trouvaille de Helleville (Manche), note additionnelle', *Revue Numismatique* 4th ser. **10**, 490–2

Backhouse, J., Turner, D.H. and Webster, L. (eds) 1984. *The Golden Age of Anglo-Saxon Art 966–1066*, London

Bagnall, R.S. and Lewis, N., 1979. *Fourth Century Documents from Karanis*, Columbia Papyri **7**, Missoula

Bagnall Smith, J., 1995. 'Interim Report on the Votive Material from Romano-Celtic Temple Sites in Oxfordshire', *Oxoniensia* **60**, 177–203

Bailey, D., 1988. 'A Bracelet from the Beaurains Treasure', *Antiq.J.* **68**, 306–8

Bailey, R., 1978. *The Durham Cassiodorus*, Jarrow Lecture, Jarrow

Bailey, R., 1996a. *England's Earliest Sculptors*, Toronto

Bailey, R., 1996b. 'Seventh-Century Work at Ripon and Hexham' in T. Tatton Brown and J. Mumby (eds), *The Archaeology of Cathedrals*, OUCAM **42**, Oxford, 9–18

Bailey, R. and Cramp, R., 1988. *Cumberland, Westmoreland and Lancashire North-of-the-Sands*, CASSS **2**, Oxford

Banaji, J., 2001. *Agrarian Change in Late Antiquity: Gold, Labour and Aristocratic Dominance*, Oxford

Baratte, F., 1993. *La vaisselle d'argent en Gaule dans l'antiquité tardive*, Paris

Baratte, F., Lang, J., La Niece, S. and Metzger, C., 2002. *Le trésor de Carthage: contribution à l'étude de l'orfèvrerie de l'antiquité tardive*, Paris

Baratte, F. and Painter, K., 1989. *Trésors d'orfèvrerie Gallo-Ramain*, Paris

Barker, H., Cowell, M.R., Craddock, P.T., Hughes, M.J. and Lang. J., 1977. 'Preliminary Report of the British Museum Research Laboratory' in Painter 1977, 25–6

Barker, P, 1979. 'The Plumbatae from Wroxeter' in M.W.C. Hassell and R.I. Ireland (eds), *De Rebus Bellicis*, Oxford, 97–9

Barnes, T.D., 1976. 'The Emperor Constantine's Good Friday Sermon', *JTS* **27**, 414–23

Barnes, T.D., 1981. *Constantine and Eusebius*, Cambridge MA and London

Barnes, T.D., 1982. *The New Empire of Diocletian and Constantine*, Cambridge MA and London

Barnes, T.D., 1985. 'The Career of Abinnaeus', *Phoenix* **39**, 368–74

Barnes, T.D., 1986. *The Constantinian Reformation*, The Crake Lectures 1984, Sackville, New Brunswick, Canada

Barnes, T.D., 1989. 'Panegyric, History and Hagiography in Eusebius's *Life of Constantine*', in R. Williams (ed.), *The Making of Orthodoxy. Essays in Honour of Henry Chadwick*, Cambridge, 94–123

Barnes, T.D., 1993. *Athanasius and Constantius*, Cambridge MA and London

Barnes, T.D., 1995. 'Statistics and the Conversion of the Roman Aristocracy', *JRS* **85**, 135–47

Barnes, T.D., 1996. 'Emperors, Panegyrics, Prefects, Provinces and Palaces (284–317)', *JRA* **9**, 532–52

Barnes, T.D., 1998. 'Constantine and Christianity: Ancient Evidence and Modern Interpretations', *Journal of Ancient Christianity/Zeitschrift für Antike Christentum* **2**, 274–94

Barnes, T.D., 2001. 'Constantine's Speech to the Assembly of the Saints: Place and Date of Delivery', *JTS* **52**, 26–36

Bastet, F.L., 1968. 'Die Grosse Kamee in den Haag', *BABesch* **43**, 2–22

Bastet, F.L., 1979. *Beeld en relief. Gids voor de verzameling en Romeinse beeldhouwkunst in het Rijksmuseum van Oudheden te Leiden*, The Hague

Bastet, F.L. and Brunsting, H., 1982. *Corpus Signorum Antiquorum. Catalogus van het klassieke Beeldhouwwerke in het Rijksmuseum van Oudheden te Leiden*, Zutphen

Bastien, P., 1988. *Monnaie et donativa au bas-empire*, Wetteren

Bastien, P. and Metzger, C., 1977. *Le trésor de Beaurains (dit d'Arras)*, Wetteren

Bauchhenss, G. and Noelke, P., 1981. *Die Iupitersäulen in den Germanischen Provinzen*, Cologne and Bonn

Baynes, N.H., 1930. *Constantine the Great and the Christian Church*, London

Beagrie, N., 1989. 'The Romano-British Pewter Industry', *Britannia* **20**, 169–91

Beard, M., North, J. and Price, S., 1998. *Religions of Rome* **1**, *A History*, Cambridge

Beckwith, J., 1970. *Early Christian and Byzantine Art*, Harmondsworth

Bédat, I., Desrosiers, S., Moulherat, C. and Relier, C., 2005. 'Two Gallo-Roman Graves Recently Found at Naintré (Vienne)', in J.P. Wild and F. Pritchard (eds), *Acts of the 7th North European Symposium on Archaeological Textiles, Edinburgh 1999*, Manchester, 5–11

Bell, H.I., Martin, V., Turner, E.G. and van Berchem, D., 1962. *The Abinnaeus Archive: Papers of a Roman Officer in the Reign of Constantius II*, Oxford

Bell, R.C., 1960. *Board and Table Games of Many Civilizations*, London

Bergmann, M., 1977. *Studien zum römischen Porträt des 3. Jhdts.n.Chr*, Bonn

Bertolotti, R. de A., Ioppolo, G. and Pisano Sartorio, G. 1988. *La residenza imperiale di Massenzio*, Rome

Bianchini, M., 1984. 'L'imperatore Costantino e una certa Agrippina. Riflessioni su CTh 8.15.1', *Sodalitas: Scritti in onore di Antonio Guarino* **3**, 1191–1206

Biddle, M., 1999. *The Tomb of Christ*, Stroud

Biddle, M. and Kjølbye-Biddle, B., 1988. 'The Repton Stone', *Anglo-Saxon England* **14**, 233–92

Biddle, M. and Kjølbye-Biddle, B., 2001. 'The Origins of St Albans Abbey: Romano-British Cemetery and Anglo-Saxon Monastery' in M. Henig and P. Lindley (eds), *Alban and St Albans. Roman and Medieval Architecture, Art and Archaeology,* British Archaeological Association Conference Transactions **24**, Leeds, 45–77

Bidez, J. and Hansen, G.C. (eds), 1960. *Sozomen, Historia Ecclesiastica,* Berlin

Binsfeld, A., 2004. 'Die Graffiti der frühchristlichen Kirchenanlage in Trier' in Ristow 2004, 235–52

Bird, J., 1986. 'The Silver Bowl' in J.M.C. Toynbee (ed.), *The Roman Art Treasures from the Temple of Mithras*, London and Middlesex Archaeological Society Special Paper **7**, London, 52–4

Bird, J., Chapman, H. and Clark, J. (eds), 1978. *Collectanea Londiniensia: Studies in London Archaeology and History Presented to Ralph Merrifield*, London and Middlesex Archaeological Society Special Paper **2**, London

Birley, A.R., 1979. *The People of Roman Britain*, London

Birley, A.R., 1981. *The Fasti of Roman Britain*, Oxford

Birley, E., 1953. *Roman Britain and the Roman Army: Collected Papers*, Kendal

Birley, E., 1966. 'The Roman Inscriptions of York', *Yorkshire Archaeological Journal* **61**, 726–34

Bishop, M.C. and Coulston, J.C.N., 1993. *Roman Military Equipment from the Punic Wars to the Fall of Rome*, London

Blagg, T.F.C., 2002. *Roman Architectural Ornament in Britain*, BAR British Series **329**, Oxford

Bland, R. and Johns, C.M., 1993. *The Hoxne Treasure. An Illustrated Introduction*, London

Bodden, M-C. (ed.), 1987. *The Old English Finding of the True Cross*, Cambridge

Boetzkes, M., Stein, H. and Weisker, C., 1997. *Der Hildesheimer Silberfund, Original und Nachbildung: vom Römerschatz zum Bürgerstolz,* Hildesheim

Böhme, H.W., 1986. 'Das Ende der Römerherrschaft in Britannien und die angelsächsische Besiedlung Englands im 5. Jahrhundert', *Jahrbuch des Römisch-Germanischen Zentralmuseums* **33**, 469–574

Böhme, H.W., 1987. 'Gallien in der Spätantike. Forschungen zum Ende der Römerherrschaft in den westlichen Provinzen', *Jahrbuch des Römisch-Germanischen Zentralmuseums Mainz* **34**, 770–3

Boissevain, U.P. (ed.), 1901. *Cassius Dio, Romanorum Quae Supersunt*, Berlin

Boon, G.C., 1972. *Isca, The Roman Legionary Fortress at Caerleon, Mon.,* Cardiff

Boon, G.C., 1989. 'A Roman Sculpture Rehabilitated: the Pagans Hill Dog', *Britannia* **20**, 201–17

Borgehammar, S., 1991. *How the Holy Cross was Found. From Event to Medieval Legend*, Stockholm

Borlase, W., 1769. *Antiquities, Historical and Monumental of the County of Cornwall*, London

Bosanquet, R.C., 1904. 'Excavations on the Line of the Roman Wall in Northumberland', *Archaeologia Aeliana* 2nd ser. **25**, 193–300

Bowersock, G.W., 1978. *Julian the Apostate*, London

Bowman, A.K., Cameron, A. and Garnsey, P. (eds), 2005. *The Cambridge Ancient History*, **12**: *The Crisis of Empire AD 193–337*, 2nd ed., Cambridge

Boyd, S.A., 1988. 'A Bishop's Gift: Openwork Lamps from the Sion Treasure' in F. Baratte (ed.), *Argenterie romaine et Byzantine: Actes de la Table Ronde Paris 11–13 Octobre 1983*, Paris, 191–209

Bracker, J., 1976. 'Zur Rekonstruktion und Deutung des Goldglastellers vom Katharinengraben in Köln' in T.E. Haevernick and A. von Saldern (eds), *Festschrift für Waldemar Haberey*, Mainz, 5–8

Breeze, D.J., 1981. *The Northern Frontiers of Roman Britain*, London

Breeze, D.J. and Dobson, B., 1976. *Hadrian's Wall*, London

Brenk, B., 1999. 'La cristianizzazione della Domus dei Velerii sul Celio' in Harris 1999, 69–84

Brodribb, A.C.C., Hands, A.R. and Walker, D.R., 1968. *Excavations at Shakenoak Farm, Near Wilcote, Oxfordshire* **1**, *Sites A & D*, Oxford

Brown, D., 1970. 'A Roman Pewter Mould from St Just, Penwith, Cornwall', *Cornish Archaeology* **9**, 107–10

Brown, D., 1973. 'A Roman Pewter Hoard from Appleford, Berks.', *Oxiniensia* **38**, 184–206

Brown, D., 1976. 'Bronze and Pewter' in D. Strong and D. Brown (eds), *Roman Crafts*, London, 25–41

Bruun, P.M., 1966. *The Roman Imperial Coinage VII Constantine and Licinius AD 313–337*, London

Bruun, P., 1997. 'The Victorious Signs of Constantine: a Reappraisal', *Numismatic Chronicle* **157**, 41–60

Buckler, W.H., Calder, W.M. and Guthrie, W.K.C., 1933. *Monuments and Documents from Eastern Asia and Western Galatia*, MAMA **4**, Manchester

Buckton, D. (ed.), 1994. *Byzantium. Treasures of Byzantine Art and Culture from British Collections*, British Museum Exhibition Catalogue, London

Bulleid, A. and Horne, E., 1926. 'The Roman House at Keynsham, Somerset', *Archaeologia* **75**, 109–38

Burckhardt, J., 1949 [1853]. *The Age of Constantine*, trans. M. Hadas, London

Burnett, A., 1991. *Interpreting the Past – Coins*, London

Buschhausen, H., 1971. *Die Spätrömischen Metallscrinia und Frühchristlichen Reliquiare*, Vienna

Butler, R.M., 1971. 'The Defences of the Fourth-Century Fortress at York' in R.M. Butler (ed.), *Soldier and Civilian in Roman Yorkshire*, Leicester, 97–106

Buttrey, T.V., 1983. 'The Dates of the Arches of "Diocletian" and Constantine', *Historia* **32**, 375–83

Cabrol, F. and Leclerq, H., 1914. *Dictionnaire d'Archéologie Chrétienne et de Liturgie*, Paris

Cahn, H.A. and Kaufmann-Heinimann, A. (eds), 1984. *Der spätrömische Silberschatz von Kaiseraugst*, Derendingen

Calder, W.M., 1956. *Monuments from Eastern Phrygia, MAMA* **7**, Manchester

Cambridge, E., 1999. 'The Architecture of the Augustine Mission' in R. Gameson (ed.), *St Augustine and the Conversion of England*, Stroud, 202–36

Cambridge, E. and Williams, A., 1995. 'Hexham Abbey, A Review of Recent Work and its Implications', *Archaeologia Aeliana* **23**, 51–138

Cameron, Alan, 2004. 'Vergil Illustrated between Pagans and Christians', *JRA* **17**, 502–25

Cameron, Averil, 2000. 'Form and Meaning: The *Vita Constantini* and the *Vita Antonii*', in T. Hägg and P. Rousseau (eds), *Greek Biography and Panegyric in Late Antiquity*, Berkeley and Los Angeles, 72–88

Cameron, Averil, 2005. 'Constantine and the Peace of the Church' in M. Mitchell and F. Young (eds), *Cambridge History of Christianity* **I**, Cambridge, 538–51

Cameron, Averil and Hall, S.G., 1999. *Eusebius, Life of Constantine. Translation, Introduction and Commentary*, Oxford

Carandini, A., Ricci, A. and de Vos, M., 1982. *Filosofiana. The Villa of Piazza Armerina. The Image of a Roman Aristocrat at the Time of Constantine*, Palermo

Carriker, A.J., 2004. *The Library of Eusebius of Caesarea*, Vigiliae Christianae Suppl. **67**, Leiden and Boston

Carson, R.A.G., 1980. 'A Treasure of Aurei and Gold Multiples from the Mediterranean' in P. Bastien, F. Dumas, H. Huvelin and C. Morrisson (eds), *Mélanges de numismatique, d'archéologie et d'histoire offerts à Jean Lafaurie*, Paris, 59–74

Cary, E. (ed.), 1927. *Cassius Dio. Historiarum Romanorum Quae Supersunt*, Cambridge MA

Casey, J., 1978. 'Constantine the Great in Britain – the Evidence of the Coinage of the London Mint, AD 312–14' in Bird, *et al.* 1978, 180–93

Casey, P.J., 1977. 'Carausius and Allectus – Rulers in Gaul?', *Britannia* **8**, 283–301

Casey, P.J., 1994. *Carausius and Allectus, the British Usurpers*, London

Casey, P.J., 2000. 'LIBERALITAS AVGVSTI: Imperial Military Donatives and the Arras Hoard' in G. Alföldy, B. Dobson and W. Eck (eds), *Kaiser, Heer und Gesellschaft in der Römischen Kaiserzeit: Gedenkschrift für Eric Birley*, Stuttgart, 445–58

Chadwick, H., 2001. *The Church in Ancient Society*, Oxford

Charlesworth, D., 1973. 'The Aesica Hoard', *Archaeologia Aeliana* 5th ser. **1**, 225–34

Chausson, F., 2004. 'Une soeur du Constantin: Anastasia', in J-M. Carrié and R. Lizzi Testa (eds), '*Humana sapit*'. *Etudes d'antiquité tardive offertes à Lellia Cracco Ruggini*, Bibliothèque de l'Antiquité Tardive **3**, Paris, 131–55

Christol, M., 1977. 'La carrière de Traianus Mucianus et l'origine des *protectores*', *Chiron* **7**, 393–408

Christol, M. and Drew-Bear, T., 1999. 'Antioche de Piside, capitale provinciale et l'oeuvre de M. Valerius Diogenes', *Antiquité Tardive* **7**, 39–71

Clapham, A.W., 1930. *English Romanesque Architecture Before the Conquest*, Oxford

Clark, L.C.G., 1931. 'Roman Pewter Bowl from the Isle of Ely', *Proceedings of the Cambridge Antiquarian Society* **31**, 66–72

Clarke, D., 1979. *The Roman Cemetery at Lankhills*, Winchester Studies **3.ii**, Oxford

Clauss, M., 2000. *The Roman Cult of Mithras. The God and his Mysteries*, Edinburgh

Coarelli, F., 1986. 'L'urbs e il suburbio' in A. Giardina (ed.), *Società Romana e Impero Tardoantico* **2**, Milan, 1–58

Collingwood, W.G., 1915. 'Anglian and Anglo-Danish Sculpture in the West Riding', *Yorkshire Archaeological Journal* **23**, 129–299

Collingwood, W.G., 1927. *Northumbrian Crosses of the Pre-Norman Age*, London

Cool, H.E.M., 2000. 'The Parts Left Over: Material Culture into the 5th Century' in T. Wilmott and P. Wilson (eds), *The Late Roman Transition in the North*, BAR British Series **299**, 47–65

Cool, H.E.M., 2002. 'Bottles for Bacchus?' in M. Aldhouse-Green and P. Webster (eds), *Artefacts and Archaeology*, Cardiff, 132–51

Cool, H.E.M., 2004. *The Roman Cemetery at Brougham, Cumbria. Excavations 1966–67*, Britannia Monograph Series **21**, London

Cool, H.E.M. and Price, J., 1987. 'The Glass' in Meates 1987, 110–42

Corcoran, S., 1993. 'Hidden from History: the Legislation of Licinius' in J. Harries and I. Wood (eds), *The Theodosian Code*, London, 97–119

Corcoran, S., 2000. *The Empire of the Tetrarchs: Imperial Pronouncements and Government AD 284–324*, revised edition, Oxford

Corcoran, S., 2002. 'A Tetrarchic Inscription from Corcyra and the *Edictum de Accusationibus*', *Zeitschrift für Papyrologie und Epigraphik* **141**, 221–30

Corcoran, S., 2004. 'The Publication of Law in the Era of the Tetrarchs: Diocletian, Galerius, Gregorius, Hermogenian' in A. Demandt, A. Goltz and H. Schlange-Schöningen (eds), *Diokletian und die Tetrarchie: Aspekte einer Zeitenwende*, Millennium-Studien **1**, Berlin and New York, 56–73

Corder, P. and Kirk, J.L., 1932. *A Roman Villa at Langton, near Malton, E. Yorkshire*, Roman Malton and District Report **4**, Leeds

Coulston, J.C. and Phillips, E.J., 1988. *CSIR. GB* **I**. Fascicule 6. *Hadrian's Wall west of the North Tyne and Carlisle*, Oxford

Cotton, H. and Rogers, G. (eds), 2004. *Rome, the Greek World and the East* **2**, *Government, Society, and Culture in the Roman Empire*, Chapel Hill NC and London

Cramp, R., 1965. *Early Northumbrian Sculpture*, Jarrow Lecture, Jarrow

Cramp, R., 1974. 'The Anglo-Saxons and Rome,' *Transactions of the Durham and Northumberland Archaeological Society* new ser. **3**, 27–37

Cramp, R., 1975. 'Anglo-Saxon Sculpture of the Reform Period', in D. Parsons (ed.), *Tenth-Century Studies*, London and Chichester, 184–99

Cramp, R., 1976. 'Monkwearmouth and Jarrow: the Archaeological Evidence', in G. Bonner (ed.), *Famulus Christi: Essays in Commemoration of the Thirteenth Centenary of the Birth of the Venerable Bede*, London, 5–18

Cramp, R., 1984. *Co. Durham and Northumberland, CASSS* **1**, Oxford

Cramp, R., 1994. 'Monkwearmouth and Jarrow in their Continental Context', in K. Painter (ed.), *Churches Built in Ancient Times*, London, 279–94

Croom, A., 2001. 'A Ring Mail Shirt from South Shields Roman Fort', *Arbeia Journal* **6–7**, 55–60

Crummy, N., 1983. *The Roman Small Finds from Excavations in Colchester 1971–9*, Colchester Archaeological Reports **2**, Colchester

Cunliffe, B., 1988. *The Temple of Sulis Minerva at Bath* **2**, *The Finds from the Sacred Spring*, OUCAM **16**, Oxford

Cunliffe, B. and Davenport, P., 1985. *The Temple of Sulis Minerva at Bath* **1**, *The Site*, OUCAM **7**, Oxford

Cüppers, H., 1969. 'Der bemalte Reliefsarkophag aus der Gruft unter der Quirinuskapelle auf dem Friedhof von St. Matthias', *Trierer Zeitschrift* **32**, 1969, 269–93

Curle, A.O., 1923. *The Treasure of Traprain: a Scottish Hoard of Roman Silver Plate*, Glasgow

Curle, J., 1931–2. 'An Inventory of Objects of Roman and Provincial Roman Origin found on Sites in Scotland not Definitely Associated with Roman Constructions', *PSAS* **66**, 277–400

Curran, J., 1998. 'From Jovian to Theodosius', in Averil Cameron and P. Garnsey (eds), *Cambridge Ancient History* **13**, *The Late Empire* A.D. *337–425*, Cambridge, 78–110

Curran, J., 2000. *Pagan City and Christian Capital. Rome in the Fourth Century*, Oxford

Dalton, O.M., 1901. *Catalogue of Early Christian Antiquities in the British Museum*, London

Danincourt, A., 1886. 'Etude sur quelques antiquités trouvées en Picardie', *Revue Archeologique* 3rd ser. **7**, 88

Davey, N. and Ling, R., 1981. *Wall-Painting in Roman Britain*, Britannia Monograph **3**, London

Davis, R., 1989. *The Book of the Pontiffs (Liber Pontificalis)*, Liverpool

de la Bédoyère, G., 1998. *The Golden Age of Roman Britain*, Stroud

Delbrueck, R., 1932. *Antike Porphyrwerke*, Berlin and Leipzig

Del Moro, M.P., 2000. 'Brocca con scene bibliche' in S. Ensoli and E. La Rocca (eds), *Aurea Roma: dalla città pagana alla città cristiana*, Rome, 614–15, no.316

Deperot, G., 1987. *Le Bas-Empire Romain, économie et numismatique*, Paris

Deppert-Lippitz, B., Schürmann, A., Theune-Grosskopf, B., Krause, R., with Würth, R. and Plank, D., 1995. *Die Schraube zwischen Macht und Pracht*, Sigmaringen

Dickinson, T. and Härke, H., 1992. *Early Anglo-Saxon Shields*, London

Dietz, K., 1993. 'Cohortes, ripae, pedaturae: zur Entwicklung der Grenzlegionen in der Spätantike' in K. Dietz, D. Hennig and H. Kaletsch (eds), *Klassisches Altertum, Spätantike und frühes Christentum; Adolf Lippold zum 65. Geburtstag gewidmet*, Würzburg, 279–329

Dietz, K., Osterhaus, U., Rieckhoff-Pauli, S. and Spindler, K., 1979. *Regensburg zur Römerzeit*, Regensburg

Dodds, E.R., 1965. *Pagan and Christian in an Age of Anxiety. Some Aspects of Religious Experience from Marcus Aurelius to Constantine*, Cambridge

Dohrn, T., 1949. 'Spätantikes Silber aus Britannien', *Mitteilungen des deutschen archäologischen Instituts* **2**, 66–139

Donati, A. (ed.), 1996. *Dalla terra alle genti: la diffusione del cristianesimo nei primi secoli*, Milan

Donati, A. and Gentile, G. (eds), 2005. *Costantino il Grande. La civiltà antica al bivio tra Occidente e Oriente*, Milan

Dorigo, W., 1971. *Late Roman Painting*, London

Drake, H.A., 1976. *In Praise of Constantine: A Historical Study and New Translation of Eusebius' Tricennial Orations*, Berkeley

Drake, H.A., 2000. *Constantine and the Bishops: the Politics of Intolerance*, Baltimore and London

Drew, C.D. and Collingwood Selby, K.C., 1938. 'The Excavations at Colliton Park, Dorchester. Second Interim Report. Excavations Carried out in the Season of 1938', *Proceedings of the Dorset Natural History and Archaeological Society* **60**, 51–65

Drijvers, J.W., 1992. *Helena Augusta. The Mother of Constantine the Great and the Legend of her Finding of the True Cross*, Leiden

Droysen, H. (ed.), 1879. *Eutropius, Breviarium*, Berlin; trans. H.W. Bird, Liverpool, 1993

Duchesne, L., 1899. *Fastes Episcopaux de l'ancienne Gaule* **2**, Paris

Dunbabin, K.M.D., 1999. *Mosaics of the Greek and Roman World*, Cambridge

Duncan-Jones, R.P., 1978. 'Pay and Numbers in Diocletian's Army', *Chiron* **8**, 541–60

Duncan-Jones, R.P., 1994. *Money and Government in the Roman Empire*, Cambridge

Duval, N., 1995. *Les premiers monuments chrétiens de la France 1, Sud-Est et Corse*, Paris

Eagle, J, 1989. 'Testing Plumbatae' in C. Van Driel-Murray (ed.), *Roman Military Equipment: The Sources of Evidence*, Oxford, 247–53

Edrich, M., Giancotta, K. and Hanson, W., 2000. 'Traprain Law: Native and Roman on the Northern Frontier', *PSAS* **130**, 441–56

Edwards, M. (trans), 1997. *Optatus: Against the Donatists*, Liverpool

Edwards, M.J., 1999. 'The Constantinian Circle and the *Oration to the Saints*', in Edwards, Goodman and Price 1999, 251–76

Edwards, M.J., 2003. *Constantine and Christendom. The Oration to the Saints, The Greek and Latin Accounts of the Discovery of the Cross, The Edict or Constantine to Pope Silvester*, Liverpool

Edwards, M.J., Goodman, M.D. and Price, S.R. (eds), 1999. *Apologetics in the Roman Empire*, Oxford

Elliott, L. and Malone, S., 1999. 'Flawborough SK780430', *Transactions of the Thoroton Society of Nottinghamshire* **103**, 88–9

Elsner, J., 1995. *Art and the Roman Viewer. The Transformation of Art from the Pagan World to Christianity*, Cambridge

Elsner, J., 1998. *Imperial Rome and Christian Triumph*, Oxford

Elsner, J., 2000. 'From the Culture of *spolia* to the Cult of Relics: the Arch of Constantine and the Genesis of Late Antique Forms', *Papers of the British School at Rome* **68**, 149–78

Elsner, J., 2004. 'Late Antique Art: the Problem of the Concept and the Cumulative Aesthetic' in Swain and Edwards 2004, 271–309

Engelmann, H., Knibbe, D. and Merkelbach, R., 1980. *Die Inschriften von Ephesos, Teil III*, Inschriften griechischer Städte aus Kleinasien **13**, Bonn

Engemann, J., 1984. 'Eine spätantike Messingkanne mit zwei Darstellungen aus der Magierzählung im F.J. Dölger-Insitut in Bonn', *Vivarium: Festschrift Theodor Klauser zum 90. Geburtstag, Jahrbuch für Antike und Christemtum Ergänzungsband* **11**, 115–31

Ergil, T., 1983. *Catalogue of the Istanbul Museum*, Istanbul

Eriksen, R.T., 1980. 'Syncretic Symbolism and the Christian Roman Mosaic at Hinton St Mary: a Closer Reading', *Proceedings of the Dorset Natural History and Archaeological Society* **102**, 43–8

Espérandieu, E., 1965. *Recueil Général des Bas-reliefs, Statues et Bustes de la Gaule Romaine* **4**, Ridgewood NJ

Evans, A., 1930. 'Some Notes on the Arras Hoard', *Numismatic Chronicle* **39**, 221–74

Evans, H.C. and Wixon, W.D. (eds), 1997. *The Glory of Byzantium*, Exhibition Catalogue, New York

Feissel, D. and Worp, K.A., 1988. 'La requête d'Appion, évéque de Syène à Théodose II: P. Leid. Z révisé', *Oudheidkundige Mededelingen uit het Rijksmuseum van Oudheden* **68**, 97–111

Fernie, E., 1982. *The Architecture of the Anglo-Saxons*, London

Ferrua, A., 1991. *The Unknown Catacomb. A Unique Discovery of Early Christian Art*, Florence

Fine, S. (ed.), 1996. *Sacred Realm. The Emergence of the Synagogue in the Ancient World*, New York and Oxford

Fiorio, M.T., 1985. *Le chiese di Milano*, Milan

Fischer-Heetfeld, G., 1983. 'Studien zu spätantiken Silber. Die Risley Lanx', *Mitteilungen des Deutschen Archäologischne Instituts Athen* **98**, 239–63

Fowden, G., 1994. 'The Last Days of Constantine: Oppositional Versions and their Influence', *JRS* **84**, 146–70

Franceschini, E.B.R. and König, M., 2003. *Palatia. Kaiserpaläste in Konstantinopel, Ravenna und Trier*, Trier

Franken, N., 1999. 'Antiken aus der Sammlung des Kölner Kaufmanns Peter Leven (1796–1850)', *Kölner Jahrbuch* **32**, 285–300

Frede, M., 1999. 'Eusebius's Apologetic Writing', in Edwards, Goodman and Price 1999, 223–50

Fremersdorf, F., 1967. *Die Römischen Gläser mit Schliff, Bemalung und Goldauflagen aus Köln*, Die Denkmäler des Römischen Köln **8**, Cologne

Frend, W.H.C., 1984–5. 'Syrian parallels to Water Newton', *Jahrbuch für Antike und Christentum* **27–8**, 146–50

Frere, S.S., 1972. *Verulamium Excavations* **1**, Research Report of the Society of Antiquaries of London **28**, London

Frere, S.S., 1978. *Britannia, a History of Roman Britain*, 2nd edition, London

Frere, S.S., 1990. 'Roman Britain in 1989: 1. Sites Explored', *Britannia* **21**, 304–64

Friesinger, H. and Krinzinger, F. (eds), 1997. *Der römische Limes in Österreich: Führer zu den archäologischen Denkmälern*, Vienna

Gauthier, N., 1975. *Recueil des inscriptions chrétiennes de la Gaule antérieures à la Renaissance Carolingienne, Première Belgique* **1**, Paris

Gem, R., 1997. *St Augustine's Abbey Canterbury*, London

Geuenich, D., 1997. 'Ein junges Volk macht Geschichte: Herrkunft und "Landnahme" der Alamannen' in *Die Alamannen*, Exhibition Catalogue, Stuttgart, 73–8

Gibson, M., 1994. *The Liverpool Ivories. Late Antique and Medieval Ivory and Bone Carving in Liverpool Museum and the Walker Art Gallery*, London

Gillam, J.P., Jobey, I.M. and Welsby, D.A., 1993. *The Roman Bath-house at Bewcastle, Cumbria*, Kendal

Giovenale, G.B., 1927. *La Basilica di S. Maria in Cosmedin*, Rome

Gose, E., 1958. *Katalog der frühchristlichen Inschriften in Trier*. Trierer Grabungen und Forschungen **3**, Berlin

Gough, M., 1973. *The Origins of Christian Art*, London

Granger-Taylor, H. 1983. 'The Two Dalmatics of Saint Ambrose?', *Bulletin de Liaison du Centre International d'Etude des Textiles Anciens* **17–18**, 127–68

Greenhill, E.S., 1954. 'The Child in the Tree', *Traditio* **10**, 323–71

Greep, S.J., 2004. 'The Miscellaneous Items of Bone, Antler and Ivory' in H.E.M. Cool, *The Roman Cemetery at Brougham, Cumbria; Excavations 1966–67*, Britannia Monograph Series **21**, London, 403

Grégoire, H., 1939. 'La Vision de Constantin "liquidée"', *Byzantion* **14**, 341–51

Grimme, E.G., 1972. *Der Aachener Domschatz*, Aachener Kunstblätter **42**, Düsseldorf

Grueber, H.A., 1900. 'Find of Roman Coins and Gold Rings at Sully, near Cardiff', *Numismatic Chronicle* 3rd ser. **20**, 27–65

Grünhagen, W., 1954. *Der Schatzfund von Gross Bodungen*, Römisch-Germanische Forschungen **21**, Berlin

Grünewald, T., 1990. *Constantinus Maximus Augustus*, Historia Einzelschrift **64**, Stuttgart

Guarducci, M., 1935. *Inscriptions Creticae* **1**, Rome

Guiraud, H., 1988. *Intailles et camées de l'époque romaine en Gaule*, Gallia, Supplement **48**, Paris

Guggisberg, M.A. and Kaufmann-Heinimann, A., 2003. *Der spätrömische Silberschatz von Kaiseraugst. Die neuen Funde*, Forschungen in Augst **34**, Augst

Guy, C.J., 1981. 'Roman circular lead tanks in Britain', *Britannia* **12**, 271–6

Haberey, W. and Röder, J., 1961. 'Das frühchristliche Frauengrab von St. Aldegund', *Germania* **39**, 128–42

Hagen, W., 1937. 'Kaiserzeitliche Gagatarbeiten aus dem reheinichen Germanien', *Bonner Jahrbücher* **47**, 77–144

Halfmann, H., 1986. *Itinera Principum*, Stuttgart

Halkon, P. and Millett, M., 2003. 'East Riding: an Iron Age and Roman Landscape Revealed', *Current Archaeology* **187**, 303–9

Halsall, G., 2003. *Warfare and Society in the Barbarian West, 450–900*, London and New York

Hannestad, N., 1988. *Roman Art and Imperial Policy*, Aarhus

Hansen, G.C. (ed.), 1995. *Socrates, Historia Ecclesiastica*, Berlin

Harden, D.B., 1936. *Roman Glass from Karanis*, Ann Arbor MI

Harden, D.B., 1962. 'Glass in Roman York', *RCHMY* **1**, 136–41

Harden, D.B., Hellenkemper, H., Painter, K. and Whitehouse, D. (eds), 1987. *Glass of the Caesars*, Catalogue of an Exhibition Organized by the Corning Museum of Glass, the British Museum, the Römisch-Germanisches Museum, Cologne, and Olivetti, Milan

Harries, J.D., 1988. 'The Roman Imperial Quaestor from Constantine to Theodosius II', *JRS* **78**, 148–72

Harris, W.V. (ed.), 1999. *The Transformations of VRBS ROMA in Late Antiquity*, JRA Supplementary Series **33**, Ann Arbor MI

Hauken, T., 1998. *Petition and Response: An Epigraphic Study of Petitions to Roman Emperors, 181–249*, Monographs from the Norwegian Institute at Athens **2**, Bergen

Hauser, S.R., 1992. *Spätantike und Frühbyzantinische Silberlöffel. Bemerkungen zur Produktion von Luxusgütern im 5. bis 7. Jahrhundert, Jahrbuch für Antike und Christentum, Ergänzungsband* **19**, Münster

Hawkes, J., 1996. 'The Rothbury Cross: an Iconographic Bricolage', *Gesta* **35**, 77–94

Hawkes, J., 1997. 'Old Testament Heroes: Iconographies of Insular Sculpture' in D. Henry (ed.), *The Worm, the Germ, and the Thorn. Pictish and Related Studies Presented to Isabel Henderson*, Balgavies, 149–58

Hawkes, J., 1999. 'Anglo-Saxon Sculpture: Questions of Context' in J. Hawkes and S. Mills (eds), *Northumbria's Golden Age*, Stroud, 204–15

Hawkes, J., 2002a. 'The Art of the Church in Ninth-Century Anglo-Saxon England: the Case of the Masham Column', *Hortus Artium Medievalium* **8**, 337–48

Hawkes, J., 2002b. 'The Plant-life of Early Christian Anglo-Saxon Art' in C. Biggam (ed.), *From Earth to Art: the Many Aspects of the Plant-World in Anglo-Saxon England*, Amsterdam, 257–80

Hawkes, J., 2003. '*Iuxta Morem Romanorum*: Stone and Sculpture in the Style of Rome' in G. Hardin Brown and C. Karkov (eds), *Anglo-Saxon Styles*, Albany NY, 69–100

Heath, M., 2004. *Menander: A Rhetor in Context*, Oxford

Hellenkemper, H. (ed.), 1979. *Trésors romains, trésors barbares: industrie d'art à la fin de l'Antiquité et au début du Moyen Age: une exposition des musées d'histoire*, Exhibition Catalogue, Brussels

Hellenkemper, H., 1987. 'Portrait Bust of a Prince' in Harden *et al.*, 1987, 24

Hellenkemper, H. 1990. 'Busto di un principe' in Sena Chiesa 1990, 43–4

Hendy, M.F., 1985. *Studies in the Byzantine Monetary Economy c.300–1450*, Cambridge

Henig, M., 1970. 'The Veneration of Heroes in the Roman Army', *Britannia* **1**, 249–65

Henig, M., 1972. 'The Aesica Amulet and its Significance', *Archaeologia Aeliana* 4th ser. **50**, 282–7

Henig, M., 1977. 'A Bronze Cube from Kingscote, Gloucestershire', *Antiq.J.* **57**, 319–21

Henig, M., 1978a. 'Bronze Steelyard Weight from a Roman Villa, Kingscote, Gloucestershire', *Antiq.J.* **58**, 370–1

Henig, M., 1978b. *A Corpus of Roman Engraved Gemstones from British Sites*, BAR British Series **8**, 2nd edition, Oxford

Henig, M., 1979. 'Late Antique Book Illustration and the Gallic Prefecture' in M.W.C. Hassall and R.I. Ireland (eds), *De Rebus Bellicis*, BAR International Series **63**, Oxford, 17–37

Henig, M. (ed.), 1983. *A Handbook of Roman Art. A Survey of the Visual Arts of the Roman World*, Oxford

Henig, M., 1984a. *Religion in Roman Britain*, London

Henig, M., 1984b. 'James Engleheart's Drawing of a Mosaic at Frampton', *Proceedings of the Dorset Natural History and Archaeological Society* **106**, 143–6

Henig, M., 1985. 'Graeco-Roman Art and Romano-British Imagination', *JBAA* **138**, 1–22

Henig, M., 1986a. 'The Statuary and Figurines' in R. Leech, 'The Excavation of a Romano-Celtic Temple and a Later Cemetery on Lamyatt Beacon, Somerset', *Britannia* **17**, 259–328, at 274–81

Henig, M., 1986b. '*Ita intellexit numine inductus tuo*: Some Personal Interpretations of Deity in Roman Religion' in Henig and King 1986, 159–69

Henig, M., 1990. *The Content Cameos. The Content Family Collection of Ancient Cameos*, Oxford and Houlton ME

Henig, M., 1993a. 'Ancient Cameos in the Content Family Collection' in Henig and Vickers 1993, 27–40

Henig, M., 1993b. 'Votive Objects: Images and Inscriptions' in Woodward and Leach 1993, 88–112

Henig, M., 1995. *The Art of Roman Britain*, London

Henig, M., 1998. 'The Temple as a *bacchium* or *sacrarium* in the Fourth Century' in Shepherd 1998, 230–2

Henig, M. and King, A. (eds), 1986. *Pagan Gods and Shrines of the Roman Empire*, OUCAM **8**, Oxford

Henig, M. and MacGregor, A., 2004. *Catalogue of the Engraved Gems and Finger-Rings in the Ashmolean Museum* **2**, *Roman*, Oxford

Henig, M. and Vickers, M. (eds), *Cameos in Context. The Benjamin Zucker Lectures, 1990*, Oxford and Houlton ME

Henkel, F., 1913. *Römische Fingerringe der Rheinlande und der benarchbarten Gebiete*, Berlin

Hettner, F., 1893. *Die römischen Steindenkmäler des Provinzialmuseums zu Trier*, Trier

Higgitt, J., 1973. 'The Roman Background to Medieval England', *JBAA* **36**, 1–15

Hilgers, W., 1969. *Lateinische Gefässnamen*, Düsseldorf

Himmelmann, N., 1973. *Typologische Untersuchungen an Römischen Sarkophagreliefs des 3. und 4. Jahrhunderts n.Chr.*, Mainz

Hoffmann, D., 1969–70. *Das spätrömische Bewegungsheer und die Notitia Dignitatum*, Düsseldorf

Hoffmann, P., 1999. *Römische Mosaike im Rheinischen Landesmuseum Trier*, Trier

Hoffmann, P., Hupe, J. and Goethert, K., 1999. *Katalog Der Römischen Mosaike aus Trier und dem Umland*, Trier

Hohl, E. (ed.), 1965. *Scriptores Historiae Augustae*, Leipzig

Holloway, R.R., 2004. *Constantine and Rome*, New Haven and London

Honoré, T., 1994. *Emperors and Lawyers*, 2nd edition, Oxford

Horn, H-G., 1989. 'Si per me misit, nil nisi vota feret. Ein römischer Spielturm aus Froitzheim', *Bonner Jahrbücher* **189**, 139–60

Horsnaes, H.W., 2003. 'The Coins in the Bogs' in L. Jørgensen, B. Storgaard and L.G. Thomsen (eds), *The Spoils of Victory, the North in the Shadow of the Roman Empire*, Copenhagen, 330–40

Howgego, C., 1995. *Ancient History from Coins*, London

Hubert, J., Porcher, J. and Volbach, W.F. (eds), 1970. *The Carolingian Renaissance*, New York

Huelsen, C., 1904. 'Neue Inschriften, Mitteilungen des Deutschen Archaeologischen Instituts', *Römische Abteilung* **19**, 142–53

Hummer, H.J., 1998. 'Franks and *Alamanni*: a Discontinuous Ethnogenesis' in I.N. Wood (ed.), *Franks and Alamanni in the Merovingian Period: an Ethnographic Perspective*, Woodbridge, 9–32

Humphrey, J.H., 1986. *Roman Circuses*, London

Hunt, E.D., 1982. *Holy Land Pilgrimage in Later Roman Empire AD 312–460*, Oxford

Hunter-Mann, K., 2005. 'Excavations at St Leonard's Hospital, York', *Yorkshire Archaeological Society Roman Antiquities Section Bulletin* **21**, 3–6

Hutchinson, V.J., 1986. *Bacchus in Roman Britain: the Evidence for his Cult*, Oxford

Ilkjaer, J., 2001. *Illerup Ådal – Archaeology as Magic Mirror*, Moesgård

Inan, J. and Alföldi-Rosenbaum, E., 1979. *Römische und Frühbyzantinische Porträtplastik aus der Türkei: Neue Funde*, Mainz

Isings, C., 1957. *Roman Glass from Dated Finds*, Groningen

Istrin, V.M., 1897. *Otkrovrenie Mefodia Patarskogo*, Moscow

Jackson, R.P.J. 2002. '27: Baldock Area, Hertfordshire: about 25 votive finds, including statuette, 19 plaques and jewellery (2002 T215)', *Treasure Annual Report 2002. 1 January–31 December 2002*, London, 38–42

James, M.R. (ed.), 1924. *The Apocryphal New Testament*, Oxford

Johns, C.M., 1981. 'The Risley Park Lanx: a Lost Antiquity from Roman Britain', *Antiq.J.* **61**, 53–72

Johns, C.M., 1984. 'A Christian Late Roman Gold Ring from Suffolk', *Antiq.J.* **64**, 393–4

Johns, C.M., 1996. *The Jewellery of Roman Britain*, London

Johns, C.M. and Painter, K.S., 1991. 'The Risley Park *lanx* "Rediscovered"', *Minerva* **2.vi**, 6–13

Johns, C.M. and Painter, K.S., 1995. 'The Risley Park Lanx: Bauge, Bayeux, Buch or Britain?' in F. Baratte, J-P. Caillet and C. Metzger (eds), *Orbis Romanus Christianusque ab Diocletiani aetate usque ad Heraclium: Travaux sur l'Antiquité Tardive rassemblés autour des recherches de Noël Duval*, Paris, 175–89

Johns, C.M. and Potter, T., 1983. *The Thetford Treasure: Roman Jewellery and Silver*, London

Johnson, S., 1976. *The Roman Ports of the Saxon Shore*, London

Johnson, S., 1980. *Later Roman Britain*, London

Jones, A.H.M., 1959. 'The Origin and Early History of the *Follis*', *JRS* **49**, London

Jones, A.H.M., 1964. *The Later Roman Empire 284–602*, Oxford

Jones, A.H.M., Martindale, J.R. and Morris, J. (eds), 1971. *Prosopography of the Later Roman Empire* **1**, AD 260–395, Cambridge

Jones, A.H.M. and Skeat, T.C., 1954. 'Notes on the Genuineness of the Constantinian Documents in Eusebius' *Life of Constantine*, *Journal of Ecclesiastical History* **5**, 196–200 (reprinted in P. A. Brunt (ed.), *The Roman Economy: Studies in Ancient Economic and Administrative History*, Oxford, 1974, 257–62)

Jullian, C., 1921. 'Un évêque du pays de Buch', *Revue des études anciennes* **23**, 128

Kastler, R., 2002. 'Legionslager an der Wende zur Spätantike – Ein Überblick zu Carnuntum und vergleichbaren kaiserzeitlichen Standlagern der Rhein-Donau-Raumes in einer Periode des Umbruchs' in P. Freeman, J. Bennett, Z.T. Fiema and B. Hoffmann (eds), *Limes XVIII: Proceedings of the XVIIIth International Congress of Roman Frontier Studies*, BAR International Series **1084**, Oxford, 605–24

Kaufmann-Heinimann, A., 1998. *Götter und Lararien aus Augusta Raurica* **26**, Augst

Keller, O., 1913. *Die antike Tierwelt* **2**, Leipzig

Kempf, Th.K., 1965. 'Die Frühchristlichen Graffiti aus dem chor der Liebfrauenkirche' in W. Reusch (ed.), *Frühchristliche Zeugnisse im Einzugsgebiet von Rhein und Mosel*, Exhibition Catalogue, Trier, 223–30

Kendrick, A.F., 1920. *Catalogue of Textiles from Burying-Grounds in Egypt* **1**, London

Kendrick, A.F., 1921. *Catalogue of Textiles from Burying-Grounds in Egypt* **2**, London

Kendrick, A.F., 1922. *Catalogue of Textiles from Burying-Grounds in Egypt* **3**, London

Kendrick, T.D., 1938. *Anglo-Saxon Art to A.D. 900*, London

Kent, J.P.C., 1978. *Roman Coins*, London

Kent, J.P.C. and Painter, K.S., 1977. *Wealth of the Roman World: Gold and Silver AD 300–700*, London

Kenyon, F.G. and Bell, H.I. (eds), 1907. *Greek Papyri in the British Museum* **3**, Milan and London

Kérdö, K., 1999. 'Die neuen Forschungen im Gebiet des Statthalterpalastes von Aquincum' in N. Gudea (ed.), *Roman Frontier Studies: Proceedings of the XVIIth International Congress of Roman Frontier Studies*, Zalau, 651–62

Keydell, R. (ed.), 1967. *Agathias, Historiarum Libri Quinque*, Berlin

Kisa, A., 1896. 'Römische Ausgrabungen an der Luxemburgerstraße', *Bonner Jahrbuch* **99**, 21–53

Kisa, A., 1908. *Das Glas im Altertume*, Leipzig

Kleiner, D.E.E., 1992. *Roman Sculpture*, New Haven and London

Kondoleon, C., 1979. 'An Openwork Gold Cup', *Journal of Glass Studies* **21**, 39–50

Kondoleon, C., 2000. *Antioch. The Lost Ancient City*, Princeton NJ

Kötzsche, L., 1979. 'Flagon with Scenes from the Old and New Testaments' in Weitzmann 1979, 431–3, no.389

Kozodoy, R., 1986. 'The Reculver Cross', *Archaeologia* **108**, 67–94

Krautheimer, R. (ed.), 1937–77. *Corpus Basilicarum Christianarum Romae*, 5 vols, Vatican City, Rome and London

Krautheimer, R., 1965. *Early Christian and Byzantine Architecture*, New Haven

Krautheimer, R., 1980. *Rome: Profile of a City 312–1308*, Princeton NJ

Krautheimer, R., 1983. *Three Christian Capitals*, Princeton NJ

Krug, A., 1980. 'Antike Gemmen im Römisch-Germanischen Museum Köln', *Bericht der Römisch-Germanischen Kommission* **61**, 151–260

Krusch, B. (ed.), 1888. Fredegar, Chronicle, *MGH: Scriptores Rerum Merovingicarum* **2**, Hanover

Krusch, B. and Levison, W. (eds), 1951. *Gregory of Tours, Decem Libri Historiarum, MGH: Scriptores Rerum Merovingicarum* **1**, Hanover

Kuhnen, H.P. (ed.), 1996. *Religio Romana*, Trier

Künzl, E. (ed.), 1993. *Die Alamannenbeute aus dem Rhein bei Neupotz*, Römisch-Germanisches Zentralmuseum Monographien **34.i**, Mainz

La Baume, P., 1964. *Römisches Kunstgewerbe zwischen Christi Geburt und 400*, Braunschweig

La Baume, P., 1967. 'Gürtelgarnitur' in O. Doppelfeld (ed.), *Römer am Rhein. Katalog der Ausstellung des Römisch-Germanischen Museums Köln*, Cologne, 311

Lamm, C.J. and Charleston, R.J., 1939. 'Some Early Egyptian Draw-Loom Weavings', *Bulletin de la Société d'Archéologie Copte* **5**, 193–9

Lander, J., 1984. *Roman Stone Fortifications: Variation and Change from the First Century AD to the Fourth*, BAR International Series **206**, Oxford

Lang, J., 1993. 'Survival and Revival in Insular Art: Northumbrian Sculpture of the 8th to 10th Centuries' in R.M. Spearman and J. Higgitt (eds), *The Age of Migrating Ideas*, Edinburgh and Stroud, 261–7

Lang, J., 2002. *Northern Yorkshire, CASSS* **6**, Oxford

Lasko, P., 1971. *The Kingdom of the Frank, North-West Europe Before Charlemagne*, London

Levison, W., 1946. *England and the Continent in the Eighth Century*, London

L'Huillier, M., 1992. *L'Empire des mots: orateurs gaulois et empereurs romains, 3e et 4e siècles*, Paris

Lieu, S., 1998. 'From History to Legend and Legend to History. The Medieval and Byzantine Transformation of Constantine's *Vita*', in Lieu and Montserrat 1998, 136–76

Lieu, S. and Montserrat, D. (eds), 1996. *From Constantine to Julian. Pagan and Byzantine Views. A Source History*, London

Lieu, S. and Montserrat, D. (eds), 1998. *Constantine: History, Historiography and Legend*, London

Lindgren, C., 1980. *Classical Art Forms and Celtic Mutations. Figural Art in Roman Britain*, Park Ridge NJ

Ling, R., 1991. *Roman Painting*, Cambridge

Liversidge, J., 1987. 'The Christian Wall-paintings' in Meates 1987, 22–40

Livrea, E., 1999. 'Chi é l'autore di *P. Oxy.* 4352?', *Zeitschrift für Papyrologie und Epigraphik* **125**, 69–73

Lloyd-Morgan, G., 1981. 'Roman Mirrors and the Third Century' in A. King and M. Henig (eds), *The Roman West in the Third Century. Contributions from Archaeology and History*, BAR International Series **109**, Oxford, 145–57

Loeschcke, S. and Willers, H., 1911. *Beschreibung Römischer Altertümer gesammelt von C. A. Niessen*, Cologne

Looker, J., 1998–9. 'Another Early Christian Tank/Font from Northamptonshire', *Northamptonshire Archaeology* **28**, 163–4

Lowden, J., 1992. 'Concerning the Cotton Genesis and Other Illustrated Manuscripts of Genesis', *Gesta* **31**, 40–53

Lysons, S., 1817. *Reliquiae Britannico Romanae. Containing Figures of Roman Antiquities Discovered in England* **2**, London

MacCormack, S., 1981. *Art and Ceremony in Late Antiquity*, Berkeley, Los Angeles and London

Macdonald, G., 1926. 'Note on some Fragments of Imperial Statues and of a Statuette of Victory', *JRS* **16**, 1–16

MacGregor, A., 1976. *Finds from a Roman Sewer System and a Building in Church Street*, The Archaeology of York **17.i**, London

Mackensen, M., 1995. *Das spätrömische Grenzkastell Caelius Mons in Kellmünz an der Iller*, Führer zu archäologischen Denkmälern in Bayern: Schwaben **3**, Stuttgart

Mackintosh, M., 1986. 'The Sources of the Horseman and Fallen Enemy Motif on the Tombstones of the Western Roman Empire', *JBAA* **139**, 1–21

Mac Lean, D., 1997. 'King Oswald's Wooden Cross at Heavenfield in Context' in C. Karkov, M. Ryan and R.T. Farrell (eds), *The Insular Tradition*, New York, 79–98

Macleod, F.T., 1914–15. 'Notes on Dun an Iardhard. A Broch near Dunvegan Excavated by Countess Vincent Baillet de Latour, Uiginish Lodge, Skye', *PSAS* **49**, 57–70

MacMullen, R., 1969. *Constantine*, New York

Maier, I.G., 2005. *Are there more Fragments of the Earliest Manuscript of the 'Notitia Dignitatum' near Walsingham?* http://members.ozemail.com.au/~igmaier/webnothw.htm

Mango, C., 1990. 'Constantine's Mausoleum and the Translation of Relics', *Byzantinische Zeitschrift* **83**, 51–61

Mango, C., 1994. 'The Empress Helena, Helenopolis, Pylae', *Travaux et Mémoires* **12**, 143–58

Mann, J. C., 1968. 'Review of "*Cornelii Taciti: De Vita Agricolae*", eds, R. M. Ogilvie and I. Richmond', *Archaeologia Aeliana* 4th ser. **46**, 306–8

Mann, J.C., 1998. 'The Creation of Four Provinces in Britain by Diocletian', *Britannia* **29**, 339–41

Manning, W.H., 1964. 'The Plough in Roman Britain', *JRS* **54**, London

Manning, W.H., 1972. 'Ironwork Hoards in Iron Age and Roman Britain', *Britannia* **3**, London

Manning, W.H., 1976. *Catalogue of the Romano-British Ironwork in the Museum of Antiquities, Newcastle upon Tyne*, Newcastle upon Tyne

Manning, W.H., 1984. 'The 1962 Hoard of Ironwork' in S.S. Frere, 'Excavations at Dorchester on Thames', *Arch.J.* **141**, 139–47

Manning, W.H., 1985. *Catalogue of the Romano-British Iron Tools, Fittings and Weapons in the British Museum*, London

Marrou, H.I., 1963. 'Synesius of Cyrene and Alexandrian Neoplatonism' in A. Momigliano, *The Conflict between Paganism and Christianity in the Fourth Century*, Oxford, 126–50

Marshall, F.H., 1907. *Catalogue of the Finger Rings, Greek, Etruscan and Roman, in the Departments of Antiquities, British Museum*, London

Martin, M., 1984. 'Esslöffel' (56–96); 'Weinsiebchen und Toilettengerät' (97–132) in Cahn and Kaufmann-Heinimann 1984, 56–132

Martin, M., 1997. 'Zwischen den Fronten: Alamannen im römischen Heer' in *Die Alamannen*, Exhibition Catalogue, Stuttgart, 119–24

Martin-Kilcher, S., 1984. 'Römisches Tafelsilber: Form- und Funktionsfragen' in Cahn and Kaufmann-Heinimann 1984, 393–404

Mason, D.J.P., 2001. *Roman Chester: City of the Eagles*, Stroud

Matthews, J.F., 1989. *The Roman Empire of Ammianus*, London

Mawer, C.F., 1995. *Evidence for Christianity in Roman Britain. The Small Finds*, BAR British Series **243**, Oxford

May, R. (ed.), 1991. *Jouer dans l'Antiquité*, Marseilles

Mayer, E., 2002. *Rom ist dort, wo der Kaiser ist: Untersuchungen zu den Staatsdenkmälern des dezentralisierten Reiches von Diocletian bis zu Theodosius II*, Römisch-Germanisches Zentralmuseum Monographien **53**, Mainz

McLynn, N., 2004. 'The Transformation of Imperial Churchgoing in the Fourth Century' in Swain and Edwards 2004, 235–70

Meates, G.W. (ed.), 1987. *The Roman Villa at Lullingstone, Kent* **2**, *The Wall Paintings and Finds*, Kent Archaeological Society Monograph **3**, Maidstone

Mendelssohn, L. (ed.), 1887. *Zosimus, Historia Nova*, Leipzig

Menzel, H., 1960. *Die Römischen bronzen aus Deutschland* **1**, *Speyer*, Mainz

Merrifield, R., 1998. 'A Mithraic Interpretation for the Silver Casket and

Strainer' in Shepherd 1998, 233–6

Merten, H., 1990. *Die Frühchristlichen inschriften*, Trier

Middleton, S.H., 1991. *Engraved Gems from Dalmatia from the Collections of Sir John Gardner Wilkinson and Sir Arthur Evans*, University Committee for Archaeology Monograph **3**, Oxford

Miescher, R., 1953. 'A Late Roman Portrait Head', *JRS* **43**, 101–3

Milburn, R., 1988. *Early Christian Art and Architecture*, Aldershot

Millar, F., 1977. *The Emperor in the Roman World*, London

Millar, F.G.B., 1983. 'Empire and City, Augustus to Julian: Obligations, Excuses and Status', *JRS* **73**, 76–96 (reprinted in Cotton and Rogers 2004, 336–71)

Millar, F.G.B., 1992. *The Emperor in the Roman World 31 BC to AD 337*, 2nd edition, London

Millar, F.G.B., 2000. 'Trajan: Government by Correspondence' in J. Gonzalez (ed.), *Trajano Emperador de Roma*, Madrid, 363–88 (reprinted in Cotton and Rogers 2004, 23–46)

Mills, K. and Grafton, A. (eds), 2003. *Conversion in Late Antiquity and the Early Middle Ages; Seeing and Believing*, Rochester, NY

Mirković, M., 1997. *The Later Roman Colonate and Freedom, Transactions of the American Philosophical Society* **87.ii**, Philadelphia

Mitchell, S., 1988. 'Maximinus and the Christians in AD 312: a New Inscription', *JRS* **78**, 105–24

Mitchell, S., 1998. 'The Cities of Asia Minor in the Age of Constantine' in S.N.C. Lieu and D. Montserrat (eds), *Constantine: History, Historiography and Legend*, London and New York

Mitchelson, N., 1964. 'Roman Malton. The Civilian Settlement. Excavations in Orchard Field 1949–1952', *Yorkshire Archaeological Journal* **41**, 209–61

Mitrev, G., 2003. 'Civitas Heracleotarum: Heraclea Sintica or the Ancient City at the Village of Rupite (Bulgaria)', *Zeitschrift für Papyrologie und Epigraphik* **145**, 263–72

Mols, S.T.A.M., 1999. *Wooden Furniture in Herculaneum: Form, Technique and Function*, Amsterdam

Mommsen, T. (ed.), 1892. *Prosper Tiro, Chronicle, MGH: Auctores Antiquissimi* **9**, *Chronica Minora* **1**, Berlin

Morin, G., 1898. 'Le *Missorium* de Saint Exupère. Notice sur un plateau offert à l'Eglise de Bayeux par son évêque', *Mélanges d'Archéologie et d'Histoire* **18**, 363–79

Morin, J., 1923. *La Verrerie en Gaule sous l'Empire Romain Nogent-le-Roi* (reprinted 1977, Paris)

Morris, R., 1986. 'Alcuin, York and the *Alma Sophia*' in L. Butler and R. Morris (eds), *The Anglo-Saxon Church: Papers on History, Architecture and Archaeology in Honour of Dr. H.M. Taylor*, CBA Research Report **60**, London, 80–9

Morris, R., 1989. *Churches in the Landscape*, London

Morris, R. and Roxan, J., 1980. 'Churches on Roman Buildings' in W. Rodwell (ed.), *Temples, Churches and Religion: Recent Research in Roman Britain*, BAR British Series **77**, Oxford, 175–209

Mundell Mango, M., 1986. *Silver from Early Byzantium: The Kaper Koraon and Related Treasures*, Baltimore

Mundell Mango, M., 1994. 'Silver-gilt Ewer from Traprain Law' in Buckton 1994, 51

Munier, C. and Gaudemet, J. (eds), 1977. *Conciles gaulois du IVe siècle*, Sources Chrétiennes **241**, Paris

Musty, J. and Barker, P., 1974. 'Three *plumbatae* from Wroxeter, Shropshire', *Antiq.J.* **54**, 275–7

Musurillo, H.H., 1972. *The Acts of the Christian Martyrs*, Oxford

Mynors, R.A.B. (ed.), 1964. *Panegyricus Latinus*, Oxford

Nash-Williams, V.E., 1950. *Early Christian Monuments of Wales*, Cardiff

Naumann-Steckner, F., 1990. 'Guarnizioni di cintura' in Sena Chiesa 1990, 63–4, no.I.e.8a

Neal, D.S., 1981. *Roman Mosaics in Britain. An Introduction to their Schemes and a Catalogue of Paintings*, London

Neal, D.S. and Cosh, S.R., 2002. *Roman Mosaics of Britain* **1**, *Northern Britain*, London

Nersessian, V., 1978. *The Christian Orient*, London

Neville, R.C., 1856. 'Description of a Remarkable Deposit of Roman Antiquities of Iron, Discovered at Great Chesterford, Essex, in 1854', *Arch.J.* **13**, 1–13

Neyses, A., 2001. *Die Baugeschichte der ehemaligen Reichsabtei St. Maximin bei Trier*, Kataloge und Schriften des Bischöflichen Dom- und Diözesan Museums Trier **6.i-ii**, Trier

Nielsen, I., 1990. *Thermae et Balnea: The Architecture and Cultural History of Roman Public Baths*, Aarhus

Nixon, C.E.V. and Rodgers, B.S., 1994. *In Praise of Later Roman Emperors, The Panegyrici Latini*, Berkeley, Los Angeles and London

Noble, T.F.X., 1984. *The Republic of St Peter: the Birth of the Papal State, 680–825*, Philadelphia

Noll, R., 1980. *Das Inventar des Dolichenusheilgitums von Mauer an der url (Noricum)*, Der Römische Limes in Österreich **30**, Vienna

Norton, C., 1998. 'The Anglo-Saxon Cathedral at York and the Topography of the Anglian City', *JBAA* **151**, 1–42

Oakeshott, W., 1967. *The Mosaics of Rome*, London

Oaks, L.S., 1986. 'The Goddess Epona: Concepts of Sovereignty in a Changing Landscape' in Henig and King 1986, 77–83

Odobesco, A., 1889–1900. *Le trésor de Petrossa*, Paris

Ó Carragáin, É., 1994. *The City of Rome and the World of Bede*, Jarrow Lecture, Jarrow

Ó Carragáin, É., 1999. 'The Term *Porticus* and *Imitatio Romae* in Early Anglo-Saxon England' in H. Conrad O'Brian, A.M. D'Arcy and J. Scattergood (eds), *Text and Gloss: Studies in Insular Learning and Literature Presented to Joseph Donovan Pheifer*, Dublin, 13–34

Oelmann, F., 1932a. 'Bericht über die Tatigkeit des Provinzialmuseums in Bonn vom 1 April 1930 bis März 1931', *Bonner Jahrbucher* **126/137**, 273–311

Oelmann, F., 1932b. 'Bericht über die Tatigkeit des Provinzialmuseums in Bonn vom 1 April 1931 bis 31 März 1932', *Bonner Jahrbucher* **126/137**, 312–51

Ogden, J., 1992. 'Gold in Antiquity', *Interdisciplinary Science Reviews* **17**, 261–70

Omont, H., 1891. *Le plus ancien manuscrit de la 'Notitia Dignitatum'*, Mémoires de la Société nationale des Antiquaires de France **51**, 225–44

Omont, H., 1909. *Code Théodosien: livres VI–VIII. Reproduction réduite du manuscrit en onciale, latin 9643 de la Bibliothèque Nationale*, Paris

O'Reilly, J., 1992. 'The Trees of Eden in Medieval Iconography' in P. Morris and D. Sawyer (eds), *A Walk in the Garden: Biblical, Iconographical and Literary Images of Eden*, Sheffield, 167–204

Ottaway, P., 1996. *Excavations and Observations on the Defences and Adjacent Sites*, The Archaeology of York, The Legionary Fortress **3.iii**, London

Ottaway, P., 2004. *Roman York*, 2nd edition, Stroud

Painter, K.S., 1973. 'A Roman Silver Treasure from Biddulph, Staffffordshire', *Rivista di Archeologia Cristiana* **49**, 195–210

Painter, K.S., 1975a. 'A Roman Silver Treasure from Biddulph, Staffordshire', *Antiq.J.* **55**, 62–70

Painter, K.S., 1975b. 'A Fourth-Century Christian Silver Treasure found at Water Newton, England, in 1975', *Rivista di Archeologia Cristiana* **51**, 333–45

Painter, K.S. (ed.), 1977. *The Water Newton Early Christian Silver*, London

Painter, K.S., 1999. 'The Water Newton Silver: Votive or Liturgical?', *JBAA* **152**, 1–23

Pattie, T.S. and McKendrick, S. (eds), 1999. *The British Library Summary Catalogue of Greek Manuscripts* **I**, London

Peers, C.R., 1927. 'Reculver, its Saxon Church and Cross', *Archaeologia* **77**, 201–18

Penhallurick, R.D., 1986. *Tin in Antiquity. Its Mining and Trade throughout the Ancient World with Particular Reference to Cornwall*, London

Perrin, R., 1975. 'A Study of the Roman Pottery from an Excavation of the Roman Civil Baths, York, in 1939 (Air Raid Control Shelter Site)', unpublished MLitt Thesis, University of Newcastle upon Tyne

Perrin, R. 1990. *Roman Pottery from the Colonia 2: General Accident and Rougier Street*, The Archaeology of York, The Pottery **16.vi**, London

Perring, D., 2003. '"Gnosticism" in Fourth-century Britain: the Frampton Mosaics Reconsidered', *Britannia* **34**, 97–127

Petch, D.F., 1961. 'A Roman Lead Tank, Walesby', *Lincolnshire Architectural and Historical Society Reports and Papers* **9**, 13–15

Petts, D., 2003. *Christianity in Roman Britain*, Stroud

Phillips, D. and Heywood, B., 1995. *Excavations at York Minster* **1**, *From Roman Fortress to Norman Cathedral*, London

Phillips, E.J., 1977. *CSIR. GB* **I**. Fascicule 1. *Corbridge. Hadrian's Wall East of the North Tyne*, Oxford

Pichlmayr, F.R. (ed.), 1961. 'Epitome de Caesaribus', in *Sexti Aurelii Victoris Liber de Caesaribus*, Leipzig; trans. H.W. Bird, Liverpool, 1994

Pietri, C., 1983. 'Constantin en 324. Propagande et théologie imperiales d'après les documents de la *Vita Constantini*', in *Crise et redressement dans les provinces européennes de l'Empire (milieu du IIIe–milieu du IVe siécle ap. J.C.), Actes du colloque de Strasbourg (décembre 1981)*, Strasbourg, 1998), 63–90 (reprinted in C. Pietri, *Christiana Respublica: Eléments d'une enquête sur le christianisme antique*, Coll. de l'école française de Rome 234 (Paris), **I**, 253–80

Pirzio Biroli Stefanelli, L., 1965. 'I tesori di argenteria rinvenuti in Gran Bretagna ed in Irlanda', *Archaeologia Classica* **17**, 92–125

Pitts, L.F., 1979. *Roman Bronze Figurines from the Civitates of the Catuvellauni and Trinovantes*, BAR British Series **60**, Oxford

Potter, T.W. and Johns, C.M., 1986. 'The Tunshill Victory', *Antiq.J.* **66**, 390–2

Potter, T.W. and Johns, C.M., 1992. *Roman Britain*, London

Price, J., 1995. 'Glass Tablewares with Wheel-cut, Engraved and Abraded Decoration in Britain in the Fourth Dentury AD in D. Foy (ed.), *Le verre de l'Antiquite tardive et du Haut Moyen Age*, Cergy-Pontoise, 25–33

Pritchard, F., 2001. 'Medieval Textiles in the Bock Collection at the Whitworth Art Gallery', *Textile History* **32.i**, 48–60

Provost, M., 1988. *Carte archéologique de la Gaule44: La Loire-Atlantique*, Paris

Reece, R., 2002. *The Coinage of Roman Britain*, Stroud

Rees, R., 2002. *Layers of Loyalty in Latin Panegyrics, AD 289–307*, Oxford

Rees, S.E., 1979. *Agricultural Implements in Prehistoric and Roman Britain*, BAR British Series **69**, Oxford

Rees, T. and Hunter, F., 2000. 'Archaeological Excavation of a Medieval Structure and an Assemblage of Prehistoric Artefacts from the Summit of Traprain Law, East Lothian, 1996–7', *PSAS* **130**, 413–40

Reinach, T., 1921. 'Un important trésor d'argenterie romaine', *Comptes Rendus de l'Académie des Inscriptions et Belles-Lettres* 1921, 333

Richardson, L., 1992. *A New Topographical Dictionary of Ancient Rome*, Baltimore and London

Richmond, I.A., 1940. 'The Barbaric Spear from Carvoran', *Proceedings of the Society of Antiquaries of Newcastle upon Tyne* 4th ser. **9**, 136–8

Richmond, I.A., 1944. 'Three Fragments of Roman Official Statues, From York, Lincoln, and Silchester', *Antiq.J.* **24**, 1–9

Richmond, I. A., 1962. 'Introduction: the Roman Legionary Fortress and City at York' in RCHMY **1**, xxix–xxxix

Richmond, I.A., 1969. *Roman Archaeology and Art. Essays by Sir Ian Richmond*, P. Salway (ed.), London

Richter, G.M.A., 1971. *Engraved Gems of the Romans*, London

Rinaldi-Tufi, S., 1983. *CSIR. GB* **I**, Fascicule 3, *Yorkshire*, Oxford

Rinaldi-Tufi, S., 2005. 'Ritratto di Costantino' in A. Donati and G. Gentili, *Constantino il Grande. La civilta antica al bivio tra Occidente e Oriente*, Exhibition Catalogue, Rimini 2005, Milan, 288–9, no.131

Ristow, S. (ed.), 2004. *Neue Forschungen zu den Anfängen des Christentums im Rheinland. Jahrbuch für Antike und Christentum*, Ergänzungsband, Kleine Reihe **2**, Münster

Rivet, A.L.F. and Smith, C., 1979. *The Place-Names of Roman Britain*, London

Rix, M.M., 1960. 'The Wolverhampton Cross Shaft', *Arch.J.* **117**, 71–81

Rizzardi, C., 1996. *The Mausoleum of Galla Placidia, Ravenna*, Modena

Roach Smith, C., 1880. *Collectanea Antiqua* **7**, privately printed

Roberts, P.C., 1996. *Romans, a Pocket Treasury*, London

Robertson, A.S., 1975. 'The Romans in North Britain: the Coin Evidence' in H. Temporini and W. Haase (eds), *Aufstieg und Niedergang des Römischen Welt* **2.iii**, 364–426

Robertson, A.S., Hobbs, R. and Buttrey, T.V., 2000. *An Inventory of Romano-British Coin Hoards*, Royal Numismatic Society Special Publication **20**, London

Rohrbacher, D., 2002. *The Historians of Late Antiquity*, London

Rolfe, J.C. (ed.), 1935–9. *Ammianus Marcellinus*, Cambridge MA

Ross, A., 1967. *Pagan Celtic Britain*, London

Ross, M.C., 1962. *Catalogue of the Byzantine and Early Medieval Antiquities in the Dumbarton Oaks Collection*, Washington DC

Routh, T.E., 1937. 'A Corpus of the Pre-Conquest Carved Stones of Derbyshire', *Derbyshire Archaeological Journal* **58**, 1–46

Rubin, Z., 1982. 'The Church of the Holy Sepulchre and the Conflict between the Sees of Caesarea and Jerusalem', *Jerusalem Cathedra*, **2**, 79–105

Russell, D.A. and Wilson, N.G., 1981. *Menander Rhetor*, Oxford

Russell, J., 1985. 'The Keynsham Roman Villa and its Hexagonal Triclinium', *Bristol and Avon Archaeology* **4**, 6–12

Şahin, Ş., 1981. *Die Inschriften von Stratonikeia 1*: Panamara, Inschriften griechischer Städte aus Kleinasien **22**, Bonn

Şahin, Ş., 1994. *Die Inschriften von Arykanda*, Inschriften griechischer Städte aus Kleinasien **22**, Bonn

Salmonson, J.W., 1964. 'Ein Porträtkopf der Tetrarchenzeit in Leiden', *BABesch* **39**, 180–4

Salway, P., 1981. *Roman Britain*, Oxford

Salzman, M., 2002. *The Making of the Christian Aristocracy. Social and Religious Change in the Western Roman Empire*, Cambridge, MA.

Salzmann, D., 1990. 'Antike Porträts im Römisch-Germanischen Museum Köln', *Kölner Jahrbuch für Vor- und Frühgeschichte* **23**, 131–220

Sarnowski, T., 1999. 'Die Principia von Novae im späten 4. und früher 5. Jh.', in G. von Bülow and A. Milceva (eds), *Der Limes an der unteren Donau von Diokletian bis Heraklios*, Sofia, 56–63

Sauer, E., 2003. *The Archaeology of Religious Hatred*, Stroud

Saxl, F. and Wittkower, R., 1948. *British Art and the Mediterranean*, London

Scherrer, P., 2003. 'Savaria' in M.S. Kos and P. Scherrer (eds), *The Autonomous Towns of Noricum and Pannonia*, Situla **41**, Ljubljana, 53–80.

Schlumberger, J., 1974. *Die Epitome de Caesaribus*, Munich

Schmidt-Colinet, A., Stauffer, A., al-As'ad, K., 2000. *Die Textilien aus Palmyra*, Mainz

Schnabel, P., 1926. *Der verlorene Speierer Codex des Itinerarium Antonini, der Notitia Dignitatum und anderer Schriften*, SPAW phil.-hist. Klasse **29**, 242–57

Schrenk, S., 2000. 'Die spätantiken Seiden in der Schatzkammer des Kölner Doms', *Kölner Domblatt* **66**, 83–118

Schulten, W., 1980. *Der Kölner Domschatz*, Cologne

Schulze, M., 1980. 'Gürtelgarnitur' in H.C. Kurt Böhner (ed.), *Gallien in der Spätantike Kaiser Constantin zu Frankenkönig Childerich*, Exhibition Catalogue, Römisch-Germanischen Zentralmuseum, Mainz, 65–7

Scott, S., 2000. *Art and Society in Fourth-century Britain*, Oxford

Scullard, H.H., 1979. *Roman Britain: Outpost of the Empire*, London

Seeck, O. (ed.), 1876. *Notitia Dignitatum*, Berlin

Seeck, O. (ed.), 1883. *Symmachus, Orationes*, Berlin

Sekulla, M.F., 1982. 'The Roman Coins from Traprain Law', *PSAS* **112**, 285–94

Sena Chiesa, G. (ed.), 1990. *Milano Capitale dell' Impero Romano 286–402 DC*, Exhibition Catalogue, Milan

Shelton, K.J., 1981. *The Esquiline Treasure*, London

Shelton, K.J., 1985. 'The Esquiline Treasure: The Nature of the Evidence', *American Journal of Archaeology* **89**, 147–55

Shepherd, J. (ed.), 1998. *The Temple of Mithras London. Excavations by W.F. Grimes and A. Williams at the Walbrook*, English Heritage Archaeological Report **12**, London

Sherlock, D., 1973. 'Zu einer Fundliste antiker Silberlöffel. Nachträge und Ergänzungen', *Bericht der Römisch-Germanische Kommission* **54**, 203–11

Shiels, N., 1977. *The Episode of Carausius and Allectus*, BAR British Series **40**, Oxford

Silli, P., 1987. *Testi Costantiniani nelle fonti letterarie*, Milan

Simon, E. and Bauchhenss, G., 1984. 'Ares/Mars', *LIMC* **2**, 505–80

Skeat, T.C., 1953. 'Two Byzantine Documents', *British Museum Quarterly* **18**, 71–3

Skeat, T.C. (ed.), 1964. *Papyri from Panopolis in the Chester Beatty Library Dublin*, Dublin

Smallwood, E.M., 1976. *The Jews under Roman Rule*, Leiden

Smith, C., 1983. 'Vulgar Latin in Roman Britain: Epigraphic and Other Evidence' in H. Temporini and W. Haase (eds), *Aufstieg und Niedergang der Römischen Welt* **2.29**, 893–948

Smith, D.J., 1977. 'Mythological Figures and Scenes in Romano-British Mosaics' in J. Munby and M. Henig (eds), *Roman Life and Art in Britain*, BAR British Series **41**, Oxford, 105–93

Smith, D.J., 1983. 'Mosaics' in Henig 1983, 116–38

Smith, L.T. (ed.), 1964. *The Itinerary of John Leland in or about the Years 1535–1543*, 5 vols, London

Smith, R.R.R., 1997. 'The Public Image of Licinius I: Portrait Sculpture and Imperial Ideology in the Early Fourth Century', *JRS* **87**, 170–202

Souris, G.A., 1989. 'Pros ta ikhnê tôn autokratorôn: Mia presbeia apo tên Hermoupolê tês Aiguptou sta melê tês prôtês Tetrarkhias', *Hellênika* **40**, 153–60

Southern, P. and Dixon, K., 2000. *The Late Roman Army*, London

Southern, P., 2004. 'The Army in Late Roman Britain' in M. Todd (ed.), *A Companion to Roman Britain*, Oxford, 393–408

Sparey Green, C.J., 1993. 'The Mausolea Painted Plaster' in D.E. Farwell and T.L. Molleson (eds), *Excavations at Poundbury 1966–80 2, The Cemeteries*, Dorset Natural History and Archaeological Society Monograph **2**, Dorchester, 135–40

Speidel, M.P., 1986, 'The Early *protectores* and their *beneficiarius* Lance', *Archäologisches Korrespondenzblatt* **16**, 451–3

Spiess, A., 1988. 'Studien zu den Römischen reliefsarkophagen aus den provinzen Germania Inferior und Superior, Belgica und Raetia, *Kölner Jahrbuch* **21**, 253–324

Stern, H., 1953. *Le Calendrier de 354. Etude sur son texte et ses illustrations*, Paris

Stevens, C.E., 1947. 'A Possible Conflict of Laws in Roman Britain', *JRS* **37**, 132–4

Stevenson, J., 1998. 'Constantine, St Aldhelm and the Loathly Lady', in Lieu and Montserrat 1998, 189–206

Stiglitz, H., Kandler, M. and Jobst, W., 1977. 'Carnuntum' in H. Temporini and W. Haase (eds), *Aufstieg und Niedergang der Römischen Welt II, Principat* **6**, 583–730

Stirling, L.M., 2005. *The Learned Collector. Mythological Statuettes and Classical Taste in Late Antique Gaul*, Ann Arbor MI

Straub, S., 1881. *Le Cimetière Gallo-Romain de Strasbourg*, Strasbourg

Stroheker, K.F., 1965a. 'Alamannen im Römischen Reichsdeinst' in K.F. Stroheker (ed.), *Germanentum und Spätantike*, Zurich, 30–53

Stroheker, K.F., 1965b. 'Zur Rolle der Heermeister Fränkischer Abstammung im späten vierten Jahrhundert' K.F. Stroheker (ed.), *Germanentum und Spätantike*, Zurich, 9–29

Strong, D.E., 1966. *Greek and Roman Gold and Silver Plate*, London

Stuart, P. (ed.), 1971. *Deae Nehalenniae*, Middelburg

Stukeley, W., 1736. *An Account of a Large Silver Plate of Antique Basso Rielievo, Roman Workmanship, Found in Derbyshire, 1729*, London

Stutzinger, D., 1983. 'Silberkanne' in H. Beck and P.C. Bol (eds), *Spätantike und frühes Christentum*, Frankfurt, 665–6, no.241

Sumpter, A.B. and Coll, S., 1977. *Interval Tower SW5 and the South-west Defences: Excavations 1972–75*, The Archaeology of York, The Legionary Fortress **3.ii**, London

Sunter, N. and Brown, D., 1988. 'Metal Vessels' in Cunliffe 1988, 9–21

Swain, S. and Edwards, M. (eds), 2004. *Approaching Late Antiquity. The Transformation from Early to Late Empire*, Oxford

Swanton, M.J., 1973. *The Spearheads of the Anglo-Saxon Settlements*, London

Syme, R., 1958. *Tacitus*, Oxford

Taylor, H.M. and Taylor, J., 1965. *Anglo-Saxon Architecture*, 2 vols, Cambridge

Taylor, M.V., 1914. 'Topographical Index of Romano-British Remains', *Victoria County History: Hertfordshire* **4**, 147–72

Thomas, A.C., 1981. *Christianity in Roman Britain to AD 500*, London

Thomas, A.C., 1998. *Christian Celts. Messages and Images*, Stroud

Timby, J.R., 1998. *Excavations at Kingscote and Wycomb, Gloucestershire*, Cirencester

Todd, M. 1981. *Roman Britain, 55 BC – AD 400. The Province beyond the Ocean*, London

Tomlin, R.S.O., 1988. 'The Curse Tablets' in Cunliffe 1988, 59–77

Tomlin, R.S.O., 2000. 'The Legions in the Late Empire' in R.J. Brewer (ed.), *Roman Fortresses and their Legions*, Occasional Papers of the Society of Antiquaries of London **20**, London, 159–81

Tomlin, R.S.O., 2003. 'The Girl in Question: a New Text from Roman London', *Britannia* **34**, 41–51

Tomlin, R.S.O., 2004. 'A Bilingual Roman Charm for Health and Victory', *Zeitschrift für Papyrologie und Epigraphik* **149**, 259–66

Tomlin, R.S.O. and Hassall, M.W.C., 2000. 'Roman Britain in 1999, II: Inscriptions', *Britannia* **31**, 433–49

Tomlin, R.S.O. and Hassall, M.W.C., 2004. 'Roman Britain in 2003, III: Inscriptions', *Britannia* **35**, 335–49

Toynbee, J.M.C., 1962. *Art in Roman Britain*, London

Toynbee, J.M.C., 1964a. 'A New Roman Mosaic found in Dorset', *JRS* **54**, 7–14

Toynbee, J.M.C., 1964b. *Art in Britain under the Romans*, Oxford

Toynbee, J.M.C., 1973. *Animals in Roman Life and Art*, London

Toynbee, J.M.C. 1978. 'A Londinium Votive Leaf or Feather and its Fellows' in Bird *et al.* 1978, 128–47

Toynbee, J.M.C., 1986. *Roman Medallions*, New York

Toynbee, J.M.C. and Painter, K.S., 1986, 'Silver Picture Plates of Late Antiquity: A.D. 300 to 700', *Archaeologia* **108**, 15–65

Trilling, J., 1982. *The Roman Heritage: Textiles from Egypt and the E. Mediterranean 300 to 600 AD* (also published as *Textile Museum Journal* **21**), Washington DC.

Tweddle, D., Biddle, M. and Kjølbye-Biddle, B., 1995. *South-East England*, *CASSS* **4**, Oxford

Underwood, R., 1999. *Anglo-Saxon Weapons and Warfare*, Stroud

Urlichs, L., 1844. 'Eine Römische Bildnissfigur aus Amethyst', *Bonner Jahrbucher* **4**, 185–92

Vagi, D., 2002. *A Highly Important Collection of Roman and Byzantine Gold Coins, Property of a European Nobleman*, Numismatica Ars Classica Auction **24**, Zürich

Van Dam, R., 2003. 'The Many Conversions of the Emperor Constantine', in Mills and Grafton 2003, 127–51

Vermaseren, M.J., 1948. 'A Mithraic Brooch in the Ashmolean Museum at Oxford', *Antiq.J.* **28**, 177–9

Vermaseren, M.J., 1977. *Cybele and Attis. The Myth and the Cult*, London

Vermeule, C. and von Bothmer, D., 1956. 'Notes on a New Edition of Michaelis' Ancient Marbles in Great Britain. Part Two', *American Journal of Archaeology* **60**, 321–50

Vieillard-Trogekouroff, M., 1978. 'Les fouilles de la basilique funéraire d'Andernos', *Cahiers Archéologiques* **27**, 8–19

Volbach, W.F., 1961. *Early Christian Art. The Late Roman and Byzantine Empires from the Third to the Seventh Centuries*, London

Von Petrikovits, H. (ed.), 1963. *Aus Rheinischer Kunst und Kultur. Auswahlkatalog des Rheiischen Landesmuseums Bonn*, Bonn

Von Petrikovits, H., 1975. *Die Innenbauten römischer Legionslager während der Prinzipatszeit*, Opladen

Von Sydow, W., 1969. *Zur Kunstgeschichte des spätantiken Porträts im 4. Jhd. n. Chr.*, Bonn

Walden, C., 1990. 'The Tetrarchic Image', *Oxford Journal of Archaeology* **9**, 221–35

Walker, S. and Bierbrier, M., 1997. *Ancient Faces: Mummy Portraits from Roman Egypt*, British Museum Exhibition Catalogue, London

Walraff, M., 2001. 'Constantine's Devotion to the Sun after 324', *Studia Patristica* **34**, 256–69

Walters, H.B., 1899. *Catalogue of Bronzes, Greek, Roman and Etruscan in the Department of Greek and Roman Antiquities, British Museum*, London

Walters, H.B., 1921. *Catalogue of the Silver Plate (Greek, Etruscan and Roman) in the British Museum*, London

Walters, H.B., 1926. *Catalogue of the Engraved Gems and Cameos, Greek, Etruscan and Roman, in the British Museum*, London

Wardman, A., 1986. 'Pagan Priesthoods in the Later Empire' in Henig and King 1986, 257–62

Ward-Perkins, J.B., 1981. *Roman Imperial Architecture*, Harmondsworth

Watts, D., 1988. 'Circular Lead Tanks and their Significance for Romano-British Christianity', *Antiq.J.* **68**, 210–22

Watts, D., 1991. *Christians and Pagans in Roman Britain*, London

Watts. D., 1995. 'A New Lead Tank Fragment from Brough, Notts, (Roman Crococalana)', *Britannia* **26**, 318–22

Watts, D., 1998. *Religion in Late Roman Britain: Forces of Change*, London

Weber, W., 1990, *Der Quadrathaus des Trierer Domes und sein Römischen Palast unter dem Trierer Dom*, Bischofliches Dom- und Diözesanmuseum Trier Müseumsführer **1**, Trier

Weber, W., 2000. *Constantinische Deckengemälde aus dem Römischen Palast unter dem Trierer Dom*, Trier

Weber, W., 2004. 'Neue Forschungen zur Trierer Domgrabung. Die archäologischen Ausgrabungen im Garten der Kurie von der Leyen' in Ristow 2004, 225–-34

Webster, T.B.L., 1929. 'The Wilshere Collection at Pusey House in Oxford', *JRS* **19**, London, 150–4

Weiss, P., 2003. 'The Vision of Constantine', *JRA* **16**, 237–59

Weitzmann, K. (ed.), 1979. *Age of Spirituality. Late Antique and Early Christian Art, Third to Seventh Century*, Exhibition Catalogue, Metropolitan Museum of Art, New York

Weitzmann, K. and Kessler, H.L., 1986. *The Cotton Genesis* I, Princeton NJ

Wenham, L.P., 1974. *Deventio (Malton). Roman Fort and Civilian Settlement*, Malton

Wenskus, R., 1961. *Stammesbildung und Verfassung. Das Werden der frühmittelalterlichen Gentes*, Cologne

Werner, M., 1990. 'The Cross-Carpet Page in the Book of Durrow: the Cult of the Cross, Adomnan, and Iona', *Art Bulletin* **72**, 174–223

Wheeler, R.E.M., 1943. *Maiden Castle, Dorset*, Report of the Research Committee, Society of Antiquaries of London **12**, Oxford

Whitehouse, D.B., 1988. 'A Recently Discovered Cage Cup', *Journal of Glass Studies* **30**, 28–33

Wightman, E.M., 1970. *Roman Trier and the Treveri*, London

Wild, J.P., 1964. 'The Textile Term *scutulatus*', *Classical Quarterly* new ser. **14**, 263–6

Wild, J.P., 1970. *Textile Manufacture in the Northern Roman Provinces*, Cambridge

Wild, J.P., 1987. 'The Roman Horizontal Loom', *American Journal of Archaeology* **91**, 459–71

Wild, J.P., 1989. 'Roman Silk and the Horizontal Loom in the Maas-Rhine Region' in *Middeleeuws Textiel, in het Bijzonder in het Euregiogebied Maas-Rijn*, Proceedings of the Congress at Alden Biesen 1989, Sint-Truiden, 209–21

Willis, W.H. and Maresch, K., 1997. *The Archive of Ammon Scholasticus of Panopolis* **1**, Papyrologica Coloniensia **26.i**, Opladen

Winkelmann, F., 1962. *Die Textbezeugung der Vita Constantini des Eusebius von Caesarea*, Texte unde Untersuchungen zur Geschichte der altchristlichen Literatur **84**, Berlin

Witt, R.E., 1971. *Isis in the Graeco-Roman World*, London

Wood, N., 1996. *The House of the Tragic Poet: A Reconstruction*, London

Woodward, A. and Leach, P. (eds), 1993. *The Uley Shrines. Excavation of a Ritual Complex on West Hill, Uley, Gloucestershire, 1977–9*, London, 88–112

Woolf, G., 2003. 'Seeing Apollo in Roman Gaul and Germany' in S. Scott and J. Webster (eds), *Roman Imperialism and Provincial Art*, Cambridge, 139–-52

Woolley, L., 2001. 'Medieval Mediterranean Textiles in the Victoria and Albert Museum: Resist Dyed Linens from Egypt Dating from the Fourth to the Seventh Centuries A.D.', *Textile History* **32.i**, 106–13

Wormald, F. and Giles, P.M., 1982. *A Descriptive Catalogue of the Additional Illuminated Manuscripts in the Fitzwilliam Museum Acquired between 1895–1979*, Cambridge

Wright, R.P., 1960. 'Roman Britain in 1959. II. Inscriptions', *JRS* **50**, 236–42

Wright, R.P.W., Hassall, M.W.C. and Tomlin, R.S.O., 1976. 'Roman Britain in 1975. II Inscriptions', s.v. 'Huntingdonshire', 32–5; s.v. 'Chesterton, Durobrivae, TL 123967', *Britannia* **7**, 385–6

Yeates, S., 2004. 'The Cotswolds, the Codeswellan and the Goddess Cuda', *Glevensis* **37**, 2–8

Yeroulanou, A., 1999. *Diatrita: Gold Pierced-work Jewellery from the 3rd to the 7th Century*, Athens

Zadoks-Josephus Jitta, A.N., 1966. 'Imperial Messages II', *BABesch* **41**, 91–104

Zazoff, P., 1983. *Die Antiken Gemmen*, Munich

Zehnder, F.G., 1999. *100 Bilder und Objekte, Archäologie und Kunst im Rheinischen Landesmuseum Bonn*, Cologne

Zienckiewicz, J.D., 1986. *The Legionary Fortress Baths at Caerleon* **1**, *The Buildings*, Cardiff

Zwierlein-Diehl, E., 1997. 'Constantinopolis et Roma. Intailles des Ive et Ve siècles après J.C.' in M.A. Broustet (ed.), *La Glyptique des Mondes Classiques*, Paris, 83–96

INDEX

PICTURE CREDITS